Storey's Illustrated Guide to

96 Horse Breeds
of North America

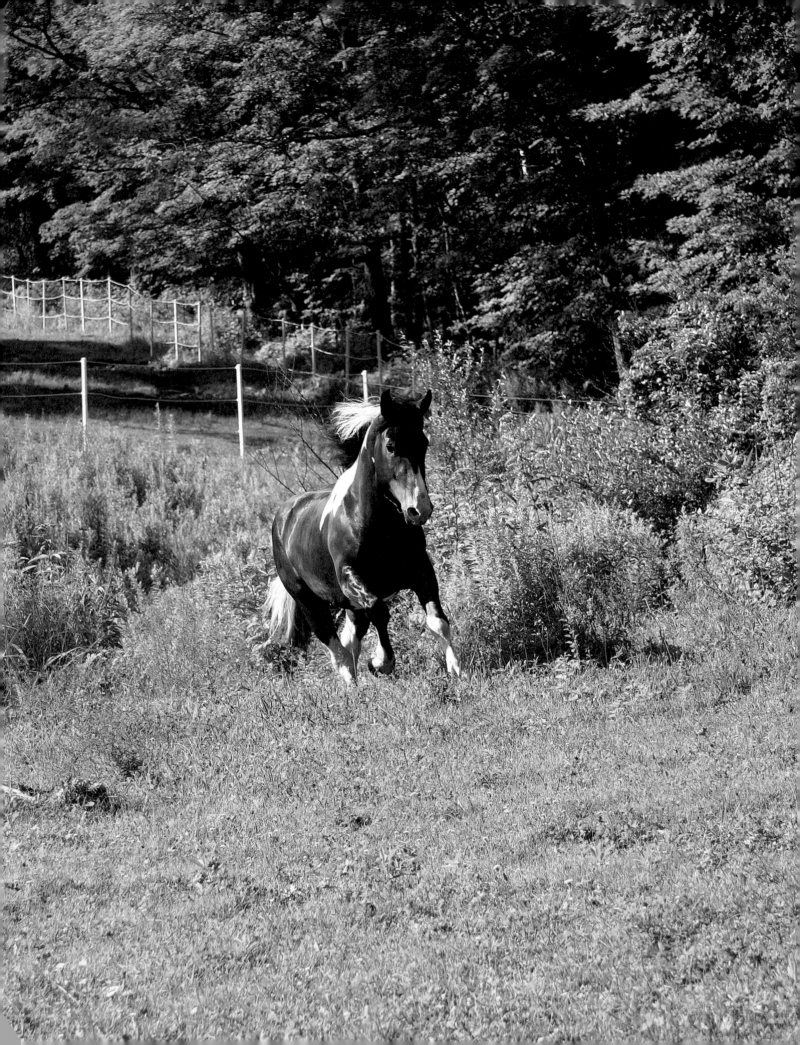

Storey's Illustrated Guide to
96 Horse Breeds
of North America

Judith Dutson

Photography by Bob Langrish

Storey Publishing

The mission of Storey Publishing is to serve our customers by publishing practical information that encourages personal independence in harmony with the environment.

Edited by Deborah Burns, Sue Ducharme, and Lisa Hiley
Editorial assistance by Candace Akins, Melinda Sheehan, and Doris Troy
Cover design and art direction by Vicky Vaughn
Cover photographs of Choctaw (front) and Rocky Mountain Horses (back) by Bob Langrish
Frontispiece photograph of North American Spotted Draft Horse by Adam Mastoon
Text design by Kent Lew
Text production by Liseann Karandisecky and Kristy L. MacWilliams
Image acquisition by Ilona Sherratt
Image management by Laurie Figary
Prepress by Kevin A. Metcalfe

Photographs by Bob Langrish, with exceptions listed on page 399
Illustrations by Jo Anna Rissanen
Indexed by Susan Olason/Indexes & Knowledge Maps

Printed in the United States by Von Hoffmann
10 9 8 7 6 5 4 3 2 1

Library of Congress Cataloging-in-Publication Data

Dutson, Judith.
Storey's illustrated guide to 96 horse breeds of North America / by Judith Dutson ; photographs by Bob Langrish.
 p. cm.
Includes bibliographical references.
ISBN-13: 1-58017-612-5; ISBN-10: 1-58017-612-7 (pbk. : alk. paper)
ISBN-13: 1-58017-613-2; ISBN-10: 1-58017-613-5 (hardcover : alk. paper)
1. Horse breeds—North America. 2. Horses—North America. 3. Horse breeds—North America—Pictorial works.
4. Horses—North America—Pictorial works. I. Title: Illustrated guide to 96 horse breeds of North America. II. Title.

SF290.N7D88 2005
636.1'097'022—dc22
 2005021730

This book is dedicated to all the world's horsemen.

What do we know of the horse's ancestral soul
We can only observe and be moved.
— Francesca Kelly

Contents

Acknowledgments

Many, many thanks to all the friends, relatives, horsemen, and breed organizations who helped me with this project in one way or another, and especially the following people, creatures, and things.

JOHN ACKER, English teacher and friend. He will be missed. TODD ADAMS, my trusted farrier. DR. JEFF ANGLES; all good horse books need Japanese literature scholars. DREW BANBURY, friend, extreme gardener, and koi breeder. BARBARA BARROW, who doesn't care all that much about horses but was encouraging anyway. ANNE BARTLEY, friend and horseman, who made many useful suggestions. KATHARINE BRADFORD, a friend whose encouragement to write kept me going for a long time. ANN BRAMSON, publisher. GARY BOERGER, who would really rather not bale hay but does it anyway. CINDY BOWERS, who provided many fine dinners along with useful suggestions and a good bit of commentary. DR. WILLIAM DREGER, who provided political commentary and mental health evaluations. VIRGINIA HARTER, a wonderful horse friend for many, many years who was endlessly encouraging. BONNIE HENDRICKS, who wrote the masterpiece. HENRY HEYMERING, fellow Clarkie, horseshoeing historian, and famous farrier. JODY HOCH, friend and horseman, who provided many useful suggestions and listened often. DR. JOHN HUBBELL, friend, horseman, and Standardbred expert. LORIE KIPP, periodic sidekick, horseman, and friend who offered useful suggestions and looked up more than a few arcane facts. DR. CATHERINE KOHN, a horse friend since the second grade and, conveniently, a veterinary expert. ROSALIND MERCIER, who brought an elegant perspective and special treats to dinners. COLLEEN OAKES, friend and horseman, who knows all about carrying on when the world appears to be against you. JANE O'REILLY, my extraordinary cousin who knows about writing, publishing, spy work, and how to keep somebody going in very long, dark times. HOPE REISINGER, my wonderful niece whose encouragement and conversation were essential. DR. LOUIS RIVAS, Andalusian breeder. FRANK RODA, who sent all sorts of useful facts about Kigers. SARA ROGERS, longtime friend and horseman, who provided much useful commentary. DR. STEPHEN SCHUMACHER, horseman, friend, and keeper of my sometimes dog. DR. FERNANDO SILVERA, a Mangalarga expert from the old country. THE OREGON HORSEMEN'S ASSOCIATION. SANDY WOODTHORPE, Union activist, writer, and friend. THE NATIONAL WRITERS UNION. DR. WEI LIN HSU, who needed to know a few things about horse breeds before she got into vet school and accidentally inspired this book. Sorry it's several years late. GOOGLE; it never failed. This project simply would have been impossible without it. ISA AND ZING, loyal dogs.

Many thanks to my unmet but oft e-mailed friends, guides, and helpers at Storey:

BOB LANGRISH, extraordinary horse photographer. DEB BURNS, editor. LISA HILEY, associate editor. MELINDA SHEEHAN, editorial assistant. VICKY VAUGHN, in-house art director. JO ANNA RISSANEN, illustrator and horse person. ILONA SHERRATT, illustration editor. LISEANN KARANDISECKY, designer. KRISTY MACWILLIAMS, designer. LAURIE FIGARY, image manager. KEVIN METCALFE, photo editing. KENT LEW, art director.

Preface

Horse breeds are more like shifting sand dunes than one might expect. Sand dunes are inclined to stay in one general location. If looked at closely, however, especially through time-lapse photography, the shape of each can be seen to change constantly with the winds, the seasons, and the storms. Over a long enough period dunes may actually move, grow, or disappear.

The details of horse breeds are equally fluid and difficult to immobilize. The best that can be done is to document available information at one point in time, knowing that it will not stay the same forever. We have made every effort to ensure that the information presented in this book is accurate and up to date. Breed associations were contacted for the most recent population statistics, which are meant as measuring posts to indicate the relative size of a breed today.

In most of the descriptions of horses, we have used the breed standards almost verbatim, shortening them occasionally to save space. Because the descriptive terminology is specific but limited, similar phrasing will appear in many of these. The terminology is sometimes quite old: it is the language of horsemen.

Many more breeds of light horses exist than of draft horses or ponies. This is because light horses have been selected to perform a wide variety of tasks, and because the group includes the horses that are best suited to the needs of most adult riders. By contrast, there are fewer breeds of draft horses, because they have all been selected for similar tasks and because the onset of gasoline-powered engines brought a sudden end to their use in many places.

Some of the breeds included here have astonishingly large numbers of horses, and some are teetering on the very brink of extinction. It is sometimes surprising to discover which are which.

Any reader who would like to send updated information about a breed is welcome to submit it to the author in care of Storey Publishing.

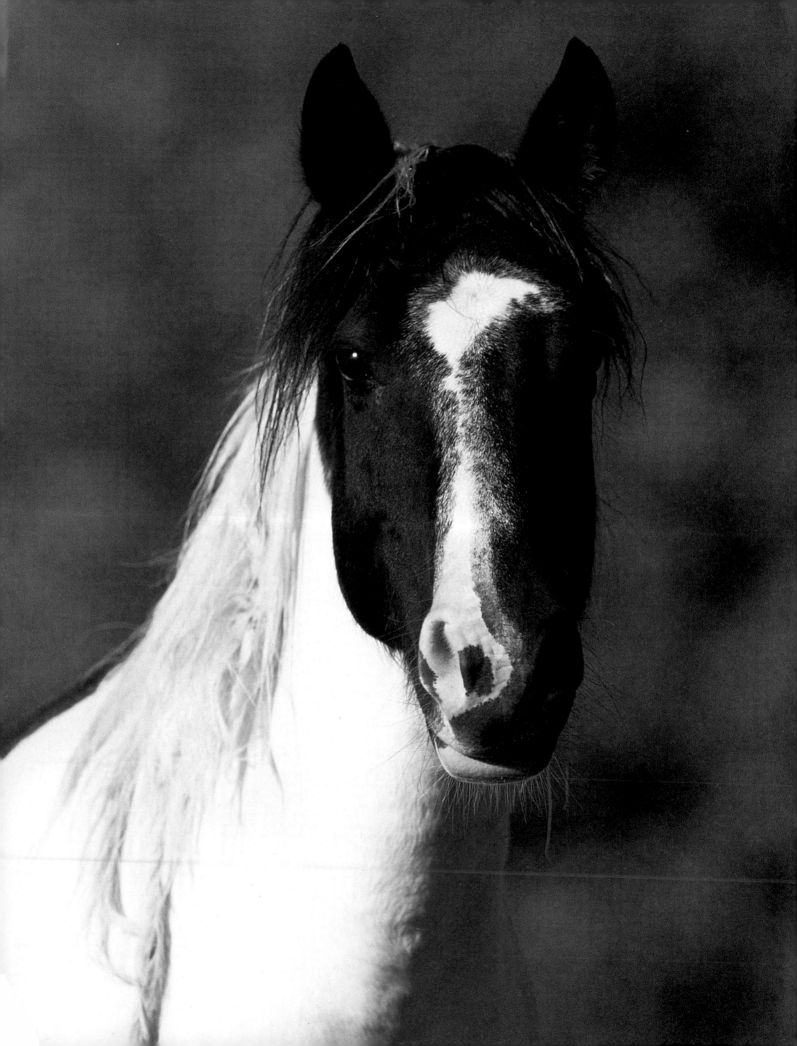

An Introduction to Breeds

THE HISTORY OF DOMESTIC HORSES, donkeys, and mules in North America is inseparably intertwined with the history of European settlement. The first domestic horses arrived in this hemisphere on Columbus's second voyage, in 1493. Soon Spanish horse-breeding operations were well established in the Caribbean, and within twenty years they were exporting horses throughout the New World. Everywhere people went they took horses, and everywhere horses were taken to they became established.

Horse types arrived first, selected for the jobs they were to perform. Continued selection for particular traits then caused types to evolve to fit a huge array of human needs and wants as well as climates and terrain, and over time the types became breeds, with each section of the continent developing its own.

In addition to native breeds, imports continue, from European warmbloods to the extraordinary Marwari of India. North America is now home to more than ten million horses who bring pleasure and their own magic to the lives of their owners.

Typical of an American Indian horse, the Choctaw is characterized by intelligence, toughness, and beauty.

About Breeds and Species

To understand what makes one horse breed special and distinct from others, you first have to understand what a species is. All of the horses mentioned in this book are from one species with the Latin name *Equus caballus.* Donkeys are a separate species, *Equus asinus,* and Przewalski Horses are another separate species, *Equus ferus przewalskii.*

The term **species** is most often used when discussing naturally occurring wild animals. For our purposes, a useful definition is: a population of genetically related animals that for biological, geographical, or behavioral reasons is restricted to breeding among its own members in order to produce offspring that are capable of reproduction.

In comparison, a **breed** is a collection of domestic animals (within a species) selectively developed by breeders to possess certain specific traits. Various cultures throughout history intentionally bred different types of horses for different purposes and thus developed distinct breeds. For example, some people needed big, heavy horses to pull plows or transport loads, while others wanted fast horses for riding or racing. To establish a breed, the desired traits must be passed on through multiple generations.

In the wild, only offspring produced from within a species can perpetuate the species. When a breeding limitation is biological, it usually involves the numbers or shapes of chromosomes. Sometimes the chromosomes of closely related species are so alike that the two species may be crossed in captivity, but this almost never happens in the wild for geographic or behavioral reasons. For example, the two species may live so far apart that they never meet, or they may have been apart from each other for so long that they no longer recognize each other's courtship displays.

In cases where it is possible to cross species in captivity, the resultant offspring, known as **hybrids,** will often be infertile. The hybrid may have a different number of chromosomes than either of the parent species. The classic example of this is the mule. A mule is a hybrid produced by crossing an ass (donkey) **sire,** or father, on a horse **dam,** or mother. The ass has 62 chromosomes. The horse has 64 chromosomes. The mule foal will have 63 chromosomes, and, under a powerful enough microscope, some of those chromosomes will appear to be in mismatched pairs.

Domestic and **domesticated** are terms that describe groups of animals that have

been selected and bred by human beings for various specific purposes. The horses, ponies, donkeys, and mules discussed in this book are all domestic animals, which means that human beings have been selectively breeding them, sometimes over thousands of years, to produce animals with specific traits that are useful for specific purposes.

Wild and Feral Horses

In contrast to domestic horses, there is only one true *wild* horse on the earth today: the Przewalski Horse (pronounced sha-VAL-ski), *Equus ferus przewalskii.* Also known as the Asiatic wild horse, it originated in Russia, Mongolia, and Kazakhstan and became extinct in the wild around 1969.

You might be lucky enough see some of these endangered horses in a zoo or a wild animal park. As of January 2004, the date of the most recent international Przewalski census, the world population totaled 1,691 horses, held in 188 zoos and collections around the globe. By the most recent count, there are 154 in North American collections.

Several international programs are under way to reintroduce captive-bred Przewalski Horses to parts of their original range. Some of these programs are better managed, better funded, and more successful than others; the most successful to date is in Mongolia. The management of the captive herds in zoos, particularly the selection of specific stallions to be crossed on specific mares in order to avoid inbreeding and other problems, is orchestrated through the International Asiatic Wild Horse Studbook. The U.S. part of the International Studbook is presently managed by the National Zoo. In addition, the Studbook and herd managers use several powerful computer programs to genetically track individual horses and mathematically model population trends in an effort to thwart future genetic problems in the herds.

Przewalski Horses are not domestic animals, and in fact they belong to a different

The Przewalski Horse is the one true wild horse on earth today, but it lives only in captivity.

species than our domestic horses, and a different **subspecies** than the only other member of that species.

A subspecies is a division of a species that has usually arisen as a consequence of geographic isolation. Subspecies members are potentially capable of interbreeding with other members of the species. They are very close relatives.

The other member of the species to which Przewalskis belong was the Tarpan, with the Latin name *Equus ferus ferus.* Zoologists sometimes call it the European horse. The original Tarpan is extinct both in the wild and in captivity, but a horse was re-created in some preserves and zoos in Europe from the last living Tarpans and very similar-looking domestic horses. These animals very much resemble the original and are also called Tarpans.

The decisions about whether Przewalski Horses, Tarpans, and domestic horses belonged to the same species, what was a subspecies, and what they should each be named make up a long and convoluted history conducted in several languages from about 1760 to the mid-1980s. The most important conclusion is that Przewalski Horses are much closer relatives of domestic horses than are asses. For this reason, hybridization between Przewalski and domestic horses works differently from how it does between asses and horses.

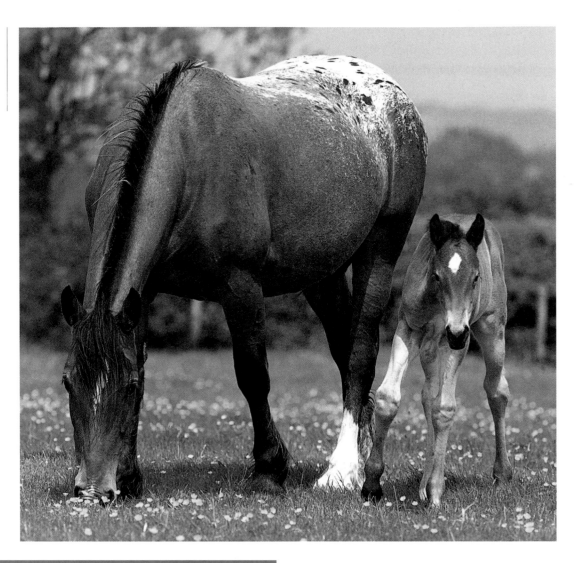

A spotted Appaloosa mare can give birth to a solid-colored foal. The foal, in turn, may produce offspring with spotted coloring.

GENETIC DECODING

Researchers such as Dr. Phillip Sponenburg and Dr. Gus Cothran have been working to unlock the genetic history of horses. In particular, they have been able to trace the ancestry of modern feral strains back to the Spanish horses that came over with the Conquistadores. Here are a few concepts with which they work.

DUN FACTOR. A particular genetic trait that dilutes body color (see appendix). It also produces dorsal stripes (also called linebacks) and sometimes shoulder crosses, "zebra striping" on the legs, and cobwebbing on the face.

GENETIC MARKER. A particular gene or gene sequence with a known location on a chromosome and associated with a particular trait.

MITOCHONDRIAL DNA. Genetic material that is passed on, nearly unchanged over generations, entirely from the mother.

GENOTYPE. The genetic makeup of an animal.

PHENOTYPE. The visual appearance of an animal or a group of animals. The Kiger Mustangs are all of a similar phenotype.

Przewalskis have 66 chromosomes, while domestic horses have 64. If you deliberately cross a Przewalski Horse on a domestic horse, you get an animal with 65 chromosomes. It is able to reproduce, but it is not genetically identical to either of the parent species. If the hybrid horse is bred back to a domestic horse, subsequent generations will have 64 chromosomes, just like the domestic horse side of the family, and very few of the characteristics of the Przewalski Horse.

The Przewalski may well be the last living ancestor of all domestic horses, and this breeding limitation is one of the reasons it has been very difficult to find pure Przewalski Horses to use to save them from extinction. The prevailing scientific opinion holds that there may be no Przewalskis that are absolutely free of the genetic influence of

domestic horses. Time and advances in DNA techniques may someday prove this point one way or the other.

Deciphering DNA

In 1988, Ollie Rhyder, of the San Diego Zoo, used **mitochondrial DNA** to estimate when Przewalskis diverged from other ancestors of domestic horses. Mitochondrial DNA is genetic material found outside of the chromosomes in a part of the cell called the **mitochondrion.** It is passed on, nearly unchanged from generation to generation, entirely from the mother. But small mutations and tiny increments of change occur in this DNA, very slowly over many, many generations. The rate of change is almost constant and thus predictable, so scientists can compare samples of two related species and determine when they last existed as one species.

Using this method, Rhyder estimates that the Przewalski diverged from domestic horses about 250,000 years ago. There are some technical challenges to mitochondrial DNA that suggest it might not be as pure a method as was once thought, but the theory itself is still widely accepted, and when used as one piece of the puzzle, it remains a powerful tool.

Mustangs

Many North Americans think of Mustangs as wild horses, but more accurately they are descendants of escaped domestic horses that now live freely in undomesticated circumstances. The biologist's term for this is **feral.** Our Mustangs are all feral horses, not true wild horses, although from a handling perspective, captured Mustangs certainly can be wild.

Establishing Breeds

To establish a breed, the chosen traits must be passed on through multiple generations. The mechanism breeders use to identify and perpetuate their desired traits is the **breed standard,** a listing of essential qualities for a breed. When a group of knowledgeable horsemen derives a breed standard identifying the qualities it wants, and then, through selective breeding over multiple generations, succeeds in producing the traits it desires most of the time, it has established a breed — even if not every horse in each generation possesses every one of the desired traits.

For example, one of the most desired traits in Appaloosas is spotted color; nevertheless, solid-colored Appaloosas turn up within the generations. At one time, such horses were unregisterable, but research has shown that solid Appaloosas may produce

BREEDING TERMINOLOGY

Breeders have their own vocabulary to describe breeding issues and procedures. Here are a few definitions.

CROSS-BREEDING. Deliberately crossing horses of different breeds. This technique produced all of our modern breeds.

CROSSING ON (IN). Deliberately crossing horses of different breeds together. Example: Arabs are crossed on Morgans to produce Morabs.

HETEROZYGOUS. The genetic term describing an individual who has received a different form of a particular gene from each parent. Example: *E* is the gene for base body color. It may appear in either the dominant form *E* or the recessive form *e*. A heterozygous horse, receiving one of each, would be *Ee*.

HOMOZYGOUS. The genetic term describing an individual who has received the identical form of a particular gene from each parent. Using the example above, a homozygous horse would be either *EE* or *ee*.

INBREEDING. Deliberately crossing horses that are very close relatives in order to increase the appearance of specific traits in future generations. This includes brother x sister, father x daughter, and mother x son matings.

LINEBREEDING. Breeding horses of the same family line together to preserve certain traits. This term does not include brother x sister, father x daughter, or mother x son matings.

OUTBREEDING, OUTCROSSING. Deliberately crossing one line of horses within a breed to a very distant or unrelated line. The term is also occasionally used as a synonym for cross-breeding.

PREPOTENCY. The unusually strong ability of an individual to transmit its traits to its offspring. In horses the term is almost always used when speaking of particular stallions. Example: Justin Morgan was a terrifically prepotent sire.

An old-fashioned working draft horse (left) has shorter legs and a thicker neck than a show-type draft horse (right), which is bred partly for visual appeal.

wonderful colored offspring. For this reason, the breed association now recognizes these animals as "breeding stock" and allows them to be registered. Although every horse in every generation may not be spotted, spotted color remains a key genetic feature of the breed.

With Quarter Horse breeders, a long-term policy requires a solid color. If a horse is born with a big white spot on its side, it is not registerable as a Quarter Horse. Breeding such an animal might produce another generation of undesirable spotted horses.

Changes over Time

When we think of a breed, we probably create a mental image of it and think that is how such horses should look forever and always. Breeds do change over time, however. Sometimes the changes have to do with the use of the breed. Before there were tractors and cars, horses did the farmwork, the heavy military work, and the lighter, faster cavalry work. There were breeds for every domestic purpose, and some of them were very old breeds. But after World War II, horses weren't required for most of that work because vehicles took over those roles, and the role for horses became largely recreational. Modern breed standards had to change to keep up with the new requirements.

In Germany, for example, Hanoverians were once used for farmwork, as elite coach horses, and for medium-heavy military work. A lighter version of the breed was used for the cavalry and for riding. The market for coach horses ended with the advent of trains in about 1850, and the majority of farmers used tractors instead of plow horses after World War II. The days of the cavalry were over forever, but breeders of Hanoverians wanted to continue. They set about adjusting their horses to fit post-war needs, emphasizing the lighter conformation that had long been a part of their breed and selecting for traits that made the horses highly suitable as sport horses.

Modern Hanoverians excel in the equestrian sports you see in the Olympics, particularly dressage, combined driving, and show jumping, as well as in activities such as fox hunting. The breed was carefully and deliberately modified to fit changing uses, although many of the original qualities found in Hanoverians for centuries are still present and still selected for in today's lighter horses. To facilitate the change in type, the breeders needed to allow admixtures of other breeds. They carefully evaluated individual horses of other breeds and then granted them special breeding stature within the registry. Today you may see a Thoroughbred or an Oldenburg stallion

advertised with a note that the Hanoverian registry has approved it. This is actually a time-honored approach used in many breeds to incorporate the best available genetics into their breeding animals.

Fashion Trends

The tradition of showing also contributes to the changing appearance and emphasis of a breed over time. Show-judging trends, as well as forces of fashion, play important roles in breeding and noticeably influence the look and often the size of breeds. Many people are surprised to learn that even huge draft horses are increasingly used primarily for recreation and showing.

Amish horsemen, as well as other farmers and loggers who still work their draft horses, express concern that the horses now winning in the show ring are not the ones that are the most useful on the farm. For their needs, the really effective, utilitarian workhorses tend to be relatively short-legged, a characteristic often paired with thick necks. The types currently winning at the shows, however, tend to be the longer-legged, longer-necked, huge, beautiful horses that are impossible for judges to overlook and are simply awesome to watch in parade hitches.

Amish farmers are, by their faith, not allowed to show horses, but they do sell horses, and so the fashion trends in the show ring put them in something of a quandary. They have to choose one type or the other. What they would most like to use on the farm is not the type that wins at shows and therefore sells for the most money. Although they aren't happy about it, many of the Amish succumb to economic pressures and breed the show or modern-type draft horses. The less elegant, old-style, shorter-legged horses in almost every draft breed are becoming something of an anomaly.

This trend probably contributes to the continued rarity of the fine, useful, old Suffolk Punch, a draft breed distinguished by being short-legged and stocky. Their breeders have remained loyal to their old-type draft horses, and although they are as useful as ever on the farm, Suffolk Punches just aren't as dazzling as some of the other breeds in parades or shows.

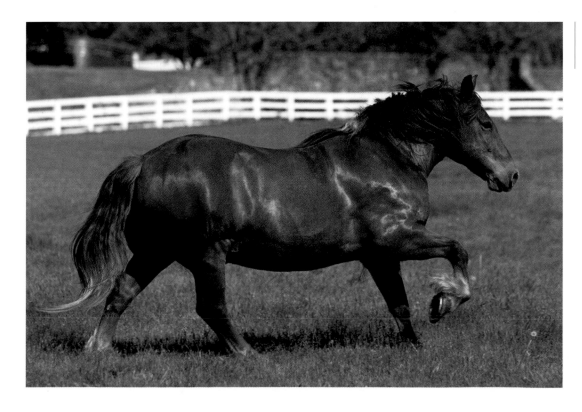

The Suffolk Punch is an old, stocky, short-legged draft breed that is now quite rare.

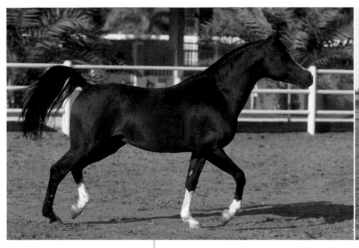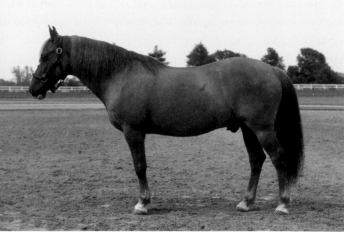

The classic Arabian traits of long legs, a small head, large eyes, a dished profile, and a higher tail set (left) contrast with the Spanish traits of small size, flat sides, a straight or Roman profile, large hooves, and a low tail set (right).

Arabization

Overall, in show rings everywhere, in every breed from Belgians to Miniature Horses, there is a tendency for bigger, longer-legged, bigger-eyed, prettier-headed horses to win the ribbons. This trend to develop a shorter head from the eye to the nostril, a more dish-faced profile, big eyes, longer legs in proportion to the body, and a higher-set tail is known as Arabizing to those interested in the genetics and history of breeds.

Long-legged, pretty horses sell. Sometimes this means that very useful, historically interesting, and possibly genetically valuable types of horses are going by the wayside. Some traits that were common in the horses ridden by the Moors, the Conquistadores, all the early ranchers, the Indians, and the cowboys — traits that have proved to be useful for hundreds of years and that persist over many generations when the horses run free — are now being selected against.

Spanish Traits

Most notably, relatively small size, a long head with a straight or convex profile, a comparatively narrow chest, a short back, flat sides, flat muscle, and a low, angled croup with a low tail set were all traits present in the first horses ever imported to the New World. This collection of traits, along with a few others, such as fairly large, very

hard, and well-shaped, durable hooves, are known as Spanish traits. This time-proven, functional conformation is not always breathtakingly pretty.

These traits persist today in the ponies from the Outer Banks of North Carolina (see Shackleford Banker Ponies in part IV), a population that has been geographically isolated with virtually no influence from other types since the late 1500s. Spanish traits can still be found in all the Indian breeds, the Spanish Mustangs, Barbs, Florida Crackers, and others, including Lipizzans. Those who like the history and the usefulness of the breeds with Spanish traits are working hard to maintain this important genetic heritage and to prevent these horses from becoming Arabized. (See chapter 2 for a further discussion of Arabian and Spanish traits.)

The Human Factor

Human errors and dishonesty have also affected breeding in North America. Until DNA came into wide use in the registration of horses during the 1980s, the tracking of individual horses was achieved strictly through registration papers and notation of markings and tattoos. This meant that it was possible through accident or dishonesty for horses to end up with the wrong papers. Usually when this happened, it was within a breed, such as when a lesser horse was sold with the papers of a better individual. But sometimes there were acciden-

tal or deceptive admixtures of breeds that facilitated large changes in the look of an entire breed over time. If the breed was a small one both in number and in size, and a proportionately large number of breeders were sneaking in big horses of various breeds, it substantially changed the original breed characteristics.

What Is a North American Breed?

Identifying and selecting North American horse breeds is a complex and imprecise process. If you take it back far enough, **crossbreeding,** the deliberate crossing of horses of different breeds, produced all of the modern breeds. Back in the plantation days it was crossbreeding that produced the Tennessee Walker, the American Saddlebred, the Standardbred, and all the other uniquely American breeds. The Morab was created long ago as a cross of Morgans with Arabians. The National Show Horse is a more recent cross of the American Saddle Horse with the Arabian.

Which of the more recent crossbreds should be included in this book? The answer relates to breed standards and consistency of type over time. In the case of a deliberate effort to create a new breed, there must be a reason for the breed to exist and a breed standard that defines the qualities that are important. In addition, the desired traits must be consistently reproducible over multiple generations, usually a minimum of three. However, every effort was made to be inclusive here, simply because horse breeds in all their diversity are interesting to horse people.

Should imported breeds be included in a book about the horses of North America? Modern horses began arriving in North America in 1493, and the importation of horses has never stopped. We have developed a wide variety of interesting and useful breeds in this hemisphere, yet people are still importing horses from Europe, Iceland, Central and South America, Australia,

and elsewhere. These horses compete on American Olympic teams; they are seen in shows and on trails all over the country. Why exclude them?

What about associations that are based on color but not on a true breed? Are Pintos worth mentioning, or Palominos, or Buckskins? Again, because the purpose of this book is to present the wonderful assortment of horses in North America, it seems wise to be as inclusive as possible.

Most entries that follow are true breeds, some might be popular crossbreds, a few others are favored colors. Some of them are horses you have heard of all your life, while others are quite rare and may be new to you, even though they have a long and fascinating history. All are horses you can find in North America at the beginning of the twenty-first century, and all are worth learning more about.

SAVING RARE BREEDS

For help in compiling this book, we have consulted the associations of the various breeds for current statistics. We have then used American Livestock Breeds Conservancy (ALBC) designations to distinguish a rare breed from a stable population and from the more common breeds.

The ALBC exists to help document and maintain the valuable and historic genetic diversity of animal breeds. Just as it has been discovered that seed banks of very old and rare varieties of domestic plants turn out to be an extremely valuable resource, so it is that maintaining populations of rare breeds of livestock is also essential. The ALBC keeps track of, and, when necessary, desperately tries to prevent the extinction of, rare and historic breeds of all sorts of animals, from chickens and turkeys to cattle, sheep, swine, and horses. They know just how few Suffolk Punches, Shackleford Banker Ponies, Choctaw Horses, and even true Texas Longhorn cattle there are.

Their work is both interesting and critically important. Who knows in what ways and at what time we might need some of the genes from the old rare breeds, perhaps for disease resistance, perhaps for some purpose we cannot yet imagine? I encourage you to join and support the ALBC; it has a nominal annual membership, it does important work, and you can read about it in its interesting newsletter or learn about it firsthand at its clinics and meetings. (See the appendix for more information.)

How Horses Arrived in North America

The first domestic horses came to the New World with the Spanish. There were horses and donkeys on board as early as Columbus's second voyage, in 1493. At that time, Spanish men were required by law to ride horses, because for a while mules had been so popular that the horse-breeding industry suffered.

Spanish men rode only stallions. Mares were strictly breeding animals, a tradition maintained to this day by Spanish breeders of Andalusians. Because of the obvious need for broodmares in the New World, however, King Ferdinand ordered that five of the twenty lancers accompanying Columbus on his second trip should have two mares each; the other lancers had one stallion each. The mares were selected to serve as riding horses and as foundation broodmares.

All of the horses going to the New World were to be very fine animals from Andalusia. The king and queen wanted to send especially good-quality horses to establish breeding herds. The sale of horses was then a huge industry for Spain, which was noted for having the finest horses in the world. Thus it was a sound business decision to quickly establish the nation's prominence as one of horse breeders and stockmen of all types in the New World.

The lancers who were to travel with Columbus on the second trip, however, had other ideas. Knowing they would be gone a long time and that they might never see their old friends again, they went out for a major celebration before they set sail. They traded their good horses for a bunch of poor-quality nags and used the monetary difference to buy drinks for all. Consequently, the first horses to arrive in the New World were not the best Spain had to offer after all.

Spanish Horses

In the early Middle Ages, Spain was a world-famous center for horse breeding. The Spanish bred fairly heavily muscled horses that were ideal for the military purposes of the time.

Both horses and men wore armor in battle. Knights rode in saddles that virtually trapped the rider between the tall cantle and the pommel, with very long stirrups. Although the saddle was quite different from a dressage saddle, the position of the knight was similar to that of today's dressage rider, a lasting link connecting the contemporary sport with its roots in the military horsemanship of the Middle Ages.

The riding style of early medieval knights was known as *a la brida.*

In 711 CE, the Moors had invaded Spain from North Africa with the goal of conquering it. Among the first Moors were many Berbers, who rode fast little desert-bred Barb horses that could run circles around the heavy Spanish horses. ("Barb," a much later term, is a derivative of the word Berber.) Riding with short stirrups, the Moors could stand up and throw their lances, using the horses' momentum to increase the range. They also neck-reined their horses, which significantly improved their mobility in battle.

This style, which came to be known in Spain as riding *a la jineta,* gave the Moors a huge advantage in war, and, in what amounted to "round one," the Moors beat the tar out of the Spanish. The Spanish, of necessity, learned from the experience.

They had plenty of time to learn. The Moorish invasions of Spain continued until just before Columbus's first voyage, a span of about 780 years. During that period, the Spanish crossed the quick little Moorish Barbs with their own horses and produced much faster, handier animals. They learned to ride with short stirrups the way the Moors did and also to neck-rein. They couldn't abandon the *a la brida* technique completely, however, because they needed to maintain that style of riding for other European military uses.

The best horsemen studied both styles. It was such a high compliment to say of a gentleman that he was skilled "in both saddles" that it was frequently engraved on tombstones.

Barbs and Arabs

The Moorish horses are sometimes alleged to be Arabians. It is unlikely, however, that North Africans brought horses all the way from Syria and the Arabian Peninsula to fight in Spain. Historians believe that a few, perhaps two hundred, of the soldiers fighting with the Moors were Arab people, possibly on Arabian horses, but that the vast majority of the invading armies were North African Moors riding their own horses, which were Barbs. Barbs do have some heritage in common with Arabs, but they are quite different from them, just as Thoroughbreds share a heritage with Arabs but are quite different as well.

One important difference between Barbs and Arabs is the shape of the croup. Arabians have always been noted for their high, flat croup and high tail carriage, whereas Barbs have a sloping croup with a low tail set. Horsemen of the time were very observant about such things because the success

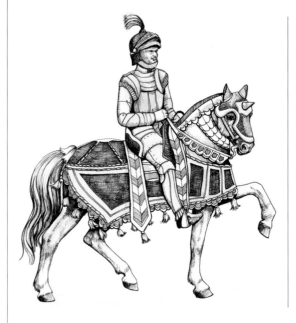

A la brida riding was the style used by knights of the Middle Ages in their formalized battles and tournaments. When a horse galloped toward a foe in a jousting tournament, the rider held the lance straight forward, and it was the power of the horse, transmitted through the lance, that unseated the rival. The stirrups were long and the pommel and cantle of the saddle were high, giving the rider maximum stability. The horses worked in straight lines, so steering them was not a major concern.

A la jineta riding was brought to Spain by the Moorish invaders, who also brought a different style of warfare. Because the stirrups were short, the riders' knees were bent, which allowed them to stand up to hurl lances. The horses were taught to neck-rein, which made them highly mobile in battle.

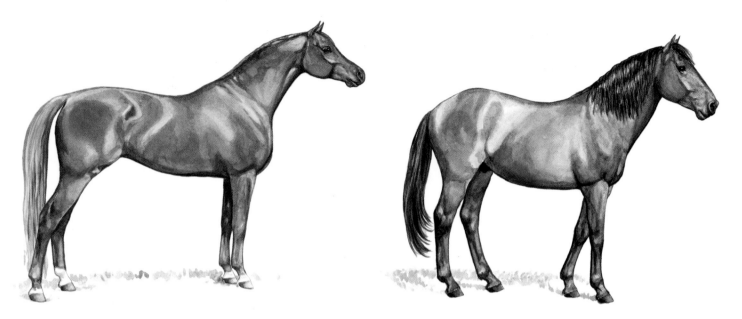

The Arabian (left) has a high, flat croup and a high tail set. The Spanish horse (right) has an angled croup and a low tail set.

of the army and survival of the country depended in part on how well adapted the horses were for battle. The sloping croup was a trait carefully selected for by the Spanish. It predisposes horses to bring their hind legs up underneath themselves, which makes it easier for them to balance and turn quickly. This trait persists in many breeds in both North and South America today, as well as in many of our feral horses.

Travel by Sea

Ship travel for horses was nothing less than hideous in those days. Woodcuts and paintings of the time show us how horses traveled. They were swung aboard from the shore by means of slings hoisted on pulleys. Once on the ship, they were allowed as little space on the tiny deck as could possibly be arranged. They were slightly suspended off the deck by means of a sort of hammock, which kept them from falling overboard or kicking free and escaping onto the deck if things got rough or if they were going crazy from the confinement. The hammock was secured by rings and ropes to parts of the ship, and the horses' front legs were tied together. Tiny mangers were in front of them, though food and water were severely rationed from the time the ship set sail because nobody knew how long the trip was actually going to take.

The horses were completely exposed to the elements; salt water and sun scalded their skin. Possibly somebody brushed them. Stallions were separated from mares. In rough weather the horses constantly slammed into things, suffering severe bruises and probably sometimes breaking ribs. When they arrived after months in this sort of confinement, they were simply untied and pushed overboard, because there was no other way to get them ashore.

As horrid as the conditions and treatment sound to us now, the Spaniards cared deeply about their horses. They had strong personal relationships with them and considered them to be true friends.

Before Columbus, no one had ever taken horses on a long, nonstop, open-ocean voyage. Horses had been transported across and around the Mediterranean, and probably other places, but every two hundred miles or so they were taken to shore or to islands where they could rest and recover. The horses coming to the New World didn't have that luxury, or *any* luxuries. The trip usually took from two to three months. Between 25 and 50 percent of the horses typically died during the trip.

But horses did arrive, and they thrived in the Caribbean, where the first breeding operations were set up. Until big herds were established, which took about fifteen years,

new stock continued to be imported from Spain, but after that, further importation ceased because Spain needed its horses at home for military campaigns in Europe.

Arrival in the New World

The first horses that arrived by Spanish ship were incredibly tough to have survived the journey at all. They were small, between 13.2 and 14.2 hands. As Robert Cunningham Graham writes in *Horses of the Conquest*, the horses of Columbus were "short backed, without much daylight showing beneath their bellies, and admirably suited for the hard work of the conquest. Their adequate pasterns made them comfortable to ride, while their legs, not too long and firmly jointed, showed that they were sure on their feet."

Some were Andalusians, long a world-famous breed, or their close kin. Some might have been Sorraia, an ancient small breed of dun-colored native ponies from Portugal. Sorraia were not favored as riding horses but were frequently used for packing and mundane tasks.

Another breed that most likely came to the New World was the Jennet, a very useful, small, often ambling or pacing horse, sometimes vividly colored, and originally from Libya. Sadly, this breed is now virtually extinct, though efforts are under way to restore it. (The breed name should not be confused with a female donkey, which is called either a **jennet** or a **jenny.**)

In addition to their skill as horsemen, the Spanish had a long tradition with donkeys and mules as riding and working animals, and they sincerely respected the amount of work these animals could perform. Donkeys traveled to the New World along with the first horses. They served as pack animals and to breed mules.

Gaited Horses

In addition to their look and size, horses were selected for comfortable gaits. Even in the first shipments that arrived, some

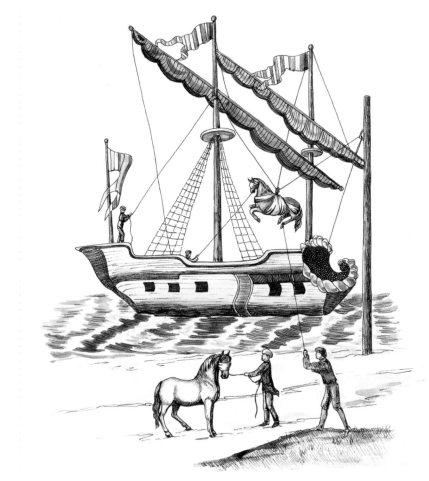

A drawing from an early woodcut showing how horses were loaded on ships in the days of Columbus. They probably tolerated the situation less well than it appears in the woodcut.

HOMEGROWN HORSES

For centuries, horse breeds were almost always types based within specific geographic areas. Breeders within one area typically bred for the same qualities in their horses, and often the breed was given the name of the geographic area. Andalusians were the type of horses bred in Andalusia, in the south of Spain. Andalusia is very close to Gibraltar, from which the Moors entered Spain, so this is where the influence of the Barbs was greatest.

horses were smooth-gaited. Diaz del Castillo left a complete list of the seventeen horses setting sail with General Hernán Cortés for Mexico. It includes the following: "Diego de Ordas had a barren gray mare, a pacer which seldom galloped."

For the purposes of this book, **gaited** will be defined as a natural tendency to offer gaits other than just the walk, trot, and canter. It was common in sixteenth-century Spain, as well as in many other places in the world, to ride and select for gaited horses. The reasons then were the same as they are now: smooth-gaited horses are comfortable to ride, and the gait can contribute speed without fatiguing the horse or the rider.

Today in North America we enjoy the descendants of the first New World gaited horses: Paso Finos, Peruvian Pasos, and Mangalarga Marchadors—a breed that is extremely popular in Brazil and just beginning to arrive in the United States—as well as many other gaited breeds.

ANCIENT HOOFPRINTS

The tendency for a horse to be gaited appears in horse breeds worldwide and has existed for a very long time. In 1979, the anthropologist Mary Leakey discovered the fossilized hoofprints of a group of *Hipparion* horses in Tanzania. These three-foot-tall ancestors of today's horses, which existed about 3.5 million years ago, had three toes on each foot. The two side toes were a good bit smaller than the central toe, and although they were functional, the central toe did most of the work of locomotion. According to Stephen Budiansky, who has described this discovery in *The Nature of Horses,* analysis of these hoofprints strongly suggests that these ancient horses traveled at the running walk. Fossilized *Hipparion* hoofprints are comparable to the hoofprints of modern Icelandic Horses traveling at a very similar gait called the *tolt.*

Budiansky writes that this correlation provides some support for the claim that the running walk (which has other names depending on the particular breed) is an instinctive and natural gait. Horse breeders have long been aware that smooth gaits occur naturally, and with this remarkable fossil discovery, word finally began to reach the wider public.

THE SMOOTH GAITS IN THE AMERICAS

Considering that smooth gaits may go back millions of years, we should not be surprised that the tendency to be gaited seems to persist, or at least to appear, even in horses where there has been absolutely no attempt to select for it. The Kiger Mustangs are an isolated subset of mustangs from the Kiger Mountains in eastern Oregon that were rediscovered in the 1970s. They have strongly Spanish traits and are most remarkable for their color, because each of them is some variation of buckskin or dun. From time to time, they are rounded up and adopted for use as riding horses, and to the wonder of the owners, some of them show an inclination to be gaited. Even 150 to 200 years of living in the wild has not eliminated this tendency to gait. Also not widely known is the fact that the Nez Percé Indians, most famous for riding and breeding Appaloosas, sometimes rode gaited, spotted horses known today as the Tiger Horse, a rare but interesting breed.

Cowboys of the nineteenth and even the twentieth century rode gaited horses,

although this detail failed to make it into the movies. Cowboys may have been tough, but comfort counts when you spend your life in the saddle. They often chose smooth-gaited horses when good ones turned up that they could afford. The smooth gait that was then called the Indian Shuffle was so much easier on horse, rider, and even equipment that cowboys of the time would pay fifty dollars more for a "shuffler" than for an ordinary horse, in the days when a good broke cow pony cost about thirty dollars.

Missouri Fox Trotters are smooth-gaited and have a well-deserved reputation for being excellent cow horses. The Florida Cracker, a tough little cow pony ridden by cattle drovers who cracked whips and thus earned the name Crackers, was, and still is if you can find one, a decidedly athletic, useful, gaited cow horse. It is a breed that arose from the first stock that was shipped directly from Cuba to Florida in 1565. All over South America, gaited horses of one breed or another are used for ranch work and competitive cattle work.

If a horse is gaited, it certainly doesn't mean it can't do anything else. Roy Rogers, king of the cowboys in the 1940s and '50s, knew this. Trigger Junior, his famous Palomino from movies and television, was a Tennessee Walking Horse who often stole the show from his human partner.

Routes to North America

Once Spanish horses were well established in the Caribbean, they moved on to North America along a variety of routes. We all learned in grammar school about the Conquistadores coming north through Mexico and bringing horses with them, some of which escaped to become the feral herds of Mustangs of the Old West. The Plains Indians were vaguely alleged to have caught and made use of horses somewhere in the 1800s. Our lessons pretty much left it there, suggesting that was how all horses came to America. Not surprisingly, the truth is considerably more complex than that.

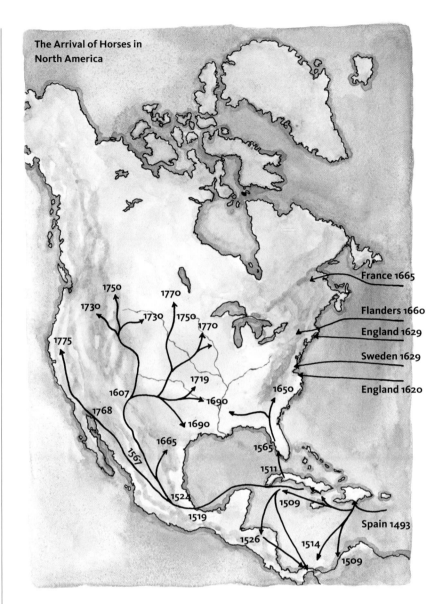

The Arrival of Horses in North America

On the island of Hispaniola in 1495, Columbus himself had the first significant military victory involving horses in the New World. Seeing a large group of natives, who seemed to be arming themselves, Columbus decided to strike first. He charged with a force of two hundred foot-soldiers, twenty horses, and a few dogs. This was the first time the natives had seen horses, and it scared them so much that they were badly defeated. Columbus recognized the value of horses in the New World, and from that point on he demanded that the king include some horses on every ship that was sent from Spain. As mentioned, the Spanish rode only stallions, but Columbus made sure that mares were included in

Once horses arrived in North America, they spread rapidly across the continent. Their impact on the history of the entire region was enormous.

every shipment. Well-managed breeding farms were set up almost immediately, and they were successful. Only five years later, one of them had sixty broodmares.

The early Spanish horse breeders knew what they were doing, and the conditions suited horses well. Looking back, José de Acosta wrote in the late 1500s that horses "multiplied in the Indies and became most excellent, in some places being even as good as the best in Spain, good not only for fast messenger work but also for war and the parade." Horses were soon exported from Hispaniola to other islands in the Caribbean, where breeding was also highly successful.

The onslaught of Conquistadore began in 1510, with consequent sudden need for many horses. These warriors demanded island-bred horses because they could be acquired quickly and could handle the climate better than animals sent directly from Europe. Cuba, Jamaica, and Hispaniola soon competed to sell horses and other supplies to the Conquistadore, but outfitting them with enough horses was hard to sustain and put a significant strain on livestock production.

The Spaniards did not comprehend at the time that no other horses were in the New World. Even after Columbus's death they believed there were horses somewhere on the mainland other than the ones they had brought or later bred. As the map on page 15 shows, early horse breeding spread to the mainlands in three streams: from Hispaniola to the northern coast of South America, from Jamaica to Central America, and from Cuba to North America.

EQUINE ANCESTORS IN NORTH AMERICA

Although the modern horse arrived on North American shores with the Spanish Conquest, its ancestors roamed this continent millions of years ago. The primitive horse evolved to live here, grazing the Great Plains and spreading throughout North America. Some wandered across the Bering Land Bridge into Asia. Around 10,000 years ago, *Equus* disappeared from the western hemisphere, and no one is certain why.

Three hundred horses arrived in Florida from Cuba with de Soto's fleet in 1539. He later marched into what is now Georgia. Settlement of Florida began in earnest when Admiral Pedro Menendes de Aviles arrived with one hundred mares and stallions as well as other livestock in 1565 and almost immediately established towns and ranches.

Menendes was known as a careful planner. When he organized his expedition, while still in Spain he wisely included 117 stockmen and farmers among his colonists. At first these colonists needed more horses than they were able to breed and raise, so some were sent directly from Spain and the rest were furnished by the king from the royal ranches on Hispaniola. By 1650, Florida and the rest of the Southeast boasted seventy-two missions, eight large towns, and two royal haciendas whose land extended well into present-day Georgia. Horses ran free on these lands, and many became feral. Some were taken by Indians who traded some to the English, and others migrated. In these ways horses spread north and west to the Carolinas.

Mexican Settlement

By about 1560, the Spanish discovered silver a bit north of what became Mexico City. This propelled a huge boom in human, horse, and cattle populations. The grassy high plains of central Mexico provided ideal pasture, and livestock numbers soared. Encouraged by success and goaded by greed, the Spaniards continued to attempt colonization both north and west of their Mexican silver strike. As they did so, they took animals with them.

Francisco de Ibarra, appointed governor of a large region to the north of Mexico City in 1562, was responsible for bringing livestock to a vast area. The first areas he settled had easy access to fertile river bottoms and grassy plains, and his livestock did well. The natives there coexisted with the Spanish, but they also stole horses and cattle. In one raid they took 250 horses; in

another skirmish they stole Ibarra's personal horse.

Ibarra attempted to cross the Sierra Madre two years later to set up colonies on the western side of the mountain range. The trip was brutal, with horses freezing to death in the mountains, but some of the party made it and set up a town. Not long afterward, native uprisings forced the settlers to abandon the town along with some of their horses and cattle and to retreat over the mountains. Twenty years, later when Hernán de le Tigro moved into the same area, he was astonished to find herds numbering in the thousands of horses and cattle. This may be one of the primary early sources of semi-feral horses that gave rise to our Mustangs.

By the time Antonio de Herrera wrote a history in the late sixteenth century, swine, sheep, goats, cattle, and horses were plentiful in Mexico. He reported that it was easier to breed livestock there than in Spain and that there were droves of workhorses, oxcarts, mule pack trains, and saddle horses. By then most of the former Spaniards who were living in Mexico were ranchers and farmers. Accounts from a few years later indicate that 50,000 head of cattle, 200,000 sheep, 4,000 mules, and 4,000 horses were sold in Mexico each year.

Central American Breeding

Honduras was also one of the great livestock-breeding countries. The city of Gracias a Dios became famous for raising mules, which originally had just been imported for use from Jamaica. The greatest horse and mule center, however, may have been in Nicaragua, where the natives wisely learned to speak Spanish and to trade with the Spanish. They also became excellent blacksmiths and rope makers, and they made fortunes by breeding and selling mules, which carried silver and other goods through the isthmus of Panama to trade with the Spanish colonists in Ecuador and Peru. It was common for 1,500 mules to

leave Nombre de Dios in one day, headed for Panama.

By the time the English were setting up colonies on the East Coast, Central America and Mexico had huge numbers of horses, donkeys, and mules. In addition, a great many animals had moved north into what is now the United States with the Spanish, with the Indians, and, quite likely, on their own.

By no means, however, were the Spanish the only influence on our horses.

The English Invasion

On Christmas Day in 1620, the Pilgrims landed on Plymouth Rock in Massachusetts. Here was an entirely different set of people, with different origins, arriving on our shores. For the most part, the original Pilgrims in Plymouth did not come from the upper classes, and, unlike the Spanish, they certainly weren't military horsemen. In England in those days the upper classes had horses, while the common people usually used oxen for farmwork and heavy pulling. As commoners, the early Pilgrims didn't know how to handle, use, or manage horses very well, and at first they weren't clamoring for them. In 1632, the only horse recorded in Plymouth Colony was a saddle horse used by Governor Bradford.

When the Pilgrims began importing horses, they brought types common to England, Ireland, Scotland, and northern Europe. By 1629, horses were sent from England to Massachusetts and from Sweden to the mid-Atlantic. In 1665, the king of France began shipping some very fine horses to Canada.

Acceptance and ownership of horses started slowly in New England, largely for cultural reasons. The early New Englanders were strongly biased against eating horses and didn't even make things out of horsehide or horse leather. It made more sense for them to import livestock from England to work, milk, or eat, and that meant cattle, sheep, goats, hogs, and chickens.

Almost all of the colonists who moved to the New World quickly recognized that life with horses had tremendous advantages over life without them, and almost as quickly decided they didn't want any of the indigenous peoples to have them. It was illegal in the colonies of New England and Virginia for Indians to own horses, but that didn't stop them. There is a documented report from a French baron fighting the Iroquois in 1687 near Rochester, New York, that reads, "In all these villages, we found plenty of horses, black cattle, fowl and hogs."

So much for the fourth-grade idea that Eastern Woodland Indians always walked and that the first horses came to the Plains tribes, who acquired them in the West in the late 1700s or early 1800s. Bonnie Hendricks, in *The Encyclopedia of Horse Breeds*, reports that all Indians who ever adopted horses as a part of their culture had them by 1710.

After a few winters passed, however, which were much harsher than the winters in old England, the New Englanders caught on to the unique value of horses. Oxen are never fast, and in deep snow they aren't of much use at all. There were few gentry in New England, so any concern about horses and class distinction faded, and, in time, anyone who could afford a horse acquired one to work on the farm, use as a pack animal, or ride. By 1687, the horse and cattle businesses in New England were thriving.

New England in the early days was nearly all wooded, with virtually no roads. Byways were mere paths through the woods, muddy, rocky, and fraught with roots, so travelers led pack strings carrying their goods and rode only occasionally. Driving wasn't a possibility in the very early colonial days. As the population grew and farms were established, along came the first primitive roads, and more people began to see the merits of horses. Propelling this change in perspective about horses was the arrival of indentured servants, especially from Ireland.

Prisoners of war were often sold into indenture, which meant slavery for a fixed period of time. Between 1648 and 1650, England was waging a brutal war against the Irish and the Scots, creating plenty of prisoners of war to ship across the Atlantic Ocean. In New England these prisoners were frequently purchased as indentured servants because they were experienced with cattle. More than a few were also good at handling horses. Thus, horse knowledge came to New England with the former prisoners, who also became America's first real cowboys.

The Breeds That Arrived with the Colonists

By 1350, there were some particularly gentle horses in England that were known for their very smooth gaits. They were natural pacers and said to be "as comfortable as a rocking chair on the hob"—the hob being the fireplace hearth, the most comfortable place in any house. These were the famed "Hobbies" that gave their name to children's rocking horses. Living Hobby Horses were common in both England and Ireland by the time of the Puritans. The names of breeds weren't often noted on ship's logs, although types such as "saddle horse" sometimes were. So there is no hard proof that Hobbies were imported, but it is very likely. The best guess is that Hobbies were imported into New England, where they became the ancestors of the famous Narragansett Pacers from Rhode Island (see page 238).

Workhorses were certainly imported once farming was truly established. People wanted animals that could do farmwork as well as serve as the family riding horses. Deck space, and later space for animals in the holds of ships, was at a premium, so even the workhorses that came over were likely to have been basic, general-purpose horses rather than the giant draft horses we have today. The ability to import specific breeds and types came later, along with prosperity.

Horses were valued for the work they could do. Any horses that worked farms in New England were going to spend some of

their time pulling stumps, hauling logs, and moving rocks, as well as working as pack animals and carrying riders. Oxen, which are incredibly strong but slow, also did a huge amount of the heavy work.

Knowing what jobs were required, what feed was available, and that there was virtually no indoor stabling, we can surmise that the early horses in New England were small, tough, and utilitarian. The better-fed ones probably would have been stocky, a guess that is confirmed by actual descriptions that still exist.

By the 1760s, enough commerce and traffic had developed among the colonies to warrant efforts to improve the poor-quality roads. In 1763, Benjamin Franklin himself drove a gig from New York to Boston, measuring distance by turns of the wheel, inventing the first odometer, and posting the first official mile markers along the way. By then, driving horses were certainly of interest to the colonists.

American Horses for Export
There were wars everywhere during colonial times, and they sometimes slowed or stopped shipments of needed supplies. After naval blockades in 1648 stopped all supplies from getting through, the governors of Newfoundland, Barbados, Bermuda, and Jamaica asked Massachusetts and Virginia for help. The two colonies obligingly sent not only food supplies, but also a few horses, thus beginning an aspect of the horse industry that was crucial, although now rarely mentioned and barely remembered.

So many horses traveled from New England to these islands and to Belize and Surinam that the ships carrying them became known as jockey ships. By the 1700s, ships from New England had built-in deck pens to hold 150 to 200 exported horses. These horses served as riding and driving animals and worked on the sugar plantations, where many endlessly walked in circles inside special buildings on heaps of raw sugarcane to press out the sugar. The conditions on the plantations were terrible, and many horses died miserable deaths from poor care and overuse.

To supply the burgeoning horse trade to the islands, horses were bred extensively in New England, particularly in Connecticut, beginning in about 1650. After some 125 very successful years, the horse trade to the islands came to an abrupt halt when our

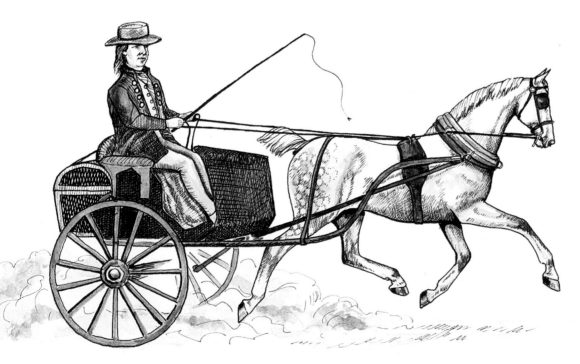

Benjamin Franklin in a gig similar to one he modified for his trip from New York to Boston. Accurate distance was clicked off by the wheels. His daughter walked behind and at measured miles unloaded rocks and placed them as markers.

own Revolutionary War began in 1775. Records show that by then, the jockey ships were transporting about 4,000 horses a year from New England to the West Indies.

New Breeds for New Needs

Although horses were shipped directly to New England and Virginia from England, some were also brought south from Canada, and some of these were natural pacers. Some of the Canadian pacers, the "freebred" descendants of the Norman and Lowland horses, may have returned as prizes of war to New England from Nova Scotia (ceded to Great Britain in 1713) and thus quite possibly to Rhode Island. Like the Hobby Horse, these Canadian horses may feature in the pedigree of the short-lived but influential Narragansett Pacers.

By the same route, some heavier types of horses also arrived in New England. In 1760, the war in Canada with the French was finally over, and a brisk horse trade developed between Canada and New England. There are records of thousands of heavy horses from Kamouraska (east of Quebec), trotters from Montreal, and pacers from Nova Scotia being herded from Canada directly to the jockey ship loading pens. Because the terrain was heavily wooded and there weren't any roads, breeders conducted the big horse drives in the winter so they could drive the horses down frozen rivers. A few of the best horses of various types from the north went to the breeding farms of Rhode Island and Connecticut, but about 95 percent of the horses that came from Canada were sent on to the "horse killer" sugar plantations on the islands.

Draft Horses

As early as 1613, a trading post opened at the mouth of the Hudson River for the Dutch and Swedish who were beginning to settle what is now New York City and the surrounding area. By 1630, these settlers were importing what were called "Holland's breed of Great War Horses," the ancestors of today's Friesians, as well as some Swedish ponies. These animals worked on farms from Schenectady, New York, to Chester, Pennsylvania. In the New York area by the late 1600s, the Dutch were importing heavy horses for draft work.

The first Mennonite settlers arrived in the land of William Penn in 1680. These farmers from Germany and Switzerland were well trained, extremely hardworking, and experienced animal breeders. They brought farm horses with them right from the beginning and were selling horses two years after they landed.

With the creation of some roads in southern New England and New York by the 1750s, freight and stagecoach lines opened. According to Robert West Howard, in *The Horse in America*, records indicate that crossbred Kamouraska draft horses, Narragansett Pacers, and Anglo-Irish hybrids were the horses that powered those stagecoaches and freight wagons between about 1780 and 1800.

Conestoga Horses

The first actual breed of draft horse to be developed in America began to be seen in Pennsylvania between 1700 and 1730. This was the Conestoga Horse, which was developed by the Pennsylvania Dutch to pull the big Conestoga wagons, which were first made near Lancaster in the town of Conestoga. The design for those big wagons probably originated in the memory of German settlers, who modified Old World designs for use in the mountains of Pennsylvania. The Conestoga is quite similar to some of the European wagons of the Middle Ages. From school history classes, everybody remembers the Conestoga wagons as the "prairie schooners" that transported settlers west in the 1800s. But before the Revolutionary War, a larger version of these wagons hauled freight, first from near Lancaster, Pennsylvania, to Philadelphia and later from Philadelphia to Pittsburgh.

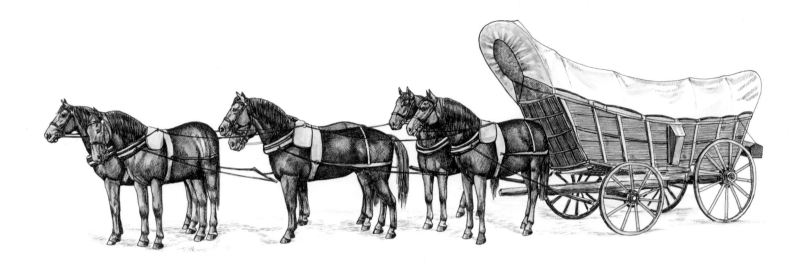

From the only drawing of a Conestoga Horse known to exist, which was sketched after the horses were gone, they were what today we would call medium to heavy draft horses. They probably stood 16 to 17 hands and weighed up to about sixteen hundred pounds. They were usually driven in six- or sometimes eight-horse hitches.

The first Conestoga wagons had no actual seat for the teamster, who either rode the left wheel horse, walked, or pulled out a special board on the left side of the wagon, called a lazy board, to sit on. The original Conestoga wagons of Pennsylvania had huge scarlet wheels; the body of the wagon was bright Prussian blue, and the tops were white linen, an interesting set of colors for the Philadelphia area in pre-Revolutionary times. These rigs were huge, and they often traveled in trains of up to thirty vehicles. Since the drivers sat or rode on the left side of the wagon, they were not about to yield to any traffic on the road. Oncoming traffic was forced to pass so that the left-hand sides of each vehicle were toward the center of the road. This is where the American tradition of driving on the right-hand side of the road originated.

The first road to connect Conestoga to the Philadelphia area, about sixty miles long, was built in 1733, and this marks the period of the introduction of these horses. Remember that the farmers who bred these horses came from Germany and had a long history with the "Great War Horse" of Europe, so the concept of a draft breed would have been familiar to them. The Dutch in the New York area had been importing heavy horses from Holland for some time, so those might also have been featured in the original pedigrees of the Conestoga Horses. There is lore that William Penn himself shipped over a load of Great War Horses, sometimes said to be Tammerlane Horses, in the 1680s.

Whatever the origins, both Conestoga horses and wagons were very successful. William Douglas estimated in 1749 that there were seven thousand of the wagons in use throughout Pennsylvania by that time. They really became famous, however, after 1790, when the first turnpikes made it possible to travel to what is now Pittsburgh. The size of the wagons was increased, so that each could carry between three and four tons. They were nicknamed Pitt Wagons for the destination, and they traveled in trains of twenty to thirty vehicles.

During this period, harness bells also became famous. There were little soprano bells for the leaders, tenor bells for the middle or swing pair, and a bass-toned bell for the right wheeler. The left wheeler was unadorned. The bells were especially important to the teamsters and became trophies of skill and success on long drives.

Six to eight horses pulled the first Conestoga wagons, which had no seat for the teamster, just a small "lazy board" on the left side. This is how American vehicles began traveling on the right side of the road.

If a wagon became stuck, as often happened on the muddy tracks through the mountains of Pennsylvania, another driver would stop to help, but the cost for his help may have been one or more bells.

A fun historical footnote is that the expression "to be there with bells on" is alleged to have come from the bells on the harnesses of these horses. The Conestoga wagons also gave us the word *stogie*. These were the cigars the drivers liked to smoke, and that name, which still signifies a cigar, is a diminution of the word Conestoga.

By 1817, it was reported that about 12,000 Conestoga wagons passed among Baltimore, Philadelphia, and Pittsburgh in a year. Many, possibly most, were pulled by the famous Conestoga Horses. Between 1820 and 1830, the Conestoga design was modified for family rather than heavy commercial use. It became traditional to paint these wagons in dull browns and greens, transforming them into the prairie schooners that made up the westward wagon trains.

Years later, when boat and canal transport, and then trains, made the shipment of freight west from Philadelphia easier and faster, the wonderful Conestoga Horse disappeared.

Southern Horses

South of Pennsylvania, the first horses to arrive were of both English and French descent. Settlers began arriving in 1607 from England to settle in Virginia's James River area. Three years later, the first horses arrived from England, but it was a nasty winter and the colonists were forced to eat them to survive. Seventeen more stallions and mares arrived in Jamestown from England in 1611.

In 1614, the Virginians received a load of Norman or Breton horses that had been taken as prizes of war in Nova Scotia. The Virginians needed more cattle, goats, and horses, so in 1620, they hired a fellow to buy some for them in Europe. He purchased the stock in Ireland and thus began a very successful trading relationship between that country and Virginia. There are also some shipping notes that "Galloways" were being imported as saddle horses; those would have come from southwestern Scotland.

In Virginia and Maryland, colonists' horses were turned loose to find their own

A representation of the only engraving done from life of a Conestoga Horse, America's first true breed of draft horse.

food much of the time. They reproduced very successfully, and of course some escaped and found plenty of feral horses of Spanish descent to breed with. Those were probably descended from the sixteenth-century herds of the explorers, or from horses that had come up from large Spanish ranching establishments in Florida, and some perhaps arrived with Indians. As Howard says in *The Horse in America,* "Thus an all-Europe hybrid developed in the Appalachian highlands of western North Carolina, South Carolina and Georgia. In the way of all feral horses, the mares produced shaggy swift offspring who grew only thirteen to thirteen and a half hands high and weighed six hundred to seven hundred pounds." By 1712, in Maryland, laws had to be written "to prevent the great multitude of horses in this province."

The Birth of American Racing

About this time, tobacco and slavery were making many people in the South wealthy enough to be considered a leisure class, with plenty of expendable money and time. Unlike the early New Englanders, the plantation owners in Virginia wanted to emulate the aristocracy in Europe, who had taken up horse racing. There were actually laws about who could race horses. In 1674, a court ruled that it is "contrary to Law for a Labourer to make a race, being a sport only for Gentlemen." A major leisure sport of the wealthy southerners was racing horses on short, straight tracks. The very first races were run right through the middle of towns, on probably the only straight, level sections of road available.

The first actual racetracks, built exactly a quarter-mile long and called quarter-paths, were in use before 1690. This followed the fashion in England, where in 1671, Charles II was building race courses and sending out to Italy, France, and Spain for "the best of Barbary mares" for his stables. However, King Charles established longer races than did the Virginians of this time. In England

FROM FARM HORSE TO SPORT HORSE

In Europe many areas had been known for horse breeding for centuries prior to World War II. Usually the horses that came from a particular region were known by the name of the region, although there were often several types of horses from one area. Medium to heavy horses were bred to do field and farmwork and pull heavy equipment for the military; a slightly lighter version with greater speed and good gaits was used for coaching; and there was a saddle type for cavalry use and general riding.

World War II devastated Europe. Huge numbers of horses were killed during the conflict, and the economy was ruined afterward. Families that had been horse breeders for generations were scattered or gone, as was much of the breeding stock, and records were lost.

After the war, as economic recovery slowly began, many farmers brought in tractors. Horses were no longer needed for war or coaching, and far fewer for farming. The remaining breeders, however, believed in their horses and wanted to keep going. They set about the difficult task of finding whatever horses were left.

From that beginning they have developed modern sport horses that excel at show jumping, dressage, and eventing. With centuries of experience behind them and very focused goals and techniques, they have created modern versions of their old breeds that are some of the finest equine athletes the world has ever seen.

they ran races in heats. Each heat was often four miles long, and sometimes one race was twenty laps around a one-mile oval.

In Maryland and Virginia, it is alleged that for some single quarter-mile races, the winning owner went home with more than $40,000, comprising the purse and the side bets, with winnings collected in gold, silver plate, cured tobacco, and bolts of cloth. Not surprisingly, plantation owners began to breed horses just for this sport. These little horses had lightning starts and could fly over the quarter-mile paths. They were 13 to 14 hands high, with powerful rear ends for fast starts, and they were known as Short Horses, or Quarter-Pathers. These horses were the predecessors of the Quarter Horse, which today we think of as a Western breed.

The first importations of English-bred racehorses to America took place between 1730 and 1770. The three foundation sires of the Thoroughbred breed—the Darley

Arabian, the Byerly Turk, and the Godolphin Arabian — were such consistent winners on English racetracks that they, along with a few other Oriental horses, came to be considered a separate breed. By 1720, their offspring were being promoted as English "Breds". The very first one imported to this continent was a stallion named Bulle Rock, probably a descendant of the Darley Arabian who arrived in Virginia in 1730. Six more Breds arrived in 1753, and a total of thirty-seven were exported before 1775.

The Breds were not just used to produce faster racehorses but also crossed on everyday saddle horses, and they produced some wonderful horses that were promptly snapped up by the military as cavalry remounts. These were the horses of the famous Virginia Dragoons under the command of "Light Horse" Harry Lee in the Revolutionary War, and they were said to have made a big impression on the enemy.

The Noble Mule

The scientific name of the horse is *Equus caballus.* The scientific name of the donkey is *Equus asinus.* The two are entirely different species and although they are fairly closely related, they are not the closest of kin. Both differences and similarities are apparent in looks and behavior and are clearly heard in voice. They also have different numbers of chromosomes: the horse has sixty-four, the donkey sixty-two.

Mules are the infertile hybrid offspring of a donkey sire and a mare dam. If the cross is with a donkey dam and a horse sire, the offspring is called a **hinny.** In both the mule and the hinny, the chromosome number is sixty-three. But it is not just the number of chromosomes that differs between the species; the structure of the chromosome does as well. This dissimilarity of structure, more than the difference in number of chromosomes, causes mules and hinnies to be infertile (see page 2).

According to David Willoughby, in *The Empire of Equus,* one of every 200,000 female mules may become pregnant by a stallion, but male mules are always infertile. Pregnant hinnies are even rarer, but that may be because there are fewer hinnies. The rarity of hinnies has to do with folklore — supposedly they aren't as strong as mules, so they have been bred less frequently. More to the point, the conception rate is about 40 percent lower in **jenny** (female) donkeys than in mares, which is usually between 60 and 80 percent.

Mules are remarkable animals known for being very long-lived, often into their 40s; extremely strong; exceptionally sure-footed; and with good night vision. Furthermore, they seem to be resistant to some horse diseases, and they can prosper on low-quality feed and forage that would weaken or kill horses. Unfortunately for them, they seem to be more tolerant of inept and even cruel handling than are horses.

The first person known to breed and promote the breeding of mules in the colonies was George Washington, who was devoted to improving agricultural practices in America. Washington asked a shipowner friend to try to buy some **jack** (male) donkeys in Spain, but this first attempt failed. Breeders in Spain were reluctant to sell jack stock, fearing they might lose their control of mule breeding and sales.

Word traveled, however, from the Spanish consul in Philadelphia to Madrid that Washington was interested in breeding some mules. The king sent him a gift of two jacks and two jennies. One of the jacks died during the trip, but the other mules landed in Portsmouth, New Hampshire, and were driven south to Virginia by Washington's groom, who named the jack Royal Gift. He was 15 hands high, quite large for a jack. Washington began advertising him at stud in February 1786.

As word spread in social and political circles about Washington's interest in donkeys for mule breeding, the Marquis de Lafayette

sent him a jack and two jennies from Malta, with word that Malta produced the finest jacks in Europe, thereby thumbing his nose at the Spanish. The Maltese jack was named the Knight of Malta. Whatever her first reaction about not selling donkeys abroad, Spain quickly grasped the reality that Malta might have just opened a potentially huge new market and sent word in 1787 that there were plenty of jacks and jennies that could be bought and shipped from Spain.

The real brilliance of Washington's experiment in mules may have been the timing. First the Army wanted mules to use for pulling artillery and commissary wagons. George Washington probably still had some pretty good connections with the Army. Then in 1795 came the cotton gin, the device that removed seeds from cotton, which suddenly transformed cotton into the primary agricultural crop of the South. Within a season or two, the number of acres devoted to cotton production vastly increased, and the mule was the perfect animal for all the heavy work. The care of the work animals in the South was no better than the care of the slaves — that is, typically hideous. Horses routinely foundered or died from overwork, but mules kept right on going.

It is worth noting that by 1860, just seventy-five years after Washington's first jacks went into breeding service, the agricultural census reported 1,129,533 mules in the United States. Mule numbers in the United States peaked at 5,918,000 in 1925, ten years after horse numbers had begun to decline. Mules continued to be a large part of the workforce, particularly in the South, until the economic recovery after the Great Depression, at which point tractors became plentiful. Today there are an estimated nine million horses in the United States, with perhaps 250,000 mules and donkeys (records are no longer kept separately for mules and donkeys, making an exact count difficult to obtain).

There aren't any breed designations for mules. In Washington's time they were

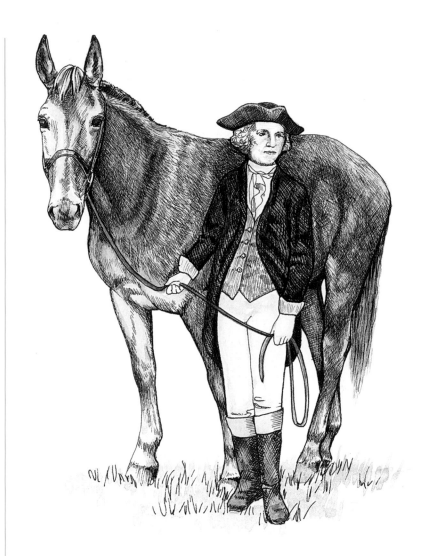

classed by size: for example, sugar mules were medium-sized animals, the right size to use on sugar plantations. Today, mules are still sometimes designated by size or by use for example, as saddle or draft mules. Others are designated by the breed of the dam. Many mule riders prefer smooth-gaited animals, so there are Walking Horse mules and Fox Trotting mules. In California there are mule races, and most of those animals are Thoroughbred mules. The largest mules come from the draft breed crosses.

Mules today remain a valued part of the rural and farm culture, especially in southern states, but they are also widely used as pack and riding animals in the mountains of Colorado and the other western states. To this day, some Amish farmers, particularly in Pennsylvania, prefer draft mules over horses for heavy farmwork.

Always interested in improvements in agriculture, George Washington was one of the first breeders and promoters of mules in the colonies.

Conformation

Conformation—the way a horse is put together—largely determines how well he can perform his job and how sound he is likely to remain throughout his life. There are some general points of conformation that horsemen largely agree on and a great many finer points of conformation that vary with the type of horse and the job he will be doing.

Fanciers of various breeds and even proponents of types within the same breed have been known to argue passionately over the benefits and detriments of various details of conformation.

When the primary function of horses was to provide military transportation, long-term and consistent efforts were made in every society to produce sound, durable horses that could carry men to battle or haul the heavy trappings of war under any condition. The study of conformation was a very serious matter to the best horsemen, whether they were the Huns, the German army, or the Apaches. Similarly, when horses performed the major work on farms and ranches and hauled everything imaginable across America, sound conformation was essential. The farmers and ranchers who paid attention to it were more successful than those who didn't. Human lives truly depended on the soundness and ability of horses to do their jobs.

Now that modern horses are largely recreational, however, fashion has played a surprisingly important, and frequently unfortunate, role in determining what is touted as the ideal within various breeds. Sometimes the current fashion defies the major principles of sound conformation. If you buy a horse because of his looks but disregard the principles of conformation, you are likely to end up with an animal that isn't suited to any job, or with an unsound animal that requires heroic interventions by both the veterinarian and the farrier.

What Is Sound Conformation?

For a horse to be functionally sound, it is essential that he have serviceable, proportionate feet, legs, and joints. There should be symmetry, meaning that the left side matches the right side. One leg should not hit another (known as **forging** or **interfering**) as the horse moves. The horse should be able to move smoothly, with appropriate

BREED REGISTRIES

For most breeds, an association or registry determines what traits are necessary, appropriate, and desirable to be passed down from generation to generation. These traits are carefully described, put in writing, and maintained as the **breed standard.** Usually the registry also keeps records of key data pertaining to the breed, such as stallion records and show records, and issues registration papers. In Canada a private corporation, the Canadian Livestock Records Corporation (CLRC), keeps records for many breeds of livestock and horses. Breed associations hire the CLRC to manage their data so they can concentrate on other activities relevant to their horses.

The Parts of a Horse

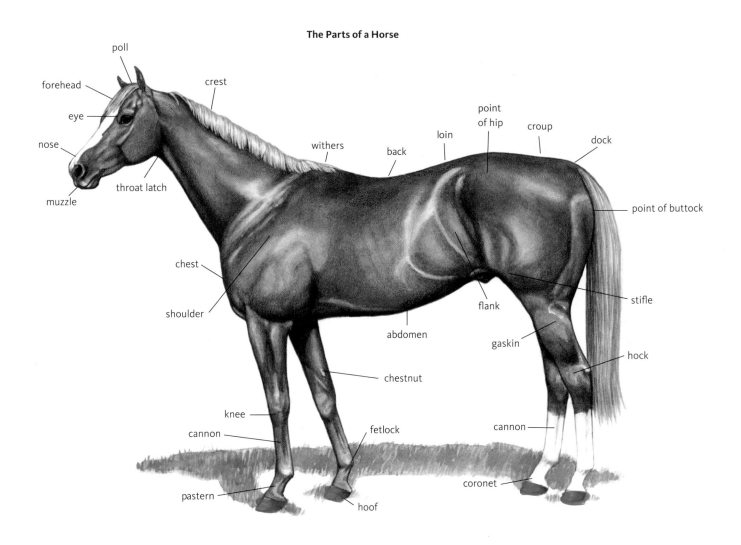

amounts of effort so he doesn't tire easily, and he should be able to see and breathe well. Discussions about ideals for pastern length, shoulder and hip angulation, croup length and tail set, and sufficient room for heart and lungs are more relevant to what suits a particular horse for a particular activity than they are absolute points of soundness for all horses.

Feet

The feet should be large enough to support the body's size and weight. The quality of the hoof wall should be hard without being

brittle. Incidentally, the folklore about white feet being weak has not held up to scrutiny. Some white feet have a poor-quality hoof wall; many don't.

The two front feet and the two hind feet should be symmetrical, meaning that the left one should pretty much match the right one. This should be apparent from all angles: front view, side view, rear view. Each foot should also be symmetrical, meaning that the left side of it should closely match the right side. Heels should be neither underslung nor compressed from side to side, and they should be even where they

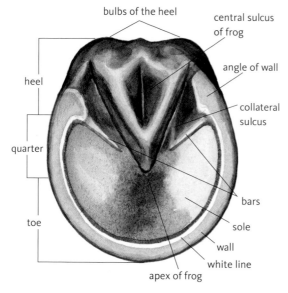

bulbs of the heel

central sulcus of frog

angle of wall

collateral sulcus

heel

quarter

toe

bars

sole

wall

white line

apex of frog

join the sole. One side should not be markedly higher than the other. A well-shaped sole is slightly concave.

Today's professional farriers can correct a world of hoof and foot problems, but they can't fix everything. Sometimes nature knows best, however. In some cases, if misaligned feet are well cared for and otherwise left alone, the horse will remain sound even in fairly hard use. Soundness problems can result if the farrier alters angles to make a foot look correct. It takes experienced horsemen, farriers, and veterinarians to tell whether a foot would be better altered or left to nature.

If the foot is fundamentally too small for a large-bodied horse, if one foot is **clubbed,** or if there are seriously **contracted** or **sheared** heels, the horse's athletic ability is likely to be limited. Sheared heels is a structural breakdown of the bulbs of the heels

that occurs when one heel repeatedly strikes the ground before the other. The horse may be unusable for periods of time or never usable for some sports, or he may develop chronic lameness problems as he ages. If the quality of the hoof wall is poor, nutritional supplements and shoeing techniques can help, but keeping shoes on is likely to be an ongoing problem. If the horse's job requires him to be a long way from a farrier, as with an endurance horse or some working ranch horses, this could be a serious concern. In today's world, however, proper shoeing can overcome most of these sorts of problems.

Legs

The legs should be straight. From the front view, if a plumb line were dropped from the point of the shoulder to the ground, it should neatly divide the entire leg, including the hoof, in half. If one or both legs are seriously out of alignment, soundness problems are likely in anything other than light use. The concussive forces that travel up the leg with each footfall will make an impact on some part of the body that isn't designed to receive them. Working speed, frequency of use, as well as repetitive, quick turns or extremely high action determine the seriousness and frequency of concussive forces. How much and where the leg deviates from the ideal alignment determines how and where the concussive forces will affect other structures. The bigger and heavier the horse, and the faster he will be used in routine work, the more serious the consequences of deviations from the ideal straight leg.

Legs should also be symmetrical. Each half of a leg should nearly match its mate, without bumps or bulges on one side. Sometimes a bump may be the site of an old, completely healed injury that won't cause problems, but any swellings should be carefully checked for their effect on present and future soundness. The pairs of legs should also match each other. If the

A clubbed foot (left) exhibits a steep pastern and a hoof-pastern angle of more than 60 degrees. On a sheared heel (right), one side of the hoof wall appears higher than the other.

side view or an angled view of one front leg differs significantly from the other, it bears close examination.

Symmetry, straightness, and correctness are as necessary for the hind legs as they are for the front.

Joints

Sound, functional joints are essential to any kind of performance horse. The joints should have the correct axis, they should be symmetrical, free from lumps, and without heat, and they should be proportionate for the age and size of the animal.

From the front view, a plumb line dropped from the point of the shoulder to the ground should bisect the knee, the fetlock, and the hoof. If the horse is facing north but its right front foot is pointing northeast, it is important to track down where the conformational deviation originates. Is it just the foot that is turned out or is the ankle in the wrong plane? Sometimes the ankle is actually correctly aligned with the foot but the knee is twisted. Does the whole leg angle out from the shoulder? Is one foot involved or both? If one or both ankles have any asymmetric lumps, they should be carefully examined and evaluated.

From the side view, the line from the front of the fetlock, along the top of the pastern, and continuing along the front of the foot to the ground should be straight. If that line makes a sharp angle at the coronary band, there is a conformational problem (sometimes called **coon foot**). How serious that problem will turn out to be depends on many factors, especially the intended use of the horse, but that misalignment could have consequences (such as strain or injury) that should be discussed with a veterinarian.

What the ideal slope of the pastern should be varies with the individual horse, the type of horse, and the job it will be doing. Upright pasterns are suggestive of jarring gaits for both the horse's body and the rider and may predispose the horse to

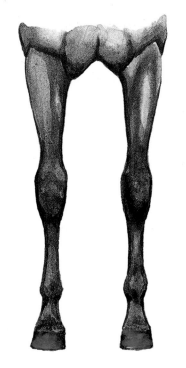

From the front, a plumb line dropped from the point of the shoulder to the ground should bisect the knee, fetlock, and hoof. From the side, a line should go straight through the fetlock and pastern without bending at the coronet.

The pastern acts as a shock absorber and should have the same angle as the hoof.

lameness. Long, sloping pasterns work as shock absorbers, but if the pasterns are too long, the ankles may actually hit the ground when the horse gallops, potentially causing problems. This matters where speed is essential, such as in race, steeplechase, event, and polo horses.

From the front, the imaginary plumb line dropped from the point of the shoulder should bisect the knee, and the left and right halves should match. If it looks as though the long bone above the knee does not line up with the long bone below the knee, the horse is said to have an **offset knee,** or a **bench knee.** This is a very serious

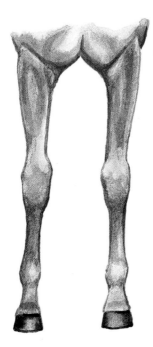

An offset, or bench, knee can interfere with performance.

conformational problem if the horse is going to be worked at speed, as with a race-horse or games horse. A horse that is going to work comparatively slowly on the trails or in the show ring is likely to have a better future with this sort of conformation, but it should be noted that this structure appears highly heritable if the horse is bred.

As seen from the side, the leg should be straight. The knee should not buckle forward, nor should the front profile of the knee be behind the vertical line so that the knee appears to arc toward the rear. This is known as a **calf knee,** and it is a seriously unsound conformation for any horse that is to work fast or jump. Knees that knuckle forward are a condition known as **over at the knee.** It is unsightly, but in terms of soundness, it is usually a less serious condition than calf knees. It is not uncommon in older hunters and jumpers.

From the side, a plumb line dropped from the rearmost point of the rump should touch the hock and then follow down the back of the hind leg, landing just behind the foot. If the line touches the hock but the rest of the hind leg is well forward of the line, the horse stands under itself.

There are some types of horses in which this is not considered to be a serious fault. It may be seen in some Standardbreds, some reining horses, and some walking horses. If the plumb line touches the hock but most of the rest of the hind leg lies behind it, the horse is said to be **camped out.** This conformation can cause problems in horses that need tremendous hindquarter strength for fast takeoffs, power pulling, or speed.

From the rear view, if the hocks seem to point toward one another while the legs below them are straight, the horse is said to be **cow hocked.** In most breeds, this is an undesirable conformation, although it is desirable in draft horses. In another variation of this defect, the hocks point inward but the legs below them widen as they descend, and the hind feet point slightly to the outside. This is also considered unsightly and seriously incorrect in many conformation classes, yet is tolerated or even desired in a few breeds and types of horses, particularly draft horses, because it enables them to pull with power. Cow hocks may be unsightly, but they rarely cause soundness problems.

From the side, a plumb line dropped from the rearmost point of the rump should touch the hock and then follow down the back of the hind leg, landing just behind the foot. Far right: Camped-out legs decrease the power of the hindquarters.

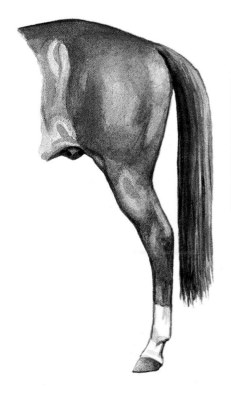

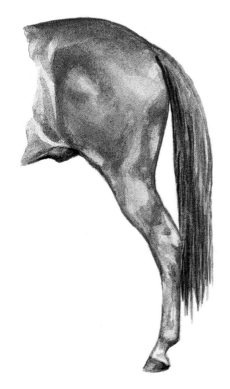

If any or all of the horse's joints seem to be too large for him, it may indicate a serious problem. If a single joint is enlarged, it suggests possible injury and should be examined. If the knees, ankles, and maybe the hocks all look disproportionate on a young horse, it may indicate a nutritional or metabolic problem, or just a growth spurt in what will be a big horse. Large joints should always be examined by a veterinarian to rule out metabolic bone problems.

Shoulders

There are endless discussions about shoulder angles. Just how much the shoulder slopes and how long the shoulder is vary with breed type and use. When many horsemen speak of the angle of the shoulder, they refer to an angle formed by drawing an imaginary line from the highest point of the withers to the point of the shoulder and then connecting that line with the perceived line of the upper arm, or humerus. This is really no more than a guess. If you want to actually measure the shoulder angle, you have to locate the ridge of the scapula and measure a line along it.

In general, any horse that is going to be used for speed should have a long, sloping shoulder. Draft horses are generally more upright than racehorses because a more upright shoulder will limit speed but may increase power. When shoulder angles are measured correctly, many top show jumpers turn out to have surprisingly steep shoulder angles, while very few successful racehorses do.

Withers

Saddle horses need to have appropriate withers because the withers keep the saddle in place. Horses with very flat, almost indiscernible, withers are said to be **mutton withered** because they are built like sheep. Mutton withers is considered a very serious problem if the horse is to be ridden up and down hills, but might be inconsequential in show classes on the flat. In cavalry mounts,

it was considered to be an extremely serious fault. Few flat-withered horses offer tremendous speed. Obese horses will have apparently low withers, because the fat obscures them.

In contrast, very high-withered horses can be difficult to fit correctly with a saddle.

Cow hocks are generally undesirable, except in draft horses.

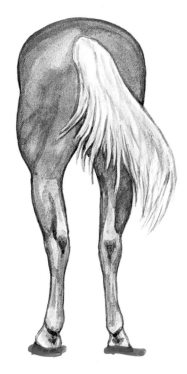

A sloping shoulder is built for speed; an upright shoulder increases pulling power.

Poorly fitting saddles can cause great pain to horses, sometimes produce serious behavioral problems related to that pain, and may cause unsoundness.

HIP AND SHOULDER ANGULATION

Ideally, the angle and length of the hip, as measured from the point of the hip to the point of the rump, should closely match the angle and length of the shoulder. There are some breeds where the length of the hip is often quite short relative to the shoulder. Though it rarely causes soundness problems, this conformation may generate less than maximum power and could limit speed on takeoff.

Back and Neck

A long back is less than ideal if the horse is to carry weight on its back, particularly if the weight is to be carried over distances, for the same reason that a long board placed between two sawhorses will sag more in the middle than a short board placed between sawhorses that are closer together. Very long-backed horses that will

be routinely ridden for many hours at a time, such as trail and ranch horses, are likely to fatigue more easily than shorter-backed horses, but long-backed horses can be quite comfortable to ride. Because the gait is unlikely to throw the rider very far out of the saddle, long backs are desired by some show pleasure riders. Some jumper trainers have noticed that many somewhat long-backed horses have good scope when they jump. If the horse is to be driven rather than ridden, especially if it is to be driven at high speed, a long back may be desirable because it allows room for tremendous movement of the legs.

The length, shape, and way the neck connects to both the chest and the back differ widely depending on type and use of the horse. In general, any horse that is going to run for a living needs a good length of neck. Some breeders look for "up-headed" horses; others, such as those with working cow horses, avoid high-headed horses. The shape and the attachment of the neck vary significantly depending on the likely purpose of the breed.

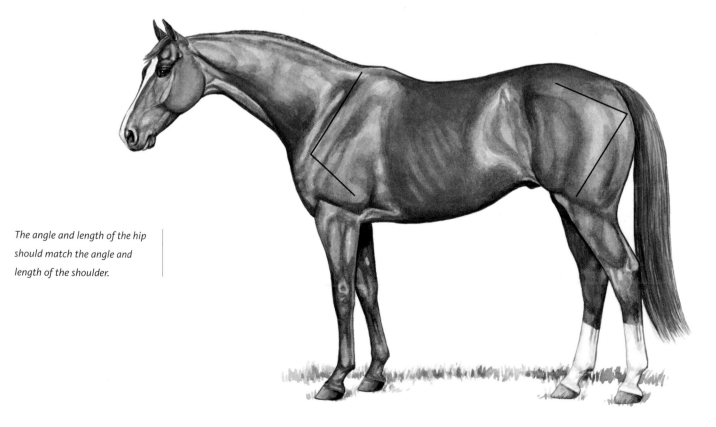

The angle and length of the hip should match the angle and length of the shoulder.

Eyes

All horses need generous, well-placed eyes. Horses with very small eyes may have medical problems or a limited field of vision and a tendency to be spooky as a result. Horses with eyes set too far toward the sides of the head are said to be **walleyed** or **fish-eyed** and they may have peculiar fields of vision, causing them to shy more frequently than other horses do.

The color of the skin around the eyes is significant. Horses with pink eye rims or **bald** faces (white covering most of their face) sunburn more easily and may be predisposed to painful eye problems.

The color of the eye itself is usually less of a problem for the horse than it may be for the owner who is considering the requirements of various breed standards. Many breed registries will not accept a horse with blue eyes for registration, for example. Very pale eyes often appear in conjunction with a good deal of white on the face, and the horse may have problems with glare in very bright light and be susceptible to sunburned eyes.

Nostrils and Airway

The nostrils should be open and symmetrical. Some racehorses with small nostrils may have limited air intake, but in general a horse used for routine pleasure sports can get along perfectly well with average to small nostrils.

If the profile of the horse's face is extremely dished, or "exotic," regardless of nostril size, the horse may experience difficulty taking in sufficient air or exhaling during hard, sustained work, such as endurance riding or long-distance races. Performance may therefore be limited.

If the horse is obese or is very thick-necked, he also may have difficulty taking in sufficient air, especially if he is ridden or driven with his face held vertical while he is doing hard work. This can be a problem for dressage horses, some flat-saddle horses, and some draft horses.

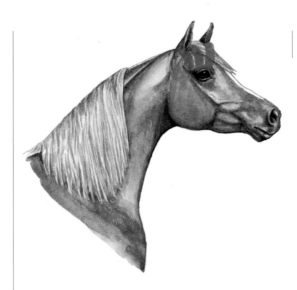

Arabians generally have more refined necks than Morgans.

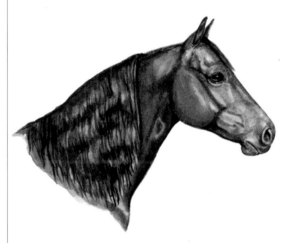

A NOTE ON COLOR

Horses exhibit an endless variety of colors, from white to palest cremello, through many shades of red, bay, brown, dun, and roan to grulla, smoky black, and black. In addition, horses have what seems like an endless variety of color patterns.

In reality, there are only seven major genes that govern horse color, whether it is intense or dilute, and where any black pigment will begin and end. There are several more genes that regulate pinto color patterns, and a group of genes — the leopard complex — that controls Appaloosa patterns. It is the interplay of the genes in endless combinations that produces the variety of colors and patterns we see on horses.

Breed registries differ tremendously in their rules about color. Some, such as the Suffolk Punch, allow only one color and minimal white. The Dales Pony registry allows white only on the fetlocks of the hind feet. Many allow horses with any solid body color, and then there are the Pintos, Paints, and Appaloosas, in which no two ever look alike.

See page 383 for more information on color.

Conformation within Breeds

In some breeds of horses, conformational subtypes have been bred for different purposes. This is particularly true with the immensely popular Quarter Horse. At a large-scale Quarter Horse show today, the horses that win in the Western pleasure ring don't look at all like the horses winning in cutting and reining, and none of those resembles the halter horses. The breed is so prevalent and so popular that, as the years have gone by, specialized lines of horses that excel in one activity above the others have been developed. Those lines have continued to diverge from other types within the breed as dictated by success in their respective sports, as well as judging trends.

The trend toward subtypes is evident in most of the other Western breeds, especially Appaloosas and Paints. Because these breeds have fewer individuals, however, the variations in type might not be quite as pronounced as in Quarter Horses.

Quarter Horses

Once upon a time, the ideal in halter Quarter Horses (QH) was the ideal for the entire breed. In early QH shows, the winning performance horses also had to be halter horses. The concept was that the best performance horses were the best-conformed horses and would become the sires and dams of the next generation. It was a sound concept, but the multiple uses of the breed have changed the effectiveness of the idea.

Over time, halter horses tended to become bigger, longer, and heavier-bodied than working horses. This development occurred in the show ring. A horse that is a little bit bigger than the others might catch the judge's eye more readily and look just a little more impressive than the smaller horse next to it. As bigger horses won more often, breeders selected for those traits.

Ultimately, halter horses became so large that cutters and reiners began to prefer a type of their own, because, in general, bigger, heavy-bodied horses cannot

consistently produce or sustain the quick turns cutters and reining horses need. Nor is the halter type what judges prefer in the pleasure ring. Also, the trend in judging is for horses with small "tidy" feet to place well in the classes, so soundness problems have crept into the halter horse ranks. Small-footed horses may look good standing in the show ring (especially as youngsters), but when they reach their mature bulk and weight, many become chronically lame.

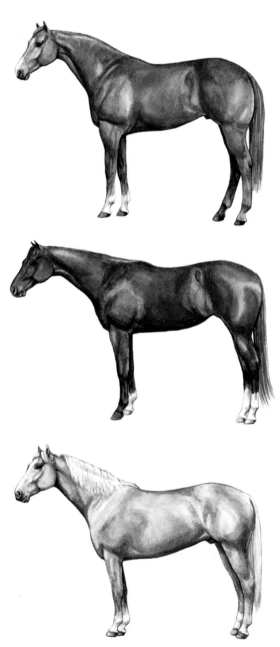

Quarter Horse conformation, from top: halter horse type; Western pleasure; cutter/reiner.

Many halter horse bloodlines were also afflicted with an unfortunate genetic defect, HYPP (see box). This was passed down from one great halter stallion but not discovered and correctly analyzed until he had produced many progeny.

CHANGING TRENDS

In Quarter Horse Western and English pleasure classes, there has been a tremendous change in type over the years. If you look at pictures of the ranch horses of the 1940s and '50s, they bear scant resemblance to today's pleasure horses, even though that standard was supposed to be the starting point for the Western pleasure horse. The horses that win at shows today tend to be long-bodied, tall horses with long necks, much taller and lankier than the cutting- and reining-type horses and noticeably narrower and lighter-bodied than current halter horses. While still registered Quarter Horses, many modern pleasure-type horses are, by pedigree, more than three-quarters Thoroughbred.

Cutters and reiners prefer small, square, very athletic individuals. Tall, long-bodied horses usually aren't agile enough to do the work, because their center of gravity is high and too far forward. Tall horses that are quick enough tend to develop serious injuries or chronic lameness problems.

There are many other uses for horses within this popular breed. Ropers usually prefer solid-bodied athletic horses that are a little higher off the ground than most reining horses. Barrel and contest horses are usually selected for individual ability over type, but the essentials of sound conformation for fast takeoffs, running, and turning are key for the job. Very small, quick horses are inclined to do well in small arenas, and some of the taller or larger ones succeed when there is an opportunity for length of stride to make a difference in the final time. Whether contest horses are tiny or tall, the keys to success are power take-offs and high-speed agility.

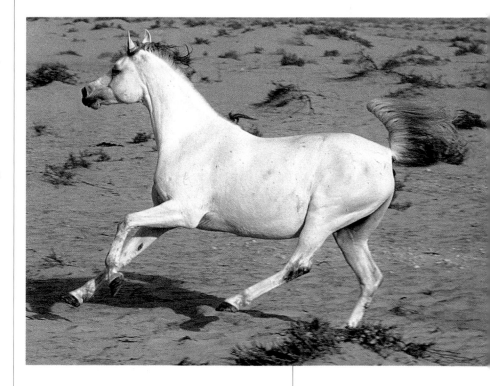

Arabians

The Bedouins who developed the Arabian breed needed horses with speed and extreme endurance over very difficult, hot desert terrain. Their desert horses, well suited to that task, happened also to be exceptionally beautiful. Arabian horses are generally considered to be the most beautiful breed of

This Arabian shows the typical high neck, head, and tail carriage of the breed.

horses in the world. In the show ring today, beauty is highly rewarded. All halter horses are judged to some extent on beauty, but with Arab halter horses, beauty is supremely important. They are art objects as well as living creatures.

Although Arabians are not typically big horses, over time halter types have become taller, bigger, and rounder than the average horses in the breed. One of the most famous features of the Arabian breed is the **dished** profile. In the halter ring, the desired dish has become more and more pronounced. Horses are now selected for having extreme or **exotic** heads. Winning halter horses are frequently priced at incredible sums of money. Because of their monetary value and hot disposition, winning Arabian halter horses are infrequently ridden. When they are ridden, it is usually in horse show classes rather than on endurance rides.

Over time, the horses selected by endurance riders have differed more and more widely from show horses. Endurance horses have remained fairly small, and they tend to be flat or **slab-sided** because that shape best radiates heat away from the body. The profile of the head has remained flat or very slightly dished, as were the heads of the pro-

totypical Bedouin horses. Very few endurance horses have extremely dished faces, because a flatter profile promotes sufficient intake of air, and, perhaps more important, allows the horse to exhale hot air easily and efficiently. The breed that is famous for "drinking the wind" can't do it successfully with an extremely dished profile.

Spanish and Modern Traits

As mentioned in chapter 1, there is now a remarkably strong tendency for many breeds of horses in North America to be longer-legged, rounder, and taller, with shorter, prettier heads. But there are a few proponents of another type that resist this tendency, because they believe that the traits that are being "modernized" out of so many breeds are the very qualities that made horses extremely hardy and versatile. The American Indian horses were well recognized in the days of the westward expansion for being incredibly hardy, very quick, handy, and able to thrive even on mediocre or poor forage.

The United States Cavalry is said to have turned out particularly slow draft-type stallions to mingle with the Indian herds, hoping that the resultant offspring would be slower. The tough little Indian horses were remarkably similar in type to the horses the Spanish first imported to the New World and used very successfully during the conquest. And, left to their own devices, little bands of this type have survived largely unchanged in several remote locations with greatly differing climates and terrains.

On the East Coast, the Shackleford Banker Ponies, which live on the Outer Banks of North Carolina, descend directly from the horses that arrived on the islands in the sixteenth century, and they have rarely been crossed with other horses. In the last twenty years, this tiny group of horses has been genetically tested and found to be distinct from other breeds. Specific genetic markers that are found in horses closely related to the old Spanish

The dished profile characteristic of the modern Arabian.

stock are present in the Shacklefords. If photographs of Shackleford horses today are compared with the descriptions, woodcuts, and various early Spanish artwork, many similarities in type can be seen. Thus the conformation selected by the Spanish also turned out to be highly functional for this little group of feral horses.

In the Kiger Mountains of eastern Oregon, a group of wild horses was discovered in the 1970s that were believed to have been isolated for at least one hundred years. They were genetically tested and determined to be distinct from other breeds, and, similarly, they exhibited strong Spanish traits. Again, although the climate and terrain were entirely different from the shores of North Carolina, the conformation of the early Spanish horses succeeded for the Kiger Horses during the century or more when they ran wild.

Finally, one very interesting breed of American cow ponies, the Cracker Horse of Florida, has conformation exhibiting Spanish traits. These little cow horses were highly successful from the 1600s until the 1930s, when bigger cattle were brought in from the West during the Dust Bowl period. The bigger cattle frequently had to be roped and handled for medication, and the little Cracker Horses were just too small for the work. But for more than three hundred years, until the cows got bigger, the early Spanish conformation worked.

Spanish traits continue to exist, mostly in a number of rare breeds of North American horses but also in the Andalusian, the Paso Fino, the Peruvian Paso, the Mangalarga, and even the Lipizzan.

Certain modern North American trends are limiting the success of some of the breeds with Spanish traits. The Spanish-type horses are usually small, but today most people, regardless of their own size, prefer big horses. Because the head is heavy-boned, sometimes long from the eye to the nostril, and often convex in profile, people don't perceive them as pretty. In other cultures in other times, a convex profile was the ideal and the dish-faced horses were considered ugly, but now the trend is toward horses with a relatively short head and a flat or concave profile.

What all these Spanish-type breeds have in common is that their history is the history of the New World. These are the Conquistadores' horses, and the Indians' horses and the cowboys' horses. Tough, durable, and useful, they should be treasured and not allowed to perish.

The Kiger Mustang (left) and the Florida Cracker (right) are examples of Spanish-type horses.

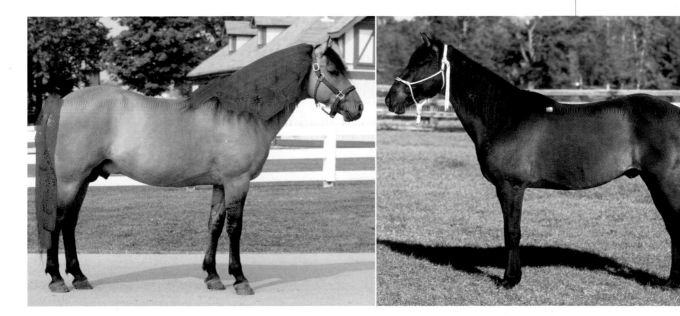

Two very different types of light-horse conformation are those known as Spanish traits and those of Arabians. Distinct and influential, these traits developed in horses used for

Spanish-type horses are generally small, agile, tough, and hardy, with superb "cow sense." Typical features include:

- A heavier neck, shoulders, and hindquarters
- Heavier, denser bone
- Larger hooves, with higher heels and soles
- Tightly crescented nostrils
- A much more angled croup and a low tail set
- Smoother gaits, with less animation and movement closer to the ground

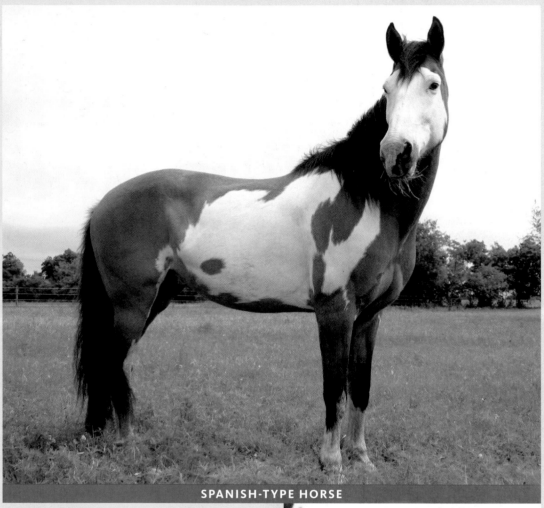

SPANISH-TYPE HORSE

Distinctive head characteristics of the Spanish horse include:

- Heavy bone over the eyes, with a broad forehead that narrows quickly to the point of the skull
- Narrow ears, often hooked at the tips; the ears may be short or long, but they are never broad and wide
- A shallow mouth, with a long, thin, flexible upper lip
- Typically straight or convex profile
- Large eyes of any usual color, including brown, blue, green, hazel, and amber

different purposes in different regions. Over the centuries, breeders have introduced both Spanish and Arabian bloodlines to improve many other breeds.

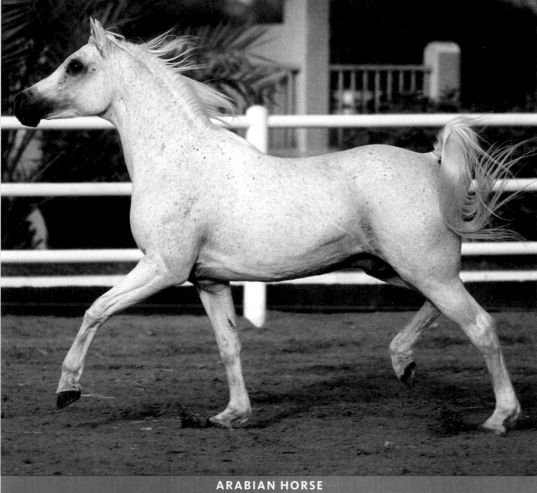

ARABIAN HORSE

Arabian-type horses are built for speed and endurance. Typical features include:

- A long, arched neck, narrow at the throatlatch and wide at the base
- Long, pronounced withers and a short back
- A deep, broad chest and long, sloping shoulders
- A high, flat croup and a tail that is set high and carried freely
- Muscular legs with broad joints
- Tough hooves, wide at the heels
- Black skin

Typical characteristics of the Arabian head include:

- A wide forehead tapering to a small muzzle
- Large, expressive eyes
- Small ears that curve in at the tips
- A concave or dished profile

Light Horses

LIGHT HORSES ARE RIDING HORSES, called "light" in contrast to the heavy draft breeds.

This large group has great variety in color, size, and shape. It includes breeds that run fast, jump high, or have great endurance or a natural ability to herd cattle. Many have three natural gaits, the walk, the trot, and the canter, and a faster gallop. Others have a gait of intermediate speed, most often an **amble,** in which the legs on each side move almost, but not quite, in unison. Because such gaits are comfortable to ride and not tiring for the horse, cultures as diverse as the Vikings, many of our early cowboys and our Indians, almost all Central and South American horsemen, and North American trail riders have chosen "gaited horses."

In this group is a breed to suit any interest, as well as an association of devoted fanciers ready to become new friends and teachers.

For many centuries, breeders have considered the Andalusian (opposite) the finest horse in the world.

Abaco Barb

HEIGHT: 13 hands

PLACE OF ORIGIN: Spain

SPECIAL QUALITIES: Colorful, Spanish-trait horses; some rack or pace; only 12 living representatives of breed in existence

The Bahamas is a chain of 700 islands with a total landmass of 5,360 square miles, a bit smaller than Connecticut. The original inhabitants, the Arawak Indians, migrated there from South America between 400 and 750 CE. Within a few decades of Columbus's landing in 1492, however, the Spanish completely depopulated the islands, shipping thousands of Arawak to work as slaves in the mines of Cuba and Hispaniola.

Horse-breeding farms began on Hispaniola soon after Columbus brought the first horses from Spain to the New World in 1493. Within about twenty-five years, horse ranching was established on other islands in the Caribbean, starting with Puerto Rico and then Cuba. Soon ranchers on Jamaica, Trinidad, and the lesser islands began to graze horses and other livestock. In 1513, Ponce de León visited Great Abaco, one of the larger Bahamian islands, where he noted the presence of wild hogs but not horses.

Sometime during the early sixteenth century, however, Spanish horses arrived at Abaco. During that period, Caribbean breeding operations were sending horses to North, South, and Central America, while ships from Spain continued to bring horses to the New World. All this shipping over poorly charted, reef-strewn waters resulted in numerous accidents and shipwrecks, which provided many opportunities for horses of Spanish breeding to reach the islands of the Bahamas. In 1595 alone, the Spanish lost seventeen treasure-laden galleons off the coast of Abaco.

Pirates and other opportunists also infested the reefs around Abaco. Not only did they find and loot shipwrecks but they also lured or drove ships onto the reefs and gathered the plunder. It wasn't until 1825 that the first lighthouse was built to light the way for ships, and even then many locals, having grown wealthy from plundering wrecks, did everything they could to stop its construction.

By then there may have been attempts by the Spanish to develop ranching on the island; however, its geography was not suited to this type of agriculture. France tried to establish a colony on Great Abaco in 1625. No one is certain what became of this early settlement.

Horses may have been deliberately imported to Abaco during the American Revolution, when groups of colonists who wanted to remain loyal to the British Crown moved to various Caribbean islands. They most likely acquired horses of Spanish descent from nearby sources such as Cuba rather than shipping them long distances from the colonies. When some Loyalists moved back to England, they left their horses behind.

Near the turn of the nineteenth century, Cuban settlers clear-cut the pine forests of Abaco and hauled out the logs with horses. These workhorses were almost certainly of Spanish stock from Cuba or Puerto Rico. When the loggers left, they abandoned some of these, although they were most likely geldings and thus did not add to the reproductive capacity of the feral herd. A veterinary authority in Nassau has stated

that there was no mingling of workhorses with the wild herds.

Logging continued on Great Abaco from the 1700s until about 1929. It resumed in the 1950s for about ten years. As one part of the forest was taken, other parts were recovering. The horses found shelter in the recovering forests and managed to survive and even thrive.

Fresh water and forage were always abundant enough on the island to support a moderate-sized herd. In fact, for centuries Abaco was something of an equine paradise, and human interference appears to have been minimal.

Discovery and Decline

A herd of about two hundred healthy horses was discovered in the 1960s when commercial loggers from the United States built a road from one end of the island to the other in order to harvest all the remaining forests for pulpwood. This opened up the most remote areas of the island, which suddenly became accessible to pickup loads of boar hunters. These hunters were not averse to shooting horses, running them to exhaustion, and even spearing them. Their dogs killed foals. In a few years, herd numbers dropped to a low of three animals.

Typical of Spanish-type horses, the Abaco's head is long between eye and muzzle, with large nostrils and heavy bone above the eye.

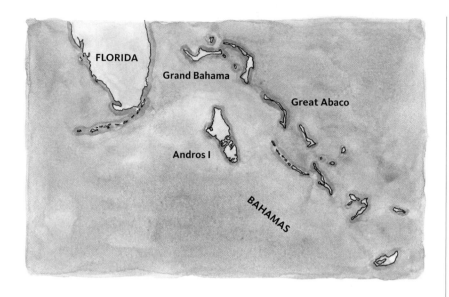

Horses may have swum to Great Abaco from shipwrecks, or they may have arrived with Loyalists fleeing the American Revolution.

Living among the orchards was less than ideal for the horses. They were left to themselves as they had been when they grazed with cattle; however, this time the outcome was quite different. The rich legumes planted for the cattle still grew among the citrus trees, but now the horses no longer had to compete with the cattle for the best grasses. They quickly became obese and too tame as they hung around the easy, rich grazing. In addition, the plants now contained pesticides that had been used on the citrus trees.

Reluctant to leave the best grazing spots, too many horses congregated in small areas. Stallions fought, horses died from infected wounds, and dogs continued to kill foals. Perhaps because of extreme obesity, perhaps because of farm chemicals, or perhaps merely by chance, several mares died giving birth. Founder became a serious problem. Chemical fertilizers and pesticides, which tend to accumulate in fat cells, were suspected of causing reproductive problems in the remaining horses. If they were to survive, the horses needed to return to the pine forest.

Of the twelve living horses, most are pintos and the rest are bay or strawberry roan.

When two local residents, Edison Key and Morton Sawyer, started a cattle operation at one end of the island, they brought the three remaining horses, a stallion and two mares, to safety. Initially the herd blossomed, sharing the grasses planted for the cattle and reaching a high of thirty-five animals. In the 1990s, however, the cattle operation proved unprofitable, and the entire farm was converted to citrus production.

Rescue and Recovery

In 1992, Milanne Rehor, a woman with a keen interest in wooden sailboats and a lifelong love of horses, found a notation in a yachting manual about wild horses on Great Abaco. Further research led her to the cattle ranch, where she hoped to see the remaining wild horses she had read about. The instant she saw them, she was completely taken by the beauty of the endangered wild Abacos. Drawn to help them, she began to publicize the plight of this tiny herd that had survived for four hundred years but was teetering on the brink of extinction. She researched their history and genetics and promoted interest in the horses in the Bahamas and around the world. It was her dream to see a strong herd again living safely in the pine forest, and she lobbied hard for a preserve.

The unprotected herd numbered twenty in 1996. By mid-2004, the number had dropped to twelve, but by then Rehor's tireless work had begun to pay dividends. Genetic testing from three different universities confirmed that the horses descended from old Iberian lines and are among the purest of any such remaining populations. Largely through the Internet, interest in these rare horses was sparked, even in some unexpected places. In Salmon, Idaho, a model horse 4-H Club began campaigning to raise awareness. It convinced Breyer Animal Creations, well-known makers of model horses, to produce a model of the strikingly marked Abaco stallion Capella. The company contributes a portion of all sales of the model Capella to the fund to save the Abacos.

The government of the Bahamas recognized the great historical and genetic treasure of the Abaco Barb horses in 2002 and generously donated a 3,800-acre preserve for their use. At present the horses have access to 200 acres, soon to be expanded to 600 acres, and are contained by a solar-powered electric fence.

A COMMON ANCESTOR

The history of the Abaco Horses brings the almost extinct Spanish Jennets to mind. The Jennets were small, smooth-gaited Spanish horses, known to have been brought to the Caribbean among the earliest shipments of horses from Spain. In addition to having a gentle nature, smooth gaits, and a capacity for work, this famous breed, which was old even then, was reported to come in remarkably wild colors. (See pages 235–237 for information on modern efforts to restore this breed.)

Although no foals have been born in several years, normal reproduction may resume now that the horses have been returned to the forest preserve, where they are losing weight and no longer ingesting agricultural chemicals.

Sadly, in 2005 there is a new peril for the little herd. Haitians fleeing terrible economic hardship in their own land have established semipermanent tent camps in the preserve on Abaco, cutting acres of the forest. Without government supervision, the mere presence of so many profoundly impoverished human beings greatly endangers this tiny semi-feral herd.

Although the horses are considered a national treasure, owned by the Bahamian government, Rehor and her organization, Arkwild, oversee their well-being. The horses find their own food and water and are handled occasionally for necessary vaccinations and hoof trimming. They are afraid of ropes and are head-shy. Great care is taken to minimize human contact and handling, because if too tame, they could easily be captured and harmed by humans.

Breed Characteristics

These horses stand about 13 hands high, with an estimated weight of 900 to 1,000 pounds. Milanne Rehor reports that several of the horses are smooth-gaited. "One mare was seen to rack," she writes. "We've had several pacers. Most exhibit the swimming of the forelegs that is characteristic of Paso Finos."

Conformation

The Abaco horse shows strong Spanish traits. The head is inclined to be fairly long from the eye to the nostril, with heavy bone above the eye. The profile of the face below the eyes is strongly convex. The nostrils are large and open during exertion but crescent-shaped when the horse is at rest. The neck is moderately long and well arched.

The back is fairly short with a long underline. The shoulder is well laid back. The croup is sloping with a low tail set. The Abaco has a deep heart girth, but seen from the front, the horses are not built on a particularly wide frame. The bone is dense and heavy relative to size, and the fetlocks are well angled. The feet are in proportion to the size of the body.

Color

One of the Abacos' most obvious and remarkable traits is their color. Many are dazzling pintos with extraordinary patterns. Dr. Phillip Sponenberg, horse geneticist, suspects that this little population has segregated a form of the "splash" gene, which is associated with the **overo** color pattern (see page 279).

According to Milanne Rehor, there are three distinct pinto patterns among the twelve living horses. One is white with brown ears and a brown mane, a pattern known to horsemen as a **war bonnet.** Another is brown on the front and on the rump with a wide white swath in the middle. Finally, several horses have white rumps and are brown in front on their neck and chest. All the pintos have white faces. Even the bays carry white blazes and stars and some have splashes of white on their undersides. Several horses have high white markings on the legs. Only two of the twelve show no patches of white, and both of these are strawberry roans.

The war bonnet pattern features brown ears and a brown mane with a white face.

Akhal-Teke

HEIGHT: 15–16 hands

PLACE OF ORIGIN:
Turkmenistan

SPECIAL QUALITIES:
Metallic sheen to coat; soft, gliding gaits; extraordinary endurance

BEST SUITED FOR:
Endurance and dressage

Most sources consider the Akhal-Teke (pronounced ah-kul TEH-key) to be a strain closely related to the Turkmenian, an ancient, influential breed that was developed in the desert east of the Caspian Sea. The Turkmenian steppe was one of the first areas in the world where horses were domesticated. It is hard to know exactly where the ancient Turkmenian, or Turkoman, breed ends and its descendant the Akhal-Teke begins. The people of Turkmenistan, where both breeds arose, refer to the present breed as the Turkmenian, but most horse historians believe the ancient breed to be extinct.

Nomads of the Kara-Kum Desert developed these horses. Because they lived largely by raiding other nomadic tribes, they needed horses that could run long distances in the desert. The Turkmenian and the ancient, smaller Caspian breed may have been the world's first hot-blooded breeds of horses. In ancient times they were dispersed throughout the then known world by various nomadic tribes. Turkmene horses traveled from Turkmenistan east as

The color of the Akhal-Teke ranges from palomino to light bay and roan, always with a golden metallic gleam to the coat.

The meaning of this lyrical name is in dispute. According to some, *akhal* means "pure" and *Teke* is the name of the tribe that bred the horses from earliest recorded times. Other sources, including the breed association, report that *akhal* means "oasis" or is the name of a particular oasis.

far as China, south and west toward what is now Syria and Jordan, into Saudi Arabia, and from there into North Africa.

In 1948, archaeologists discovered carefully bridled and adorned, meticulously preserved horses frozen in tombs in Pazyryk, Siberia, that date to 1000 BCE. The horses in the tombs exactly matched today's Akhal-Tekes in height, bone structure, coat color, and other qualities.

A Military Horse par Excellence

By 1000 BCE the breed was already widely recognized by military horsemen as a racehorse, a warhorse, and a horse of tremendous endurance, particularly in the desert. Fairly recently, archaeologists and historians have proved that the Turkmenian breed predated the Arabian, and it is likely that it contributed a great deal to the pedigree of both the Arabian and the Barb.

The army of Alexander the Great rode Turkmenians. Some historians report that Alexander's horse Bucephalus was probably of this breed, although he is usually identified as being a Thessalonian.

Alexander at one time claimed as a spoil of war 50,000 horses from Persia (present-day Iran), which is directly south of the Turkmenian's region of origin. It is probable that many, if not most, of these horses were Turkmenian. Various armies then rode these horses to many locales and crossed them with native horses everywhere they went.

According to the official history of the Akhal-Teke, the influence of the Turkmene horses was one of the main reasons Rome was never able to conquer the Parthians, who ruled much of the Middle East from 247 BCE to 228 CE. Some of these crossbred horses were eventually used by the Roman cavalry, which took them even farther afield. Thus began the influence of this great breed on the light horse breeds of Europe.

The Turkmenian also strongly influenced the horses of the Middle East, contributing much to the Arabian and, in North Africa, to the Barb. From there the breed has gone on to affect the pedigrees of most of the light horse breeds in the world.

Systematic Breeding

The original breeders kept the bloodlines absolutely pure. The Turkmene people had an oral tradition for maintaining accurate pedigrees, which could go back as far as four generations. They based breedings on the results of races and the quality of previous foals, sometimes taking mares long distances to be bred to the best stallions. Inbreeding was prohibited, other than in rare and exceptional circumstances.

Turkmenian horses are traditionally described as being very lean, without excess muscle or fat. The tribesmen conditioned their horses by keeping them blanketed, both to warm them in the cold desert nights and to sweat out fat during the heat of the day. The horses were rigorously worked and carefully fed, making them extremely fit but with their ribs showing.

The feeding program was unusual. Natural forage occurred in the area only about three months of the year. At other times, the horses, particularly the racehorses, ate pellets of corn, alfalfa, barley, bread, and animal fat, usually mutton or chicken.

Many Turkmenian horses were imported into Britain about the time of the development of the English Thoroughbred, in the early to middle 1700s. Some of these horses were referred to as Turks; others were called Arabs only because they were purchased from Arab people; and still others were called Barbs. Some authorities believe that the Byerly Turk, one of the three foundation sires of the Thoroughbred breed (see page

251), was actually a Turkmenian, and that the Godolphin Arabian, another of the three foundation sires, was a Barb. More recently, strong evidence suggests that the Byerly Turk was in fact foaled in England but was of Turkmene descent. Whatever the precise breeds of the three sires, the blood of the Turkmenian was greatly influential in the foundation of the Thoroughbred.

Recent Threats to the Breed

This famous and ancient breed came to near extinction in the twentieth century. While Russia controlled Turkmenistan from 1885 to 1991, the ancient tradition of nomadic raids ended, and with it went the need for the purebred Akhal-Tekes. The Russians had long made use of these horses in their cavalry; however, after World War II there was no longer much need for army horses.

Although the breed is tremendously athletic, its small size and light frame made it unsuitable for the Russians to use competitively in most European and Olympic horse sports, which were dominated by large, heavy, warmblood breeds. The exception was dressage: in 1960, an Akhal-Teke stallion named Absent won the Olympic gold medal. By the time this horse's career ended, he had won more Olympic medals than any other horse.

Nevertheless, the breed fell entirely out of favor with Russian breeders. Some nomadic tribesmen had already abandoned their purebred horses because they could no longer justify the expense of raising them. Many were sold to Iran, Turkey, Afghanistan, and India, while others went

With its long, thin neck, the Akhal-Teke often appears longer than it is tall.

to the slaughterhouse. Still others were used to produce crossbred foals. By 1973, there were only eighteen purebred mares and three purebred stallions in Russia.

At virtually the last moment, however, the Russians pulled the breed back from extinction. With concerted effort, the number of purebred horses increased markedly between 1980 and 1989. Before the breakup of the old Soviet Union, breeders planned to increase the herd to seven hundred purebred mares. The breed is now found in Turkmenia, Kazakhstan, and the North Caucasus. It is very likely that some of the horses used in the recent war in Afghanistan were either pure or part Akhal-Teke.

The breed has slowly begun to spread internationally. Since 1979, Akhal-Tekes have been imported to the United States, and enough reside here now to warrant a tiny Akhal-Teke Association of America.

The Nez Percé Indians of Idaho, the first breeders of Appaloosas, have begun crossing Akhal-Teke stallions with registered Appaloosa mares to develop a new Nez Percé Horse, one that exhibits the qualities prized in the Nez Percé horses of the 1800s. They believed that over the years their original horse stock became Americanized through crosses with other breeds. Akhal-Tekes were selected because of their famed endurance and because they can thrive on slight rations, they rarely get sick, they have speed and can jump well, and they recover quickly from exercise. The first crosses produced a number of foals with the characteristic Akhal-Teke metallic sheen and Appaloosa coloring.

Breed Characteristics

The Akhal-Teke is famous for its very fine, silky coat, which often has an unusually beautiful metallic sheen. Within the individual hairs, the opaque core of the shaft is greatly reduced in size and sometimes absent. In its place is a transparent medulla of the shaft, which acts in a way similar to fiber optics, bending light through one side of the hair and refracting it out the other. The light often emerges with a golden cast. For this reason, many of the horses are gold or have a golden glow to their coats, whatever the color.

Gait

The breed is also known for its peculiar, soft gaits. Although not a "gaited breed" as we have defined it, these horses are said to glide over the ground. They are particularly famous for incredible feats of endurance, especially in desert conditions. In 1935, the Russian army tested several breeds of horses by riding them 1,800 miles, including about 225 miles of desert. The horses covered the desert portion of the trek in three days, during which they went without water or food. The Akhal-Tekes fared far better on this ride than any of the crossbred horses and markedly better than the part-Thoroughbreds.

Conformation

Akhal-Tekes range in height from about 14.2 hands to about 16. Typical weight is 900 to 1,000 pounds. The head is long, with a straight or slightly dished profile; large, expressive, often hooded eyes; and large, thin nostrils. The ears are long, mobile, high set, and very alert. The head attaches to the long, thin neck at a fairly abrupt angle, creating a profile historically described as similar to a cobra ready to strike. The withers are high. It is not

uncommon for a horse to appear ewe-necked. The mane and tail are typically sparse, and sometimes the forelock is absent.

Characteristically, the Akhal-Teke is longer than it is tall, with a long back that sometimes dips a little. The croup is short and sloped, with a low tail set. Though the chest is narrow, the heart girth is deep. Shoulders are very long and well sloped. The legs are long and straight, with short cannon bones; sometimes the forearm is twice the length of the cannon. The horses are said to have excellent and very dense bone. Most breeds of horses have hind pasterns slightly shorter than front pasterns, but the Akhal-Teke has unusually long and slanted hind pasterns. The feet are well formed and very hard.

Color

The most common colors are light bay, light chestnut, dun, and palomino, all generally found with a golden metallic cast to the color. In a partial list of the wide variety of other colors, the Akhal-Teke Association includes dominant black, which glitters with a blue or purple sheen; mahogany bay; liver chestnut; **claybank** or red dun; gray; golden with darker mane and tail; grulla, cream grulla; cremello; and perlino.

In race condition Akhal Tekes are very lean. With its sloping croup, long pasterns, pronounced withers, sparse mane and tail, and golden color, this horse exemplifies the breed standard.

American Curly Horse

HEIGHT: 14.3–15.2 hands

PLACE OF ORIGIN: Western North America

SPECIAL QUALITIES: Unique curly coat and mane; smooth lateral gaits

BEST SUITED FOR: Ranch work, trail riding, endurance, and all pleasure sports

Nevada rancher Giovanni Damele and his family first saw horses with dense, curly coats running wild on their new spread in 1898. Not until 1931, however, did the family catch one of the horses, break it to ride, and sell it. The next winter was extremely harsh, and most of the wild and domestic horses running on the range either starved or froze to death. Among the few survivors were several Curly Horses.

Intrigued by their hardiness, the Damele family began a concerted effort to capture, use, and breed them. They found the horses easy to train, good at ranch and cattle work, and comfortable to ride because of their naturally smooth shuffling gait. They had great endurance and were extremely hardy. Some Curlies also have the odd characteristic of annually shedding and regrowing the mane and sometimes the tail.

As neighboring ranchers bought and worked the Curly Horses, word spread about their hardiness, versatility, and tractable nature. The fanciers researched their unusual breed and found that the animals were not limited to Nevada. In fact, Crow and Lakota Sioux had captured Curly Horses from South Dakota in the early 1800s. It is reported that in 1881, when Chief Red Cloud made some drawings of the Battle of Little Big Horn, he included an Indian riding a curly-coated horse.

The American Bashkir Curly Registry was founded in 1971 amid major concerns about the likelihood of inbreeding problems because the population of Curlies was so small. At that time it was believed that the breed traced its history back to the ancient Bashkir breed of Russia, and so the name Bashkir was incorporated into the breed's official title. Before the dawn of the Internet, it was exceptionally difficult to gather information on obscure horse breeds from remote parts of Asia, so for quite some time the theory of Russian origin persisted.

This theory was probably mistaken on two counts. First, the Lokai is the correct name of the Russian breed known for its curly coat. Second, it is extremely unlikely that any horses escaped from early Russian settlements in Alaska and over the years managed to migrate to Nevada. The distance between Alaska and Nevada alone makes this nearly impossible, but in addition, it is now known that the Russians shipped very few horses from Siberia to their settlements in Alaska. It is doubtful that any of those were of specific breeds, or had curly coats, although this is not proved.

The Russian settlements in Alaska never succeeded at any sort of animal breeding because of the extremely severe climate. The few horses that may have been imported from Russia probably perished in Alaska. Thus the origin of the American Curlies remains a mystery.

Outcrossing

The registry members decided that in order to save the Curlies, it would be necessary to outcross to other breeds. Four breeds were selected for specific reasons. Arabians were chosen because they have

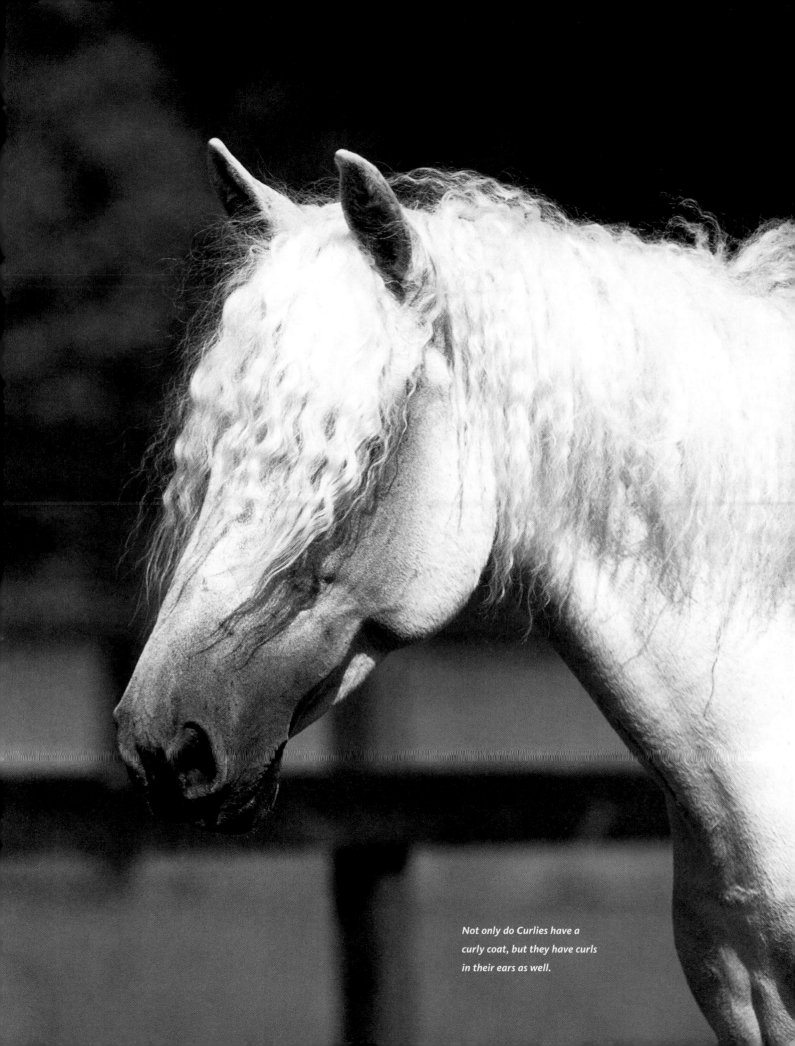

Not only do Curlies have a
curly coat, but they have curls
in their ears as well.

the same short back, sometimes with five lumbar vertebrae, and, like the Curly Horses, they are known for great endurance. Morgans were chosen because their conformation is similar to that of the Curlies. Appaloosas were selected because they had been bred for endurance and because some share the very unusual Curly trait of shedding the mane and the tail annually. Finally, the organizers selected Missouri Fox Trotters because their gait is most like the natural gait of the original Curlies.

In 2000, the American Bashkir Curly Registry closed the studbook to all other breeds. Horses now are admitted only by proven pedigree, not simply because of coat characteristics. However, a second registry, the International Curly Horse Organization, continues to register all horses with curly coats, regardless of pedigree. This allows Curly Horses from the Bureau of Land Management and crossbreds to be tracked.

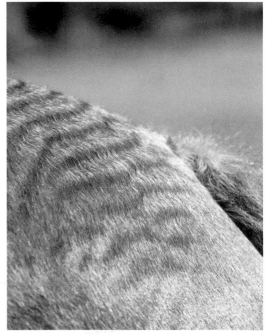

When viewed in the right light, the Curly coat has a wavy pattern similar to rippling water.

Breed Characteristics

Curlies are born with dense, curly coats, including curls in the ears and curly eyelashes. It is said that people with allergies to horses are not allergic to Curlies, but this is not proved.

Curlies transmit the curly characteristic to their offspring about half the time, even when crossed on horses with ordinary, straight coats. It is sometimes easier to see the curls when the horses are in their winter coats, but close examination of a Curly in summer also reveals the characteristic.

Curlies are used for ranch work, trail riding, endurance, and all pleasure sports. They make good all-purpose and family horses.

Conformation

These sturdy horses stand 14.3 to 15.2 hands and weigh between 950 and 1,100 pounds. A typical Curly resembles the early Morgans. The eyes are wide-set, providing good peripheral vision. The muscular neck is of medium length and attaches to a wide, deep chest and powerful, rounded shoulders. The back is short and strong. The round croup has no crease. The breed is known for its extremely hard, black, almost round hooves. Many individuals have no ergots; some have small, soft chestnuts.

Color

Curlies come in all common horse colors, including all solids, pintos, and Appaloosa coloring.

Curly Horses resemble early Morgans in type, and the Morgan was one of four breeds used to help establish the breed. The others were Arabian, Appaloosa, and Missouri Fox Trotter.

BREED ASSOCIATION FACTS AND FIGURES

According to the American Bashkir Curly Registry (founded in 1971):

- More than 4,000 horses were registered as of 2004.
- About 100 new foals are registered each year.
- The breed is found in many parts of the United States and Canada.

American Indian Horse

HEIGHT: 13–16 hands

PLACE OF ORIGIN:
Throughout North America

SPECIAL QUALITIES:
Tough and durable; features
vary according to tribal and
family lines

BEST SUITED FOR: Endurance

The history of the American Indian Horse is the history of the American West. These animals transformed entire indigenous cultures into swift nomadic hunters and fearsome warriors. They were used as warhorses, racehorses, and stock horses, as well as beasts of burden. They truly changed the face of the nation.

Domestic horses first arrived in the New World with the Spanish in 1493.

After a mere fifteen years, Spanish breeders were so successful on the islands of the Caribbean that they stopped importing horses from Spain and began exporting them to Central America, Mexico, and, by 1560, directly to Florida.

Initially the indigenous peoples were awed by the sight of men on horses, variously fearing them and believing them to be gods. Very quickly, however, they came to understand the nature and the potential of horses, and from that time on the history of the Americas was changed.

Both the Spanish and later the English colonists so feared what would happen if Indians acquired horses that in the very early days laws were written to prevent Native Americans from owning or riding horses and to prevent anyone from selling horses to them. Over time, however, horses were lost and stolen and feral herds became common, so Indians soon had a ready supply.

All the tribes that would become horsemen were mounted by 1710. Plains Indians, especially the Kiowa and Comanche, became some of the finest mounted warriors in the history of the world. Some tribes established systematic breeding herds in an effort to improve the quality of their horses.

One Overall Breed

The American Indian Horse is the name now given to all Indian horses. At one time many individual tribes had types of horses they preferred, but when the tribes were decimated, their horses were largely lost. In order to preserve these horses, the American Indian Horse Registry researched the conformation and combined the remaining tribal lines of horses into one all-encompassing breed.

Nevertheless, there are still breeders who select horses only from particular tribal lines. One of the most famous of the very early Indian horses was the Chickasaw horse from the Southeast. The genes of these extraordinarily tough little horses were certainly passed on to the Florida Cracker and to the earliest Quarter-Pathers, the ancestors of our Quarter Horses. Excellent Chickasaw horses still exist, but today's breed is something of a re-creation of the original since the old lines have been lost.

Breed Characteristics

The typical Indian horse carries strongly Spanish traits. It has always been small and tough, with great endurance, yet each of the tribes preferred and developed particular qualities in their horses.

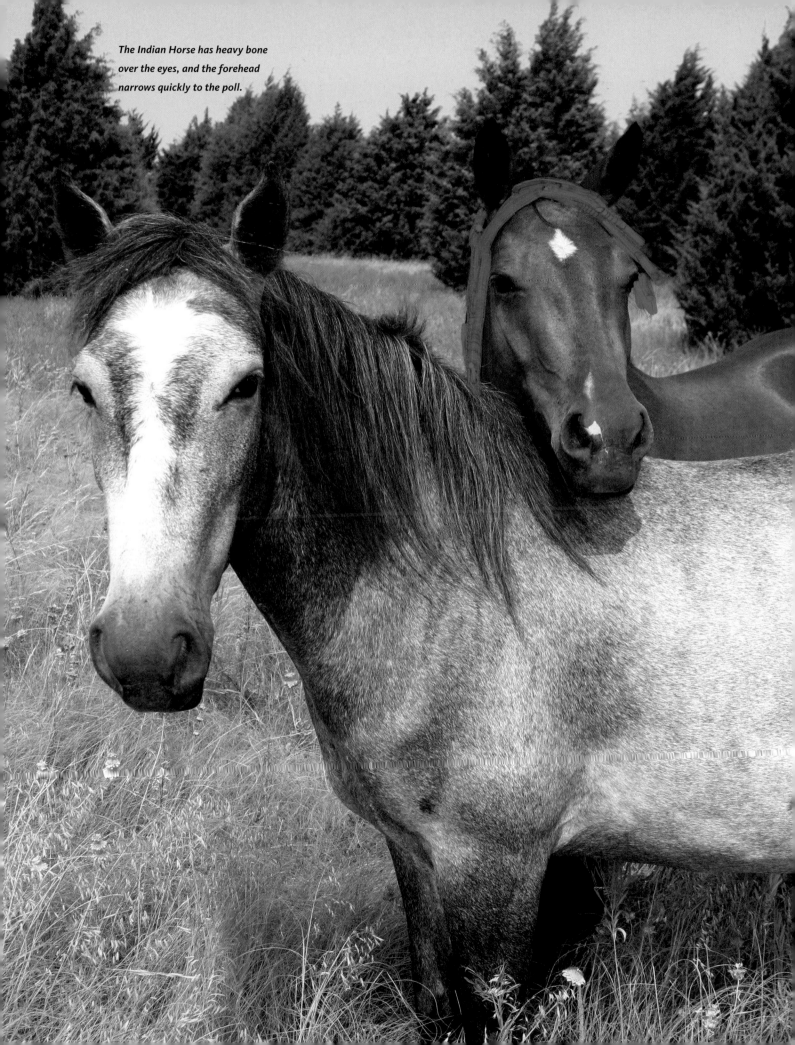

The Indian Horse has heavy bone over the eyes, and the forehead narrows quickly to the poll.

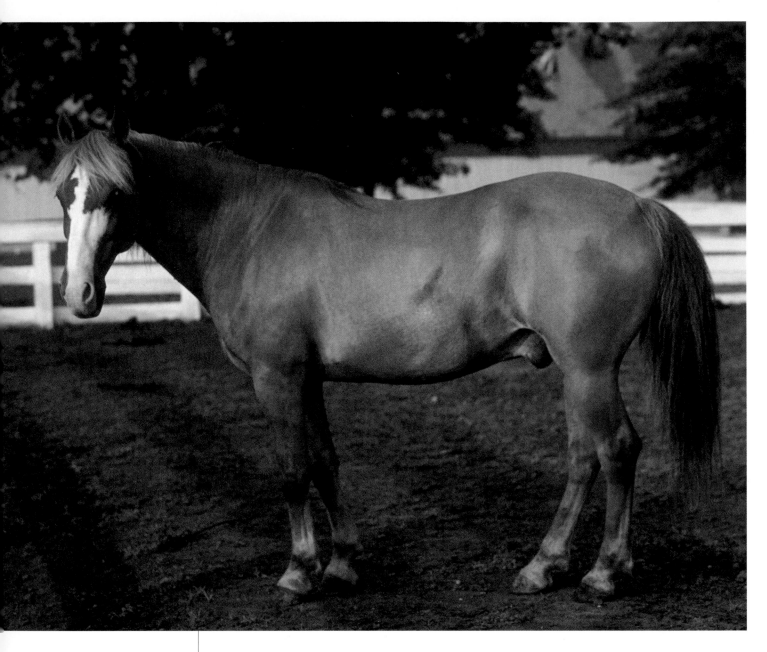

With typical Spanish traits, the Indian horse has an angled croup, a low tail set, and a heavy neck.

Conformation

The Indian horse can range from 13 to 16 hands and weigh 700 to 1,000 pounds, although most are in the 14.2- to 15-hand range. Horses should be well made, with excellent feet and legs. The head and body demonstrate Spanish characteristics—

BREED ASSOCIATION FACTS AND FIGURES
According to the American Indian Horse Registry (established in 1961):
- There are 3,605 horses currently registered.
- About 75 new foals are registered each year.

notably heavy, dense bone relative to the size of the horse, a short back and a long underline, a well-laid-back shoulder, a sloping croup with a low tail set, and a fairly short, often arched and somewhat heavy neck.

Indian horses have long, sloping pasterns and solid, well-constructed hooves of great density. Typical of Spanish horses, they do not show any tendency toward small feet relative to their size.

Heavy bone over the eye and a broad forehead that narrows quickly to a point on the skull are typical. The ears may be either

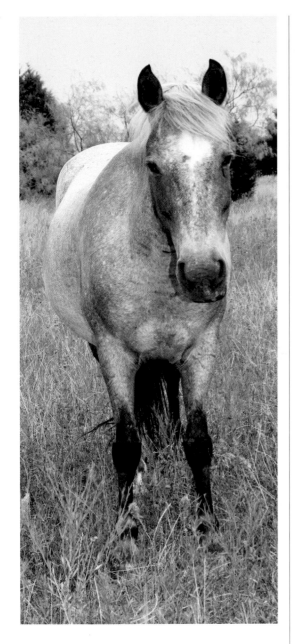

short or long but never broad and wide, and may be hooked at the tips. The profile is usually convex or straight, but a slight dish is sometimes evident. The eyes are large and may be any known color that occurs in horses, including brown, blue, green, gray, hazel, or amber.

Color

Virtually every color known to the horse appears in this breed, including Appaloosa patterns, pinto coloration (both the overo and tobiano patterns), palominos, roans, grullas, and all solid colors.

REGISTRATION GUIDELINES

The American Indian Horse Registry collects, records, and preserves the pedigrees of American Indian Horses. There are five classifications of registration.

- Class O horses preserve original bloodlines of Native American tribes. Class O horses registered since 1979 trace bloodlines back to various American Indian tribes and families.
- Class AA horses are at least 50 percent Class O by breeding or are of exceptional O type. Bureau of Land Management horses may qualify for AA classification. To qualify as AA by inspection, a horse must be at least four years of age.
- Class A horses are horses of unknown pedigree but of Indian Horse type. At age four, Class A horses are eligible for inspection and may be passed on to Class AA type. Bureau of Land Management and grade horses may qualify for a registration.
- Class M horses include breeding of modern type. They may have parents that are registered Quarter Horses, Paints, Appaloosas, or others. The parentage is noted on the registration.
- Class P registers ponies of Indian Horse type. Eligible ponies include those with Galiceno, Pony of the Americas, or others in their pedigrees. Ponies of unknown registry may also qualify.
- No horse or pony showing draft horse breeding will be registered.

American Paint Horse

HEIGHT: 14.2–16.2 hands

PLACE OF ORIGIN: The American West

SPECIAL QUALITIES: Striking color patterns, stock-type conformation, versatility, athleticism, gentle temperament

BEST SUITED FOR: Western competition, ranch work, and trail riding

That colored horses have always attracted attention is well documented in the art of many cultures. Egyptian tombs dating from the fourth century BCE contain representations of horses colored like today's Paints. The nomadic tribes of the Gobi Desert drew paint-colored horses and made many references to such horses in the oral history they passed down from generation to generation. Early statues from Chinese burial mounds document familiarity with paint coloring, as does the art from some ancient sites in India. Similar coloring can also be traced in horses that were brought with the Huns and other barbarians during invasions of the Roman Empire around 500 CE.

The influence of colored horses was particularly prevalent around the Mediterranean basin and in Spain. By 700 CE, Spain had many colored horses with both the tobiano and the overo color patterns (see page 63). In Europe, paintings from the sixteenth century on indicate that paint-colored horses were highly prized by the wealthiest individuals. Later, colored horses fell out of fashion in much of western Europe. When this happened, more than a few were put on boats that were headed for North America. When they showed up in colonial New England, they were primarily traded off, often to Indians or Canadian trappers, because the Puritans thought the colors were too flashy.

According to historians, the first documented arrival of a paint-colored horse on North American shores was in 1519, when Cortés landed in Mexico. Seventeen horses, both mares and stallions, accompanied him on the voyage. (A stallion died shortly after arrival; one mare foaled on the ship.) A record was kept of type, sex, and color.

There was a tobiano with white stockings on his forefeet and a dark roan with white body patches. This indicates that both the tobiano and the overo color patterns landed with Cortés. Once colored horses arrived, they continued to attract attention.

As horse numbers boomed first in Mexico and then farther north, various Indian tribes quickly developed horse cultures. They often sought the paint-colored horses during trading and stealing ventures and deliberately incorporated them into the breeding herds. Most Indian tribes were not goal-oriented horse breeders the way we think of breeders today; they kept the ones they liked and traded the ones they didn't like. Because they kept herds of mares and stallions together, over time they ended up almost inadvertently selecting and breeding for type and color.

Paint-colored horses were more easily camouflaged than other colors, yet another reason for their appeal to Indians living on the plains. They reportedly rode horses that blended in with the natural and seasonal coloring of the country they were riding through. Duns, light roans, and light sorrels, as well as pinto horses with these base body colors, matched the colors of the prairies and were ridden in summer and fall. White,

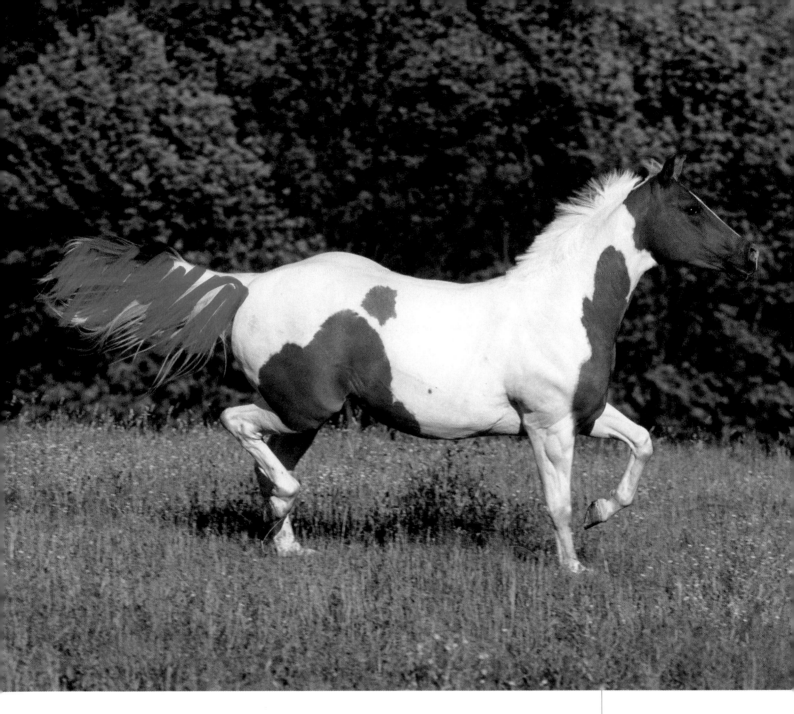

light gray, and palomino horses, and pintos of these colors, were ridden in winter. In sagebrush country, blue roans were favored. Painted horses with less-than-perfect base body colors could be temporarily altered with a little mud, ocher, or other natural pigment to fit the occasion. Paints were also often used to show off. The Comanches particularly favored very loud-colored Paints.

Indians weren't the only ones who admired colored horses. Old songs mention them: for example, "Old Paint" and "Goodbye Old Paint," both of which were well known before the 1870s. Early Western artists such as Frederic Remington painted them. Because they were both attractive and plentiful in Mustang herds, a major source of cheap horses for early cowboys and settlers, painted horses were ridden everywhere. They were used on ranches, and they made appearances in Wild West shows, trick acts, and parades.

When cattle ranches began to take up the land used by wild horses, and every attempt was made to eradicate all Indians and all remnants of their culture, millions of Mustangs and Indian Horses of all colors were sent to slaughter or shot for "sport."

Colored horses came to North America with Cortés and have been extremely popular ever since.

Some Indian tribes considered colored horses and particular color patterns to be magical. The Comanche and the Cheyenne particularly revered **Medicine Hats** — white horses with color only on a "bonnet" over the ears and on a "shield" over the chest. Only warriors who had proved themselves in battle were allowed to ride them. Among the Comanche, a warrior who rode a Medicine Hat into battle was considered invincible.

At this time there was also a significant but little-discussed element of racism involved in horse selection. Many white men carefully avoided having anything to do with colored horses, largely because they were favored by Indian, Mexican, and Spanish horsemen. Despite the racial undercurrents, there were always horsemen interested in loud color who prized beautiful painted horses.

Blue eyes are common on Paints.

Registry History

As horses came to be used more and more for pleasure, interested individuals saw the need to organize an association and registry to document bloodlines and ultimately to create a true breed of stock-type colored horses, the American Paint Horse.

In the early 1960s, there were two organizations, the American Paint Stock Horse Association and the American Paint Quarter Horse Association. In 1965 they merged to form the American Paint Horse Association (APHA), which continues to the present day. The APHA represents a breed of colored stock horses based upon and regulated by restricted bloodlines. Outcrosses are limited to Quarter Horses and Thoroughbreds. The APHA does not recognize gaited breeds, draft horse breeds, or pony breeds in its pedigrees.

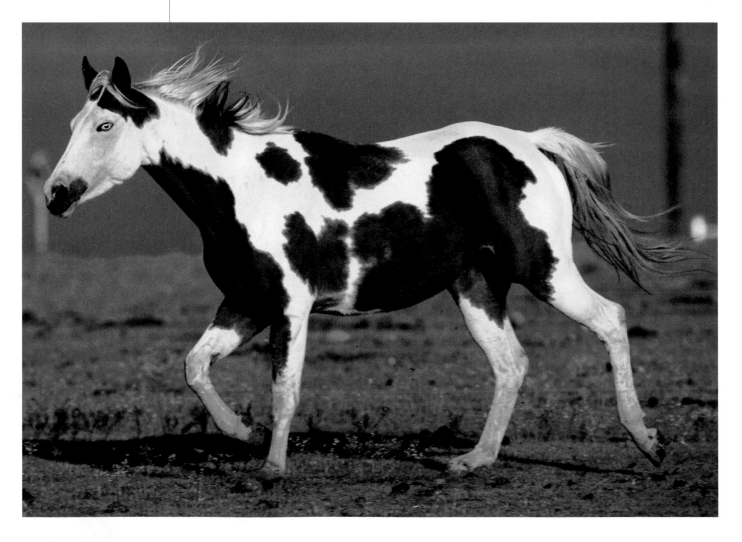

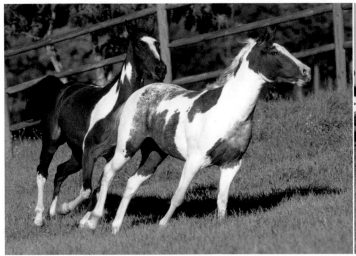
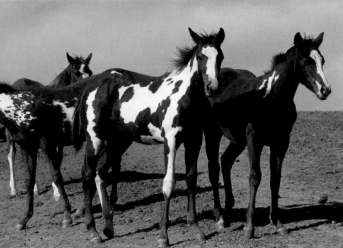

Breed Characteristics

This attractive breed has become very popular in North America and has also made its mark in European, Central and South American countries, and Australia, as well as in South Africa and Japan. Paints are found in virtually all working and pleasure disciplines. They particularly excel in "Western sports," from Western pleasure to roping, reining, cutting, and contesting, but also in English show classes, the hunt field, events, and pari-mutuel Paint races, and on trails.

Conformation

The American Paint Horse is a solidly built stock horse, compactly made but refined. They range from 14.2 to 16.2 hands. Typical weight is 1,000 to 1,200 pounds. The head has a straight profile, large eyes, and pricked, average-sized ears. The neck should be nicely formed and muscular. The shoulder is sloped, the back short and strong, and the legs solid and well muscled, with strong joints and tendons.

Color

There are two main color patterns within the breed, gradations between the main patterns, and some less common patterns.

TOBIANO

The first main color pattern is the **tobiano.** The face of a tobiano horse usually has markings like those of any solid-colored horse: a blaze, stripe, star, or snip. The tobiano often has four white legs, at least below the hocks and the knees. Spots are regular and distinct, often appearing in oval or round patterns that extend down over the neck and the chest. White may extend across the back. Tobianos tend to have a dark color on one or both flanks, and the tail may be multicolored.

OVERO

The second main color pattern is the **overo** (o-VAIR-o). Overo horses rarely have any white extending across the back between the withers and the tail. Generally, at least one leg, and often all four, is colored. The head markings often include a bald or bonnet face. The body markings tend to be irregular, scattered, and splashy. Usually the tail is one color.

See Pinto (page 277) for more on spotted coloring.

The tobiano color pattern (left).
The overo color pattern (right).

BREED ASSOCIATION FACTS AND FIGURES

According to the American Paint Horse Association (APHA) (founded in 1965):

- The APHA originated with about 3,900 registered horses.
- As of 2005, there are more than 600,000 registered horses.
- In 2000 alone, 62,000 new foals were registered.
- The American Paint Horse is the fifth largest breed in the world, and has one of the fastest-growing breed associations.

American Quarter Horse

HEIGHT: 14.2–17 hands

PLACE OF ORIGIN: North America; originated along the eastern seaboard and solidified into a breed on the ranches of the American West

SPECIAL QUALITIES: Exceptional athleticism and versatility; extreme speed for short distances; most highly developed "cow sense" of any breed

BEST SUITED FOR: Ranch work; short-distance racing, cutting, reining, and other competition

The Quarter Horse is truly an American creation. It may be the first horse "type" to have been deliberately produced on this continent. Its history can be traced back even before the earliest days of the American colonies, all the way to the official royal breeding farms established on this continent by the very early Spanish in what is now the southeastern section of the United States, an area then known as Spanish Guale. The Quarter Horse's pedigree includes Spanish Barbs, Colonial mid-Atlantic Quarter-Pathers, Rhode Island racing stock, English Thoroughbreds, Andalusians, Mustangs, and the small but excellent horses of the Chickasaw Indians, among others.

Historians report that the first individuals to import English horses to Virginia did so around 1620. Quite soon thereafter, horse racing became legal and immediately grew popular, particularly as a leisure activity for the sons of wealthy plantation owners. By 1690, very large purses were being offered, some reportedly worth as much as $40,000 in gold and other commodities. There were no racetracks, and long, straight stretches of road were hard to find, so the races were short, most often a measured quarter-mile.

Races were often run down the main street of the town, because that was usually the only flat, cleared stretch available. They were almost always match races, and the horses were known as Quarter-Pathers, Short-racing Horses, or sometimes Short Horses. J. F. D. Smith, who toured the colonies before the Revolutionary War, reported, "They are much attached to quarter racing, which is always a match between two horses run a quarter of a mile, straight out . . . and they have a breed which performs it with astounding velocity."

Short racing was also popular in Rhode Island, where some of the best colonial running horses were raised. The relaxed laws of Rhode Island allowed horse racing, while other, more Puritanical New England states did not. William Robinson, a deputy governor of Rhode Island, bred some of the very best racers. His original sire was a horse named Old Snipe, who was discovered in a group of wild horses. It is strongly believed that Old Snipe's closest ancestors were Barbs from Andalusia, or Córdoba, in Spain. When races were arranged between horses of Virginia and Rhode Island, the offspring of Old Snipe did so well that soon they were being exported to Virginia.

Virginia's earliest racing Short Horses already had some Spanish blood. By the early to mid-1600s, there were horses of Spanish descent in the backwoods of Virginia, some wild and some owned by Indians, including the Chickasaw, who were known for having small horses of excellent quality. A traveler from England described the horses as being "not very tall, but hardy, strong, and fleet." The wild Spanish horses originally came from what was then known

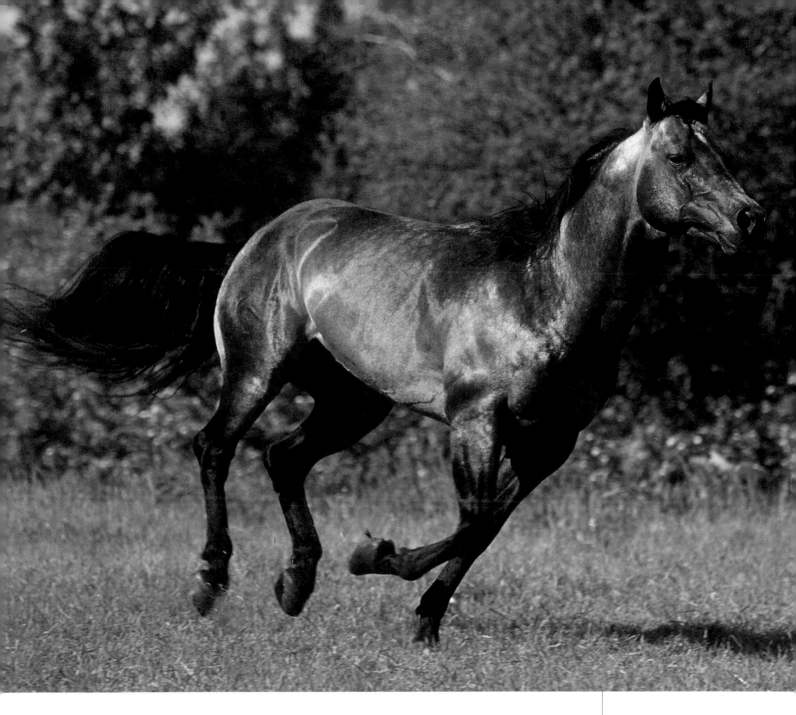

as Spanish Guale, a huge ranching district in the Southeast that had been established by Pedro Menendes de Aviles (best known for naming St. Augustine in Florida in 1565). By 1650, this area had seventy-nine missions, eight large towns, two royal ranches, and many horses. Repeated raids by both the English and the Indians on the Spanish settlements, and subsequent trading, spread livestock far into the North.

Thoroughbred Influence

Although many believe the Thoroughbred was a cornerstone in the foundation of the Quarter Horse, in fact, the colonial Short Horse was well established before the earliest English Thoroughbreds could have significantly influenced the breeding. The original studbook for American Thoroughbreds specifically included "Short-Horses" in the pedigrees of the first recorded American Thoroughbred Horses.

The earliest individual English Thoroughbred to make an impact on Quarter Horses was Janus, who was imported to Virginia in 1752. A terrifically prolific sire, he was said to have produced horses with more early speed than endurance. After

The Quarter Horse originated in the colonial era with the blood of many breeds, each contributing excellence.

Janus, the greatest Thoroughbred influence on early Quarter Horses was Sir Archy, a 16-hand distance horse. Many of the greatest Quarter Horses of the nineteenth century, such as Cold Deck, Shilo, and Billy, trace back to Sir Archy, as do two well-known horses of the twentieth century, Joe Bailey and Peter McCue.

From the time of Janus to the present day, Thoroughbreds have repeatedly been crossed in. Without this occasional cross, there was a tendency for the running ability of the Quarter Horses to become too "short," meaning they could not maintain any significant speed over distance, and for coarseness to appear in their features. Thoroughbred blood also helped counteract a tendency for Quarter Horses to become "mutton withered" and to have short, upright pasterns. Thoroughbreds are still crossed in, more in some types of Quarter Horse than in others.

From Racing to Ranching

In the nineteenth century, longer races supplanted short-distance racing. Racetracks were built, and by 1850, the fashion in racing was four-mile heats. As longer distances became the norm, the Quarter-Pather lost a great deal of favor to English horses that could run farther. Quarter-Pather breeding fell off dramatically.

In this same era, however, settlers were moving west, and the functional little Short Horses moved with them, pulling wagons, buggies, and plows. As the settlers turned to managing livestock, these horses were discovered to have exceptional "cow sense," as well as the quickness and athleticism that made them ideally suited for ranch work. By then the breed was more commonly known as the Quarter Horse. When cattle ranching became a major industry, Quarter Horses were indispensable.

Quarter Horses were also popular because they made excellent **using horses** — meaning they could do a wide variety of highly useful things, particularly on ranches. Because of their kind disposition, they were often the first choice as family mounts as well. Today, the breed is by far the most popular and successful in the world, with more than 4,000,000 registered horses. American Quarter Horses can be found just about everywhere doing just about everything that horses can do.

Breed Characteristics

The Quarter Horse has become so popular that there are now several types within the breed, their qualities varying dependent on the activities they perform. Today's cutting horses don't look like the pleasure horses, and the pleasure horses don't look like the halter horses. (See chapter 3 for more information on Quarter Horse conformation.)

Conformation

Quarter Horses can stand between 14.2 and 17 hands, with a typical weight range of 1,000 to 1,500 pounds. Generally, the Quarter Horse has a short, fine head with a straight profile, small, alert ears, and lively eyes set well apart. The neck is muscular, well formed, and somewhat arched. The

Originally developed on the East Coast to run races over short distances, the Quarter Horse found its place in the development of the West as an outstanding ranch horse with innate "cow sense."

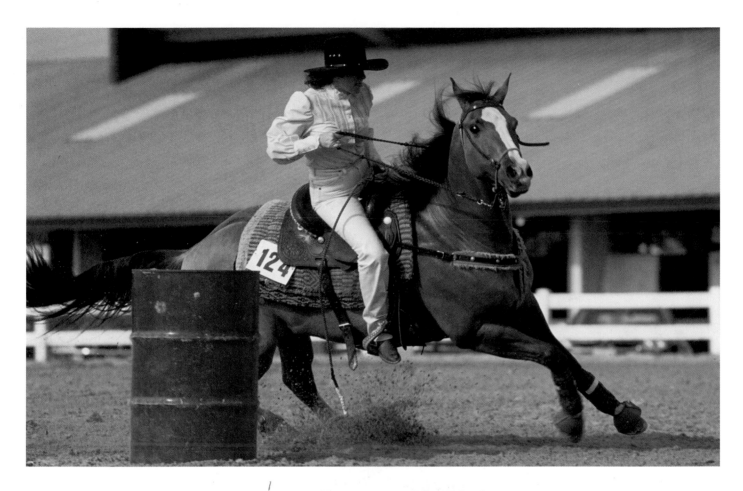

withers are well defined and set prominently into the short, straight back. The long, muscular, and rounded croup drops gently to the haunches. The chest is wide and deep, and the shoulder long, muscular, and usually well sloped.

The legs are solid and well formed, with broad, clean joints and very muscular thighs, gaskins, and forearms. The feet are generally good, but on some horses may be less than proportionate to body size.

Color

The AQHA recognizes bay, black, brown, sorrel, chestnut, dun, red dun, grulla, buckskin, palomino, gray, red roan, blue roan, bay roan, cremello, and perlino.

Sorrel is by far the most common color, making up about one third of registered horses. White markings on the face and lower legs are permitted (and common), but white above the knee or the hock and white body patches are not allowed.

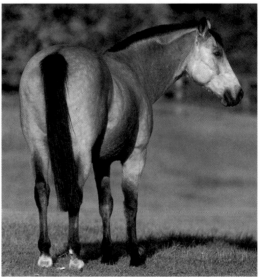

Although blazes and other facial markings are common, Quarter Horses (above) do not exhibit pinto coloring. Buckskin (left) is typical.

BREED ASSOCIATION FACTS AND FIGURES

According to the American Quarter Horse Association (founded in 1940):

- Worldwide, there were more than 4,000,000 horses registered as of 2003.
- Approximately 150,000 new foals are registered each year.

American Saddlebred

HEIGHT: 15–17 hands

PLACE OF ORIGIN: Eastern United States, especially Kentucky

SPECIAL QUALITIES: Elegance and beauty; can have three or five gaits

BEST SUITED FOR: Showing (riding and driving); trail and pleasure riding

The roots of this truly American breed go back to the founding of the United States. The American Saddlebred was developed using as initial stock almost every light breed of quality being ridden or driven at the time. Refinements and improvements continued, mostly in Kentucky, where the breed became known first as the Kentucky Saddler, then as the American Saddler, and finally as the American Saddlebred.

According to the American Saddlebred Horse Association, an all-purpose riding horse, commonly called the American Horse, was recognized by the time of the American Revolution as a definite type known for its stamina, good looks, and easy gaits. In 1776, an American diplomat in France wrote to the Continental Congress requesting that one be sent as a gift to Marie Antoinette.

The famed Narragansett Pacer was certainly important in the Saddlebred's development and may have been the central root from which the breed's easy gaits arose. Narragansett Pacers may not always have been true pacers but rather **amblers,** a gait just out of the true pace. The **pace** is a gait in which both legs on the same side move in unison, while the **amble** is almost but not quite a true pace. Although the pace isn't comfortable to ride, the amble is, and Narragansett Pacers were famous as both riding and driving horses. Narragansetts were little and tough, but they weren't very flashy.

Other breeds added other qualities. Early Morgans probably improved the Kentucky Saddlers by contributing substance, short backs, compact bodies, and stamina. Canadian Pacers, a type that originally arose in Canada from pacing horses imported from France, are a documented branch of the ancestry. The most famous of these was a blue roan stallion named Tom Hal, who was exported from Canada first to Philadelphia then to Kentucky. This horse also was strongly influential in the establishment of the Tennessee Walker and the Standardbred. Somewhere along the way, the blood of good trotters was blended in, bringing gameness and a good driving gait to the breed.

Breeders eventually introduced Thoroughbred genes, which added elegance, speed, and refinement. The great Thoroughbred Denmark, a Kentucky-born son of the imported Hedgeford, was bred to a naturally gaited mare, producing the horse Gaine's Denmark. This horse's name appeared in so many early pedigrees that he was long designated the single foundation sire of the breed. Several other stallions were influential as well, however, and in 1991, Harrison Chief was added as a second foundation sire; the Thoroughbred blood in this great horse came from Messenger, who was imported from England in 1788

EXTRA GAITS

At horse shows today, the **slow gait** is a slow, balanced gait during which the horse's weight is suspended on one foot. It is comparatively difficult for the horse to perform, but when well done is spectacular to watch. The **rack** is a much faster version of the same gait. The rack is an extremely smooth gait to ride, and good Saddlebreds seem to fly over the ground.

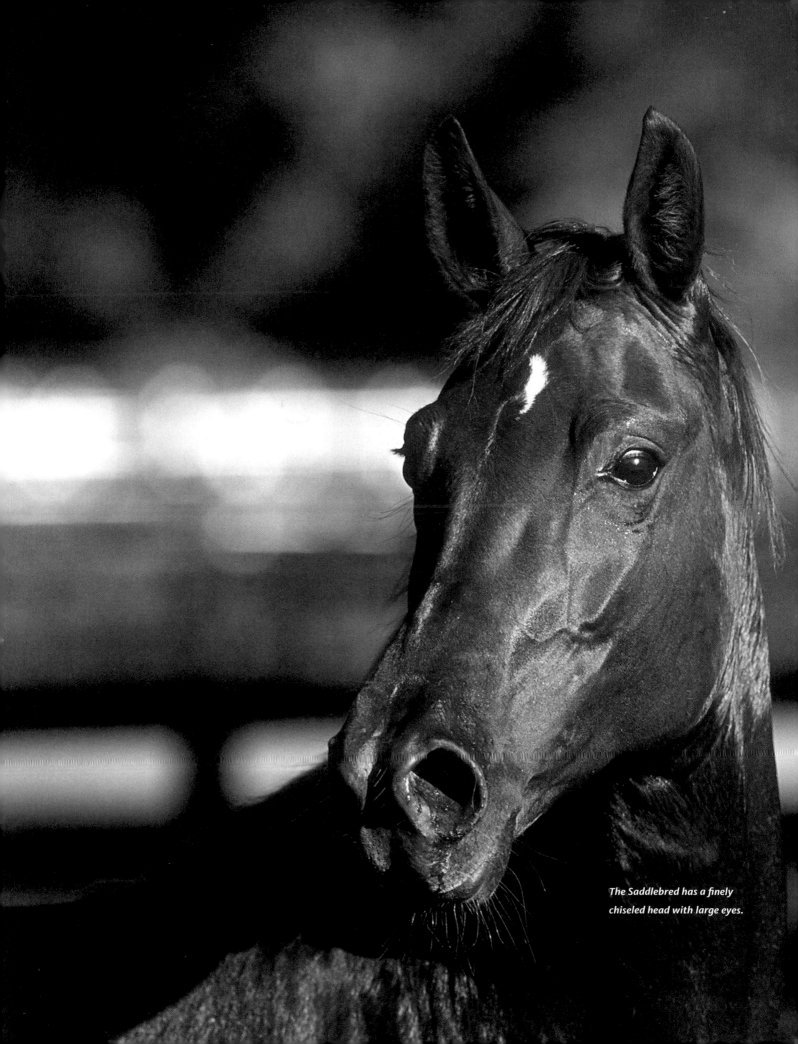

The Saddlebred has a finely chiseled head with large eyes.

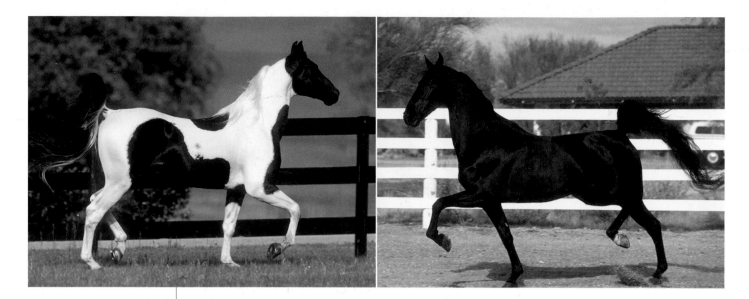

and is also one of the foundation sires of the Standardbred.

Military Mounts

Kentucky Saddlers had a long and illustrious career in the Civil War, usually as officer's mounts, where they were sometimes selected for their looks and noble bearing but proved themselves, on both sides of the conflict, as horses of incredible endurance and bravery. General Lee's Traveler was a Saddlebred type, as were Grant's Cincinnati, Sherman's Lexington, and Stonewall Jackson's Little Sorrell.

Breed Characteristics

Saddlebreds are beautiful horses with graceful, elegant bearing. They should be spirited at work, yet easily trainable and gentle.

BREED ASSOCIATION FACTS AND FIGURES

According to the American Saddlebred Horse Association (founded in 1891):

- There are 247,000 registered American Saddlebreds.
- Each year, 2,800–3,000 foals are registered.
- The American Saddlebred Horse Association was the first horse breed association established in this country and is the oldest association still in existence in the United States.
- The breed is most common in Kentucky, Ohio, Pennsylvania, Tennessee, and Virginia, but there are registered Saddlebreds in Canada, Australia, South Africa, and Europe.

Although used for many activities, Saddlebreds are probably best known as show horses in both riding and driving divisions. When ridden, the horses may be shown either as three-gaited horses, at the walk, trot, and canter, or as five-gaited horses, at the walk, trot, canter, slow gait (also sometimes called the stepping pace), and rack (see box). Outside of the show ring, when shod differently, Saddlebreds make wonderful trail and pleasure riding horses and are used successfully somewhere for almost everything light horses do, including ranch work, dressage, and jumping.

Conformation

Saddlebreds usually range in size from about 15 to 17 hands and typically weigh 1,000 to 1,200 pounds. They have a finely chiseled heads with small, alert ears and large eyes. The neck is long, nicely arched, and attached to the head with a fine throatlatch. They are fairly wide-chested and have a short strong back and powerful hindquarters, with a high flat croup and long, flowing tail. They are structurally sound horses with very good joints and naturally well-formed feet.

Color

Saddlebreds come in almost all colors, including pintos and palominos. The breed registry does not have color restrictions.

Andalusian and Lusitano

The differences between Lusitanos and Andalusians are a matter of time and geography. Both breeds sprang from the same roots and have a generally similar appearance. Both are noted for their splendid qualities. After several hundred years of selection in the countries, however, there is a difference in type, obvious to breeders in the Iberian Peninsula (Spain and Portugal), although subtle to most North Americans.

In Spain, the Andalusian was known even before the time of the Romans as a great warhorse that combined beauty, agility, strength, and fire with an even temperament. For centuries, it was known throughout Western civilization as both the finest horse breed and the finest warhorse in the world. Today Spain's famous national horse is immensely popular for riding, ranch work, and dressage.

Lusitania is the Latin name for Portugal, which gained independence from Spain for the first time in 1143. This land is home to the Lusitano, the most popular riding horse in the country and the breed most commonly used in mounted bullfights. In these

HEIGHT: 15–16 hands

PLACE OF ORIGIN: Spain and Portugal

SPECIAL QUALITIES: Exceptionally even temperament, elegance, agility, power, "cow sense"

BEST SUITED FOR: Dressage, all general riding purposes, ranch and cattle work, and mounted bullfighting

The Andalusian (left) and the Lusitano (right) have a similar background and appearance.

bullfights the bull is not killed, and it is considered a great disgrace for a horse to be injured. These highly trained horses must be extremely agile while remaining calm and responsive to the rider under terrifying circumstances.

Indigenous to Iberia

The histories of the Andalusian and the closely related Lusitano are long and exceptionally complex. Their lineage includes almost every breed of significance indigenous to Iberia as well as many others that arrived with a long string of invaders.

According to historians, one indigenous horse, *Equus stenonius,* still exists, represented by a small remnant band of horses known as the Sorraia breed. This horse migrated from Iberia into North Africa about two thousand years before the horse was domesticated. Most historians place the domestication of the horse at about 5000 BCE, yet cave paintings in Spain dating from 15,000 BCE or earlier appear to depict horses wearing rope halters, although some dispute this interpretation. In any case, these paintings clearly show the heavy-boned head and slightly convex profile that is typical of the ancient breed we know today as the Barb.

Celtic peoples came through Iberia in waves between the eighth and the sixth century BCE, bringing with them Celtic ponies, at least some of which were amblers. The Romans brought the Camargue horse. From Sweden came the Goths, who invaded the peninsula in 414 CE, which argues for the influence of the Gotland horse and, considering where else these visitors had been before Spain, probably some horses from central Asia.

Other old breeds and types of horses were still in Spain when the Moors arrived three hundred years later: the Sorraia in Iberia, as well as a type called the Asturian, which may have been in the background of the famous Spanish Jennet, a natural ambler. Some of these ancient breeds have passed into history; other contributors, such as the Galician, the Garrano, and the Basque pony, still exist in small numbers.

The Moorish Influence

The Moorish invasion of 711 CE brought horses from North Africa into Spain, actually returning these ancient bloodlines to their country of origin. The light, fast Moorish horses, which we know as Barbs, were derived from various desert-bred horses of the East, which had been crossed for many generations with the descendants of Iberian horses in North Africa. At the time of the Moorish invasion, the best Spanish warhorses came from Andalusia, near Gibraltar, the point where the Moors entered Spain. Spanish horses were heavier and slower than the horses of North Africa. Contrary to prevalent belief, the Barb did not stamp its characteristic convex profile on the Spanish horse, because the ancient Iberian displayed that profile centuries before the Barb even existed.

Crosses with the Barbs lightened the heavy Spanish horses and made them faster

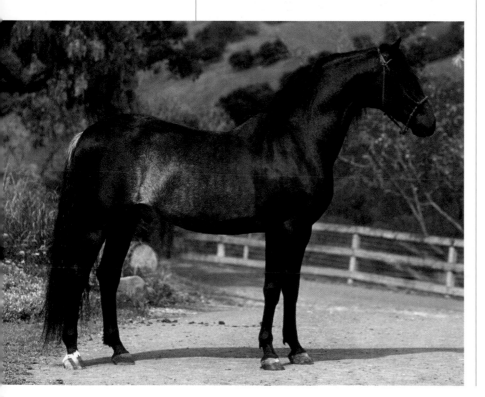

Not only does the Andalusian have stunning visual appeal, but it also has a gentle, willing disposition.

and more agile, an important development because in this same time frame the Moors were changing mounted warfare significantly. They rode with much shorter stirrups than did the Spanish, allowing them greater accuracy and power when throwing lances from the saddle, and they neck-reined their horses, which tremendously improved mobility during battle.

The lighter Andalusian was still able to carry a good deal of weight, yet it was pleasant to work around. This new version of the long-renowned breed was the type exported to the New World. Nevertheless, until the advent of gunpowder changed everything, the older, heavier Andalusian type was still used wherever knights in armor rode.

Breed Characteristics

Since the need for warhorses declined, Andalusians and Lusitanos have earned fame as stock horses that have a strong natural "cow sense," a trait they seem to pass on when crossed with other breeds. In addition to use in the bullring, Andalusians and Lusitanos have performed in dressage throughout the history of the discipline.

Their disposition, admired since before the Middle Ages, remains one of the strongest characteristics for both breeds. Historically, the Spanish rode only stallions, a tradition that continues to the present day. The stallions are so gentle and tractable that children can ride them safely, even in the company of other stallions. If you have not seen or experienced the behavior of Andalusian stallions, it is hard to imagine how incredibly easy they are to work with.

Conformation

Andalusians and Lusitanos average 15 to 16 hands. Typical weight is 1,000 to 1,200 pounds. The horses have a straight or slightly convex profile on a head of great elegance and character. They have a highly arched, sometimes cresty, neck. They are

solidly built with short backs, wide chests, and rounded croups with low-set tails. The legs are strong and well jointed and the feet are well formed and strong. The mane and tail are profuse and often wavy.

Color

Both breed associations recognize only solid colors, the most common being bay, gray, and black. Chestnut is not accepted for the Andalusian breed but is recognized for the Lusitano.

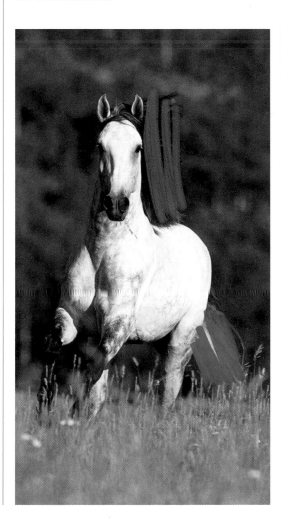

The Lusitano is strong and muscular with a wide chest and a short back.

Appaloosa

The distinctive patterns that North Americans recognize as Appaloosa coloring have been seen and prized on horses throughout the ages and all over the world. The earliest known documentation comes from cave paintings in France that date back twenty thousand years, and since that time, artists in the far corners of the world have continued to portray horses with spots. Spotted coloring was familiar to the nomads of central Asia, who are thought to have acquired horses by about 3500 BCE and ultimately rode them out of the steppes and into what was then the "civilized world."

Seeing Spots

The spotted pattern appeared in the art of ancient Greece and Egypt by 1400 BCE and that of Italy and Austria by 800 BCE. In ancient Persia (modern Iran), spotted horses were worshipped as the sacred horses of Nisea, and the great hero of Persian literature, Rustam, rode a spotted horse named Rakush, who was chosen from thousands of horses. Rakush was a great warhorse and the sire of beautiful spotted foals. Central Asian nomads introduced the spotted horse to China around 100 BCE. The Chinese quickly recognized that their own horses were no match for the swift horses of the steppes and although they valued all horses, they admired spotted horses most, considering them gifts fit for royalty. Spotted horses appeared in Chinese art by about the seventh century CE.

From Europe to the Americas

Although spotted horses have appeared in western Europe throughout recorded history, they were deliberately bred in only a couple of places, notably Denmark and Austria. From the sixteenth through the eighteenth century, the famous Lipizzan horses often exhibited spots. Spotted horses were also common among Spanish Andalusians, which were transported to the New World.

As trade and warfare brought horses north and west in the Americas from about 1600 to 1800, Spanish horses, including spotted ones, were frequently captured by various indigenous tribes. It is believed that most tribes — eastern as well as western — were mounted by 1710. Of the early mounted tribes, several became great horsemen, but few were accomplished breeders.

The exception was the tribe known to whites as Nez Percé, but who referred to themselves as the Ni Mee Poo. These people

Horses with Appaloosa coloring appear in this cave painting from southwestern France, dated at 20,000 BCE.

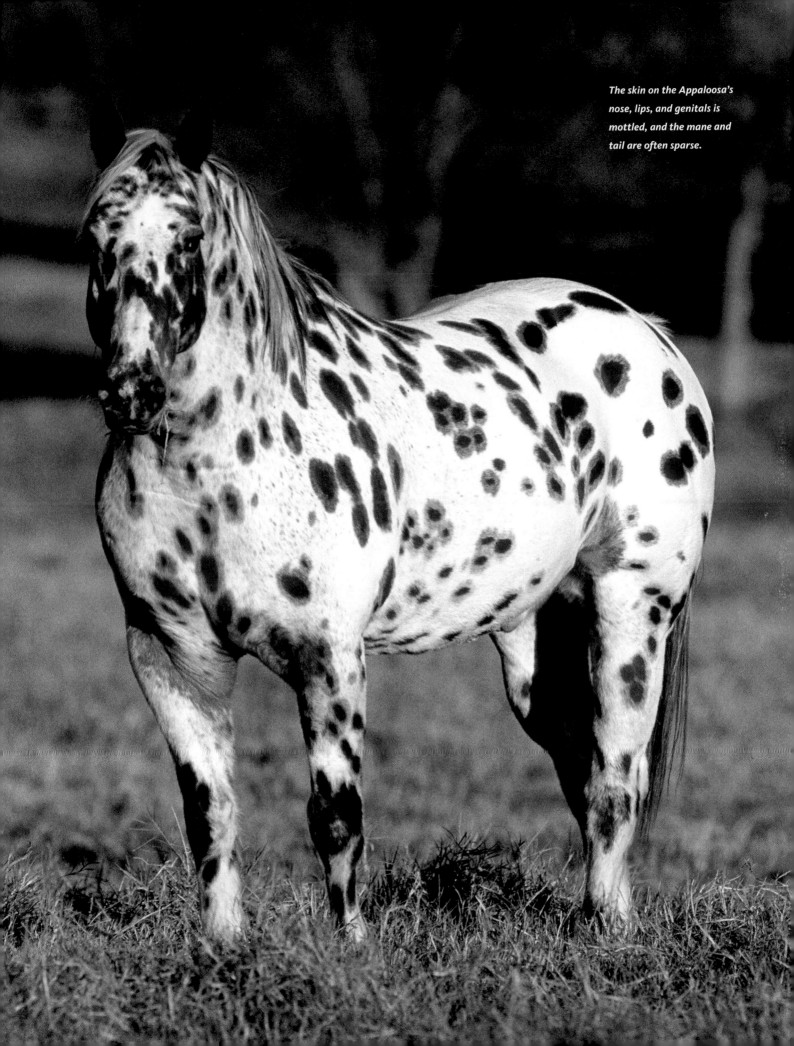

The skin on the Appaloosa's nose, lips, and genitals is mottled, and the mane and tail are often sparse.

APPALOOSA PATTERNS

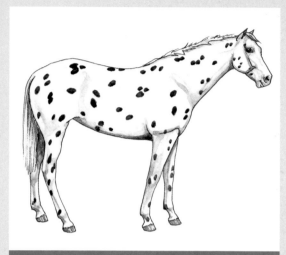

LEOPARD

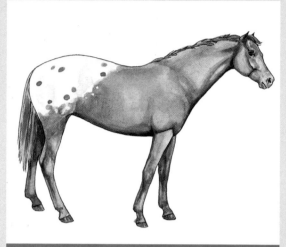

SPOTTED BLANKET

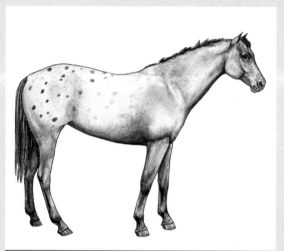

FROST

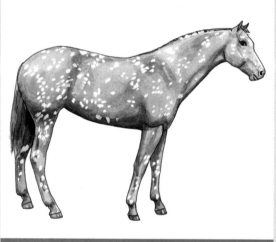

SNOWFLAKE

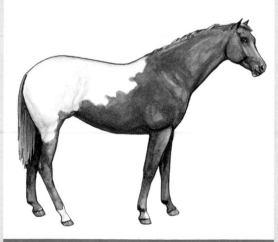

WHITE BLANKET

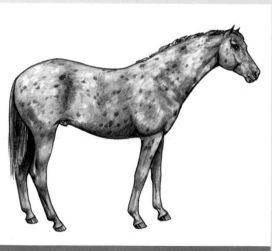

MARBLE

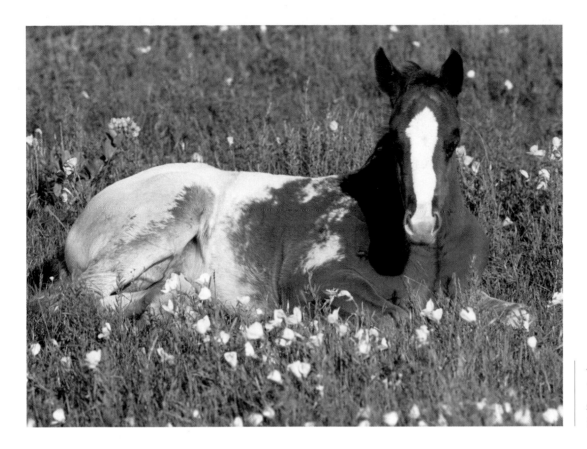

Appaloosas exhibit a wide variety of base colors, though gray is not recognized by the registry.

came from the region of the Palouse River in what is now eastern Washington and central Idaho. They allowed only their best horses to breed; slow and unattractive horses were traded away. The Ni Mee Poo grew famous for their fast, sure-footed horses with tremendous endurance.

The very best were warhorses, and of those, the spotted horses were the most valuable. The white settlers of the area began to refer to the Nez Percé spotted horses as Palouse horses. After several permutations, the name became Appaloosey. The spelling in use today was selected by the Appaloosa Horse Club when it was founded in 1938.

Devastation and Rescue

In the late 1800s, the U.S. cavalry was at war with virtually all indigenous peoples, including the Nez Percé. For months the Indians were forced to flee over extremely rugged terrain, traveling some 1,300 miles on their Appaloosas. Recognizing the extreme hardships his people were suffering,

and knowing that the United States had broken treaties with them in the past, Chief Joseph of the Nez Percé finally surrendered with the elegant, immortal words, "I shall fight no more forever."

To ensure surrender, the cavalry set out immediately to destroy the Indian horses. Hundreds were shot, stallions were gelded, and mares were bred to draft-type horses both to produce workhorses for settlers and to make sure the offspring weren't as swift as their parents. The unique Nez Percé breed was almost destroyed. A few escaped, however; some were hidden by local ranchers; and a couple of pockets of horses somehow survived, including a few in western Canada, to which some of the Indians had fled.

Some ranchers and horsemen recognized how good the Appaloosas were, and they set out to save the breed. The Appaloosa Horse Club formed in 1938 to protect and promote the stock that was left. In the early days, breeders brought in Arab blood to minimize inbreeding

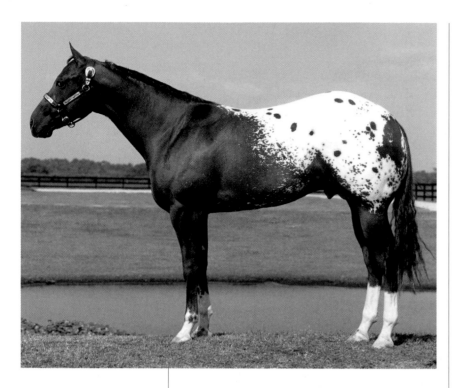

Although the color is the most obvious feature of Appaloosas, their strength and versatility are prized by horsemen. One of the most common Appaloosa patterns is the blanket.

the color, horsemen often stay with the breed for its other qualities.

Appys make good ranch, working, and trail horses, and they excel at "Western" sports, yet they are also frequently used for eventing, foxhunting, and other "English" sports. More than a few are very good jumpers. There is an active Appaloosa racing association. Appaloosas are usually middle-distance racing horses, the most popular distances being 350 yards and four furlongs (a half-mile). In 1989 the Appaloosa Ole Wilson ran 4 ½ furlongs in 0:49 ⅘ seconds, breaking the all-breed world record for this distance. His record still stands.

Conformation

Today's Appaloosas usually range in size from 14.2 hands to a little over 16 hands. Typical weight is 1,000 to 1,500 pounds. The head should be small and well shaped, with a straight profile and pointed ears. The eyes are typically large, with obvious white sclera. A long, muscular neck connects to moderately pronounced withers. The mane and tail are sometimes sparse, although most breeders do not find this a desirable trait and it is being seen less and less. The back should be short, the chest deep, and the shoulders long and sloping. The croup is usually slightly sloping. The legs are solid and well muscled, with good bone structure. The hooves should have vertical light or dark stripes. The skin of the nose, lips, and genitals is mottled.

Color

There are several recognized Appaloosa color patterns, including snowflake, marble, frost, spotted blanket, white blanket, and leopard, the last being the most immediately recognizable of the patterns. Most solid base body colors are recognized by the association. The exception is gray, because it is genetically associated with fading color. Solid-colored horses that meet registration requirements may be registered. Pinto Appaloosas are not allowed.

among their few initial horses while maintaining the breed's fabled endurance. They also intended for the Arab influence to counteract a tendency toward coarseness that resulted from the crosses with draft horses.

Although the association no longer allows crosses to Arabians, over the years it has continued to permit crosses to Quarter Horses to solidify the stock type. At one point, the famous Quarter Horse Impressive was owned by an Appaloosa syndicate, and he has left his indelible stamp on the breed.

Breed Characteristics

The breed's color is its hallmark and has attracted many fanciers, but the horses are versatile, strong, athletic, and known for endurance. Although initially attracted by

BREED ASSOCIATION FACTS AND FIGURES
According to the Appaloosa Horse Club (founded in 1938):
- There are more than 650,000 registered Appaloosas.
- About 5,500 foals are registered each year.
- The highest concentrations of Appaloosas are in California and Texas, although the breed is common in all states and is found in Europe, Australia, and New Zealand.

Arabian

Among the most beautiful of all horses, the Arabian is also one of the oldest pure breeds in the world. It is the most widespread breed on earth and the most influential, having been used to improve almost every other breed at some time in history. There are Arabian breed associations in nearly every country, and Arabians can be found working, competing, and participating in just about any type of horse-related activity.

They are the breed of choice for endurance competitions.

But vehement arguments and misunderstandings arise over the details of the breed's history. In the *International Encyclopedia of Horse Breeds,* Bonnie Hendricks reports that every book she consulted claims the breed originated in Saudi Arabia.

When she consulted Arabian Horse experts in Saudi Arabia, however, she was told that despite the legend, the horses actually originated in Iran (Persia), Iraq, Syria, and Turkey. She learned that even today some of the best Arabian Horses are to be found in Iran and Jordan, and that Saudi Arabia never had many good horses.

HEIGHT: 14–15.3 hands

PLACE OF ORIGIN: Middle East, especially Iran, Iraq, Syria, Turkey, and Jordan

SPECIAL QUALITIES: Great beauty, tremendous endurance, high tail carriage, and unflagging spirit

BEST SUITED FOR: Endurance, pleasure, and showing

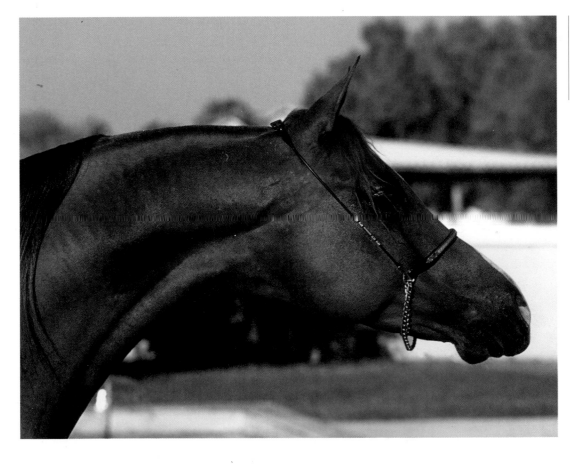

Arabians always have black skin. They can be chestnut (as here), bay, gray, black, or roan, with white facial and leg markings, but no pinto coloring.

One point of confusion has to do with the word "Arab." Sometimes it names the breed; sometimes it refers informally to the Arabian Peninsula. Sometimes it describes the modern country of Saudi Arabia; sometimes it refers to Arab people who come from many areas in the Middle East. Regardless of how the word itself may be used, we know that horses were developed by Arab people long before Saudi Arabia became a country, and it is from them that the breed received its name.

A second point of confusion involves the term "Oriental horse," which is used in many texts about the history of breeds to describe horses that originated in Asia or the Middle East. The Arabian is one of the Oriental horse breeds, but it is not the only one: the Akhal-Teke is another example. Older sources say the Arabian Horse descended from other Oriental horse breeds, almost certainly the Turkmenian (see Akhal-Teke, page 47).

The domestic horse was introduced to Asia Minor, northern Syria, and Mesopotamia (modern Iraq) by invaders and migrants from the north, shortly after 2500 BCE. Horses still were not present on the

Arabian Peninsula, however, at the time of the Hyksos (Hittite) invasion of Egypt from Anatolia (in what is now Turkey) in the seventeenth century BCE. All of the peoples of western Asia and northern Africa had horses by then, *except* for the people of the Arabian Peninsula. They were riding camels at the time, which were better suited to the extreme desert conditions found there.

Just before the rise of Muhammad, in about 600 CE, the Arabs of the Arabian Peninsula began to breed horses on a small scale. The size of the horse herds was limited by the amount of feed that could be produced. Some of their first breeding stock were obtained during raids into Persia (Iran).

The Egyptian Agricultural Organization in Cairo reported to Hendricks that the first known pure Arabian Horses in Egypt belonged to King El Nasir Mohamed, who ruled Egypt in 1300 CE. This also indicates that the breed did not arise in what is now Saudi Arabia, immediately to Egypt's east, or Arabian Horses would have been common in Egypt well before the time of King Mohamed.

Horses were taken everywhere, creating additional confusion about the origin of particular breeds. For example, in Europe in the early 1700s, when Oriental horses were obtained, whether by purchase, theft, warfare, or other means, they were commonly alleged to have come from Arabs or Turks, although the true ethnicity of the original owners was of less concern than the quality of the horses. Furthermore, the horses may have changed hands and handlers many times before reaching their ultimate destinations. The inherent language problems make stories about point of origin unreliable. More than a few alleged Arabian Horses in Europe were actually Turkmenians, or Barbs, or something else. These problems are what caused confusion about the actual breeds of the Godolphin Arabian and the Byerly Turk, foundation sires of the Thoroughbred.

This horse's arched neck and high tail carriage are characteristic of the Arabian.

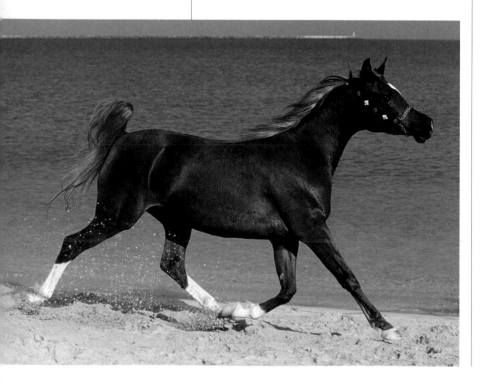

Arabians in North America

According to David Willoughby, in *The Empire of Equus,* the first purebred Arabian in this country was the stallion Ranger, who arrived in New London, Connecticut, in 1760. General Harry Lee gave a gray, half-bred son of this horse, known as the Lindsay Arabian, to George Washington.

The first imported purebred Arabian to be recorded by the Arabian Horse Club of America was Leopard, who was given to General Ulysses S. Grant by the sultan of Turkey in 1878, along with Linden Tree. Although Grant technically owned the horses, all breeding decisions were managed by Randolph Huntington, who wanted to use the Arabians as a part of the new American breed he was trying to establish. Huntington was quite successful until his secretary ran off with $100,000, and Huntington had to sell most of his horses at auction. Linden Tree was never bred to a purebred Arabian mare, but in 1888, Huntington imported Naomi, who was crossed on Leopard, producing a purebred colt named Anazeh. He grew up to sire eight purebred foals, four of which can still be found in some of today's Arabian pedigrees. Leopard and Linden Tree later turned up as foundation sires of the Colorado Rangerbred (see page 100).

Breed Characteristics

Arabians are known for their great beauty, tremendous endurance, and unflagging spirit. Their dished profile and high tail carriage make them one of the most recognizable of breeds.

Conformation

Arabians are not large horses, averaging 14 to about 15.2 hands and weighing 900 to 1,100 pounds. A few show horses today may reach 16 hands. Traditionally, the head was small with either a straight or only a slightly dished profile. In modern show Arabs, the dished profile may be extreme. Arabs have large expressive eyes, a wide

Arabians arrived in North America before the Revolution, and George Washington was an early admirer of the breed.

forehead, and a small muzzle. The ears are small and should curve in at the tips. The neck is long and arched, narrow at the throatlatch and wide at the base. The withers are long and pronounced. The back is short, with a high flat croup. The tail is set high and carried freely. The chest is deep, broad, and muscular; the shoulder is long and sloping. The legs should be muscular, with broad, strong joints and tough hooves, wide at the heel. The coat should be fine and silky.

Color

Arabian horses may be bay, gray, black, chestnut, or roan. The skin is always black. White markings on the face and lower legs are allowed. Body spots or pinto color patterns are not permitted.

BREED ASSOCIATION FACTS AND FIGURES

According to the Arabian Horse Association Registry (founded in 1908):

- 585,000 horses have been registered since the inception of the registry.
- Approximately 9,000–10,000 foals are registered each year.
- California and Arizona have the most Arabs, but they are found in every state and almost every country.

Azteca

HEIGHT: Male horses 15–16.1 hands, mares 14.3–16 hands

PLACE OF ORIGIN: Mexico

SPECIAL QUALITIES: Spirit, intelligence, agility, power, strength, elegance, and style

BEST SUITED FOR: Dressage, bullfighting, reining, cutting, team penning, roping, polo, and pleasure riding

Although the Azteca is the national horse of Mexico, it is not every man's horse. The breed first appeared in 1972; it was deliberately created to serve as the horse of the *charro,* or "gentleman cowboy." It is a breed of comparatively few registered horses, in part because requirements for registration are extraordinarily difficult to meet. The foundation breeds used in its development were the Andalusian, the Quarter Horse, and the Mexican Criollo, all chosen to produce physical beauty combined with an ideal temperament and athletic ability. No registered Azteca may carry more than three quarters of the blood of any foundation breed.

The most common cross used to produce the first-generation Azteca is an Andalusian stallion on a Quarter Horse mare. The offspring of that cross, which is half Andalusian and half Quarter Horse, may be crossed back to any of the foundation breeds. If the cross is back to an Andalusian, the resulting offspring is three-quarters Andalusian and one-quarter Quarter Horse. If that second-generation horse is crossed back to an Andalusian, the offspring, a third-generation cross, is known as a pure Azteca. It will be five-eighths Andalusian and three-eighths Quarter Horse.

In addition to having the correct bloodlines, all horses must strictly conform to the phenotype that was developed by the association. Phenotype is the way an animal looks, the observable traits, based on his or her genotype (genetic background). Both the Mexican association and the International Azteca Horse Association require a rigorous evaluation and inspection process before a horse is accepted for permanent registration. Just because a foal has two registered parents does not mean that it will be accepted for registry. A foal must be inspected at seven months. If he passes this inspection, he is microchipped with a registration number. The horse must then pass a second and much more rigorous inspection at three years of age before permanent registration papers can be granted.

Breed Characteristics

The International Azteca Horse Association praises the Azteca for excelling at activities that require spirit, intelligence, agility, power, strength, elegance, and style. The breed has repeatedly done well at dressage, bullfighting, reining, cutting, team penning, roping, polo, and pleasure riding. Aztecas are widely known as horses that are ridden and treasured by their owners. Once acquired, they are rarely sold.

Conformation

Male horses stand about 15 to 16.1 hands and mares are 14.3 to 16 hands. Typical weight is 1,000 to 1,200 pounds. The head is lean, elegant, and aristocratic, with a straight or convex profile, expressive, intelligent eyes, and small pricked ears. The neck is well muscled and slightly arched. The withers are high, the back fairly short and straight, the croup broad and well

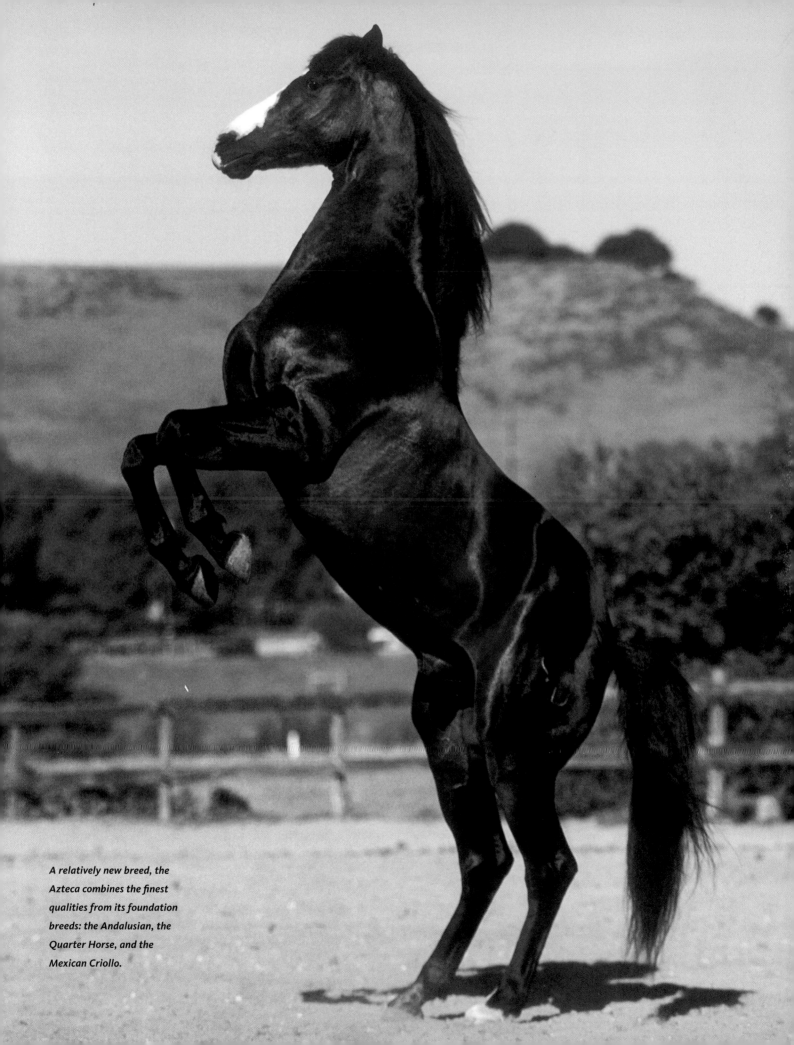

A relatively new breed, the Azteca combines the finest qualities from its foundation breeds: the Andalusian, the Quarter Horse, and the Mexican Criollo.

The Azteca has a strong, lean head, with intelligent eyes and small ears.

BREED ASSOCIATION FACTS AND FIGURES

Figures were unavailable directly from the association in Mexico City. The following figures were collected by the Texas Department of Agriculture in 2005.

- The Azteca Horse Association in Mexico has registered between 10,000 and 15,000 horses.
- About 1,000 horses a year pass the rigorous inspection process and are added to the registry.
- The vast majority of Azteca Horses are in Mexico.

The original organization for the breed is the Asociación Mexicana de Criadores de Caballos de Raza Azteca, in Mexico City, which also maintains the worldwide registry for the horses.

In 1992, the International Azteca Horse Association was created to further the development of the breed worldwide. It is the only organization approved by the government of Mexico to register Azteca Horses and to legally use the name Azteca. At the same time, regional affiliates were developed.

A separate and distinct breed organization, the Azteca Horse Registry of America, has rules that differ somewhat from those of both the Mexican association and International Azteca Horse Association. The American registry accepts horses of all colors, not just solid colors, and will allow some Thoroughbred in the pedigree, while the Mexican association strictly excludes them.

rounded. The chest is deep and broad and the shoulders long and sloping. Muscular legs end in feet that are hard and well proportioned. The mane and tail are long and flowing, with a medium-low tail set.

Color

An Azteca horse may be any solid color, although gray is the most common. White markings are permitted on the lower legs and face.

An Azteca foal must pass two rigorous inspections before being officially registered.

Canadian Horse

The Canadian Horse has a long, underreported yet illustrious history, marked by repeated surges and precipitous falls in popularity. The breed has contributed much to the history of Canada and to many other breeds of horses but has never received adequate credit.

According to the *History of the Canadian Horse*, by Yvonne Hillsden, the Canadian traces its ancestry to France. The first horses went from France to New France (Quebec) as a gift to the governor in 1647, but they were stolen by members of Samuel Argall's expedition from Virginia. In 1665, King Louis XIV sent two stallions and twenty mares to the colony, although eight of the mares died during shipment. These were some of the best horses from the king's royal stud and are thought to have originated from the stock of Normandy and Brittany, the two most famous horse-breeding areas in France at the time.

The Breton horses of the day were small but noted for soundness and vigor. The Norman horses were much the same in overall type but showed evidence of Oriental blood,

HEIGHT: 14.3–16.2 hands

PLACE OF ORIGIN: Quebec

SPECIAL QUALITIES: Hardy, sound, easy keeper

BEST SUITED FOR: Riding, jumping, and driving

Most Canadian Horses are black or very dark brown.

such as Arab, Turk, or Barb, and may have benefited from a significant infusion of Andalusian as well. It is well documented that Andalusian stallions had been brought to Normandy and La Perche, home to the Percheron breed, beginning in the late sixteenth century. Some of the Norman horses arriving in Canada were probably of strains closely related to the Percherons of the time (which they resembled), as the bloodlines were frequently crossed.

Types within Breeds

In the seventeenth and eighteenth centuries there were not standard types for the Norman, the Breton, or, presumably, the Perche. Each breed had several types and these types were crossed on each other depending on the fashion and needs of the moment. Among the horses arriving in Canada from France were some draft-type horses, some pacers, and some excellent trotting horses. In 1667, fourteen more horses arrived in New France, including at least one stallion, and in 1670, a stallion and eleven more mares arrived. Not long after that, the shipments from France ended because the governor thought there were enough horses in the colony to form a dependable supply.

In the early days of New France, horse production and use were managed in a unique way by the government, which leased horses to those farmers who had done the most to promote colonization and cultivation. The farmer either paid an annual fee for the horse or returned a weanling, which the government raised for three years and then leased out to another farmer. After three years of leasing, a horse became the property of the farmer.

The program succeeded. In 1679, there were 148 horses in the colony; by 1688, 218 horses; and in 1698, 684 horses. By 1709, a mere thirty years after the breeding program was introduced, the government issued a regulation limiting the number of horses. Each farmer was to be allowed only two horses and a foal. Excess horses were to be slaughtered. Not surprisingly, attempts to enforce this law utterly failed.

Although farmers bred horses rather indiscriminately for the next one hundred years, people noted that even after a century, the horses' appearance hardly altered from the prototypes and still closely resembled both the Norman and the Perche. There were recognizable subtypes within the breed depending on use. By the early 1800s, the horses were used for riding, driving, racing, and pulling sleighs. Oxen, however, performed the heaviest draft work.

During the eighteenth century, Canadian Horses were transported from New France to the western settlements in Detroit and in Illinois. These horses were kept in large herds and caught only when needed for work. Inevitably, many escaped and some were stolen or lost. There is little doubt that these horses contributed significantly to both the numbers and the quality of feral horses on the northern Great Plains.

Until 1780, the French Canadian Horse, as the breed was also known, was bred largely without any additional influence of foreign horses. After this point, Canadian breeders increasingly imported horses from the British Isles and the United States. The imported horses were crossed on the Canadian Horses and contributed to the further development of distinct types within the Canadian breed. In time these types earned names of their own.

Canadian Pacer. Breeders crossed pacing horses, derived from early imported French pacers, on Narragansett Pacers, imported from New England, to produce pacing horses that were especially good at racing over ice. These bloodlines later contributed much to the development of the American Standardbred.

Frencher or **St. Lawrence.** Thoroughbreds were crossed in to produce horses with great speed and power. These horses, as well as the lines related to the early imported French Trotters, are involved in the history of the American trotters.

Canadian Heavy Draft, also sometimes called the **St. Lawrence.** These were probably the result of crosses with imported Shires or Clydesdales. This type disappeared by the end of the 1700s. It's a good bet that many of them were sold to New England, which had a sizable horse industry providing horses to the plantations of the Caribbean until the dawning of the American Revolutionary War in 1775.

Influence on Morgans

Canadian mares appear in the pedigrees of early Morgan horses, and many think it likely that the stallion Figure, who became known as Justin Morgan, was himself a Canadian Horse. Justin Morgan (the man) lived in Vermont, near Quebec. His parents lived in Quebec, and he frequently visited them. It is quite possible that he brought a horse back with him from one of his trips.

Genetic research indicates that the Canadian and the Morgan are quite closely related. Certainly the two breeds closely resemble one another. There is also documented Canadian blood in the famous Morgans Ethan Allen and Black Hawk, who had much to do with the foundation of the Standardbred and the Tennessee Walker, as well as other breeds.

By 1847, Canadian Horses were well known in Michigan, Illinois, and New York, as well as in New England. They performed as trotters and roadsters, and heavier ones pulled freight wagons and stagecoaches. They were often the favorites of coach drivers because they had tremendous stamina and were easy to maintain. Canadians were so popular and so frequently outcrossed for the improvement of other breeds that purebreds nearly became extinct.

In 1885, worried that the breed was virtually gone, the government of Quebec established a studbook for Canadian Horses and in 1886 passed a law forbidding their export. All horses to be registered had to be inspected and approved. In 1913, the government of Canada became involved with the preservation of the French Canadian Horse and a breeding program was started at the Experimental Station at Cap Rouge, with a goal of increasing the size of the horses without sacrificing endurance or vitality. By 1938, the stallions stood between 15.2 and 16 hands and weighed 1,200 to 1,500 pounds. The mares were a little smaller.

Ultimately, two World Wars and the advance of technologies that rendered horses obsolete ended the government breeding program. Many of the best horses were sold at auction. During the 1970s, interest in the Canadian Horse dropped to an all-time low, with only five horses registered and fewer than one thousand horses in existence. But just at the brink of extinction, the horses were saved, this time by a few private breeders who began acquiring the best Canadians and showing them in major horse shows in Canada and the United States. When a team of Canadians won the North American Driving Championships in 1987, the world noticed, and

Canadians are hardy, strongly built, and muscular.

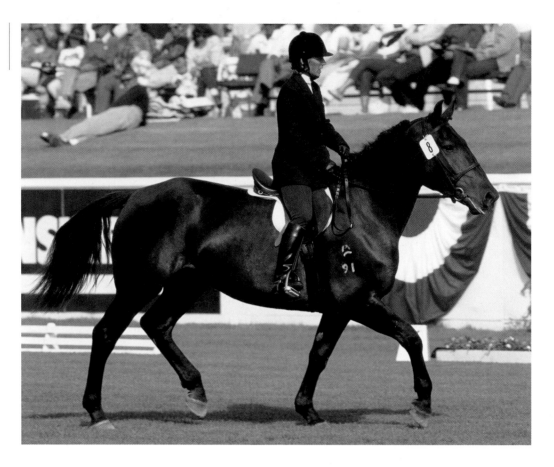

interest in the breed grew. Popularity of these versatile horses continues to increase.

Breed Characteristics

Canadians are excellent riding and driving horses, good jumpers, and flashy trotters with good action. They are very hardy, easy keepers, and long-lived.

BREED ASSOCIATION FACTS AND FIGURES

According to the Canadian Livestock Records Corporation, which maintains the registry for the Canadian Horse Breeders Association (Société Éleveurs des Chevaux Canadiens):

- The living, registered population as of 2005 is around 2,000 animals.
- Over the past four years, an average of 525 new foals were registered annually.
- Of the new foals, 15 to 20 each year are foaled in the United States.
- There are about 10,800 horses in the database since the association was formed in the early 1900s.
- In 2002, the Canadian Horse was officially proclaimed the national horse of Canada.

Conformation

A Canadian should be solidly built with good proportions and stand between 14.3 and 16.2 hands. Stallions should weigh 1,050 to 1,350 pounds, mares 1,000 to 1,250. The head is short and quite wide between the eyes, with a fine muzzle. The neck is strong and arched, the body long and deep, the barrel rounded. The tail should be set high on a heavily muscled rump. The mane and the tail are long and usually wavy.

Color

About 80 percent of Canadian Horses are black or very dark bay or brown. There is no longer gray in the breed, the gray gene having been lost when numbers fell to a precarious low. Chestnuts, sometimes with flaxen mane and tail, occur only occasionally. A very few cream-colored foals have been born, all sired by one particular stallion. There is some question as to whether this color should be recognized by the breed.

Canadian Sport Horse

Despite the similarity in names, the Canadian Sport Horse is an entirely different breed from the Canadian Horse, with its own distinct history. An English lieutenant stationed in Ontario wrote in his journal in 1893 that the horses "which were produced from the farmers here were remarkable for their ability to jump timber fences." Quite a few of these horses were sold to people in the United States for various uses.

Then came World War I, during which vast numbers of horses from Canada were sent to the war in Europe. About this time, the Canadian Racing Association imported sixteen English Thoroughbred stallions, which they made available to local farmers for the production of crossbreds. The blood of those crossbred horses influences the pedigrees of many of the foundation lines of today's Canadian Sport Horse.

As the Canadian Sport Horse Association reports, "Although the horse has lost its centuries' long significance as a partner in battle and work, it has vastly increased its special place as a partner in sport." As the need for horses has shifted from work

HEIGHT: 16 hands and taller

PLACE OF ORIGIN: Canada, especially Ontario

SPECIAL QUALITIES: An evolving breed of large, solid horses that are structurally correct and have fluid movement, excellent jumping talent, and a natural ability to work with their human partners

BEST SUITED FOR: Jumping, dressage, eventing, foxhunting, and driving

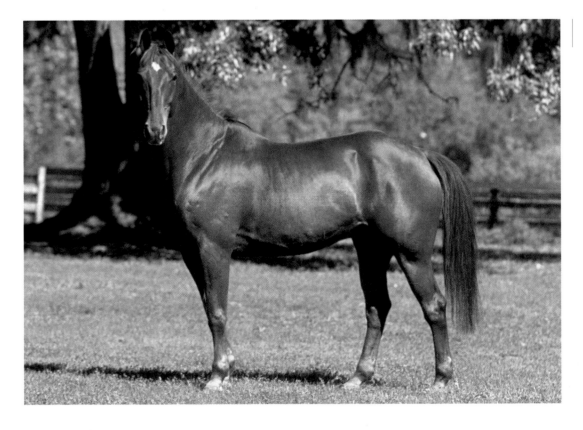

Thoroughbred blood is evident in this Canadian Sport Horse.

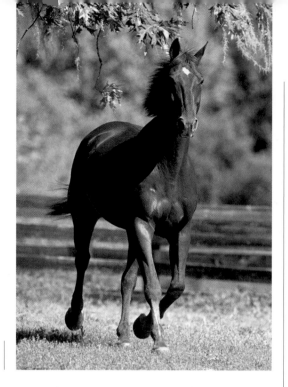

The Canadian Sport Horse must have excellent action.

and war to sport, the type of horse has also shifted. This breed was specifically developed to excel at sport, particularly the Olympic sports of dressage, show jumping, eventing, and driving, as well as foxhunting. Breeders aim to produce horses that are structurally correct and that are supple, with big, fluid movement both on the flat and over jumps. They also want to maintain the horses' easy ability to work with their human partners. The Canadian Sport Horse Association says that this is an "evolving" breed, but it is a breed that exists for a purpose.

When the Canadian Hunter and Light Horse Improvement Society was first established in 1926, Canadian draft mares were crossed on selected Thoroughbreds. The

BREED ASSOCIATION FACTS AND FIGURES

The records for this breed are kept by the Canadian Livestock Record Corporation. The information below is for the year 2000, the most recent statistics available:

- The original breed association was founded in 1926.
- 12,430 horses have been registered since record keeping began.
- Approximately 300 of the registered horses are purebreds alive and active today.
- Forty non-pure horses were also included in the total of registered animals.

society itself evolved into the Canadian Hunter Improvement Society and finally into the Canadian Sport Horse Association, but while it changed names, the goal of producing athletic horses for sport use remained intact. Now, in addition to lines of Canadian Sport Horses and Thoroughbreds, warmbloods of other registries are being used to produce fine, durable sport horses.

Mares that are not of Canadian Sport Horse breeding are inspected by a committee for acceptance to the Appendix Broodmares list. Stallions undergo a rigorous inspection and a performance test or must achieve the equivalent in sport before being accepted for breeding.

Breed Characteristics

Movement is very important in this breed. It should be sequentially correct, straight, balanced, and with impulsion. Over jumps, the horse should show good leg technique and good **bascule,** which is the arc of the body over the fence. All of this should be embodied in an animal with intelligence, courage, and character.

Conformation

A Canadian Sport Horse should stand 16 hands or more and be suitably balanced with strong bone. The eyes should be large and quiet. The neck should be well set and of proportionate length. The heart girth should be deep, with a broad chest. There should be good withers; long, sloping shoulders; deep, well-muscled quarters; and solid, correct joints. The knees and hocks should be low to the ground with properly aligned pasterns and healthy feet to match the size of the horse. Horses should have an even bite, sound heart and lungs, and an "overall look of quality."

Color

These horses can be bay, dark bay, brown, dark brown, black, chestnut, gray, pinto, cremello, or palomino.

Caspian

In an astonishing and incredibly lucky accident in 1965, an American woman rediscovered a famous, ancient breed of horse thought to have been extinct for more than one thousand years. Louise Firouz had married an Iranian she met in college. They moved to Iran, where she started a riding school. Looking for suitable mounts to use for small children, Firouz heard there were small horses and ponies available near the southern end of

the Caspian Sea, which forms part of the northern border of Iran. While searching for suitable school ponies, she came across three very fine, small, graceful animals that didn't look at all like other ponies—they were proportioned much more like Arabian Horses.

They had big eyes, large jaws, and high-set tails. Firouz knew of the ancient literature and lore about tiny horses from this area, so she took all three back to her riding school, and in so doing managed to save an ancient breed from almost certain extinction.

HEIGHT: 10–12 hands

PLACE OF ORIGIN: A very ancient breed rediscovered in northern Iran in 1965

SPECIAL QUALITIES: Small, beautiful, fine-boned, tractable horses of surprising, strength and athleticism

BEST SUITED FOR: Driving, jumping; elegant and reliable children's mounts

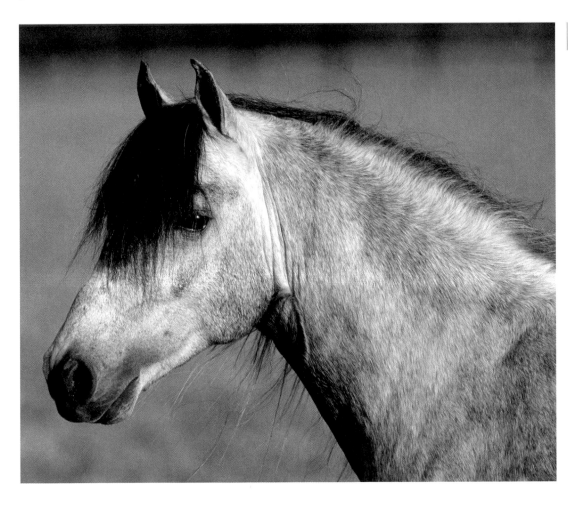

The Caspian is an ancient breed closely related to the Arabian.

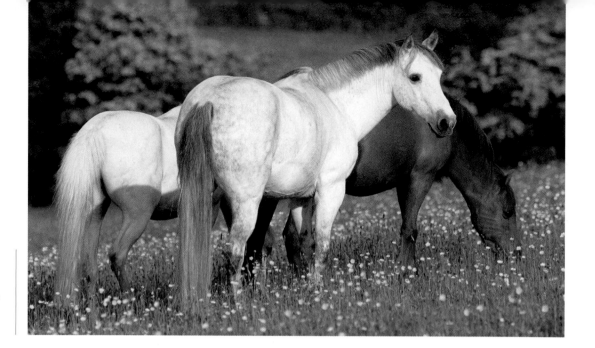

Over the past several decades, the number of Caspian Horses, while still only in the hundreds, has risen steadily in North America.

A Long History

Documents from the sixth century CE tell of a little horse with small ears and a head "unlike [that] of a horse." Since most horses of the day had Roman noses, a good guess, confirmed by the art of the time, is that these animals were dish-faced. The Caspian, as Firouz named the breed, appears in ancient Persian art and writings going back to 3000 BCE. Small Caspian-type horses decorate the seal of King Darius the Great (521–486 BCE).

In the days of King Darius, Persian kings demonstrated their fitness to rule in public displays of strength and courage. Unfortunate lions were captured and taken to an arena, where the king killed them from a chariot. The chariot horses had to be small, handy, fast, brave, and very tractable to do such dangerous work in the confined space of the arena. Archaeologists and historians believe that the little horses depicted on King Darius's seal represent the actual horses used: that is, the little dish-faced, small-eared, fine-legged Caspian type. Small horses were also depicted in the rock relief of King Ardashir's investiture in 224 CE and were last mentioned in writing in about 600 CE.

The last Zoroastrian king of the Sassanid dynasty was defeated by followers of Islam in 637 CE. As power shifted from Zoroastrianism to Islam, rituals changed and the little chariot horses became unnecessary. As centuries of wars, invasions, and uprisings followed, great libraries and art were lost, and with them the knowledge of these beautiful horses.

Miraculously, some survived as feral horses in the remote areas of the Elburz Mountains, near the southern end of the Caspian Sea, where a few were caught occasionally and used by the locals. But until Firouz stumbled upon them, they had been lost to the rest of the world for some thirteen hundred years.

A Bright Future

In 1968, Firouz wrote, "We are still searching for them: diminutive . . . Arab looking creatures with big bold eyes, prominent jaws and high-set tails which so distinguish their larger cousins. It has been a losing battle as the already pitifully small numbers are further decimated each year by famine, disease and lack of care, until now we must accept the sad fact that the survivors must number no more than 30." Further searching turned up about fifty, but clearly they were on the very edge of extinction.

In addition to the three acquired on her first trip, Firouz was able to purchase thirteen more. She and her husband began a private breeding herd to save the little horses. The herd was taken over by the Royal Horse Society of Iran in 1970 under

the guidance of the crown prince, although the horses were kept at the Norouzabad stud, the Firouz breeding operation, until 1974. As the political situation for the royal family of Iran became increasingly precarious, Firouz wisely managed to export nine stallions and fourteen mares to Europe between 1971 and 1976, and again, by her actions, may have saved the breed. In 1977, all further exports of the horses from Iran were stopped. After the royal family fell out of power, the royal breeding herds were sold. All of Firouz's carefully rescued stock still in Iran became pack animals or were sold for meat.

Since 1977, political upheavals in Iran have seen the Caspians rise to the peak of honor as national treasures, only to fall to the point that they were used for food. Firouz herself started a second foundation herd of twenty-three animals, but during the Iran–Iraq War, these horses were confiscated by the Revolutionary Guards and sent to the front, where they were run across minefields to clear them.

Over the past several decades, some Caspians made their way from Europe to the North America, where they have been bred very successfully, mostly on several large ranches in Texas.

Breed Characteristics

Genetic research as well as archaeological evidence proves the Caspian to be a genetically distinct breed, with genetic markers that authenticate its ancient status. They are of an old, old breed, closely related to the Arabian. Bonnie Hendricks, in the 1995 *International Encyclopedia of Horse Breeds*, writes, "If continuity with the ancient breed can be absolutely proven, it is likely that this breed is the ancestor of all modern breeds of hot blooded horses." Ongoing research points to this continuity.

Caspians have an exceptionally gentle disposition. They show superb jumping ability and are still, as they were in the time of King Darius, excellent driving animals.

Conformation

Caspians stand between 10 and 12 hands. They are delicate-looking and quite beautiful, but, as their history indicates, extremely tough and durable. The head is short and fine with short ears, a small muzzle, and large nostrils that are placed low. The forehead is vaulted and the neck fine and graceful. Pronounced withers lead to a straight back, and the tail is set high on a level croup. The legs are fine, but with strong, dense bone. There is no feathering at the fetlock. The feet are very strong, and oval, shaped almost more like those of a donkey than those of a horse.

Color

The most common color is bay, but chestnut, black, and gray are also allowed. There are some very light duns, and many of the bays have dorsal stripes. Most Caspians display a minimal amount of white, perhaps a star, strip, or snip, and maybe socks. The breed standard specifically disallows piebald and skewbald.

With their gentle disposition and athletic ability, Caspians make wonderful mounts for young riders.

BREED ASSOCIATION FACTS AND FIGURES

According to the Caspian Horse Society of America (founded in 1994):

- In 2005, there were 540 Caspians in North America.
- About 75 new foals are registered each year.
- All U.S. horses are also registered with the International Caspian Association.
- Currently 90 percent of the Caspian horses in North America are in Texas.

Cerbat

HEIGHT: 13.2–14.2 hands

PLACE OF ORIGIN:
Northwestern Arizona;
genetic heritage goes back to
the early Spanish horses

SPECIAL QUALITIES:
A critically rare breed of
sure-footed, tough, athletic
horses; conformation is rep-
resentative of Spanish Colo-
nial Horses; some are gaited

BEST SUITED FOR:
Endurance, trail, ranch work,
and pleasure

The Cerbat mountain range runs across northwestern Arizona, not too far from Kingman. The altitude climbs from 5,000 to 7,000 feet, and the area contains some of the roughest, driest, rockiest terrain in the state. One of the first families of settlers in the area arrived in the 1860s. From documents passed down in this family and made public in 1966, we know that wild horses have lived there for many years. The local Indians said that the "horses had always been there," which means the horses go back further than tribal memory. Because of the extreme isolation of the area and the evidence from the family's careful records, it appears that no outside blood was ever introduced to these feral herds.

In all probability, the Cerbat herd arose from horses that escaped or were lost by the early Spanish explorers. The history of the area reveals a number of early Spanish expeditions into Arizona, New Mexico, and California. Blood testing of the Cerbat Horses shows they carry on their DNA what are known as "old Spanish markers," which links them very closely to the early Spanish horses.

A severe drought in 1971 caused local ranchers to begin eliminating the horses in an attempt to provide more water for their cattle. They did not realize that wild horses will dig for water in dry streambeds, and in so doing provide water for cattle as well as themselves. Twenty horses were trapped, brought down out of the mountains, branded, and issued the required Arizona paperwork that allowed them to be moved out of state. This group was divided up, with several of the horses going to Washington state and some to Colorado. A few of the remaining horses ended up on the Wyoming ranch of the founder of the Spanish Mustang Registry, who decided to make an effort to save this genetically distinct, rare group of horses. He bought two mares from the Colorado group and began to breed up the herd.

It is very likely that the Cerbat herd is one of the purest groups of feral Spanish horses in existence. Genetic testing demonstrates they are highly inbred, but almost none have health or soundness problems. It seems that maladaptive traits have been "bred out" of the herd. Weak, genetically inferior horses were presumably picked off by predators or died in accidents.

In 1990, a very small group of horses, believed to be descended from the herd caught in 1971, was discovered still living in the Cerbat range. Eight of these horses were caught and removed from the mountains. Blood testing indicates they are even more highly inbred than the first horses caught, but they still had no physical problems. Their blood markers matched those of the 1971 group.

Breed Characteristics
A number of the Cerbat Horses are laterally gaited. They are said to be extremely tractable and easy to teach. Cerbats are very long-lived. Mares from the herd caught in 1971 continued to produce foals well into their twenties.

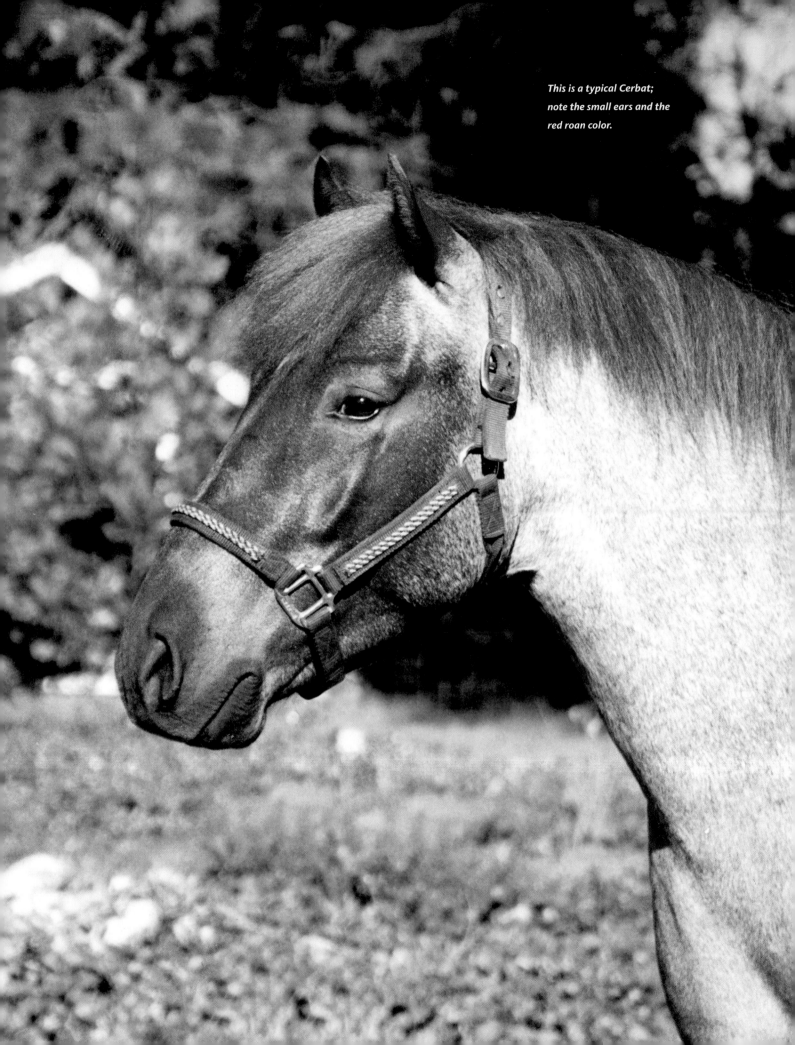

This is a typical Cerbat; note the small ears and the red roan color.

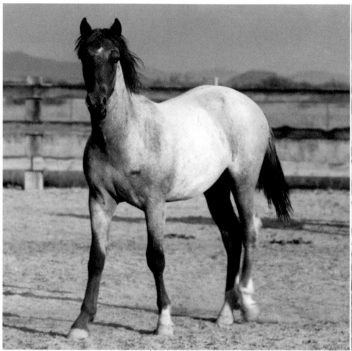
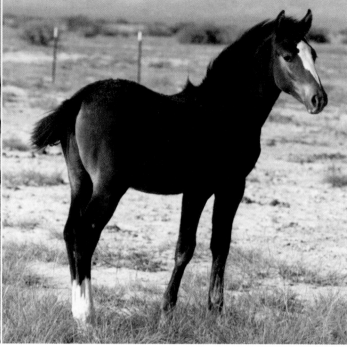

The eyes are set high in these solidly built young horses.

Conformation

The original horses were about 13.2 hands, but the next generation was almost a hand bigger, which indicates that the quantity and quality of food and a very tough environment were size-limiting factors for the wild horses.

The ears are small and curved and the eyes fairly high set. The profile is straight, as is typical of all Spanish-type breeds. The chest is somewhat narrow compared with modern Western breeds, but muscular. The shoulders are well laid back and the heart girth is deep. Their legs are excellent, with good bone. Chestnuts on the front legs are small and smooth and are small or absent on the hind legs, as are the ergots. The feet are quite strong, with thick hoof walls.

Color

Almost all of the horses are basically bay or chestnut, though many are red roan. White socks or facial markings are common. Uniquely, roan Cerbat foals are born roan. In other breeds, the roaning appears after the foals have at least shed their foal coat, and in some it develops years later.

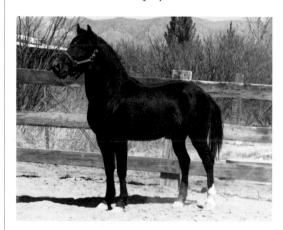

The harsh environment of the Cerbat Mountains has produced well-proportioned, athletic horses.

BREED ASSOCIATION FACTS AND FIGURES

There is no formal Cerbat registry at this time. Cerbats may be registered with the Spanish Mustang Registry.

- In 2005 the total number of living Cerbats registered with the Spanish Mustang Registry is 34, down from a high of 45.
- The decline in numbers has to do primarily with the death from old age of horses foaled in the 1970s.
- There are two foals pending registration.
- Only one ranch maintains both purebred Cerbat mares and stallions.
- Cerbat stallions have been crossed on other Spanish Mustang lines.

Cleveland Bay

One of the great breeds of English horses, and the oldest of England's native breeds, the purebred Cleveland Bay is quite rare, numbering only about five hundred horses throughout the world. Originating in northern Yorkshire, England, the Cleveland Bay is thought to have been developed by crossing local bay mares on Oriental (Arab, Turk, or Barb) and Andalusian stallions during the seventeenth century. Even early in

their history they were a very distinct type —strong, short-legged, and able to carry great weight. The breed was initially known as the Chapman Horse, for the salesmen, called "chapmen," who used this breed exclusively for packing goods prior to the advent of passable roads and wheeled carriages in rugged Yorkshire.

Northern Yorkshire is known for its harsh climate and rough, hilly terrain, but these horses thrived and grew strong there. Cleveland Bays were used as farm, riding, and packhorses in the mining area of the North York Moors. They could reportedly carry six hundred pounds of ore per load out of the mines. Loaded horses were led

HEIGHT: 16–16.2 hands

PLACE OF ORIGIN: Yorkshire, England

SPECIAL QUALITIES: A category 1, Critical Rare Breed; demonstrates great uniformity in color, type, and quality; has long been used for the improvement of other breeds

BEST SUITED FOR: Field and show hunters, dressage, combined driving, improvement of other breeds

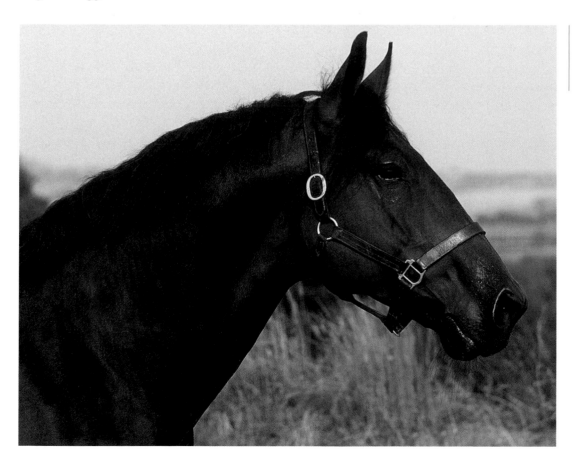

This Cleveland Bay has a mildly convex profile and demonstrates the calm, kind, and assured expression known to the breed.

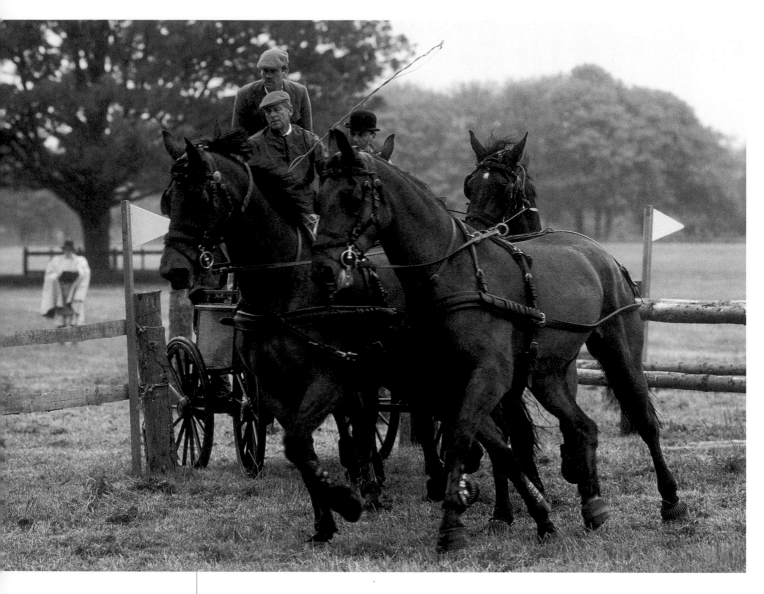

Cleveland Bays and Cleveland Bay crosses are almost born to drive. They are ideal competitors in the sport of combined driving.

long distances in pack strings over very rough hills to the iron smelters.

Close to Extinction

By the mid-1800s, the pure Cleveland Bay almost became extinct because it was crossed extensively, especially with Thoroughbreds, to produce superior carriage horses. The most famous of these crosses was the Yorkshire Coach Horse, which was widely regarded as the finest coach horse in England. In 1884, the Cleveland Bay Society was formed to prevent the breed's extinction. By the end of the coach and carriage era, it was the Yorkshire Coach Horse that had disappeared, but the Cleveland Bay continued to hang on.

The numbers of remaining horses were greatly reduced when they were used to pull artillery in World War I, and declined further as the age of mechanization ascended and use of horses waned. By the 1960s, only five or six purebred stallions still existed. But just as the breed seemed certain to vanish, determined breeders from Yorkshire managed to save it.

The Queen of England became the patron of the breed and carries on the tradition of using Cleveland Bays and Cleveland crossbreds in royal ceremonies. Prince Philip's famous team of international driving horses was composed of Cleveland Bay–Oldenburg crosses.

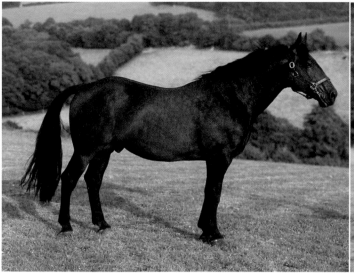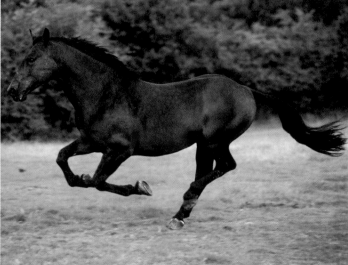

Since the late 1840s, the pure Cleveland Bay has carefully been bred without any infusion of Thoroughbred genes. The breed has been, and is still, widely used to improve other breeds. In Europe, Cleveland Bays have been used for improvement of the Oldenburg, the Holsteiner, and the Hanoverian. Breeding programs in Japan, Pakistan, the United States, Canada, New Zealand, and Australia also use Cleveland Bays to improve a number of their horse breeds.

The first Cleveland Bay stallions were imported to the United States in the early 1800s, and they caught on. William Cody, better known as Buffalo Bill, used Cleveland Bays in his Wild West Show. In western states, Cleveland Bays were often crossed with wiry range horses to produce excellent ranch horses.

Breed Characteristics

Cleveland Bays are well known as dressage horses, driving horses, and top-notch hunters. Crossbred Cleveland Bays have made excellent event horses.

Conformation

Cleveland Bays stand 16 to 17 hands high and weigh 1,225 to 1,500 pounds. The head, often featuring a pronounced convex profile, is bold and not too small, carried on a long, lean neck. The eyes are well set and kindly in expression, the ears large and fine. The shoulders are sloping and muscular. The body is deep and wide, with muscular loins, and the back is strong but not overly long. The quarters are quite level, powerful, long, and oval, with the tail "springing well" from the quarters. The legs and thighs are muscular, with large, strong joints, sloping pasterns, and very good feet.

Color

Cleveland Bays must be true bays with black points. Other than a very small star, white is not permitted. Gray hair in the mane and tail is characteristic in certain strains of purebred Cleveland Bays.

The cannons are quite short in these strong, powerful horses, and they are good gallopers, a trait often passed to crossbred offspring.

BREED ASSOCIATION FACTS AND FIGURES

There is no American registry for Cleveland Bays. According to the Cleveland Bay Society in the United Kingdom (founded in 1884):

- Seventy stallions are licensed worldwide.
- There are 300 mares worldwide and an unknown number of geldings.
- About 50 new foals are registered each year, almost all of them in the United Kingdom.
- The Cleveland Bay Society also registers part-breds.
- The North American Society (formed in 1885) reports there are 99 purebred Cleveland Bays in North America, of which 47 are mares.

Colorado Rangerbred

HEIGHT: 14.2–16 hands

PLACE OF ORIGIN: The high plains of eastern Colorado

SPECIAL QUALITIES: Excellent endurance, athleticism, and "cow sense"; some individuals exhibit the leopard-complex genes (Appaloosa coloring)

BEST SUITED FOR: Ranch work, pleasure and trail riding, all Western events

The story of the Colorado Ranger Horses begins not in Colorado but rather in Turkey, in 1878, with Ulysses S. Grant and Sultan Abdul Hamid. Grant had visited the sultan, and on the last day of his visit, as a token of friendship, the sultan presented him with a well-chosen gift of two stallions, an Arab named Leopard and a Barb named Linden Tree. (See Arabian entry for more on these two horses.) Grant was an excellent horseman who appreciated fine horses. While at West Point, he set a high-jumping record that stood for twenty-five years.

The Turkish stallions reached Virginia in 1879, and they immediately attracted the attention of renowned horseman and breeder Randolph Huntington. Huntington had spent nearly fifty years breeding trotters and roadsters. It was his goal to develop an all-American breed, which he proposed to call the Americo-Arab, both for use in this country and for export to Europe. He saw potential in the two stallions to improve the offspring from his mares. For fourteen years he used Grant's stallions most successfully, but his timing was unfortunate; the horseless carriage came into being just as his career of breeding road horses reached its pinnacle. In 1906, because of financial troubles caused largely by substantial theft by his secretary, his entire herd was sold off.

Before Huntington's downfall, however, General Colby, an old Army friend of Grant's, leased the stallions for one season in 1896 to cross on large numbers of his ranch mares in southeastern Nebraska. His goal was to improve the quality of his ranch horses, and he was decidedly successful. Within a few years, word spread to the high plains of eastern Colorado about the excellent horses on the Colby Ranch. Several large Colorado ranches got together and sent one of their most respected horsemen, Ira Whipple, with money and instructions to buy a band of mares and a stallion from Colby. Whipple came back with a group of young mares, all sired by either Leopard or Linden Tree, and an unusually marked stallion, simply named Tony, who was a double-bred grandson of Leopard.

Tony appeared to be white with black ears, but was actually a few-spotted leopard. At the time, the ranchers did not particularly care about color; they were trying to improve their horses for ranch and cattle work. The crosses from Tony and the Colby mares produced the desired results, and the Colorado Ranger Horse was born. Though at the time the breed remained unnamed, it was nonetheless a superior ranch horse.

Many of the horses were wildly colored, and some ranchers began to cultivate color in their breeding programs. In 1918, the W. R. Thompson Cattle Company imported a purebred Barb stallion, Spotte, from North Africa, to introduce more color to the breed. Another influential stallion was a black-and-white leopard colt named Max, born in 1918 on the ranch of the governor of Colorado. This horse came to be owned by Mike Ruby, one of the greatest horsemen of the High Plains. Max sired many outstanding Colorado Ranger

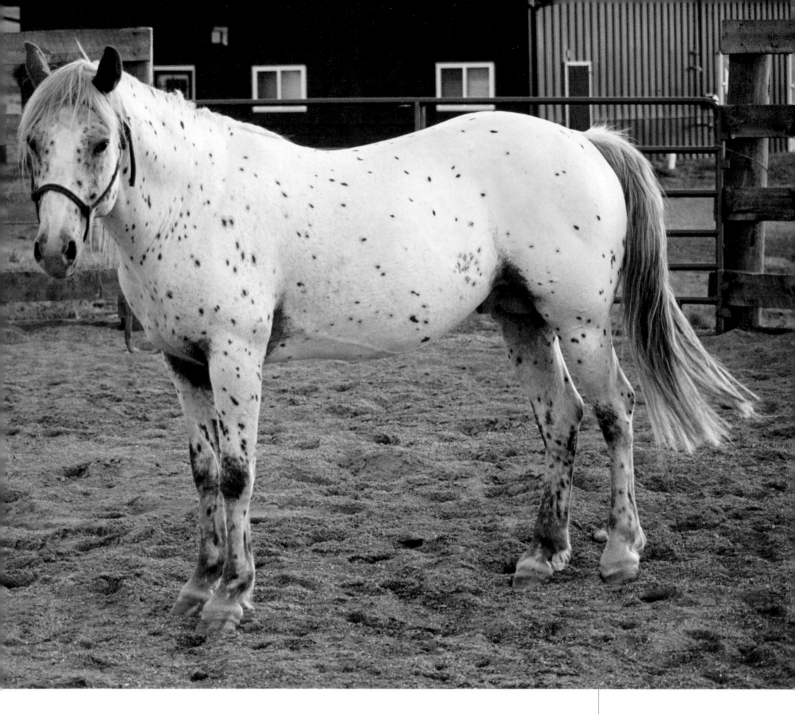

Horses, and his name can be seen on many pedigrees.

In 1934, Ruby impressed many horsemen with two stallions he took to the Denver Stock Show, and it was there that the breed, developed on the high ranges of Colorado, received its name.

In the mid-1930s, during the Dust Bowl era, the high plains suffered a very serious drought. Mike Ruby, not wanting to lose the herd of excellent horses he had been breeding for many years, drove them three hundred miles in hideous drought conditions to leased pasture in the Rockies of western

Colorado, where there was grass and water. Two years later, when the drought abated, he drove them back home, and thus saved some of the best Ranger-bred stock.

Breed Characteristics

To qualify for registration, it must be possible to trace a horse's pedigree in an unbroken line back to Max #2 (son of the original Max) or Patches #1, a son of one of the stallions from the Colby Ranch. Color is not a consideration, although a pedigree may not show Paint or Pinto breeding in the last five generations. Outcrosses are allowed with

Coat colors are not restricted other than that pinto coloring is not allowed.

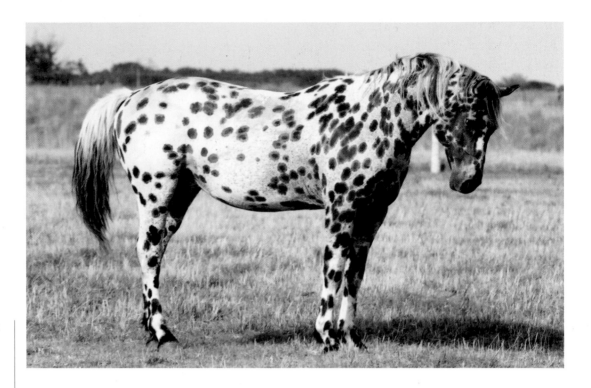

Loud color is not a requirement for registration but is often chosen.

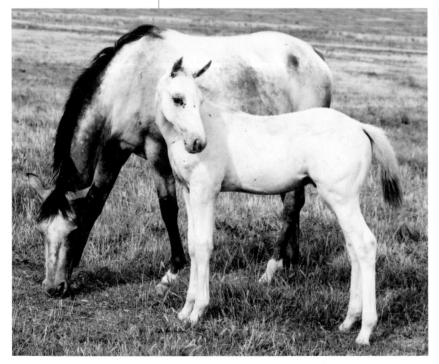

BREED ASSOCIATION FACTS AND FIGURES

According to the Colorado Ranger Horse Association (founded in 1938):

- More than 6,000 horses are currently registered.
- About 100 to 125 new foals are registered each year.
- Rangers seem to be most prevalent in Pennsylvania, Ohio, and Michigan, and on one large farm in Canada.

Thoroughbreds, Quarter Horses, Appaloosas, Arabs, and Ara-Appaloosas. Between 1980 and 1987, some Lusitano crosses were allowed, but this is no longer permitted. All pony and draft blood is excluded from registration.

Rangerbreds began as working ranch horses and they still maintain strong working abilities and athleticism combined with an easy disposition. They are now used mostly as pleasure, trail, and show horses, appearing most often in Western events but also in various events under English tack.

Conformation

Colorado Ranger Horses stand between 14.2 and 16 hands. The head should be well shaped and small, with a straight profile and pointed ears. The neck is long and muscular and connects to moderately pronounced withers. The chest is deep with long sloping shoulders. The back is short, with a slightly sloping croup. The legs are well muscled with good solid bone.

Color

Coat colors are not restricted other than that pinto coloring is not allowed.

Dutch Warmblood

Although most North Americans think of Holland as primarily a country of tulips and windmills, the Dutch tradition of breeding excellent horses goes back for centuries. In the case of the Friesian, the breed has been kept pure for more than two hundred years. Dutch Warmblood breeders, however, have a different purpose and a different technique. One of their primary goals since World War II has been to produce the best

HEIGHT: 15.2–17 hands, average is about 16.1

PLACE OF ORIGIN: Holland

SPECIAL QUALITIES: World-famous for their athletic ability

BEST SUITED FOR: Jumping, dressage, and driving

sport horse in the world. Like all sport horse breeds, Dutch Warmbloods are evolving. Breeders maintain three "breeding directions." The most popular by far, and the most famous, are the riding horses, which include jumpers and dressage horses. The breed also includes the higher-headed, higher-moving harness horse or Tuigpaard, which is quite rare in North America, as is the light draft type, the Gelders.

Prior to World War II, breeders sought to produce a superior horse for riding, another for driving, and a heavier horse for farm use. They selected for soundness, character, and willingness to work. There was never an effort to produce horses for

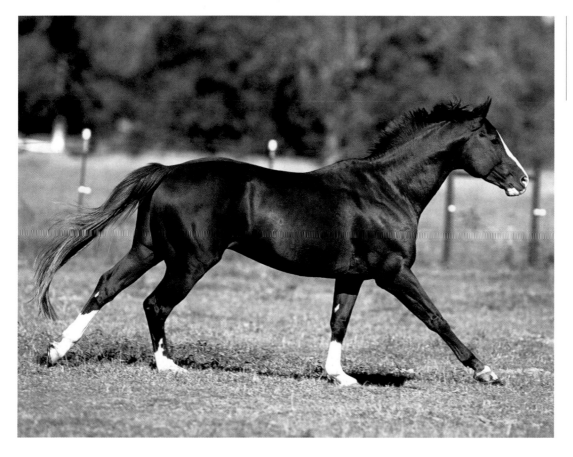

Well made and powerful, Dutch Warmbloods are often found on the rosters of the most elite jumping and dressage horses in the world.

Not all Dutch Warmbloods are branded. Individuals are inspected at age three and only the finest receive brands.

the military, as was the tradition in most European countries. To achieve their goals, the Dutch Warmblood breeders have maintained an open studbook, allowing the best stallions of various breeds to be crossed in.

The foundation breeds of the Dutch Warmblood were the heavy Gelderlander, from the regions of dense clay soil in southern Holland, and the lighter Groningen, from sandy soil in northern Holland. The Groningen is actually the same breed as the Danish Oldenborg and the early German Oldenburg. Both the Gelderlander and the Groningen descend from Friesians or other heavy horses. After 1850, Holland imported many stallions from Oldenburg, Holstein, Hanover, and France. During this era, the needs of horsemen changed from exclusively farm use to carriage use to general riding, triggering the transition from heavier workhorses to the modern Dutch Warmblood. This animal also shows the influence of Thoroughbred, Cleveland Bay, Hackney, Holsteiner, and Anglo Norman blood. The first warmblood studbook was published in 1887.

New Directions after the War

World War II caused massive destruction to Holland's agriculture. After the war, as mechanized farming became routine, some breeders recognized that the only substantial market for horses in the future would be for recreation. They realized their horses would have to change with the times. A system of riding clubs was set up throughout the country as horse breeders adapted their horses for recreational riding.

The aim was to maintain the traditional farm horse qualities of soundness, character, and willingness to work, while producing a riding horse with good gaits and a competitive spirit. Breeders rigorously culled horses that did not meet the criteria and selected only the very best animals for breeding. To improve jumping ability, they added more German and French lines. In 1970, they reorganized the studbook (*Warmbloed Paardenstamboek in Nederland,* or WPN), combining the regional studbooks, and adopted the brand of a rampant lion.

The careful breeding and culling efforts paid off. In the 1980s, Dutch Warmbloods

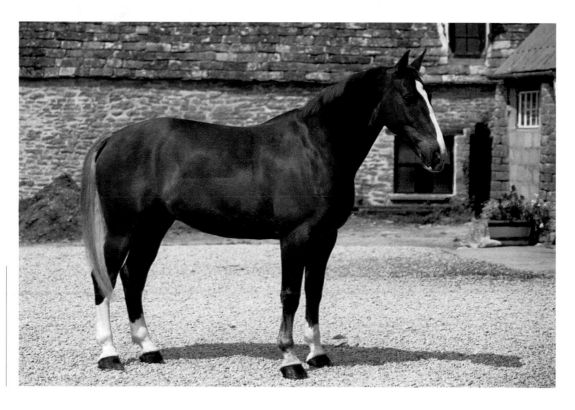

This horse nicely demonstrates some points of the breed standard. The chest is deep and full, the back straight and fairly long, and the croup short, broad, and flat with a fairly high-set tail.

began to dominate the international jumping circuit. The Freak won a gold medal for Germany's equestrian team in 1988, among his many other credits. The breed also began to produce top dressage horses. Limandus won the individual bronze for Switzerland at the 1984 Olympics, and Germany's gold medal team at the 1990 World Championships included the Dutch Warmblood Ideaal.

Dutch Warmbloods also excel in combined driving. All-Dutch teams won the World Championships in 1982 and 1986. Today the equestrian teams of many nations use Dutch Warmbloods. In 1988, Queen Beatrix of Holland granted the breed the honored title of Koninklijk, or "Royal," and the studbook became the KWPN. This well-deserved honor recognized the breeders of Dutch horses for a century of contributions to the nation's prestige and agricultural economy.

Breed Characteristics

Breeders of Dutch Warmbloods are unrelenting in their efforts to develop the perfect sport horse, and this world-class, competitive breed continues to evolve. Dutch Warmbloods are always bred to be sound performance horses but are not necessarily always beautiful horses. Some are very attractive, while others have a plain head with a Roman nose and big ears. Today, beautiful horses have become much more common in the breed than they once were. These horses move naturally from behind, with animated action and equal strength from hindquarter to forehand. Dutch Warmbloods are known for their tractable disposition and are said to be highly trainable, willing, and less stubborn than many other warmblood breeds.

Conformation

Dutch Warmbloods range from 15.2 to 17 hands with an average of 16.1 hands, a suitable size for excellence in jumping or dressage. They weigh between 1,200 and 1,500 pounds. The head is well shaped, with a straight profile, and the neck is muscled and arched, merging neatly into fairly prominent withers. The chest is deep and full and the shoulder well sloped. The back is straight and fairly long; the croup is short, broad, and flat. The tail set is high. The legs are strong, with a long forearm. Hindquarters are powerful and highly muscled.

Color

Dutch Warmbloods are usually chestnut, bay, black, or gray and frequently have white markings on the face and lower legs.

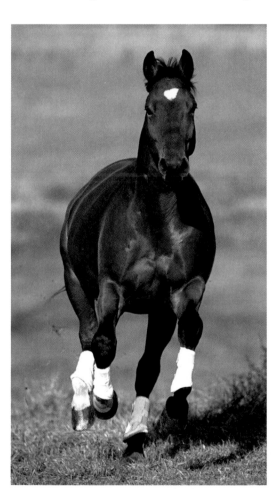

The power and correctness of movement can be seen even from the front.

BREED ASSOCIATION FACTS AND FIGURES

According to the Dutch Warmblood Studbook in North America (founded in 1983):

- The association does not track total numbers registered.
- Between 350 and 450 new foals are registered each year.
- An additional 300 or so imports are registered.

Florida Cracker

HEIGHT: 13.2–15 hands

PLACE OF ORIGIN:
Southeastern United States;
descended from early
Spanish horses

SPECIAL QUALITIES: An
extremely rare breed of
gaited horses with excellent
"cow sense"

BEST SUITED FOR: Ranch
work, endurance, trail riding,
team penning, team roping

The Florida Cracker Horse's long, remarkable history was shaped by the early Spanish, their cattle, the Dust Bowl of the 1930s, and a parasite. Soon after the Spanish arrived in the Caribbean, they began their exploration and conquest of Central and South America and what is now the continental United States. Horses arrived in the Southeast in 1521, when Ponce de León brought them on his second trip to Florida. The horses were used by ranking members of the expedition, by scouts, and by riders who herded livestock.

From this point on, most subsequent Spanish expeditions to Florida brought horses and cattle. Cattle ranching became firmly established by the late 1500s. By 1650, the district the Spanish referred to as Guale, which included northern Florida and southern Georgia, had seventy-nine missions, eight large towns and two royal haciendas, and many horses and cattle. By the end of the 1600s, the Spanish cattle industry, in what is now Florida, was enjoying success.

The Spanish horses were a utilitarian mixture of breeds that included the Barb, the Garrano, the Jennet, Sorraia ponies (originally from Portugal), some Andalusians, and probably other breeds from Iberia. They ranged in size from 13.2 to 15 hands, with short backs; sloping shoulders, pasterns, and croups; low tail sets; good limbs and hooves; wide foreheads; delicately formed nostrils; and, it was often noted, lively, beautiful eyes.

This collection of traits, along with a few others, including a tendency to be smooth-gaited, is referred to as Spanish traits (see pages 38–39.) Spanish traits tend to persist over time if the breed is not genetically diluted. Spanish traits are readily apparent in the Florida Cracker, visually linking these horses to their early Spanish roots.

What's in a Name?

Early cattle drovers moved their animals along with cracking whips. The sound of the whips gave the drovers, their rough cattle, and their cow ponies the name Cracker. The horses have had a host of other names over the years, including Chickasaw Pony, Seminole Pony, March Tackie, Prairie Pony, Florida Horse, and Grass Gut.

The cattle of the time were small, wild, and wily and the terrain was brush covered and difficult to work in. It took quick, tireless, agile little horses with tremendous herding ability to do the work. The Cracker Horses were perfect for the task. They were so well suited to the terrain and work to be done that they remained the predominant type from Florida and Georgia to the Carolinas from the mid-1500s until the 1930s.

During the Dust Bowl years, the U.S. government encouraged the movement of cattle from parched western states into Florida. The western cattle were considerably larger than the Cracker cattle, and they brought with them the parasitic screwworm. This meant they had to be frequently roped and held for veterinary treatment. The little Cracker Horses just couldn't hold the large cattle as well as

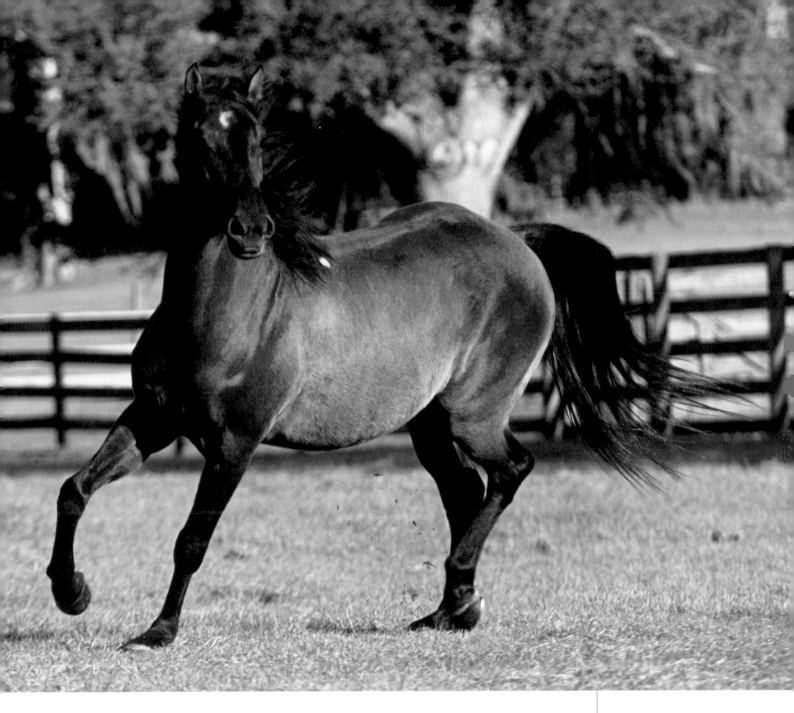

bigger horses could, so they soon were replaced by Quarter Horses.

In short order, Cracker Horses became so rare that they almost disappeared. However, in the past fifteen years, through the efforts of interested owners, a breed registry and association, and now the state of Florida, these interesting and useful horses are returning from the edge of extinction.

Breed Characteristics

Crackers are small, comfortable horses and willing workers. Exceptionally quick and agile, they make fine trail and endurance horses and they excel at activities where agility is important. With their strong herding abilities, Crackers shine at ranch work and in sports such as working cow horse, team roping, and team penning.

Conformation

Like their ancestors, Crackers range from about 13.2 to 15 hands and weigh between 750 and 1,000 pounds. The head has a straight or slightly convex profile, with a short, well-defined jaw. The eyes are keen and alert with good width between them. The well-defined neck without excessive

The Florida Cracker is a naturally gaited breed with several variations, including a flatfoot walk, running walk, trot, and an ambling gait.

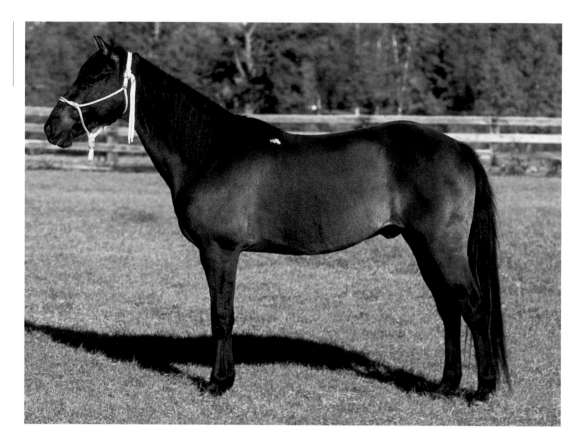

Cracker Horses are small, quick, and agile. Bay, brown, and black are the most common colors.

crest measures about the same length as the distance from the withers to the croup. The back is narrow and strong, with well-sprung ribs. The croup is sloping and short and the tail set is medium to low.

Gait

The breed is gaited. The Florida Cracker Horse Association recognizes the flatfoot walk, the running walk, the trot, and an ambling or Paso-type gait. The horses also canter and gallop. All gaits are ground covering, comfortable, and easy for both horse and rider.

Color

Florida Cracker Horses may be found in all colors known to the horse, although bay, brown, black, and gray predominate. There are occasional grullas, duns, and sorrels.

Though now quite rare, the Cracker played an important part in the development of the southern United States.

BREED ASSOCIATION FACTS AND FIGURES
According to the Florida Cracker Horse Association (founded in 1989):
- The Florida Cracker Horse Registry was established in 1991.
- In 2005, there were 720 registered horses.
- About 40–60 foals are added each year.
- As of 2005, there are five horses in Texas, one in New York, six in Alabama, and six in Georgia. The rest are in Florida.

Friesian

Friesland, a province in the Kingdom of the Netherlands that lies along the coast of the North Sea, was settled by 500 BCE. The inhabitants became tradesmen, seafarers, farmers, and excellent horse breeders. In 120 CE, the Romans, from what is now England, hired mercenaries from Friesland who brought large, strong horses with them to help build Emperor Hadrian's wall, which defined the northern boundary and defense line of Roman Britain. Beginning in about the year 1000 CE, Netherlanders began building their own walls to keep the sea from flooding their sinking land. From that time until mechanized equipment became common, large, strong horses were essential to this critical activity and were carefully developed and maintained. Horses from Friesland were widespread and famous by the thirteenth century. There is written documentation of Friesian horses in Cologne in 1251 and in Munster in 1276, and the breed is praised in many books that date from the mid-sixteenth century. Friesians, which were prized for their strength and agility, carried knights in armor during the Middle Ages.

The silhouette of a Friesian is virtually unmistakable, with a noble head set on a long, gracefully arched neck as well as feathering on the lower legs. The mane and tail are always full but on this horse are exceptional.

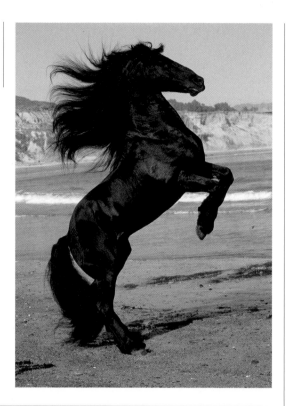

Though powerfully built and quite strong, Friesians are known for their gentle, friendly nature.

KEEPING THE BLOODLINES PURE

Having a Friesian, particularly a stallion, accepted for breeding in Holland is a huge honor and an extremely difficult, multistep process. As weanlings, individuals are inspected and judged on conformation and correctness of gait. The judges look for balanced, rhythmic action and animation in both the front and the hind feet. Each February, forty to sixty of the best three- and four-year-old stallions, chosen from the top yearlings inspected two years earlier, are brought to one location to be rigorously judged and inspected for conformation and movement over two days.

Usually only two to fourteen of these young stallions qualify for acceptance at a government-sponsored stallion school, where they spend fifty days being trained for riding and driving while their manners and temperament are carefully and constantly judged. The horses are also tested under saddle and in harness by experts in the breed. At the end of the training and testing, the very best stallions, usually no more than one or two, but in some years none, are branded with an *F* on the left side of the neck, which signifies that they have earned the right to be bred to stud-book mares to produce registered foals. The selected stallions are used for breeding until they are eight years old, at which time forty of their offspring are randomly selected for judging. A stallion must show that he is benefiting and improving the breed. He and his get are inspected annually in this manner until the stallion is twelve. If he fails any of these tests, he is disqualified as a breeding stallion and will never be considered again.

The Friesian appears to have descended from *Equus robustus,* the largest of the wild horse prototypes that roamed Europe in prehistoric times. The lineage of the modern Friesian began in Holland in the early sixteenth century. During the sixteenth and seventeenth centuries, Andalusian blood was introduced to the Friesian breed, along with admixtures of other breeds from western Europe. The Friesian probably gained its high knee action and elegance from these crosses, traits that established it as one of the most elite carriage horses in the world. The Friesian is one of the very few European breeds with no Thoroughbred crosses in its history. For the last two hundred years, Friesian breeders have maintained extremely high standards and kept the breed pure.

The Friesian has greatly influenced many other breeds in Europe and North America, among them the Old English Black Horse, the Fell Pony, the Dales Pony, and the Norwegian Dole. Trotting breeds in particular trace back to the Friesian, including the Standardbred, the Canadian Horse, the Hackney, the Orlov Trotter, and the now extinct Norfolk Trotter. It is highly likely that the Shire is a direct descendant of the Friesian.

Coming to America

The Friesian was first introduced to the Americas when the Dutch settled on the southern tip of Manhattan Island in 1625. After New Amsterdam fell to the British in 1665 (and was renamed New York), the Dutch horses soon disappeared, but by then they had made their mark. Although not absolutely proved, Friesian horses almost certainly appear in the pedigree of America's first true breed of draft horse, the Conestoga Horse of Pennsylvania (see page 20), which first appeared before the Revolutionary War. Newspapers in 1795 and 1796 advertised "trotters of Dutch descent," which most likely meant Friesians or horses of Friesian lineage. Friesians also influenced

other breeds and types, particularly coach horses, in this country.

During the nineteenth century, trotting horses from Russia and America replaced Friesians as popular harness-racing horses in Europe, and Friesians became increasingly rare. By the turn of the century, in Europe, extensive crossbreeding of the few remaining purebreds nearly ensured the breed's demise. A few interested breeders founded the Friesian Horse Society in 1913 in an effort to save this fine old breed. At the time, there were only three registered stallions. Thanks to the tremendous efforts of these Friesian admirers, the breed, though still uncommon, is now found around the world. Its future seems secure.

Although Friesians came to North America in the early seventeenth century and were influential in the establishment and improvement of many breeds here, the breed dwindled and nearly disappeared. The first two Friesians to be imported to this country in recent times came in 1975 by special arrangements on a ship. Others soon came by plane. Since its arrival, the breed has steadily gained popularity. These great black horses with bold, forward action now draw large crowds of awed admirers at dressage shows, driving shows, and large horse expositions throughout North America.

JUDGING MARES

Friesian mares are assessed for conformation, temperament, and movement at age three. If a mare qualifies as a studbook mare, she can be bred to a qualified stallion to produce registered foals. Studbook mares are branded with an *F* on the left side of the neck. Exceptionally fine mares also receive an *S* on the left side of the neck, designating them as Star mares. At seven, a mare may be judged for Model classification, which requires superb conformation and nearly perfect movement. There are fewer than fifty Model mares in the world. A Model mare is branded with an *M* on the left side of the neck. Mares that fail to earn Model classification may be presented again in subsequent years.

Both stallions and mares can become Preferred, which is the very highest classification, by a system of points they earn from the merits of their offspring. If they gather enough points, they receive a brand on the right side of the neck in the shape of a crown. This exceptionally rigorous system of classification has ensured great consistency and excellence in the breed. It is small wonder that Friesian horses are so often breathtaking.

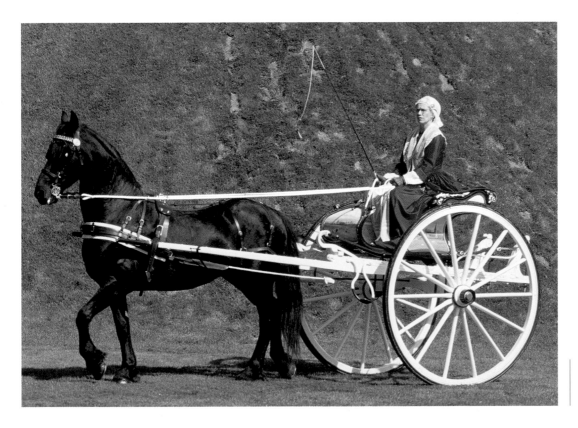

Friesians have always made excellent and memorable driving horses.

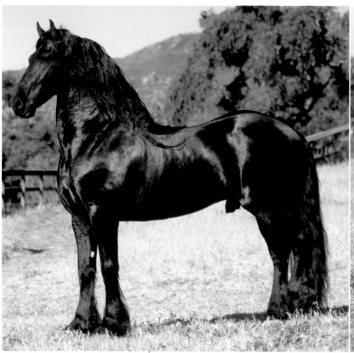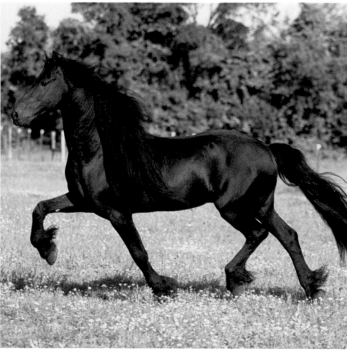

Breed Characteristics

The silhouette of the Friesian is instantly recognizable. The horses are substantial, tall, and upright, and always characterized by feathering on the lower legs. The natural action is high, fluid, and bold. It is showy yet powerful. The horses have a regal bearing but are known for gentleness and friendliness. They excel in dressage and as carriage horses. The fluid gaits are square, elegant, and elevated and are emphasized by the feathering on the lower legs.

Conformation

Friesians stand between 15 and 17 hands and weigh between 1,250 and 1,450 pounds. The overall appearance is of a well-constructed horse of strength and luxuriance. The build is compact. The head is noble and long, with a flat profile, but overall relatively small. The ears point inward at the tips. The neck is graceful and swanlike, carried high and proudly. The shoulders are strong, sloping, and of good length.

The body is well balanced, of good depth with well-sprung ribs, but not too wide. The back is strong, joining to a croup of good length that should not slope too greatly. The legs are strong with well-developed forearms. The feet are hard and well formed. The mane and tail are abundant, as is the feathering on the lower legs, which should cover the hoof but not be as full as on draft breeds. Trimming of any hair from the mane, tail, or legs or even braiding the mane or tail is frowned upon.

Color

Today's Friesian is always black, although years ago it came in other colors. The last brown mare was accepted for registry in 1918. The only white allowed is a small star, which is permitted only on geldings and studbook mares.

BREED ASSOCIATION FACTS AND FIGURES

According to the Friesian Horse Society of North America (founded in 1983):

- The association is the North American representative of the *Friese Paarden Stamboek* (FPS), the official studbook.
- There are currently 2,438 registered Friesians in North America.
- About 250–300 foals are added each year.
- There are approximately 40,000 Friesians worldwide.
- In the United States, Friesians are found primarily on the East and West Coasts.

Galiceno

The Galiceno breed originated in the northwestern province of Galicia in Spain, probably from crossing local horses with the Garrano Mountain ponies and the ancient, indigenous Sorraia of Portugal. Because of the beauty and overall look of the Galiceno, there are those who believe Andalusian may also be in their heritage; however, Dr. Hardy Oelke, a renowned horse geneticist and historian, believes it was the

Sorraia that formed the most important part of the foundation of the Andalusian.

Oelke writes, "The Sorraia horse is the most important ancestor of the Iberian breeds such as Lusitano and Andalusian. It is this horse that contributed the proud carriage, the ability to flex at the poll, to collect and to work off the hindquarters to

these breeds, and via the Lusitano and the Andalusian to all modern warmblood breeds. It also contributed a latent tendency for lateral gaits and the talent for cow work."

It therefore seems that the Sorraia may have done the same for the Galiceno. Horses of recognizable type were usually

HEIGHT: 12–14.1 hands

PLACE OF ORIGIN: Northwestern Spain

SPECIAL QUALITIES: A very rare breed of gaited, pony-sized horses with the character, presence, courage, and stamina of other Spanish breeds

BEST SUITED FOR: Trail and endurance riding, cutting, and reining

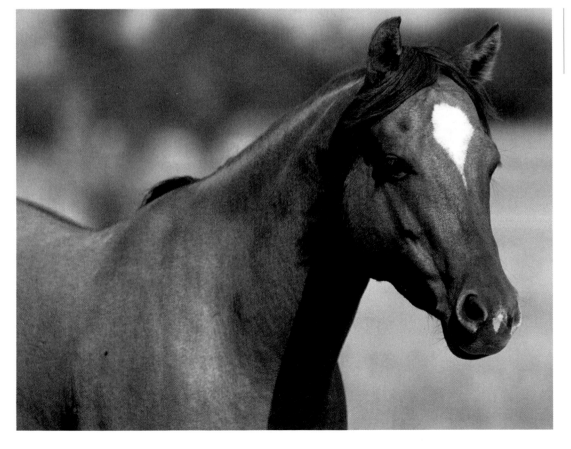

This very old and rare breed of attractive small horses is not well known in most of North America.

given the name of the region from which they originated. The horses of Galicia were known by the time of the Conquistadores. The Galiceno made its entrance to the New World in 1519 on the first load of seventeen horses brought by Hernán Cortés when he invaded Mexico. These small horses were known then as they are now for their beauty, smooth gaits, gentle nature, strength, and endurance.

As the horse population of Mexico increased, local people began to catch and use horses from the free-ranging herds for a wide variety of tasks. The tough Galiceno became a highly prized possession, especially in coastal regions. Galicenos were also used by the Conquistadores to work in the Mexican silver mines. When mines closed, the horses were sometimes released to fend for themselves in the mountains. They survived and multiplied and were occasionally captured by native people. The horses living with remote populations of people remained virtually isolated from other breeds and more or less forgotten or unnoticed by the rest of the world for centuries.

In other places in Mexico, the little Galicenos were ridden or packed north by the Spanish into what is now the United States. As Spanish missions expanded their holdings and activities beyond the Mexican

These are very strong, well-balanced, stock-type horses.

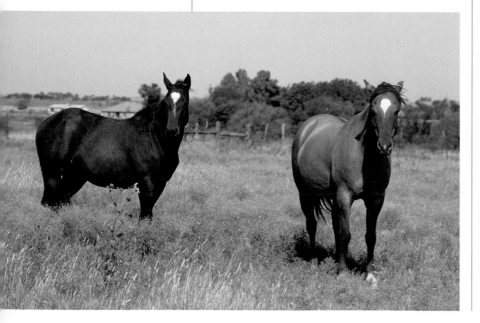

border, additional Galiceno-type horses were brought into and bred in more northern regions. Inevitably some escaped or were lost in battle, while others were stolen by Indians who then took the horses wherever they went, keeping some and trading others. In these ways Galicenos became part of the vast herds of Mustangs that populated the great plains. Our Spanish Mustangs can certainly trace an important part of their ancestry to the Galicenos, as can Florida Cracker Horses and many others. The Galicenos were also part of the ancestry of many Indian ponies.

The first Galicenos in modern times intentionally imported from Mexico into the United States were a herd of 135 brought by Walt Johnson and John Le Brett in the 1950s. At least some, and possibly all, of these horses had been wild-caught in Mexico. The good-looking, small, smooth-gaited horses with natural "cow sense" attracted the attention of horsemen and ranchers. The Galiceno Horse Breeders Association was formed in 1959.

Breed Characteristics

Where people are familiar with the breed, North Americans have accepted these pony-sized horses as excellent mounts for children and small adults; but outside of a few ranches in Texas, North Americans have been slow to recognize and make use of their strength and endurance. A 13-hand Galiceno can easily carry a 200-pound man over rough country all day. This is a gaited breed, known for its ground-covering movement. The horses have a running walk that is distinctive to the breed.

Galicenos have always been recognized for their substance, style, and beauty. Although they are pony height, these animals are said to possess the character, presence, courage, and stamina of other famous Spanish horse breeds. They are reported to form particularly strong bonds with their human companions. Galicenos make ideal family and trail horses, and they are well

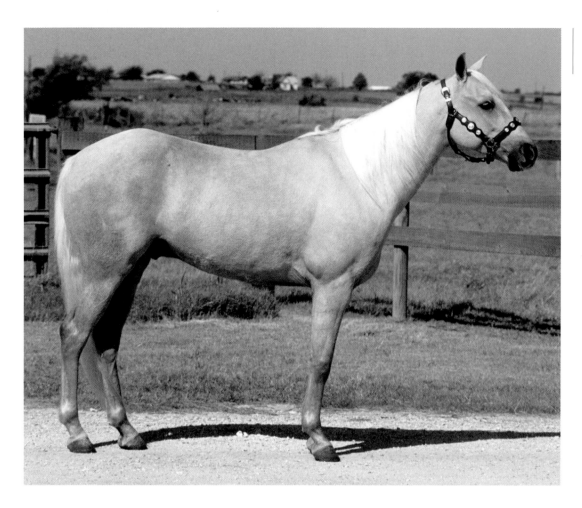

Smooth-gaited and agile, Galicenos make very nice all-around mounts and family horses.

suited to endurance riding. They are quick enough to use in contest sports and make very good cutting and reining horses.

Conformation

The average height of the horses is between 12 and 13.2 hands, but the breed has increased slightly in size since coming to the United States, and some are now about 14.1 hands.

The head has good width between the large, lively eyes, a small muzzle, and pointed ears. The neck is slightly arched with a clean throatlatch. The mane is thick and full and often lies on both sides of the neck. The neck fits smoothly into prominent withers. The body is smoothly muscled. The shoulders are well sloped, which contributes to the long, low, smooth gaits. The forearms are well muscled. The back is short and straight, with a slightly sloped croup and low tail set, typical of Spanish

traits. The tail itself is usually very long and full, often sweeping the ground. The hindquarters are set slightly more under the body than in other breeds. The joints are strong and clean. The feet are well shaped, hard, and open at the heel.

Color

All solid colors other than albino are accepted for registration. White on the face and lower legs is permitted. Pintos are not accepted for registration.

BREED ASSOCIATION FACTS AND FIGURES

According to the Galiceno Horse Breeders Association (founded in 1959):

- Galicenos that meet requirements for color, conformation, and height may also be registered with the American Indian Horse Registry.
- There are 7,000 Galicenos registered in North America.
- About 20 foals are registered annually.

Gypsy Vanner

HEIGHT: 14–15.2 hands

PLACE OF ORIGIN: England

SPECIAL QUALITIES:
Compact, strong cobs; often black-and-white pintos; abundant manes and tails and heavy leg feathering

BEST SUITED FOR: Driving, pleasure riding, dressage

It is highly unusual for an entire breed of horses to go quickly from rags to riches, but it happened to the Gypsy Vanner. An unlikely set of circumstances brought this spectacular horse from complete obscurity in England to almost overnight stardom in the United States. In 1994, Dennis and Cindy Thompson, longtime horsemen, traveled to England on business and found themselves with enough free time to visit horse country. Captivated by

a filly at the Shire Center in England, they almost bought her but decided first to drive to the north of Wales, where farmers have lived and breathed Shire horses for centuries, to talk to breeders and learn more about Shires.

Returning to London on a country road at night, Dennis noticed a moonlit horse in a field like none he had ever seen before. They turned the car around to get a closer look at the black-and-white piebald horse, built like a draft horse but only about 14.2 hands high. It had extensive feathering from the knee and the hock to the ground, and when it trotted up to them with full mane, tail, and feathers flowing in the wind, their lives were changed.

The horse was being kept by a local farmer for a Gypsy. In Great Britain and other parts of Europe, Gypsies, a much maligned minority, still travel by horse-drawn caravans. Since 1968, the British government has established one hundred permanent sites where Gypsies may park their caravans legally. As long as they are on the caravan sites, laws protect them from harassment by other people.

Gypsy culture is very old, with customs that have been passed down for centuries. Many, if not most, of the people are illiterate, but family histories and important events are kept accurately and passed

down orally, as are the pedigrees of prized horses. The Gypsy tradition with horses is ancient, and some Gypsies are excellent breeders. They have a clear vision of the horses they want to produce and know how to achieve their goals, while storing relevant information only in their memories.

In England, the Gypsies own three types of horses, although the types are not specifically named.

- There is what might be called the Classic Vanner, sometimes called a Gypsy Cob. (A **cob** is a small, sturdy horse standing about 14.2 hands.) Developed to pull wagons, this is the type that was imported into the United States.
- A smaller type, which Dennis Thompson calls the Mini Vanner, stands about 12.2 hands.
- The third type is lighter in body and bone but much less consistent in conformation and is primarily bred to have a good trot. It is common for this type to be bred rather indiscriminately and for pedigrees to be lost.

Since World War II, the goal of the best Gypsy breeders in England was to produce an ideal horse to pull the highly decorated Gypsy caravan wagons. The horse was to be a small replica of the Shire but with more feathering and a more attractive head. It

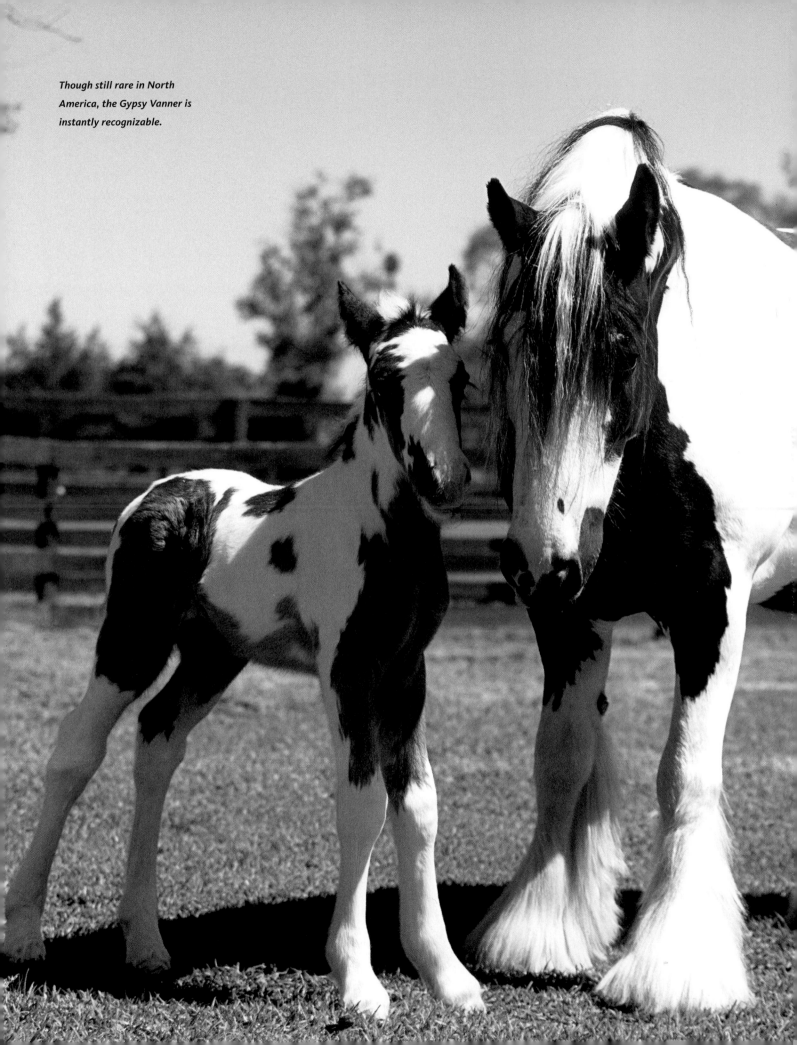

Though still rare in North America, the Gypsy Vanner is instantly recognizable.

There is some confusion between the names Irish Tinker and Gypsy Vanner. In Ireland there is a culture of nomadic people called Irish Travelers. Although not related to Gypsies, they live a somewhat similar life, and they also have a long tradition with horses.

The Gypsies and the Travelers have little to do with each other, but they respect one another's abilities with horses. Irish Tinkers are horses from the Travelers' tradition and contain Connemara breeding, among others.

the Vanner are Friesians, Shires, Clydesdales, and Dales Ponies.

A New Name in a New Country

The breed had no official name when it was first exported to the United States. The Thompsons were the first outsiders ever to conduct extensive research on Gypsy horse pedigrees and the first to write down the pedigrees. They were also the first Americans ever to attend the extensive Gypsy horse sale. It took nearly three years of research and effort to bring the stallion they had seen in the field that night to their farm in Florida.

Wanting to help establish this old and wonderful breed in a modern world, the Thompsons knew it needed a name. According to Dennis Thompson, "The name Gypsy Vanner Horse is the first ever to recognize a specific Gypsy horse breed. The name is culturally sensitive and represents extensive

To the Gypsies, color, mane, tail, and feathering are important features of the horses that pull their colorful wagons.

had to be extremely gentle and tractable, because the Gypsies live intimately with their horses, and small children often entertain themselves by sitting on and playing with the horses for hours. The ideal horse had to be a good mover for long-distance traveling, and it had to be beautiful, because the appearance of the horses and the wagons is extremely important to the culture. The main breeds in the pedigree of

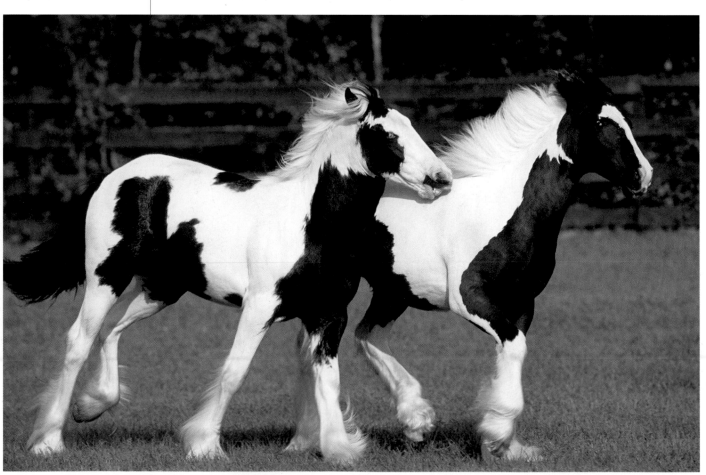

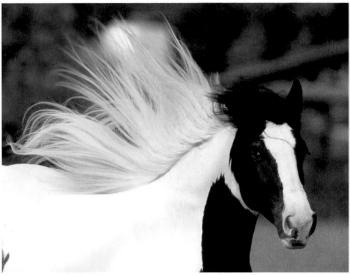
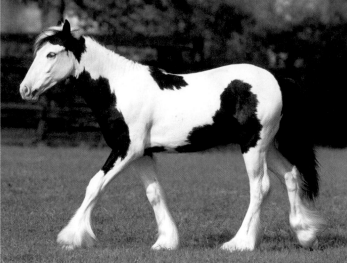

research and understanding of the vision that created the breed."

The Thompsons imported two more stallions and fourteen mares in 1996. There are now nearly 140 Vanners in the United States, and they have made a big splash at horse fairs such as the Equine Affaire and Equitana. The horses have become something of a fad. There is a Vanner at Kentucky Horse Park, one at Disney in Florida, one in Minnesota that helps teach inner-city children about the consequences of prejudice, and at least one in Hollywood, California, working in movies.

Breed Characteristics

Working with the Gypsies in England, the Thompsons have established a breed standard for Vanners. The perfect caravan horse is strong, intelligent, athletic, and colorful, with excellent endurance. A docile nature is vital; in Gypsy society any horse showing ill temper is banished. Vanners are extremely sound and very easy keepers. Their abundant mane, tail, and feathers give them a magical look. Gypsy Vanners were developed to be excellent driving horses. They are a good choice for combined driving. They have very good gaits, making them suitable as dressage horses. Because of that easygoing, docile temperament, they make good mounts for children, new riders, and riders with physical or emotional limitations. They can readily carry adults.

Conformation

These horses are compact, standing 14 to 15.2 hands, with a short neck and a short back. They range in weight from 1,100 to 1,700 pounds. The withers are rounded, making them suitable both for harness and for bareback riding. Heavy bone, flat knees, and ample hooves provide a solid foundation to support the body, which includes a broad chest and heavy hips.

Color

Piebald (black-and-white pinto) and **skewbald** (any pinto other than piebald) are the most common colors, but solid colors occur and are also valued. Blazes on the face and white socks or stockings are common.

These young horses show characteristics of the breeds that most influenced the Gypsy Vanner: Friesian, Shire, Clydesdale, and Dales Pony.

BREED ASSOCIATION FACTS AND FIGURES

According to the Gypsy Vanner Horse Society (founded in 1996):

- Gypsy Vanner Horses were first introduced to the North American public in 1998.
- There are about 140 horses presently in the United States.
- Twenty new foals are registered each year.
- Gypsy reports from England claim there are 2,000–5,000 worldwide, of which about 10 percent are Classic Vanners.

Hackney Horse

HEIGHT: 14.2–16 hands

PLACE OF ORIGIN: England

SPECIAL QUALITIES:
Driving horses of substance,
soundness, and endurance
famous for their spectacularly
high ground-covering motion

BEST SUITED FOR: Driving,
jumping, and improvement of
other breeds

The word *hackney* derives from *haquenée* in French, a language commonly spoken in England in medieval times. The term originally described a horse with a very comfortable trot or amble. Over the years it came to mean a general-purpose riding and driving horse of great soundness and stamina, but the horses were always best known for the trot. Hackney is also the name of a town in England.

As far back as the Middle Ages, English horse breeders produced trotting horses. The best ones, which came from Norfolk, brought very high prices. Another excellent type from a different region came to be known as Yorkshires, Yorkshire Trotters, or Yorkshire Roadsters, which were very similar to, or identical with, Cleveland Bays. Although both were outstanding trotters with great endurance, the Norfolk type was sturdy and coblike, while the Yorkshire showed more quality and refinement.

The early Hackneys were multipurpose animals, used for hunting and farmwork as well as for traveling over the poor-quality, muddy, rutted tracks that served as roads. Hackneys were also used as light cavalry horses in many wars and skirmishes during this era.

In the early 1700s, Hackney breeders crossed in some Arab stallions to add refinement. Later, when road quality improved, faster coaching horses were suddenly in much demand. At this time, people valued Hackneys for their great stamina

FIT FOR A KING

Hackneys were highly regarded, even by monarchs. Henry VII, Henry VIII, and Elizabeth I all passed acts concerning horse breeding and the value of the Hackney. Henry VIII even penalized anyone who exported one without authority.

and road-covering trot; there was no emphasis on high knee action. Hackneys were frequently used in road races under saddle. Sometimes the wagers on the outcome were astonishingly high.

The Modern Hackney

One of the most influential sires in the history of the breed was a grandson of the Darley Arabian named Shales, sometimes referred to as Original Shales, foaled in about 1755. His sire was a Thoroughbred named Blaze, and his dam is listed as a "Hackney mare." Two horse breeders, a father and son, Robert and Philip Ramsdale, were instrumental in the development of the modern Hackney. They took the best Norfolk stallions, containing the blood of the Original Shales, and crossed it on high-quality Yorkshire mares. When the sturdy Norfolk Trotter and the Yorkshire Coach Horse, which was three-quarters Cleveland Bay and one-quarter Thoroughbred, were blended through Shales lines, the resulting crosses founded the modern Hackney breed.

As horse-drawn vehicles became more sophisticated and elaborate in the Regency period (1811–1820), fashion dictated flashy, high-headed horses with lofty knee action. Horses were terribly expensive to keep, particularly in cities, because of the scarcity of

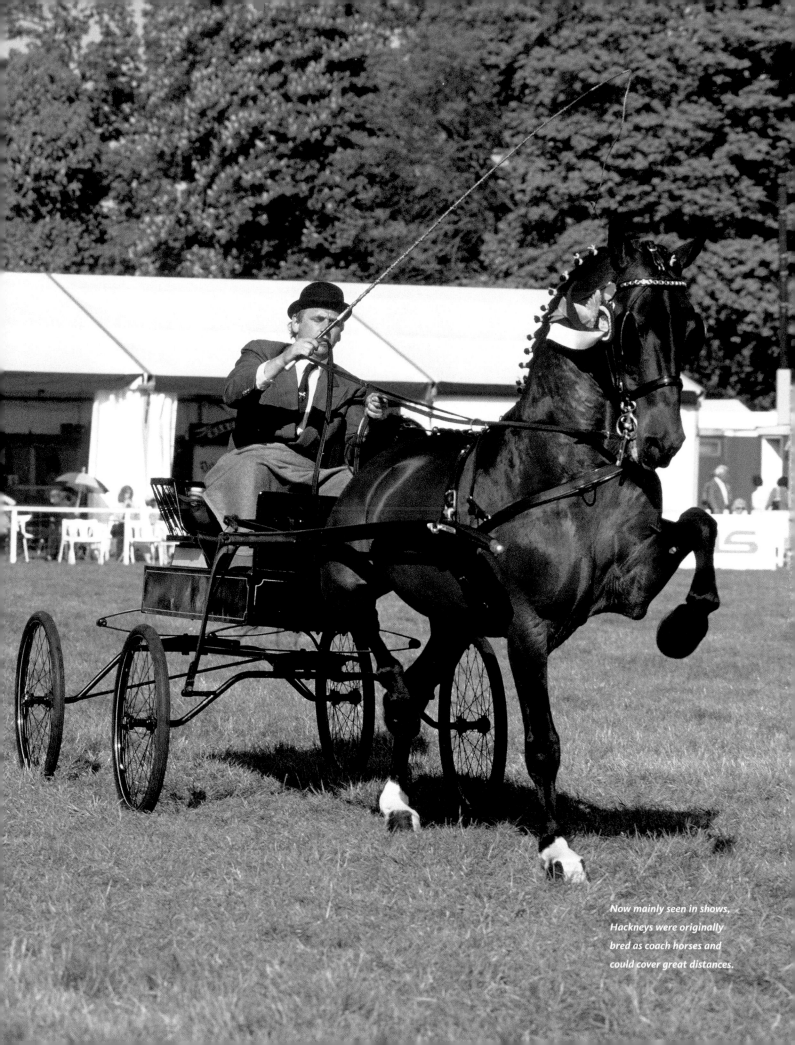

Now mainly seen in shows, Hackneys were originally bred as coach horses and could cover great distances.

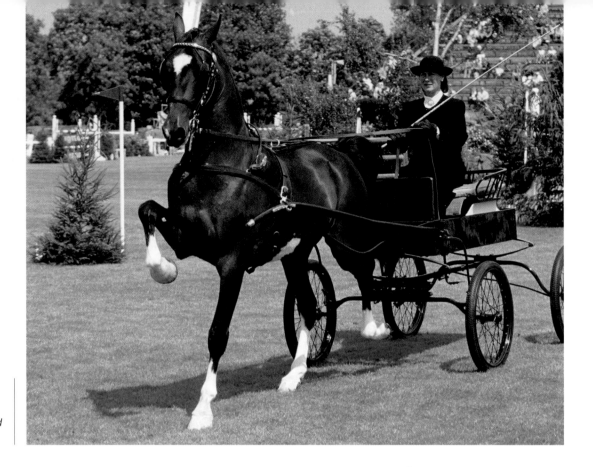

Though best known for their action in harness, Hackneys also make fine riding horses and are excellent jumpers.

stabling space and the difficulty in acquiring and storing hay. Even wealthy families rarely owned horses, choosing instead to rent them from huge horse liveries. The fanciest carriages and teams commanded top prices, and elegant Hackneys were very popular.

Unfortunately, no horse could sustain the high action and extreme head position demanded by fashion for long. As hard-used horses began to look less flashy and animated in harness, they were moved down the ranks of the liveries to lower-quality drivers, longer hours, and shoddier care. Sad old horses were so commonplace on the streets of London that the word *hackney* came to mean overworked or overused.

At the same time, however, the Hackney was playing an important role in the development of other breeds in Europe and North America. They added elegance, refinement, and lively gaits to Holsteiners, Gelderlanders, American Saddlebreds, and Morgans, among others. The first Hackney exported to America was Jary's Bellfounder, foaled in 1816. One of his daughters, known as the Charles Kent mare, was the dam of the great trotter Rysdick's Hambletonian, a

foundation sire of the Standardbred breed.

Hackneys were exported all over the world and featured at shows in England and abroad. The 1916 London Hackney Show had 626 entries. The breed thrived until railways made coach horses and roadsters obsolete. The darkest time in the breed's history was between 1939 and 1945. Because of World War II and the war effort, there were no large shows, exports were at a standstill, and commercial trade in England was extremely limited. Yet the breed continued to be a horse of choice for the very wealthy. By the end of the war, prices were reaching record highs. The National Hackney Show resumed in 1946.

Today, this long-proven breed is underrepresented in many locations including the United States. The breed is somewhat better known in Canada, but still rare. Enthusiasts hope the Hackney will be rediscovered as interest in pleasure and combined driving increases. In addition to their famed talents as driving horses, Hackneys are excellent movers and make fine saddle horses. They have also long been known to have considerable ability over fences. A Hackney named

Confidence jumped 7 feet 2 inches at the 1910 National Horse Show and later cleared 8 feet 1½ inches at Syracuse. Sir Ashton, later named Greatheart, jumped 8 feet 2 inches in Chicago and then won the national high jump in 1915. The Hackney Tosca was the gold medal winner in show jumping for the Germans at the 1936 Olympics. However, after World War II, emphasis within the breed was on driving. Hackney stallions are still crossed on other breeds to improve substance, motion, and endurance. Crosses with Hackneys also produce excellent sport horses and show jumpers.

Breed Characteristics

The breed is best known for its spectacular action. The shoulder action is very fluid and free, with high, ground-covering motion. The motion of the hind legs is similar but not quite as extreme. All joints should show extreme flexion including the hocks, which should be brought well under the body and lifted high. The action is straight and true; it should be arresting and show great brilliance.

Conformation

The Hackney Horse must stand over 14.2 hands, and weighs an average of 1,000 to 1,200 pounds. The Hackney has a small head, muzzle, and ears. The body is compact; the neck is long and blends smoothly into a broad chest with well-rounded ribs. The shoulders are powerful and sloping and the back is level. The loin is short, the thighs and quarters well muscled, and the croup level, with a high tail set.

The legs are of medium length with large, strong joints. The pasterns are of good length and slope. The Hackney has excellent feet and a reputation for soundness.

Color

The modern Hackney Horse is black, brown, bay, or chestnut, with or without white markings on the face and lower legs.

Hackney Horses are solidly built with sloping shoulders and strong legs. They have good gaits but were born to trot.

BREED ASSOCIATION FACTS AND FIGURES

The registry database does not include an actual count of all animals registered, nor does it separate Hackney Horses from Hackney Ponies.

- About 400–500 new animals are registered each year, of which 90 percent or so are Hackney Ponies.
- Hackney Ponies are most popular in the Midwest, especially in Ohio, Michigan, Indiana, and Illinois.

Haflinger

HEIGHT: 13–15 hands

PLACE OF ORIGIN: The Tyrol region of Austria and Italy

SPECIAL QUALITIES: Attractive, sturdy small horses with an excellent disposition; always some shade of chestnut or sorrel with white or flaxen mane and tail

BEST SUITED FOR: Pleasure, competitive, and hitch driving; pleasure riding, packing; farmwork; lower-level dressage; eventing and jumping; all-around family horse

The Haflinger brand.

Long ago, high in the Alps of southern Austria and northern Italy in an area known as the Tyrol, a breed of beautiful, strong, sturdy horses arose. Early settlers in the region, the Ostrogoths, who were driven there by Byzantine troops after the fall of Conza in 555 CE, crossed their Arab-type horses on native mountain ponies. The resulting horses remained isolated from other breeds for hundreds of years due to the mountains.

A stallion sent as a wedding gift to the margrave (military governor) Louis of Brandenburg in 1342 appears to have influenced the further development of the breed. Arab blood was introduced again with the half-Arab stallion El Bedavi XXII beginning in 1868. His son Folie, foaled in 1874 out of a native Tyrolean mare, became the foundation sire of the modern Haflinger. Folie was a chestnut with a white mane and tail. Inbreeding to this horse fixed the color in the breed. All modern purebred Haflingers trace their ancestry directly back to Folie through any of seven different stallion lines, denoted A, B, M, N, S, ST, and W.

In Austria, these horses are sometimes described as being "a prince in front, a peasant behind," because they have a beautiful head with a long, flowing mane combined with incredibly muscular hindquarters. They are still used as all-purpose animals for plowing, carrying packs up steep mountain trails, and skidding logs, as well as serving as riding and driving animals. One American breeder appropriately refers to them as the "tractor of the Alps."

Members of the Family

The Haflinger was an integral part of traditional Alpine farm life. Families housed their animals underneath the main living quarters, and the rising body heat from the animals helped to warm the house. Because the horses were essential and so intimately connected with the families in many ways, they were always carefully selected to have a gentle disposition and a willing nature. When the rest of the world began to use mechanized farm equipment, Tyrolean farmers stuck with their sturdy horses, which were more efficient on the small, steep mountain farms.

During World War II, Haflingers served as military packhorses, traveling to some of the coldest and most difficult fronts of the war. During the war years, breeding efforts in Austria shifted to produce a draftier type of horse to accommodate military use. After the war, the Austrian government took over Haflinger breeding, and the emphasis returned to a more refined type. The Austrian selection process is one of the strictest in Europe, and the results show in the consistent quality of the horses.

The first two herds of Haflingers exported to the United States arrived in the 1960s. One herd went to the state of Washington, the other to Illinois. The breed is now found all over the country, though they are especially popular in Indiana and Ohio, where the Amish use them for driving and farming. Haflingers make excellent

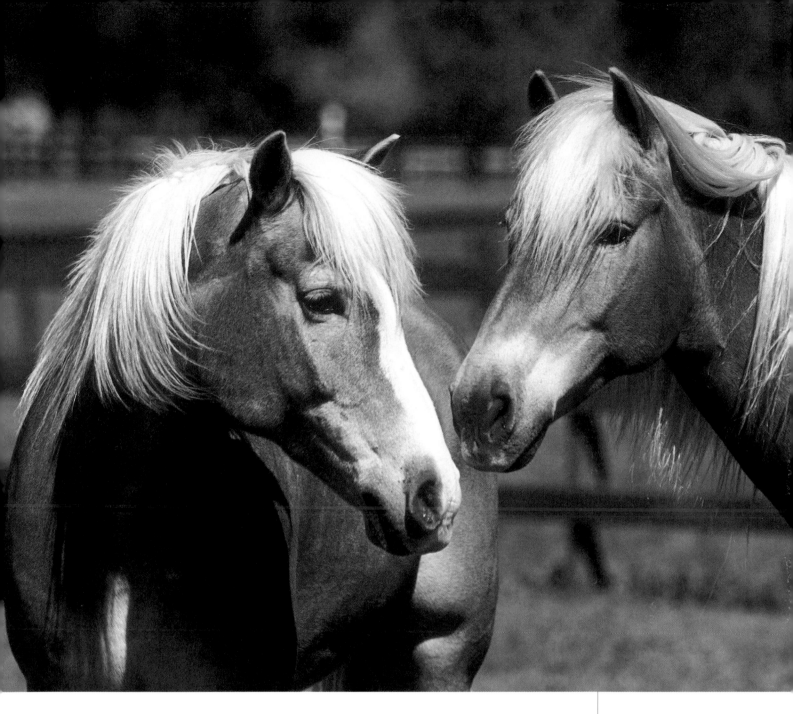

all-around family horses for many riding and driving sports.

Breed Characteristics

There are two types of Haflingers. The heavier draft type is used for farmwork and in parade hitches. The pleasure type is a little lighter, longer legged, and longer necked. They make superb driving horses, good event ponies, and fine low- to medium-level dressage horses. The Haflinger has rhythmic, ground-covering gaits showing a little knee action, particularly at the canter.

Haflingers are exceptionally long-lived. They mature slowly and in Austria are not commonly put to work until they are four years old. They often remain sound and strong for decades, even into their forties.

Conformation

Haflingers stand between 13.2 and 15 hands, but owners usually refer to the height in inches. Typical weight is 900 to 1,000 pounds. They are solid horses, yet elegant and refined. Stallions should have masculine features and mares should exhibit undeniably feminine lines. The head is

All Haflingers are some shade of chestnut or sorrel with a light mane and tail. Many have a blaze.

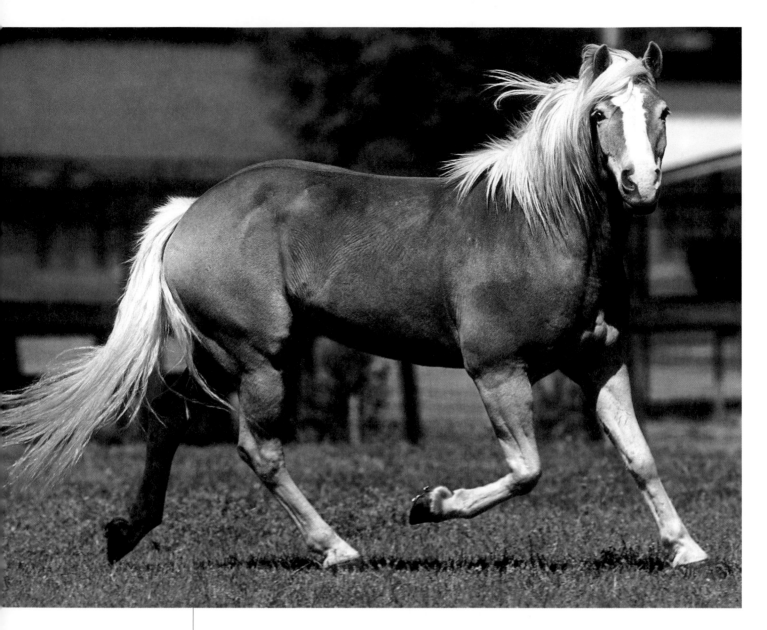

Haflingers have a broad, deep chest and a powerful hind end, making them suitable for light draft work as well as for riding and driving.

small, refined, and well proportioned, often showing Arab influence. The poll should be light and the ears correctly positioned. The eyes are large and positioned well forward. The nostrils should be large and wide. The neck is of medium length, narrower toward the head, with freedom through the jowls.

The shoulders are large, well muscled, and sloped. The chest is deep and broad. Pronounced withers reach far into the medium-length back, which is muscular with a long, well-shaped, slightly sloping croup. The legs are clean with well-formed, clearly defined joints.

Color

Haflingers are always chestnut, although the color may range from rich gold to chocolate. The mane and tail range in color from flaxen to white. White blazes on the face and white on the lower legs are common and often desired.

BREED ASSOCIATION FACTS AND FIGURES

According to the American Haflinger Registry (founded in 1997):

- About 18,000 horses are registered in North America.
- Some 2,000 foals are registered each year.
- There are strong concentrations of Haflingers in Ohio and surrounding states, but the breed is now be found almost everywhere in the United States.

Hanoverian

Strong, elegant horses of noble bearing have been selectively bred in Hannover, Germany, for more than four hundred years. By the year 1517, Germany was known either as the German Empire or, more commonly, as the Holy Roman Empire. The emperor had lost much of his authority during the great church versus state conflicts of the twelfth century. Further political challenges arose because the empire consisted of some

three hundred states. Some, like Saxony, were large; others, such as the Palatinate, were quite small; while others were mere city-states. The rulers of these states differed in rank from kings (Bohemia) to dukes (Saxony).

During these politically disunited times, many dukes maintained private stud farms, where local farmers bred their mares to produce cavalry horses. Horses were also exported to Sweden and England for military use. Though the local type was recognized for its quality quite early, crosses to Spanish and Neapolitan stallions improved the breed. The stud in Memsen, founded in 1653, bred excellent cream-colored coach

Hanoverians are strong, elegant horses of noble bearing.

horses for the nobles of the house of Hannover. These elegant carriage horses signified the height of fashion and grew quite famous throughout Europe for their color, good gaits, and ability as driving horses. They achieved even greater visibility as the horses of the British royal family in the nineteenth century.

Influence of King George I

The Hanoverian became established as a true breed rather than a general type when Ludwig George, Elector of Hannover, became King George I of England in 1714. His ascension to the throne strengthened the commercial connection between Hannover and England, and horses were freely traded between the two. In 1727, when George II ascended to the throne of England, he remained Elector of Hannover. He wanted to improve horse breeding in Hannover to benefit his subjects, and he needed to develop Hannover's military strength against the threat of France's power. A rivalry developed with his brother-in-law, Freiderich Wilhelm I of Prussia, who established a royal stud at Trakehenen in 1732. In 1735, George II established the state stud at Celle in northern Germany, which still stands, and the next year, thirteen or fourteen carefully selected black stallions from Holstein arrived.

The breeding goals at the time were determined by the needs of the army and of agriculture. To ensure that the breed would continue to improve, state-sponsored studs like the one at Celle offered the services of top stallions for low fees to local farmers who maintained small bands of broodmares. Today, German farmers still produce top-quality foals from crossing their mares with carefully selected state-owned stallions. Many mares are used exclusively as broodmares, while the majority of riding and competition horses are geldings and stallions.

Through George II's influence, the breed became closely linked with the Thoroughbred in England. Hanoverians descend from Eclipse, Herod, and Matchem, as do English Thoroughbreds. George II established races for Hanoverians and lines of Hanoverian racehorses in the mideighteenth century.

By 1748, the Hannoverian stud had established seventeen stallion stations throughout the region so that local farmers had access to the best stallions. Because of the great popularity of the breed, many privately owned stallions stood at stud as well. In 1776, the state assumed authority from the king to operate the stud. Managers improved the breed with infusions of English Thoroughbred, Cleveland Bay, Pommern

World-class athletes, this breed has won numerous Olympic medals.

(from Pomerania, which is now in Poland), Mecklenburg, and Yorkshire Coach Horses. Two types of horses evolved: a heavier type for pulling coaches and artillery and a lighter type for riding and the cavalry.

In 1844, the state implemented a system of exclusive licensing of approved stallions to reduce the number of low-quality, privately owned stallions. In 1894, the rules for stallions became stricter, with new rigid demands for conformation and pedigree before licenses were issued. The first breed society for the hugely popular breed was formed in 1867, and the studbook was established in 1888. In the last decades of the nineteenth century, state stallions covered 34,000 mares each year.

The Modern Hanoverian

As with many breeds, the Hanoverian's role has had to change with the times. At the end of the nineteenth century, breeders were producing primarily excellent cavalry and artillery horses with straight, ground-covering gaits. Because the horses were also used on farms, a secondary requirement was that every horse be able to pull a plow, making a furrow 30 centimeters deep. After World War II decimated the numbers of horses and greatly hastened the switch to mechanized farming, breeders had to shift to producing riding and competition horses, disciplines in which the Hanoverian excels.

Hanoverians are widely imported into North America, as well as being routinely bred here. (Although in Germany the breed name is spelled "Hannoverian," in North America it is customary to use only one *n*.) Before being accepted for breeding, North American stallions must undergo an inspection, testing, and approval process designed to be rigorous, similar to the system in Germany.

Breed Characteristics

Hanoverians are world-class athletes. The gaits are long, straight, and elastic, with tremendous power coming from behind.

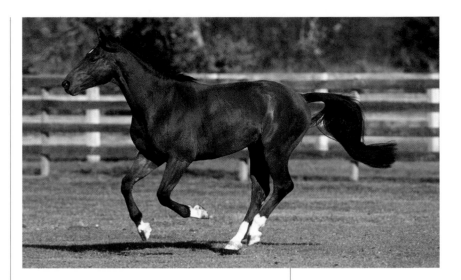

The gaits are long and straight, with power coming from behind.

Worldwide, Hanoverians are the most popular of any warmblood breed. They are consistently present at top world shows and represented on many Olympic teams, particularly in dressage and show jumping but also in combined driving. In the United States, they are also commonly found among the top ranks at hunter shows.

Conformation

Hanoverians stand 16 to 17.2 hands, with good bone and muscle in proportion to their size. They weigh between 1,200 and 1,300 pounds. The head is sometimes plain, usually with a straight profile. The long, muscular neck is well set on the sloping and powerful shoulders. The body is deep with extremely powerful hindquarters. A Hanoverian should be a strong, well-made horse with good feet.

Color

Typical coloring is chestnut, but bay, brown, and black are also found. Grays are allowed but not favored in Germany. White markings on the face and lower legs are common.

BREED ASSOCIATION FACTS AND FIGURES
According to the American Hanoverian Society (founded in 1978):
- There are 7,955 horses in the North American Registry.
- About 500 foals are registered each year.

Holsteiner

The Holsteiner brand may also have numbers below it, which are used to identify individual animals.

The first written record of Holstein Horses appears in 1285 CE, when the count of Holstein and Storman gave permission to the monastery at Uetersen to graze its fine horses on private land. After the Reformation, in the mid-sixteenth century, all the property of the monasteries was transferred to private ownership. The landlords continued the work begun at the monastery in an effort to produce top-quality horses for use on farms and in war. The first Holstein studbook shows that both noblemen and farmers owned fine horses in the sixteenth century. The Crown also exerted influence on the horse-breeding business through a variety of laws. One law passed in 1686 in Holstein required each owner of substantial acreage to keep good-quality broodmares and to use good stallions. The government offered incentives to promote the best breeding.

The soil in the area was deep, extremely heavy when wet, and almost like concrete when it dried out, so the horses had to have power and stamina. Their strength, good gaits, and majestic looks made Holstein horses desirable as warhorses as well as for farm use. They were exported to Spain, Italy, England, France, Austria, and neighboring Denmark, where they left their mark on many other breeds.

France in particular used Holsteiners in war, and many were commandeered by Napoleon's invading troops. The stable master of the king of France said in 1730 that Holstein Horses had beautiful gaits, were well built, and made fine high school and coach horses. By 1770, France was buying two thousand Holsteins every three years. In 1797, more than 10,000 horses were exported from the relatively small area of Schleswig-Holstein. To make certain that Holstein received proper credit and fair prices for its fine horses, breeders began to brand good Holsteiners with the shield-and-crown design in 1781, which is still used today.

The Holsteiner has been influential on many other breeds over the centuries. By the mid-1400s, quite a few horses from Holstein had been crossed with Andalusians in Spain, which means there might conceivably have been a trace of Holstein blood in the first horses shipped to America. George II used stallions from Holstein to help found his stud in Hannover in 1735.

The Modern Holsteiner

The nineteenth century brought several crises to Holstein's horse breeders. In the face of greatly increased demand, especially for coach horses, quality fell. Breeding had been left largely in the hands of farmers. Some could not afford top-quality mares or expensive stud fees; others made money selling the breed's reputation without regard for the quality of horses they produced. Farm crop failures and a bad flood in the 1820s forced many families to sell off their breeding stock. A series of wars from 1840 to 1871 further depleted stocks of horses and interfered with exports.

Eventually, conscientious breeders, afraid that the breed was near ruin, brought

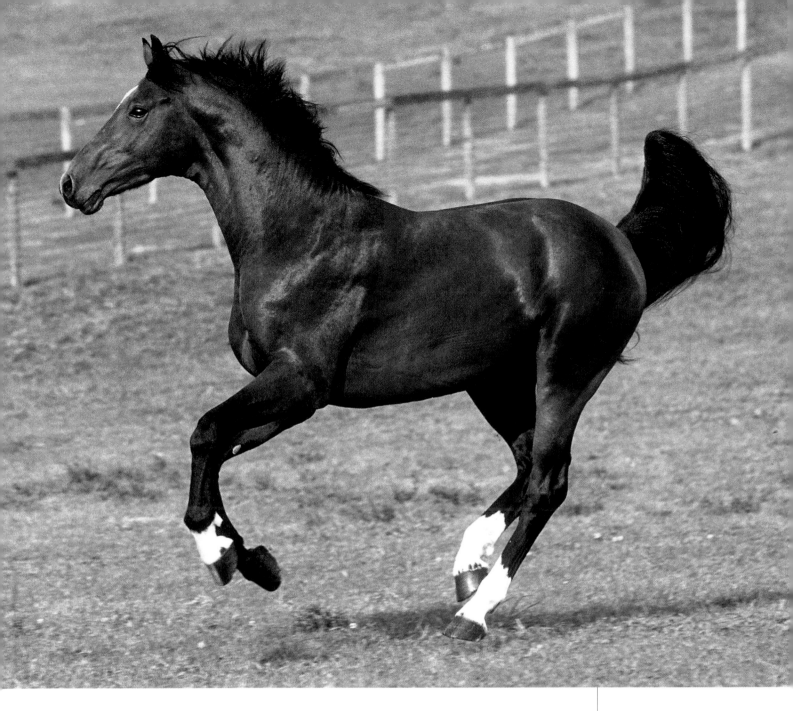

in Yorkshire Coach Horses, Cleveland Bays, and Thoroughbreds from England to improve the remaining Holstein stock. At the time, the breed's reputation abroad was still good, and geldings were fetching such high prices that good stallion prospects were all but eliminated. With disaster looming for the breed, a new association, formed in 1883, selected one hundred quality mares to use to reestablish the breed using the few remaining stallions. The goal was to produce a powerful coach horse with strong bone and high action (a trait of the Yorkshire Coach Horse) that could also be used as a heavyweight pleasure horse.

After World War I, the horse market demanded workhorses for farm use. Later the Third Reich ordered Holstein to produce heavy workhorses to pull artillery. After World War II, there was no longer a need for horses to pull caissons, and heavy coaching horses were no longer in demand. Shifting emphasis to sport horses was clearly the only future for the breed, so breeders added more Thoroughbred blood. In the aftermath of the two World Wars, the numbers of horses were greatly reduced. There were 20,000 Holstein mares in 1947, but by 1960 there

With its bold action and striking good looks, the Holsteiner has enjoyed a long history as a popular harness horse.

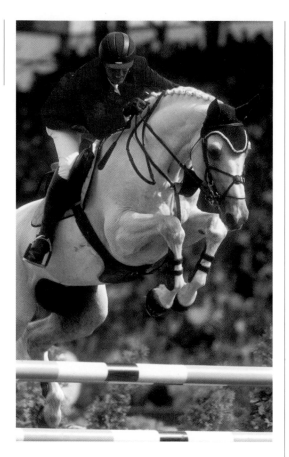

Once valued as a warhorse, the Holsteiner has become a versatile athlete that excels in jumping and dressage.

In Germany, the Verband outlines strict standards for breeding and was the first German breed association to recognize both mare and stallion lines. Stallions must be licensed and hold a current service permit before being bred. About six hundred Holstein colts are born each year. When they are two and a half years old, they are judged on conformation and movement by a panel of experts. About ten prospects are selected. In the fall of their three-year-old year, after a careful veterinary exam they begin a one hundred-day test during which they are trained, ridden, and rigidly evaluated for soundness, temperament, gaits, and ability.

The results of the tests are recorded so that breeders may choose the abilities that best suit their interest, such as jumping or dressage. Once a stallion has foals on the ground, they are carefully evaluated, and only those stallions improving the breed are allowed to continue breeding mares.

Mares are usually shown as two-year-olds to a committee, which selects the best for the premium mare show. Judges evaluate type, topline, depth, width, and the qualities of both front and hind legs. The committee also evaluates correctness of movement, including elasticity and suspension of gaits. There is a point system for mare judging. The rare horses that reach the highest level become Premium Mares, which greatly increases their value.

were only 1,300. The state disbanded its stud in 1960, and wisely the Verband (breed association) bought the state's stallions. By 1980, numbers had rebounded to three thousand one hundred mares—better, but still very few compared to the numbers of the popular Hanoverian. It is striking to note that in the 1980s, although the breed made up only about 5 percent of the horses in competition in Europe, it was winning about 35 percent of the prizes.

The first Holsteiners were exported to North America late in the nineteenth century, primarily for use as coach horses. Beginning in the late 1970s, the breed was again exported to the United States and promoted, particularly by Emil Jung, who was famous for his combined driving teams. From that point on, its popularity has continued to escalate.

Breed Characteristics

Though widely noted as carriage horses, Holsteiners also excel in dressage and show jumping and are frequently seen on the hunter circuit. Adherence to the highest standards for the selection of breeding animals has resulted in consistently superb offspring. Holsteiners are exported all over the world, and they populate many Olympic teams.

Conformation

Holsteiners are large, standing between 16 and 17.1 hands. The breed has a bold, expressive face, with a deep body and a

Holsteiners have bold, expressive faces.

short, flexible back. A smooth topline connects the long, muscular neck to the hindquarters. Holsteiners have strong joints and abundant bone, with the hind legs well set under the body, giving the horses natural balance. The cannons are short and the hocks are well let down.

Today's horses fall into two types. The "old"-style horses are massive, with tremendous bone and large, square knee and hock joints. The "modern" type is lighter and more refined, but still shows great strength, excellent movement, and a wonderful disposition.

Color

The usual colors are brown, black, and bay. White markings on the face and lower legs are allowed.

Holsteiners have deep bodies and short, flexible backs.

Hungarian Horse

HEIGHT: 15.3–17 hands

PLACE OF ORIGIN: Hungary

SPECIAL QUALITIES: Outstanding athletic ability, excellent gaits

BEST SUITED FOR: Show jumping, dressage, eventing, and combined driving

Hungary's renowned position among the finest horsemen in the world goes back for centuries. Horses formed the essence of the culture of the Magyar tribesmen, who first swept in from Asia during the ninth century, mounted on swift little dun-colored horses. In the tenth century, Duke Géza imposed central control over what had previously been a confederation of some eighty nomadic clans that united only for purposes of war. Until they were united, the clans of Hungarians lived through a combination of agriculture, animal husbandry, and Viking-like raiding campaigns conducted on horses. These people later became known as the Hussars of the Hapsburg Empire, and they are still famed as being among the best light horsemen of all time.

The original horses of the Magyars were gradually crossed on heavier, cold-blooded horses for agricultural needs and then crossed back on the best Turks (Turkmene or Akhal-teke), Arabs, Andalusians, and Lipizzans. Hungarian Horses long served as the dominant cavalry horse choice for European armies. The first government-run breeding plan known in Europe was established in 1780 in the Austro-Hungarian Empire, using a technique of farming out stallions to remount agents. In addition, three separate breeding farms, or studs, served different purposes. The farm at Mezohegyes provided horses of particular crossbred types. The stud at Bablona produced Arabians and Arabian crosses. The Kisber stud crossed Thoroughbreds on the horses that had been produced by the other two farms. All three farms bred only the very best horses that were representative of their type and were proven by use.

The Hungarian government operated the stud farms without interruption until the Russian invasion near the end of World War II, when the German army took most of the horses to southern Bavaria. General George Patton, an expert horseman, led the rescue of these Hungarian Horses, as well as a number of Austrian Lipizzans. Ultimately a group of the rescued Hungarian Horses arrived in what was then occupied Germany, where Colonel Hamilton, chief of the Remount Services for the U.S. Army, sent them to the United States to be used in the Army Remount Breeding Program. They arrived not long before the remount program was disbanded in 1949, at which time many horses were sold at auction and some stallions were sold to private owners who had been leasing them. It took quick work on the part of exiled Hungarian Countess Magrit Sigray-Bessenyey and

A LUCKY CLOVER LEAF

According to ancient Hungarian legend, very rarely a horse would be born with a slate-blue mark in the shape of a three-leaf clover on its muzzle. This was a sign that a gift of great good fortune had been bestowed on all horses of that line. According to the legend, any family owning a "Clover" horse would grow and prosper and be safe from danger, and if a Clover horse was stolen or taken by force, it would one day find its way back to the owner. At least one of the Hungarian stallions in the United States is of Clover lineage, and in Washington state in 2000 produced a Clover filly, Magyar Velvet, the first to be born in the world in fifty years.

The modern Hungarian shows great strength and excellent movement.

several Americans, who tracked down and acquired as many of the horses as they could find, to save the breed. Without their intervention, some of the best Hungarian bloodlines developed over centuries would have been gone forever.

Also during the war, an unstoppable Hungarian countess and former international jumper rider, Judith Gyurky, fled her estate in Hungary with sixty-four Hungarian Horses, seventeen carts of feed, and a cart carrying small foals, just ahead of the invading Russian army. Despite tremendous hardship and loss, she managed through sheer will to bring a small breeding group of these horses to the United States, where they later provided an outcross for the former U.S. Army Remount group.

Countess Sigray-Bessenyey also purchased some Hungarian Horses in the 1960s that had originally been imported by Tempel Smith, who was renowned for having imported Lipizzans as well as for founding the famous Tempel Farms. The bloodlines of these three groups of horses — the remount horses, Countess Gyurky's horses, and the Tempel Farms horses —

along with a few additional imports, have combined to produce the Hungarian Horse that exists in North America today.

Breed Characteristics

Hungarian Horses are known to be excellent, sometimes spectacular, movers and outstanding jumpers. Prior to World War II, riders of many countries sought them for international competition. In North America today they are used primarily for show jumping, dressage, eventing, and combined driving, often at the highest levels of all sports.

BREED ASSOCIATION FACTS AND FIGURES

According to the Hungarian Horse Association of America (established in 1966):

- There are 1,000 horses currently registered.
- About 15 new foals are registered each year.
- Part-breds are accepted for registration.

INTERNATIONAL COMPETITION

Hungarian Horses have figured prominently in a variety of sports. Both Olympic gold medalist David O'Connor and top trainer Jo Struby rode Hungarian Nicolaus in advanced three-day eventing competitions. HMS Dash, bred by Countess Gyurky and ridden by Kerry Milliken, was on the U.S. equestrian team in three-day eventing. Hilda Gurney, Olympic dressage team member, competed on her Hungarian Pasha. Linda Tellington-Jones showed Hungarian stallions at hunter/jumper shows, in three-day eventing, and in the grueling Tevis Cup endurance ride, in which M Brado, bred by Countess Gyurky, placed in the top ten. Having drawn the 127th start position out of 127, he passed more horses than any other horse in history to achieve his final position.

From a population of only about 1,000 horses in North America, Hungarians have succeeded at the highest levels of sport in eventing, dressage, and endurance.

Conformation

Usually standing 15.3 to 17 hands, Hungarians are powerful horses without being massive. The head is well shaped with good width between the eyes, and the expression is kind and alert. The throatlatch is well defined and the neck long and nicely set on long, sloping, well-muscled shoulders. The withers are prominent. The chest is deep. The strong back is moderately long, the croup somewhat rounded, and the tail is set fairly high. The legs are well muscled, the joints clean, and the cannons short with clearly defined tendons and solid hooves.

Color

Hungarian Horses can be any solid color, including palomino and buckskin.

Icelandic Horse

The first act of the first Alting, the Icelandic parliament, in the year 930 CE, was to ban all further importation of horses to Iceland. That law still stands. Vikings arrived in Iceland about 770 CE and had established several colonies by 847 CE. By the time of the first Alting, the human population was about 50,000. The first settlers brought tough, smooth-gaited little horses along with other livestock. Farmers were able to grow hay and

several kinds of grain. Dairy cattle, sheep, and horses prospered. The horses did so well that by 930, concern about horse over-population resulted in the law banning additional importation.

The first Viking horses from western Norway and the British Isles trace their ancestry back to the ancient Celtic ponies, which were known to be smooth-gaited. Because there has been absolutely no admixture of other breeds for more than 1,000 years, the present-day Icelandic horse is virtually the same horse that arrived with the Vikings. From 874 to 1300, strict rules governed horse breeding, and individuals were selected for color, conformation, and friendliness.

HEIGHT: 12.2–14.3 hands

PLACE OF ORIGIN: Iceland, with genetic contributions from the horses of the ancient Celts

SPECIAL QUALITIES: A small gaited breed with the strength and stamina to carry adults; known for its very fast and extremely smooth gait, the *tolt*

BEST SUITED FOR: Trail, trekking, and endurance

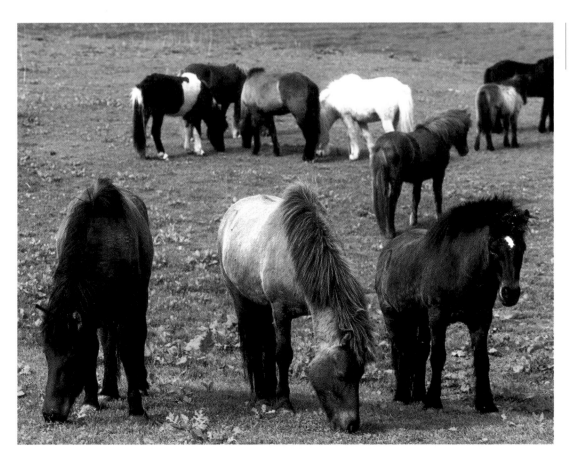

The horses in Iceland today are nearly unchanged from the horses the Vikings rode.

Between about 1300 and 1900, a period now known as the Little Ice Age, scant attention was paid to selective horse breeding, because all human efforts focused on survival. Climatic conditions became exceptionally harsh across all of northern Europe, particularly in Iceland. It was so cold that the North Atlantic froze, stopping shipments of food and goods, and even cold-water codfish, a major food source, moved south to warmer waters. No hay could be grown, and barley, with its short growing season, was the only harvestable grain. In addition, between 1782 and 1784, nearly 70 percent of the remaining horses died of starvation or poisoning from volcanic ash. Somehow, a few of the tough little horses survived.

At the beginning of the twentieth century, as the climate eased a bit, horse breeding in Iceland resumed its importance. In 1920, organized breeding efforts began. The first exports of riding horses were initiated in 1950, and since 1959 breeders have sought to upgrade the quality and appearance of the breed without losing any of the original characteristics. In 1969, an international association of friends of the Icelandic Horse (FEIF) was formed by several Icelandic societies in Europe. The FEIF now has nineteen member countries, made up of Austria, Belgium, Canada, Denmark, Faeroe Islands, Finland, France, Germany, Great Britain, Iceland, Ireland, Italy, Luxembourg, the Netherlands, Norway, Slovenia, Sweden, Switzerland, and the United States.

The breed has become extremely popular in continental Europe, which has between 80,000 and 100,000 Icelandics. Germany alone has close to 50,000. Iceland itself has about 100,000 of the horses—impressive in a country with a human population of 270,000, half of whom live in a single city.

Breed Characteristics

The Icelandic breed is five-gaited, though not all individuals perform all five. In addition to the usual four-beat walk and the two-beat trot, which is used most during the training of young horses, there is a correct three-beat canter and a natural **tolt,** which is a smooth, fast, four-beat amble. The tolt is a gait without suspension. In it the horse always has one or two feet on the ground and can reach speeds as fast as a fully extended trot or a canter. Many Icelandics also exhibit a **flying pace,** a very fast two-beat gait in which the legs on the same side move in unison. In Iceland there are under-saddle races run at this flying pace, which can be as fast as a gallop.

Because Icelandic Horses mature slowly, training is not started until the horses are four, and even then there is only light riding. Without exception, all breeders and riders in Iceland believe that horses should not be trained at an earlier age. At five, real training and work begin for most horses. Icelandics usually live twenty-five or thirty years, and it is not unusual for them to be ridden well into their twenties.

The tolt is an extremely smooth, fast gait performed naturally by Icelandic Horses. Some can also do a flying pace, which is even faster.

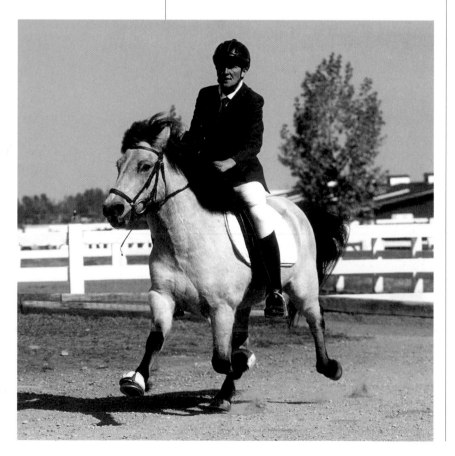

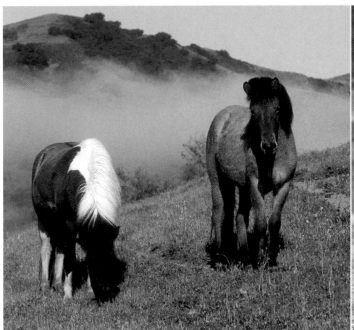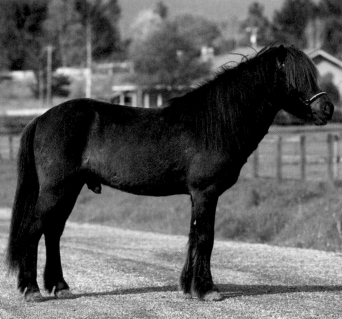

Island isolation has fostered some unique character traits. Because there are no natural equine predators, Icelandics are calm and not inclined to spook. They are exceptionally friendly toward people, making them ideal companions. They have virtually no immunity to most horse diseases, however, because no horses are ever imported and horses that leave Iceland are never allowed to return.

In the United States, the breed continues to gain popularity. Icelandics make excellent mounts for children and riders with a painful neck or back. They are superb trail, trekking, and endurance horses and are sometimes used for lower-level dressage and jumping.

Conformation

Although these horses are small, usually between 12.3 and 14 hands, owners traditionally refer to them as horses rather than ponies because of their energy, attitude, and impressive strength. These horses routinely carry adults over long distances.

An Icelandic Horse should be rectangular and well proportioned. The head is clean-cut and expressive, with a straight profile. The neck is long, supple, and well set. The shoulders are long and sloping with good muscling. The back is flexible, leading to a wide, muscular croup. The legs are strong with well-defined joints and hard, strong hooves.

Color

Icelandics come in all colors and color patterns known to horses as well as some that are rarely seen in other horse breeds. One Web site mentions forty-two distinct colors or color patterns, all of them with Icelandic names that are difficult to translate into English. In winter the horses have extremely dense, heavy coats. In summer they are sleek but always have an abundant mane and tail.

Forty-two colors and patterns are recognized in the breed. Various shades of dun are common.

BREED ASSOCIATION FACTS AND FIGURES

According to the United States Icelandic Congress (established in 1987):

- The association is the North American representative to the International Federation of Icelandic Horse Associations.
- The U.S. registry was started in 1988.
- There are about 2,000 horses in the North American registry.
- About 50 new foals are registered each year.
- The Icelandic Horse is the only breed that has a single breed standard, one set of competition rules, and one set of registry rules in all countries in which it is resident.

Irish Draught

HEIGHT: 15.2–17 hands

PLACE OF ORIGIN: Ireland

SPECIAL QUALITIES:
Consistency of type, excellent gaits, gentle disposition, jumping talent

BEST SUITED FOR: Jumping, hunting, driving, dressage, and eventing

By today's North American standards and current usage, the Irish Draught (pronounced draft) Horse isn't technically a draft horse. It originally developed as a type rather than as a true breed and was the common and utilitarian horse of the countryside: an all-purpose farm, riding, driving, and hunt horse. It was lighter in bone and moved more freely than the heavier English draft breeds we recognize today, such as the Shire

and the Clydesdale. The Irish Draught has its roots in the Connemara Pony, which descended from ponies brought to Ireland by the ancient Celts around 500 BCE. The early ancestors of the Irish Draught stood between 12 and 14.2 hands, and the type didn't begin to grow larger until the Normans arrived with their bigger, heavier warhorses in 1172.

During the Middle Ages, the Irish rode smooth-gaited little Irish Hobbies, which also traced their ancestry back to the ancient smooth-gaited Celtic Ponies. Irish Hobbies were exported all over the world. There were several periods when laws were passed that banned their exportation because they were in danger of becoming too rare in Ireland. When decent roads were developed in Ireland, people began to ride in carriages and coaches rather than on horseback, and the demand for the comfortable Hobbies declined in favor of good trotting breeds. By the time the Hobbies finally did vanish, larger Norman horses had long been present in Ireland, and trade had opened with Spain, bringing in Andalusians and Spanish Barbs. Later, Thoroughbreds arrived from England. All these imports provided a variety of larger horses to cross with the little Irish horses.

The first written record of the Irish Draught dates from the late 1700s. In addition to carriage horses, Irish farmers needed larger, stronger horses to use as packhorses and for plowing, riding, and hunting. Big draft horses were brought over from England, but the heavy feathering on their legs proved a liability. The feathers did protect the horses' legs from wetness, but stickers and burrs, absent in England but common in Ireland, clung to the feathers, creating more problems than the feathers solved. The burr problem was serious enough that the English breeds were almost useless on Irish farms. Furthermore, the Irish wanted horses that could be driven smartly to town and also be taken hunting when the occasion arose. The heavy horses were just too big and slow.

A True Irish Breed

Ultimately, the horse-wise Irish farmers developed their own horse. Without the aid of a breed association or government help, they began by selecting from the heavier types available. Somehow breeders managed to incorporate an excellent trot and good movement for driving, as well as exceptional jumping ability, a characteristic also common in the Connemara. It was actually English horse dealers and purchasing agents for the English army who began calling these functional farm horses *draughters,* even though that term in England

meant a much heavier horse. Some say the name came from the fact that horses were commonly drafted for military use.

The Irish Draught was recognized as an official breed in Ireland in 1901, and a studbook was started. The Irish Department of Agriculture approved thirteen stallions in 1904 and 264 mares in 1911, but because the stallions were often too far from the mares, this first organized breeding plan failed.

World War I was something of a boom period for Irish Draught breeders. Because the horses were strong and clean-legged, had a good trot, did well on meager rations,

and were placid, they were ideal for military use. Breed numbers continued to rise from World War I through the 1940s and '50s.

Mechanization and tractors ultimately caused a decline in numbers, but as demand for farm horses dropped, the Irish Draught was discovered to have another significant talent that brought it great fame. When crossed on Thoroughbreds, they produced terrific jumpers. The product of this cross is the world renowned Irish Hunter, which has been exported to every country in which people like to ride and jump or fox-hunt.

The purebred Irish Draught consistently passes on its solid conformation, good disposition, and exceptional jumping talent.

Because Irish Draught crosses, especially with Thoroughbreds, are so popular, purebred Irish Draughts are hard to find.

Ireland has become a major exporter of superb competition horses. Irish Draught–Thoroughbred crosses have appeared on various Olympic teams and in many world-class shows. There have been so many exports of the part-breds, there is concern that the purebred Irish Draught could disappear. Although full-bred horses are rare, because they are used primarily to produce half-bred foals rather than to produce more purebreds, breeders and the breed association in Ireland are working hard to make sure the quality remains high and that the breed continues in its purebred form.

Breed Characteristics

The Irish Draught is a proud, powerful horse of substance and quality, known for its gentle nature and strong constitution. It is also noted for consistently breeding to type.

Conformation

The Irish Draught is tall, usually standing between 15.2 and 17 hands and weighing 1,150 to 1,600 pounds. The well-shaped head has a flat profile, wide forehead, and long ears. The neck is of average length, set high and proudly carried. The withers are well defined, and the heart girth is deep. Irish Draughts have a strong back and loins, with powerful hindquarters and a long, gently sloping croup. The forearms are long and powerfully muscled, with short cannons. The legs are clean and hard, with a bit of silky hair at the back of the fetlocks. The pasterns are strong and sloped, and the hooves are hard and round.

Color

Although any solid color is allowed, gray and chestnut are common and dun is seen very rarely. White markings on the face and lower legs are allowed. Excessive white, pinto coloring, and obvious "Clyde" markings, meaning very wide blazes or bald faces and white legs above the knees and hocks, are not permitted.

BREED ASSOCIATION FACTS AND FIGURES

According to the Irish Draught Horse Society of North America (established in 1993):

- The registry lists about 30 purebred stallions and 170 purebred mares.
- About 250 part-breds are registered.
- One hundred new foals are registered each year, both purebreds and part-breds.
- A foal registered with the IDHSNA is not automatically registered with the society in Ireland, but many owners have independently acquired Irish registration for their horses.
- In North America, numbers are increasing slightly. In Ireland numbers are decreasing, as the best horses are often exported.
- The IDHSNA has members in Canada, Germany, Australia, and Ireland.

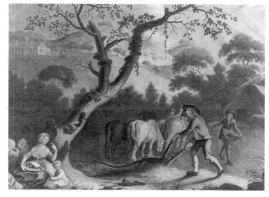

This 1783 engraving by William Hincks depicts Irish farmers plowing with light draft horses.

Kentucky Mountain Saddle Horse

The Kentucky Mountain Saddle Horse and the Mountain Pleasure Horse were developed by farmers living in the isolated, rough, beautiful hills of eastern Kentucky who kept few written records. The horses have been around for some 160 to 200 years and probably trace back to the Narragansett Pacer and to some of the smooth-gaited horses that came up from Florida to the western Carolinas in the very early days of

settlement. They clearly share some ancestry with Tennessee Walkers and other gaited breeds, but no one knows exactly what went into the mix or when. In the early years, most breeding took place among unnamed types and individuals that were selected for their ability to work.

The Kentucky breeds arose to meet the needs of farmers working small, rough areas of land who needed smallish but powerful horses. The farmers also wanted comfortable and sure-footed riding horses. The gait had to be comfortable for the horse as well as for the rider, and the horses had to be naturally sure-footed because of the long distances to be traveled, over

HEIGHT: 11–15.2 hands

PLACE OF ORIGIN: Eastern Kentucky

SPECIAL QUALITIES: Small to medium, attractive, gaited horses known for sure-footedness, stamina, and their ability to carry riders safely and comfortably over extremely rough ground

BEST SUITED FOR: Trail riding, all-purpose family horses, small-scale farming

Although known for their smooth mid-speed gait, these horses are willing and able to canter.

mountainous, rocky ground. Because an entire family might share one or two horses, and everybody, including very young children, rode, the horses had to be gentle and tractable. Times were often tough, so horses had to be easy keepers and self-sufficient. Although the people who developed these horses did not have fancy stud farms or keep reliable written records of pedigrees, they knew what they wanted, and they figured out how to achieve it.

There are several Mountain Horse registries, and their rules and philosophy differ somewhat. For this reason, a number of the horses are double registered, and some are triple registered.

One difference among registry requirements is height. The founder of the Kentucky Mountain Saddle Horse Association (KMSHA) felt that some of the best gaited horses were short, so the lower size limit for the KMSHA is 11 hands (44 inches) instead of 14.2 (58 inches), as in the other Mountain Horse associations and registries.

KMSHA horses may be any solid color, and they may have white on the face, legs, mane, and tail, including white above the knees and hocks, but white on the body is limited to thirty-six square inches behind the breastbone and under the ends of the rib cage.

There is a separate association for Spotted Mountain Horses.

The Mountain Pleasure Horse Association requires that horses be no smaller than 14.2 hands, and white above the knees and hocks is not permitted.

BREED ASSOCIATION FACTS AND FIGURES
According to the Kentucky Mountain Saddle Horse Association (founded in 1989):
- More than 11,000 horses are registered.
- Some 600 foals are registered each year.
- Horses are found primarily in areas where there are many trail riders, especially Kentucky, Tennessee, Ohio, Pennsylvania, and Missouri.

According to the Mountain Pleasure Horse Association (founded in 1989):
- About 3500 horses are registered.
- Each year about 170 new foals are registered.
- The breed is most popular in Kentucky but also in Pennsylvania and other states east of the Mississippi. There are several horses in the West, some in Canada, and some in Germany.

Many of the farmers were skilled at animal husbandry and breeding on a small scale. They kept pedigrees in their heads and took their mares to stallions that were known to produce the desired traits, even if the stallions were far away. This careful selection of breeding stock produced a consistent type that has remained strong and durable over the centuries: a small, sturdy, gentle, smooth-gaited, easy-keeping horse.

Breed Characteristics
These horses make excellent family horses and are among the best trail mounts that can be found today for the very same reasons they were prized in Kentucky two hundred years ago. Mountain Horses have three gaits: a trail walk, a single foot or amble, and a canter. They have been tested and proved for generations by hard work in rough country. They always earn acclaim as exceptionally comfortable pleasure mounts with a gentle disposition.

Conformation
In general, Kentucky Mountain Saddle Horses and Mountain Pleasure Horses are small- to medium-sized animals with medium bone and feet appropriate to the size of the horse. They have bold eyes and well-shaped ears. The profile is flat, neither dished nor Roman. The balanced neck is of medium length, breaking at the poll and arching gracefully, giving the horses a naturally proud bearing. The shoulders are well sloped. They have a wide, deep chest and clean legs with good joints. The mane and tail are ample.

Color
The horses may be of any solid color, including bay, black, chestnut/sorrel, roan, gray, cremello, buckskin, palomino, and chocolate. White on the face or lower legs is permitted. White above the knees or the hocks and white body spots are permitted by the KMSHA but not allowed by the MPHA (see box at left).

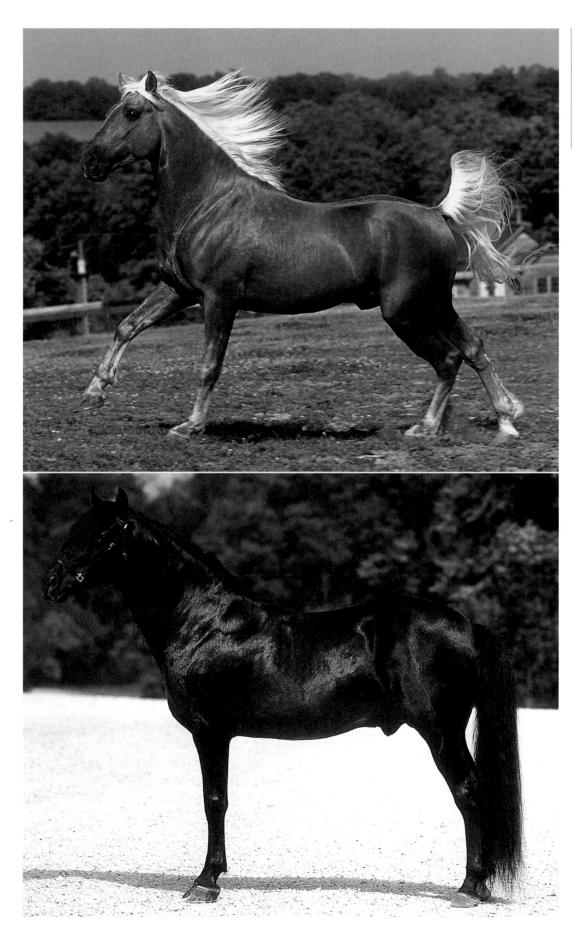

Good all-around and family horses, Kentucky Mountain Saddle Horses have a naturally proud bearing with sloping shoulders and a wide, deep chest. They come in many attractive colors.

Kiger Mustang

HEIGHT: 14–15 hands

PLACE OF ORIGIN:
Discovered in the Kiger
Mountains of eastern
Oregon, but genetic heritage
goes back to the early Span-
ish horses and the ancient
Sorraia of Iberia

SPECIAL QUALITIES: Always
dun, grulla, or buckskin with
dorsal stripes, exhibit "Span-
ish conformation," and may
be gaited

BEST SUITED FOR: Working
cattle; endurance, trail, and
pleasure riding

The history of the Kiger Mustang involves a long string of remark-
able events that cross continents, cultures, and ages. To begin
somewhere in the middle of the story, when Columbus made his
second voyage to the New World in 1493, he intended to bring along some
fine Andalusian horses. The night before they sailed, however, some of his men
sold the fancy horses, bought cheap local horses of the Sorraia type, and

spent the difference on a huge drinking
binge. Furious, but on a schedule dictated
by the tides, Columbus ended up bringing
the tough, plain, dun-colored Sorraia types
to the Americas.

Sorraias are indigenous to Spain and
Portugal. Despite having been profoundly
important in the development of the
Andalusian and Lusitano breeds, these
horses were not highly regarded in either
Spain or Portugal at the time, but they were
widely used for everyday work as pack-
horses and riding animals. Those first indi-
viduals that arrived in 1493 were tired,
worn-out horses in fairly poor condition.
On later voyages to the New World, many
more Sorraia types were sent, because they
were cheap and available. Spain didn't want
to risk sending its best horses, which it
needed for military purposes in Europe and
for stock replenishment of top-quality
horses at home. Because it was present, the
Sorraia played an important part in the
first large-scale horse-breeding experiments
in the New World, which were highly suc-
cessful. Its genes were widely incorporated,
first in the Caribbean, then later in Mexico,
Florida, and the American West.

Francisco Vásquez de Coronado arrived
in the New World in 1540. In his quest for
Cíbola, the city of gold, he traveled north
and was one of the first Europeans to be

seen by the Indians in North America.
Before long, the Indians learned to ride,
and as the era of Spanish missions began,
horses were sometimes given to Indians
who worked for the missions. By the late
1600s, however, the Indians deeply detested
the Spanish, and they stole horses in
increasingly large numbers. The Indians
and others often kept horses in semi-feral
herds from which some escaped. Huge
herds of ownerless horses, known as Mus-
tangs (Spanish for *mongrel*), developed on
the western plains over the next 150 to two
hundred years.

Horses of the Wild West

The Shoshone had long traveled a network
of trails extending from what is now Ore-
gon all the way to the Aztec capital in cen-
tral Mexico. These well-trotted trails were
highways of commerce among distant
tribes. Once horses were acquired, some-
where in the second half of the sixteenth
century, Shoshone culture changed quickly
from a pedestrian society to one of skilled
horsemen. With the added strength and
speed of horses, they traded over larger dis-
tances and hunted larger game, which
enabled them to feed larger family groups.

They also gained a huge military advan-
tage over unmounted tribes. Horses
became the primary trade item and the

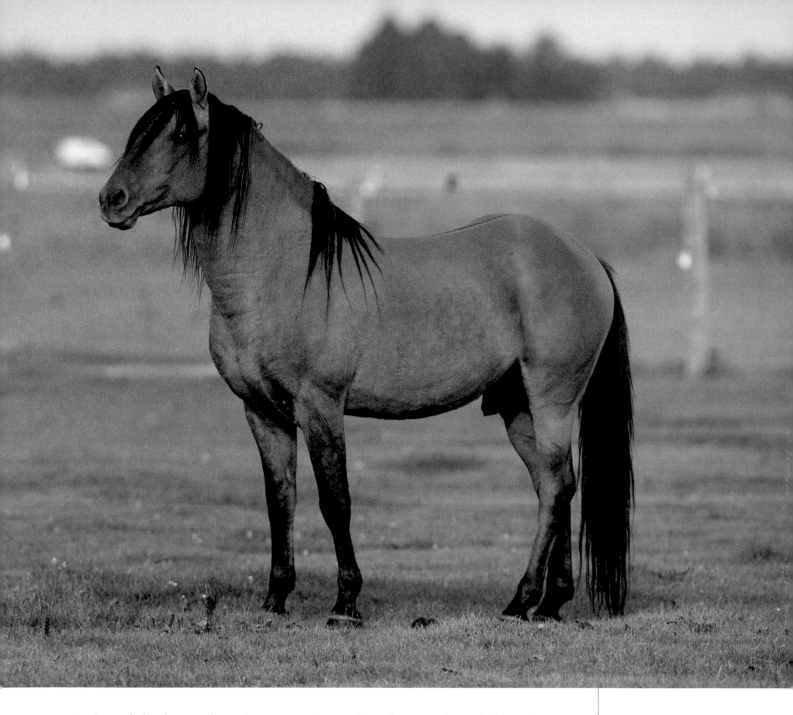

centerpiece of Shoshone culture. Horse raids into Mexico became so important and so successful that a group split off from the main Shoshone nation to form a permanent supply source for the northern tribes. These people were known among themselves as Kansas, but the increasing numbers of Europeans called them Comanches.

The horses that lived wild on the plains or with Indians flourished on nothing but the native grasses. They were quick and resilient, usually no more than about 14 hands high, and initially, of course, they were of strictly Spanish descent. But as the

continent began to be settled by other Europeans, other types of horses arrived, particularly draft types to pull wagons and to work on farms. Inevitably, some of these horses escaped or were stolen, and they also joined the wild and Indian herds.

The U.S. cavalry wanted military horses that were bigger than the readily available Mustangs. They brought in some Thoroughbreds and Morgans to develop larger remounts and officer's horses, and they began a systematic program of shooting Mustang stallions and releasing draft breed stallions to mix with the wild herds. Draft

Kigers are closely related to the early Spanish horses. They often display the typical Barb head and body proportions of the Spanish Colonial Horses. They are always some shade of dun, buckskin, or grulla, with dorsal stripes.

horses were also deliberately allowed to run with Indian herds whenever possible in an effort to slow down the Indians. Large numbers of horses of French descent from

THE SORRAIA HORSE

For thousands of years an indigenous horse roamed the Iberian Peninsula. These horses bore a striking resemblance, in color and type, to the drawings found on cave walls in La Pileta, Spain, that go back some 25,000 years. They stood about 14 hands and were always some variation of dun, mostly a gray dun, with dorsal stripes. The muzzle was dark, the legs sometimes had faint zebra striping, and some individuals had cobweb markings on the forehead. Foals were born with zebra striping on the legs, neck, and rump, which usually faded as the horse matured. Their heads were plain with either a flat or with a slightly convex profile all the way from the forehead to the muzzle. In horsemen's terminology, these horses were somewhat Roman headed, not just Roman nosed. From the front, the heads were narrow with a long distance from the eye to the muzzle.

Sorraias had a tendency toward lateral gaits. These native horses contributed genetically to Andalusians and Lusitanos, and are given credit for the conformation that allows these great breeds to flex at the poll and to collect from behind. They also contributed a seemingly natural ability to work cattle.

Herds of Sorraia horses roamed the wilds of Portugal from at least the time of the cavemen until the 1920s when Dr. Ruy d'Andrade gathered some of the very last remaining horses and brought them to live in a semi-wild state on his ranch. He called them Sorraia, which was the name of the river near where they were found, or Marismeno, which meant horses of the swamps, because of the type of remote, nearly inaccessible land where he found them and where they had survived for thousands of years. About two hundred semi-wild Sorraia continue to exist in Portugal but they hover on the brink of extinction. According to Dr. Hardy Oelke in *The Sorraia Horse:* "A population that numbers around 200 head is extremely threatened by any biologist's standard. At least half of these are non-breeding animals — older horses, stallions that aren't being used as studs, or youngsters. But that is only half of the story. The population in Portugal is divided basically among a few owners: four d'Andrade family members (grandchildren of the late Ruy d'Andrade), each with a band of Sorraias; the Portuguese National Stud; and a few private breeders with just one or two mares. All these horses stem from d'Andrade's herd."

At the time Oelke was writing, neither the breeders nor the National Stud had plans for preservation of the breed.

Canada also intermingled with both wild and Indian herds in the West. All of these efforts greatly diluted the influence of the Spanish horses in the herds of Mustangs.

When ranchers moved in, they believed Mustangs were competing with their cattle for food and systematically killed as many as possible. During the second half of the 1700s, there were reported herds of "many millions" of Mustangs on the Great Plains. At the end of the 1800s, there were an estimated two million wild Mustangs, but within thirty or forty years the numbers had been reduced to 150,000. By 1971, the estimate was 30,000, and it was virtually taken for granted that the original Spanish Mustangs were extinct.

The Kiger Horse Is Discovered

In 1971, through the Wild Free-Roaming Horse and Burro Act, the Bureau of Land Management (BLM) took over management of wild Mustang herds, attempting to balance the numbers of wild horses with available grazing. Among other activities, they rounded up horses and put them up for adoption. In 1977, an unusual group of twenty-seven horses came in from the Kiger Mountains in remote southeastern Oregon.

All were some shade of dun, ranging from **grulla** (a mouse gray) to reddish claybank dun to very pale buckskin. They had dorsal stripes, and some had zebra striping on the legs or cobweb markings on the forehead. Typical of most Mustangs, they were not large horses, usually between 700 and 800 pounds, but they had the classic Barb head, with a flat or very slightly convex profile from forehead to muzzle and considerable length of muzzle from eye to nostril, as well as many other Spanish traits.

The horse experts at the BLM recognized that these horses were something special. Blood samples tested by the University of Kentucky showed that this little population of horses was a genetically distinct group.

They were clearly of Spanish descent and closely linked with the early Andalusians and Sorraias, with almost no admixture of anything else. Because of the remoteness of the region in which they were discovered, apparently no other horses found their way in to dilute the Spanish blood. Considering the degree of dilution found in most Mustang herds and the huge systematic removal of horses that took place at times throughout the West, historians find the discovery of the Kigers all the more remarkable.

To prevent the possible loss of the newly discovered horses to some natural disaster, the BLM separated the original herd of twenty-seven into two groups. Twenty were released back to the Kiger herd management area and the other seven were sent to the Riddle Mountain area, both in southeastern Oregon. The BLM continues to manage these herds and it sells some of the horses at auction from time to time. A few private breeders have acquired horses from the BLM to begin their own Kiger breeding programs. Kigers are now well known, especially in the West. Their fame spread and their prices soared when a Kiger stallion became the model for the horse in the Disney cartoon adventure *Spirit: Stallion of the Cimarron.*

Breed Characteristics

Kigers are quick and agile and seem to be naturals at working cattle, a strong characteristic of Spanish-type horses. They also make good choices for endurance, trail, and pleasure riding.

Interestingly, one of the first private owners of Kigers has noted that, over the years, several of his horses have shown a clear indication of lateral gaits. At first he thought they were lame, but soon realized they were perfectly sound and that their tendency to amble occurred most often when the horses were running free and playing. He feels that trainers familiar with gaited horses would have no trouble bringing out smooth lateral gaits in these animals, although he adds that not all Kigers exhibit this tendency.

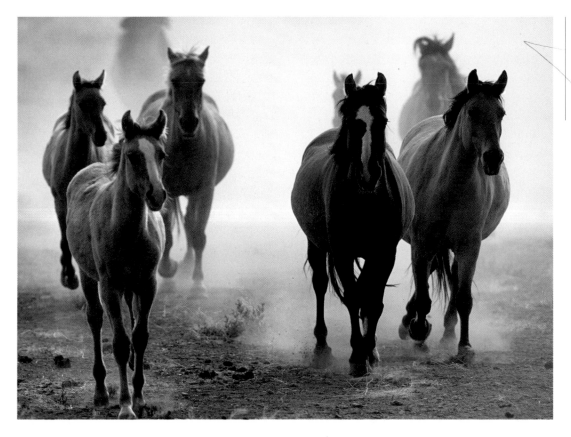

When a group of horses that looked like these was rounded up from the remote Kiger Mountains, they were immediately recognized as something special.

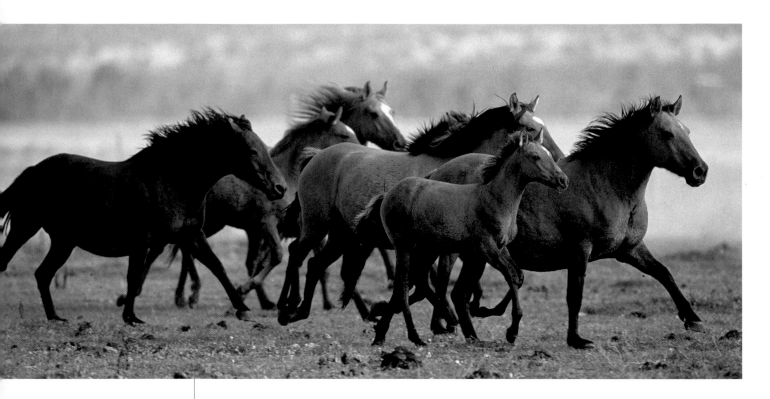

Conformation

The Kiger Mustang exhibits typical Spanish-type conformation. The head is small, with a slightly convex or flat profile. The eye is placed high and is usually almond-shaped. The small ears curve inward. The arched, well-muscled neck connects to a clean throatlatch. The withers are pronounced and long. The back is short, the croup gently sloped with a low-set tail. The narrow but deep chest connects to muscular shoulders. The hindquarters are rounded and smoothly muscled. The long and comparatively fine legs have plenty of good bone and broad, strong joints. The extremely tough feet are always black and well shaped.

BREED ASSOCIATION FACTS AND FIGURES

There are several Kiger Mustang organizations. The Bureau of Land Management also maintains some records.

According to the primary Kiger Mustang Association (founded in 1987):

- It has registered about 300 horses.
- Between 75 and 100 foals are inspected for registration each year.
- Foals must be a year old before being registered.

Color

All Kigers are some shade of dun or buckskin, ranging from grulla to reddish clay-bank dun all the way to very pale buckskin. All have dorsal stripes. Zebra striping is sometimes present on the legs, as are cobweb markings on the forehead.

Many Kigers have cobweb marks on the forehead and zebra stripes on the legs.

Lipizzan

s far back as the period of the Romans, horsemen from around the world sought Iberian horses. This was particularly true after the region then known as Hispania sent Caesar some famous "snow white steeds." The Spanish continued breeding superior horses after the time of the Romans, although the quality of the horses waxed and waned, depending on which invading force was ruling the Iberian Peninsula at any given

time. Under the Vandals and the Goths, horse breeding suffered, but during the 700-year occupation by the Moors, it flourished. The Moors brought with them considerable knowledge and excellent horses, mostly Barbs, possibly a few Arabs. The crosses between these breeds and the Spanish horses proved to be excellent.

The Moors were driven out of Spain in the late fifteenth century. At the time, Spain was recognized everywhere as having the finest horses in the world, a reputation it intended to keep by developing even better-organized horse-breeding efforts. Many European countries were clamoring for Spanish bloodlines to cross into their own

HEIGHT: 15–15.3 hands

PLACE OF ORIGIN:
Developed in Lipizza, which was then in Austria but is now in Slovenia, from Spanish bloodlines

SPECIAL QUALITIES:
Uniformity of conformation, size, and color; faces of great character; remarkable talent for dressage

BEST SUITED FOR: Dressage, pleasure riding, and driving

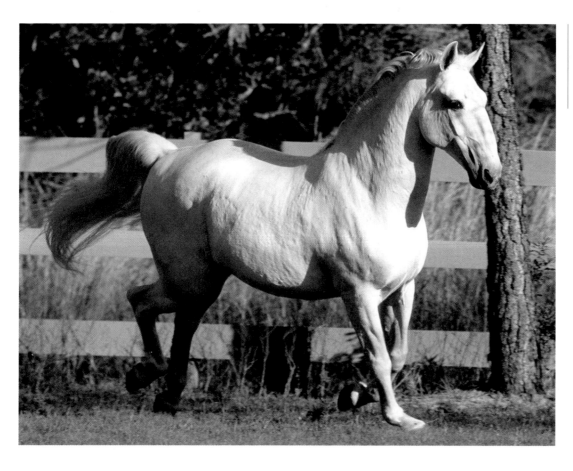

Lipizzans are best known for their skill at dressage, but in North America they are now sometimes seen in jumping classes and at lower-level events.

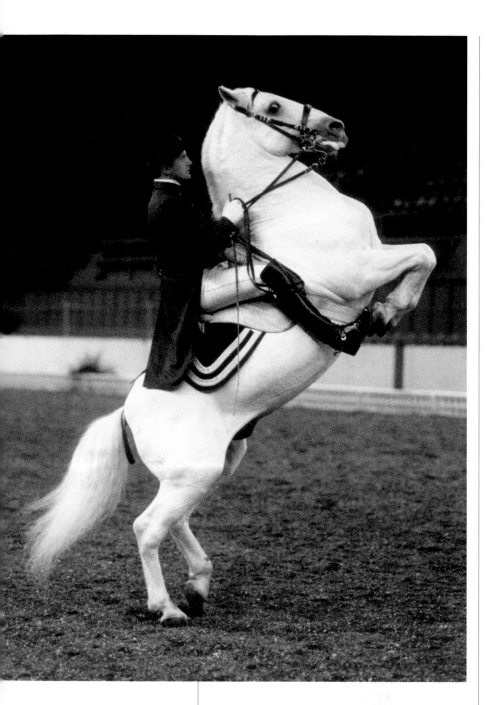

It takes tremendous strength in the hindquarters and back for a horse to perform the classical movement called the levade *correctly. The uniform and presentation are from the centuries-old Spanish Riding School.*

known by the Romans, who even built a temple to them at the source of the Timavus River. These horses matured late, reaching their prime around the age of seven. They were relatively small but were able to sustain hard work even to the age of thirty, which was quite a remarkable achievement in those days. They were also known to have excellent feet and high knee action.

In 1562, Maximilian II, a son of Austrian Emperor Ferdinand I, introduced Spanish horses to Austria, founding the court stud at Kladrub. His brother Archduke Charles established a similar stud in 1580 at Lipizza (Lipica) in the Karst region. Archduke Charles picked the site by consulting with the best horsemen of the time. It was an area of limestone-enriched soil recognized since the time of the Romans for the production of superior horses. Charles then bought the entire town and all the surrounding land, which happened to include an established stud of Karst horses that he made use of in his breeding program. The resulting horses were known as Karst horses or Karst horses of Lipizza for some two centuries.

Because Spanish horses were regarded as the best in the world, when Archduke Charles purchased horses for his new breeding operation, he selected only horses with the best Spanish bloodlines, although not all of the individual horses came directly from Spain. From the chosen bloodlines he selected individual horses that were beautiful and elegant, and had great courage and stamina. Because the studbooks for the breed have been kept only since 1701, records from the beginning are incomplete. Charles was said by some to have imported Andalusians, Barbs, and Berbers but by others to have brought Andalusians, Neopolitans, and Arabians, which he crossed on the best Karst mares. Several stallions, also of pure Spanish descent, were purchased during the eighteenth and nineteenth centuries from Denmark and Holstein for use at

breeding operations. Spanish horses went to Italy, bringing renown to the Italian Polesina and Neapolitan breeds. In Denmark, at the still-famous stud at Frederiksborg, there were always fine Spanish horses.

Spanish Horses Arrive in Austria

Across the northeast border of Italy in the beautiful region known as the Karst, then in Austria but now part of the Republic of Slovenia, fine horses were also a tradition. The fast white horses of the Karst were well

both Lipizza and Kladrub. In the 1800s, Arabs were chosen to replenish the Lipizzan lines.

The Modern Lipizzan

Of all the sires used during the eighteenth and nineteenth centuries, only six were accepted to establish the family lines of Lipizzans that we know today. In addition to the stallion lines, there are sixteen mare family lines.

The old naming tradition, which exists to this day, is that every stallion is given two names: one is the sire's and the other is the dam's. Consider, for example, the stallion Pluto Balmora. The line he came from was Pluto (his own sire was Pluto Bona) and his dam was Balmora. Mares' names always end in *a*. Mares are given only one name, followed by a Roman numeral. The name indicates the female line; the numeral is the number of that individual horse.

In 1996, the nation of Slovenia took responsibility for the care, protection, and development of the breed. All other breeding studs and associations must obtain special authorization from the Republic of Slovenia before they use the Lipizzan name.

Airs above the Ground

It was traditional for the best young stallions to be taken from the stud in Lipizza to the Spanish Riding School in Vienna, where they were trained for dressage and carefully evaluated. A few of the strongest were eventually taught the spectacular airs above the ground. Some stayed in work there for twenty years. The very best were returned to Lipizza for breeding. The stud at Kladrub also sent horses to the school in Vienna. There was also frequent exchange of breeding stock between the two studs and, later, with the short-lived stud at Halbturn (1717–1743). The stud at Kladrub focused on producing an elegant, heavy coach horse, the Kladruber, which still exists in Europe and has earned recent fame in combined driving, while at Lipizza

the emphasis was on riding and light carriage horses.

A Dramatic Rescue

During World War II, officials of the Spanish Riding School in Vienna hastily removed the horses to St. Martin in upper Austria as the German army advanced. There they gave a formal dressage demonstration to American General George Patton, which was accompanied by a desperate request for help by the school's director. Patton immediately put the entire Spanish Riding School under the care of the U.S. Army to protect this great national treasure until it could be returned to a secure new Austria, which occurred in 1955.

Patton also rescued the Lipizzan stud, essential for the continuation of both the breed and the Spanish Riding School, from Czechoslovakia, where the German high command had moved it. He returned them to Austria under American military escort. Far fewer horses returned than had left, but the breed was saved from near-certain extinction. The Army brought a few Lipizzan stallions back to the United States after the war, and importations increased in the 1950s. Though still rare in North America, Lipizzans are seen in dressage and carriage competitions, and have proved to be fine pleasure mounts as well.

Breed Characteristics

Like many breeds that mature at a later age, Lipizzans are relatively long-lived. Many animals, including broodmares, remain sound and healthy and able to work into their late twenties or early thirties.

LIMES FOR LIPIZZANS

Lipizza means "small lime." In the local mythology, the lime tree (a nut tree grown in limestone-rich soil, not the lime fruit we are familiar with) was the tree of life. Every time a young stallion left Lipizza, three lime trees were planted along the road in front of the stud. A lime-lined avenue still exists in that location, nicely linking the present horses with their fascinating past.

The Spanish Riding School of Vienna is the only location in the world where the Renaissance tradition of horsemanship has been preserved and cultivated for more than four hundred years to the present day. The usual date given for the founding of the school is 1572. Wars with Turkey damaged the building, and reconstruction began in 1685, but it took 150 years to finish the project. Charles VI took up reconstruction in 1729 and finally completed the building we know today in 1835. A portrait of Charles VI still hangs in the royal box.

Since 1735, only horses from the stud at Lipizza have been used at the school. It was a tradition, begun in 1740 by Maria Theresa, for royals to hold knights games and riding tournaments called carousels at the riding school, as well as magnificent parties and masked balls. The last carousel was held in 1894. The Spanish Riding School was privatized in 2001, but it maintains many of the old traditions.

Because the selection of horses for breeding has remained virtually unchanged for hundreds of years, horse historian and geneticist Dr. Phillip Sponenberg has stated that the Lipizzan today, more than any other breed, shows us what the very best Spanish horses looked like at the time of Columbus.

Conformation

Lipizzans are small by today's warmblood standards, standing between 15 and 15.3 hands and weighing 1,000 to 1,200 pounds. They are elegant and proud, with smooth, elastic gaits and high knee action. Their faces have great character. The head is usually long, with a straight or slightly convex profile, small ears, and large, expressive

The most famous Lipizzans are the ones that give formal performances at the Spanish Riding School in Vienna.

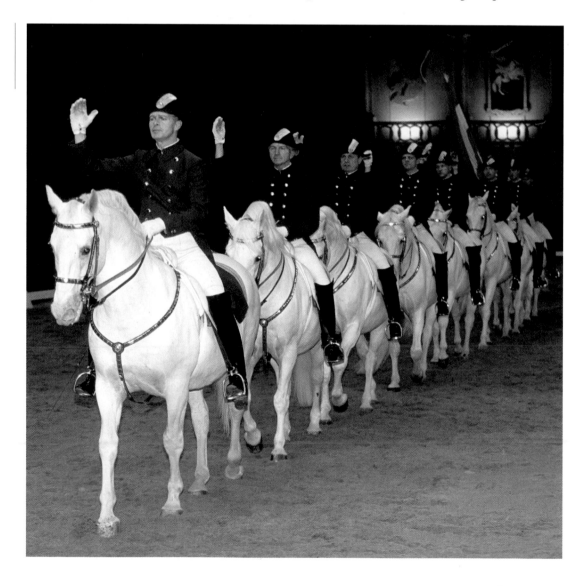

eyes. The nostrils are flared. The neck is muscular and arched; it connects to withers that are somewhat flat. The back is inclined to be long, the loins strong, and the croup slightly sloped, short, and broad, with the tail set high. The legs are strong and muscular, with broad, clean joints and well-defined tendons. The feet are relatively small but quite hard.

Color

Gray is the dominant color of the breed today. Very occasionally a black or bay may turn up, and it is traditional for one stallion of a color other than gray to be kept at the Riding School. The original royal family preferred white horses, so that color was historically emphasized in breeding programs, and, of course, the horses of the Karst were often white. However, as recently as two hundred years ago, blacks, bays, chestnuts, duns, and even **piebald** (black-and-white pinto) and **skewbald** (any color other than black-and-white pinto) were fairly common.

> **BREED ASSOCIATION FACTS AND FIGURES**
>
> According to the U.S. Lipizzan Registry (founded in 1980):
>
> - There are about 1,200 purebred, registered Lipizzans in the U.S.
> - Thirty to 40 new foals are added to the registry each year.
> - The registry includes a number of imported horses, most from the Piber stud in Austria, which is also a source for horses in the Spanish Riding School. There are also some from Romania, Transylvania, Hungary, and the former Yugoslavia.
> - California, Oregon, Washington, Michigan, and Illinois have the highest concentrations of Lipizzans.
> - In 2005 the U.S. registries and the American Lipizzan Breeders Association, which is not a registry, formed an umbrella group called the Lipizzan Federation of America so that the United States may be fairly represented at the Lipizzan International Federation.

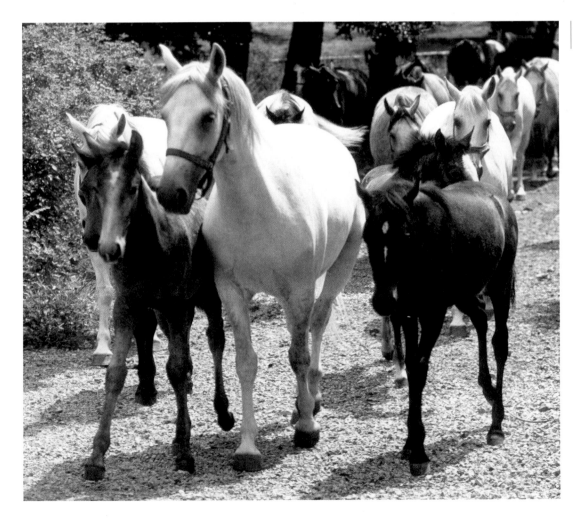

Lipizzan foals are often dark at birth, graying as they age.

Mangalarga Marchador

HEIGHT: 14.3–15.2, averaging 15 hands

PLACE OF ORIGIN: Developed in Brazil, but the ancestral bloodlines are from Portugal

SPECIAL QUALITIES: A uniquely smooth *marcha* gait characterized by moments when three legs support the horse; tremendous endurance; *brio,* a regal, spirited bearing combined with docility

BEST SUITED FOR: Ranch and endurance work, as well as trail and pleasure riding; good choice for riders with back or knee pain

The national horse of Brazil, the Mangalarga Marchador is by far the most popular breed in that country. It is just beginning to have a presence in North America. Although the Mangalarga traces its history to ancient Iberia, its primary genetic influence comes not from Spain but from Portugal, the country that became a nation in the twelfth century and later settled Brazil. As was true in Spain, most of Brazil's early horse-breeding efforts were military, centered on battling the Moors who invaded from North Africa. Although the horses of Portugal and Spain were quite similar and often arose from the same breeds, the Portuguese had their own goals and selection processes, and their horses differed a bit from their Spanish kin. During the 1500s, Portugal became deeply involved in discoveries and conquests, establishing colonies in Brazil, Africa, India, China, Japan, and the East Indies and exporting horses to Brazil and other colonies.

Spain annexed Portugal between 1580 and 1640. During this period, all the horses from the region came to be designated as Spanish, even if the breeding was Portuguese. This designation contributes some confusion to the history of the Mangalarga.

In Portuguese the word *real* means royal. The royal Braganza family of Portugal founded a breeding farm near the town of Alter do Cháo to supply themselves with suitable high school and carriage horses. Horses from this farm, or later from its bloodlines, are known as Alter Reals.

In the late 1600s, gold and diamonds were discovered in Brazil. Immediately the region became the focus of increasing interest from the Portuguese Crown. Friends and relatives of the royal family received important political appointments and large tracts of land in Brazil.

Later, in 1807, as Napoleon advanced on Portugal, the royal family moved to Brazil, taking with them some of the finest horses in the country.

Alter Real Influence

The hacienda (large ranch) Campo Alegre was founded in Brazil in 1740, and it soon had the need, and the necessary interest, to develop good working ranch horses. Within seventy-five years, the hacienda developed a strain of horses with smooth lateral gaits, excellent "cow sense," and outstanding endurance. These were the original Marchador horses.

ORIGIN OF THE NAME

The origin of the name of this breed comes from the hacienda Mangalarga, which acquired stock from Campo Alegre and went on to promote the horses and to develop a market among local ranchers. During the many years when horses were ridden everywhere, the reputation of these horses spread across Brazil. Although alert, active, and proud, Mangalargas are also gentle and extremely easy to handle, so they make perfect family and pleasure mounts as well as top ranch horses.

The second part of the name derives from the **marcha,** the breed's naturally occurring, smoothly rhythmic gait.

Development of the breed continued when the emperor of Brazil gave an Alter Real stallion named Sublime to one of the twelve children of the founder of Campo Alegre. Sublime descended from two horses from the Alter breeding farm in Portugal that had been brought to Brazil in an effort to save the best horses from the Napoleonic invasions. Sublime was crossed on mares of several breeds said to include Spanish Jennets, Criollos, and Andalusians. Of these crosses, the most profound genetic influence on the Marchadors probably came from the old Spanish Jennet, a famous but now extinct breed that was a fast, smooth ambler.

The cross of Sublime to the hacienda mares produced what became known as Sublime Horses, the first to exhibit the characteristics that are still evident in the Mangalarga Marchador today: excellent "cow sense," exceptional endurance, unique, smooth gaits, as well as docility and **brio,** a very regal, spirited bearing. The smooth *marcha* gait comes in two forms, either the **marcha batida** or the **marcha picada.** The marcha gait may be ridden at a wide range of speeds, from very slow to the speed of a

These nice young Mangalargas show the proud bearing and triangular head shape typical of the breed, as well as great consistency of type.

The Mangalarga's chest is deep and muscular, the back of medium length, and the hindquarters muscular. Chestnut is a common color in horses of this breed.

canter or faster. It is comfortable for both horse and rider over long distances. Today, in gait classes for Mangalargas in Brazil, the horses usually perform for about an hour. They are judged on gait, carriage, brio, elegance, and consistent timing over a wide range of speeds. Endurance tests often cover thirty-two- and sixty-two-mile distances.

Traditional Mangalarga breeding has concentrated on the bloodlines from Campo Alegre. Recent studies indicate that the breed is genetically distinct and that there has been virtually no infusion of other breeds. The Mangalarga Paulista is a similar breed, but its history includes crosses to several outside breeds, including Thoroughbreds, Standardbreds, and Arabians. Some say that for this reason the blood is not as

ENDURANCE ACHIEVEMENT

Mangalargas earned a *Guinness* World Record for endurance in 1994, when two sixty-year-old Brazilian men completed an 8,694-mile ride across Brazil. For a year and a half, the same horses carried the men by day and rested at night. Their travels took them from sea level to 15,000 feet and they encountered temperatures from 0° to 115°F.

pure as that of the Marchador.

In Brazil, temporary papers are issued to a foal at birth but permanent registration may not be granted until the horse has been inspected and evaluated at three years of age or older for conformation, gait, and temperament by licensed technicians from the Ministry of Agriculture.

Mangalargas were first exported to the United States and exhibited at the Centennial Exposition in Philadelphia in 1876, but political upheavals in Brazil stopped exportations and a breeding population was not established. It was not until the early 1990s, when Lucas Guerra imported several stallions and mares to Florida, that the breed was reintroduced.

Breed Characteristics

Mangalargas demonstrate agility, elegance, vigor, excellent conformation, and soundness. They are known to be active and to demonstrate a proud bearing, but they are gentle and easy to handle. These versatile horses excel at ranch and cattle work, endurance events, trail and pleasure riding, jumping, and polo.

Conformation

This is a medium-sized breed, averaging a little over 15 hands and weighing 900 to 1,100 pounds. Horses under 14.2 hands are not accepted for registration. The head is triangular with a large flat forehead tapering to a fine muzzle, with a flat, not concave, profile. The eyes are large, dark, and set well apart. The mobile, erect ears are proportional to the head, and the tips turn inward. The mouth is of medium width and sensitive to the bit. The nostrils are large, flared, and flexible. The neck is arched and well muscled, proportionate to the head, with ideal attachment to the body, and has a thin, fine, and silky mane. The chest is deep, long, and muscular.

The back is of medium length, straight, and muscular. The loins are short, straight, and well proportioned. The muscular hindquarters are symmetrical, and the croup is long and slightly sloping. The tail is set at a medium height, with a short fine dock that is raised slightly when the animal moves. The shoulders are long, broad, sloping, and muscular to provide a wide range of movement.

The legs, muscular on both the inside and the outside, are long, with short cannons. The forcarms are long, straight, powerful, and muscular. The pasterns are strong and sloping and set at an angle slightly lower than in most American breeds but typical of Spanish horses. The lower angle allows horses in motion to naturally overreach their front feet with their hind feet without straining their hind suspensory ligaments.

Color

Most colors known to the horse are found in the breed, but bays, grays, and chestnuts are the most popular. Mangalargas have a silky coat and fine, smooth skin.

Gait

While performing the marcha the horse may move his legs either laterally or diagonally,

but in both versions there are moments when three legs support the body. When the horse places the feet diagonally with moments of triple support, the gait is called the marcha batida. *Batida* means to hit, and it describes a gait that is in fact a broken trot. If the legs move laterally and separately (ambling, not pacing), also with moments of triple support, the gait is called the marcha picada. *Picada* means light touch, and this gait may be a bit smoother than the batida. Due to the triple support, the Marchador gives an extremely smooth ride in either gait. These horses are not supposed to trot or pace, but shift from the smooth marcha gait directly into a canter.

Most riders prefer the comfortable marcha, but the horses are able to canter well.

Marwari

HEIGHT: 14.2–15.2 hands

PLACE OF ORIGIN: India

SPECIAL QUALITIES: An extremely rare breed with a bold, arrogant presence and scimitar-shaped, hooked ears; some individuals are gaited

BEST SUITED FOR: Endurance riding, spirited pleasure riding, dressage

There have been horses in India for a very long time. Excavations in Gujarat, in northwestern India, have found bones and other evidence indicating that domestic horses lived in the Indus Valley civilization by 2500 BCE.

The state of Rajasthan, in northwestern India, lies not far from the Khyber Pass in Pakistan, which for many centuries was the gateway for invaders to enter South Asia, such as the Huns, Arabs, Afghans, Turks, Mughals, and others. In Rajasthan and throughout northern and central India live a group of people known as Rajputs, descended from the Huns or from tribes that entered India with Hun invaders. The Rajputs are believed to be the descendants of the ancient warrior caste, the *kshatriyas*. The majority of Rajputs are Hindu, but some are Sikh. Known for their fierce loyalty (especially to their faith), their deadly determination and skill in war, and their adherence to traditions, Rajput warriors would fight until the last man and a Rajput widow would throw herself on her husband's funeral pyre.

The Rajputs' horses were such an integral part of their lives, wars, art, celebrations, and traditions that it is almost impossible to separate them meaningfully. In northern India, from the end of the seventh century on, breeding warhorses was a necessity. In the ninth and tenth centuries, the Rajputs repelled an Arab invasion. The Arabs did not attempt invasion again for two hundred years, largely because of the reputation of the Rajput warriors and their horses.

One Rajput clan, the Rathores, ruled Marwar, a territory that included vast grasslands supporting huge herds of livestock. Charans, nomadic breeders of cattle and horses, managed the livestock. Eventually the Charans sought the leadership and protection of the Rathores, providing in return large numbers of the very best horses. They also recorded the deeds of the Rathores in song, poetry, and prose.

Warhorse par Excellence

During the Middle Ages, warhorse breeding and training were major endeavors; at one point the Rathores fielded a cavalry of 50,000. They schooled their horses to be supremely responsive during hand-to-hand combat, to pirouette at any speed, to extend the gallop like racehorses, and to collect on their haunches. According to Francesca Kelly, in *Marwari*, the horses "were trained to be fluent in many complex maneuvers, echoes of which are to be seen in Europe's classical riding schools."

The Rathores were driven from their own kingdom in the twelfth century, resettling in the desert of Maru Pradesh, a name that translates to the "land of death." There, the rugged desert-bred Marwari, well adapted to the extreme conditions, became superb, unspeakably brave warhorses for the Rathores. The accepted belief was that there were only three ways a Marwari horse could leave a battlefield: in victory with his master, by carrying his wounded master to safety, or by death.

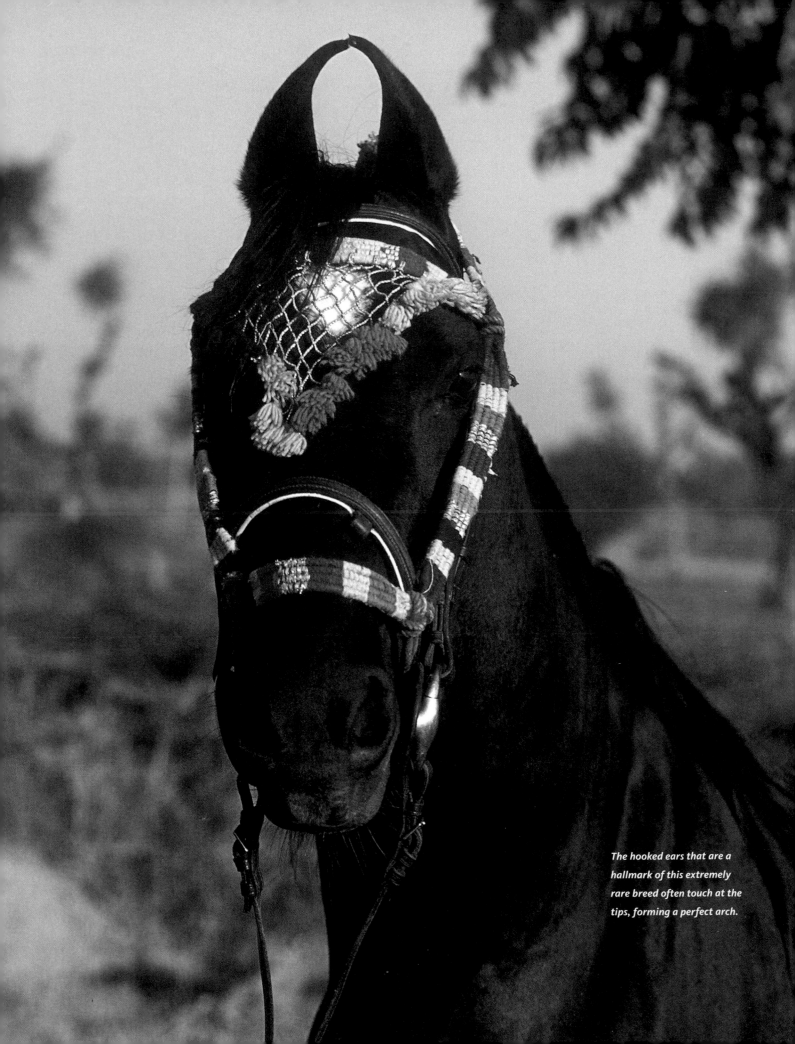

The hooked ears that are a hallmark of this extremely rare breed often touch at the tips, forming a perfect arch.

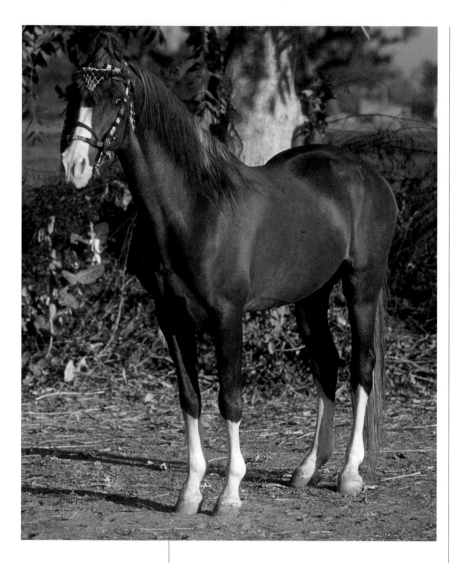

An impostor. Although the ears and expression are typical of the Marwari, the breed association specifically excludes this color. It is believed to show outcrossing to Thoroughbreds.

British Raj. After India became independent in 1947, Rajputana was renamed Rajasthan, and became an Indian state in 1950.

Decline and Recovery

During the British administration, the great glory of the centuries-old Marwari faded almost to nothing and the breed became imperiled. Preferring horses they knew, British officers initially imported Thoroughbreds, but those failed to thrive in Indian conditions. Later they brought in boatloads of tough, cheap Australian Walers (the name comes from New South Wales). When in 1950 the British enacted the **jagirdari,** or land-owning abolition act, they deprived Indian noblemen of the means to support their many animals; consequently, thousands of Marwari were shot, castrated, or sold off to become beasts of burden. Scattered far and wide and subjected to extensive, indiscriminate crossbreeding, the breed was nearly wiped out.

Even after this extreme low point in the 1950s, however, a tiny spark of interest remained. The states of Punjab, Rajasthan, and Gujarat began to implement projects to protect and upgrade their indigenous breeds. Progress advanced when researchers found some good horses on tiny farms, landed gentry began their own breeding programs, and wealthy former rulers took an interest in the breed's salvation and began promoting it. Additionally, tourism and riding safaris greatly boosted the revival of the Rajput culture, which included the Marwari.

In 1995 Francesca Kelly, the stepdaughter of a British ambassador to Cairo, saw some Marwari horses and immediately became enchanted with them. Remembering her own childhood midnight gallops across the desert, she set out do whatever she could to learn about the horses, to help save the breed in India, and ultimately to import some of the extremely rare horses into the United States. At the time, the estimated

In the first half of the eighteenth century, a sage named Shalihotra wrote a highly detailed manuscript on horses that was beautifully and lavishly illustrated. A study of the origins, characteristics, and care of the horse, the book is an exhaustive reference work documenting breeds, their geographical origins, and their castes as well as both favorable and unfavorable markings and whorls. Of the horses the author documented, the Rajput warhorse was most elite.

Most of the Rajput states lost their independence to the Mughal Empire in the sixteenth century and then regained it in the eighteenth century. In the mid-eighteenth century, however, under pressure from the Maratha Empire, they asked for protection from the British. As a result, fifteen Rajput states became princely states under the

number of purebred Marwari in all of India was five hundred to six hundred horses. Kelly's herculean efforts to import horses were ultimately successful, and there are now ten Marwari in the United States.

Kelly has also worked closely with those trying to save the breed in India, where there is now a breed association and a written breed standard for the first time in history. Among horse owners and participants at horse fairs in rural India, however, there is less emphasis on the breed standard than on selection of horses based on traditional beliefs about auspicious colors and placement of whorls.

Desert-Bred

Marwaris are extremely sturdy horses well designed for the desert. The unique and most obvious characteristic of the breed is its inwardly hooked, lyre-shaped ears. On some horses the ears touch and form a perfect arch when pricked. "To ride a Marwari," writes Kelly, "is to realize new levels of joy. It is to view the path ahead through a pair of perfectly curved ears, a gateway to the heart of India's spiritual and ceremonial heritage." Marwaris are known to have exceptionally acute hearing, which allowed warhorses to hear and avoid impending danger. They have thin fine skin that helps to radiate heat. Their extremely long eyelashes protect their eyes from sandstorms.

The Marwari's body is compact with a slightly more upright shoulder than in many breeds. According to the Marwari Horse Breeders Association in India, this is an adaptation for readily extricating their legs from deep sand. The legs are quite long, believed to be an adaptation for keeping the body away from the hot desert floor. The horses seem to float when they move, an adaptation to movement in sand. They are also said to possess an exceptional ability to find their way home. There are many stories of Marwari carrying back riders who became lost in the desert.

Breed Characteristics

According to the Marwari Breed Standard, the breed is defined by its personality and vigor, handsome forthright presence, arrogant bearing in the stallions, and doe-eyed beauty in the mares.

Conformation

The Marwari's head conveys indefinable Oriental presence and should be expressive with a high forehead; large, sparkling, prominent eyes; and a straight or slightly Roman but chiseled and clean profile, with well-defined and rounded jaws. The nostrils are large and gently flared, set over firm lips and an even bite. The ears should be of medium length and shapely, curving and curling inward at their points in the scimitar or lyre shape typical of the breed. The ears are somewhat longer in mares. The throatlatch is deep to allow proper flexion and normal respiration at all times. The neck is proudly carried, neither thickset nor narrow but arched, well-muscled, and tapering, and joins an extremely well-angulated shoulder of good breadth. Additionally, the neck should be set high enough to allow the proper head position well above the lines of the withers to display the "Marwari look."

The withers are well defined and in proportion to the angulation of the shoulder. The chest is not particularly broad but should be well developed. The body should be compact and rounded with a medium to short back and close coupling, well-sprung ribs, and deep loins. The croup is long and well muscled, with the tail attached high and curved gracefully. Viewed from the rear, the croup should be well rounded.

BORN TO DANCE

Within the breed, a strain of horses known as the Natchni was considered to be "born to dance." Horses from these lines were selected to learn complex and difficult leaping and prancing movements and perform them to music, decked in silver, bells, and jewels, at weddings and other ceremonies. Dancing horses are still in demand in the countryside in India.

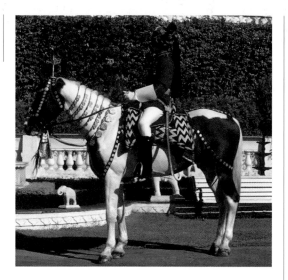

The extreme angulation of the shoulders places the front legs farther forward on the body than on most breeds. The front legs should be straight, with flat bone, good length of forearm, and short, strong, slender cannons. The pasterns are of sufficient length to provide a light, flexible, springy step.

The conformation of the rear legs is extremely important. The stifle should be placed well forward and low in the flank area. Lack of proper smooth flexion of hock and stifle is not tolerated. The thighs and gaskins should be muscular and full, with the gaskin longer than the cannon.

Gait

The Marwari breed is often gaited, with many individuals performing the gait known as the **aphcal** or **revaal,** an amble. When exhibited, this gait must not include paddling, winging, or landing on the heels. The breed standard does not require that a Marwari horse perform the aphcal; nevertheless, horses that do not do so naturally are often forced to do it with training devices.

Whether or not the horse is performing the aphcal, all gaits are described as floating and should be performed with great style, collection, and lightness of motion. The horses must show purpose and intent to travel forward without undue restraint or use of aids. The Marwari should be able to achieve a full gallop from a standing start and stop very quickly on command. He should be able to reverse with ease and at all times display the bold and fearless presence of the breed.

Colors

According to the breed standard, albinos are bred in India specifically for religious use, but otherwise are not accepted as Marwaris. Chestnut is considered a sign of crossbreeding with non-Oriental imports and is not accepted for breeding or showing. A **nukra,** or cremello, may be accepted if it is of exceptional type and conformation.

The distinctive, metallic, bright bay is highly desirable. All other solid colors, as well as **piebald** (black-and-white pinto) and **skewbald** (brown-and-white pinto), are accepted. White blazes and white on the lower legs are common.

According to traditional beliefs, gray is the most auspicious color, and these horses are the most expensive in India. Colored or piebald horses are the second most favored. Black is considered a highly unfortunate color, the symbol of darkness and death. A blaze and four white socks are considered most favorable. A whorl below the eye is unfavorable, but long whorls down the neck or at the base of the neck are good luck. Whorls on the fetlock bring victory.

BREED ASSOCIATION FACTS AND FIGURES

Current breed statistics are difficult to obtain. According to *Smithsonian* magazine, there were 500 to 600 horses in India in 1995. If half of those horses were female, and half of those females had viable foals each year, about 150 foals may have been added per year since then.

According to Francesca Kelly, in 2005:

- There are nine Marwari in the United States, of which eight live with her.
- Her horses comprise three stallions, four mares, and a filly. Three foals are due in 2006.
- These are the only Marwari outside of India.

McCurdy Plantation Horse

Just after the Civil War, the McCurdy brothers of central Alabama operated a Standardbred breeding and racing farm. Their most famous trotting stallion was McCurdy's Hambletonian (see Standardbred), but they owned several other top horses as well. In addition to racing horses, they needed dependable, durable, and comfortable horses for overseeing and working their land and for riding long distances. The two brothers and their father

had adjoining plantations, and they frequently traveled back and forth between them. They used horses to plow, to pull buggies, to herd livestock, and to transport children to school. In their leisure time, the McCurdys liked to bird and fox-hunt on horseback. With generations of family experience breeding top horses, they knew

how to select and cross horses to achieve their goal: extremely versatile horses that were easy to handle and willing and able to do whatever was asked of them.

The two brothers purchased a horse from Dr. Jim McClain, a gray stallion that came to be known as McCurdy's Doctor. The McCurdy brothers crossed Doctor on

HEIGHT: 14.2–16 hands

PLACE OF ORIGIN: Alabama

SPECIAL QUALITIES: A gaited horse, specializing in the "McCurdy Lick," a four-beat, single-footing gait; other gaits are the flat walk, the running walk, the natural rack, and the stepping pace

BEST SUITED FOR: Trail and pleasure riding, following hunts, and field trials

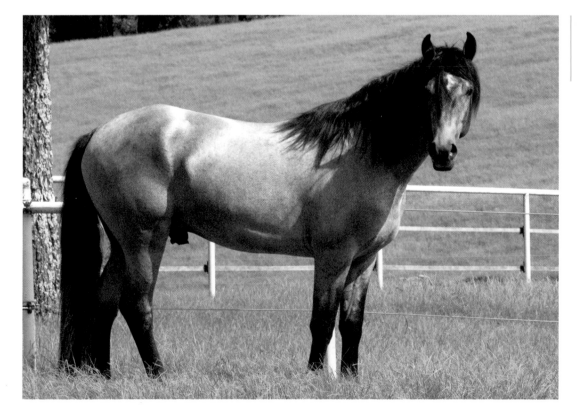

The McCurdy Plantation Horse is often used to view bird-dog field trials and for hill topping at foxhunts.

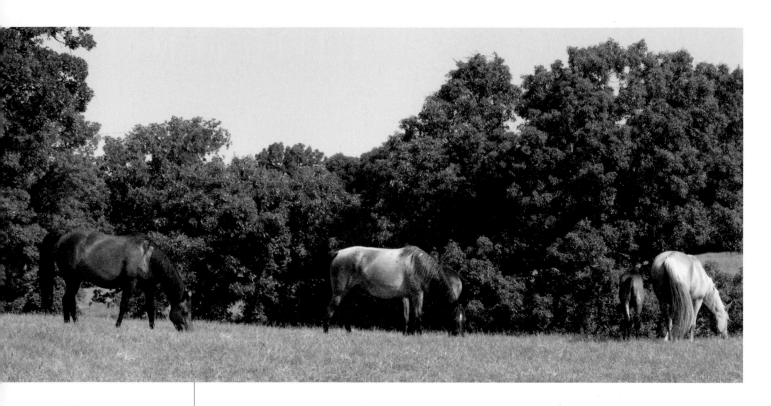

Gray is the most common color but bay, roan, and palomino also occur.

some of the best plantation mares in central Alabama but never on any of their fine Standardbreds, which were trotters. The results were exactly what they were after: smooth-gaited, tractable, durable, versatile horses. Many were reported to have natural "cow sense."

Kinship with Tennessee Walkers

When Tennessee Walking Horses were first developed in the late nineteenth century, they were known as a breed of light horses that could also perform plowing and heavy farmwork. It was widely believed that experience with farmwork made them better riding horses. Because this type of horse

BREED DIVISIONS

There are three types of registration in the McCurdy breed.
1. Foundation mares and stallions have been inspected, videotaped, and ridden by at least one registry director before being approved by the registry board.
2. Pedigree registered horses are the result of a cross between two foundation horses.
3. Appendix registered horses are the result of crossing a foundation McCurdy on one of the other approved breeds of gaited horses.

was extremely popular for riding and for working on plantations throughout the South, it meant there were good, smooth-gaited horses with plenty of substance available in central Alabama, which was a hub of horse interest and expertise.

By the early 1900s, plantation walking horses were well established and were the favored type in the area, although there was no breed registry for many years. When the Tennessee Walking Horse Registry was established in the 1930s, it was the only registry available, so the McCurdy Plantation registered its own horses as Tennessee Walkers. The association gave McCurdy's Doctor the designation F- (for foundation) 79. Several other McCurdy horses also appear in the foundation registry of the Tennessee Walker. The most renowned horses sired by Doctor F-79 were John McCurdy and McCurdy's Fox.

Over the years, the McCurdy horses gained fame of their own, and people began breeding specifically to them. Although the lines are closely intertwined with those of Tennessee Walkers, a separate breed was ultimately established from the McCurdy bloodlines.

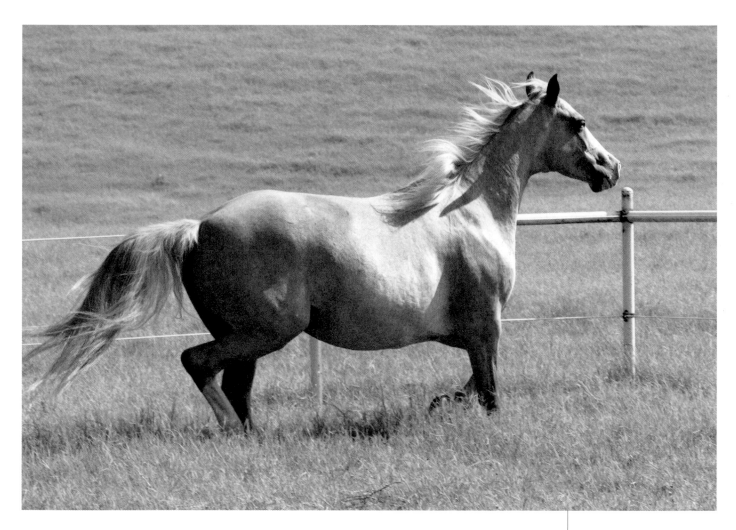

Breed Characteristics

McCurdys are naturally gaited. Their gait is known as the McCurdy Lick, an exceptionally smooth, lateral, four-beat, single-footing gait that is not nearly as exaggerated as the "Big Lick" of the Tennessee Walker show horses. McCurdys also perform the flat walk, the running walk, and, unlike Tennessee Walkers, the natural rack and the stepping pace. Many will also fox trot. McCurdy Horses are known for giving a safe, secure, smooth ride over any terrain or condition. Fanciers of the breed emphasize that the horses are born naturally gaited and that they do not require artificial means such as exotic shoeing, bits, and training to bring out their talents.

Conformation

McCurdy Horses can range from 14.2 to 16 hands but the average is 15 hands. They are generally refined in appearance, with rounded hips and a broad chest, short back, and good bone. They usually have a heavy mane and tail.

Color

Many of the horses are gray, but there are also chestnut, sorrel, bay, and black horses, as well as both red and bay roans. White markings on the face and below the knees are common.

McCurdys are generally refined in appearance but with rounded hips and powerful hindquarters.

BREED ASSOCIATION FACTS AND FIGURES

According to the McCurdy Plantation Horse Registry and Association (founded in 1993):

- Today, 368 horses are registered.
- Twenty-five to 30 new foals are registered each year.
- The largest populations of McCurdys are in Alabama, Texas, Oregon, and South Carolina, but there are some in California, Minnesota, and England.

Miniature Horse

HEIGHT: 34" and under for Division A, 38" and under for Division B

PLACE OF ORIGIN: Developed in this country, but the original stock probably came from England

SPECIAL QUALITIES: Diminutive animals of strength and athleticism with the proportions of full-sized horses rather than ponies

BEST SUITED FOR: Showing, driving, and as companion animals

Small horses are known to have been the playthings of nobility at least as far back as the 1600s. By 1765, paintings and articles featured Miniature Horses. The Hope family of England, particularly Lady Estella Hope and two of her sisters, bred very small horses at least until the 1950s, selecting stock from the earliest English lines. Many of the smallest American Miniatures are said to have come from the Hope lines.

Although little horses were often royal pets, some came from hardworking, blue-collar mining backgrounds. After the 1847 Mines Act made it illegal for children to work in coal mines, the English switched to the use of Shetlands and any other suitable strong small ponies. The mine ceilings were low and space was at a premium. The remote ancestry of today's Miniature Horses certainly includes some Shetland and perhaps also mixes of other pony breeds.

The date generally given for the first importation of a very small horse into the United States is 1888. In 1861, however, Ohio native John Rarey, the most famous horse trainer in the world at the time, traveled through his home state with two very small ponies that he acquired in England. The *Ohio State Journal* of September 1861 mentioned his Franklin County Fair entry:

"One new feature is the entry by Mr. J. S. Rarey, of four full blooded Shetland ponies. They were imported by Mr. Rarey direct from the Shetland Islands. One of these ponies is really a curiosity. We should think it is scarcely 24 inches in height, and not larger than a house dog. It is five years old; and we presume, the smallest of the horse kind in America. We understand that Mr. Rarey intends breeding from this lot, and introducing them among stock-raisers."

After Rarey's time, little horses were used in coal mines in Ohio, Kentucky, Illinois, and Indiana until about the 1950s or '60s. The American Miniature Horse may also be distantly related to various Dutch and English mine horses that were imported during the nineteenth century. It was not until the twentieth century that Miniatures finally caught the attention of enough horsemen that an association was organized and people began breeding and showing them.

Registry History

This is the only breed in the world that measures the height of the horse at the last hair of the mane rather than at the highest point of the withers.

The American Miniature Horse Association Inc. (AMHA) was founded in 1978. Its stated purpose is to aid and encourage the breeding, use, and perpetuation of the American Miniature Horse, separate and apart from ponies and other small equines. By the definition of the AMHA, Miniature Horses must not exceed thirty-four inches in height.

A second major registry for the breed is the American Miniature Horse Registry (AMHR). The AMHR has two size divisions. The first is the A division for horses at or below thirty-four inches. The second is the B division, which allows horses up to thirty-eight inches.

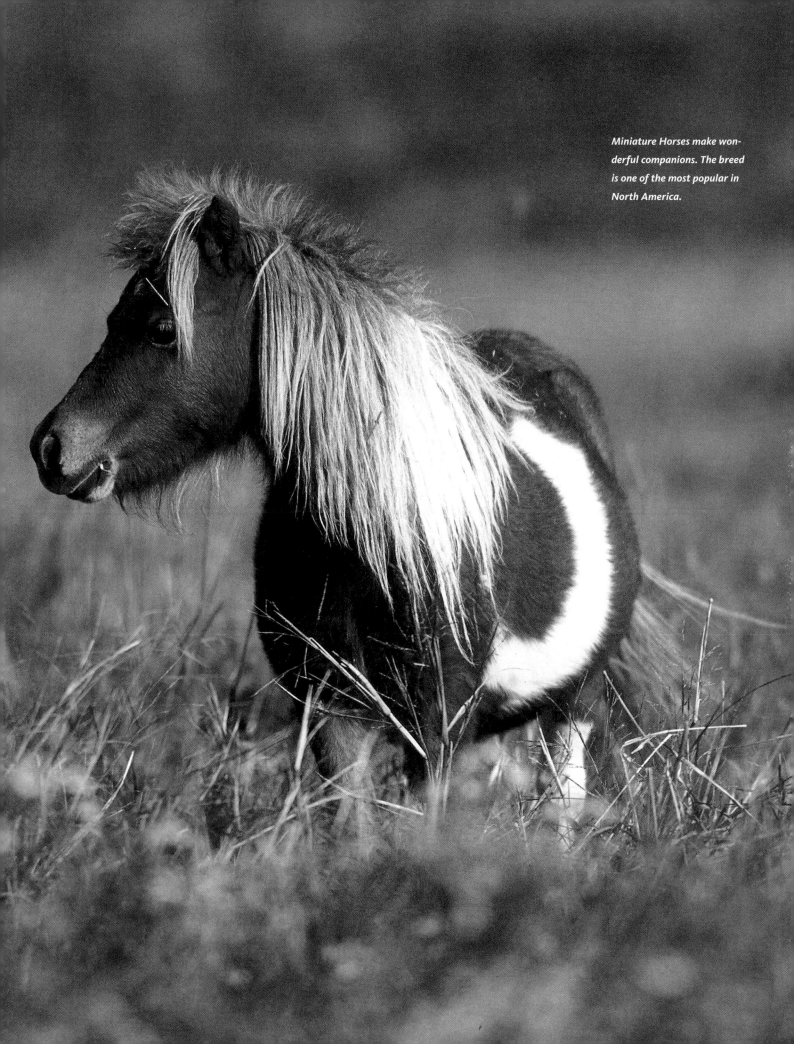

Miniature Horses make wonderful companions. The breed is one of the most popular in North America.

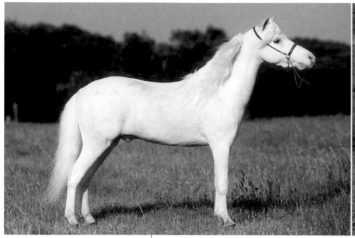
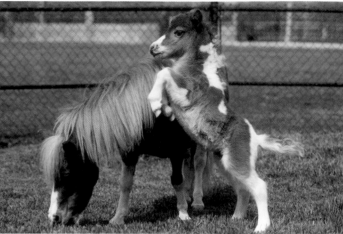

Today's Miniature Horses most often look like small Arabians. The pale cremello color is used by breeders to produce buckskins and palominos in the next generation.

Both organizations have strict guidelines for registry and both promote the breed through shows and events. At this time, Miniature Horses are one of the fastest-growing breeds in North America.

Breed Characteristics

Miniature Horses, particularly mares and geldings, are known to be quiet and easy to handle, but some of the stallions are surprisingly hot tempered. Well-chosen Minis often make good horses for children and for people with physical limitations, as well as for horsemen with limited stabling and pasture space. Minis make nice companion animals and can be fun for anyone.

Miniature Horses, especially the smaller ones, are usually too little for anyone but the smallest children to ride; often by the time a child is coordinated enough to ride, he is too big for the Miniature Horse. They do make excellent driving animals. In addition to halter, obstacle, and even some jumping classes, there are always many driving classes at shows. There are also clubs of Mini fanciers that drive on appropriate trails with their horses. At least one nationally known drill team of driven Minis appears at major horse events, and a couple of Miniature Horses have been trained as assistance animals for the blind.

Conformation

The ideal Miniature Horse is an elegant, scaled-down version of a full-sized horse. In today's show ring, there is emphasis on horses that resemble miniature Arabians. The proportions of a Mini should be the proportions of a true horse. The general impression should be of symmetry, strength, agility, and alertness. Mares should show femininity and stallions should show boldness and masculinity.

Color

Miniature horses come in all colors found in full-sized horses. They also appear in a few colors that are rarely seen in anything but Miniature Horses, such as bay silver dapple, which is a light bay-colored body with black legs and white mane and tail.

BREED ASSOCIATION FACTS AND FIGURES

There are two registries for Minis:

- The American Miniature Horse Registry, which is part of the American Shetland Pony Club, has 148,000 horses listed.
- The American Miniature Horse Association (founded in 1978) lists 162,000 horses.
- About 9,000 new foals are registered each year by the AMHA.
- The AMHA is one of the fastest-growing registries in North America. Only breeds such as Quarter Horse, Paint, Tennessee Walker, and Thoroughbred register more horses in a year than the AMHA.
- Texas, Florida, and California have the most Miniature Horses, but they are found in every state and all over the world.

Missouri Fox Trotter

The Ozark Mountains of Missouri are low and largely forest covered, but they are also rugged and rock-strewn. During America's westward migration, the first settlers to arrive in the Ozarks came from Tennessee, Kentucky, and Virginia, and they brought with them the types of saddle horses that were popular in those areas. They preferred smooth-gaited horses with a calm disposition that could be used to pull plows or to ride. Because of the difficult, rocky terrain, sure-footed horses were essential.

Even before Missouri became a state in 1821, it was clear that the horses best suited for the Ozarks were those that had a natural, easy **fox trot,** a rhythmic diagonal smooth gait with alternating three-hoof, two-hoof support and a reaching step in front rather than high action. On a relatively even surface, a fox trotter can be observed sliding its hind feet forward, giving the rider an extremely smooth ride. The gait allows a horse to be exceptionally sure-footed, even in rough going. It is a comfortable gait for the

HEIGHT: 14–16 hands

PLACE OF ORIGIN: Ozark Mountains of Missouri

SPECIAL QUALITIES: A gaited breed known for its rhythmic diagonal gait called the fox trot

BEST SUITED FOR: Ranch work, trail riding, forest service work, handicapped riding programs, team penning, and showing

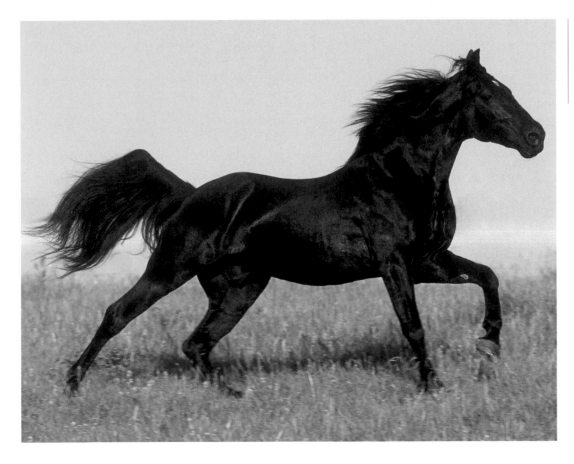

Although known best for their intermediate-speed gait called the fox trot, these horses are versatile and athletic. They make excellent ranch horses.

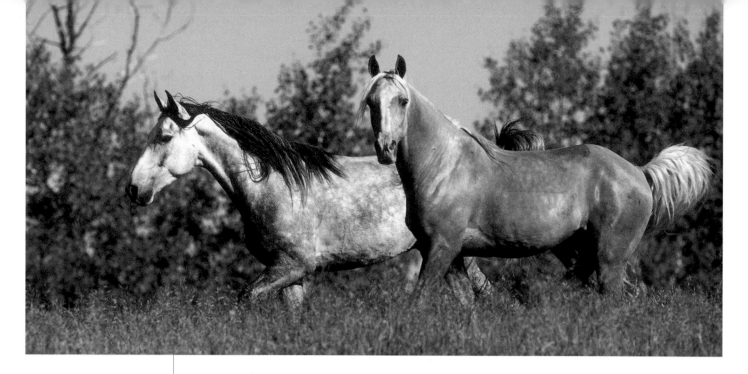

Fox Trotters come in a wide array of attractive colors.

horses to perform, one they are able to maintain for long distances.

Breeders quickly began selecting for horses with this ability, and the horses became extremely popular in the region.

When cars and tractors replaced most working horses, the Missouri Fox Trotters survived because they continued to be the choice of Missouri's many cattlemen. Not only were they comfortable to ride, but they also were good working ranch horses.

In 1948, a breed organization was founded to preserve the type of horse that had long been held in such high esteem in the Ozarks. The Missouri Fox Trotter

Smooth-gaited horses were favorites in the old West, and they are still popular there today.

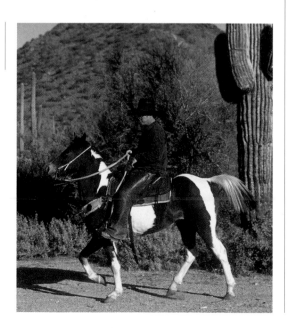

studbook remained open until 1982, selecting horses that had the fox trot gait along with other specifically designated traits. The first such animals were admitted as "characteristic" foundation stock. Since 1982, all horses admitted to the registry must have a sire and a dam that are registered Missouri Fox Trotters.

The breed has gained wide fame, especially among trail riders, because the horses are easy to get along with, comfortable to ride, and able to carry weight. They also have excellent stamina and are well suited to work in mountainous regions. For these same reasons, they are used by the U.S. Forest Service and many other organizations that need comfortable, easygoing, reliable horses. There is also a fairly large show circuit for Fox Trotters. Fox-trotting mules (a Fox Trotter mare x donkey sire) are widely used in the West for trail riding and for carrying hunters into the mountains for elk hunts.

Breed Characteristics

Because they are inclined to be gentle as well as comfortable to ride, Fox Trotters make an excellent choice for families with children, for handicapped riding programs, and for adults with limited riding experience or with bad backs or knees. They are excellent ranch horses.

Conformation

Fox Trotters stand 14 to 16 hands. The head is well proportioned, with a straight profile. The eyes are large, the ears pointed. The neck is well formed and of medium length. The withers are pronounced. The back is short and straight, with a rounded and muscular croup. The tail set is fairly high. The chest is broad and deep, the shoulders sloped and muscular.

The legs are muscular and sturdy, with good joints and clearly defined tendons. The hooves are well formed and proportional to the size of the horse.

Color

Missouri Fox Trotters may be either solid or pinto and they may be bay, black, roan, brown, buckskin, chestnut, gray, palomino, sorrel, white, cremello, perlino, or champagne. White face markings and white on the lower legs are common.

Gait

In addition to the fox trot, the horses perform a smooth, flat-footed walk and a nice canter. When working, the Missouri Fox Trotter travels gracefully, with the head and tail slightly elevated. The head nods slightly, giving the horse a look of relaxation in movement. Fox Trotters are not high-stepping horses, but they are known to be exceptionally sure-footed.

BREED ASSOCIATION FACTS AND FIGURES

According to the Missouri Fox Trotter Horse Breeders Association (founded in 1948):

- It has registered about 83,000 horses.
- Each year, 8,500 horses are registered.
- Fox Trotters may be found in almost every state, as well as in Canada, Germany, Austria, Switzerland, and France.

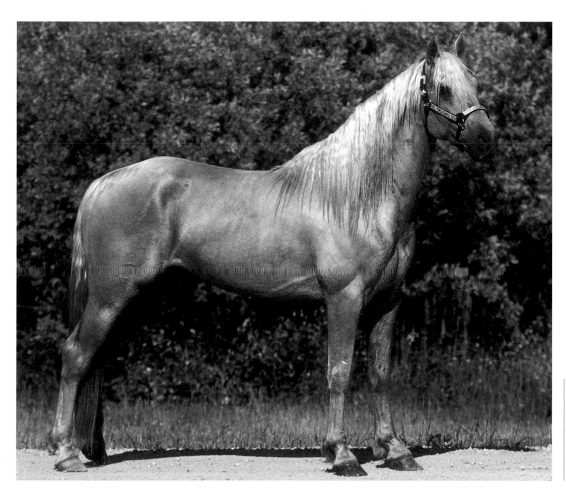

Fox Trotters are soundly built. They do not require exotic shoeing in order to perform the gait. There are many palominos and champagne-colored horses in the breed.

Morab

HEIGHT: 14.3–15.3 hands

PLACE OF ORIGIN:
The United States; the
geographical history of the
breed extends from New
England, to Kentucky, to
Texas, to California

SPECIAL QUALITIES:
Steady disposition,
strength, sensitivity,
excellent free gaits

BEST SUITED FOR:
Family and pleasure horses,
trail riding, driving, jumping,
and showing

The name Morab is thought to have been coined by William Randolph Hearst, who bred and used Morabs on his San Simeon ranch in California in the 1920s, but the history of these useful horses predates Hearst by many years. In 1855, L. L. Dorsey, who was interested in developing a national carriage horse for the United States, purchased a spectacular weanling for the grand price of $1,000 from breeder Andrew Hoke,

who lived near Louisville, Kentucky. This was the great horse Golddust, who was properly registered, by the rules of the time, with the Morgan Horse Association as #70 and is one of their foundation sires. A closer look at his own pedigree reveals that he was part Arab. His sire was Vermont Morgan MHA #69, but his dam was an unregistered daughter of the excellent imported Arabian stallion Zilcaadi (also spelled Zicaaldi) owned by Andrew Hoke.

Golddust was remarkable in almost every way. He was stunningly beautiful. At 16 hands, his conformation was excellent. His color was said to be pure gold. In addition to conformation and color, he was one of the fastest-trotting stallions at a time when there was heavy emphasis on trotting speed both for roadsters and racehorses. In 1861, Golddust beat the great trotting stallion Iron Duke in a match race for the best three out of five heats, winning $10,000.

Golddust was also a great sire, consistently producing offspring with great speed that were exceptionally successful in the show ring. The Civil War ended Golddust's career, but by then he had sired 302 foals and left forty-four trotters of record. His offspring were shown, and usually won, at all the biggest shows and fairs in the country. One of his famous grandsons won at the St. Louis World's Fair in 1904.

The Morgan-Arabian cross may have gained its first real fame with Golddust in Kentucky, but its reputation soon traveled westward. As the cattle industry grew in the West, more than a few cattlemen discovered Morgan Horses to be excellent ranch horses. While Morgans gained a reputation as solid working animals, so did the crosses with Arabians. Several famous ranches, including Hearst's San Simeon, crossed Morgan mares on Arabian stallions with excellent results. In Texas, a breeding program at the famous SMS Ranch, operated by the Swenson brothers, used Morgan stallions on their ranch mares. They improved this stock by crossing in three Arabian stallions that they acquired from the U.S. Army Government Remount Program and ended up producing some very fine cutting horses. To this day there is strong interest in Morabs in western states, especially in California.

Breeding True

The name Morab seems to lead people to regard these animals as a recently invented crossbred and to be unwilling to consider it as a breed in its own right. One of the key requirements of a breed is that it must consistently transmit selected characteristics to progeny; the Morab has repeatedly proved this ability for at least six documented generations. Although one may think of

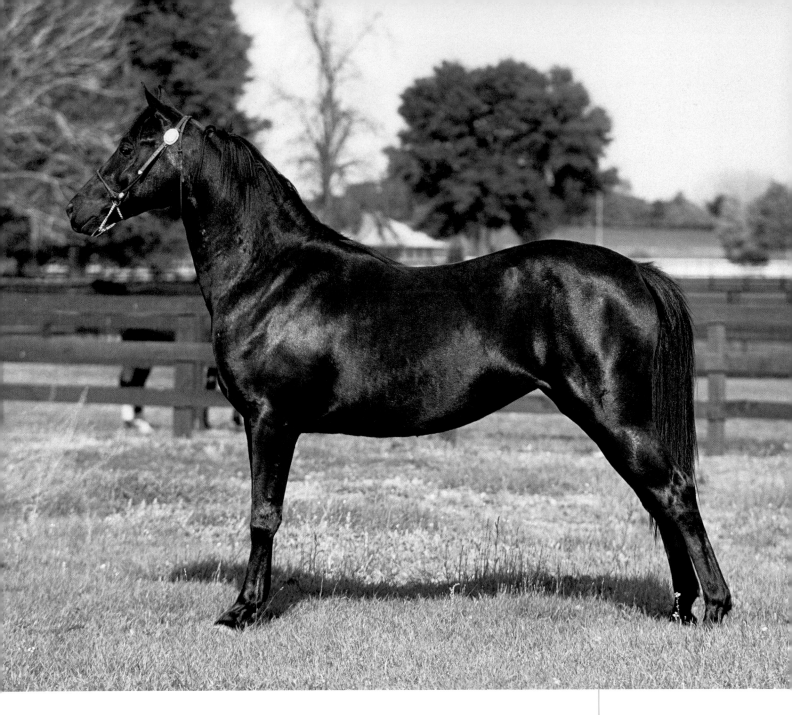

Morabs as always being half Morgan and half Arabian, the rules of the Morab Association dictate that a registered animal may be no more than 75 percent of one of the two foundation breeds while being no less than 25 percent of the other. For example, a horse that was 25 percent Morgan lineage would have to be 75 percent Arabian in order to be accepted by the registry. The registry does not accept any other breeds.

Breed Characteristics

Morabs are tractable and easy to train. They are late maturing, often not reaching their potential until the age of about seven. Like other late-maturing breeds, they are long-lived.

Morabs have free gaits, working well off their hindquarters and carrying themselves well collected. They may have a naturally high action or a lower, quieter, pleasure-horse action, depending on the breeding of the animal. Most registered Morabs are three-gaited, performing the walk, trot, and canter, but the International Morab Registry also accepts horses that meet all other requirements and are also smooth-gaited.

You can see both the foundation breeds in this horse. The head shows traces of the Arabian; the neck is more refined than on many Morgans. The croup is flatter than on some Morgans but rounder than on Arabs. The color is common to Morgans.

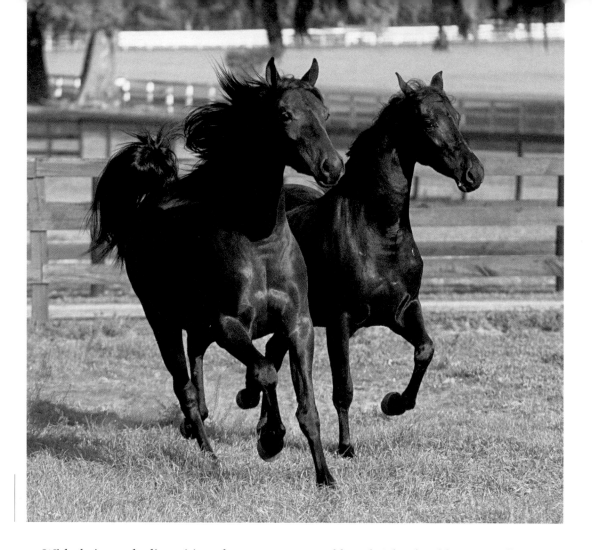

The beauty of the horses first attracts many to this useful breed.

With their steady disposition, these horses are desirable as family and pleasure horses. They also make good trail horses, nice driving horses, and successful show horses in almost every discipline.

Conformation

Morabs are powerful, muscular horses that also exhibit grace and refinement. They usually stand between 14.3 and 15.3 hands. The head is refined, with a straight or slightly concave profile and large expressive eyes. The cheeks are broad, the muzzle narrow. The nostrils are large and flared. The neck is heavy, but with refinement and good length. The shoulders are well muscled, long, and sloping. The withers are moderately high over a short, strong back. The croup is level and muscular, with a high tail set. Hipbones are never evident on adult horses. The chest is broad and deep. The legs are sound: viewed from the front they are narrow, but from the side they are wide and strong, with flat bones, large joints, broad forearms, and short cannons. The hooves are of medium size, nearly round, and open at the heels.

Color

The Morab Horse Association does not restrict color as long as the horse meets all other breed requirements. But a second major organization, the Purebred Morab Horse Association, accepts only brown, bay, black, buckskin, gray palomino, and dun. It does not allow white above the hock or the knee or either pinto or appaloosa color patterns.

BREED ASSOCIATION FACTS AND FIGURES
According to the International Morab Breeders Association (formed in 1986):

- There are 980 horses in the International Morab Registry.
- About 90 new horses, including foals, are registered each year.
- The registry was formed in 1993.

Morgan

One of the greatest true American horse stories is the tale of Figure, an undersized, handsome, three-year-old bay stallion who in 1792 was given to a Vermont music teacher and sometime blacksmith in partial repayment of a debt. The little stallion matured to barely 14 hands. Possibly because his small size meant that he wouldn't bring much at a sale, the teacher, Justin Morgan, did not try to sell him right away. Morgan

HEIGHT: 14.1–15.2 hands, may reach 16

PLACE OF ORIGIN: Vermont

SPECIAL QUALITIES: Exceptional strength, staying power, soundness, and versatility

BEST SUITED FOR: All-around athletes; compete successfully in almost every discipline, from dressage and jumping to Western pleasure and cutting

sometimes managed stallions as a business, so perhaps he saw potential in the horse and preferred to keep ownership. He leased the horse to a local farmer for fifteen dollars a year, and ultimately sold him in about 1795.

The little horse stunned everybody by being able to outwork every other horse in the state, and he seemed to do it with ease and even a carefree, happy manner. It was said that after a hard day in the fields or skidding logs out of the woods, Figure would return to the barn bright-eyed and looking as though he had just enjoyed a relaxed day off.

One of the horse's most famous feats had to do with a bet placed at a tavern after

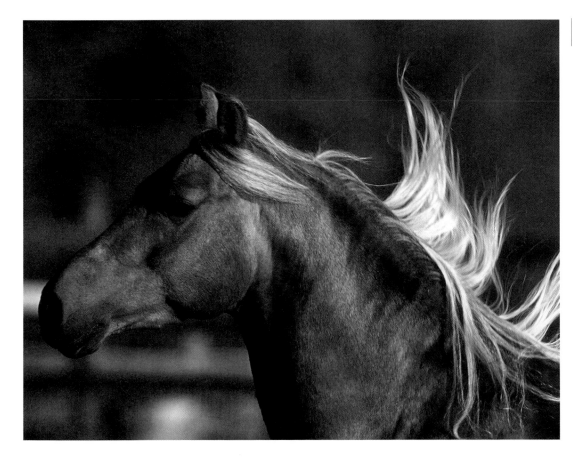

This unusual color for Morgans is sought after by some fanciers.

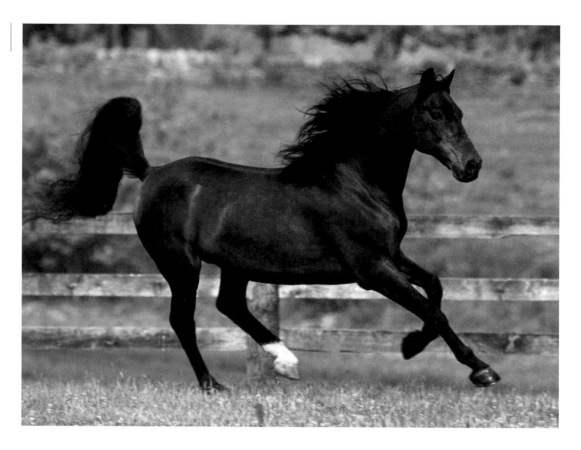

a hard day of logging. Robert Evans, who had been working Figure and knew his strength, was told there was a huge pine log ten rods from the lumber mill. (A rod is sixteen feet, six inches.) No horse or team of horses had been able to budge it. Evans bet that Figure could pull the log to the mill in three starts; to make it a little more of a challenge, he asked three of the largest men in the tavern to sit on the log, which they happily did.

Without commotion, the little horse sat back on his haunches, leaned forward with his head bowed, and pulled steadily, just slightly to one side. The log wobbled, then moved, and continued moving. Halfway to the mill, Evans stopped the horse to let him catch his breath, and then they finished the trip. Figure moved the log the entire distance in two starts, for which Robert Evans won a gallon of rum.

Figure's fame spread as fast as the story could travel, and he became a much-sought-after breeding stallion. He had excellent gaits and was also a lovely driving horse. In addition to the famous log pull, Figure outperformed every horse ever put against him in any sort of contest: trotting, running, or pulling. Owners held walking races in those days, which he also won.

Although the horse was known as Figure for most of his life, after the death of his owner in 1798 he came to be called the Justin Morgan horse, and later Justin Morgan. He contributed the Morgan name and type to an entire breed. Justin Morgan the horse stood about 14 hands but weighed about 1,000 pounds. He was a solid dark bay with a thick wavy mane and tail and feathering along the back of his legs and fetlocks. His back was short, his body rounded and very compact with well-sprung ribs, a very deep chest, and powerful quarters. He was a good-gaited horse, with gaits that were square and even but not high stepping. His legs were short, and he was much more heavily muscled than most horses of his size, although he showed no signs of coarseness or draft horse breeding.

Notable Offspring

Justin Morgan turned out to be far more than just an exceptional working horse. He was an incredibly **prepotent** sire, meaning that he stamped his type on his offspring. His offspring looked like him and inherited many of his exceptional traits, even when the foals came from dams of unknown ancestry and differing types. This suggests strongly that he himself was **linebred,** meaning that he was the result of the breeding of closely related animals, although it may have happened by accident. In those days, everybody had horses, and there were a good many stallions around. Fences were not always of the quality we have today; escapees and fence jumpers were fairly common. A stallion may have jumped a fence and bred a close relative.

Such an accident could account for Justin Morgan's small size, although other factors may have contributed, and it could also explain his ability to stamp his type on subsequent generations. The ability of closely linebred animals to do just that is why people sometimes use linebreeding or inbreeding in their breeding programs.

Although there were certainly many sons of Justin Morgan, records have been found for only six that became breeding stallions in New England, and of those, three were particularly notable.

Sherman was a bright chestnut who matured to just under 14 hands. He sired the very famous Black Hawk, who himself sired the great Ethan Allen.

Woodbury was a high-strung dark chestnut with a white stocking and a unique blaze. He matured to 14.3 hands and was the showiest of the sons. He spent many years in New England but ultimately was sold to an owner in Alabama. The trip south by boat was very difficult, and he arrived in poor condition. Never really regaining his health, he died two years later, leaving no record of offspring in Alabama.

The third son was Bulrush, who, like his sire, stood about 14 hands and weighed about 1,000 pounds. He had a few white hairs on the forehead but other than that was a solid dark bay. Bulrush's forelock fell to the tip of his nose, and his mane came nearly to his knees. Like Justin Morgan, he had feathering at the back of the cannons. Bulrush was the fastest of the three sons in harness and was famous for his endurance. He died at the age of thirty-six, reputed to have never had a lame day in his life.

Black Hawk, a son of Sherman foaled in 1833, was known for great beauty, speed at the trot, and endurance. He was never beaten in trotting races and became a very famous sire. Some of his colts sold for between $1,000 and $3,000. Black Hawk was crucially important in the heritage of the Standardbred, the American Saddlebred, and the Tennessee Walker.

Also important in the lineage of those breeds was Ethan Allen, foaled in 1849, a Black Hawk son. Ethan Allen was the fastest trotting stallion in the world in his day, earning that title at the age of eighteen by winning three incredibly fast heats against a horse named Dexter in front of a crowd of nearly 40,000 people.

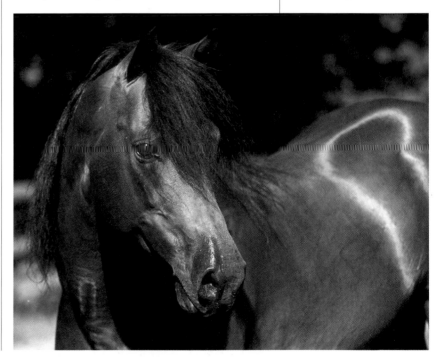

Morgans often have large dark eyes and an abundant mane and tail.

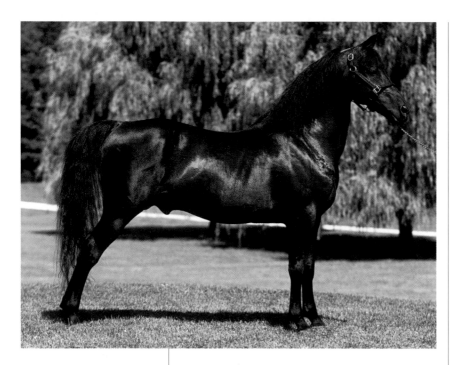

Morgans today still closely resemble Figure (Justin Morgan), progenitor of the breed.

Versatile and Hardy

The Morgan Horse played a part in the history of the United States. As more miles of good roads were developed in the young country, the breed became popular as coach horses. Many stage companies, even as far away as Chicago, chose all-Morgan teams because they were sound, fast, able to do a tremendous amount of work, and very easy keepers. They were immensely popular as light driving horses, as well as riding and ranch horses, and the forty-niners used them during the California gold rush. The Army selected Morgans to pull artillery and also as officer's mounts during and after the Civil War. The only horse to survive the Battle of Little Big Horn was of Morgan breeding.

By 1870, there were Morgans in every state and territory, used for just about every purpose anyone could imagine. At about that time, however, fashion shifted, and there emerged a desire for horses with longer legs. Morgan mares were frequently crossed on other breeds in the hopes of getting the best of both types. In time, the original style of Morgan almost vanished, but enough of them survived in small pockets, mostly on farms in Vermont, that the original type was preserved.

Breed Characteristics

To this day the Morgan breed remains sound and versatile, and a large number of the horses still look very much like the drawings and sculptures of little Figure. Morgans make excellent pleasure and driving horses, but they are also at home as ranch, trail, and endurance horses. They compete successfully in almost every discipline, from dressage and jumping to Western pleasure and cutting.

Conformation

Morgans are known for beautiful heads with an alert expression; large, wide-set eyes; and small active ears. They have a finely shaped, arched, well-muscled neck. The withers are prominent. The shoulders are long and sloping, the ribs well sprung and angled toward the rear. The distance from the withers to the floor of the chest is greater than from the floor of the chest to the ground. This exceptional depth gives the horses great staying power. The legs are not long but are sturdy with clean joints and well-defined tendons. The feet are of excellent quality.

Color

Morgans are typically bay, black, brown, or chestnut, though gray, palomino, creme, dun, and buckskin are seen.

BREED ASSOCIATION FACTS AND FIGURES

According to the American Morgan Horse Association (founded in 1909 as the Morgan Horse Club):

- Currently, 155,000 horses are registered.
- Between 3,100 and 3,400 foals are registered each year.
- The worldwide estimate of Morgans is between 175,000 and 180,000.
- The first register of Morgans was published in 1894.
- Morgans are most popular in New England, California, and Michigan.
- The breed is also popular in Great Britain and Sweden and is represented in many other countries.

Moyle

One of North America's most remarkable breeds is not a horse with a registry and a member association. They are the product of diligent breeding over many generations on one Idaho ranch. The nucleus of breeding horses on that ranch has a long history that encompasses generations of horsemen from the same family, the Mormon migration west, and a fortuitous accident.

Porter Rockwell (1813–1878), a bodyguard for both Joseph Smith and Brigham Young, had a strong interest in horses and seemed to regard it as his obligation to acquire and develop the very best for use by members of the Mormon faith. Throughout history, high-quality horses have always endowed their owners not only with prestige but also with a decided tactical advantage in any sort of conflict. Rockwell intended to exploit that advantage to its fullest extent.

He acquired the best local horses available, and he imported and later bred special horses to be owned and used only by Mormons. The original horses he bought were imported from overseas. The Mormons

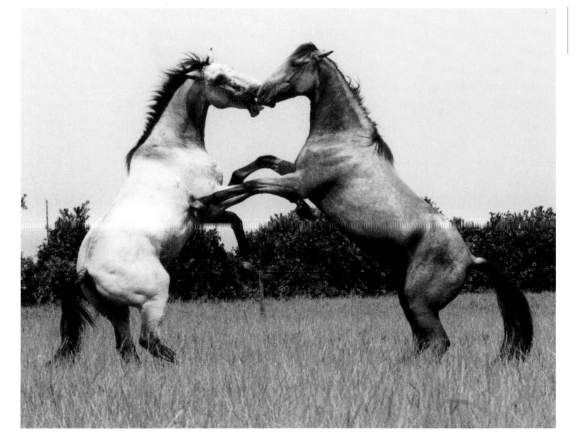

The forelegs of Moyles are far forward on the rib cage, and the back is relatively long.

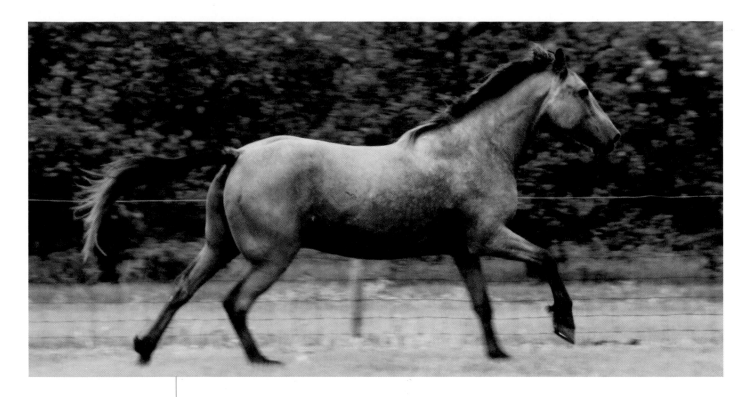

Moyles are long horses, which allows for tremendous length of stride and for excess heat to radiate easily from the body.

jealously guarded their good horses, refusing to sell or trade any breedable horse to anyone outside the faith. The horses were recognized throughout the West for their extraordinary endurance.

For a brief period in 1856, the Mormons had a contract to carry mail from Salt Lake City to Missouri. They ran their own pony express route during this period, and it may be presumed that they selected mounts from their own herds of fast, tough horses. Deteriorating relationships between the Mormons and the U.S. government caused the Mormons to lose the mail contract shortly after the service had begun. Not many years later, the short-lived but more famous Pony Express, which ran only from 1860 to 1861, somehow managed to buy at least a few of the Mormon pony express horses. Purchase documents indicate that a Mr. Kimball was paid $250 per head for Mormon horses at a time when $25 would have bought the best horse available. Quite possibly this was Hiram Kimball, who originally held the Mormon mail contract.

At some point during the era of Porter Rockwell and the Mormon migration, a rancher named Chris Hansen seized a rare opportunity. He happened to live near a route that was traveled one day by a Mormon messenger carrying an urgent message. The mare the messenger was riding began to stagger after twenty-eight miles at a full gallop. This amazed the messenger, because he had run this horse much farther than that on many occasions with no problems. Realizing he was soon going to be on foot, the desperate messenger stopped at the Hansen ranch and asked to borrow a horse, promising to return it and pick up the mare at a later date.

Hansen recognized the opportunity to acquire one of the special horses, so he refused to loan a horse. He insisted on a trade. By that time in the discussion the mare was lying down gasping, and the messenger reasonably thought she was about to die, so a trade seemed like a good idea. He violated the rule never to sell or trade one of the special horses, collected a gelding, and went on his way.

It was almost immediately apparent to Hansen that the mare was extremely winded because she was heavy in foal. She recovered from the long gallop, and in about a month she produced a filly, which

was given to Chris Hansen's sixteen-year-old daughter. About two years later, this girl married into the Moyle family. One of her sons was Rex Moyle, who later developed the present-day Moyle Horses. The filly became an excellent broodmare, producing sixteen foals, the foundation stock for the Moyle family ranch horses.

This line of horses is distinctive in several ways. One of their truly unusual characteristics is a pair of little bony knobs above the eyes, larger in some horses than in others. Although everybody calls them horns, these knobs are skin-covered bony protuberances, much like very small versions of the horns on a giraffe. The formal name for them is **frontal bosses.** These "horned" horses were also known for incredible endurance. The Moyles used them primarily as working ranch horses. On most ranches in that area, a cowboy would typically have a string of eight to ten horses. On the Moyle ranch, cowboys had one horse and were often able to outwork anybody in the neighborhood.

Dilution and Revitalization

An unfortunate political event for the Mormon horse bloodlines occurred around 1900, when Utah passed a law that made it a felony to keep a stallion that was not a registered purebred. As a result, the lines of horses Rockwell had so carefully and successfully bred were crossed only on registered breeds and ultimately nearly bred away. By the 1930s they were few and far between, and the line of ranch horses that had come from the original mare had been diluted to almost nothing. The strain of horses first bred by Porter Rockwell had almost disappeared after his death.

Recognizing that they needed to revitalize the ranch breeding stock, and knowing that the stock had come from Mormon lines, Rex Moyle went to the mountains near Salt Lake where the Mormons of Rockwell's era had grazed some of their best horses. He looked at hundreds of

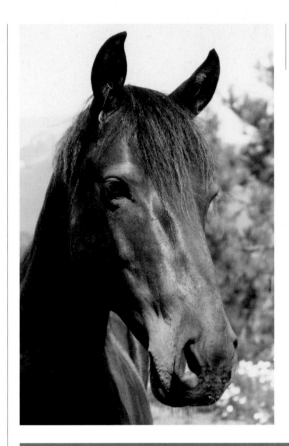

A frontal boss, or "horn," can just be seen above this horse's right eye.

"HORNED" HORSES

Two other horse breeds in the world (as well as a smattering of incidental reports about individual horses) are known to have "horns." All the horned horses seem also to be noted for extraordinary endurance.

One of these breeds is actually a strain, possibly the purest strain, of Andalusians, those that were bred by Carthusian monks in Spain beginning around 1400 CE. The monks' herd of Andalusians was dispersed in 1835. They were said to have been sold to carefully selected Andalusian breeders, but the time frame for this dispersal puts it just slightly ahead of Porter Rockwell's horse-breeding efforts. Possibly these "selected" Andalusian breeders sold some of these horses or their offspring. Genetic tests done on Moyle horses in 1990 show that they do carry markers in common with Andalusians, so perhaps there is kinship with the Carthusian horses.

The other "horned breed" is the ancient Datong of China, known as the Dragon Horse. Only royalty could own these horses; commoners were forbidden to have them. They were alleged to have incredible endurance. There is some speculation that a genetic chain runs from China's ancient Dragon Horses through Asia, then to the Carthusian Andalusians, on to the Mormon horses, and finally to the Moyles. If this long, winding chain exists, it remains unproven.

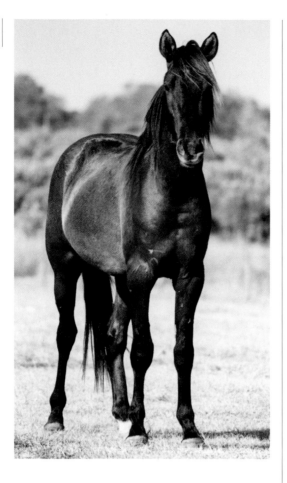

captured Mustangs and found a few mares that resembled the type that his family had long used. He took these back to the ranch and bred them carefully to build up the herd. To avoid excessive inbreeding, he made some outcrosses to a Cleveland Bay stallion. He continued to produce horses of excellent endurance, many of which exhibited the strange bony knobs on their head.

Excelling in Endurance

In the 1960s the Moyles began to compete in endurance rides. One of their first competitive horses was an eleven-year-old mare, which they broke to ride in August. She was taken on an 83-mile ride that Labor Day by a twelve-year-old Moyle son and won the ride. The other Moyle entrant came in sixth.

BREED ASSOCIATION FACTS AND FIGURES
No breed association or registry exists at this time.

In 1962, a Moyle Horse was entered in the grueling 100-mile Tevis Cup and finished sixth. In 1964, the family took three horses to the Tevis Cup, two of which were unconditioned for endurance riding but had been used consistently for ranch work. The third had just been broken to ride about two months before the competition. Because of extreme heat, the Tevis Cup was so difficult that year that half the entrants failed to finish, but the Moyles finished second, third, and fourth.

One of the Moyles' horses, Sweet Pea, was hauled 3,000 miles to Pennsylvania a week after the Tevis Cup. Less than a month later, she won the Vermont 100-mile trail ride. A week after that she was grand champion in all divisions of a 50-mile, seven-hour contest in Maryland. During all of this she managed to gain condition on good hay and less than three quarts of grain a day.

In 1983, Marge Moyle won the best-condition award on a five-day, 250-mile ride with her horse Hawk, who was then fifteen years old. Hawk completed more than 5,000 competitive endurance miles in five years and is in the Endurance Horse Hall of Fame.

Breed Characteristics

In addition to the peculiar "horns," Moyle Horses have unusual freedom of movement in the shoulder. The foreleg is placed extremely far forward on the rib cage. The back has long muscles, well suited for carrying a saddle. The hindquarters are long and elastic. All muscling is long and smooth. The skin is thin but tough and covered with a dense coat.

The feet are large, wide at the heel, and very tough. The walking stride of the Moyle is exceptionally long. Many of the horses do not have chestnuts. The liver and the spleen of the Moyle are said to be nearly twice the size of those of other horse breeds. This would greatly enhance their ability for both sustained effort and quick recovery.

Mustang

No other horse is quite as American as the Mustang. The genuine history of these horses is often so overshadowed by folklore, however, that most people are unaware how deeply these tough, enduring horses reflect the history and influences of the many nationalities and peoples that came west or were forced to confront westward expansion. The American Mustang, just like the American people, is an amalgamation of

HEIGHT: 13.2–15 hands, average about 14.2

PLACE OF ORIGIN: North America, particularly the Great Plains

SPECIAL QUALITIES: Toughness, cleverness, adaptability

BEST SUITED FOR: Trail riding

everything that went before. The word *Mustang* comes from the Spanish *musteño,* meaning stray, which in turn comes from the Latin *mixta,* meaning mixed animals. Mustangs are exactly that: mixed strays, or mongrels.

Christopher Columbus brought the first load of horses, five broodmares and twenty stallions, to the New World in 1493. From that point on, horses were carefully and selectively bred with great success on the islands of the Caribbean. By 1501, one ranch on Hispaniola had sixty broodmares. For a while, Spain continued to send mares and stallions to the Americas, but it needed horses for military purposes at home and

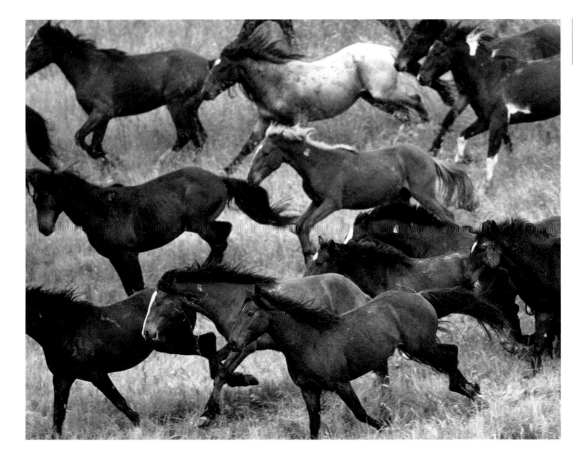

You cannot look at Mustangs without thinking of the Old West.

stopped exporting them as soon as breeding capacity in the New World reached sustainable levels.

The first imports to the Caribbean included some very fine animals along with many very average ones. The Caribbean herds quickly expanded, and it was not long before horses were exported directly from the Caribbean islands to the United States, Mexico, and Central and South America. The Conquistadores preferred the island-bred horses because they were easier and quicker to obtain and also because they tolerated the climate better than did horses coming directly from Europe.

Not pretty but typical, the mare's profile is long and slightly convex. She has good bone. This is the most common type, one that has done well in North America since the late 1500s.

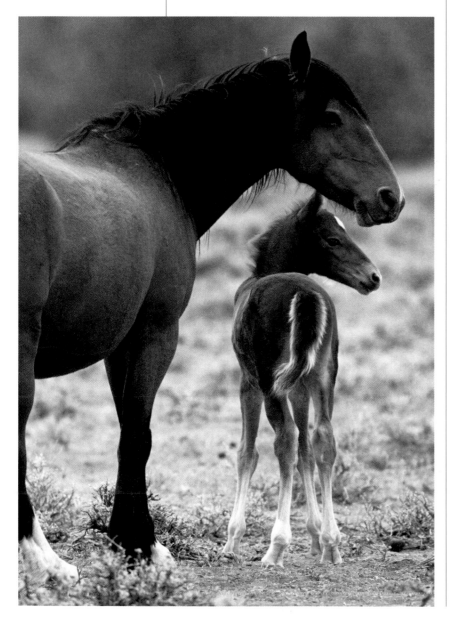

A shipment of fifty horses arrived in Florida with Ponce de León in 1521. The Indians promptly ran off the settlers, who left behind their horses. Eighty more horses arrived in Florida in 1528. Eighty-nine horses were brought to the coast of South Carolina in 1526. DeSoto arrived in what is now Tampa Bay with five hundred men and three hundred horses in 1539. By that time there were already horses on the Outer Banks and possibly in other parts of North and South Carolina, offspring of horses that had been left in the 1520s when a Spanish colony was abandoned. By 1541, Cartier had landed with twenty horses at the future site of Quebec. Thus, in about twenty years, horses were introduced along a two-thousand-mile coastline that was rich in grasslands and fresh water and quite suitable for the species. The total number of horses actually brought to these shores in that time period was probably fewer than six hundred animals.

Quite early in the Spanish conquest, there was also a tremendous surge in horse numbers in Mexico. The first real economic boom in Mexico occurred with the opening of large silver mines. With the mines providing the market and the money, cattle ranching began in earnest on the Mexican high plains, requiring large numbers of horses. Everywhere the Spanish went, even as explorers, they were driving livestock, first as a food source and then to establish herds as settlements were formed. For this reason, "cow sense," already present in the Spanish horses, was consistently selected for as the Spaniards became ranchers.

In the mid-1560s, Francisco de Ibarra took horses and cattle to the fertile river bottoms and grassy plains of the regions now called Durango and Sinaloa in Mexico, where the numbers of both horses and cattle increased dramatically. Ibarra dared to cross the Sierra Madre range, a trip so difficult that thirty-eight horses froze to death along the way. He founded a town that lasted for two years, but ultimately the settlers were run out by Indians and were

forced to leave behind horses and cattle. When, two decades later, Hernán de le Trigo tried to reestablish the lost province, he was astonished to find more than 10,000 horses and cattle grazing on the plains. From that point on, the numbers exploded.

Despite the best efforts of white men to stop them from achieving the advantage of learning how to ride, the Indians rapidly became familiar with horses. They stole horses or caught them, traded for them with other tribes, and won them in battle. Some tribes, notably the Apache and the Kiowa, became some of the finest horsemen in the world. By 1687, when one of the first Spanish expeditions crossed the Rio Grande from Mexico into what is now Texas, they encountered Indians mounted on horses. The Indians traded horses extensively with each other all the way from the Rio Grande to what is now western Canada, and also with the French and the English when they were able to do so. All Indian tribes that came to have horses were mounted by 1710.

By the 1620s, horses were also coming to this country from England and Sweden and then from Flanders by 1660. France was shipping horses to New France (Quebec) by 1665. Each of these countries sent horses of the types and breeds with which they were familiar, including draft horses, saddle horses, and, fairly early on, racehorses. The northern European people were inclined to bring bigger, heavier horses than those the Spanish brought.

Horse housing and fencing were rare in the early days, so there were plenty of loose horses. By the 1690s, their numbers increased so successfully that large, free-ranging bands of horses had become an agricultural problem in Virginia. By that time, huge herds were also ranging on the western plains, most originating from the vast herds in Mexico. By 1700, there were very large herds of horses both in the Southeast and in the West. Initially the ancestry of both groups was largely Spanish, but as time passed it became increasingly mixed.

Also at that time, horses were being exported in large numbers from Canada to New England for sale to the sugar plantations of the West Indies and for use in the "western territories" of Detroit and Illinois. Many loose horses in central Canada also made it into the wild horse populations of the Mississippi Valley and ultimately to the western herds. Quite soon there was a strong genetic influence from the Canadian breeds and types, the ancestry of which usually traced back to France.

In addition, large numbers of horses were taken everywhere as military transport. Some were sold, some traded and stolen, and some escaped or wandered off all along the way. Later on, horses provided much of the pulling power for the huge migration west, and those horses also wandered off or were stolen from time to time. The grasslands of the western plains were ideal for horses, so the equine population boomed.

As time passed, the Mustang herds became a blend of every type of horse that was ever brought to or bred in this country, Canada, or Mexico.

BREED ASSOCIATION FACTS AND FIGURES

Many organizations register Mustangs, BLM horses, Spanish Mustangs, and Spanish Colonial Horses. The following information was compiled from several sources:

- In the 1800s, the estimated population of Mustangs ranged from 5 to 10 million.
- Around 1900, the estimated population was two million wild horses in the United States.
- By 1926 that number had been cut in half, and by 1935 there were estimated to be only 150,000.

As of February 2002:

- The estimated population of wild Mustangs was 34,496.
- 10,822 were removed for adoption.
- Of those removed, 5,987 were adopted.
- About 8,500 remain in long-term holding facilities.

In western Canada:

- There are an estimated 300 wild Mustangs.
- "Sport" shooting of these animals is allowed on private land.

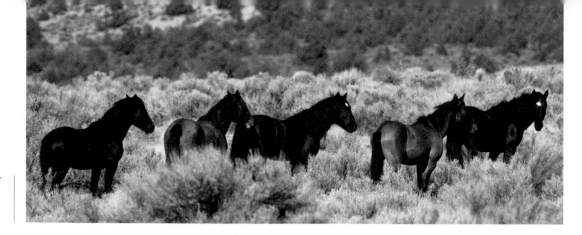

Mustangs are as much a part of our heritage as the land. Some must always run free.

Mustangs in the West

In the 1850s, the westward migration was in full swing, as was the attempt to eradicate all native peoples and their horses. When the U.S. Army did not kill the Indian horses outright, in an attempt to slow down the better-mounted Indian tribes it turned out particularly coarse draft stallions to run with Indian pony mares, producing large, heavy-boned, coarse offspring. From the late 1800s to the early 1900s, the U.S. government bought 150 East Friesian stallions each year. These were heavy-boned coach horses, suitable to cross into cavalry herds to produce animals to pull heavy wagons or artillery. Everywhere the Army went, horses with a good bit of East Friesian blood also went. Many of these horses also eventually ran with the wild herds.

SPANISH TRAITS

Some, but not nearly all, modern Mustangs show decided Spanish traits, notably the characteristic head, arched neck, comparatively narrow chest, short back, low tail set, fairly well-angled croup, pasterns of good length, and well-formed upright hooves of extreme hardness. Such Spanish-type Mustangs are considered by contemporary horse historians to form a separate subgroup of Mustangs. Genetic testing has confirmed their close kinship to the early Spanish horses. A couple of particularly interesting small pockets of horses, the Cerbat (see page 94) and the Kiger Mustang (see page 146), have been discovered since the 1970s in Arizona and Oregon and have been proved by genetic testing to be virtually uncontaminated links to the original Spanish horses. See also the Pryor Mountain Mustang (page 209). A small herd of free-ranging Nokota horses (see page 192) on park service land also has Spanish traits. It is quite possible that the tiny, very isolated populations of wild Mustangs in western Canada will also prove to have strong, nearly direct links to Spanish ancestry.

As ranches became established in the West, ranchers increasingly saw wild horses as competitors with cattle, sheep, and domestic horses for available grazing. They particularly despised wild stallions because they ran off with or bred ranch mares. For these reasons, wild horses were routinely rounded up and sold for slaughter, run off cliffs, and shot. These brutal activities continued until the Wild Horse Protection Act of 1971 gave responsibility for the management of wild horses on public lands to the Bureau of Land Management. Today, the Bureau of Land Management (BLM) manages nearly all of the free-ranging herds on public lands in the United States. Excess horses are periodically rounded up and made available for adoption.

Breed Characteristics

Mustangs are wiry and tough and generally have strong, very hard feet. They are known for their endurance, and many make excellent, athletic ranch horses. Some still are naturally smooth-gaited, displaying an ambling middle-to-fast gait.

Conformation

Although horses showing decided draft characteristics can still be seen in Mustang herds, the type that predominated, shaped by the environment, was small, ranging from about 13 to 14.2 hands. A 15-hand Mustang is still considered to be quite large.

Color

Mustangs come in an enormous variety of colors, reflecting the genetic contribution of many breeds.

National Show Horse

I n 1981 Gene LaCroix, an Arabian horse trainer from Arizona, had the idea to develop a new horse registry and ultimately a new breed that would combine the best qualities of both the Arabian and the American Saddlehorse. Horses that were blends of the two breeds had long been winners in the show ring, but the cross did not have a name of its own. The National Show Horse Registry (NSHR) was established in August 1981.

The ideal horse was to have the Saddlebred's extremely long neck, high-stepping action, and exceptional show presence combined with the Arabian's beauty, refinement, and stamina. With LaCroix as the force behind it, and the obvious beauty and sparkle of the horses in the show ring, the breed caught on quickly. The founders of the new registry wisely developed a lucrative system of prize money that provided incentives for exhibitors to show their horses. In its first show, in 1984, the NSHR awarded more than $100,000 in prize money.

Initially the NSHR offered a period of open registration from both breeds in

HEIGHT: Not specified by breed standard

PLACE OF ORIGIN: Arizona

SPECIAL QUALITIES: Beauty, presence, brilliance, and stamina

BEST SUITED FOR: Showing under saddle and in harness

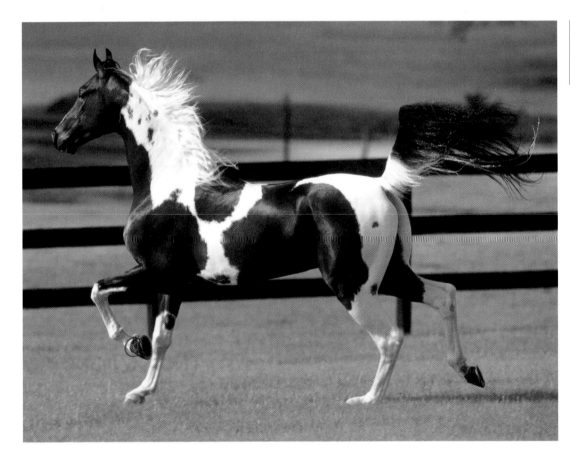

The pinto pattern, which was passed on to this National Show Horse, comes from the Saddlebred side of the pedigree.

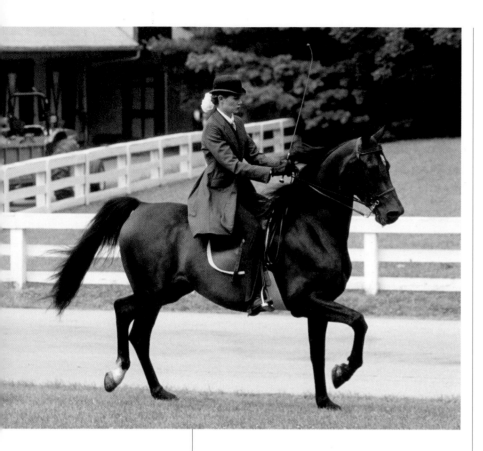

The horses are most often exhibited in saddleseat classes.

mare. Any combination of the three breeds may be used, as long as the foals produced meet the requirement of having from 25 to 99 percent Arabian blood.

Breed Characteristics

When observed either at rest or in motion, the National Show Horse must exhibit a natural presence, and when in motion show extreme brilliance. The motion is balanced with obvious power flowing from the hindquarters to an elevated front end, with the front legs showing both flexion and extension.

Conformation

A particular height is not specified by the breed standard, but Arabians range from 14 to 15.2 hands and Saddlebreds from 15 to 17 hands. The National Show Horse has a relatively small, refined head with large eyes; small, well-placed ears; and a straight or slightly concave profile. A Roman nose or convex profile is not desirable. The neck is very long, relatively upright, and set high on the shoulders, with a fine throatlatch. The neck should be well shaped but without a pronounced crest. The withers are pronounced. The shoulders are very deep and well laid back.

The back is proportionately short and closely coupled, with long hips and a relatively level topline. The natural and flowing tail is relatively high set. The legs are correct from all angles, with long forearms and short cannon bones and long and well-angled pasterns. There is refinement of bone but plenty of substance, especially in the chest, girth, shoulders, and hips.

Color

As with height, the NSHR breed standard does not mention color. Registered Arabians may be bay, gray, black, chestnut, or roan with white markings on the face and legs, but no pinto coloring. Saddlebreds, on the other hand, come in all colors, including pinto and palomino.

order to develop a set of horses to be used as the foundation for the new breed. Since then the rules have become more restrictive regarding which horses may be used for breeding. Eligibility for registration requires that a foal be sired by an NSHR-nominated sire. A nominated sire must be a registered Arabian, a Saddlebred, or a National Show Horse, and the owners of the stallions must have nominated their horses to the NSHR and received approval prior to breeding.

Breeders may use registered mares of any of the three foundation breeds to produce NSH foals when crossed with an NSHR-approved stallion appropriate for that

BREED ASSOCIATION FACTS AND FIGURES

According to the National Show Horse Registry (founded in 1981):

- Currently, 14,760 horses are registered.
- About 350 foals are registered each year.
- National Show Horses are found in all parts of the country.
- The NSHR was the first registry to offer a performance-based scholarship program for its Youth Equitation competitors.

In this horse, the Arabian side of the family tree is more apparent.

Sometimes the Saddlebred's long neck, elegant head, and powerful shoulders can be readily seen.

Nokota

HEIGHT: Traditional Nokotas, 14–14.3 hands; Ranch Nokotas, 14.2–17 hands

PLACE OF ORIGIN: North Dakota

SPECIAL QUALITIES: Tough, intelligent, sound horses of Spanish ancestry

BEST SUITED FOR: Pleasure and trail riding, endurance racing, ranch work, dressage, and jumping

The Nokota Horses from the southwestern corner of North Dakota have close ties to Sitting Bull's horses. They are a distinct type that once ran wild in the Little Missouri Badlands. When cattle ranching expanded north into the area in the late 1800s, wild horses were plentiful. This was an era of open-range grazing; there were no fences, so domestic horses were often turned out to breed among the range bands. Whatever the bloodlines of the domestic horses, they were incorporated into, and therefore had influence on, the wild herds. Theodore Roosevelt ranched in the area at the time, and he was thoroughly familiar with the horses, according to his own writings.

Many of the early ranches acquired and bred local "Indian Pony" or "Spanish" mares, exported from the Southwest, to Thoroughbred, draft, early Quarter Horse, and harness-bred stallions to produce tough, all-purpose horses. The huge HT Ranch near Medora was typical of this approach. The HT bought sixty Sioux mares during the summer of 1884 from the Marquis de Mores, a French entrepreneur, who had purchased 250 head, including all of the mares, from Sitting Bull's confiscated herd which was originally sold at Fort Buford in 1881. Some of the HT mares had visible bullet wounds from their lives with the Hunkpapa Sioux, who had fought in the Battle of Little Big Horn in 1876. Interestingly, the HT Ranch also purchased the great Thoroughbred stallion Lexington from Kentucky, and they crossed him on some of the Sitting Bull mares.

In the early twentieth century, bands of wild horses continued to run in the area, but they became the targets of political and emotional issues — and guns. Local ranchers wanted to limit any grazing competition between their cattle and the wild horses, so they often rounded up the horses, took some for using horses, and sold the rest for slaughter or shot them for "sport." After the drought and the Great Depression of the 1930s, federal and state agencies, under great pressure from cattlemen to prevent future dust bowls, cooperated with ranchers to eradicate wild horses from western North Dakota. During the 1940s and 1950s, most of the remaining bands of horses were shot from aircraft or rounded up and sold for slaughter.

Meanwhile, also during the 1940s, the Theodore Roosevelt National Park was being developed, and a few bands of wild horses were accidentally enclosed within the 70,000-acre park's perimeter fence. By 1960, these were the last surviving wild horses in North Dakota. The National Park Service continued to try to eliminate the horses, and it also fought for exemption from the federal laws that were passed in 1971 to protect wild and free-roaming horses and burros. The park service won that battle, and today it is not subject to the laws and regulations governing wild-horse management on public lands.

Public opposition to the removal of the horses and a growing understanding of their importance in the history of the area led to a change in policy in the late 1970s. Since then

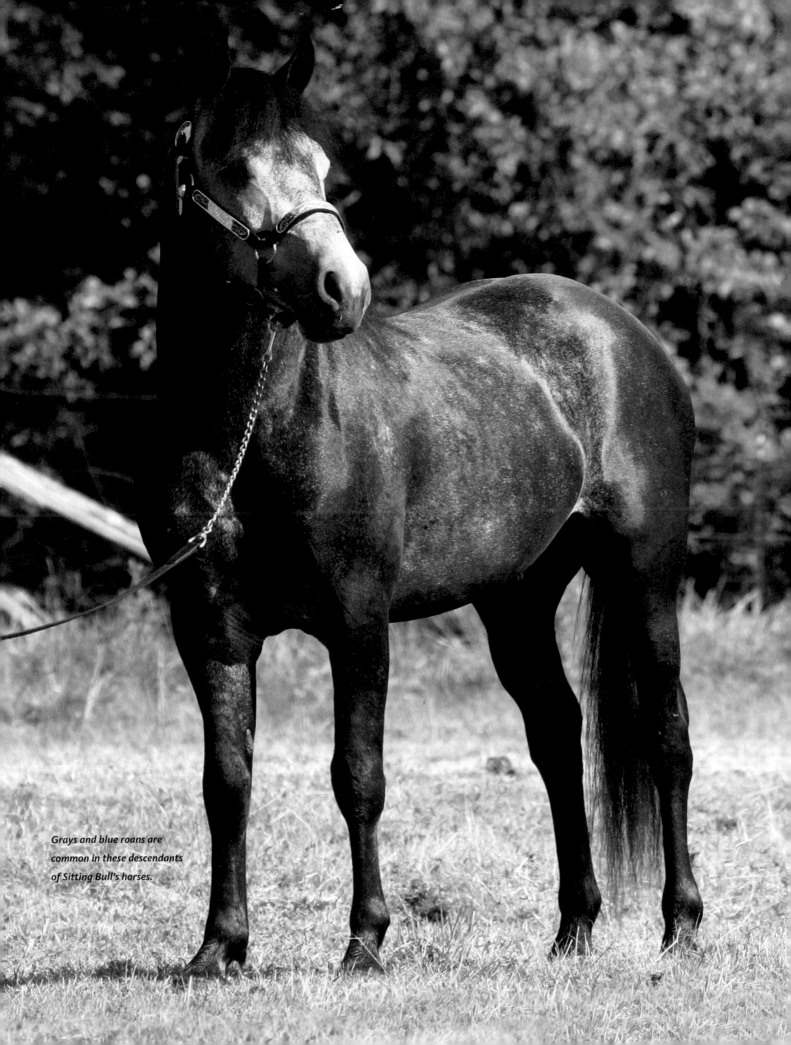

Grays and blue roans are common in these descendants of Sitting Bull's horses.

The athleticism and staying power of the Nokotas has earned them fame in endurance races.

the park has managed a "historical demonstration herd." Sadly for those interested in preserving the original type and lines of horses, in the 1980s the park's administrators decided to modify the appearance of the horses by adding outside bloodlines. The dominant stallions in the park bands were either shot or removed. They were replaced with an Arabian, a Quarter Horse, two feral BLM stallions, and a part-Shire bucking horse. At about the same time, several large roundups were held and many of the park horses were sold at auction.

Rescue and Revival

Concerned about the future of these horses, Leo and Frank Kuntz, of Linton, North Dakota, began buying as many of the original park horses as they could. They had become interested in them after purchasing

DAKOTA NATION

The Dakota Nation originally consisted of native people who inhabited the northern forests along the upper Mississippi River. It was divided into three groups: the Dakota, the Nokota, and Lakota. The Nokota moved west to what are now South and North Dakota.

a few for breeding and for use as cross-country racehorses. The Kuntz brothers became convinced that the horses were a unique and historical type, and they had high respect for their endurance and agility. Researching the origins of the horses, they discovered that the Marquis de Mores (who founded the town of Medora, right where the park headquarters were later located) had purchased and range-bred Sitting Bull's confiscated Indian ponies. The Kuntzes grew to believe that Sitting Bull's horses were related to the herds of horses that later were enclosed within the park.

Since their discovery of the link to Sitting Bull's horses, the Kuntz brothers have devoted their lives to preserving this strain, which now survives on their ranch near Linton. The breed name reflects this history of both the land and the horses on it. Until the Nokota Horse Conservancy was founded in 1999, the Kuntz brothers were the only force standing between these special horses and extinction.

In 1994, Dr. Phillip Sponenberg evaluated the park horses and the Kuntzes' horses and concluded that about twenty animals owned by the brothers and, sadly,

none in the park, were phenotypically consistent with accepted standards for Spanish Colonial Horses. Since that time, Leo Kuntz has selectively bred those animals to maintain their Spanish characteristics.

Indian people and others urged the state of North Dakota to designate the Nokota Horse the Honorary State Equine, which it did in 1993.

Breed Characteristics

The Nokota Horse Conservancy reports that these horses look a great deal like the horses that belonged to the Northern Plains Indians of the late nineteenth century, a type that was larger and rangier than the horses of the southern Plains. It was a type often painted by the great Frederic Remington, and its outline is also that of the Spanish Colonial Horses.

Nokota owners describe their horses as intelligent, quick to learn, kind, and versatile. Nokotas are used for endurance racing, ranch work, and all Western sports, and a few have found their way into dressage, show jumping, eventing, and foxhunting. Many of the horses exhibit a smooth amble, which was once known as the Indian shuffle and was prized for its comfort by riders in the old West.

Conformation

According to the Nokota Horse Conservancy: "Nokota Horses look much like the northern Plains Indian horse of the late nineteenth century, a type that was rangier and larger than the horses of the southern plains. As a group, they are quite consistent in terms of conformation. Nokota Horses tend toward a square-set, angular frame, tapering musculature, V-shaped front end, angular shoulders with prominent withers, distinctly sloped croup, low tail set, strongly built legs, and Spanish Colonial pigmentation. Their ears are often slightly hooked at the tips. Beyond such commonalities, there exists a range of variation, creating several different subtypes."

TRADITIONAL NOKOTA

This subtype tends to be smaller and somewhat more refined and to exhibit more concentrated "Spanish Colonial" traits. These animals are known by the Nokota Registry as National Park Traditional, or NPT, horses.

RANCH-TYPE NOKOTA

This subtype reflects "a history of interbreeding between Spanish/Indian animals and other early ranch strains, of both saddle and utility types," and resemble early foundation Quarter Horses. Known as National Park Ranch, or NPR, horses, these are the living descendants of the old ranch hybrids. They possess many of the characteristics of the traditional horses, but also exhibit some traits that were common in popular domestic breeds of the time, such as the Thoroughbred and the Percheron.

Color

Nokotas are frequently blue roan, which is rare in most populations of horses; other common colors are black and gray. These colors are all associated with Spanish and Indian breeding. Less common colors among the Nokota include red roan and bay. Chestnut, dun, grulla, and palomino occur occasionally. Blue eyes and both the overo and **sabino** color patterns are not uncommon. The sabino color pattern has not been well studied. It comprises a wide array of variations, from near solid to extremely roaned, speckled, or patched, all the way to apparently solid white, including everything in between.

BREED ASSOCIATION FACTS AND FIGURES

According to the Nokota Horse Conservancy (founded in 1999):

- The Nokota Horse Registry has been established with several categories for the various types of Nokota Horses.
- The conservancy currently tracks 1,000 horses, both past and present.
- While the majority of Nokotas reside in North Dakota, they can be found in many other states, such as Pennsylvania, Montana, Minnesota, and Oregon.

Norwegian Fjord

HEIGHT: 13.2–14.2 hands

PLACE OF ORIGIN: Norway

SPECIAL QUALITIES: Good disposition, sure-footedness, extremely comfortable gaits, and excellent endurance

BEST SUITED FOR: Riding, driving, packing, farmwork; excellent children's mounts and all-around family horses; successful at the lower levels of dressage, jumping, and eventing

P rimitive wild horses, very similar in type and color to those seen in cave paintings, migrated into Norway at least four thousand years ago and probably even earlier than that. There is some archaeological evidence that they were domesticated around 2000 BCE. Archaeological excavations from Viking burial sites document that the Fjord Horse has been selectively bred since about the time of Christ.

The Vikings were excellent horsemen and used the Fjord Horses as war mounts. Their horses went where they went, so the Norwegian Fjord inevitably left its genetic mark on many other breeds, notably the "mountain and moorland" breeds of Great Britain, the Icelandic Pony, and the Swedish Gotland.

The Vikings were also the first western Europeans to use horses for farmwork. As they invaded neighboring lands, plowing with horses spread. It is thought that all present-day draft breeds in western Europe descend in some part from this ancient breed.

The first organized breeding program for the Fjord began in the mid-1880s. Prior to this time the horses were somewhat smaller than they are today, averaging about 12.1 hands. At the end of the 1800s, all crossing with other breeds was stopped and since then the breed has remained pure. The first Fjordhorse Studbook was established in 1910. Today a considerable number of Fjord Horses are bred outside of Norway in Europe and in North America.

In the mid-1950s, twenty-one registered Fjords, all champions, were imported into the United States. The distinctive looks, all-around usefulness, and pleasant disposition of the horses have made them increasingly popular.

History of the Registry

The Norwegian Fjordhorse Association is the international governing body for the breed. Its goal is to unite all those interested in the breed and to encourage them to work for the common good. The organization was founded in 1949, and is divided into national, district, and local groups. The Norwegian Fjord Horse Registry maintains the registry guidelines and statistics and keeps the studbooks, including one for Fjords in North America, to trace accurate records of bloodlines and preserve genetic purity and type.

Breed Characteristics

Fjords have an excellent disposition, and they are quite sure-footed in rugged terrain. They are used in Norway for farming, forest work, packing, riding, and driving. They make fine children's mounts and fine versatile family horses. They are quite capable of succeeding at the lower levels of dressage and jumping. They are also noted for having extremely comfortable gaits and excellent endurance.

Conformation

Fjords generally range in height from about 13.2 to 15 hands, with most animals measuring between 14 and 14.2 hands and weighing between 900 and 1,200 pounds.

They have a nicely proportioned, medium-sized head with a concave profile, pronounced jaw, and width between the eyes. The eyes are large and kind, the ears small and set well apart. The nostrils are flared and open. The neck is short and well muscled. The withers are low, flat, and well muscled. The shoulders are laid back and muscular. The body is compact but deep, with well-sprung ribs. The back is short to medium length and often slightly hollow. The loin is broad and strong. The croup is rounded, sloping, and well muscled. The legs are sturdy, short, and powerful with broad, strong joints; clearly defined tendons; and light feathering at the fetlocks. The pasterns are long and sloped. The hooves are black, hard, and well shaped.

Color

The most distinctive features of the Fjord today are its color and markings. The horses are always some shade of dun — the color of true wild horses, such as the Przewalski and the Tarpan, and the color of horses in cave paintings. In addition, Fjords always have a dorsal stripe and some sort of zebra markings on the legs. The dorsal

Norwegian Fjord Horses are always dun with a dorsal stripe. They have a sturdy, muscular appearance.

The hardy Fjords can withstand extremely low winter temperatures.

With their calm, willing temperament, strength, and easily matched colors, Fjords make ideal driving teams.

stripe runs from the forelock down the neck through the middle of the mane, across the back, and into the tail. Dark stripes may also be seen over the withers.

At the present time, approximately 90 percent of all Fjord Horses are brown duns. The remaining 10 percent are either red, gray, pale gold, or yellow dun. The shade of the dorsal stripe and leg markings varies with the shade of dun. Red duns have dark reddish brown stripes and leg markings.

Gray duns have dark gray or black stripes and leg markings. Yellow dun is a very rare color within the breed. Yellow duns may be distinguished by the very light or white forelock and mane and a darker yellow dorsal stripe and markings. Although current Fjord Horses are all some shade of dun, historians note that in earlier times, the color varied.

The mane of the Fjord is very coarse and tends to stand straight up for a few inches. For many centuries the tradition has been to trim it short and in such a way as to emphasize both the nicely arched shape of the neck and the color of the mane, which is lighter on the outsides and darker in the center. The light outer hair is trimmed slightly shorter in order to clearly display the distinctive inner stripe.

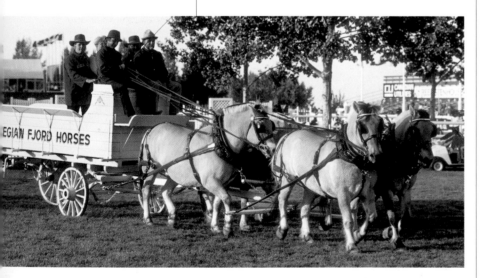

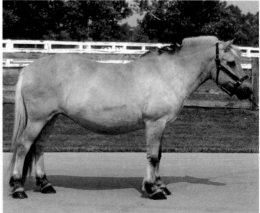

The upright mane is pale on the outsides with a dark stripe running through the center.

BREED ASSOCIATION FACTS AND FIGURES
According to the Norwegian Fjord Horse Registry (founded in 1949):
- About 5,120 horses are in the registry.
- In 2005, 390 foals were registered.
- The highest population density of Fjord Horses in North America is in Minnesota and Wisconsin.

Oldenburg

The history of the development of the Oldenburg has two "chapters." The first extends from the foundation of the breed in the mid-1570s up until World War II. The second, more modern aspect extends from just after World War II until the present time. The foundation of the breed is credited to Count Johann XVI (the Younger) von Oldenburg, who ruled the region from 1573 to 1603. He based his breeding program on the large East Friesian Horse, which he used for a foundation as he developed a lighter riding horse.

Count Johann's successor, Count Anton Günther von Oldenburg, who reigned from 1603 to 1667, solidified the breed. He controlled the state's horse industry, establishing a royal stable at Rastede as well as a network of stud farms and breeding stations. With breeding stallions imported from Spain, Turkey, Poland, and Italy crossed on the region's strong mares, the count's stock included more than one thousand riding and driving horses. He made the breed quite famous throughout Europe by both selling and giving valuable

HEIGHT: 16.2–17.2 hands

PLACE OF ORIGIN: Germany

SPECIAL QUALITIES: Power combined with a kind disposition, good movement, and an air of nobility

BEST SUITED FOR: Dressage, jumping, and combined driving

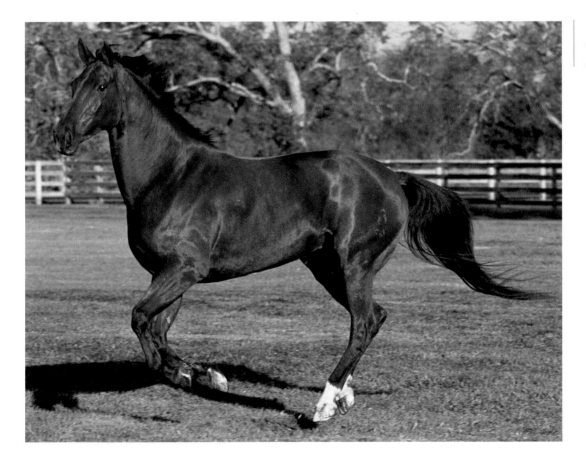

The Oldenburg has a long history as a fine light riding and harness horse.

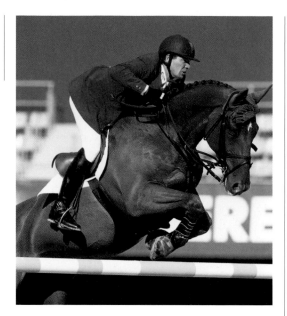

With their size, powerful gaits, and willing disposition, Oldenburgs make outstanding sport horses.

horses to important people in order to curry favor, a move that reportedly helped prevent an invasion of Oldenburg in 1623 during the Thirty Years War (1618–1648).

This marketing strategy also worked well for the people of Oldenburg. As demand for the horses rose, the fortunes of local horse breeders soared. At that time there were two types of horses: "a beautifully built and colored riding horse," meaning that the bays were bright with no smuttiness and the chestnuts were bright and clear, and a somewhat heavier yet elegant carriage horse for four-in-hands. The main colors were dappled gray, chestnut, black, and dun.

Denmark ruled Oldenburg from 1667 to 1773, and although horse breeding continued quite successfully, there came to be more emphasis on quantity than on quality. By 1784, there were more than 16,000 horses in the area, disparaged by many

horsemen of the day as "altogether nothing but Roman noses," often with eyes and ears that were too small, or as horses that seemed to have "one too many joints in their backs."

In the nineteenth century, breeding responsibility was transferred to the private sector. Unlike other breeds, such as the Hanoverian, the Oldenburg had no state stud. Local horse breeders made all selections of stallions and all breeding decisions. The farmers followed popular trends by crossing in Cleveland Bay, English Thoroughbred, and Hanoverian Horses. Some very fine stallions of these breeds were imported, and although some of these crosses apparently produced some less than desirable animals at first, the horses improved as efforts continued.

The horse breeders of Oldenburg established a studbook to register their breeding stock in 1861. Their aim was to continue to produce a heavy carriage and coach horse, despite the introduction of Thoroughbred and half-bred bloodlines. It took some time, but the breed was finally improved enough both in quality and in numbers so that by 1880 the Oldenburg was considered to be the only European breed from which large numbers of stallions could be purchased for big breeding programs elsewhere, such as those supplying horses to coaching lines.

Versatile and Adaptable

Oldenburgs drew attention in a variety of areas. The Oldenburg cavalry found them to be excellent, and they were highly valued in agriculture and in the horse-drawn mail service between Oldenburg and Bremen, one of the fastest connections in Europe until the advent of the railway in 1867. Around this time, a horse expert described the breed as follows: "The whole animal gives the impression of massiveness and power and at the same time nobility and refinement." They were reputed to be very easy keepers and easy to handle. Demand

BREED ASSOCIATION FACTS AND FIGURES

According to the International Sporthorse Registry/Oldenburg Registry of North America (founded in 1983):

- About 15,000 horses are currently registered in North America.
- Each year, 700 North American foals are registered.
- The highest population density is probably on either the East or the West Coast, but there are also many in the Midwest.

came from as far away as North America, where they were known as the German Coach Horse.

The breed continued to thrive until World War II. The war itself caused great losses in the breed, and after the war, tractors and automobiles began to replace the horses. A new type of Oldenburg was needed. Breeders quickly recognized that the days of the heavy coach and cavalry horse were over. Between 1944 and 1984, numbers fell from 55,400 to about 10,000. Ultimately the concept of the "German riding horse" came into being, calling for an elegant, correct riding horse with spirited, ground-covering movement. Thoroughbred and Anglo-Norman blood was introduced to refine and lighten the breed.

History of the Registry

In the United States, the Oldenburg Registry is maintained by the International Sporthorse Registry/Oldenburg Registry of North America (ISR/OLD NA). This organization also owns the right to the Oldenburg brand in this country, an *O* with a crown above it, the letter *N* to the left, and the letter *A* to the right.

The ISR/OLD NA reports: "The International Sporthorse Registry and the Oldenburg Registry of North America belong together. They have the same approved stallions and the Main Mare books are identical." The ISR by itself also maintains a Pre Mare book, which accepts mares without appropriate proof of pedigree from an approved registry if they have scored well during rigorous evaluation, and its own Mare book, which offers a greater variety of warmblood mares to be registered and approved.

Breed Characteristics

Today the Oldenburg is an all-purpose riding horse that is considerably finer than its coaching ancestors but still retains the coach horse's fairly high knee action. The breed makes an outstanding sport horse, combining powerful gaits with a kind disposition. It excels at dressage and show jumping. Oldenburgs are known for their kind yet bold nature. Unlike many of the other large European warmbloods, the breed matures early.

Conformation

Most Oldenburgs today stand between 16.2 and 17.2 hands. The head is of average size, with a straight or convex profile. The neck is of average length and muscular, well set on, and carried elegantly. The withers are pronounced. The shoulders are sloping and muscular, the chest deep. The back is straight. The croup is fairly flat and well muscled. The hindquarters are powerfully built. The legs are strong and proportionately somewhat short, with plenty of bone.

Color

Oldenburgs are usually bay, brown, black, or gray; chestnuts are rare. White on the face and lower legs is permitted.

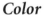

The original Oldenburg Brand.

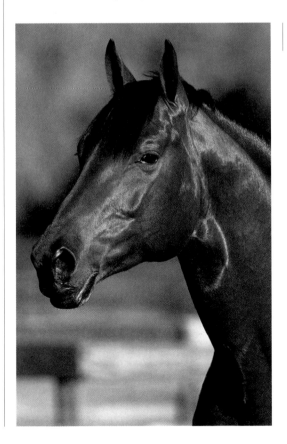

Oldenburgs are often bay, with a straight or convex profile.

Paso Fino

The name Paso Fino means "fine step," and that is indeed the hallmark of the unique, animated, four-beat lateral gait born into these traditional horses of Puerto Rico and Central and South America. Their ability to perform the gait is entirely inherited. Horses not born into the breed cannot be trained to perform it, and not every horse in the breed can do it correctly.

The remote beginnings of this breed significantly predate the importation of horses to the New World by Columbus in 1493. In ancient times, various groups of barbarians invading Iberia (Spain and Portugal) brought with them small ambling horses, some of which may have descended from ancient Celtic ponies, which were sometimes amblers. One type, the Asturian of northern Spain, which is rare but still exists, had such a comfortable gait that it was a favorite of the early Romans.

Smooth-gaited small horses became known as the Hobbeye and later the Hobby Horses of Ireland and the palfreys of England, where they were popular mounts for children and ladies. The Asturians probably comprised a major part of the foundation of the old, famously smooth-gaited Spanish Jennet, which though now extinct was common in the time of Columbus (see the profile on page 235).

Spanish Jennet mares were included in the first shipments of horses to arrive in the New World with the early Spanish explorers. Historians of South America's horses believe that the Paso Fino resulted from crossing Spanish Jennet mares, which were either true pacers or amblers, to Andalusian stallions, which were trotters. Subsequent generations were frequently crossed back to Andalusians. In addition, there is good evidence that some Sorraia-type horses (see page 148), the indigenous, small, dun-colored horses of Iberia with lateral gaits, also came to the New World with the first shipments from Spain.

The very first shipments of horses to the Caribbean arrived in what is now the Dominican Republic in 1493, and in 1509 Martín de Salazar brought the first horses to Puerto Rico. By 1550 horses were plentiful, and many equine breeding and training centers had been established throughout the Caribbean. By this time, a distinctive type of tough, smooth-gaited horse was emerging in several locations. Breeders continued to select breeding stock from Spanish Jennet, Andalusian, and Barb bloodlines. The Spanish were reputed to be the finest livestock breeders in the world, so they had the skills to produce horses of excellent quality that suited the local conditions.

Different lines of horses developed in what are now the Dominican Republic, Cuba, Puerto Rico, Colombia, and Venezuela. Occasionally these lines were crossed, but for the most part breeders preferred to preserve the horses of their own country. Over time, the breeds developed into slightly differing types depending on local terrain, use, and fashion.

The breeders from Puerto Rico developed a horse with a great deal of style that

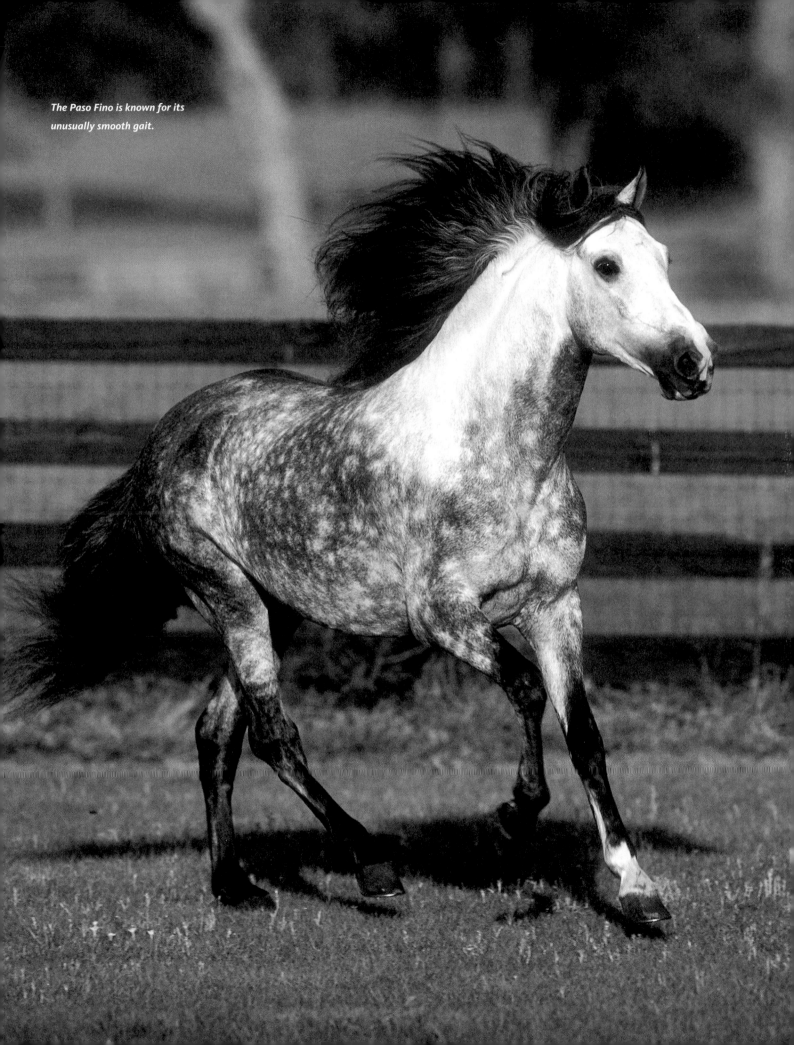

The Paso Fino is known for its unusually smooth gait.

is believed to have originally carried more Spanish Jennet than Andalusian blood. The breeders took great pride both in the appearance of the horses and in the execution of the gait, so they selected for these qualities in their breeding programs. The unique, short-strided, very rapid footfall of the classic *fino* became highly prized.

Breed Characteristics

With their smooth gait, these horses make excellent riding horses on the trail and outstanding competitors in the show ring. They have great endurance and can carry a large adult for miles without tiring. Paso Finos are also known for **brio,** which means fire, sometimes also known as *brio condido,* which means hidden fire. The horses should be very gentle in hand but show great spirit under saddle. They are easy keepers and said to have great individual personality and to be quite fond of and affectionate with their owners.

Conformation

The Paso Fino is a small- to medium-sized horse of beauty and vivacity, usually standing from 14 to 15 hands and weighing between 700 and 1,100 pounds. The head is small, with a slightly convex profile and large eyes that are spaced well apart but do not show white sclera. The lips are firm and

well shaped, the nostrils wide and flared. The neck is of medium length, upright and well arched. The shoulders are oblique and deep through the heart, the chest moderately wide. The withers are definite but not extremely pronounced. The back varies from short to long, but either an extremely long or short back may disqualify a horse from registration.

The legs are straight and delicate in appearance, with strong tendons that are well separated from the bone. The hooves are small, without excess heel. The mane and tail are encouraged to grow as long and full as possible.

Color

All solid and pinto colors and patterns are found. Appaloosa patterns are excluded.

Gait

Paso Finos are distinguished primarily by their gait, which in the show ring is performed at three specific speeds and in several styles.

In the classic **fino,** the horse is balanced and highly collected; the forward motion is slower than a walk, but the feet move with extreme speed and each footfall is clear and distinct. Only a small percentage of horses in the breed are able to perform this difficult gait correctly. In the United States, this

All colors and patterns except Appaloosa are found.

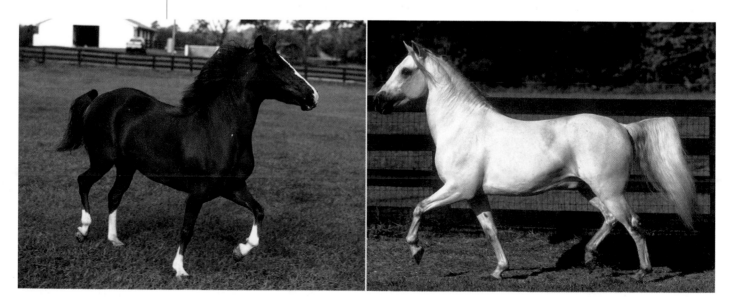

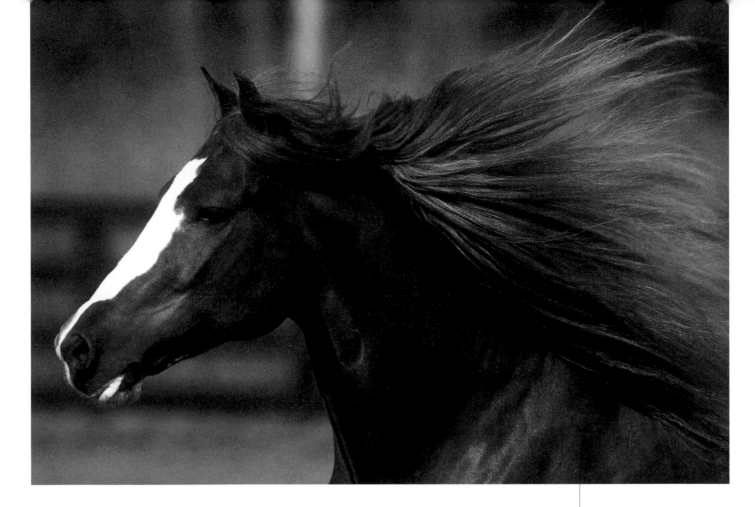

is now a gait primarily for the show ring, but historically the dons of the countries of origin found it a point of great pride to own and ride the very best classic fino stallions. These men often weighed well over 200 pounds, and the horses carried them for hours at a time as they surveyed their land. In the show ring the classic fino is demonstrated on a slightly elevated, hollow platform called the **fino** or sounding board. Individually, each horse is asked to move down the board, halt, then start again on a judge's signal. The judges use the sound to evaluate how quickly, evenly, and precisely the horses can achieve the pure gait.

The *paso corto* is a relaxed, medium-speed gait roughly equivalent in speed to a jog trot. It is the ideal gait for trail riding. Within the breed, the corto is performed in two styles: pleasure and performance. The pleasure corto is the faster and more relaxed of the two; the performance corto, as typically seen in the show ring, is a bit slower, with a shorter stride and a more rapid footfall. Hock action and drive are also stressed in the performance corto, which is elegant and exciting to watch and exceptionally smooth to ride.

The *paso largo* is the extended form of the gait. It is done at speeds ranging from a canter to a full hand gallop. For performance horses, hock action, rear-end drive, and proper execution of the gait are desirable, and there must be an obvious extension of the stride length, not just an increase in speed. Paso Finos are also able to canter and gallop.

Paso Finos exhibit remarkable spirit and beauty.

BREED ASSOCIATION FACTS AND FIGURES

According to the Paso Fino Horse Association (founded in 1972):

- 43,816 horses are registered.
- About 2,300 foals are registered each year.
- Horses registered in this country are not automatically registered in any foreign registry.

According to the Pure Puerto Rican Paso Fino Federation of America Inc. (founded in 1988):

- Today, 459 horses are registered.
- Twenty new foals are registered each year.

Peruvian Paso

The word *paso* means step or gait. The Peruvian Paso is a smooth-gaited horse from Peru whose history, derivation, and type are quite different from that of the Paso Fino of Puerto Rico (see page 202). The first horses to reach Peru with the Spanish arrived with Francisco Pizarro in 1531. These horses included Spanish stock that came from in and around the Caribbean islands, particularly from what is now Jamaica, as well as from some Central American locations, notably Panama.

Two types of horses were established almost immediately. One was an elegant type used by the highest-ranking and wealthiest individuals to practice the cultured equestrian sports that they had known in Spain. The other, considered "ordinary," was used for all other sorts of work and in the expeditions of the conquest.

During most of the 1500s, smooth-gaited horses were the norm in much of the civilized world and certainly in Spain. Because Spanish roads were rudimentary and often impassable by wheeled vehicles, a great deal of travel was done on horseback. People wanted the most comfortable ride available, so breeders selected for smooth gaits. Common ambling breeds like the famous Spanish Jennet (see page 235) were often included when horses were shipped to the New World.

During the 1600s, as networks of roads began to be built, the emphasis shifted to trotting breeds, which were faster for pulling vehicles along the new roads. The seventeenth century thus marked a historic change: at the beginning it was unusual to see a horse that trotted, but by the end, it was unusual to see a horse that did not trot.

At the same time, horse racing became extremely popular in many locations in Europe and again the emphasis shifted, particularly among the wealthy, to breed for speed rather than for smooth gaits. In time, particularly through imported horses, this cultural shift in horse types also reached the New World.

Selective Breeding

After Peru won its independence from Spain in 1823, records document that breeders imported purebred Hackney, Arab, Thoroughbred, and Friesian Horses, among others. The careful blending of several of these Old World trotting breeds with existing Peruvian smooth-gaited horses provided the foundation for the modern Peruvian, which developed quickly into three main types. The first of the three is the Coastal Horse, known as the *Costeño de Pas,* the breed we know today as the Peruvian Paso; the second is the High Altitude Coastal Horse, a breed used for cattle work in the high mountains; the third is the Andean.

AN INHERITED GAIT

Among Peruvian Paso breeders it is a matter of pride that the gait is entirely natural, never aided in any way by training devices or shoeing. In both the United States and Peru, horses are shown without shoes of any kind and always with a short, natural hoof.

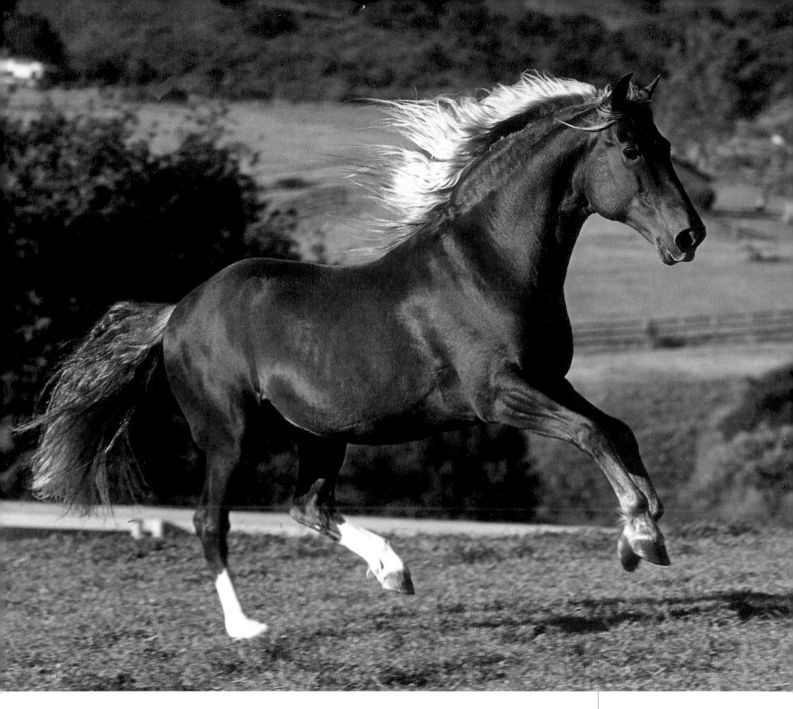

Over a period of years, widespread and indiscriminate crossbreeding nearly eradicated the traditional Spanish type. Horsemen who remembered the excellent Peruvian horses of the past, however, recognized the need to save the desired type and qualities, which they did by selecting only the ideal breeding animals.

These breeders wanted a smooth-gaited horse with endurance, brilliance, and spirit, one that was spectacular to watch but easy to handle and ride. They have been quite successful in achieving their aims.

Breed Characteristics

Today the Peruvian Paso is known as a spirited horse with an extremely soft gait, great sensitivity to the rider, a soft mouth, tremendous endurance, and the ability to adapt to various climatic conditions. Its exceptionally smooth, four-beat gait is an inherited trait. The modern breed retains its brilliant, unique action marked by high lift of the knee and fetlock combined with natural *termino,* a graceful, flowing movement in which the front legs roll toward the outside as the horse strides forward. Termino is often described as

On the Peruvian Paso the depth of the body and the length of the legs should be approximately equal.

Termino, the graceful, outward-rolling movement of the front legs, is a feature of the Peruvian Paso's smooth, four-beat gait.

BREED ASSOCIATION FACTS AND FIGURES
According to the American Association of Owners and Breeders of Peruvian Paso Horses (founded in 1962):

- More than 12,500 horses are registered.
- Thirty to 50 new foals are added each year.
- Horses registered with the American association are not automatically registered with the association in Peru.

being comparable to the arm motion of a swimmer.

Conformation

Pasos usually range in size from 14 to 15 hands and weigh between 900 and 1,100 pounds. The head of a Peruvian Paso is medium-sized, with a straight or slightly concave profile, and a small muzzle and mouth. The jaws are widely separated at the throat, moderately pronounced, and strong. The eyes are rounded, dark, expressive, and well separated; in breeding classes, **glass eyes** (blue eyes) are penalized. The ears are medium in length, with fine, slightly inwardly curved tips. The nostrils are oblong and extend easily. The neck is gracefully arched at the crest and of medium length. Compared with most light breeds, the neck is slightly heavier in proportion to the body.

The chest is wide, with moderate muscling. The long, inclined shoulders are well muscled, especially at the withers. The rib cage is well sprung, the girth and barrel deep. The length of legs and depth of body are approximately equal. The underline is nearly level from the brisket to the last rib. The back is strong, rounded, and short to medium in length. The loins are broad and well muscled over the kidneys. The croup is long, wide, moderately sloped, and nicely rounded. The tail set is low and carried straight.

The bones of the legs should be well articulated and straight, with strong, prominent tendons and medium-length pasterns that are springy but show no weakness. The cannon bones are short. The hocks are slightly more angled than are those of other breeds.

Color

Colors are bay, black, brown, buckskin, chestnut, dun, gray, grulla, palomino, and roan.

Pryor Mountain Mustang

The Lewis and Clark expedition passed through south-central Montana in 1806. One of the members of that mapping and exploration party was Sergeant Nathanial Pryor, whose name was later given to the nearby Pryor Mountains. How horses first made their way to the rugged and isolated Pryor Mountains is unclear. Some believe they were first brought there by Crow horse traders, others that they descend from horses

that escaped or were stolen from the Lewis and Clark expedition. What is clear from historical records is that they have been in the area for at least two hundred years.

In 1968, three years before the Wild Free-Roaming Horse and Burro Act extended federal protection to wild horses, the 31,000-acre National Wild Horse Refuge was established in the Pryor Mountains. Just south of Billings, Montana, and north of the Wyoming border, the refuge is adjacent to the Big Horn Canyon National Recreation area. The land ranges from arid lowlands to alpine meadows at 8,700 feet of elevation, and wild horses roam throughout depending on the season and

HEIGHT: 13–15 hands, with an average of 14–14.2.

PLACE OF ORIGIN: Pryor Mountains, on the border between Montana and Wyoming

SPECIAL QUALITIES: A gaited breed of Spanish Colonial type, showing a wide array of solid colors; many exhibit primitive markings such as dorsal stripes, shoulder crosses, and zebra stripes on the legs

BEST SUITED FOR: Trail, pleasure, endurance riding; ranch work; good choice for riders with physical limitations or a bad back and bad knees

Two members of the Pryor Mountain herd engage in mutual grooming.

A number of foals are born to the herd every year. Without the influence of any outside breeds, the Pryor Mountain Mustangs are true exemplars of Spanish characteristics in conformation, gait, and color.

the temperature. The horses tolerate winter temperatures that dip to 20 to 30 degrees below zero.

Observation always suggested that the Pryor Horses were a distinct type. When Gus Cothran, of the University of Kentucky, performed genetic testing, he confirmed both that this is a distinct population and that the horses have what are known as old genetic markers or old Spanish markers (see page 324) linking them quite directly with the early horses brought to North America by the Spanish. Furthermore, there has been very little

Although many of the rugged Pryors exhibit dun coloring and dun-factor markings, they come in a range of colors.

dilution of the Spanish markers, indicating that almost nothing else was ever crossed in among them.

The Pryor Mountain Horses are among the purest of any populations of horses of Spanish descent in North America. Typical of such horses, the Pryor Horses are smooth-gaited. Many of them, including those caught from wild herds as well as those born in captivity, will naturally demonstrate an amble, and they seem particularly to fall in to the smooth ambling gait when put under saddle. This makes them very comfortable to ride. They also fox trot.

The refuge is home to between 120 and 160 wild horses, which share it with elk, bighorn sheep, and other wildlife. In the past the horses were protected from predators, but observers have noted that mountain lions are now present and have taken a few foals.

The horses separate themselves into small herds of five or six mature animals, consisting of a stallion, a dominant mare, and several other mares and their foals. Bachelor stallions, often immature animals, follow along, joining and leaving groups from time to time.

Pure Spanish Blood

The word *mustang* comes from the Spanish word for "stray," which in turn derives from the Latin word *mixta*, meaning "mixed." Mustangs are mixed-breed strays. In the case of the Pryor Mountain Mustangs, the Kiger Mustangs, and other true Spanish Mustangs, they may have been of mixed Spanish descent two hundred or more years ago, but since that time no other horse breeds have been added to their population.

Furthermore, ever since the Pryor herd was established, all selection has been environmental, with no human intervention. The weak and unsound horses were killed or have died off in accidents. The survivors are compact, tough horses well adapted to their world.

Breed Characteristics

Well put together and attractive, Pryor horses have a reputation for excellent endurance as well as for the ability to carry weight. People familiar with them say that they carry themselves with **brio** (fire) and pride, and that their temperament is noble and kind. Pryor Horses are easily gentled and form a strong bond with their handlers. Experienced owners note that the horses have a natural wariness, which comes from their life in the wild, but that they are very quick learners and exceptionally easy to work with once trust has been established. They readily accept training as long as they are taught rather than forced, but will resist unreasonable handling.

Pryor Horses have high knee action and sometimes exhibit **termino,** swinging front leg placement (see page 208). They are sure-footed, well balanced, and athletic.

Conformation

Pryor Mountain Mustangs usually stand between 13 and 15 hands, with an average size of 14 to 14.2 in wild-caught horses. Horses born on ranches from wild-caught parents tend to be at the larger end of the size range because of better nutrition.

The conformation is typical of Spanish Colonial Horses. They have a medium to long head with a flat or slightly convex profile. As seen from the front, the forehead is wide with large, very expressive, almond-shaped eyes, and the face tapers to a fine muzzle. The medium-length neck is slightly thick and the body somewhat narrow but deep. The shoulders are generally long and sloping with distinct withers.

The back is fairly short. Some Pryor Mountain horses have only five lumbar vertebrae, or the fifth and sixth vertebrae are fused. Many of the horses have the typically Spanish sloping croup with a low tail set. The horses have substantial, dense bone. The chestnuts are very small or absent. The feet are of good size and extremely hard.

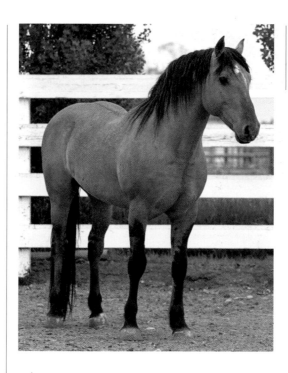

Pryor Mountain Mustangs often exhibit primitive markings such as zebra stripes on the legs.

The mane and tail are long, full, and silky, and the winter coat is extremely thick and curly.

Color

Pryor Horses exhibit a wide variety of solid colors, and many of the horses have "primitive" markings, such as dorsal stripes, shoulder crosses, and zebra stripes on the legs, sometimes extending as high as the gaskins. There are various shades of grulla and duns in many shades, from apricot and claybank to golden, as well as red and blue roans, palominos, and true blacks.

White markings on the face and lower legs are minimal if they occur at all. Pintos and grays are virtually unknown.

BREED ASSOCIATION FACTS AND FIGURES

The Pryor Mountain Breeders Association was started in 1992 to establish and preserve a gene pool. The breeders association also strives to demonstrate the versatility, endurance, and intelligence of Pryor Mountain Mustangs.

- As of 2004, there were 164 horses registered with the association.
- The horses are found in 11 states: Montana, Wyoming, North Dakota, Idaho, Oregon, Missouri, Illinois, Massachusetts, South Dakota, Utah, and Florida.

Racking Horse

HEIGHT: 15.2 hands (average)

PLACE OF ORIGIN: Southern United States

SPECIAL QUALITIES: A natural rack, stamina, willingness, and versatility

BEST SUITED FOR: Pleasure riding, trail riding, bird-dog field trials, and showing

Racking Horses have been popular, especially in the deep South, since before the Civil War. Plantation owners valued the smooth, rapid gait (the **rack**), which could be maintained comfortably for hours, and admired the breed's stamina, calm disposition, handsome good looks, willingness, and versatility. In addition to carrying riders, the horses performed various farm duties, including pulling buggies and plowing.

About the time that horse racing fell into disfavor in the South in the late 1800s because of gambling, showing horses became increasingly popular and Racking Horses appeared at small country shows in large numbers, often the most numerous breed or type represented. They made their way to bigger shows as well, though they did not have their own breed association and registry until 1971. Several years of hard organizational work by a group of Alabama businessmen then paid off, and the U.S. Department of Agriculture finally recognized the Racking Horse Breeders Association of America.

History of the Association and Registry

When the association was formed, one of the objectives was to create an organization that would serve the needs of the amateur horseman doing his own training at home. To this end, it was decided that the general membership would always have a voice in the decisions of the organization.

Initially, eligibility for admittance to the registry was determined by the performance of the gaits natural to the breed. Horses of all ages could be registered by gait performance alone. Once a large enough base of horses joined the registry, the eligibility rules became more restrictive. Today, foals must be gaited and must also be the offspring of two registered Racking Horse parents. Because of the careful selection procedures and insistence on gait, the rack occurs naturally in this breed; the horses are not trained to do it, as they are in some other breeds.

The Racking Horse breed came into being at a time when there were no shows being organized for pleasure riding horses. At Walking Horse and gaited horse shows, only horses with built-up shoes and tail sets were seen. Because the Racking Horse organization has always supported the amateur breeder, rider, and trainer, this

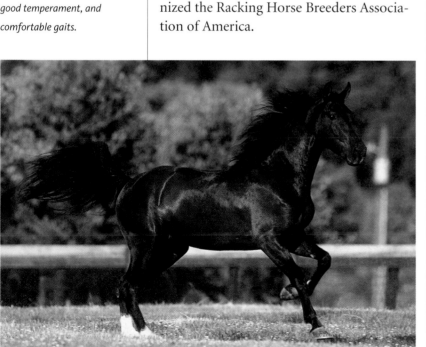

The Racking Horse has a handsome appearance, a good temperament, and comfortable gaits.

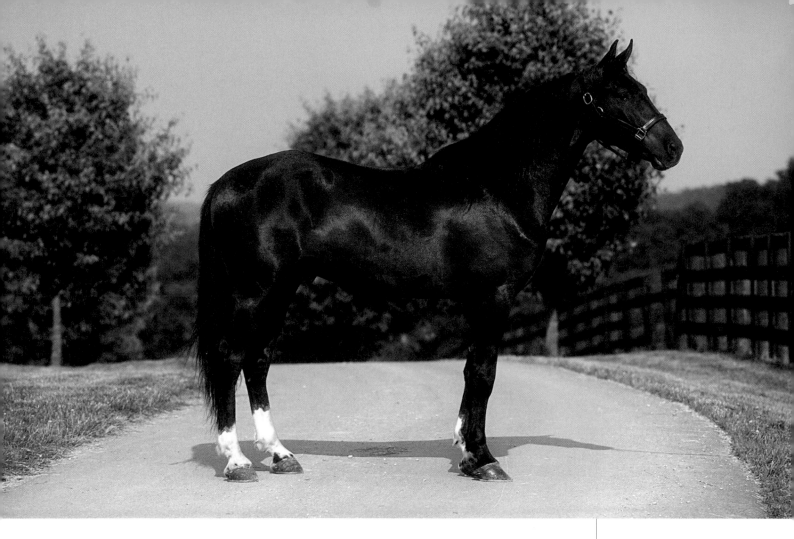

breed has always been shown without artificial devices, extreme shoeing, or tail sets.

Breed Characteristics

Known for their calm temperament, intelligence, and willingness to learn, Racking Horses are popular in the show ring and on the trail. Racking Horses are shown under saddle, in harness, and in hand. They can perform a smooth fast rack for long periods of time. The breed's earliest origins trace back to the Walking Horse, but the gaits of the two differ.

Conformation

These horses average about 15.2 hands and weigh about 1,000 pounds. They are attractive and gracefully built, with long, sloping shoulders, a long, slightly arched neck, full flanks, a moderately sloped croup, and a medium tail set. The horses are known for having good bone and well-constructed legs. The hair coat is fine.

Color

Racking Horses may be black, bay, sorrel, chestnut, brown, gray, palomino, or pinto (known as "spotted" within the breed).

Gait

The gait of the Racking Horse is a lateral pickup, even setdown, four-beat ambling gait that can reach considerable speed. In the rack, also known as the single-foot, only one foot strikes the ground at a time. As performed by this breed, the emphasis is on speed and correctness of gait rather than on exaggerated elevation of the knees and hocks. At shows, Racking Horses are not asked to canter.

The Racking Horse was declared the state horse of Alabama in 1975.

> **BREED ASSOCIATION FACTS AND FIGURES**
> According to the Racking Horse Breeders Association of America (recognized by the USDA in 1971):
> - 80,000 horses are registered.
> - The breed is most popular in the Southeast.

Rocky Mountain Horse

HEIGHT: 14.2–16 hands

PLACE OF ORIGIN: Eastern Kentucky

SPECIAL QUALITIES: A naturally gaited horse known for gentleness and versatility; many are a striking chocolate color with white mane and tail

BEST SUITED FOR: Pleasure riding, trail and endurance riding, showing, ranch work; well suited to new riders, children, and riders with physical limitations

The Rocky Mountain Horse did not originate in the Rocky Mountains, although the foundation sire, Old Tobe, was said to have been sired by a horse from Colorado. The breed itself is one of the Mountain Pleasure breeds that arose in the rugged rocky hills of eastern Kentucky. This area was significant in the early development of several horse breeds because it was a "mixing pot" where Spanish horses from the South and Southeast were frequently crossed on English horses from the Northeast. It was from this genetic foundation that almost all of the gaited breeds later created in North America originated. Besides Mountain Pleasure Horses, other breeds with origins in the area are the American Saddlebred, the Tennessee Walker, and the Missouri Fox Trotter.

All of the Mountain Pleasure breeds were shaped by two hundred years of work as farm and family horses in the hills of Kentucky and Tennessee, where they were used to plow, work cattle, drive, ride, and pack to town, as well as to babysit the youngest riders. The horses are gentle and easy to get along with. Because their smooth gait is natural, it is unnecessary to train them to perform it. Mountain Horses are sure-footed, easy keepers, quite able to tolerate the winters in the Appalachians with a minimum of shelter.

As an official breed, rather than a type, the Rocky Mountain Horse is a relative newcomer to the Mountain Pleasure group. It differs from the other Mountain Pleasure horses in that there is one foundation sire, Old Tobe, who lived in eastern Kentucky around the end of the nineteenth century. Every horse in the Rocky Mountain breed today must in some way descend from him. Old Tobe belonged to Sam Tuttle, of Spout Springs, Kentucky, who owned the horseback riding concession in the Natural Bridge State Park. This sure-footed, gentle stallion would carry the least experienced riders safely. His gait was perfect, as was his disposition. He sired foals until he was thirty-seven, many of which grew up to be trail horses in the park.

History of the Breed Association

The breed's organization was haphazard for quite some time, and there was a danger that the horses would fade away, but in 1986 the Rocky Mountain Horse Association was formed to maintain the breed, expand its area of acquaintance, and increase its numbers. Devotees attended large horse fairs and shows all over the country, giving wonderful demonstrations that highlighted the breed's many attributes. Trail riders took Rockies to many competitions and pleasure rides, where they attracted quite a bit of attention. The association grew quickly. Buyers from most states and several countries have purchased Rockies and continue to spread the word about the breed.

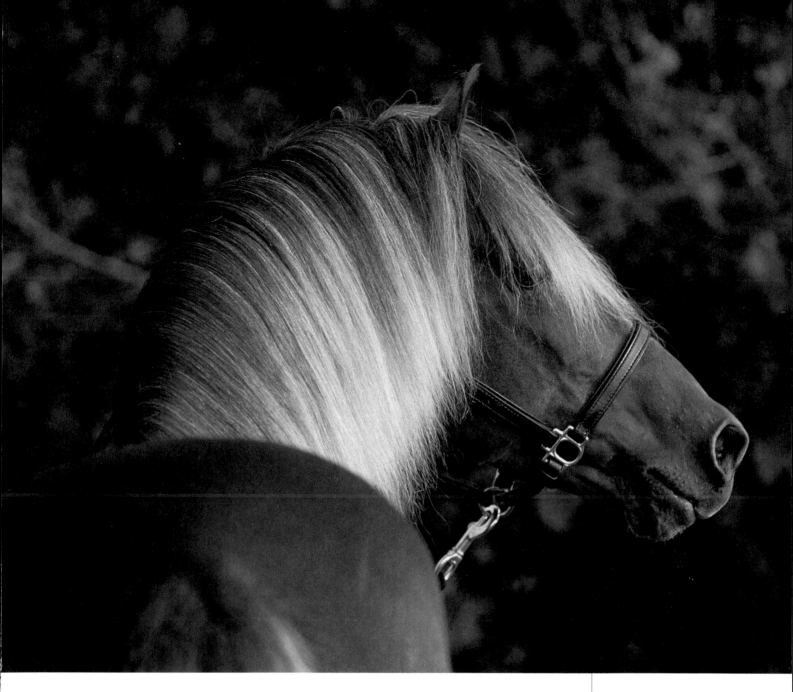

Breed Characteristics

The Rocky Mountain Horse is still some-what variable in type. Some individuals show distinct Spanish features, while others appear more like larger, modern breeds. Each horse has its own speed and natural way of going, traveling from about seven to twenty miles per hour. A horse of this breed must be of good temperament and easy to manage.

Conformation

The ideal Rocky Mountain Horse is between 14.2 and 16 hands. It has a wide chest, very well-sloped shoulders, bold eyes, and nicely shaped ears.

Color

This breed has unusual, striking color combinations. The body of the Rocky Mountain Horse is always a solid color. The preferred color is chocolate (genetically a form of liver chestnut), with a white mane and tail, but any solid color is accepted. White markings are usually minimal; they may not extend above the knees or hocks. White facial markings are accepted but they must not be excessive.

Rockies have bold alert expressions.

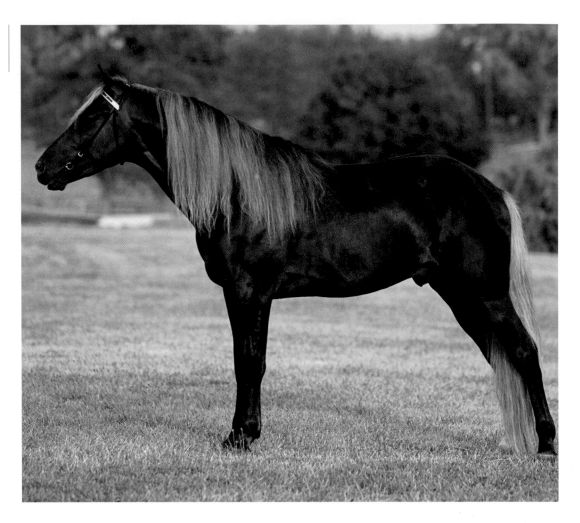

Gait

The Rocky Mountain Horse has a natural gait, which is not enhanced with any aids or devices. The gait is a **single-foot,** a four-beat gait with no evidence of pacing or trotting. When the horse moves, it produces four distinct hoofbeats of equal rhythm. Rockies do not trot. They are able to canter, but most riders do not request it because they find the single-foot gait so comfortable to ride and so fast.

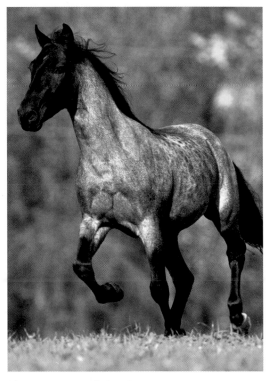

Blue roans occur in the breed.

BREED ASSOCIATION FACTS AND FIGURES

According to the Rocky Mountain Horse Association (RMHA) (founded in 1986):

- More than 12,000 horses are registered.
- About 1,000 new foals are registered each year.
- The RMHA is one of the few breed associations that require that each horse meet certain conformation and performance standards before competing or being accepted for breeding.

Sable Island Horse

Sable Island, a twenty-mile-long, treeless, grassy sandbank, lies about one hundred miles off the east coast of Nova Scotia. Feral horses have been present on the island for a very long time, and considerable controversy exists regarding their origins. Some believe that the first horses to arrive on Sable Island came with Portuguese explorers in the sixteenth century. Others believe that the first horses were survivors of the many shipwrecks in

the area. According to the Sable Island Preservation Trust and the Nova Scotia Museum of Natural History, however, there is no evidence to support the shipwreck theory, and they give no credence at all to the Portuguese theory. Although there may well have been earlier horses present on the island, the first horses positively known to have reached Sable Island were sent to graze there by a Boston clergyman in 1737. Passing fishermen and privateers probably stole most of those animals.

The first horses sent to New France (Quebec) by the French king in the early 1600s were of Breton, Andalusian, and Norman descent. In 1632 French settlers of Acadia, the

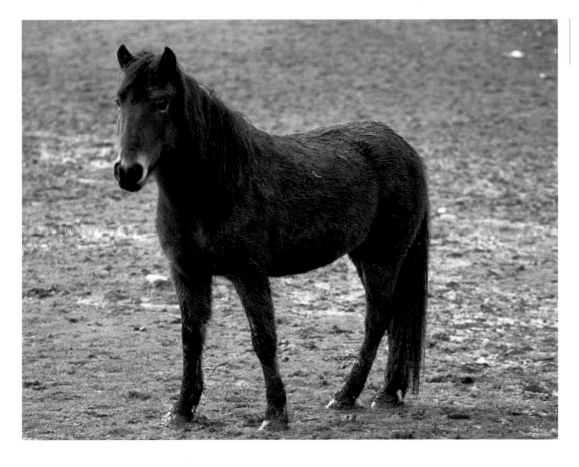

The ancestors of this tough feral horse have survived in harsh conditions for centuries.

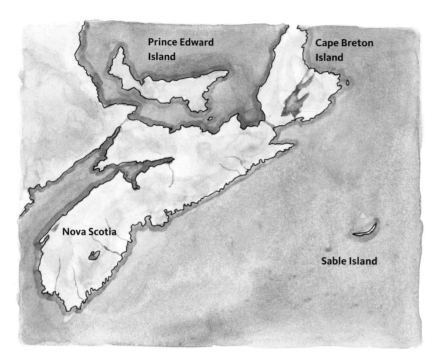

Horses have lived on tiny, remote Sable Island for more than two centuries.

coastal area from Nova Scotia to northern Maine, brought in from France a shipment of horses that were mixtures of several French breeds. After about 1680, breeders frequently interbred French horses in Nova Scotia with stallions from the New England colonies, often selecting Spanish Barb stallions because of their stamina and ability to thrive in tough conditions.

During the French and Indian War (1755–1763), however, British soldiers expelled these French immigrants if they refused to swear allegiance to the British Crown. The soldiers seized all their assets, including livestock, and deported the Acadians to various American colonies and to prisons in Britain and France. Some were sent to Sable Island. During this time, a ship owner from Boston, who had a contract to transport Acadians to American colonies, seems to have taken sixty Acadian horses for himself and turned them loose on Sable Island. These horses survived and became feral.

The mix of French, Spanish, and possibly some English breeds formed the gene pool for the Acadian horses and the Sable Island Horses. Barbara J. Christie, in *The Horses of Sable Island*, writes that the first record of origin for a particular island

horse was for a stallion of the old Acadian breed named Jolly in 1801. Many horses had been taken to Sable Island before him, but he was the first individually identifiable horse on the island, and he left his mark on subsequent generations of horses.

Between 1801 and 1940, feral horses were periodically rounded up on the island. Some ended up with the small colony of islanders, but most of the captured horses were thrown, tied, and wrestled onto stretchers that were then lifted into small boats, four horses to a boat. Handlers then hoisted the horses by their tied legs onto larger ships, which transported them to Halifax, where they were ultimately sold, often for meat.

By the late 1950s, people were rounding up and selling the horses almost exclusively for dog food. As word that these long-surviving feral horses might be so cruelly exterminated reached newspapers across Canada, huge numbers of children wrote to government officials begging them to put a stop to this practice. In 1960, the horses of Sable Island were spared from all such

Usually bay, the Sable Island horse has a full mane and tail and in winter an exceptionally shaggy coat.

activities and given full protection by the government of Canada.

Today the horses run free. There is no management of the herds on the island, although some noninvasive, observational research is conducted.

Life in the Herd

The horses live in small family bands of about six animals, usually comprising a stallion, mares and foals, and possibly some young bachelor colts that tag along. There are forty to fifty herds on the island, each with a home range of about three square kilometers. Foals are usually born in May and June. The population of the island rises in mild years and falls during severe winters, typically fluctuating between about 160 and 360 animals.

Because they are the only land mammals on Sable Island other than humans, the horses have no natural predators. Their primary food source is a tough grass called marram, which wears down their teeth, as does constant exposure to sand. Older horses may die of starvation when their teeth become too worn down to manage the grass.

Breed Characteristics

The Sable Island Horse represents one of the few gene pools of early breeds that have not been "improved" by selective breeding, and therefore could be a valuable resource of genetic material in the future.

Many of these horses are natural amblers. The coat is extremely shaggy in winter and the mane and tail are long and full.

Conformation

The typical Sable Horse is 13 to 14 hands. Stallions may weigh about 800 pounds; mares are usually about 660 pounds. Their size is limited by the quantity and particularly the quality of the food. Horses removed from the island and fed improved diets have produced offspring

As with many island breeds, the quantity and quality of food determine the size of the horses.

that are considerably larger than island horses. The feral horses on the island today continue to possess recognizable Spanish traits, including shape of the head, arched neck, sloping croup, and low tail set. They have short pasterns that are adaptive for life on rough ground and sand. Sable Island Horses are thick-bodied, stocky, and short. Some have a dished profile, but a straight profile or a Roman nose is more common.

Color

The most common colors are bay and a wide range of browns. Light bays with mealy muzzles and dorsal stripes are common. No zebra stripes on the legs have been observed, and there are no grays, roans, duns, palominos, or spotted horses. Several individuals have been described as being black but may have actually been dark bays or browns seen from a distance. About 45 percent of the horses have white markings on the face or lower legs.

BREED ASSOCIATION FACTS AND FIGURES
According to the Sable Island Green Horse Society, the Sable Island Horses are not managed by any governmental agency or private group, though they have been protected since 1961 by the Sable Island Regulations.

Selle Français

HEIGHT: 16 –17 hands

PLACE OF ORIGIN: France

SPECIAL QUALITIES:
Exceptional temperament,
jumping ability

BEST SUITED FOR: Show
jumping, dressage, eventing

S elle Français means "French saddle horse," but today these horses are internationally renowned for their jumping ability. Olympic show-jumping teams from many countries include individuals of this breed among their best horses. Although the focus of French breeding efforts since the 1950s has been to produce the world's finest jumping horses, and recently dressage horses as well, the history of the breed is quite long, convoluted, and complex, with the bloodlines of many breeds contributing to the mix.

France, particularly Normandy, has produced excellent horses as far back as the time of William the Conqueror. In fact, when William marched on England in 1066, he took a large number of Norman horses with him. These were big, powerful warhorses, which, when later crossed on native English mares, noticeably improved the English stock.

After several hundred years and frequent changes in desired type, the quality of the once superior Norman horses deteriorated, a consequence of too many outcrosses.

After 1775, Arabs and English Thoroughbreds were frequently used for breed improvement. These crosses came to be known as Anglo-Normans, although other breeds were also intermingled.

Of the two types of Anglo-Normans, one, a draft type, stood about 15.2 to 17 hands. It had a good bit of Percheron blood and later some influence from the Boulonnais, a heavy draft horse native to northwestern France. This type of Anglo-Norman was used to pull mail carts, among other things, and could pull heavy loads at a steady, fast pace.

The second type was lighter and more suitable for cavalry use and for sports, including racing, which had long been popular in Normandy. The breeding centers in Normandy and Béarn have racing records that date back to the sixth century. Horse racing became quite fashionable, with regular races held, during the reign of King Louis XIV (1643–1715).

During this period the state became involved in France's horse industry. Louis XIV wanted to enlarge France's kingdom, and to do so required superior cavalry. In 1665, a series of national studs were established. Breeders imported stallions from Mecklenberg, Holstein, and Denmark to improve the quality of the horses. France opened its very famous cavalry school in Saumur in 1771. After the French Revolution, in 1789, the state studs were closed until Napoleon (1804–1815) reestablished them.

INTERNATIONAL EXCELLENCE

Selle Français horses have won impressive honors in international competition. The only three-time winner of the World Cup in show jumping (1998, 1999, and 2000) was Baloubet du Rouet. At the 2002 World Equestrian Games, the French team, all mounted on Selle Français horses, won the team gold medal in show jumping, and they also won the individual silver medal. At the same games, in three-day eventing, the French won the individual gold medal as well as the team silver medal. At the 2004 Olympics Baloubet du Rouet won the individual silver medal for Brazil, and the French won the team gold medal in eventing, again mounted on Selle Français.

The Selle Français is an elegant, powerful breed.

Under Napoleon's rule, fifteen hundred selected stallions stood at stud across the country. The Napoleonic wars introduced new blood from captured horses in Prussia, Egypt, and Austria. In the 1830s, the French studs began adding English Thoroughbreds for improvement. In 1836 the Ministry of Agriculture was established to direct, encourage, and control the horse industry.

Between 1834 and 1860, there was also a large admixture of Norfolk Trotter to produce horses both for the military and for coaching. This coaching and light draft type became known as the Anglo-Norman Trotter and later the French Trotter, and it is the influence of this breeding that sets apart today's Selle Français from other European warmbloods.

After World War II and reconstruction, mechanized farming began to reach Europe on a large scale. There was no longer a need for cavalry or for many light draft horses. As happened with other light draft breeds, the French horse survived because breeders began to develop warmblood saddle horses to be used for sport rather than work.

The conformation of these horses is similar to that of a Thoroughbred, but usually with more bone and substance.

History of the Registry

In 1949, a Norman studbook was founded for saddle horses, and in 1958 officials consolidated all the regional types and crossbreds under one name, Selle Français. The Anglo-Norman formed the basis for this breed, although many other breeds played, and continue to play, a part.

The first studbook for the breed, published in 1965, included the Selle Français, the Arabian, and the Anglo-Arab. Within the studbook, crosses are permitted between these breeds. Crosses to Thoroughbreds and French Trotters are also permitted and do occur.

In France, the horses are divided into three classes: the competition horse, the racehorse, and the riding horse. They are also divided into five groups by height and weight-carrying ability.

Breed Characteristics

The Selle Français breed is known for its exceptionally pleasant temperament. The horses are said to sometimes display an almost doglike willingness to please and are often greatly affectionate with their owners. These athletic horses are outstanding jumpers and perform well at all levels of competition.

Conformation

Today's Selle Français usually stands between 16 and 17 hands. The conformation is similar to a Thoroughbred's, but with more bone and muscle. The breed is elegant, but retains its robust, muscular strength. Most of these horses have a long neck; some may have a large head. Those Selle Français with a strong concentration of Anglo-Arab breeding are inclined to be square-framed and close-coupled, rather than rectangular.

Color

During the breed's fairly recent history, many of the influential sires were chestnut, and that color predominates, although bay is also common. Red roan and gray are seen occasionally.

Shagya Arabian

During the Turkish occupation of Hungary (1526–1686), a great many Arabian and other Oriental types of horses came to that nation. Although these horses' attributes were widely recognized and their bloodlines treasured, formally organized state stud farms did not appear in Hungary until late in the eighteenth century. The first was founded in 1785, and the second, at Babolna, in 1789. By this time Hungary was already

HEIGHT: 15–16 hands

PLACE OF ORIGIN: Hungary

SPECIAL QUALITIES: A rare breed with the beautiful look of the Arabian but with more bone and substance; known for exceptional athleticism, endurance, courage, and an affectionate nature

BEST SUITED FOR: Jumping, dressage, endurance, eventing, and driving

famous for its superb Arabian horses, and the stud at Babolna became the center for their breeding.

Babolna had twin advantages. It was managed by Magyars, native horsemen from the region with highly developed skills as horse breeders, and it was located in an ideal area for horse production. By 1816 the stud at Babolna concentrated its efforts on producing both purebred Arabians and crossbreds known as Arabian Race, which were crosses of purebred stallions on mares of very Oriental appearance that carried Hungarian, Spanish, and Thoroughbred blood. Lipizzans were also crossed in occasionally to improve movement and

Gray is the most common color, but the breed includes all Arabian colors.

riding qualities. In pursuit of the best Arabian horses, experts from Hungary repeatedly set forth on dangerous expeditions to the deserts of Arabia, where they paid extremely high prices for the horses they wanted. Meticulous records were always maintained.

The Arabian Race crossbred lines ultimately produced the Shagya Arabian. The breed was founded by and named for the gray or cream-colored stallion Shagya, who was born in Syria in about 1830 and imported to Babolna in 1836. All sources agree that he was large for an Arabian at the time, standing between 15.2 and 15.3 hands. He was noted for the beauty of his head, as well as for his substance and overall quality. His profile was dished, his muzzle tapered and fine, and his eyes large and expressive. He had an excellent shoulder, which contributed to length of stride and freedom of movement, and fortuitously, he was an extremely prepotent sire. He fathered many successful stallions, and his

Shagya Arabians have a bigger frame and more substantial bone than purebred Arabians.

direct descendants still reside at Babolna and at studs throughout Europe.

The original purpose of the breed developed from this horse was to produce a superior cavalry and carriage horse and also to provide a source of prepotent breeding stallions to be used to improve other breeds. The foundation stallions of the Shagya were desert-bred Arabians, and many of the mares showed a great deal of Arabian influence as well. Shagyas were used as cavalry mounts in many battles in Europe and as parade horses for Europe's royalty. In Vienna, the Imperial Guard of the Hapsburgs was always mounted on Shagyas. At the time, parades of military and royal horses allowed countries to show off their wealth, military might, and skill with horses, and possibly to intimidate potential rivals. Such displays also promoted international horse sales.

The reputation of the breed spread, as did demand for the horses. Their toughness, endurance, and courage in battle were

legendary. Breeding of Shagyas was expanded to the stud farms at Radautz and Piber in Hungary, and later to stud farms in Czechoslovakia, Romania, and Bulgaria. Statues still stand in Hungary commemorating the heroic deeds of these horses.

In the United States, purebred Shagya breeding officially began in 1986, with the use of Bravo, then twenty-four years old. Bravo's sire, Pilot, foaled in Poland in 1939, and dam, 52Gazall II, foaled at Babolna in 1937, were brought to America in 1947 under the direction of General Patton as prizes of war. Bravo produced three sons after 1986, one of which is now standing at stud in Venezuela. He also produced eleven daughters that are being used in Shagya breeding today.

Breed Characteristics

After more than 185 years of very selective breeding, Shagya Arabians have a bigger frame and more bone and are said to possess better riding qualities than purebred Arabians. Their action is ground covering, free, and elastic, as though the horses move on springs. Correct movement at all three gaits is heavily stressed in the breed. They excel at jumping, dressage, endurance, eventing, and driving, having proved themselves repeatedly in open competitions against various breeds of warmbloods. Shagyas are also known to be unusually friendly with people and to make excellent family pleasure horses.

Conformation

Shagyas are beautiful animals, typifying Arabian horses in every respect but with increased bone and substance. The circumference of the cannon bone just below the knee is at least seven inches, which is larger than for Arabians. The chest should be broad and well muscled. The depth of girth and barrel should harmonize with the frame.

The back should be close-coupled. Many Shagya are reported to have 17 ribs, 5 lumbar

From its origins as a cavalry mount, the Shagya has come to excel as a versatile sport horse.

vertebrae, and 16 tail vertebrae, rather than the 18-6-18 ratio in most other breeds. The croup should be long. In the United States, the registry strongly emphasizes that the frame should be rectangular rather than square. Shagyas have very well sloped shoulders and withers that may be more prominent than those of purebred Arabians.

The legs are clean. The cannons should be short in relation to the forearms and the gaskins. Shagyas have excellent feet—the hooves are usually nearly perfect in size and shape.

Color

The predominant color in the breed is gray, but all Arabian colors can occur.

BREED ASSOCIATION FACTS AND FIGURES

Because the Shagya is such a rare breed, careful management is required in order to protect it genetically. To this end the North American Shagya-Arabian Society (NASS) and the International Shagya organization (ISG) are working together with highly motivated breeders to promote the breed while maintaining its historical legacy of superb quality.

According to the North American Shagya-Arabian Society (founded in 1985):

- In 2005 in North America there are 213 purebred Shagya Arabians and 187 part-breds.
- Each year, 15–20 new foals are registered.

Single-footing Horse

The term **single-foot** refers to a particular type of smooth gait. It comes from the tendency, among horses able to perform it, for the horse's weight to be supported by one foot on the ground at a time. Ideally the single-foot is an intermediate, four-beat gait with very even timing. It can be performed at a wide range of speeds, from a trail speed of 7 to 9 mph to a road gait of 12 to 15 mph up to a racing speed of more than 20 mph.

The speed at which an individual horse begins to single-foot varies; some will perform it at the road gait and others only at racing speed.

Historically, there have been many breeds and strains of single-footing horses in North America, including free-ranging feral horses. Good single-footing horses have been discovered within several gaited breeds as well, where certain lines produce single-footers instead of the prevalent gait for the breed. An occasional single-footer may also turn up in non-gaited breeds.

History of the Breed Association

The North American Single-footing Horse Association (NASHA), a performance-based organization, was established in 1991 by ranch owners and avid trail riders interested in developing horses that naturally travel with a true single-footing gait. Each of the founding groups logged many miles in the saddle every year under a wide variety of conditions, and each group held strong opinions about what makes a useful, smooth-gaited horse.

Despite the differences in their type of riding, both groups noticed that in general they desired the same traits in their horses: a natural, solid single-footing gait with a wide range of speeds and maximum smoothness at all speeds. They wanted a tractable, willing temperament that was neither hot and explosive nor lethargic and stubborn. In addition, they looked for good general working conformation, including good feet and legs and a strong back, well formed for saddles. All these traits were to be combined with reliable endurance and athletic ability.

The range of speeds at which the single-foot could be performed was another important consideration. For long-distance and trail riding, the single-foot has been recognized for centuries as being easy and comfortable for both horse and rider. Today's riders seem less aware that, given the medium length of stride at most speeds, horses of good stock-type conformation can perform this gait while executing stock horse moves, such as quick turns and roll-backs. Smooth-gaited ranch horses can and do work cattle, rein, and compete successfully against other breeds.

The trail riders in the organization wanted horses with natural lift in front to clear uneven ground without stumbling. This is a natural tendency for horses that are well built to perform the gait, because the front end has to get out of the way of the driving rear end, especially at speed. The association agreed that both excessive hock action and low, skating action in the rear that might lead to tripping were to be

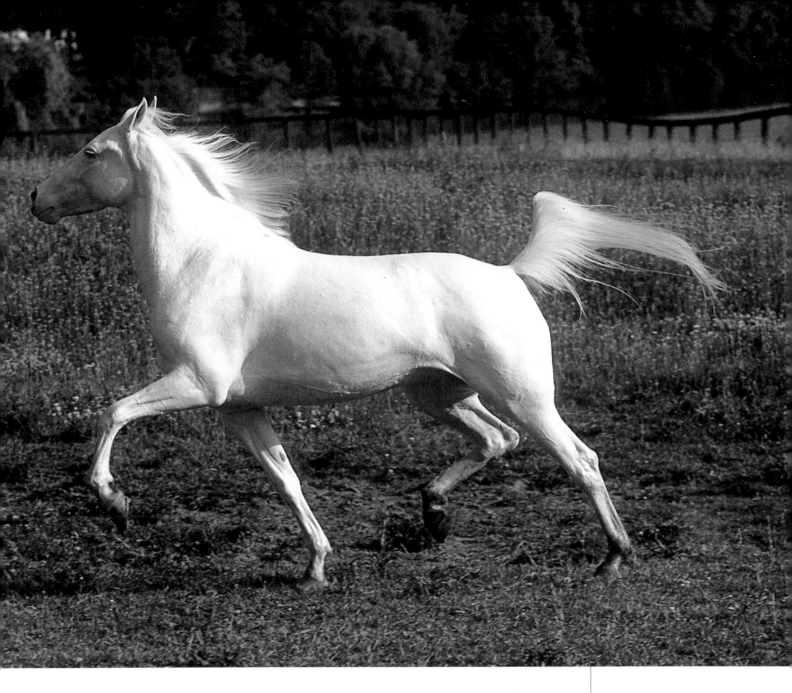

avoided. The gait was to be evenly timed and not extreme in length of stride, so they felt there should be no head nod as the horse worked.

Working Qualities Rewarded

It was absolutely essential to the organizers of the registry that these horses continue to be working horses. The rules were specifically set up to reward working qualities. To this end, the rules require that no horse in any show class may carry a shoe heavier than a trail shoe. Of the forty-five categories offered for high-point awards, only two are show ring classes.

Road gait is the premier gait class at shows, but rather than simply reward a perfectly trained horse, the judges of these classes push the horses to see at what point the gait breaks down. This is to confirm the strength of gait, which is essential in good trail horses, thus emphasizing the genetics of a horse's gait rather than the training. Training is important, however, particularly regarding good trail manners, so horses in road-gait classes are asked to stand quietly while the rider mounts and dismounts, to ground-tie, and to back willingly. In addition to showing, horses may earn points and awards for trail and endurance riding.

The Single-footing Horse must naturally lift its front legs to get them out of the way of the driving rear legs.

All colors are acceptable in the registry of Single-footing Horses.

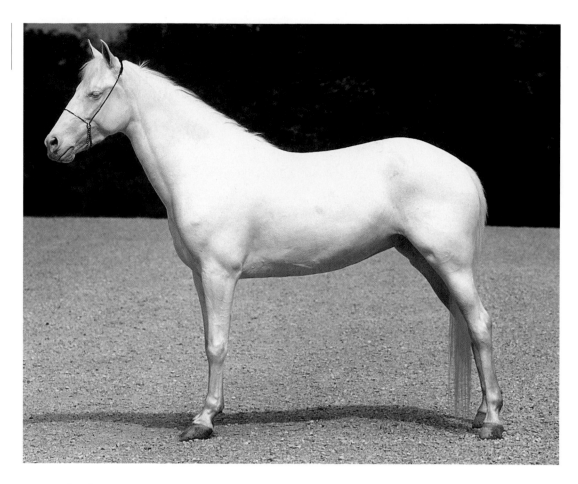

Breed Characteristics

Initially, the association accepted for registration any horse of any breed with a demonstrated intermediate, four-beat gait, as long as the owners were dedicated to producing single-footing horses from that point on. Beginning in 1998, horses with a running walk, fox trot, or pace, and horses with either extremely long or short strides, were no longer eligible. Beginning in 2000, any horse that did not exemplify the true single-footing gait as well as display superior conformation was excluded from registration. The registry's books remain open, but the organization will continue to place appropriate restrictions on new applications to ensure overall quality and correctness of gait. Horses with several generations of registered NASHA parentage do not need to be evaluated in order to be registered.

Conformation

Not surprisingly, as time has passed and single-footing horses have been selectively bred for several successive generations, a conformation has emerged that lends itself to the type of horse that the members find highly useful. This seems to be a horse similar to the old-type Morgan but with a slightly more refined neck and, of course, a natural, well-balanced, single-foot gait.

Color

Color is not a consideration in the registry of single-footing horses.

BREED ASSOCIATION FACTS AND FIGURES

According to the North American Single-footing Horse Association (established in 1991):

- There are about 700 registered horses.
- Fifty new foals are added to the registry each year.
- The horses are found throughout the United States and Canada. There are some very active Single-footing Horse breeders in Virginia, Tennessee, Kentucky, and Texas.

Spanish Barb

The history of this world-conquering breed began with the Berbers of North Africa. In 711 CE, these highly adept warrior horsemen, riding hot-blooded, desert-bred horses, invaded Spain. During the nearly eight centuries that they remained, the Berber horses, later known as African Barbs, were frequently crossed on the heavier Spanish warhorses. The result was one of the most successful horse types in history, an ideal

blend of elegance, agility, and durability. They were world famous during the Middle Ages and sought for royal breeding farms throughout Europe. They developed an extraordinary and heritable "cow sense" that made them useful in all herding and ranching situations, as well as for mounted bullfighting. They had exceptional endurance.

The name Spanish Barb was actually coined quite a bit later in the United States and refers to this heritage of crosses between the African Berber horses and Spanish breeds. When the Spanish set about to colonize the New World, they brought horses of this lineage with them. Originally transported to the islands of the

HEIGHT: 13.3–14.3 hands

PLACE OF ORIGIN: Spain

SPECIAL QUALITIES:
A critically rare breed of medium-sized, solid, well-built horses that exhibit Spanish traits

BEST SUITED FOR:
Ranch and cattle work, all Western sports, and trail and endurance riding

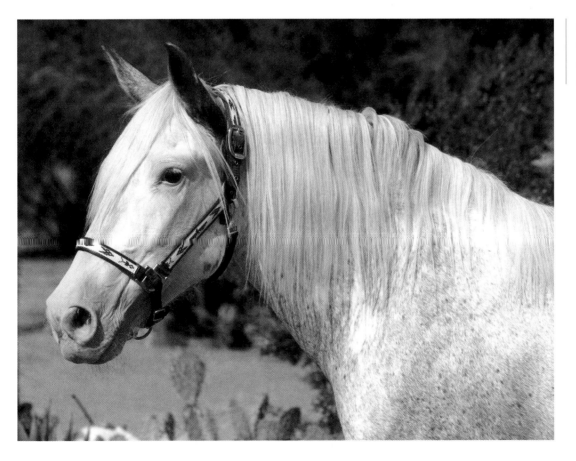

Strong, intelligent, and adaptable, the Spanish Barb has influenced numerous other breeds.

Caribbean, the Spanish Barb was soon introduced to what are now Mexico, the United States, and South America. Horses flourished, and there were soon huge free-ranging herds.

Although the Spanish controlled most of the territory of North America in the sixteenth and seventeenth centuries, during this period the English began to colonize the East Coast from the mid-Atlantic area to what became New England. At the same time the Chickasaw, Choctaw, and Creek Indians acquired quite a few Spanish horses, which they frequently traded during their travels north and west. The English acquired some of these horses, but they seem not to have realized that they were actually of Spanish breeding.

By the last quarter of the seventeenth century, wealthy plantation owners from Virginia began to import English race-horses, which at the time were very often line-bred Oriental Barbs blended with a good bit of Irish blood. When breeders crossed these imported racehorses back onto the horses they had acquired from the Indians, they were largely crossing Oriental Barbs to Spanish Barbs. The result was the deep-bodied little horse known as the Short Horse or sometimes the Quarter-Pather that they used for their popular sprint races. This type later became the Quarter Horse.

Until at least 1803, when the Americans acquired the western territories, and probably well after that time, Spanish Barb blood was dominant across much of the country. In the West, Spanish horses were raised on large missions and huge ranches, and they ran free by the millions. Spanish-bred mares often were used as broodmares when English stallions were brought west.

Destruction and Rescue
As the western migration began, however, there was an almost immediate attempt to control both the Indians and Spanish-speaking people. The military confiscated,

sold, or destroyed their horses. Overwhelming racism meant that horses that either Indians or Mexicans might have used were considered unworthy for use by whites, despite the abilities of the horses. By the latter half of the nineteenth century, slaughter and extensive crossbreeding very nearly extinguished the old Spanish Barb. Had it not been for the foresight and regard of a very few western ranchers who recognized the abilities of the breed, it would have become extinct in North America.

The Spanish Barb Breeders Association (SBBA) was formed in 1972, having located about thirty horses to be used in its initial effort to perpetuate the breed. The founders began by noting the merits and faults of each horse in order to give direction to the breeding program. They were well aware that the only way to perpetuate the breed from this tiny nucleus of horses was by judicious use of line-breeding and inbreeding. The success of their breeding methods became evident in the quality of the foals and the stabilization of the desired attributes of the breed.

Registry Requirements
The SBBA is concerned primarily with accurately documenting and preserving the breed. For this reason, the registration process involves the inspection of every horse, regardless of bloodlines. To be eligible for registration, a horse must be out of two SBBA-registered parents and must also be evaluated on its own merit.

Before the age of three, accepted horses are given either Appendix or Tentative Registration papers. At three or older, horses are again evaluated. Attaining permanent status depends on several factors, the most important being the degree to which the horse conforms to all SBBA breed standards. In addition to overall merit, each evaluation involves fifteen different precise measurements of the horse. Only those horses most closely approximating the ideal for the breed are given

permanent registration papers, and breeders are encouraged to select animals for breeding only from their ranks.

Breed Characteristics

The overall appearance of the Spanish Barb is balanced and smooth, with proportionate depth of neck and body, roundness of hips, short, clean legs, and a well-set, distinctively refined head.

Conformation

These horses average 13.3 to 14.3 hands; a few individuals may mature slightly above or below this range, but they do not represent the norm. The Spanish Barb's head is distinctively Spanish in type, lean, refined, and well formed, with a straight or slightly convex profile. The ears are short to medium, curved inward and slightly back at the tips. The eyes are set well forward on the head and are usually brown, although blue eyes do occur. Prominent bone structure above the eyes is characteristic. The muzzle is refined, short, and tapered, with a shallow mouth and firm lips. The nostrils are crescent shaped and of ample size when flared during exertion. The chest is strong, of medium width, and sufficiently muscled inside the forearms to form an arch. The ribs are well sprung, never slab-sided. The heart girth is deep.

The shoulders are well angled and in balance with the back and the heart girth. The back is short and strong and in proportion to the length of the shoulders, forelegs, and depth of girth. The loins are short, straight, strong, and full, with deep flanks. The croup is round and sufficiently full in width and length to be in balance with the body. The hindquarters are not heavily muscled. The tail set is medium to low.

The straight and well-formed legs have long muscling in the forearms and thighs and short clean cannons. The joints are well developed, strong, and free of excess flesh. Chestnuts on the front legs should be

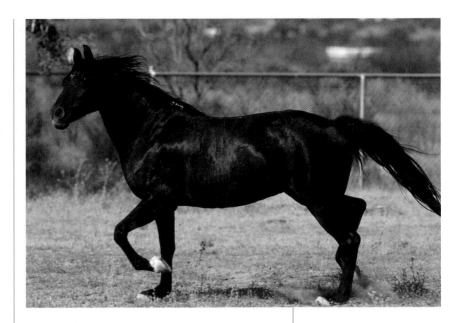

This breed exhibits a wide variety of colors and patterns.

small, smooth, and non-protruding. When present, chestnuts on the hind legs should be extremely small and flush with the legs. Ergots are either lacking, very small, or appear as calluses. The pasterns are strong, medium in length and slope, and flexible, which contributes to the smoothness of gaits. The hooves are ample and well shaped, with excellent frog formation and thick walls that are extremely hard.

The mane, forelock, and tail are long and full, the mane sometimes falling on both sides of the neck.

Color

All colors are found within the breed. Dun and grulla are relatively common. Chestnut, black, bay, roan, and both overo and tobiano patterns appear, as do other color variants.

BREED ASSOCIATION FACTS AND FIGURES

According to the Spanish Barb Breeders Association (SBBA) (founded in 1972):

- 613 horses are currently registered.
- About 20 new foals are registered each year.
- The American Livestock Breeds Conservancy lists the Spanish Barb as a critically rare breed.
- SBBA horses are most common in Texas, Arizona, and New Mexico, but are also found in Mississippi, New York, Colorado, and Tennessee.

Spanish Colonial/ Spanish Mustang

HEIGHT: 13–14.2 hands

PLACE OF ORIGIN:
Original genetic contribution from Spain, with different influences in many parts of North America

SPECIAL QUALITIES:
Spanish conformation, natural herding ability, endurance

BEST SUITED FOR:
Ranching, trail riding, endurance riding, and pleasure riding

To most people, the term *mustang* suggests a feral or free-ranging horse from the western plains. In the case of the Spanish Mustang, that image is not necessarily correct, although the similarity between the two names leads to a good bit of confusion. For many generations, quite a few Spanish Mustangs have been bred and raised as domestic, not free-ranging, horses. But they are nonetheless direct descendants of horses brought to this hemisphere by the Spanish Conquistadores, and have had very little, if any, other blood mixed in over the centuries.

Some Spanish Mustangs may have feral strains included in their lineage. Others have bloodlines from specific isolated ranches that used only Spanish stock, while at least one line is descended from early Spanish mission-bred horses. There are also Spanish Mustangs descended exclusively from Native American lines.

To reduce the confusion about the names, some researchers, particularly Dr. Phillip Sponenberg, prefer the term Spanish Colonial Horse to Spanish Mustang to designate horses with particular genetic markers that indicate lineage from early Spanish horses. This definition also encompasses several East Coast populations, such as the Shackleford Banker Ponies of North Carolina, which most of us wouldn't immediately think of when we hear the words Spanish Mustang. Although the term Spanish Colonial Horse is more scientifically accurate and reflective of the history of these animals, the name has not quite caught on yet with the general public.

Whatever their name, these horses descend from Spanish lines, from an early period when Spanish horses were widely used for improving other horse types throughout Europe. As Sponenberg points out, other breeds, particularly Arabians and Thoroughbreds, eventually surpassed the dominance of Spanish horses in Europe. For the five centuries since the time of Columbus, horses in Spain have been selectively bred for various purposes, and modern Spanish horses are consequently quite rare in Europe and may in fact be in need of conservation in Spain, if any remain at all.

Those genetically isolated remnants of the first New World Spanish horses that still exist in this country are actually closer to the historic horses of the Golden Age of Spain than are any other horses, and they are also highly in need of genetic conservation. The use of DNA to identify populations of historically significant horses has greatly aided the research, but there is still a tremendous amount of work to be done to save important populations that are in peril of genetic dilution and extinction.

Over the years, several breed registries and associations have been founded to document and protect various Spanish horse lines in North America, but not all associations have approached the problems

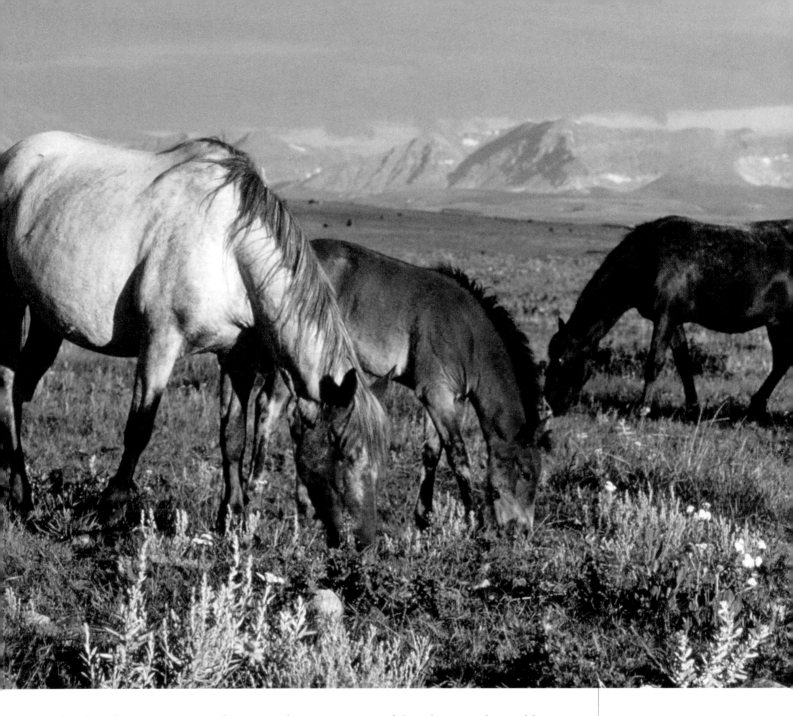

related to the management of rare populations in quite the same way. Philosophical and political differences of opinion have caused some of these groups to merge, while splinter groups have split off from larger organizations. Despite their differences, however all of these groups are still unified in their appreciation for the history, talent, and abilities of the Spanish Colonial Horse.

The oldest of the Spanish horse–based organizations is the Spanish Mustang Registry, spearheaded by Robert Brislawn, of Wyoming, who in the mid-1950s bought as many of these horses as he could identify. The group's intent was to identify and preserve the last of the true, old-type Spanish Mustang lines and to form a breeding herd with a large and diverse gene pool in order to avoid heavy inbreeding and eliminate the need to resort to crossbreeding. They have worked closely with geneticists since DNA testing became available.

A very different and equally valid approach was taken by the Spanish Barb Breeders Association, which has chosen to put heavy emphasis on preserving the

Spanish Colonials are more closely related to the horses of the golden age of Spain than are any other breeds.

These young foals show the intelligence and alertness necessary in a free-ranging horse. With improved nutrition, they will probably grow to be larger than their ancestors.

Spanish phenotype as well as on bloodlines. They began with a tiny group of horses and have chosen to maintain both type and quality through careful selection and inbreeding.

Some of the other associations also dedicated to the preservation of horses of Spanish heritage include the Kiger Musteno Association, the American Indian Horse Association, the Sorraia Mustang Association, and the Ranchero Stock Horse Association. Almost all of these organizations use some combination of selection based on type, as well as DNA and pedigree research, to select individuals for registration. Many horses are listed in more than one of these registries.

Breed Characteristics

The Spanish Colonial Horse is still valued for the qualities that brought it to the New World centuries ago. They are tough, strong, quick, and willing to work; many have a particular aptitude for working cattle. Comfortable to ride, they make good endurance and trail horses. Quite a few are gaited. Enthusiasts prize them for their steadiness, intelligence, and ability to form a strong bond with their owner.

Conformation

These small horses generally stand no more than 14.2 hands and weigh between 700 and 800 pounds. Some can reach 15 hands, and with better nutrition and selective breeding, it is likely that the average height will increase somewhat over time. They display the classic Spanish-type head with a broad, straight forehead and tapered, convex nose. The chest is narrow but deep, with long, well-angulated shoulders and prominent withers. They have a short, strong back, muscular hindquarters, and a sloping croup with a low tail set. The legs are sound, with small, upright hooves.

Color

These horses come in a wide variety of solid colors, including black, bay, brown, chestnut, sorrel, grullo, red dun, buckskin, palomino, and cream. They also show a range of pinto and spotted coloring, notably a frame overo pattern that is found predominantly in Spanish-type horses.

BREED ASSOCIATION FACTS AND FIGURES
Because several different organizations register Spanish Colonial Horses, and many horses are registered with more than one, it is not possible to get an accurate estimate of the total number of these horses. One group, the Spanish Mustang Registry, reports approximately 3,100 horses on its books.

Spanish Jennet

The Spanish Jennet is a very old breed that may have originated in Libya, although absolute proof is sketchy. The horses were small to medium-sized and had a natural four-beat smooth gait. Smooth-gaited horses were extremely popular in Europe when roads were of such poor quality that driving was impossible and people rode their horses rather than drive them. Smooth-gaited amblers were selected because they were

comfortable to sit on and the gait was not tiring for the horse. Horses that ambled were popular in Spain at the time of Columbus, and they were taken to the New World among the first shipments of horses to the Caribbean.

The name Jennet comes from the Spanish word *jinete,* which is originally from the Berber word Zenete. The Zenete were a powerful tribe from North Africa, famous for their ability as horsemen and warriors. They participated in the Moorish invasions of Spain, which began in 711 but did not end until 1492, and in fact composed the bulk of Mohammedan cavalry. According to Robert Denhardt, in *The Horse of the Americas,*

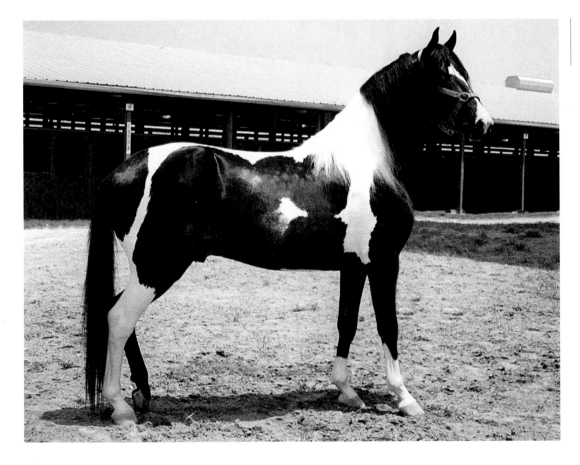

This stallion shows the aristocratic bearing typical of Spanish Horses.

"*Jinete, ginete, genete,* or *zenete,* as it was variously used by the earlier writers, had a pagan connotation, since it referred to the Moorish tribe of North Africa from which it is derived. . . . As time went on the word *zenete* or *jinete* was applied to all horsemen who rode in the fashion of North Africa or the Moors. Since the Moors were excellent horsemen, it also came to be applied to a person who was a skilled rider—he would be called *muy jinete.*" (See page 11 for more information on the *a la jineta* riding style, which involved relatively short stirrups and neck reining, in Spain.)

According to some writers of the 1600s, this style of riding was more highly perfected on the islands of the Caribbean than anywhere else in the world. Again to quote

REGISTRY RULES

The Spanish Jennet Society divides colored Paso horses into two groups. **Pintados** are pinto Pasos and **Antigrados** carry the leopard complex.

Because the leopard complex is very rare or no longer found within the allowed parent breeds, the society allows horses that are crosses to Appaloosas or Tiger Horses, but they must contain a minimum of 50 percent purebred Paso or Paso Fino. Only one outcross is allowed to obtain the Appaloosa color. All 50 percent crosses must provide video proof of gait before registration of their offspring is complete. Non-patterned female offspring from these registered individuals will be registered as breeding stock Antigrado but may not compete in the show ring. Non-patterned male Antigrados must be gelded before registration. Because of their association with fading color in leopard-complex horses, gray horses are not accepted for registration.

The Pintado is the division for pinto-pattern Paso or Paso Fino Horses. All horses must be purebred, gaited individuals. There are three ways for these horses to be eligible for registration as a Spanish Jennet:

1. A horse must be registered with one of the approved purebred registries; or
2. Proof must be given by parental verification that the horse is the offspring of registered Paso or Paso Fino parents; or
3. The horse must be the verified offspring of registered Spanish Jennet Horses.

Any horse foaled after January 2004 whose sire or dam is gray is ineligible for registration.

Denhardt, "*A la jinete* riding seems to find its ideal location in the wide open spaces and hot countries, where the simplest armor and tough, agile horses with good mouths and great hearts are needed. This style of riding flourished in the New World." The quick, agile horses that were best suited to this style of riding also came to be known as jinetes, which has filtered down to us as Jennets. It originally referred to the type of horse suitable for riding in this manner rather than to a breed of horse as we recognize the term *breed* today. The word Jennet is sometimes unfortunately confused with **jennet** or **jenny,** meaning female donkey.

North American Strains
Spanish breeders brought smooth-gaited horses of jinete type to the islands of the Caribbean and established them on their breeding ranches. The Paso Fino and Peruvian Paso arose from these roots. Many of the early horses were pintos and some carried what is known as the leopard-complex genes, or what we know as Appaloosa coloring. The original Spanish Jennets were often wildly colored.

In Europe, colored horses went in and out of fashion. After the Baroque Period, from the second half of the sixteenth to the beginning of the eighteenth century, Europeans began to think of colored horses as vulgar and discarded them in favor of solid bays, grays, and blacks. Europeans in North America generally followed this trend as well, although some Spanish settlers, particularly in Puerto Rico and Mexico, continued to ride and breed spotted horses for many years.

On the Brink of Extinction
It is generally believed that the old Spanish Jennet is now extinct, although some suspect that its genes may still exist in the tiny, critically endangered population of Abaco Barbs, the Paso Fino, and the Peruvian Paso.

The Spanish Jennet Society was formed in 2002 to provide a registry and association

exclusively for colored Paso Fino or Peruvian Paso Horses in North America. Although pintos are well known and leopard-complex horses previously existed in these breeds, they are no longer favored and are discriminated against in the show ring in the United States, although less so in other countries. In contrast, the Spanish Jennet Society welcomes these horses.

In its efforts to establish the Spanish Jennet as a breed of high-quality, Spanish-type gaited horses of color, the society has carefully restricted the acceptance of animals for registration as foundation horses. Accepted individuals are chosen based on show records, conformation, and quality of gait, as well as color.

Breed Characteristics

The Spanish Jennet has a bold, energetic appearance, indicative of strength, stamina, and elegance. The breed's conformation is well proportioned, with moderation being the key concept. Extreme muscling is not typical and detracts from the appearance of great refinement.

Conformation

Spanish Jennets stand between 13.2 and 15.2 hands. The head is aristocratic, of medium size, with a flat or slightly convex profile, never coarse. The eyes are large and well spaced and have a pleasant expression. The nostrils are oblong or crescent shaped; the muzzle is small and refined. The ears are of medium length and well shaped. The throatlatch is well defined and connects to a medium-length, well-arched neck, which is set on high and in such a manner as to allow proud carriage and the ability to flex well at the poll. The withers are well defined, the chest deep, the back of medium length and strong.

The loins are broad and well muscled. The croup is somewhat angular but well rounded, and the tail set is medium to low. The legs have prominent joints and long, well-refined bones. The cannons are short

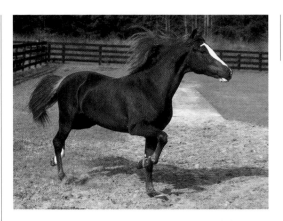

The Paso Fino probably contains genes from the original Spanish Jennet.

and refined but extremely sturdy. The hind legs are set well under the body, contributing to great agility. The hooves are small and tough.

The mane is thick and full and may fall on both sides of the neck. The tail is long and full.

Color

Any base body color other than gray is allowed. The pinto patterns of tobiano and sabino are common. There is some doubt that the true overo pattern exists in this breed. Leopard-complex patterns of all varieties and colors are permitted. Because gray is associated with fading color in leopard-complex horses, it is not allowed in this breed.

Gait

All horses exhibit the true *paso*, the four-beat lateral gait, with propulsion from the hindquarters absorbed by the horse's back and loins, resulting in extremely smooth movement with no perceptible up-and-down movement of the croup.

BREED ASSOCIATION FACTS AND FIGURES
According to the Spanish Jennet Society (founded in 2002):
- As of 2005, there are about 350 registered horses, comprising about 250 in the Pintado division and about 100 in the Antigrado division.
- Twenty-five to 50 new foals are registered each year.
- Spanish Jennets are now found mostly in the southern United States, especially in Georgia and Florida, and in California.

Standardbred

HEIGHT: 15–15.3 hands

PLACE OF ORIGIN: Eastern North America

SPECIAL QUALITIES: Extremely fast trot or pace; excellent endurance and ability to tolerate work; tolerant, calm disposition.

BEST SUITED FOR: Harness racing, pleasure driving, and pleasure riding

The first horses to come to Massachusetts arrived in Boston from London in 1629. Six years later, a Dutch shipment of twenty-seven mares and three stallions arrived in Salem Harbor. These were sturdy, small horses averaging about 14.1 hands. The New Englanders preferred the Dutch horses over the English for general work because they were more heavily muscled and had heavier bone. The English horses, however, had good saddle qualities, unlike the Dutch horses. Because New England was heavily wooded with virtually no roads, horses were primarily ridden rather than driven.

In time, the two varieties were crossed and then selectively bred to produce a stout little horse that could **pace** long distances. In those days the pace, a two-beat gait in which the legs on each side of the horse move in unison, or the **amble,** in which the legs on each side move almost in unison, were the preferred gaits for riding horses because they were comfortable to sit.

Within thirty years, horses began to arrive in New England from Canada. Many of these were French-Canadians, a breed known for producing both pacers and trotters. Horse races in early Massachusetts were sometimes matches between trotters and/or pacers and sometimes between gallopers. These ridden races were held in secret, because the clergy condemned horse racing as the work of the devil. Court records from Salem and Plymouth in the 1630s document that those caught riding or even watching races were fined or sentenced to the pillory.

The Narragansett Pacer

In neighboring Rhode Island, which was settled in 1636, it was possible to hold horseback sports events openly because Governor Roger Williams advocated freedom of conscience. Over time, Rhode Island became a successful center of horse breeding, and by the 1670s, a good many of the best New England pacers were purchased and brought there as breeding animals.

From these roots of English, Dutch, and French-Canadian horses came the plain little Narragansett Pacer. This now extinct breed was for almost 150 years the most sought-after saddle horse in the Americas. These horses averaged about 14.1 hands, and they were usually sorrel.

Observers were not apt to call them good-looking or stylish, although James Fenimore Cooper left this rare description made from personal observation: "They have handsome foreheads, the head clean, the neck long, the arms and legs thin and tapered."

The first American edition of the *Edinburgh Encyclopedia* reads, "The hindquarters are narrow and the hocks a little crooked, which is here called sickle hocks. . . . They are very spirited and carry both the head and tail high. But what is most remarkable is that they amble with more speed than most horses trot, so that it is difficult to put some of them upon a gallop."

Horsemen considered them sure-footed, easy to ride, and dependable, and they soon became an everyman's horse. Narragansett

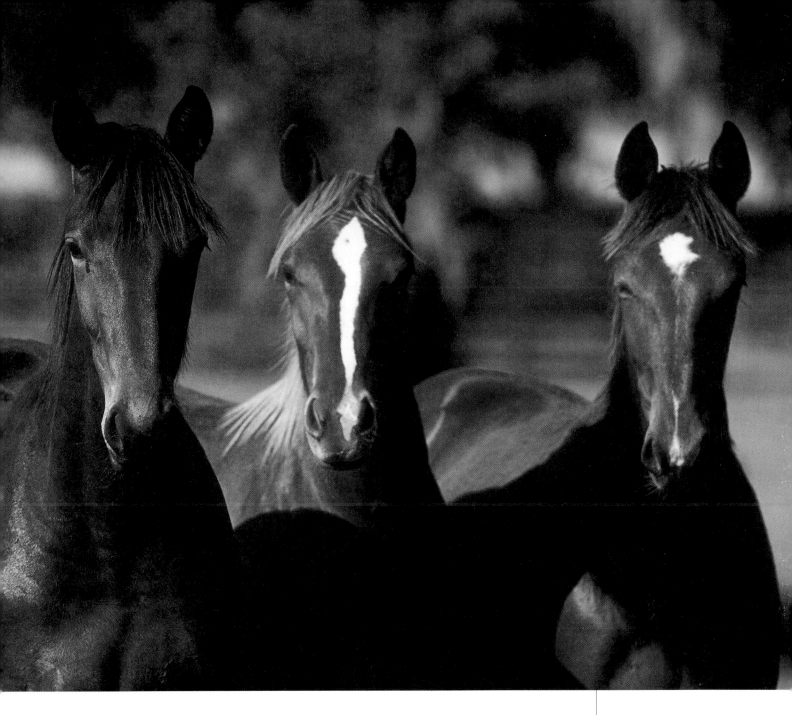

Pacers were famous beyond the colonies; in fact, so many were shipped to Cuba and other islands for use on sugar plantations that their numbers in North America fell dramatically. The utilitarian little Narragansetts disappeared forever as roads were improved, wheeled vehicles became widely used, and big, good-looking trotting horses became fashionable.

From this functional stock, however, came racehorses that both trotted and paced. By the second half of the eighteenth century, the racing of pacers under saddle was well established. Horse owner George Washington, a meticulous record keeper, noted that on August 29, 1768, he paid Robert Sanford twelve shillings to ride one of his pacers in a race.

The Influence of Messenger

The Revolutionary War halted the shipment of horses from England and also caused huge losses in the number of horses here, but as soon as the war was over, importations resumed. Racing history changed forever with the arrival of the gray Thoroughbred Messenger in Philadelphia in 1788. He won eight races and lost six; in

A stripe or star is usually the most white a Standardbred will have.

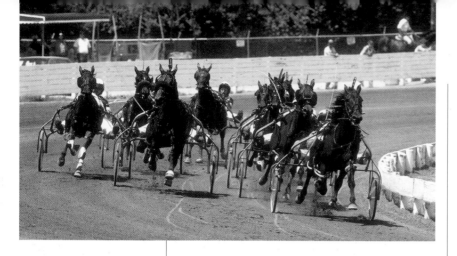

Trotters and pacers do not compete against each other. The pace is slightly faster than the trot.

two races, the opponent forfeited the purse rather than run against him.

Although he competed in relatively few races, Messenger stood at stud for twenty years, producing six hundred foals. They were inclined to be large. Some were very good running horses, and surprisingly, some were superb trotters, known for exceptional speed, good form, and great competitiveness. Today Messenger is the ancestor of many of the best American Thoroughbreds. All Standardbreds trace back to him on the paternal side.

Historians believe that while the Thoroughbred added size and competitiveness to the Standardbred, even the great Messenger could not have been solely responsible for excellence in both the trot and the pace. That credit must be shared with the Canadian Horse, a breed known to produce those gaits. Credit also goes to the Morgan, which had several lines of great trotting horses that were frequently crossed in among other breeds to produce excellence at the trot.

Harness Racing

Harness racing began informally in this country when natural human competitiveness and a need for speed met opportunity,

STANDARDBRED RACING

Standardbred racing is a major sport in much of Canada and on most of the East Coast of the United States, as well as in Michigan, Ohio, Kentucky, Indiana, and Illinois, and California and elsewhere on the West Coast. Standardbreds also race in other countries, including England, Norway, Sweden, Australia, and New Zealand, among many others.

and this seems to have happened first on frozen rivers and lakes. Parish priests in the St. Lawrence Valley were voicing concern before 1700 about the dangers of horse and sleigh racing on frozen rivers on the way to and from Mass. The trot and the pace were probably selected for these races because they were marginally safer than the gallop on glare ice.

The first records of harness races on land date from about 1806, although racing had obviously been going on for many years before becoming an organized sport. When Rysdick's Hambletonian, a descendant of Messenger, was foaled in 1849 in New York, the sport received a huge boost. Although only lightly raced, he turned out to be the greatest progenitor of speed and gait in history. Almost all trotters and pacers today trace back to him.

Also foaled in 1849 was the influential Ethan Allen, a Morgan who at the age of eighteen set the world record for the trot by beating Dexter, a son of Rysdick's Hambletonian. The fastest of their three one-mile heats was 2 minutes, 17 seconds, which is astonishing considering the condition of the tracks in those days and the size and weight of the vehicles they pulled.

Record Times

The popularity of racing finally mandated that a studbook be founded for trotting and pacing horses. When the book was established in 1871, the requirement for registration was that a horse must be able to trot or pace the mile in a standard time, which was then 2 minutes, 30 seconds (2:30) for the trot and 2:25 for the pace. Because they trotted or paced to a standard, the horses became known as Standardbreds.

Since that time, tracks and equipment have improved, as have selective breeding methods and training techniques, so the time for the mile has steadily decreased. The original standard is now considered to be training speed rather than racing speed.

The current (2005) record on a one-mile track for the trot, set by three-year-old Tom Ridge, stands at 1 minute, 50.3 seconds (1:50.3). The present record for the pace on a one-mile track, set by five-year-old Cambest, is 1:46.1.

Although it was common in the early days for pedigrees to allow horses that both trotted and paced, lines have long since developed that produce almost exclusively one type or the other. Trotters and pacers no longer race against each other. In general, the pace is slightly faster than the trot.

Breed Characteristics

Today Standardbreds are almost exclusively used as racehorses, although their generally calm disposition makes them excellent pleasure horses, and their ability to tolerate work makes them the breed of choice as Amish buggy horses. They are commonly used for pleasure driving and occasionally even for foxhunting in the Midwest. A number of organizations promote the use of Standardbreds as pleasure horses after they complete their racing careers.

Conformation

The Standardbred's average height is between 15 and 15.3 hands, but some individuals are well above or below this average. The head is not as refined as the Thoroughbred's; the profile is often straight or slightly convex. Quite a few horses are plain-headed. The nostrils are capable of considerable extension, allowing generous air intake at racing speed. Particularly in some lines of trotters, the ears are inclined to be very long. The neck is usually somewhat shorter and straighter than in Thoroughbreds.

Generally more heavily muscled than Thoroughbreds, Standardbreds also have a longer body with a flatter rib cage. The quarters slope more than do the Thoroughbred's, and the muscles of the quarters, especially in the thighs, are long and powerful. The length of the muscles in the thighs and quarters combined with the

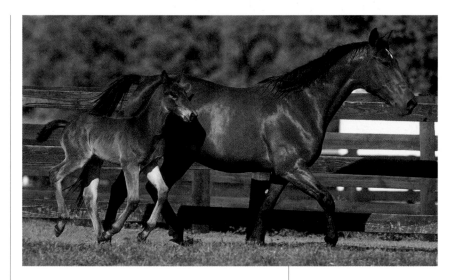

extra slope in the quarters give the breed its great forward movement at racing speed.

After its racing career, this foal may well go on to a career as a pleasure driving or trail horse.

Color

The predominant colors are bay, brown, and black, with minimal white on the face or lower legs. Mane and tail are usually thick and long. Chestnuts, roans, and grays exist but historically have not been favored by breeders or trainers, although one of the most famous horses in the breed's history, Greyhound, was gray, as was one of the top sires in recent history, Laag.

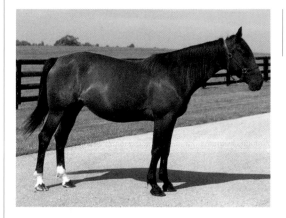

Standardbreds usually have longer bodies than Thoroughbreds do.

BREED ASSOCIATION FACTS AND FIGURES
According to the United States Trotting Association (founded in 1939):
- 750,000 horses are currently registered.
- In an average year, some 11,000 foals are registered.

Sulphur Horse

HEIGHT: 13–15.1 hands

PLACE OF ORIGIN: Southwestern Utah

SPECIAL QUALITIES: Horses of Spanish Colonial type, many of which are dun or buckskin

BEST SUITED FOR: Trail and endurance riding, ranch work, pleasure riding, and all Western sports

I f you look at a road map of Utah, you will observe that the western side of the state seems to be crossed by very few "principal highways" and only an open meandering network of "other roads." The few towns appear as very small dots on the map. The towns and roads are widely spaced because even in these days of wondrous technological advantages, the terrain and climate are astonishingly inhospitable. In the southwestern quadrant of

Utah, along the western edge but not quite to the southern border, is a range of mountains labeled on the map as either the Mountain Home or the Needle Range; locals call it the Indian Peak Range. The southern end of this area has long been home to bands of wild horses.

When the Bureau of Land Management (BLM) began to oversee the wild herds after 1971, it designated an area of nearly 143,000 acres, including the Needle Mountains, as the Sulphur Springs Herd Management Area (HMA). In his essay "Wild Horses of Utah's Mountain Home Range," Ron Roubidoux described this area as follows: "The highest elevation is 9,790 feet . . . elevations of the surrounding valley floors are between 5,000 and 6,000 feet. Low areas are generally sandy while the mountain slopes are very rocky. . . . From the dry, lifeless hardpan of the valley floors the land gently rises over native grass–covered flats to sagebrush-covered benches, and finally to the pinion-juniper covered mountains. Benches and mountains are broken up with many rugged canyons and draws."

Most of this land is unfenced and although it is difficult country to travel, the Bureau of Land Management has routinely rounded up wild horses in the area, eventually putting some of these up for adoption. Between 1971 and 1979, the BLM invento-

ried the horses but none was removed. In 1980 they captured the first nineteen animals and put them up locally for adoption.

In 1985 and 1986, while removing seventy-eight horses from the Sulphur Springs HMA, BLM managers noticed that some of the horses that had come from the northern end of the Needle Range had unusual characteristics. A number of them were dun-factor horses, and their conformation was also unusual. A report described them as "a bunch of heavily marked-up line-back duns with strong Spanish characteristics." *Line-back* is another term for the dorsal stripe characteristic of early Spanish horses.

Because of these obviously significant and unusual traits, the BLM released many of these horses back onto the HMA. An official Sulphur Herd Management Area Plan was signed in 1987 with the objective to: "increase the occurrence of animals with good conformation and those displaying the characteristics of the wild Tarpan type of horse and with colors that occur less frequently to increase the adoptability of horses removed for management purposes."

The BLM captured seventy-eight more Sulphur Horses in 1988 and 1989 and put them up for adoption within the state of Utah. In 1992 the BLM discovered seventeen horses that had been illegally captured. Three of the animals died; the agency

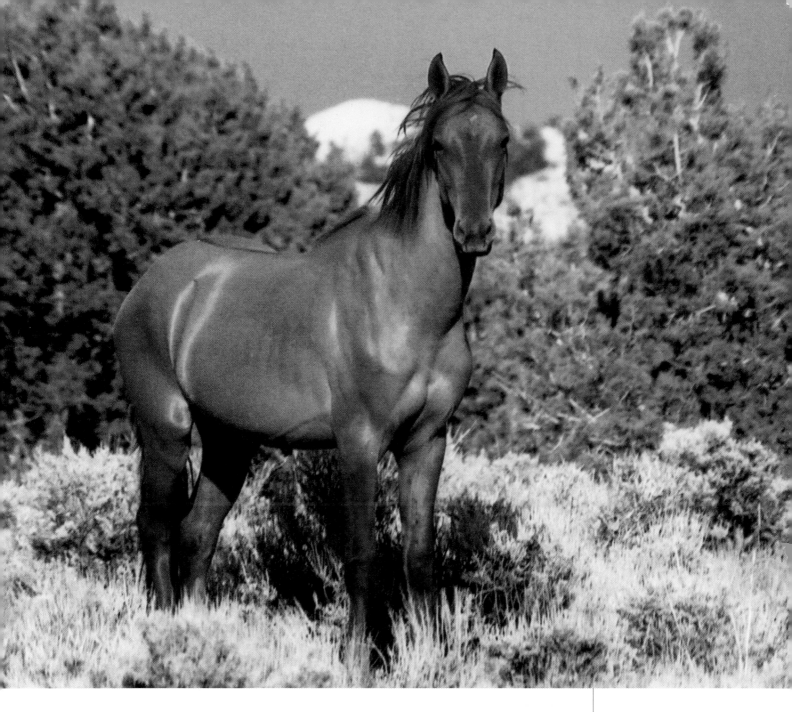

released two and put up the others for adoption.

Spanish Blood

As part of the investigation of the attempted theft of the horses, the BLM took blood samples and sent them to geneticist Gus Cothran at the University of Kentucky. He blood-typed and tested the mitochondrial DNA of the samples and subsequently tested blood from more than fifty adopted horses from the area. He concluded that the test results confirmed a strong Spanish heritage in the Sulphur Horses, saying, "The total analysis shows a more clear Iberian relationship of the Sulphur herd than for any other feral horse population."

The BLM hired Dr. Phillip Sponenberg, famous horse geneticist and Spanish Colonial Horse expert, to visit and evaluate the Sulphur Horses in 1992. In a 2003 update to his original findings, he stated, "The Sulphur herd management area in southwest Utah is one area that still has Spanish type horses today. This region is along the Old Spanish Trail trade route, along which many horses traveled during Spanish and

Sulphurs come in all colors except pinto. This one is a claybank dun.

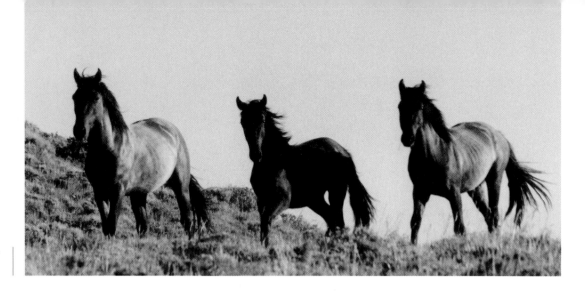

Grullas, blacks, and roans occur in the Sulphur Horse breed.

later times. Both traders and Ute Indians used routes through the area repeatedly, and the feral horses are thought to have originated from this source. Chief Walkara and others made many horse raids into California, and it is likely that the horses in this region have a California origin, making them distinct from other feral strains. Many of the horses from the northern end of this management area have very Spanish type. The usual colors in these herds are dun, grullo, red dun, bay, black and a few chestnuts. These horses show remarkable adaptation to their harsh environment."

When sixty-eight horses were rounded up at Pot Sum Pah, Utah, in August 2003 and placed for adoption, the herd included a bay horse with excellent conformation but a curly coat. The Sulphur Horse Registry adopted this horse, and he has become a traveling emissary for the organization, demonstrating the diversity of horses that may be properly included within this unique group of Spanish descent.

Earlier Evidence

Some argue that the first horses to reach the area probably came along well before Chief Walkara's horse-theft raids in the mid-1800s. An extraordinarily detailed, excellent Web site (www.sulphurs.com) includes in its history section a long list of Spanish explorers, associated dates, and the areas they explored. From this information it seems plausible that some horses were brought to the area as early as the mid- to

late sixteenth century. Furthermore, escaped horses, and those stolen from the Spanish and brought by very early Indian horse traders on their travels north, probably crossed the area.

Whatever the original geographical source of the horses, the heritage is distinctly Spanish. The conformation and genetic markers of Sulphur Horses indicate a long-isolated population of horses of early Spanish ancestry. This tiny pocket of horses is surely a genetic and historical treasure worth saving.

History of the Breed Registries

The philosophies of the major breed registries differ. For the Sulphur Horse Registry (SHR) the goals are: "to encourage and promote the establishment of captive herds of Sulphur horses for the purposes of preserving the gene pool as found in the wild, and to establish a registry and stud book for the registration and preservation of the pedigrees of adopted Sulphur Mustangs and their progeny." At this time, the Sulphur Horse Registry does not require DNA or blood marker parentage verification except for some captive-born foals.

The American Sulphur Horse Association exists to preserve, promote, and perpetuate the Spanish/Iberian American Sulphur Horse, in cooperation with the Cedar City Bureau of Land Management (BLM), and to enhance the wild herds of Iberian Mustangs that currently inhabit the Mountain Home Sulphur Herd Management

Area. Founded in 2003, the ASHA was formed to support the true Spanish American Sulphur Horse breed.

The ASHA has three divisions in its registry. The first division is for BLM Sulphur Horses that have passed an inspection. This division is called the Foundation Division. BLM freeze-branded foals are registered in the Foundation Division after inspection at two years of age.

Captive-born Sulphur Horses are placed into the Permanent Division of the registry. If the horse is from non-registered parents, it must pass inspection. If it is from registered parents, DNA must be on file to verify parentage, but these horses do not have to go through the inspection process. All registered horses must have DNA on file before offspring can be registered.

The third division, the Half Sulphur Division, is for half-Sulphur Horses. The foal resulting from a cross must have at least 50 percent pure Spanish American Sulphur Horse for it to be eligible to be registered. The Sulphur parent must be registered in the ASHA and have DNA on file within the registry.

Breed Characteristics

The Sulphur Horse shows distinct Spanish qualities in its conformation and color.

Conformation

The American Sulphur Horse Association (ASHA) has established the following written breed standard.

"The height is 13 to 15.1 hands. The head is of medium length, narrow, and clean-cut with the lower jaw not too pronounced and the cheeks inclined to be long. The side profile is straight or convex. The eyes are large and almond shaped, expressive, and confident. The ears are medium to long, narrow, and expressive. The neck is of medium length, clean-cut at the throatlatch, deep at the base, and well inserted between the shoulders, which are long, slanting, and smooth muscled. The neck may be slightly

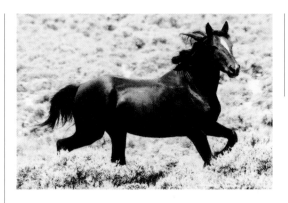

The wild Sulphur Horses of southwest Utah may be the descendants of animals used by early Spanish and Indian traders.

crested in some individuals.

"The withers are prominent and always higher than the croup. There is a smooth transition from the neck to the back. The chest is narrow as seen from the front but deep when viewed from the side. The back is short to medium in length and straight; it forms a smooth connection between the withers and the loins. The croup is strong, of medium length, and slightly sloping. As viewed from the rear, the hip shape may range from rafter-shaped to round. The tail set is medium to low.

"The cannons tend to be long, with well-pronounced tendons. The hocks are long and strong. The pasterns are relatively long and sloping. The fetlocks have little hair. The hooves are medium sized, well formed, and extremely hard."

Color

The ASHA accepts all solid colors but excludes pintos. The colors most common to the Sulphur Horse are dun, red dun, claybank, grullo, bay, black, Palomino, sorrel, roan, buckskin, brown, and chestnut. Stars, strips, snips, and white stockings are allowed.

BREED ASSOCIATION FACTS AND FIGURES

According to the American Sulphur Horse Association (formed in 2003):

- The association registers only horses with either BLM certification of Sulphur HMA origin or proof of descent from Spanish-type Sulphurs.
- Horses must pass a physical inspection before being admitted to the registry.

Tennessee Walking Horse

HEIGHT: 14.3–17 hands

PLACE OF ORIGIN:
Tennessee

SPECIAL QUALITIES:
Naturally smooth-gaited, known for nodding their head at the running walk

BEST SUITED FOR: Trail, pleasure, and showing

The Tennessee Walking Horse is American made. It was bred to work from a number of breeds that are still common, as well as from the Canadian Pacer, now extremely rare, and the Narragansett Pacer, which has vanished. Walking Horses gained fame for their free, smooth, and comfortable gaits, which they passed on to their offspring, as well as for their easy speed and ability to navigate the rocky hills of central Tennessee.

Although many people today know Walkers only as show horses, the breed originated as a highly functional, hard-working horse that could perform every job on small farms and large plantations, from pulling plows to taking the children to school and the family to church. They also raced, and before the Civil War good horses were often shipped by rail to compete in horse shows. Even show horses worked all week at home, however, frequently at very mundane tasks, and attended shows on occasional weekends.

Very early breeders of Walking Horses brought in gaited Spanish Mustangs from Texas to Natchez, Mississippi, and then up to the excellent limestone-based pastures of middle Tennessee. Primary development of the breed centered in about six counties in roughly the center of the state. Breeders crossed these horses on pacing and trotting stock to produce a new breed known for a time as Tennessee Pacers. These horses also owed a great deal to both Canadian and Narragansett Pacers that had been brought in from North Carolina by early pioneers as far back as 1790. North Carolina was quite famous for horses of these breeds, as well as for some fine Thoroughbreds.

In 1886, a cross between the stallion Allendorf from the Hambletonian line of trotters and Maggie Marshall, a Morgan, whose family contained many great Morgan racehorses, produced a black colt with a white blaze, an off-hind coronet, and a near-hind sock. His name was Black Allen. Although he was small, his royal trotting pedigree meant that great things were expected of him as a harness racing horse. He was a complete failure, however, because he would not trot at all. He wanted only to pace, and no amount of training changed that. Although he paced the mile in 2:25, which was very fast for that era, he was never raced and instead was used as a breeding stallion.

Albert Dement, of Wartrace, Tennessee, purchased Black Allen, also known simply as Allen, at the age twenty-three. Dement wanted to produce a breed of horses that would naturally perform the running walk. Allen bred 111 mares the last year of his life, before he died at age twenty-four. Among the mares he bred during his long career was Gertrude, a red roan with four white socks and a bald face. Her pedigree traced back to the great foundation sires of the American Saddlebred, Morgan, and Standardbred breeds.

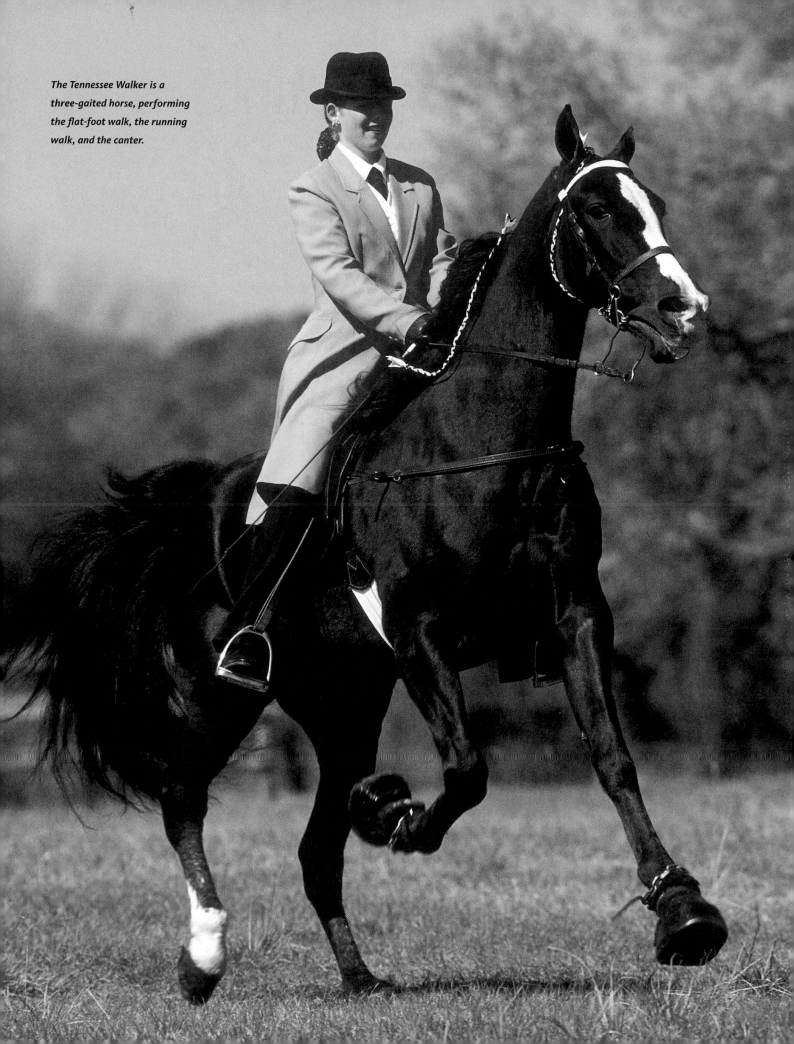

The Tennessee Walker is a three-gaited horse, performing the flat-foot walk, the running walk, and the canter.

In 1904, this union produced Roan Allen, a strikingly beautiful horse whose natural gaits included the flat-foot walk, the running walk, and the trot, as well as the fox walk, the fox trot, the slow gait, and the rack. He performed superlatively at all gaits, winning many classes in a variety of styles. Observers noted the long overreach of his hind legs in front of the tracks of his front feet at each stride and his habit of nodding his head when he worked, which is now a characteristic of the Tennessee Walking Horse. Roan Allen sired many of the most famous Walking Horses in the breed's history.

Registry History

Although horses that sometimes performed the running walk had been around since well before the Civil War, the effort to build a true breed did not really start until Dement began his operations in the early 1900s. The Tennessee Walking Horse Breeders' Association was formed in 1935, at which time it designated the little stallion Black Allen as the foundation sire of the breed. He is now known as Allen F-1. The Tennessee Walking Horse was developed not only through his son Roan Allen, F-38, but also through others of his get that were crosses to Tennessee Pacers.

These horses can now be found in all fifty states and many other countries. The studbook was closed in 1947, and from that point on all Tennessee Walkers had to have two registered Tennessee Walking Horse parents. In 1974, the association's name was officially changed to the Tennessee Walking Horse Breeders' and Exhibitors' Association (TWHBEA).

Breed Characteristics

Walkers make excellent family and trail horses and are often ridden at field trials for upland game dogs. Because of their comfortable gaits, they are a good choice for riders with a bad back or bad knees. They generally have a very quiet disposition and are ideal for both young and timid riders, as well as for those with physical limitations.

Conformation

Tennessee Walkers stand between 14.3 and 17 hands high and weigh from 900 to 1,200 pounds. They are refined and elegant, yet solidly built. The coarseness that was once common in the breed has largely disappeared. The modern Walker should have a pretty head with small, well-placed ears, a long neck, long sloping shoulders, a fairly short back with strong coupling, and long sloping hips. The bottom line is longer than the topline, allowing for length of stride.

The Tennessee Walker is refined and elegant, yet solid and muscular.

On this horse, the bottom line is longer than the topline, typical of Tennessee Walkers. This conformation contributes to the long strides of the running walk.

Color

Tennessee Walkers come in all solid colors and roans as well as pintos. No color is discriminated against.

Gait

Tennessee Walkers naturally perform three gaits: the **flat-foot walk,** the **running walk,** and the **canter.** The flat-foot walk is comparable to the walk in other breeds, though Walkers usually effortlessly outwalk other breeds, traveling between four and eight miles an hour. Their famous running walk is an extremely long, fast, gliding walk that can cover from ten to twelve miles an hour. As the speed increases, the hind feet overstep the tracks left by the front feet by six to eighteen inches. The greater the overreach, the better the horse is considered to be, because this gives the rider the feeling of unbelievably smooth gliding power. The horses often relax some muscles while they perform the running walk, so many nod their head and neck, swing their ears, or even click their teeth in rhythm with the gait.

The third gait is the canter. Walkers are known for the lift and fall of the forequarters at the canter, producing what is often called a rocking-chair gait.

In the show ring, Tennessee Walkers compete in several divisions of classes. Show horses that compete with built-up pads under heavy shoes, take giant strides, and have astonishing overreach of the hind feet, particularly at the running walk, are sometimes informally known as "Big Lick" Walkers. These horses are also shown in a Plantation division, with moderately heavy shoes, and a Lite Shod division with more typical, ordinary shoes of the type one would use for trail riding.

> **BREED ASSOCIATION FACTS AND FIGURES**
> According to the Tennessee Walking Horse Breeders' and Exhibitors' Association (founded in 1935):
> - Since the registry opened, 450,000 horses have been registered.
> - Between 13,000 and 15,000 new foals are registered each year.
> - The breed is found everywhere in the United States, but is most common in the southern and southeastern states.

Thoroughbred

Horse racing probably began very shortly after horses were first domesticated. By the time humans began to keep written records, racing was an organized sport in all major civilizations from central Asia to the Mediterranean Sea. Both chariot and mounted horse racing were events in the Olympics in Greece in 638 BCE. By 200 CE, the Romans had imported well-bred racing animals, usually of Oriental stock, into England.

The origins of modern racing lie in the twelfth century, when English knights returning from the Crusades brought back swift desert-bred horses. Over the next four hundred years, a great many Oriental horses, particularly stallions, were imported into England and crossed on English horses to produce animals that had both speed and endurance. From the sixteenth century on, the mares used in these crosses came to be known as the English Taproot mares.

For the most part, the imported Oriental stallions are reported as having been Arabs, and sometimes that was true, but quite often the word Arab was used to designate any horse that came from an Islamic country. The general designation of Arab denoted both people and horses from the Caspian Sea to the Mediterranean regions, including what are now Iran, Iraq, Syria, Jordan, Lebanon, Saudi Arabia, Turkey, Egypt, Libya, and Morocco. Furthermore, the true Arab people have always been very reluctant to sell their good horses, especially the mares, so unless proved otherwise, the word Arab must be considered to be a somewhat generic term in relation to the history of the horses in England.

King Stephen, who ruled England from 1135 to 1154, imported both mares and stallions into his royal stables, horses that were always referred to as "hot blooded" or "imported." Records show large numbers of Spanish Jennets, Andalusians, and Barbs from what is now Morocco, and Turks from Turkey and Syria. To improve Britain's horses, the king granted the commoners breeding access to the royal stallions, and consequently England became a rich breeding ground of imported, hot-blooded horses.

During the sixteenth and seventeenth centuries, the royalty of England, France, and Italy began to import horses for the primary purpose of improving the speed and stamina of their racing stock. The British royal family became involved in racing when Charles II began attending the races at Newmarket in 1660. He was the first royal to offer large purses for the winners. He also laid out preliminary rules for racing, marked courses, and settled disputes among participants. Charles II sent Sir Christopher Wyvil, his official Master of the Horse, in search of mares for his breeding program. It is thought that Wyvil went as far as India, as well as to Arabia, Persia (Iran), and Andalusia, to collect magnificent mares, which came to be known as the Royal Mares.

There were other horses racing in England at the time, particularly the Galloway Ponies from Scotland. These little, fairly stocky horses raced well. By the late

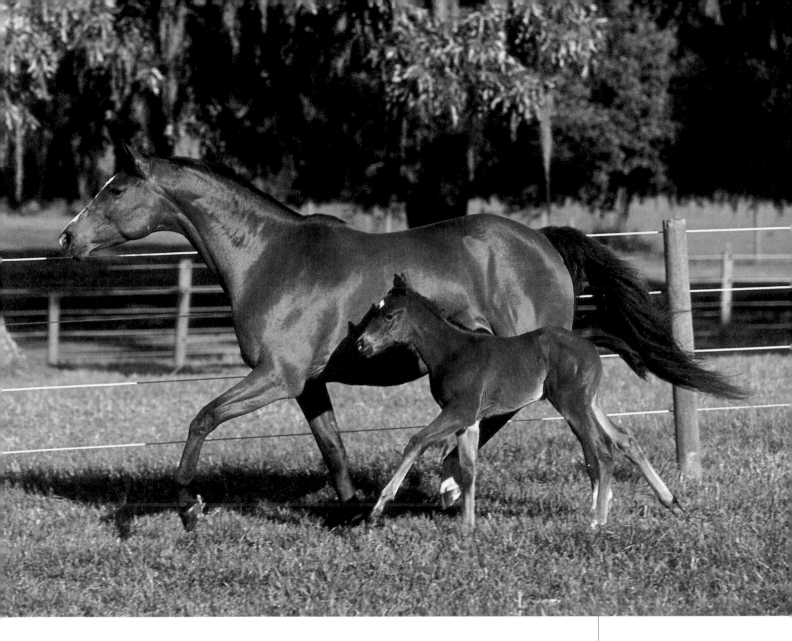

seventeenth and early eighteenth centuries, more breeders of all types of racehorses were seriously concentrating on improving their animals. Wanting to add size, agility, and endurance, they imported stallions from Andalusia, Turkey, Arabia, and the Barbary Coast (Morocco). More than one hundred stallions were imported from Turkey and Arabia between 1690 and 1730.

Foundation Sires

Three of the imported stallions became known as the foundation sires of the modern Thoroughbred, although others were also influential. The three foundation stallions were the Godolphin Arabian, the Byerly Turk, and the Darley Arabian. Their lines remain active to the present day. The pedigree of every modern Thoroughbred can trace back to one of these stallions.

The Byerly Turk was foaled about 1679 and was imported into England in 1689. Many historians believe that he was actually a "Turk" or Turkmene horse, an ancient racing breed now known as the Akhal-Teke. There is uncertainty regarding how this horse came to be in the hands of Captain Byerly. What is known for certain is that Byerly Turk stood at stud in County Durham and later in Yorkshire. He did not breed many of the best mares, but he did produce a horse named Jigg, who is in the pedigree of several important stallions including Tetrach, who was never defeated in a race. The Byerly Turk's great-grandson Tartar sired

Thoroughbreds have been celebrated for centuries for their beauty, speed, endurance, refinement, and heart.

The first breeding programs focused on developing speed and heart for racing.

Herod, one of the most important stallions in Thoroughbred history.

The Darley Arabian was foaled about 1700. When he came to England in 1704 from a famous horse market in what is now Syria, he was certified to have come from the best Arabian racing stock. He stood at stud at Yorkshire. One of the mares he bred, Betty Leedes, was from the famous Leedes Arabian line. This cross produced Flying Childers, the first great racing horse in England. It also produced Bartlett's Childers, who did not race because he was a bleeder, but he was the grandsire of Marske, who produced one of the greatest horses of all times, Eclipse.

The Godolphin Arabian seems to actually have been a Barb from Morocco. He arrived at the stud of Lord Godolphin about 1730. When bred to Roxana he produced Cade, who founded the famous Matchem line.

Thoroughbreds in North America

The first exportations of English "Bred" or racing horses to the United States occurred between 1730 and 1770, by which time short or quarter-path racing was well established in Virginia, Maryland, and Rhode Island. The owners of the fine imported English racehorses were rather surprised to find that the small American short-racing horses could beat them from the start. The races weren't long enough for the English horses to get up to speed. The only one of the early imports to have had much influence on American racing at the time was Janus, who arrived in Virginia in 1752. He was noted for his power, strength, and compactness of form, and he became important in pedigrees of short-racing horses.

Short-racing gradually gave way to longer races, but distance racing did not become widely popular until the nineteenth century, when many racetracks were built. By 1850, the fashion of four-mile heats reached its peak. The Thoroughbreds were specialists at the longer distances, and their popularity increased while that of the short-racing horses diminished. Interestingly, the first American Studbook of the Thoroughbred Horse openly included "Short Horses" as foundation animals. The preface to Patrick Nisbett Edgar's Studbook in 1832 listed many horses with abbreviations such as C.A.Q.R.H.—Celebrated American Quarter Running Horse. Later studbooks written by others seem to have dropped such notations.

The famous gray Thoroughbred Messenger was imported in 1788. In his career he won eight races and lost six; in two races the opponent forfeited the purse rather than run against him. Messenger sired many great running horses among his six hundred offspring.

Following the fashion in Europe, American Thoroughbred racing became the sport of the very rich, but by the early twentieth century it was also the sport of scoundrels. A number of tracks were closed because of corruption. More reputable American breeders and trainers then set their sights on England, but England refused them admission by passing the Jersey Act, which legally closed the British studbook to American horses unless their pedigree could be traced without flaw, on both sides, to horses already in the English Book. Horses that did not meet the requirement

were sneeringly deemed "half-breds" by the British, who were soon embarrassed to find that some of these "half-bred" horses were winning major races outside of England, beating English full-breds, and becoming great breeding stallions. It became clear that the Jersey Act was not helping English racing, because the Americans could import the great English horses and bloodlines, but the English could not import the American ones, including Equipoise, War Admiral, and Seabiscuit. The Jersey Act was rescinded in 1949.

Breed Characteristics

Thoroughbred racing remains tremendously popular and is the major force behind the production of 36,000 Thoroughbred foals each year. Because of their beauty, speed, and staying power, Thoroughbreds also compete in a great many other sports. No other breed has ever had the combination of speed, endurance, and heart found in Thoroughbreds. Today they are used almost exclusively in high-goal polo and in upper levels of three-day eventing. Thoroughbreds also excel as both field and show hunters, jumpers, and occasionally upper-level dressage horses. They have been crossed successfully on almost every breed imaginable to add speed, refinement, and heart.

Conformation

Thoroughbreds average between 15 and 17 hands and weigh 1,000 to 1,250 pounds. In general, the Thoroughbred's head is relatively small and elegant, with a straight profile, well-proportioned, active ears, and large and lively eyes. The nostrils are flared. The neck is usually very long, often straight but sometimes arched. The chest is high and wide, especially in horses bred for sprint racing, although it tends to be deeper in horses bred for distance. The shoulders are very well sloped and muscular.

The withers are prominent, and the back is usually long. The loins are well attached to the croup, which may be quite sloping. The tail set is high. The legs are long and have large, clean joints and muscular forearms. The cannon bones are usually slim. The pasterns are long and sloped. The hooves are relatively small. The skin is thin and the hair coat is very fine.

Color

Thoroughbreds may be bay, black, chestnut, or gray. Roans occur but are not common. Very rarely palominos occur, but because the color is a dilution of chestnut, they are registered as chestnuts. White markings are common on the face and lower legs. Although is not widely known, a very few purebred Thoroughbreds are pintos. The Jockey Club does accept these animals for registration.

A Thoroughbred is built for speed, with a long neck, wide chest, prominent withers, well-sloped shoulders, and long, sloping pasterns.

BREED ASSOCIATION FACTS AND FIGURES
According to the Jockey Club (founded in 1894):
- The Jockey Club assumed responsibility for the American Stud Book in 1896.
- The cumulative number of Thoroughbreds registered in the American Stud Book is more than 1.8 million.
- About 36,000 new foals are registered each year.
- In 2002, about 30 percent of the expected foal crop, almost all of it in Kentucky, was lost to mare reproductive loss syndrome, but numbers have since rebounded.

Tiger Horse

HEIGHT: 13–16 hands, with 14–15.2 hands being most typical and desirable

PLACE OF ORIGIN: Northwestern United States

SPECIAL QUALITIES: A rare gaited breed with Appaloosa color patterns

BEST SUITED FOR: Trail riding, ranch work, pleasure riding; good horses for riders with physical limitations

Tiger Horses have spots, not stripes. The name Tiger Horse comes from the Spanish word *tigre,* which refers to cats with patterned coats, not just tigers. Horses with leopardlike spotted coats occur or have occurred almost everywhere horses are found, from China and Siberia, across the Russian steppes, throughout Asia, and in Europe from Norway to Spain, from where they were brought to the Americas.

There are records of them in works of art going back thousands of years. In some places the color patterns have simply been observed, in other places they have been treasured, and in some places they have fallen in and out of fashion. Leopard-patterned horses, now often now referred to as leopard-complex horses for the gene group that causes the color pattern, were a fad in Spain, Holland, Germany, Denmark, Austria, and France during the 1700s, but toward the end of that century the fad waned. Boatloads of spotted horses were subsequently shipped off to Mexico, California, and the colonies. In the New World, in places where the influence of the mostly solid-colored English was strong and in fashion, the wild-colored horses were traded off, often to Canada.

Various native peoples admired the loud colors, and they acquired such horses whenever they could. The Ni Mee Poo (Nez Percé) of the Northwest particularly valued the spotted horses and featured them in their breeding programs, which were quite sophisticated. The tribe was so closely associated with these horses that it is often reported as having developed them. The Ni Mee Poo themselves deny this, but controversy still remains. The Ni Mee Poo acquired some horses from Canadian traders, and there are also stories from oral tribal history of special "Ghostwind" stallions bought from Russian traders. The horses were pushed off boats and tribesmen swam them ashore. Historical evidence indicates that the story is true, but adds the information that the Russians obtained these decidedly Spanish-type horses in California from established ranches.

The Ni Mee Poo had well-established herds of excellent horses, many with spotted coats, by the time Lewis and Clark encountered them in 1804. Meriwether Lewis, a horse breeder himself, recognized high-quality animals when he saw them. He was very favorably impressed with the horses of the Ni Mee Poo, saying in his notes that they compared well in form and fleetness of foot with the blooded horses of Virginia.

In addition to the color, the most notable trait of these Tiger Horses was their willingness and ability to perform a smooth, intermediate four-beat gait that came to be known as the "Indian shuffle." This gait was so much easier on horse, rider, and even equipment that cowboys of the time are reported to have paid $50 more for a "shuffler" than for an ordinary horse, and this was in the days when a good broke cow pony cost about $30.

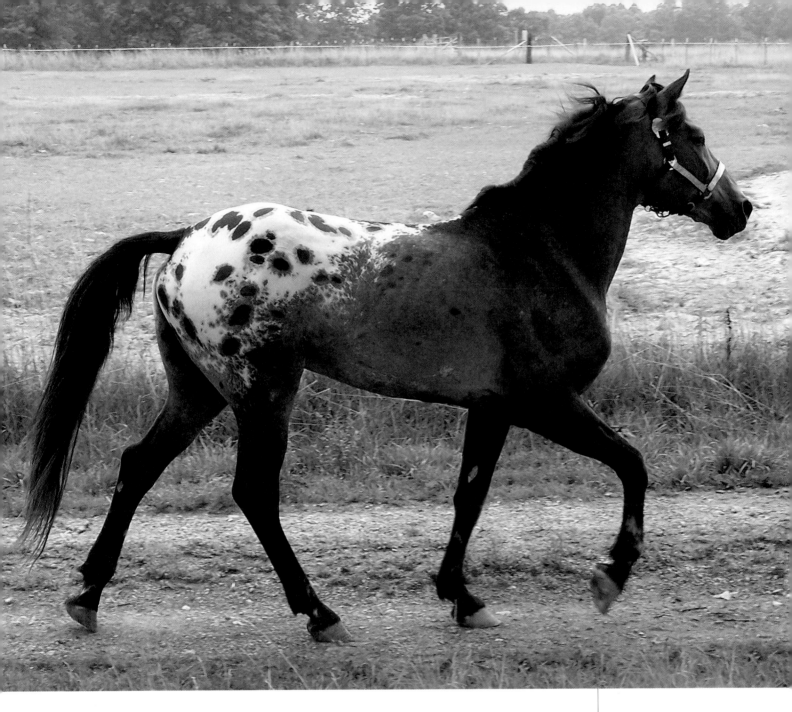

The origin of the gait in this country goes back to the Spanish Jennet, which is credited with being the ancestor of all North American gaited breeds. Furthermore, for quite a long time Spanish Jennets were known to come in wild color patterns. At the time of Lewis and Clark, horses in the colonies showed the influence of the smooth-gaited English Hobby and Narragansett Pacer, both of which had a strong Spanish Jennet heritage. Through trading, escapes, theft, and sales, the bloodlines of these horses were also randomly incorporated into the Tiger Horses.

On the Brink

The 1887 war between the United States Army and the Ni Mee Poo resulted In the conquest of the tribe and its relocation, as well as the nearly complete dispersal or destruction of its horse herds. But a few small pockets of the horses remained in the Pacific Northwest. They had been well distributed by trade with various tribes, and some ranchers either owned a few or held them in trust for the eventual return of the Ni Mee Poo. In 1938, Claude Thompson, an Oregon farmer, established a registry to preserve the spotted horses

Horses with colorful patterns, like this Tiger Horse, have occurred throughout recorded history and all over the world. This breed's gaits include the "Indian shuffle," an intermediate four-beat gait.

then believed to have been developed by the Ni Mee Poo.

The Appaloosa Horse Club that Thompson founded brought attention to the horses and prevented their extinction, but over the years this organization allowed crossbreeding to Quarter Horses, Arabians, and Thoroughbreds, which eliminated some of the original characteristics of the Tiger Horse, especially the gait. A few of the original Tiger type remained in Canada, in remote areas of the Pacific Northwest, and on some ranches. In addition, a number of breeders of "foundation" Appaloosas have regularly produced horses of the old Spanish type with the characteristic four-beat gait.

The Tiger Horse Registry, known as Tigre, was founded in 1990. This organization strives to reproduce as closely as possible the famous horses from ancient Siberia, but with a contemporary American flair. Since the original horses are extinct, they rely on horse types that were developed in the New World but which obviously exhibited some of the ancient ancestors' phenotype. To this end they emphasize the palomino color and the sabino pattern gene, as well as the leopard complex of genes. They put primary emphasis on disposition, followed by conformation, gait, and color.

Early in the development of the organization, a rift regarding the registry's philosophy led to the formation of the entirely different Tiger Horse Association, founded in 1994 to preserve and perpetuate what was left of the original Tiger-type horses. Owners and breeders of this group are trying to find and register as many of the horses that resemble the old type as possible in order to guarantee their survival. To ensure that the organization stays along its carefully chosen course over the long term, it works closely with members of the Ni Mee Poo tribe and with Dr. Phillip Sponenberg and Dr. Gus Cothran, horse geneticists who are experts in rare breeds, the early Spanish horses, and techniques of managing small populations.

They have also worked with Dr. Deb Bennet, a horse historian.

The group has carefully developed the breed standards and genetic requirements for registration that will ensure long-term genetic health of the population. They began by registering horses with the leopard-complex coat patterns, an intermediate four-beat gait, and at least some Spanish conformation characteristics. Registered horses may be Appaloosa, Spanish Mustang, any of the Paso breeds, some of the lesser-known breeds of Spanish descent such as the Florida Cracker, as well as Native American herds.

Since the ability to perform the gait has been actively bred out of most leopard-complex horses, the Tiger Horse Association recognizes the need for occasional outside gaited blood to be brought in. All outcrossing is for one generation only, and only to individual horses approved by the association. Foals resulting from such crosses have an *O* put at the end of their registration number. These *O* horses may be bred back only to registered horses or to other *O* horses to produce eligible foals. Wholesale outcrossing is not allowed.

Breed Characteristics

Both breed associations agree that Tiger Horses are expected to be gentle and sensible, with excellent learning capacity and great heart. In addition to a walk and canter, a Tiger Horse must perform an even, natural, four-beat gait. The Tiger Horse Association adds that they also often demonstrate the controlled spirit and pride known in Spanish as *brio*. Tigers make good trail and ranch horses as well as excellent pleasure riding horses. Like other smooth-gaited breeds, they are a good choice for riders with physical limitations.

Conformation

According to the Tiger Horse Association, the ideal Tiger Horse should be a colorful, gaited, light horse that is well balanced and

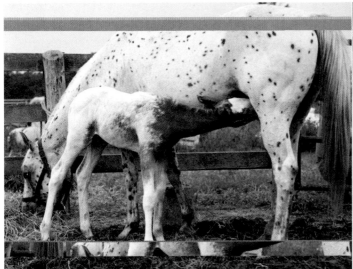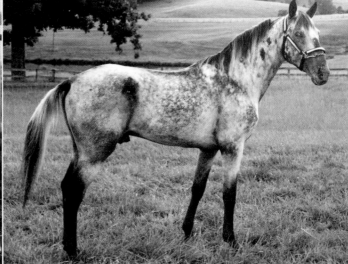

sturdy, without extreme muscling. Height ranges between 13 and 16 hands, with 14 to 15.2 hands being most typical and desirable. The ears are of medium length, curved and notched, mobile, and alert. The eyes are large and prominent, with white sclera. Viewed from the front, the head should look lean and show no cheekiness. The eyes should be widely spaced, the forehead broad and flat and tapering to a fine muzzle with large sensitive nostrils. The profile may be straight or slightly convex, but in the ideal, the convex curve does not extend as far up as the eyes. A concave or dished profile is neither typical nor desirable, nor is a Roman nose.

The neck should be high set, moderate to long, well balanced, blending smoothly into the wither, and well arched, with a clean throatlatch. The withers should be well defined, with sloping shoulders; the ideal angle is 45 degrees. There should be good depth of heart girth. The legs should be straight and long with large, clean joints. The cannons should be relatively short. Viewed from the front, the chest should be of medium width, frequently with a well-defined V between the forelegs. Muscling of the forehand should be long and flat. The back should be short-coupled and strong, with a sloping croup and low-set tail. Viewed from behind, the thighs should be fairly flat without bunchy muscling that

gives the appearance of an "apple-" or "heart-shaped" rear. The pasterns should be of moderate length, strong, and flexible. The hooves should be dense, resilient, and substantial, and are usually striped. Neither toes nor heels should be particularly long. Mane and tail hair can range from nearly nonexistent to extremely long and full, but must always be completely natural.

Color

The Tiger Horse can be of any base color, though ideally, Tiger characteristics and coat pattern should be present. These characteristics are white sclera, striped hooves, and mottled skin. Common coat patterns are leopard, blanket (with or without spots), roan (with or without spots), and snowflake. Horses with the graying gene or any pinto gene are not acceptable.

BREED ASSOCIATION FACTS AND FIGURES

According to the Tiger Horse Association Inc. (founded in 1994):
- There are 45 registered horses.
- The number of new foals in an average year varies from zero to as many as eight.

According to Tigre, the Tiger Horse Registry (established in 1990):
- There are 50 registered horses of this type.
- Three to 5 new foals are registered each year.
- These horses are not concentrated in any one geographical region. There is one in Germany.

Trakehner

Most North Americans today think of the Trakehner as an elegant warmblood from Germany, but the breed was actually developed on the easternmost side of what was then East Prussia and is now Lithuania. Its very early history can be traced back to a local breed of small utilitarian horses, the Schweiken, known for their great endurance. The Schweiken itself has a long history tracing back to the ancient Scythians,

who inhabited the area in the fifth and sixth centuries BCE. Every Scythian owned at least one gelding to use as a riding horse, as well as rough ponies to use as pack animals. As revealed in their tombs, wealthy individuals had many horses: the best were Ferganas (ancient Turkmenians), but the majority were Mongolian horses. The little Lithuanian Schweiken was strongly influenced by both the best Turkmenian horses, known for their endurance and speed, and the unbelievably tough Mongolian horses.

When the Knights of the Teutonic Order conquered Prussia in the thirteenth century, they established one of Europe's earliest stud farms at Georgenburg in 1264. Building more than sixty studs in the following decades, the order required that landowners supply horses to the cavalry, which supported their goal of spreading Christianity.

In the early 1700s, King Frederick William I recognized the need for lighter, faster horses for the Prussian army. War tactics had changed significantly with the widespread use of gunpowder. There was no longer a need for lumbering medieval warhorses. The king wanted his officers mounted on horses that were attractive and impressive enough to represent his army. These horses had to be sound and solid, with good stamina. They also needed

comfortable, ground-covering gaits, particularly the trot, to enable them to travel long distances quickly and efficiently. The king chose the best horses from seven of his royal breeding farms in 1732 and moved them to a new, 15,000-acre stud at Trakehnen.

A Meticulous Breeding Program

The king's famous mare herds, stabled at sixteen barns removed from the main complex, were sorted and bred by color, with the different herds representing different traits that were useful to the breed. The black herd consisted of strong mares that made the best workers. The chestnut mares were collected near the stud at Trakehnen; elegant and sensitive, they exhibited the greatest performance potential. The bay and brown mares had outstanding temperament and excellent rideability. There was also a herd of mixed colors.

At the same time, a significant number of mares still belonged to the small breeding establishments of East Prussian farmers outside of the official breeding program. The quality of these mares improved with the development of the Trakehnen stud and with access to the best stallions.

After the death of Frederick in 1787, the stud was transferred to state ownership

The noble Trakehner is the result of centuries of careful breeding.

under the direction of a chief stud administrator named Lindenau, who established well-defined breeding objectives and began to improve the entire local horse population. He allowed private breeders to bring their mares to the state stallions, and he eliminated two thirds of the royal stallions and one third of the broodmares. Then he brought in new blood, beginning with the hardy Lithuanian Schweiken and eventually adding Thoroughbred, Mecklenburg, Danish, and Turkish stallions. In the final stage of the breed's development, a Turkmenian (what we know today as an Akhal-Teke)

stallion and three of his sons exerted considerable influence. Breeders added the blood of selected English Thoroughbreds and Hungarian Arabs between 1817 and 1838. The Trakehner studbook was started in 1878.

During World War I, the population of Trakehner horses dropped by nearly half, but by 1938, there were nearly half a million horses living in East Prussia. The breed was tremendously successful until World War II, excelling as a military and endurance horse while also doing light draft work on farms.

In action, this breed is graceful, elegant, and athletic.

International Achievement

The breed has produced outstanding performance horses. Trakehners won both the gold and silver medals in dressage in the 1924 Olympics and the bronze medal in three-day evening in the 1928 Olympics. The year 1936 is sometimes called the year of the Trakehner. At the Olympic Games, Kronos won the gold and Absinth the silver medal in dressage, and Nurmi took gold in three-day eventing. Also in 1936, the Trakehner Dedo won the Prix de Nations in show jumping at Madison Square Garden. Between 1921 and 1936, the Pardubice, the second most difficult steeplechase in the world, was won a total of nine times by East Prussian horses. The East Prussian warmblood, as it was also called, was exported all over the world.

Devastated by War

World War II nearly caused the extinction of the Trakehner. In 1944, almost at the end of the war, the Soviets were closing in on the area around Trakehnen, and orders came to evacuate the horses from the stud. About eight hundred of the best horses were moved by rail and by foot, but they did not go far enough west, and most of them, along with their documentation, fell into the hands of the advancing soldiers and were shipped to the Soviet Union.

THE TRAKEHNER TREK

Private Trakehner breeders were not permitted to leave their farms until 1945, after the Russians broke through the last of the German lines. Hitching their horses to wagons filled with all their possessions and all the feed they could carry, a group mostly of women, children, and aged relatives fled in the middle of winter with about eight hundred horses, including many broodmares heavy in foal. They headed west, running for their lives, unable to stop when mares

foaled or when horses went lame or became sick. Their feed ran out. The "trek," as it came to be named, covered six hundred miles and continued for two and a half months, during which time they were relentlessly pursued by ground troops and by Soviet planes.

At one point they were trapped on the shores of the frozen Baltic Sea, their only escape across treacherous ice. At times knee-deep in water, they crossed, galloping to stay ahead of breaking ice, still being strafed by aircraft. Many did not make it. The survivors, with one hundred pitifully starved horses, many with burlap bags frozen to their feet in place of shoes, limped into West Germany.

Of the 80,000 Trakehners in East Prussia before the war, only about eight hundred to one thousand made it to West Germany by the war's conclusion. Many of those were lost to the breed, from injuries sustained during the trek, from continuing hardships after the war, or simply because they were never located when efforts at breed recovery began.

Recovery and Resurgence

The next decade was spent reestablishing the breed in West Germany. In addition to the group that had survived the trek, other East Prussian refugees and their horses were scattered all over West Germany. The West German association, known as the Trakehner Verband, was founded in 1947. Over time, many of the surviving horses were located and accounted for. The German federal government joined with the state of Lower Saxony in 1950 to provide support for a small breeding farm. The last original Trakehner broodmares from the main stud were collected there and used to breed future generations.

The war and politics separated East and West Trakehners. In Poland, herds of stallions and mares were gathered and identified by their brands or registration papers. Poland reestablished many of the East

Prussian studs to continue the breed, although right after the war they selected for moderately heavy horses that were able to perform farmwork. Today the Polish Ministry of Agriculture registers Trakehners in its Great Polish Horse Stud Book.

During and after the war, Russia took many stallions from Trakehnen and used them wisely, becoming a respected source of good-quality Trakehners. A stud in Lithuania has 950 purebred Trakehner mares. Some say that in Russia all the best sport horses are actually Trakehners, and that a Trakehner there will bring seven times the price of another breed.

To North America

In 1957 German-born Gerda Friedrichs imported four Trakehner stallions and twelve mares to her farm in Canada; she added eleven more mares in 1963. An approved stallion and a mare that had actually survived the trek also arrived in the United States in 1963. From that point on, interest has grown steadily.

Breed Characteristics

Trakehners are recognized for their distinctive type, which displays sound conformation, compelling presence, and nobility of bearing. These horses present a picture of refinement and elegance. The skin is fine and thin and lies close to the bone, with the veins close to the surface and musculature well defined. In motion, the gaits are light and flowing. The athletic ability of the breed is undisputed.

The Trakehner brand.

The American Trakehner brand.

The Canadian Trakehner brand.

TRAKEHNER VERBAND RULES

Although other warmblood breed associations frequently admit stallions of various breeds, including Trakehners, for "improvement" of their own, the Trakehner Verband only rarely allows infusions of very carefully selected individual Thoroughbreds and Arabs. No other breeds are ever used. Offspring that result from crosses between approved Thoroughbreds or Arabians and Trakehners are full-blooded Trakehner horses in the eyes of the West German registry.

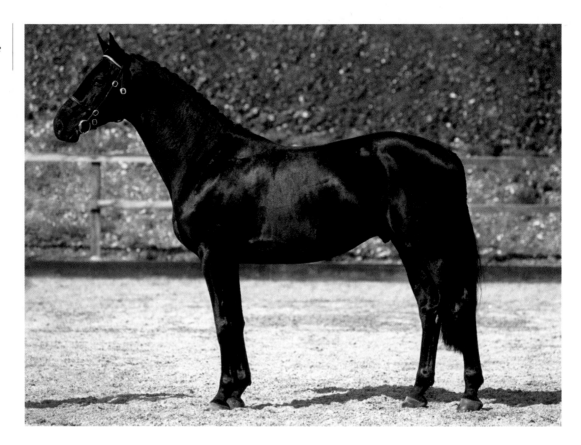

Conformation

The Trakehner is a rectangular horse, standing between 16 and 17 hands but with a shorter length of leg than most Thoroughbreds. The head is distinctive in its charm and nobility, reflecting the breed's Arabian ancestry; many show a slightly dished profile. The forehead is wide with large, kind eyes. The throatlatch is slim and well defined, the neck long and graceful. The withers are prominent.

Compared to heavier warmbloods, the Trakehner has lighter, medium bone. The girth is deep with round full ribs. The chest is deep, the shoulders sloping and well muscled. In general, the Trakehner has flatter hindquarters than other German breeds, and the tail set is higher. The croup is very gently sloped. The legs are well muscled with clean joints, clearly defined tendons, and solid hooves. The pasterns are of medium length and slope.

The Polish Trakehner differs slightly from the German strain. These horses are larger and heavier, with more substance. Some believe the Polish horses have a calmer disposition. Polish breeders do not emphasize a pretty head. The Poles are said to prefer big, strong, galloping, free-moving horses, especially well suited to three-day eventing and jumping.

Color

The most common color is chestnut, then bay, brown, black, and gray. White markings on the face and lower legs are common but not excessive. Piebald (pinto) horses do occur in this breed and, although not encouraged, may be registered if their conformation and other characteristics are good.

BREED ASSOCIATION FACTS AND FIGURES

According to the American Trakehner Association (ATA) (founded in 1974):

- About 11,000 horses are registered with the ATA.
- Some 300–600 new foals are registered each year.
- The breed is found throughout both the United States and Canada and is, of course, well known throughout Europe.

Westfalen/ Westphalian

The province of Westfalia, south of Hannover in Germany, is an area traditionally known for horse breeding. For many years, individual breeders of Westfalens maintained their own records, unlike the owners of some other warmblood breeds. In Europe, families tend to remain in the same location and in the same business for a very long time, so the bloodlines of horses have always been known and preserved, dating

back through many generations of both human and equine families. However, for quite a long time no central location for the records existed. The Westfalen officially received its own name and identity as a breed in 1904, when the studbook was founded. The Westfalen brand wasn't established until 1966.

Westfalia became a part of Prussia in 1815, and by 1826 horse breeders had organized a central stud at Warendorf with thirteen East Prussian stallions. They later added stallion stations across the province, so that by 1830 there were fifty stallions, and by 1878 there were one hundred. Because of their proximity to Hannover,

HEIGHT: 16–17 hands

PLACE OF ORIGIN: Germany

SPECIAL QUALITIES: Tremendous and powerful gaits and athletic ability combined with a willingness to accept direction from the rider

BEST SUITED FOR: Show jumping, dressage, field and show hunters; all sport horse activities

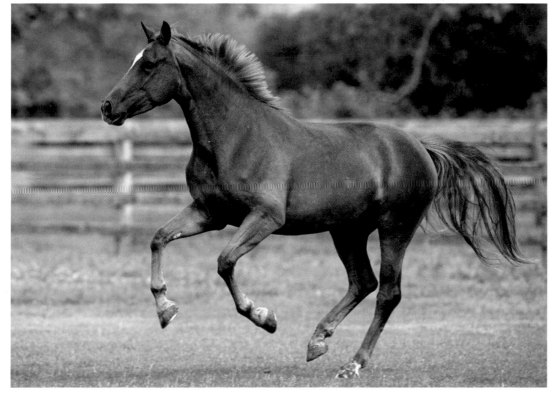

The Westfalen, once a farm horse, is now one of the most popular warmblood breeds in the world.

The Westfalen brand.

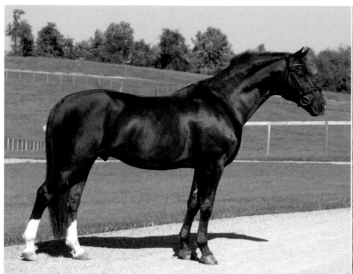

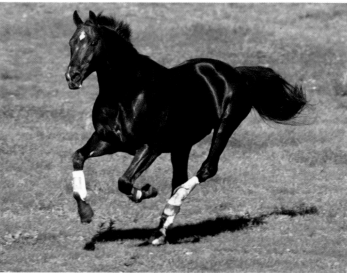

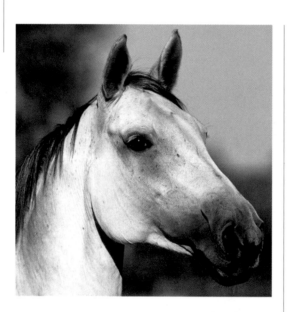

These tall horses have powerful necks and shoulders.

many breeders used Hanoverian horses in the Westfalen's development. They also incorporated other breeds, including the Thoroughbred, the East Prussian, the Berbecker, and the Graditzer. A good many of the early Westfalen horses that were bred specifically for farm and heavy military use had straight shoulders, short pasterns, and straight hind legs — traits that are rare in the modern horses.

Today the Westfalen is one of the most popular breeds in Germany, but the horse has changed since the days when it was primarily a working farm horse. Beginning in about the 1920s and continuing after the devastatingly hard years of World War II, breeders have worked to develop the breed as a sport horse. Today's Westfalen is lighter and more rideable than the earlier versions, thanks to the contributions of the great Shagya Anglo-Arab Ramzes in the late 1940s, as well as several Trakehner and Thoroughbred stallions. At the state stud at Warendorf today, Thoroughbred and Hanoverian stallions stand along with the Westfalens.

The Westfalen Warmblood Association of America was founded in 1987 to recognize the achievements of individual horses and to promote the breed. This association has now been formally disbanded and it has been replaced with the Westfalen Horse Association.

INTERNATIONAL ACHIEVEMENT

The breed is fortuitously headquartered near the German National and Olympic riding schools, where top horses have every opportunity to be discovered by top riders. The selection of breeding animals is exceptionally strict; only horses that pass demanding tests for conformation, character, riding, and pedigree are approved. Because the selection process is so rigorous, it is not surprising that stallions from the Westfalen stud have often held first place as the most successful German breeding stallions, as measured by the success of their progeny. Modern Westfalens frequently win in dressage and jumper shows at all levels up to the Olympics. A prime example is the spectacular dressage horse Rembrandt, winner of the gold medal at the 1988 Olympics and gold at the 1990 World Championships, where his score was the highest ever awarded.

Breed Characteristics

The Westfalen is generally heavier than the Hanoverian, which it closely resembles. The breed, one of the most popular competition breeds in the world, is known for its spectacular movement and willingness to accept direction from the rider.

Conformation

These are tall horses, standing 16 to 17 hands. The head is attractive, with good width between the eyes and a straight or sometimes slightly dished profile. The neck is long, muscular, and well set. The shoulders are powerful and sloping. The tendency toward steep shoulders and short pasterns, once commonly seen on the heavier work-type Westfalens, has largely been replaced in the modern type with sloping shoulders and longer pasterns. The body is deep and muscular. The hindquarters are very powerful. The croup is often much flatter than in the Hanoverian.

Color

As with most warmblood breeds, the Westfalen can be any color.

BREED ASSOCIATION FACTS AND FIGURES

According to the Westfalen Horse Association (WHA) (founded in 2002):

- All Westfalen horses in North America are registered in Germany with the German association.
- The WHA does not track the number of Westfalens in North America.

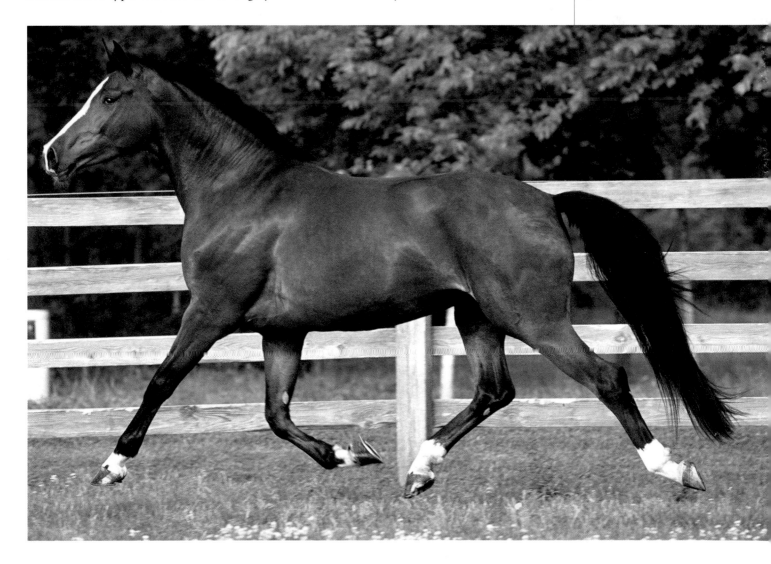

The Westfalen has exceptionally good movement. This horse seems to float above the ground.

Wilbur-Cruce Mission Horse

HEIGHT: 14–15 hands

PLACE OF ORIGIN: Southern Arizona

SPECIAL QUALITIES: A strain of the critically endangered Spanish Barb; exhibits Spanish conformation, sure-footedness, courage, and inborn "cow sense"

BEST SUITED FOR: Ranch work, trail and endurance riding, all Western sports

A Jesuit priest named Father Eusebio Kino brought the first Spanish horses to the area that is now southern Arizona and northern Mexico in the late 1600s. He established his headquarters in the San Miguel River Valley, where he founded Mission Dolores and Rancho Dolores. Mission Dolores was Father Kino's central breeding operation for Spanish horses, as well as for other livestock. The Wilbur-Cruce Mission Horses originated from this area.

Two hundred years later, a horse trader named Juan Sepulveda bought a herd of several hundred horses from Mission Dolores, intending to drive them to the stockyards in Kansas City for auction. His first stop on the drive was the homestead of Dr. Rueben Wilbur, who bought twenty-five mares and a stallion. Dr. Wilbur was a physician and the first rancher to settle in that district of the Arizona Territory.

He turned the horses out in the high desert mountains, allowing them to multiply and letting the forces of nature toughen his horses and eliminate the weak. Because they were already well adapted to the dry climate and the extremely rocky terrain, these sturdy horses managed quite well without human assistance. On the ranch, they were referred to as "little rock horses," which nicely describes both the horses and their environment. For the most part, the rock horses stayed in the mountains. The ranch hands caught and trained only as many of the horses as they needed for work and left the rest alone.

The ranch remained in the family and the horses were isolated for 113 years, protected by their remote location and the dedication of the Wilburs. Eva Antonia Wilbur-Cruce, a granddaughter of Dr. Wilbur, took over management of the ranch in 1930. She deeply valued the quickness, sure-footedness, intelligence, and courage of the horses, and worked hard to keep the herd free from outside influences. She finally sold the ranch in 1990, feeling that she was too old to stay in the business. The Nature Conservancy bought the land but did not need or want the horses. Recognizing the genetic and historical value of the Wilbur-Cruce Horses, the American Livestock Breeds Conservancy (ALBC) provided the funding to trap and remove them. Dr. Phillip Sponenberg, the technical coordinator for the ALBC, divided the total herd of seventy-seven into breeding groups and distributed those groups among conservation breeders.

Eventually the Spanish Barb Breeders Association (SBBA) created a division in its registry for the Wilbur-Cruce Mission strain, allowing these horses to be documented as a distinct population, which provides maximum opportunity for long-term conservation. The SBBA also keeps historical documents about the Wilbur-Cruce Horses.

It is easy to become confused by the number of names that may be correctly

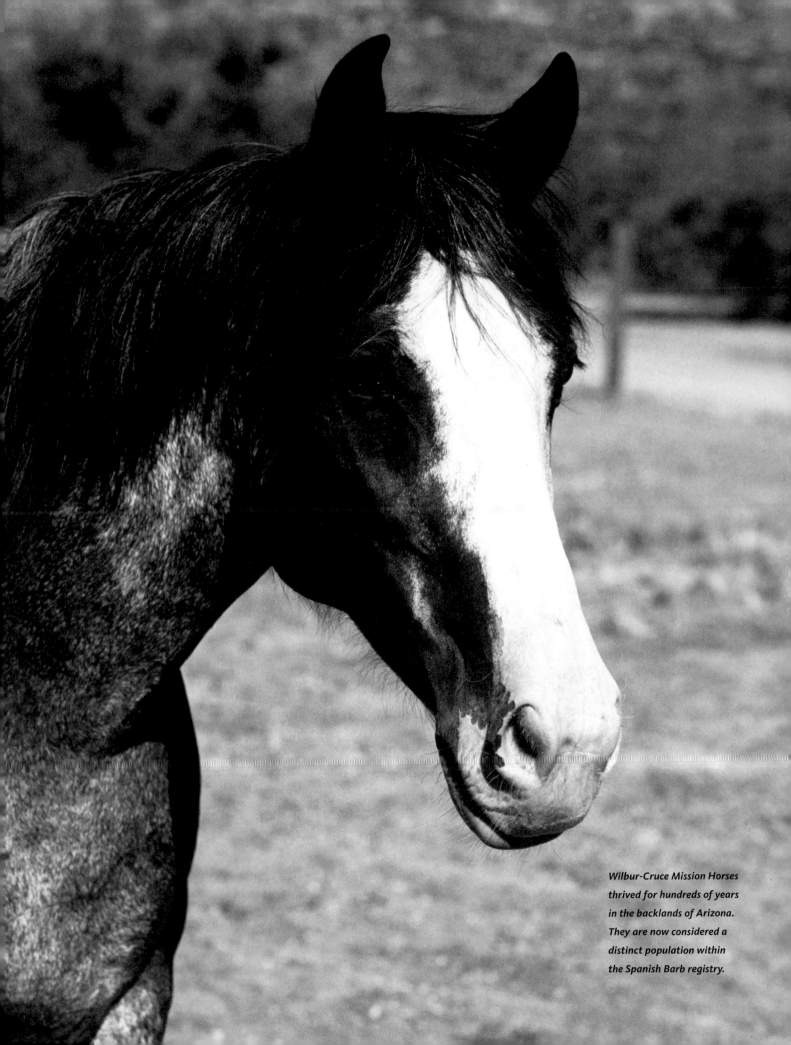

Wilbur-Cruce Mission Horses thrived for hundreds of years in the backlands of Arizona. They are now considered a distinct population within the Spanish Barb registry.

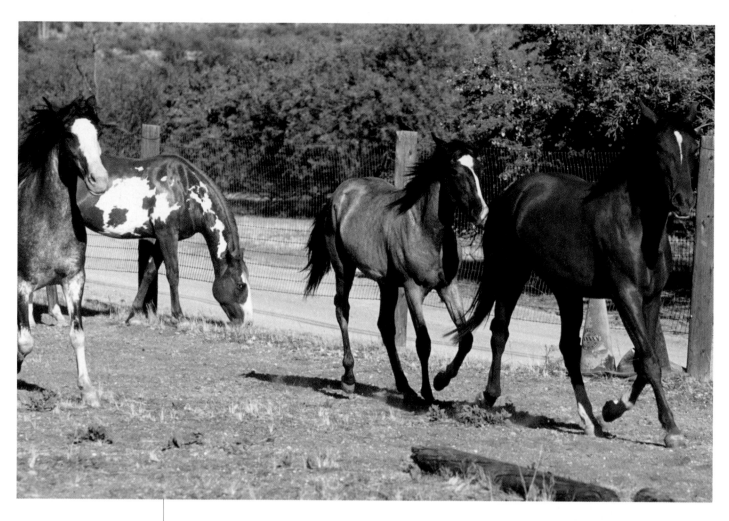

applied to the Wilbur-Cruce Horses. They are registered as Spanish Barbs, but it is also correct to refer to them as a strain of Spanish Colonial Horses, or even as Spanish Mustangs.

Breed Characteristics

As a subset of Spanish Barbs, Wilbur-Cruce Horses have the typical breed characteristics, including a straight or slightly convex profile, very expressive eyes, a relatively narrow but deep body, a sloped croup with a fairly low-set tail, good legs, and extremely hard feet. Although there aren't very many of them, they still make excellent ranch horses and good mounts for trail and endurance riding.

Conformation

The Wilbur-Cruce stands 14 to 15 hands. The profile of the head is straight to

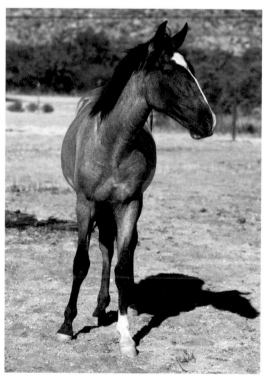

Blue roans are common in this breed.

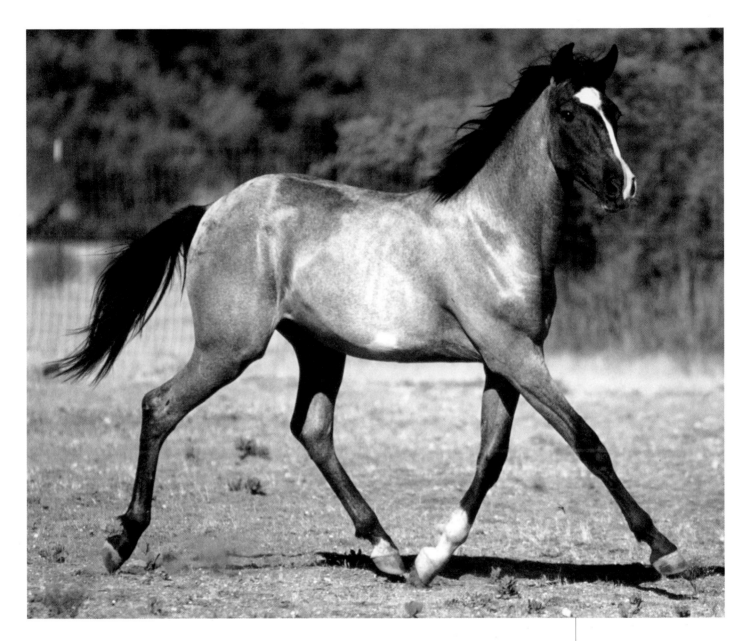

This Wilbur-Cruce Horse is an excellent mover.

slightly convex. The ears are short to moderate in length, often being notched at the tip. The eyes are expressive. The broad forehead narrows to a small muzzle. The neck is well arched at the topline, broad at the base, and blends into shoulders of good length and angle. The back is short to medium in length with strong and powerful loins. The croup may be rounded or slightly angular, with a medium to low tail set. The legs are of medium length, but the cannons are of excellent circumference. The hooves are ample in size and extremely tough. The mane and tail are full, especially in the stallions.

Color

Like the Spanish Barb, these horses can be black, sorrel, chestnut, roan, grulla, dun, or buckskin. Although the Spanish Barb is usually a solid-colored horse, pintos are common in Wilbur-Cruce Horses.

BREED ASSOCIATION FACTS AND FIGURES

According to the Spanish Barb Breeders Association (SBBA) (founded in 1972):

- The SBBA has tracked Wilbur-Cruce Horses as a distinct type since 1995.
- The total number of these horses is between 70 and 80.
- About a dozen foals are registered each year.

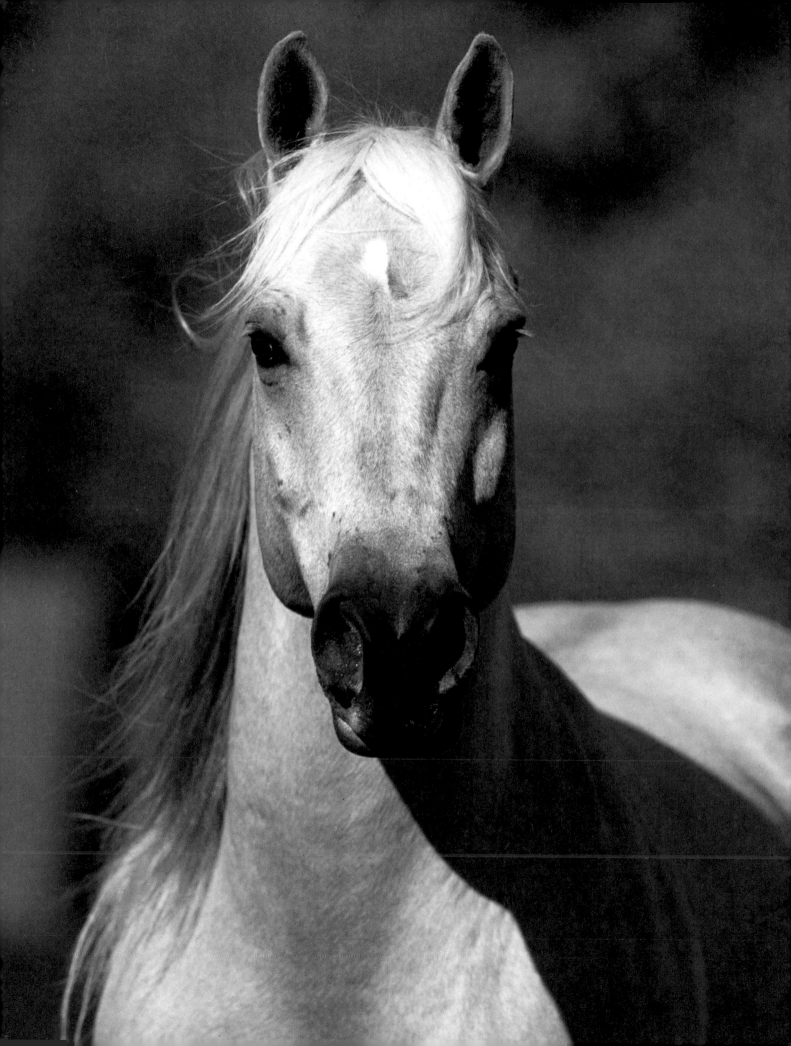

1111

11

111

11111

Color "Breeds"

COLOR IS ONE OF THE FIRST THINGS one notices about horses, and many people never look past it. Some patterns have inspired myths, with some colors indicating good fortune and others, bad luck. The myths vary with the culture: although very old, they are often still believed.

In North America, racism once played its ugly part in choice of colors. People alive today can still remember their grandfathers saying, "White men never ride colored horses." But horses with interesting colors have always attracted their own followings. Royalty often rode golden horses, the color signifying their worth. Pintos have been favored by many riders because no two look alike and because so many are strikingly patterned. Buckskin, dun, and grulla horses seem to symbolize the Old West.

These are not actually breeds in the true sense of the word. The organizations listed here admit horses with specific coat colors that are passed down genetically; sometimes the horses must meet other requirements as well. These extremely popular colors and patterns can be found on many breeds of light horses in North America today.

Beautiful-colored horses, like this Palomino, have been sought after throughout history.

Buckskin

Buckskin is a color, not a particular breed of horse. A perfect Buckskin is the color of tanned deer hide, although acceptable shades range from almost cream to deep bronze. All Buckskins have a black mane and tail and black legs from the knees and the hocks to the ground; most true Buckskins do not have a dorsal stripe. This coloring is frequently found in Quarter Horses, Miniature Horses, and Spanish Mustangs, among others.

COAT COLOR: Usually gold, but can range from cream to deep bronze

MANE AND TAIL: Black

SKIN: Dark

MARKINGS: Legs black from knees and hocks to ground; rarely, a dorsal stripe

RELATED COLORS: Dun

Splitting Hairs

People often use the term *dun* as a synonym for buckskin, but it is actually a different color. At first glance, dun coloring appears to be similar to Buckskin, but if you look closely, a dun isn't as light and clear in color as a perfect Buckskin. You might think that this is a case of splitting hairs, and it is.

Dr. Ben K. Green, a Texas veterinarian who spent his life with horses, became interested in the differences among coat colors. Examining horses' hairs under a high-powered microscope, he discovered that although the shaft of each hair is clear, inside the shaft tiny globules of pigment are arranged in particular patterns. The different patterns of pigment refract different amounts of light, causing us to see a particular coat color. Green's 1974 book, *The Color of Horses,* includes diagrams of the arrangement of the pigment within the hair shafts, as well as remarkably beautiful and accurate illustrations of solid-colored horses.

According to Green, dun hairs have a peculiarly dense pigment arrangement at the tip of the shaft, but the shaft behind the tip is uniformly pigmented along one side. When a dun horse turns his neck, the darkly pigmented tips of the hairs come together, giving a characteristic smuttiness to the coat color, where in horses of other colors you would observe a sheen. Buckskin hairs have no concentration of pigment at the tip end of the hair, so the color is clearer, with no dark overcast.

The Dun Factor

Another phrase commonly used in reference to Buckskins and duns is **dun factor**. This gene contributes the darker **points**: the dorsal stripe, the shoulder stripes, and the zebra stripes sometimes found on the legs of dun-factor horses and especially those in the wild. The dun factor may also occur in colors other than buckskin: there are red duns of various shades and even some bays that show the dun factor.

According to the International Buckskin Horse Association (IBHA), "The red dun will vary in shades of red, in the range of peach to copper to rich red. In all shades the accompanying points will be darker red or chestnut and be in contrast to a lighter body color. Red dun must have a definite dorsal stripe. The dorsal stripe will usually be dark red and predominant. Leg barring and shoulder stripes are common."

The dun factor is also associated with the color **grulla** (pronounced GREW-ya) or **grullo,** a soft mouse or dove color. The IBHA defines grulla as a body color that may be mouse, blue, dove, or slate with dark sepia to black points. Grulla has no

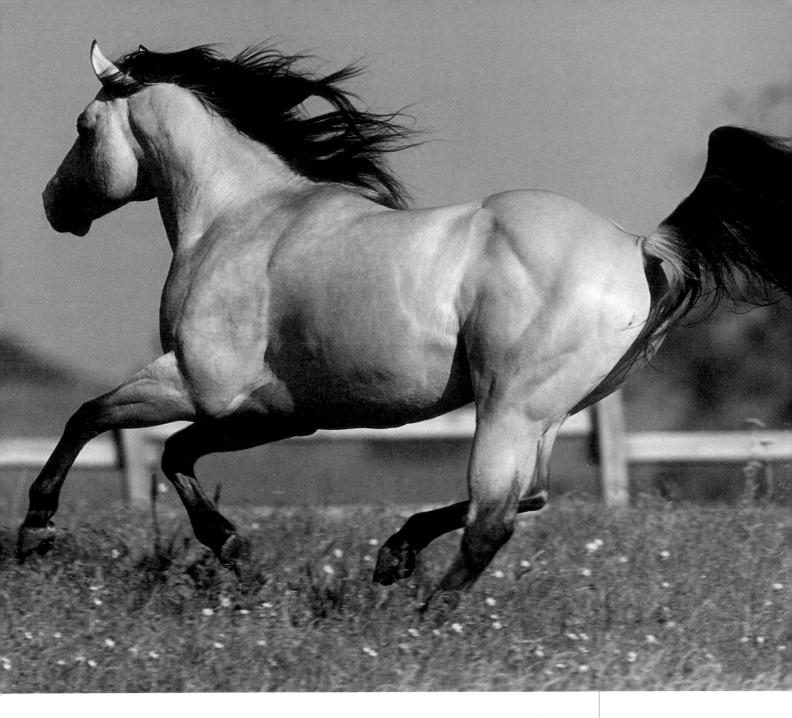

white hairs mixed in the body hairs. These horses have dorsal and shoulder stripes and may have leg barring. Genetically, grulla is a different color from gray.

The Original Horse Color?

Dun and buckskin, seen often in Quarter Horses and Mustangs, seem to be adaptive colors for both wild and domestic horses. Bonnie Hendricks, in *The International Encyclopedia of Horse Breeds,* points out that most dun-factor horses in the United States are descended from the Conquistadores' horses. She believes the color traces back to some very ancient types of dun horses, such as the Przewalski Horse and the now extinct but re-created Tarpan. The ancient Sorraia Horses of Portugal that accompanied the Spanish explorers to the Americas also exhibited buckskin and dun coloring. Buckskin and dun were the only coat colors found in the long-isolated mustangs discovered in the Kiger Mountains in eastern Oregon in the 1970s.

Are Buckskins Better?

The lore about Buckskin horses holds that they have tremendous endurance and

The clear color, black mane and tail, and black legs make a stunning combination on this Buckskin. Most do not have a dorsal stripe.

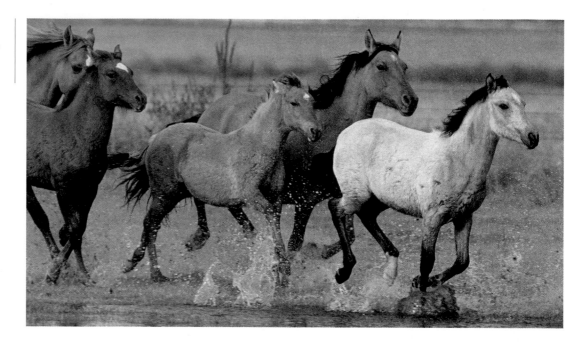

A Buckskin can be any shade from cream to a very dark gold, almost brown. The ideal shade is that of a tanned deer hide.

extremely hard, durable feet. Interestingly, this notion pervades many of the ranching areas of the United States, as well as in other countries where this color is common. Both Buckskin and dun horses usually have black feet, which many horsemen believe contributes to their hardiness of foot.

Green, however, points out that the Buckskin/dun color occurs primarily in indigenous-type horses such as Mustangs but virtually never in Thoroughbreds. After a lifetime of riding ranch horses of various colors, types, and breeds, he believes that ranch horses' reputation for endurance has more to do with the type of horses being ridden than the color. Native-bred stock types are well suited to heavy

work and rarely wear themselves out, whereas hotter-blooded Thoroughbreds often worry themselves into exhaustion before the day is done.

Whether or not the color is truly associated with hardiness and exceptional endurance remains unproved, but Buckskin and dun cover a particularly beautiful range of colors that can certainly be appreciated on their own merits.

The Buckskin Horse Association also registers grullas.

BREED ASSOCIATION FACTS AND FIGURES

The International Buckskin Horse Association registers and promotes horses of any breed that are buckskin, dun, red dun, and grulla. Many registered Buckskin horses are also registered with other breed registries. According to the association (incorporated in 1971):

- About 22,000 horses are currently registered worldwide.
- There are 900 to 1,000 new registrations per year, not limited to foals.
- In the United States, the Midwest shows a strong interest in buckskins, but they are found all over the country.

Palomino

The word *palomino* comes from a Latin word meaning pale dove. Beautiful golden horses with white manes and tails occur in many breeds around the world, and have appeared in myths, legends, and art for centuries. In Japan and China there are depictions of Palominos going back 2,000 years. They appear in very old tapestries and artifacts from both Europe and Asia. Crusaders brought home stories of desert chiefs riding them. Because they are beautiful, and because gold has always represented great worth, in many places Palominos were the horses of choice for emperors, kings, and queens.

In the early sixteenth century, Palominos were known as *Isabellas* (named for Queen Isabella) by the Spaniards who first brought them to North America. Queen Isabella favored golden horses. She sent a Palomino stallion and five mares to Mexico in order to establish golden horses in the New World. The color became particularly popular in Mexico and California.

The golden color is caused by the action of a single copy of an incompletely

COAT COLOR:	Clear gold
MANE AND TAIL:	White
SKIN:	Dark
MARKINGS:	White acceptable on legs and face
RELATED COLORS:	Cremello

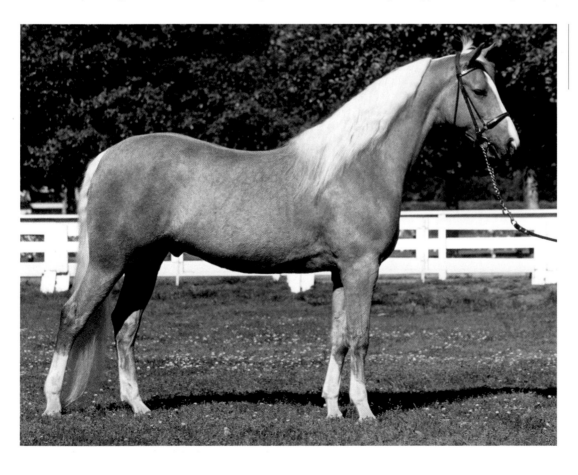

Queen Isabella of Spain particularly loved the golden coat and white mane and tail of the Palomino.

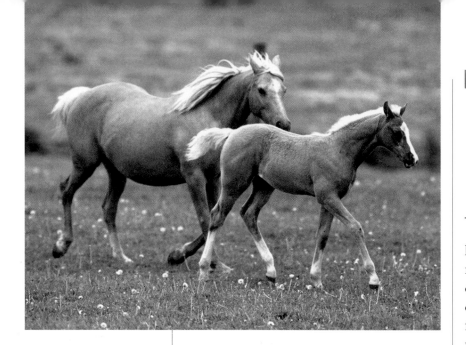

A foal inherits the genes for palomino coloring from its parents. If the dilution gene is not present, the foal will be a sorrel. With one dilution gene, the foal will be a Palomino; with two copies, it will be a cremello.

dominant gene that dilutes the body color of what otherwise would have been a sorrel foal. The genes for color and for dilution are separate. If a single copy of the dilution gene is carried by only one parent, the foal may or may not inherit it and has a one in four chance of being a Palomino. If each parent carries a single copy of the dilution gene, it is still possible for the foal either to inherit it or not, but the chances increase to 50 percent that it will be a Palomino. If the foal inherits one copy of the dilution gene, it will be a Palomino. If it inherits two copies of the dilution gene, it will be born a cremello.

Cremello is an extremely pale yellow that is often confused with albino, but it is not the same thing. A true albino has no pigment at all, while a cremello has highly diluted pigment. The action of the dilution gene lightens whatever color is present; it does not remove the color. Since a cremello

has two copies of the dilution gene, and it must pass one on to its offspring, a cremello crossed on a sorrel- or chestnut-colored horse guarantees dilute color in the foal, although the color may be either palomino or cremello.

Color Definition

According to the rules of the Palomino Horse Breeders of America (PHBA), "The ideal body coat color is approximately the color of a United States gold coin." The mane and the tail must be a minimum of 85 percent white with no more than 15 percent black, sorrel, chestnut, or other colored hair.

Black or brown dorsal stripes, shoulder stripes, and zebra markings are not allowed.

Both eyes must be the same color and have black, brown, or hazel irises, although blue or glass eyes are permitted on geldings or spayed mares or if they are accepted by the horse's breed of origin. Palominos may have white on the leg and face, within very specific restrictions. The skin must be dark without pink spots,

The PHBA recognizes Morgans, Quarter Horses, Saddlebreds, Arabians, Racking Horses, Thoroughbreds, Tennessee Walkers, Mountain Pleasure Horses, Rocky Mountain Horses, Missouri Fox Trotters, Morabs, Paints, Pintos, Appaloosas, Holsteiners, and Quarabs (Quarter Horse–Arabian crosses). Horses registered with these breeds must meet the appropriate qualifications regarding body color and the presence of white markings to be registered as Palominos.

BREED ASSOCIATION FACTS AND FIGURES

According to the Palomino Horse Breeders of America (founded in 1935):

- The PHBA accepts horses of fifteen breeds for registry.
- 1800–1900 new registrations are accepted each year.
- The highest percentage of Palominos is Quarter Horses, followed by Paints and Appaloosas.
- The association does not recognize pony and draft breeds.

Pinto

COAT COLOR: Base coat white; spots black, brown, or red

MANE AND TAIL: Vary

SKIN: Varies

MARKINGS: Blazes, snips, stripes, stars; bald or bonnet face

All the horse colors and patterns we know today have existed among horses for thousands of years. They do not seem to be geographically limited. Going back to the earliest cave paintings, one finds horses with both the tobiano and overo patterns well documented in ancient art throughout the Middle East. For this reason, some historians think that pinto patterns first arrived in Europe with particular strains of imported Arabian horses. However, the tobiano color pattern was common among the horses of the Russian steppes, suggesting that this pattern may have come to Europe with various nomadic tribes well before the first importation of Arabians. Historians also believe it quite likely that pinto patterns were present in Europe even during the days of the Roman Empire.

Pintos arrived in the New World with the Spanish. As extensive feral horse herds spread in Mexico and later farther north, both the tobiano and the overo color patterns were evident among the free-ranging horses. The prevalence of colored horses

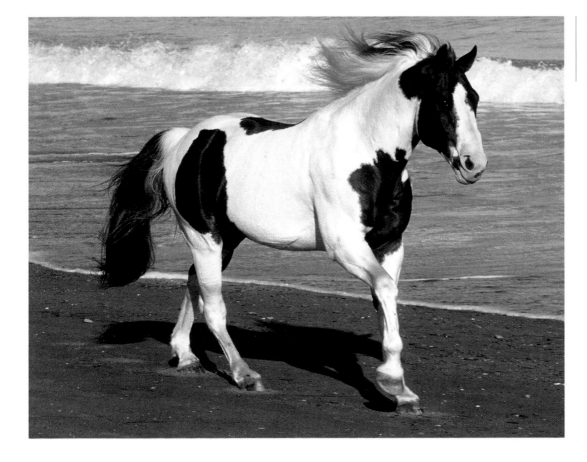

This Pinto shows the tobiano pattern, with its colored head, white legs, and white extending over the back.

did not diminish over time in wild herds, so it is clear that pinto patterns were not selected against by environmental factors. This was also true in the large herds of the Russian steppes.

PINTOS AND PAINTS

People often confuse Pintos and Paints. The difference has to do with registry requirements rather than color patterns.

The Pinto Horse Association accepts horses of many breeds that meet the required color qualifications. It does not accept Appaloosas, draft horses, or mules. Among the breeds most often seen at Pinto shows are Miniature Horses, ponies of many breeds, Arabians, Morgans, Saddlebreds, and Tennessee Walking Horses. The PtHA also accepts crossbred horses with qualifying color. Recently, Pinto warmbloods of various breeds have entered the registry.

The American Paint Horse Association, on the other hand, limits registration to horses of documented and registered Paint, Quarter Horse, or Thoroughbred breeding. Many Paints are also registered as stock or hunter-type Pintos.

Throughout history, people of all sorts have been attracted to colorful horses. So many Indians rode these flashy horses that even today, for many people the word *pinto* brings to mind Indian ponies. Some Indians are said to have believed that specific colors and patterns held magical powers. Many Mexican vaqueros and American cowboys also preferred the fancy colors, so in North America Pintos came to symbolize western horses.

Today Pintos are certainly not limited to the West. They can be found everywhere and in every riding discipline. There are pinto ponies and pinto draft horses.

In Europe, Pintos have faded in and out of fashion several times over the years, though they have always been favored for parades and displays. Today, especially in North America, pinto warmbloods can often be seen in the very conservative world of dressage.

Throughout the ages, pinto horses have been highly valued for their visual appeal.

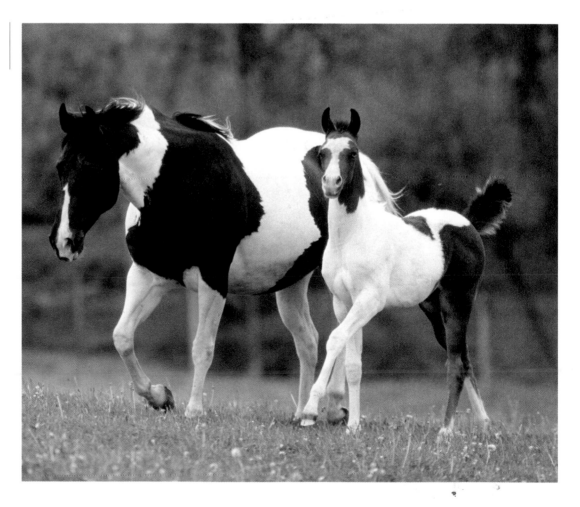

Pinto coloring is a fascinating study in genetics. Each Pinto is a unique combination of white markings on a solid base. Some of the more common patterns are described below.

TOBIANO

Tobiano horses often have a solid-colored head, though the face can have a marking such as a snip, star, or blaze. The legs are white, at least below the hocks and knees. Spots are regular and distinct, often appearing in oval or round patterns that extend down over the neck and the chest. Tobianos usually have dark color on one or both flanks, and the tail may be multicolored.

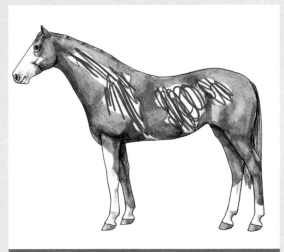

OVERO

Overo horses rarely have any white extending across the back between the withers and the tail. Generally, at least one and often all four legs are colored. The head markings often include a bald, or bonnet, face. The body markings tend to be irregular, scattered, and splashy. Usually the tail is one color.

FRAME OVERO

Frame overo is another name used for overo horses, especially those in which color surrounds the white markings making a sort of a frame.

SPLASH OVERO

Another overo variation is the splash pattern, which features white spots that look as though the horse was dipped in paint from the ground up. Markings can be extensive or quite minimal.

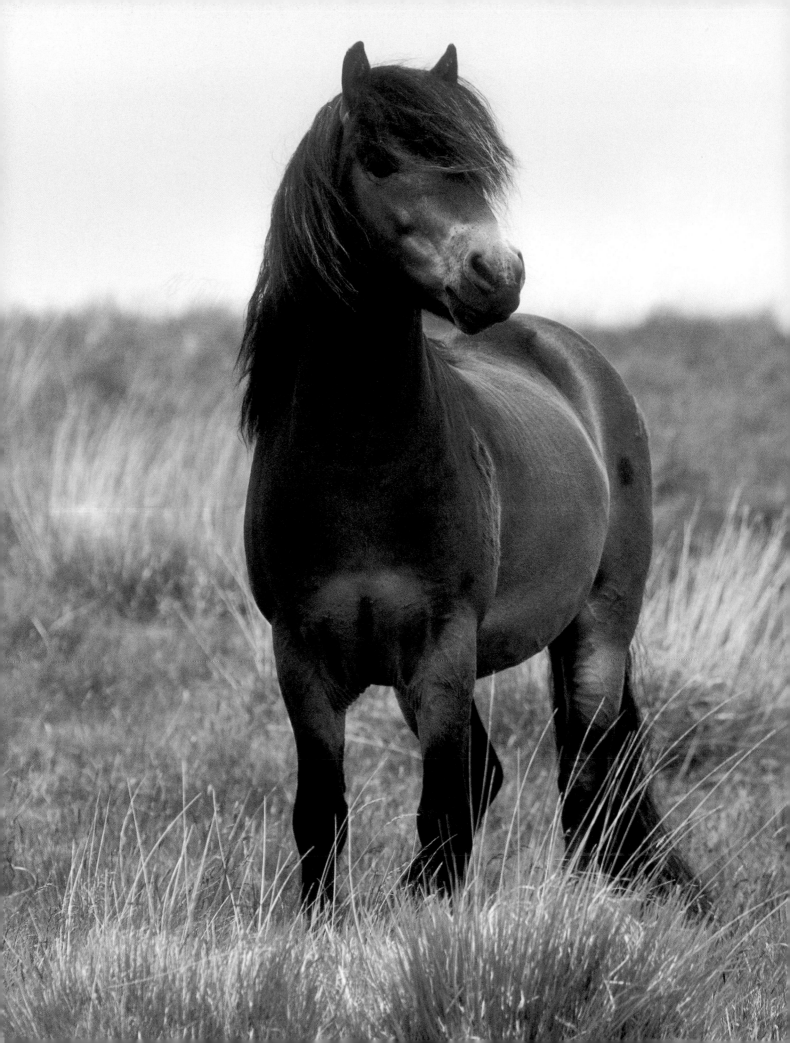

Ponies

COMPACT IN SIZE BUT FULL of energy and talent, these are the sport models. The usual dividing line at horse shows is 14.2 hands, or 58 inches, to the top of the withers. To some this is the only difference between a horse and a pony, but to others there is much more. Several British pony breed standards require that the animal have true pony character, meaning that it should be kind, willing, and easy to handle, without being dull.

In North America, ponies remain somewhat undiscovered, considered first mounts for children but little else. The smaller ones are often maligned for being mean. In reality, well-handled small ponies are passed like heirlooms among friends as children outgrow them. For adults as well, however, ponies can be excellent mounts, topnotch jumpers, great trail and trekking choices, small ranch horses, and wonderful driving animals.

Ponies require less acreage and smaller trailers than horses do, but they can usually match bigger horses in their ability to do work. They are economical, family-friendly, long-lived, and fun.

Far from just being small horses, pony breeds have their own distinct histories and characteristics.

American Quarter Pony

HEIGHT: 11.2–14.2 hands

PLACE OF ORIGIN: The first Quarter Pony Association started in Iowa, but the breed has long been found across the United States.

SPECIAL QUALITIES: Extremely athletic, heavily muscled, stock-type animals

BEST SUITED FOR: Western competition and ranch work

I n the early 1960s, Iowa horseman Harold Wymore purchased two sorrel pony geldings at a local sale. He knew nothing of their pedigrees, but as he worked them on his farm, he found them to be willing and versatile; when a neighbor's son showed them, they did well. But as time passed, Wymore became frustrated at the lack of shows that accepted unregistered animals, so in 1964 he started his own organization, the American Quarter Pony Association,

which registered small stock-type horses and ponies of unknown ancestry.

The association established an awards system for members who were interested in showing. Registration requirements called for a height of 11.2 up to but not including 14.2 hands. Gaited animals were not accepted, nor were albino, Appaloosa, or Paint-colored animals. Crossbreds or ponies from other registries were welcome (and still are) as long as they met the American Quarter Pony Association (AQPA) requirements. Today the AQPA registers ponies in every state in the United States and in all Canadian provinces, as well as in several foreign countries.

The International Quarter Pony Association (IQPA) was founded in the 1970s. This organization does accept colored horses, including Appaloosas, pintos, cremellos, and albinos. Known Quarter Horse bloodlines are encouraged but not required. The IQPA accepts crosses to Quarter Horses, Paints, Appaloosas, and Pony of the Americas, but does not accept crosses to gaited breeds. The IQPA now divides ponies into "solid," "paint," and "Appaloosa," depending on characteristics. The IQPA promotes a correct, well-balanced, sound pony with Quarter Horse conformation and enough body, speed, and eye appeal to compete with other pony breeds as well as horse breeds. Over the years, several other Quarter Pony organizations have come into and gone out of business. Several of the remaining ones joined together in 2005, and others are expected to join at a later date.

Breed Characteristics

Quarter Ponies are known for their calm, even disposition, as well as for their compact size. The Quarter Pony is collected in action and turns or stops with noticeable ease and balance, with the hocks always well underneath the body. Although Quarter Ponies meet pony height standards, they are

BREED ASSOCIATION FACTS AND FIGURES

According to the International Quarter Pony Association/ Quarter Pony Association (IQPA/QPA), which became one organization in February 2005:

- The QPA is the membership part of the organization. The IQPA is the registry.
- There are about 3,000 registered Quarter Ponies (estimated total from all Quarter Pony organizations).
- Each year new registrations for adult animals outnumber those for foals. Owners often wait to register animals until they are old enough to show under saddle.

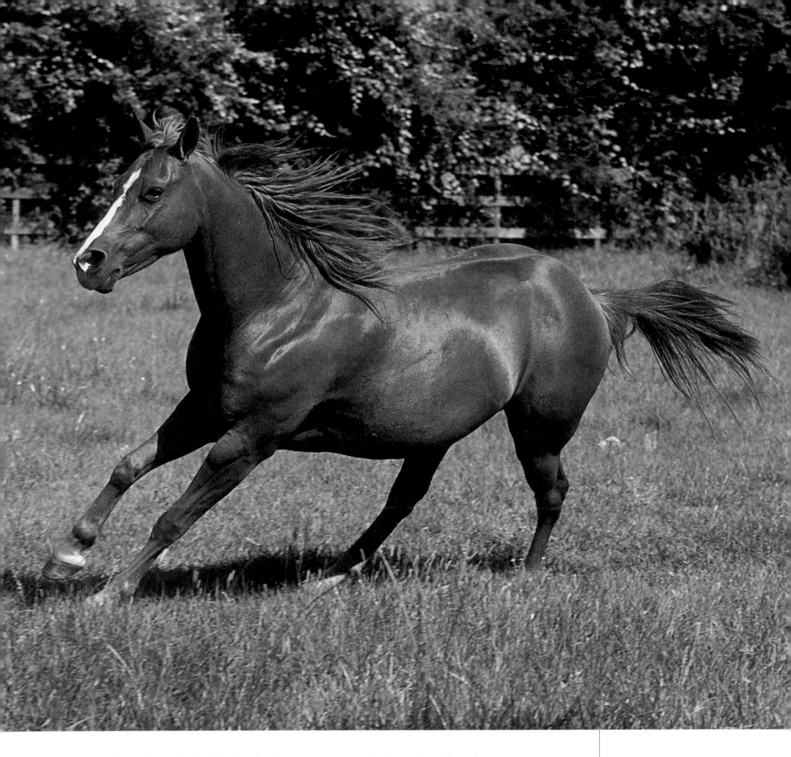

inclined to be substantial animals, the larger ones easily able to carry adults. They are widely used as Western contest ponies, as working ranch horses, and for bulldogging, roping, and steer wrestling. They make excellent trail and family mounts, and have found their way into pony clubs, eventing, pleasure driving, and many other arenas.

Conformation

Most Quarter Ponies average around 13.2 hands and weigh between 800 and 900 pounds. Some breeders, however, are beginning to raise animals that are about 14 hands and may weigh as much as 1,100 pounds. These heavily muscled animals are popular with adults who compete in events such as bulldogging and steer wrestling.

A Quarter Pony should have a short, broad head with wide-set eyes, small ears, and a firm mouth. The head should join the neck at a nearly 45-degree angle. The neck should be of medium length and slightly arched, blending smoothly into long, sloping

Quarter Ponies are known for their quickness and agility and are popular mounts for Western competitions such as bulldogging, roping, and team penning.

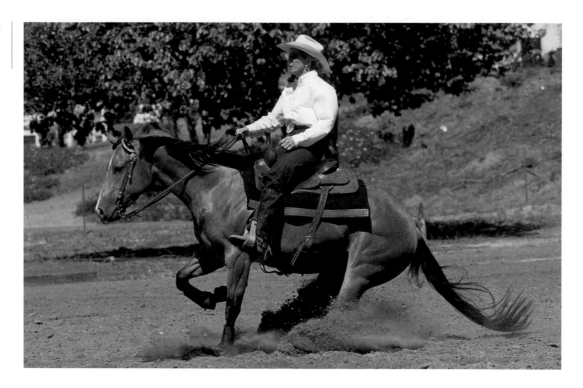

Larger Quarter Ponies can easily carry adults and are ideal for Western events and ranch work.

shoulders. The pony should have medium-high, prominent withers; a deep, broad chest; and a short, powerful back. The hindquarters should be full through the thighs, stifle, and gaskin down to the hocks.

The heavily muscled forearms should taper to the knees whether viewed from the front or from the side. The hind legs should be muscled inside and out. A Quarter Pony should have smooth joints, short cannons, and sound feet.

Color

The AQPA accepts all solid body colors but does not permit albino, Appaloosa, pinto, or pintaloosa coloring. White on the face and lower legs is allowed. The IQPA permits all colors and color patterns.

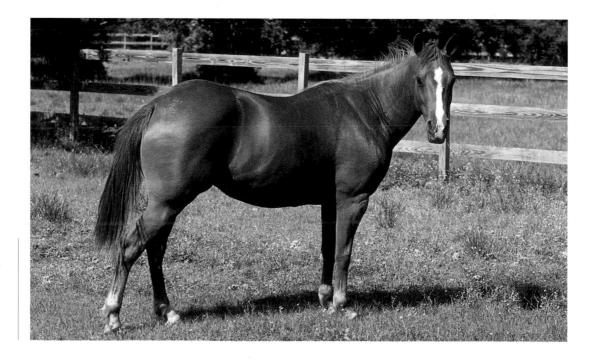

The original association registered only solid-colored ponies, but the International Quarter Pony Association accepts all color patterns as well as solid colors.

American Walking Pony

Lifelong horsewoman Joan Hudson Brown, of Macon, Georgia, set about developing a breed of large, attractive, smooth-gaited ponies in 1956. She began by crossing Welsh Ponies and Tennessee Walking Horses. The Welsh bloodlines contributed a lovely head and long, arched neck, while the Walking Horse lines produced the desired smooth gaits. Twelve years later she reached her first major goal when she produced what she felt was an ideal pony, BT Golden Splendor, a palomino colt with lovely gaits; a long, flowing mane and tail; and a high tail carriage. The embodiment of the perfect pony she had long been trying to produce, he became the foundation sire for the breed. Brown founded the American Walking Pony Registry in the fall of 1968.

Walking Ponies are shown under saddle and in both pleasure and fine harness driving. They also have considerable jumping ability and are highly successful at open shows in the pony hunter division. An American Walking Pony was national champion in competitive trail at a time when there were only 175 ponies in the

HEIGHT: 13.2–14.2 hands

PLACE OF ORIGIN: Georgia

SPECIAL QUALITIES: A gaited pony breed of great beauty, versatility, and athleticism; some individuals can perform seven gaits

BEST SUITED FOR: Pleasure, harness, jumping, and trail

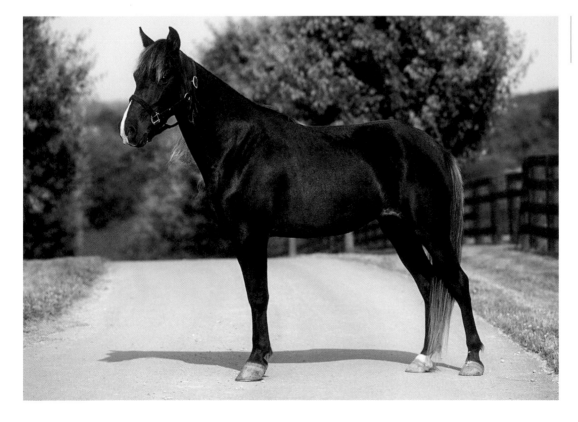

The American Walking Pony is a versatile, smooth-gaited pony with excellent jumping ability.

breed. These ponies make ideal trail and pleasure mounts for children and small adults.

Owners have such a good time riding their animals that surprisingly few are used for breeding. The association encour-ages any breeder interested in producing top-quality animals to join its ranks.

Breed Characteristics

The light and flowing gaits of the American Walking Pony are inherited and unique. They are the walk, pleasure walk, merry walk, trot, and canter. The **pleasure walk** is a slow, easy, four-beat gait, a little bit faster than a regular walk. In this gait, Walking Ponies move their head slightly in rhythm with the gait. The **merry walk** is a faster, yet still smooth, four-beat gait with a little bit more head motion. American Walking Ponies also trot. And, like the great founda-tion sire of the Tennessee Walking Horse, Roan Allen, some of these ponies can per-form the slow gait and the rack. It is thus possible to have a pony that is actually seven-gaited.

Conformation

Correct conformation is strongly stressed by both the association and breeders, who desire a sound, well-made pony, not just an animal that can perform the gaits. The American Walking Pony is a large pony, usually 13.2 to 14.2 hands.

It has a small, neatly chiseled head. Its bold eyes, set well apart, often show white sclera. The ears are pointed and well shaped; the neck is long, arched, and well muscled. The neck may be slightly cresty in stallions but leaner in mares and is carried high and connected well back into moder-ately high withers. The shoulders are long and sloping. The ribs are well sprung, with a deep heart girth and wide chest. A short back connects to a croup that is moderate in slope and length, with muscular hips.

The front legs must be straight, but the hocks may turn in slightly. The pasterns should have medium length and slope.

Color

All solid colors and pintos are eligible for registration. Appaloosa coloring is not allowed.

The natural gaits of the Ameri-can Walking Pony are the walk, pleasure walk, merry walk, trot, and canter. Some individuals also perform the slow gait and the rack, making them seven-gaited.

BREED ASSOCIATION FACTS AND FIGURES

According to Joan Hudson Brown, of the American Walking Pony Registry (founded in 1968):

- There are about 400 ponies in the breed.
- Ten to 15 new foals are registered each year.
- The ponies are most common in Georgia, California, Washing-ton, and Canada.

Chincoteague Pony

Marguerite Henry made the ponies of Virginia's barrier islands internationally famous with her 1947 story *Misty of Chincoteague.* That wonderful children's book (and the two later books about Misty's life) still captivates readers of all ages. Without the publicity from the stories of Misty, it is doubtful that the ponies or the volunteer fire department of Chincoteague would have survived so long and so well in modern times.

The little herd of ponies has lived for a very long time on the barrier island of Assateague and its smaller neighbor Chincoteague. Some believe the original ponies descended from animals that escaped from early Spanish shipwrecks along the coast. Evidence shows, however, that by the late 1600s colonists had brought horses, cattle, sheep, and hogs to the island from the mainland. For this reason, federal government officials believe it is more likely that the first sustained population of horses arrived during the seventeenth century with mainland farmers who wanted to escape fencing laws and livestock taxes.

HEIGHT: 13.2–14.2 hands

PLACE OF ORIGIN: Assateague Island, Virginia; original stock possibly from Spain

SPECIAL QUALITIES: Pretty faces with straight or slightly dished profile, small muzzle, and large soft eyes; famous from the books of Marguerite Henry and as fund-raisers for the volunteer fire department of Chincoteague

BEST SUITED FOR: Pleasure riding, hunter events, driving, trail; ideal first mounts for children

These tough, hardy ponies have survived the harsh conditions of Assateague and Chincoteague for hundreds of years.

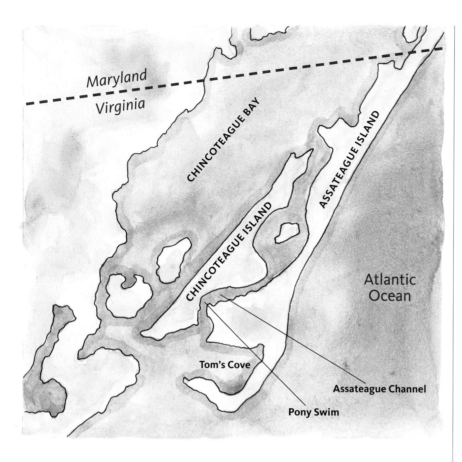

The map shows Maryland / Virginia border, Chincoteague Bay, Chincoteague Island, Assateague Island, Chincoteague Bay, Atlantic Ocean, Tom's Cove, Assateague Channel, Pony Swim.

The Assateague herd on the Maryland side is managed by the National Park Service, while the Chincoteague Volunteer Fire Company owns and maintains the Virginia herd.

Assateague and Chincoteague lie right on the border between Maryland and Virginia. Today there are actually two herds of 120 to 150 ponies each on Assateague Island. One herd lives at the Virginia end of the island, near the village of Chincoteague, and the other at the Maryland end. They are separated by a fence at the state line and are managed quite differently from one another.

The Assateague (Maryland) Herd

The National Park Service owns and manages the Maryland herd, which grew from twenty eight in 1968 to more than 165 in 1997. Overgrazing by a herd of this size had a negative impact on the local environment. To keep the population at 120 to 140 ponies, the number that the available grazing can support, managers have employed a long-term, non-hormonal contraceptive. Administered by dart gun, the contraceptive works well for about a year, after which booster shots are required. During seven years of field trials, it proved to be about 95 percent effective with no harmful side effects.

The Chincoteague (Virginia) Herd

The Chincoteague Volunteer Fire Company owns and manages the Virginia herd, which is allowed to graze on the Chincoteague National Wildlife Refuge through a special-use permit issued by the U.S. Fish and Wildlife Service. The Virginia herd is usually referred to as the Chincoteague Ponies.

Stallions of other breeds have been turned out with the Chincoteague herd from time to time to minimize inbreeding. Twenty wild Mustangs were purchased in 1939 from the Bureau of Land Management and added to the herd. Years later, an Arabian stallion was turned out with the ponies, but he did not survive.

On another occasion, a number of Chincoteague mares were trucked to a farm where they ran with an Arabian stallion until they were believed to be in foal, then were returned to the island. Herd managers hoped that the genetic contribution of the Arabian would add some height, length of leg, and refinement to the ponies.

PONY PENNING

The first written description of pony penning comes from 1835, but by then it was already a very old custom. This famous event, which keeps the free-ranging herd at about 150 animals, actually began during the seventeenth century. Every year the settlers rounded up unclaimed horses and marked them for ownership in the presence of their neighbors (just to keep everybody honest).

The annual roundup became a day of festivity, and by 1885 penning was held at Assateague one day and Chincoteague the next. At the time, Assateague also had a sheep-penning event. Over time the sheep-penning event diminished, but the pony penning grew larger. Meanwhile, during the early 1900s, tourists and sportsmen discovered Chincoteague Island. At first they had to travel there by boat, but

by 1922 a causeway and bridges connected the barrier islands to the mainland.

Also in 1922, two fires ravaged Chincoteague. With no firefighters on the island, the town was devastated on both occasions. Townspeople organized the Chincoteague Volunteer Fire Company and in 1924 took up a collection and gathered $4.16 — not enough to buy the 750-gallon pumper and 2,000 feet of fire hose they wanted. To raise money, they held a carnival on Pony Penning Day, this time auctioning off some ponies with the proceeds going toward the fire equipment. At the time the ponies sold for twenty-five to fifty dollars, and the sale was a great success.

With the exception of the war years of 1942 and 1943, the auction has taken place annually since 1924 on the last Wednesday and Thursday of July. Mounted horsemen round up the Virginia herd and swim them across the channel at low tide in front of as many as 50,000 spectators. The swim takes five to ten minutes, which doesn't seem like much, but horses are inefficient swimmers and the channel crossing is quite a taxing athletic effort. Ponies sometimes stagger briefly after they come to shore, but they quickly catch their breath and recover. It is particularly exhausting for young foals, so observers in the water and on land stand ready to lend a hand.

Once on shore the ponies are herded into pens, and most of the larger foals are auctioned on Thursday. Very young foals stay with their mothers and return with the rest of the herd to Assateague Island on Friday.

The highest price a Chincoteague foal ever brought was $10,300 in 2001, out of a field of eighty-five ponies. The average selling price at the time was about $2,000. All new owners are required to have safe, humane transportation ready for their purchases.

Breed Characteristics

Ponies purchased at the auction gentle down quickly with good handling. They have made first mounts for generations for

children and are used as hunter ponies, driving ponies, and trail ponies, and for a wide variety of other sporting purposes.

Conformation

In the wild, adult ponies tend to be about 13.2 hands and weigh around 850 pounds. With better nutrition, they sometimes grow as tall as 14.2. Because there have been outcrosses to other breeds, there is quite a bit of individual variation within the Chincoteague Pony herd. Nowadays most of the animals resemble either Arabians or Welsh Ponies, although some look more like Mustangs.

In general the head is attractive with a broad forehead, large, soft eyes, and a straight or slightly dished profile. The ears are wide set and slightly tipped in. The muzzle is small and tapered, the jowls fairly

This Chincoteague Pony displays the distinctive pinto coloring made famous by Misty.

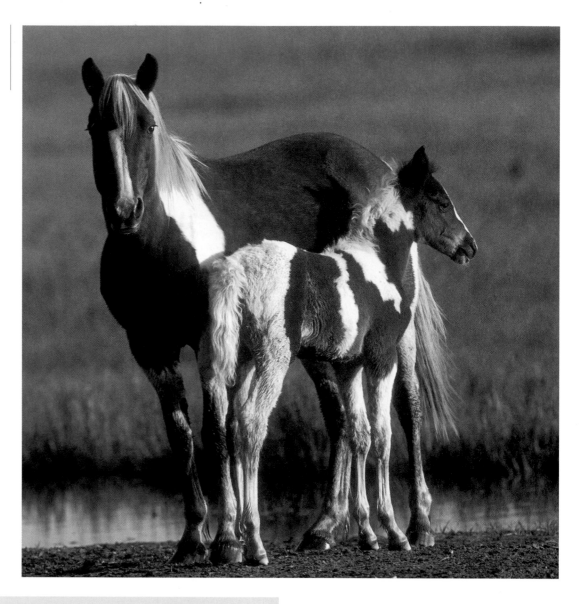

BREED ASSOCIATION FACTS AND FIGURES

According to the National Chincoteague Pony Association (founded in 1985):

- Chincoteague Ponies are a recognized breed with two main registries. Many animals are double registered.
- The Chincoteague Pony Association was founded in 1994. The association is open to all animals sold by the Chincoteague Volunteer Fire Company.
- The National Chincoteague Pony Association provides a registry and a trustworthy studbook and keeps transfer of ownership records for all Chincoteague Ponies, including those from the islands and those from private breeders.
- There are about 980 Chincoteague Ponies in private hands scattered across the United States and Canada.
- The wild herd is kept at 120 to 150 animals.
- Thirty to 45 foals are born on the island each year.

prominent and rounded. The throatlatch is moderately refined, as is the neck. The shoulders are well angulated. The chest and loins are broad and the ribs well sprung. The back is short, with a rounded croup and low-set tail.

The legs are straight, sound, and sturdy, with dense bone. The hooves are round and hard. The mane and tail are very thick and often quite long.

Color

All solid colors may be found, but many of the ponies (like Misty of Chincoteague) are pintos, displaying both the tobiano and overo color patterns (see page 279). Pintos usually bring the best prices at the auction.

Connemara Pony

There have been free-ranging ponies on the rugged western coast of Ireland since ancient times. When the Celts, who were fine horsemen, came through the area in the fourth century BCE, they almost certainly brought horses with them. The early wild Connemaras were typically dun colored, much like other ancient types of horses and similar to the horses the Celts used.

Many centuries after the Celts, wealthy merchants of Galway City imported Andalusians and Spanish Barbs, then considered the best horses that money could buy. Some of these Spanish horses probably found their way to Connemara and were crossed with the native ponies. One legend claims that horses came to shore when the Spanish Armada sank in the late 1500s. Other breeds that might have crossed with the ponies include imports from Spain, Morocco, and Arabia. As late as the 1850s, Arabian horses were being imported into the district of Connemara.

Under British rule, the Congested Districts Board was established in 1891 to try to

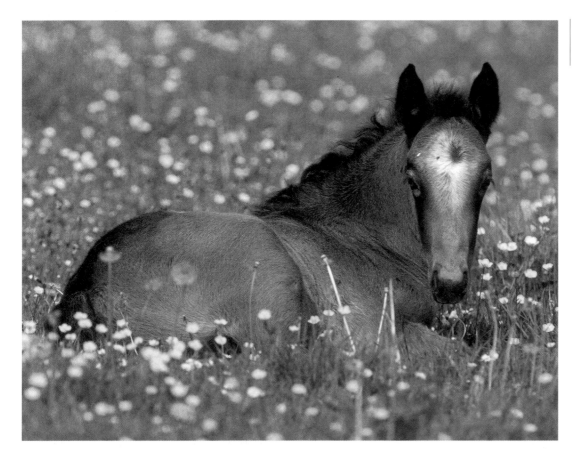

This foal may keep its baby coloring or it may turn gray as it grows older.

HEIGHT: 13–14.2 hands

PLACE OF ORIGIN: Western Ireland

SPECIAL QUALITIES: Hardiness, stamina, great jumping talent

BEST SUITED FOR: Jumping, hunting, dressage, eventing, driving, and even light draft work; are also well suited for trail riding and make ideal children's mounts

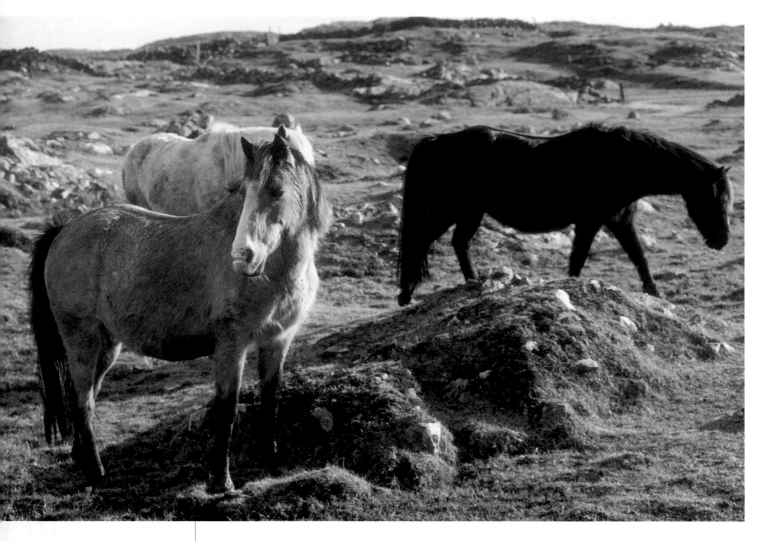

The harsh climate and rocky terrain of the Irish coast shaped the Connemara into a hardy and agile breed.

encourage the very poor people of the area to find ways to improve their lives. As part of these efforts, Welsh and other breeds of stallions were crossed on the local mares. Some of these lines produced good results, but many were unsatisfactory.

The Department of Agriculture commissioned a study in 1900 to explore development of the local Connemaras into a top-quality breed. To perpetuate the best qualities of the ponies, the study concluded, breeders needed to develop excellent broodmares as well as to keep top stallions at local stud farms. The objectives were to increase bone and to improve the makeup of the breed without destroying its temperament, hardiness, stamina, and vigor.

Interest was sparked, eventually leading to the formation of the Connemara Pony Breeders Society in 1923. This group felt that although there had been a good bit of outside breed influence, especially since the British had brought in Welsh stallions, there was enough of the old Connemara still to be found, and that the best results would come from crosses among carefully selected native stock. The first Connemara studbook was published in 1926, at which time the ponies became a recognized breed. Breed society goals were to gather the best of the native mares and to improve the breed by selecting only the very best stallions from the area. Members also felt it was essential to persuade local farmers to breed their mares only to these stallions.

Breed Characteristics

The western coast of Ireland is either rock-strewn and mountainous or boggy. Waves

The Connemara's dense coat keeps the ponies warm even in heavy rain.

hit the shore with spectacular force and storms are common, but because of the Gulf Stream, which brings warm air, the average temperature is about 42 degrees F. This unique environment has shaped the animals that live there. To survive the ferocious storms, Connemaras developed a peculiarly waterproof coat, which allows them to withstand weeks of unending rain. Their winter coat is not long, but it is extremely dense, and rain simply does not penetrate.

Connemaras are hardy, agile, and intelligent, all traits necessary to survive on Ireland's western coast. To find scarce food in arduous terrain, they had to make huge leaps from rock to rock without slipping, because a fall meant almost certain death. They are also noted for being sensible and cool-headed, a trait historians note is common in primitive-type breeds that have survived on their own. They move with little knee action but with surprisingly long strides, considering their height.

Excellent mounts for children, Connemaras are used for dressage, eventing, and hunting; as driving animals; and even as light draft ponies. Connemaras are also well suited for trail riding and would certainly excel in North America's Western sports, but they are best known for their outstanding jumping ability. One of many famous Connemara jumpers, The Nugget, cleared a 7'2" wall and subsequently won more than three hundred international jumping prizes — at the age of twenty-two.

Conformation

The typical Connemara is 13 to 14.2 hands, although some may be up to 15 hands. It has a well-shaped head with a straight profile, small ears, large eyes, and flared nostrils. The neck is long and well formed, with a full mane. The withers are pronounced. The back is long and straight, the croup muscular and slightly sloped. The chest is wide and deep, with long, sloping shoulders.

The legs are short and sturdy, with clean joints, short cannons, clearly defined tendons, and well-formed hooves.

Color

The most common colors are gray and dun, but there are blacks, bays, browns, palominos, chestnuts, and an occasional roan or dark-eyed cream. The registry does not accept pintos. Many foals are dun when born but turn gray within seven years.

BREED ASSOCIATION FACTS AND FIGURES

According to the American Connemara Pony Society (ACPS) (founded in 1955):

- About 4,000 ponies are currently registered in North America.
- One hundred purebred and 100 half-bred foals are registered each year.
- Horses registered with the American Connemara Pony Society are not automatically registered with the Connemara Society in Ireland, or in its studbook.

Dales Pony

HEIGHT: 14–14.2 hands

PLACE OF ORIGIN: Northern England

SPECIAL QUALITIES: Sturdiness, tractability, excellent gaits

BEST SUITED FOR: Dressage, hunting, trail riding, driving; ideal first mount for a child

Dales Ponies were bred especially as pack animals for the lead-mining industry in northern England. The stages of the lead-mining process had to occur in several remote environments. The mines were located on the high moors, which are open, treeless, boggy plains; the ore-washing area had to be near a stream. Smelting took place on a hill, where the wind kept the wood-fueled fires burning consistently at the necessary high temperatures. Then the final smelted product had to be transported to the ports of the northeast coast of England.

Before there were roads in the high hills of the eastern Pennine range, pack ponies were the answer, traveling from one remote processing area to another. They traveled in groups of nine to twenty loose ponies, accompanied by one mounted man. Packing 240 pounds of lead each, the ponies covered up to two hundred miles a week over some of the most difficult terrain in England. Dales Ponies, then called Dale Galloways for the admixture of Scotch Galloway blood, were favored for their great strength, toughness, and endurance, as well as for their ability to get over rough country fast. (The Scotch Galloway, which had some Friesian blood, was itself a fast, sturdy pony.)

The Dales were also comfortable riding animals, strong enough to do draft work, and able to survive on little feed. For these reasons they were often chosen to work the small farms of the area, hauling carts, serving as shepherds' ponies, and pulling plows. They had an excellent fast trot and were also clever jumpers when used for hunting. When the railways solved transportation problems for the lead industry, the ponies continued to have value as farm animals because they were so well suited to the very small, rough plots of farmland in the area.

Roads improved greatly in the late eighteenth century, creating a demand for faster animals for mail and stage lines. Norfolk Cobs were the fastest roadsters at the time, and many were brought into Yorkshire to cross on the local horses. The result was the wonderful Yorkshire Trotter. As trotting races came into vogue, the best Norfolk, Yorkshire, and sometimes Welsh Cob stallions were crossed on the Dales mares to add speed to the local ponies. The best of these crossbred Dales gained spectacular action but lost nothing as farm or riding horses.

Early in the twentieth century, city dwellers increasingly needed **vanners,** horses to pull commercial wagons of all sorts, while the military required **gunners** to pull artillery. For both these tasks, animals larger than ponies were useful. Crossing Clydesdale stallions on the Dales mares became such a large business that it threatened to wipe out the Dales. The Dales Pony studbook opened in 1916, in an effort to preserve the breed.

In 1923 and 1924, the army bought two hundred of the best Dales ponies from the small remaining population. The army buyer selected only ponies that showed no sign of carthorse blood, stood between

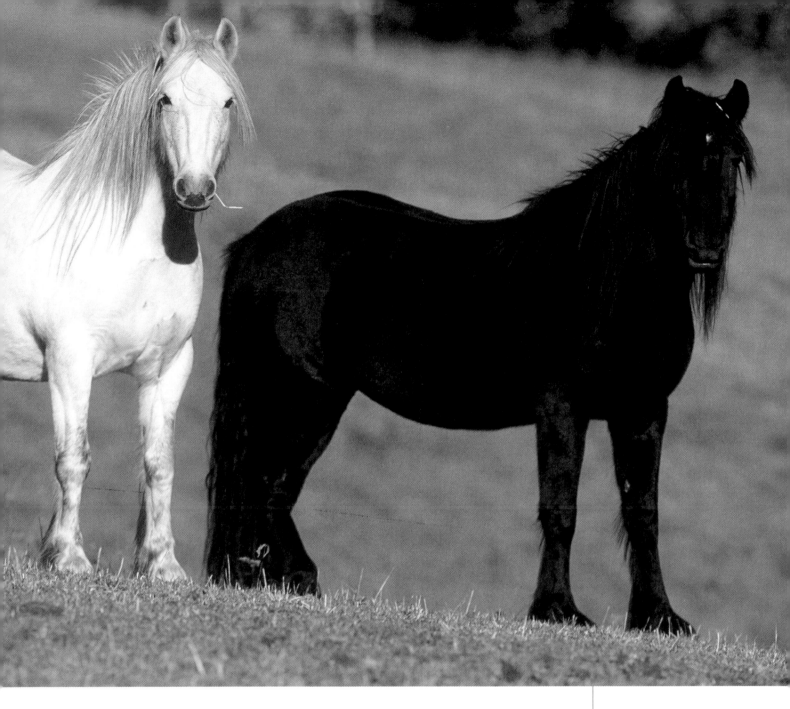

14 and 14.2 hands, and were five years old or older. Each had to weigh 1,000 pounds, have a 68-inch girth, and be able to carry 21 stone (294 pounds) on a mountain.

World War II nearly saw the extinction of the breed. The army again took ponies, and others were used to breed vanners. Very few pure Dales remained. By 1955, only four ponies were registered. In 1964, the Dales Pony Society reorganized itself and implemented a "Grading-up Register" to find and develop ponies that showed the best of the old Dales qualities. This register succeeded to the extent that it closed in

1971. The number of registered ponies has risen steadily since then, and the quality remains excellent.

Breed Characteristics

Dales have always been valued for their tractability, strength, and excellent movement. Their action is described in the breed standard as "going forward on all fours with tremendous energy," with lifted knees and hind legs flexed under the body for powerful drive. Today they are used for dressage, hunting, and trail riding and make beautiful driving animals. Because

Originally bred to work as pack-horses, today the Dales Pony can be seen in a variety of equine endeavors, including dressage, driving, and trail riding.

This Dales Pony shows the typically long forelock of the breed.

their size is not intimidating but they are very strong, Dales make excellent mounts for both children and adults.

Conformation

Dales range from 14 to 14.2 hands and weigh 800 to 1,000 pounds. The head is broad between the eyes and has typical pony ears that curve in slightly. The neck is strong and of ample length, with a long, flowing mane. An ideal Dales has a long forelock of straight hair down the face. The muscular shoulders are well laid back, and the withers not too fine. The body is short-coupled and deep through the chest, with well-sprung ribs.

The hindquarters are deep and powerful. The tail is well set, not high, with plenty of long straight hair reaching the ground. Dales have excellent feet and legs with good joints and dense, flat bone, showing quality with no coarseness. The pasterns slope nicely, with ample silky feathering at the heels. The feet are large, round, and open at the heels with well-developed frogs.

Color

Dales are usually black or brown, although some are gray or occasionally roan. White markings are minimal; only a star or snip on the face or white on the fetlocks of the hind legs is allowed.

BREED ASSOCIATION FACTS AND FIGURES

According to the Dales Pony Association of North America (DPANA) (founded in 1993):

- DPANA is the liaison to the Dales Pony Society of the United Kingdom and is also the registry for all Dales Ponies in both the United States and Canada.
- In North America, there are approximately 100 Dales ponies.
- There are 20 to 25 new foals registered in an average year.
- Animals registered with the DPANA are not automatically registered with the Dales Society in the United Kingdom.
- The English registry accepts animals with at least one parent from the United Kingdom, but ponies of pure domestic breeding must be registered with the association in their country of origin.

According to the Dales Pony Society of America Inc., a second organization with slightly different rules (founded in 1999):

- About 20 ponies were registered as of 2002.
- The society does register part-breds.
- Ponies registered with the American Dales Society are not automatically registered with the association in the United Kingdom; however, many ponies carry double registration.

With a pleasant character and excellent movement, Dales Ponies make popular mounts for both children and adults.

Dartmoor Pony

The Dartmoor is an old breed: the earliest written reference to it appears in the will of a Saxon bishop in the year 1012. It originated in the region of Dartmoor, in southwestern England, which was a center of tin production from the twelfth to the beginning of the twentieth century. When the mines of Dartmoor were flourishing, the ponies were used to transport tin. As the tin industry faded, many ponies were left to run free.

Toward the end of the nineteenth century, the Polo Pony Society, now known as the National Pony Society, recognized that old, traditional breeds of English ponies were declining to the point of near extinction. In 1898, the organization set up committees to produce descriptions of each of England's native pony breeds. Five Dartmoor stallions and seventy-two mares were inspected and entered into the first studbook. The height limit at that time was 14 hands for stallions and 13.2 hands for mares, but very few ponies came near that upper limit. The breed society, formed in 1924, eventually fixed the height limit at 12.2 hands. Other than the height, today's breed standard

HEIGHT: 12–12.2 hands

PLACE OF ORIGIN: Southwestern England

SPECIAL QUALITIES: A rare breed; world population of only 5,000 to 7,000 animals, with fewer than 100 in North America

BEST SUITED FOR: First mounts for children; jumping and driving

These shaggy little Dartmoor Ponies show the typical dark coloring of their breed.

Sure-footed and gentle, Dartmoors make an excellent first mount for children. They are good jumpers and drive well.

remains identical to the one defined then.

Less than twenty years after the founding of the studbook came World War I, which hit the breed hard, as many ponies were conscripted for military service and private breeding efforts came to a halt. At about the same time, however, the Duchy Stud, owned by the Prince of Wales, began buying Dartmoor ponies for a program to develop an all-around saddle horse. Some outstanding animals emerged from this program. Several of today's most influential bloodlines first attracted attention during this period.

World War II also took its toll. Ponies were taken for military use and to feed hungry families. By the end of the war very few ponies remained. Out of necessity, breeders began registering ponies by inspection rather than pedigree. To increase breed numbers, prizewinning ponies at selected shows, regardless of their pedigree, were automatically eligible for registration. Membership and registration gradually increased, and by 1957, the process of registering ponies only by show wins or by inspection was eliminated. After that, all registered animals were required to have registered parents.

Dartmoors were introduced to the United States in the 1930s, with more following in the '40s and '50s. Because breeders used many of those first animals to produce crossbreds, most of the pure blood was lost. Later imports were more successful. Today there is renewed interest in this attractive and useful pony, although the breed is still quite rare here.

Breed Characteristics

The sure-footed, quiet, and gentle Dartmoor makes an excellent mount for children, though these ponies are certainly capable of carrying a small adult. The breed is versatile, excelling at both jumping and driving. Its action is straight, low, free, and fluid.

It is hardy and strong and well adapted to harsh weather. Many horsemen consider these attractive ponies to be closer to warmblood horses in type than to the Welsh Ponies to which they are often compared.

Conformation

Dartmoors usually stand between 11.2 and 12.2 hands and weigh from 500 to 650 pounds. The head is small and well set, with large nostrils and prominent eyes. The ears are small and neatly set. The throat and jaws should show no signs of coarseness, and the neck is strong but not too heavy. Stallions have a moderate crest.

The shoulders are well laid back and sloping, but not too fine at the withers. The back is of medium length and strong, with well-muscled quarters. The tail is very full and set high. There should be a good depth of girth, allowing plenty of heart room. The legs have dense, flat bone, and the hooves are tough and well shaped.

Color

Dartmoors are usually bay, brown, or black, although an occasional gray or chestnut appears. White markings are minimal.

BREED ASSOCIATION FACTS AND FIGURES

According to the American Dartmoor Pony Association (founded in 1993):

- As of 2005, there are 62 registered ponies.
- Part-breds are registered as Dartmoor Sport Ponies.
- The breed is most common on the East Coast of the United States.
- The society in Great Britain does not register animals outside of the country.

Exmoor Pony

xmoor lies in southwest England, spanning Devon and Somerset. The high cliffs of the Bristol Channel form its northern boundary. This area of high moorland, divided by steep, wooded valleys and farmland, is subject to extremely wet, cold winters, with relentless, driving winds. Fossils and other remains show that a pony very much like the Exmoor in grazing habits, coat color, and **dentition** (the number and

arrangement of teeth) was widespread on the earth a million years ago. The Exmoor Pony itself is believed to be the oldest pure descendant of ponies that lived in Britain 100,000 years ago. The very first wild ponies arrived in Britain by walking over a swampy plain that became the English Channel 5,000 to 8,000 years ago.

These wild Exmoor ancestors wandered the British Isles in pre-Celtic times. Later, wild pony stallions often bred with Celtic pony mares, but in Exmoor, the crossbred offspring did not survive. Written records from 1086 mention the Exmoor Ponies, but further references are scarce until 1818.

HEIGHT: 11.2–12.3 hands

PLACE OF ORIGIN: The remote moors of southwestern England

SPECIAL QUALITIES: A water-repellent winter coat with coarse, greasy outer hair covering a soft, springy undercoat

BEST SUITED FOR: Children's mounts, driving, endurance, and work with disabled

All Exmoor Ponies are some shade of brown, with a lighter "mealy" color around the eyes and muzzle.

Because of an extraordinarily harsh climate, Exmoor until very recently was largely a forgotten place, with a tiny, highly independent population. From time to time, people in Exmoor tried crossing the wild Exmoor Ponies on various other breeds, but all of these herds seem to have died out. They could not thrive or even exist in Exmoor's extreme climate.

Today's Exmoor ponies all descend from animals raised wild on the moors. Until 1818, most of the open expanse of Exmoor was designated a Royal Forest, a legal term signifying a royal hunting ground but not necessarily a wooded area. An appointed game warden managed it both as a hunting ground and as an upland grazing ground, where farmers could pay for the right to graze their animals. The warden also oversaw the wild pony herds.

The Royal Exmoor Forest was sold by the Crown in 1818 to a private owner with plans to "improve" the wild ponies by outcrossing them. But the outgoing warden, Sir Thomas Acland, bought thirty of the ponies and took them to his own estate. Some other local farmers also purchased a few. The Acland ponies continue to this day as the Anchor herd (Anchor is the name of the Acland estate). These animals were, and still are, branded with an anchor, and then left to run free on their native terrain. Descendants of several of the farmers who saved ponies in 1818 are still involved in Exmoor breeding today.

During World War II, Exmoor was used for troop training, and some soldiers practiced shooting on live targets, including ponies. Many ponies were also stolen and transported to cities to feed hungry people. By the end of the war, it was estimated that only fifty ponies remained. Enthusiasts rallied behind the breed to promote and protect the ponies. Two Exmoors were even exhibited at the London Zoo.

People outside of Exmoor bought some of the ponies as a commitment to conservation, moving them to private farms where they were well cared for and their lives were far easier than on the moors. These efforts saved the Exmoor Pony from near-certain extinction. But always some ponies were left to live on the moors, protected from human interference but subject to the harshness of nature just as they had been for thousands of years. This population has remained at two hundred or fewer. With the protection and preservation

Small herds of Exmoors have been established on various nature preserves in England, recapturing their ancient wild past.

measures instituted after World War II, total numbers increased gradually, and by the 1970s, about thirty foals a year were being registered. In the 1990s, the National Trust, English Nature, and several other organizations established small, free-ranging herds of Exmoors on various nature reserves to manage vegetation. This arrangement has worked out extremely well. The vegetation stays in check, visitors can see ponies living free, and pony numbers are increasing.

Breed Characteristics

All Exmoor Ponies are nearly identical, conforming to a design developed in the harshest conditions in the wild. Variations in color, markings, and size are virtually nonexistent. Exmoors are extremely strong for their size and can carry up to 170 pounds. They are now used for riding (frequently as first mounts for children), driving, and endurance riding, as well as in riding and driving programs for the disabled.

Every Exmoor in England today is branded with a four-point star, as well as a herd number on the left shoulder and an individual number on the left hindquarter. Ponies from the Acland herd have an anchor brand instead of a herd number. All ponies born after 2003 also have a microchip implanted in the neck muscle.

Conformation

Exmoors range in size from 11.2 to 12.3 hands, with the majority standing around 12.2 hands and weighing 700 to 800 pounds. They are very stocky and strong, with a deep chest and a large girth. The ears are short, thick, and pointed. The forehead is wide. The eyes are large, wide-set, and prominent, with a unique fleshy hood and pale coloration outlining the eyes. In England, this is known as "toad eyes."

The clean, short legs are designed for movement over hilly terrain, being set both well apart and square. The feet are extremely hard and blue-black in color.

Color

All Exmoors are some shade of brown, with darker legs and light oatmeal, or "mealy," color on the muzzle, around the eyes, and sometimes under the belly. The mane and tail are usually darker brown than the body, but sometimes the long hair of the mane and tail is a lighter, mousy color. Foals are born with the light, mealy color markings on the nose and around their eyes and a light-colored birth coat that changes as they shed the foal coat. By six months of age, the foals match the adults.

Exmoors have a summer coat and a winter one. The winter coat grows in two layers, which gives the combined effect of "thermal underwear" below an outer "raincoat." The insulating hair next to the skin is fine and springy. The coarse and greasy outer hairs are water-repellent. The hair forms an ideal drainage pattern with whorls that maximize water dispersal away from the body. The tail, mane, forelock, and winter beard also drain water away from the body. In the winter the ponies have what is known as an "ice tail," a thick, fanlike growth of hair at the top of the tail. The summer coat, which is visible only from late spring until about mid-August, retains the drainage abilities but consists of only one layer.

BREED ASSOCIATION FACTS AND FIGURES

According to the Canadian Livestock Records Corporation (founded in 1905):

- Around 75 Exmoors are registered in North America, with slightly more than half living in the United States.
- Generally only one or two foals are born each year in the United States and 3 or 4 in Canada.
- The greatest populations of North American Exmoors are in New York, Virginia, California, Ontario, and British Columbia.

According to the Exmoor Pony Society in the United Kingdom (founded in 1921):

- There are about 1,200 ponies worldwide, of which some are geldings and some mares not used for breeding.
- In the mid-1990s, the world breeding population was about 500, of which fewer than half live free in natural habitats. As of 2005, about 140 still live free on the moors.

Fell Pony

HEIGHT: Average height 13.2 hands; maximum allowed is 14 hands

PLACE OF ORIGIN: Northern England

SPECIAL QUALITIES: Sure-footed, gentle, excellent gaits and stamina, and though compact are quite able to carry an adult

BEST SUITED FOR: Trail riding and driving

Before the English Channel formed sometime around 6500 BCE, wild horses migrated across swampy marshes from what is now continental Europe to what is now England. These were the ancestors of the indigenous British ponies. The first people known to have used horses in the area were the "Battle-Axe" people, and they arrived between 3370 BCE and 2680 BCE. Remains of the Tarpan, an ancient wild pony now extinct in its

original form, have been found at Battle-Axe sites. (Although the Tarpan died out, it lives on today, having been re-created in modern times by breeding back to type from existing horses.)

By the time the Romans arrived in 55 CE, a distinct type of pony existed in northern England. It stood no larger than 13 hands and was bay, dun, or brown. These wild ponies roamed steep, treeless, rocky hills called *fells*. The ponies survived and thrived, despite the harsh climate and limited quantity of poor forage.

In 120 CE, the Roman emperor Hadrian decreed that a vast wall be built across northern England to keep the very aggressive Picts from attacking from the area that is now Scotland. To this end, the Romans hired mercenaries from Friesland, a province located in what is now the Netherlands and Germany. These mercenaries supplied their own equipment, weapons, and horses. Most of the horses they imported were stallions of a type not too different from the modern Friesian. This was a large dark or black horse, substantially built, and noted for strength, long-striding action, and docility. Presumably, its feet were feathered. Friesians also had the ability to survive on poor-quality pasture.

When the Friesians were crossed on the local mares, a useful new type of pony

resulted. It inherited substance, bone, color, and gentle temperament from the Friesian side of the pedigree, yet it retained the hardiness and tremendous stamina of the local ponies. In time this new sort of pony became known as the Fell.

Over the many generations since the Fell first came into being, few other breeds or even individuals have been crossed in. The ponies have remained true to type. In the late eighteenth century, a few Yorkshire and Norfolk stallions were crossed on Fell mares, as was the well-known Welsh stallion Comet, but beyond that there were few outcrosses.

A Versatile Work Pony

Initially the Fell was used as a pack pony, and it was ideally suited for the work. It was extremely strong, sure-footed, easy to work with, and small enough to load easily yet big enough for a man to ride. For centuries, these ponies packed almost all the goods that came in or out of the area. They transported wool, fresh fish, tanned hides, bolts of cloth, and live chickens. According to Clive Richardson, in *The Fell Pony*, three hundred Fell Ponies used to leave the little market town of Kendal every working day, carrying goods all over the country.

By the time of the Industrial Revolution, when iron and lead ore began to be heavily mined, the well-established pack

pony system of transport in northern England was ideal for the burgeoning mining industry. The ponies usually worked in strings of ten to twenty, each carrying about two hundred pounds of ore in two large wicker baskets, or panniers, attached to a wooden pack saddle. Not tied together, the ponies followed a lead horse with a bell around its neck that was ridden or led by the packman. The unshod ponies routinely traveled two hundred to 250 miles each week over extremely difficult, steep terrain.

Fell Ponies were also reportedly used by smugglers in the eighteenth and nineteenth centuries, as well as by the post office. One Fell stallion carried mail on an eighteen-mile trip every day of the year without a break for twelve years. Fells were also used by shepherds and farmers and in cross-country trotting races under saddle.

Decline and Recovery
The advent of motor vehicles caused working ponies to disappear almost overnight. Many were sold to slaughter. Two world wars also severely depleted pony numbers. After World War II, however, there was renewed interest in the breed. Pony trekkers

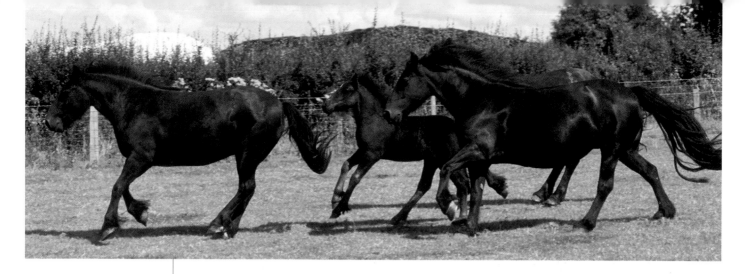

Fell ponies are often dark with very little or no white markings.

enjoyed riding the same routes the mining ponies had used for so long. Because of their ground-covering gaits, great stamina, and wonderful look, Fells became popular as driving ponies. They were also used for hunting.

There are not yet many Fells in North America, but as they become more familiar here, it is hoped and expected that their numbers will increase.

Breed Characteristics

A versatile and attractive pony, the Fell is athletic and tough while showing a consistently pleasant temperament and

BREED ASSOCIATION FACTS AND FIGURES

There are two Fell organizations in North America: the Fell Pony Society of North America (FPSNA) and the Fell Pony Society and Conservancy of the Americas. The Fell Pony Society (FPS), in the United Kingdom, recognizes both groups, which have different philosophies regarding the breed, though both function to promote Fell Ponies. Neither of them is a registry.

According to information compiled from both the FPSNA and the conservancy:

- The conservancy was founded in 1999.
- The FPSNA was established in 2001 and incorporated in 2002.
- The conservancy has members in the United States, Canada, Wales, England, Belgium, and the Netherlands.
- All eligible North American–born ponies are registered with the Fell Pony Society (FPS) in the United Kingdom (established in 1912).
- There were about 150 Fell Ponies in North America in 2005.
- There were 27 foals born in North America in 2004. Eight additional foals were imported in utero.
- There are about 5,000 Fell Ponies worldwide.

intelligence. They have excellent gaits and are good jumpers.

Conformation

A Fell Pony may stand no taller than 14 hands and averages about 13.2 hands, weighing 700 to 900 pounds. The head is small and well chiseled, with a straight profile and a broad forehead that tapers to a moderately broad nose and large nostrils. The eyes are prominent and intelligent and the ears neatly set and small. The well-proportioned neck is strong but not heavy, often with a moderate crest in stallions. The standard emphasizes the correctness of the shoulders, which are well laid back and sloping, not too fine at the withers. The mane and tail are heavy and full.

The back is long and straight, the loins broad and strong. The thick body is round-ribbed from shoulders to flanks, as well as short and close-coupled. The hindquarters are square and muscled, with a short, sloping croup. The tail set is medium to low. The straight legs are sturdy, with short cannons and large, well-formed knees. The round, blue-black feet are of good size, open at the heel, with feathered fetlocks.

Color

Fells may be black, brown, bay, or gray, preferably with no white markings, although a small star or a small bit of white on a foot is allowed. In the past, bay and dark brown were the most common colors, but in recent decades black has become the most popular.

Gotland Pony

The island of Gotland lies in the Baltic Sea, east of Sweden. Small horses, very similar in type and color to the Exmoor Ponies of England, have lived there since the Stone Age. These horses, and the people who eventually settled on the island, contributed much to the history of Europe and the world. By 1800 BCE, the Goths had established their civilization on Gotland, and from these people the island got its name.

Sculpture from 1000 BCE shows the people using Gotland-type horses to pull chariots. By approximately 200 BCE, the Goths began to migrate and settle in eastern Europe, taking with them their household goods and livestock, including horses. Their travels took them through what is now eastern Germany, Poland, and western Russia all the way to the Black Sea. Around 270 CE, they migrated into the Danube Valley. A hundred years later they were driven into the Roman Empire by the Huns. At first the Goths cooperated with the Romans, but later overthrew them in the famous sacking of Rome in 410 CE. Goths invaded the Spanish peninsula in 414 CE, ruling from their

HEIGHT: 12–14 hands

PLACE OF ORIGIN: Gotland, Sweden

SPECIAL QUALITIES: An ancient but now rare breed of stocky ponies characterized by their "primitive" color and markings

BEST SUITED FOR: Driving, jumping, children's pleasure mounts

The Gotland is an ancient breed that has changed very little over the centuries.

Gotland Ponies roamed their island home for centuries before the arrival of humans.

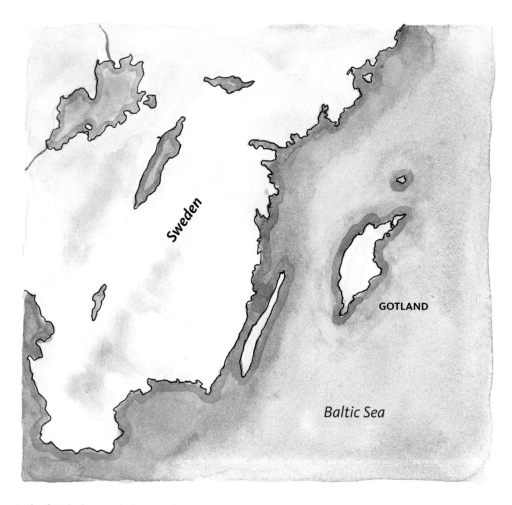

capital of Toledo until the Muslim conquest in 711.

Although the Goths left no written records, experienced horse historians can make solid educated guesses about breeds of horses that were influenced by the Gotland Ponies over the centuries. A number of these are European and Russian breeds not found in North America, but they also include the Garrano of Spain and possibly the ancient Sorraia of Portugal, both of which were directly involved with the history of horses coming to the New World.

An Ancient Lineage

Gotland Ponies lived for thousands of years in the forests of their Baltic island before humans arrived. They are believed to be directly descended from the ancient Tarpan, which became extinct in 1876 but was re-created in the early 1930s through careful selective breeding of individuals of similar types, including Gotlands. Gotland Ponies, known in Sweden as Russ and as Gotland Skogruss, which means "little horse of the woods," existed in the wild quite successfully until the mid-1800s, when people began settling, dividing up the forests of the island of Gotland, and killing the horses. By the early twentieth century, only about 150 Gotlands survived. Food shortages during World War I led poachers to hunt the ponies almost to extinction, but they were saved at virtually the last moment by a group of farmers who fenced in two hundred acres of pasture for them. Semi-wild Gotlands still roam the area, under the watch of human caretakers.

Gotlands were first imported into the United States in 1957. They became quite popular, with their numbers growing into the hundreds, until a series of tragic events occurred. After the death of the registrar of the breed association and the loss of all breeding records, interest plummeted,

nearly eliminating the breed in this country. In 1989, with fewer than ten known Gotlands scattered across the country, the last known herd, consisting of a stallion and several mares, was gathered up and brought to a farm in Corinth, Kentucky. This herd is still maintained under good management and has been augmented with several animals imported from Gotland.

Breed Characteristics

Gotlands have not changed very much over their long history. They are excellent movers and can maintain their ground-covering trot with ease for a very long time. A few individual horses may be naturally smooth-gaited, but the largest breeder in the United States says that this ancient trait rarely occurs in the horses currently found in this country. With their calm disposition, Gotlands make wonderful mounts for children. They are fine driving animals and have significant natural jumping ability. They are long-lived, often remaining sound well into their thirties.

Conformation

Gotlands range in size from 12 to 14 hands, but generally stand about 13 hands and weigh 600 to 700 pounds. They are stockier than Hackney Ponies of the same height.

The head has a straight or dished profile, with small, alert ears, a broad forehead, a shapely muzzle, large nostrils, wide-set eyes, and a round deep jaw. The neck is short and well muscled. Pronounced withers are set into a long, straight back with a slightly sloping croup. The chest is deep and the shoulders muscular, long, and well sloped. Strong legs have solid joints, clearly defined tendons, and long cannons. The feet are round, strong, and extremely hard. Shoes are often unnecessary.

The mane and tail are full; the fetlock feather is light. In winter, Gotlands have an exceptionally long, dense coat, but they shed out fully in summer.

Color

Common colors include gray dun, liver dun, buckskin, and black. Many Gotlands are bay with "mealy" light color around the eyes, on the muzzle, and on the belly. A few sorrels and palominos also exist. There are no longer any white horses or pintos in the breed. Dorsal stripes are common. A few horses have bars on the legs.

Known in their native land as russ or "little horse of the woods," a few semi-wild Gotlands still roam in protected forests in Sweden.

BREED ASSOCIATION FACTS AND FIGURES

According to the Gotland Russ Association of North America (founded in 1997):

- The association is affiliated with the Swedish Russ Breeders Association and follows its guidelines to maintain breed standards.
- The world population of Gotlands is approximately 7,000, with about 200 horses in North America, including Canada.
- About 20 new foals are registered in North America each year.
- North American horses are not automatically registered with the international society.
- In the United States, the breed is most common in Kentucky, West Virginia, and Virginia.

Hackney Pony

HEIGHT: 12.2–14.2 hands

PLACE OF ORIGIN: Northern England

SPECIAL QUALITIES: Effervescent ponies of great presence with brilliant high action and excellent stamina

BEST SUITED FOR: Fine harness, pleasure and roadster driving

The Hackney Pony resulted from the efforts of one British breeder, Christopher Wilson of Westmoreland. He wanted to create a small animal with all the brilliance of a good Hackney Horse but with distinct pony character. He began in 1872 with a brown roadster pony stallion named Sir George, foaled in 1866, that carried both Norfolk and Yorkshire blood and was said to be an exceptionally good-looking pony. He crossed this animal primarily on Fell Pony mares but also tried a few crosses on Welsh Ponies. Sir George, who stood just under 14 hands, seems to have contributed speed and elegance, while the Fell Pony side of the family added high knee action and substance.

Wilson's ponies were an immediate success. They were fancy, fast trotters that made quite an impressive sight when hitched to light carriages, and prices soared for the best ones. According to the Hackney Horse Society in England, Mr. Wilson believed in maintaining the hardiness of the ponies by leaving them to fend for themselves on the moors over the winter. He may also have used wintering on the moors to limit the height of his ponies, which means they didn't eat very well when they were turned out. Nonetheless, they survived and sustained their abilities as wonderful driving ponies.

Hackney Ponies have been exported to many countries. After World War II, they began to be bred almost exclusively as show ponies. Because of their brilliance and snappy movement, they are always show-stoppers in fine harness, pleasure, and roadster classes. In shows in the United States, Hackney Ponies are divided by size as well as activity. Ponies measuring 50 to 56 inches are known as Cob-Tails and compete in fine harness with docked tails, a tradition that goes back to their early days in England. Cob-Tails must exhibit very high action and are shown pulling formal, four-wheeled driving vehicles. Smaller ponies, 50 inches and under, are shown with full-length tails. There is also a pleasure pony division in which ponies of any size may be shown. In these classes, the manes and tails are long but the required action is not quite as extreme as in the more formal classes. The pleasure vehicles are two-wheeled.

Hackney Ponies, particularly those that lack the brilliant action needed for the show ring, often find their way into other lines of work where they have proved to be first-rate jumpers; good trail, hunter, and event ponies; successful Western contest ponies; superb pleasure driving ponies; and generally fine athletes.

Breed Characteristics

The Hackney Pony is prized for its high flashy action, dazzling show presence, and athletic good looks.

Conformation

The Hackney Pony stands between 12.2 and 14.2 hands. It has a light, somewhat long head with a straight or slightly convex profile and large, expressive eyes. The ears are small and pointed. The arched, muscular

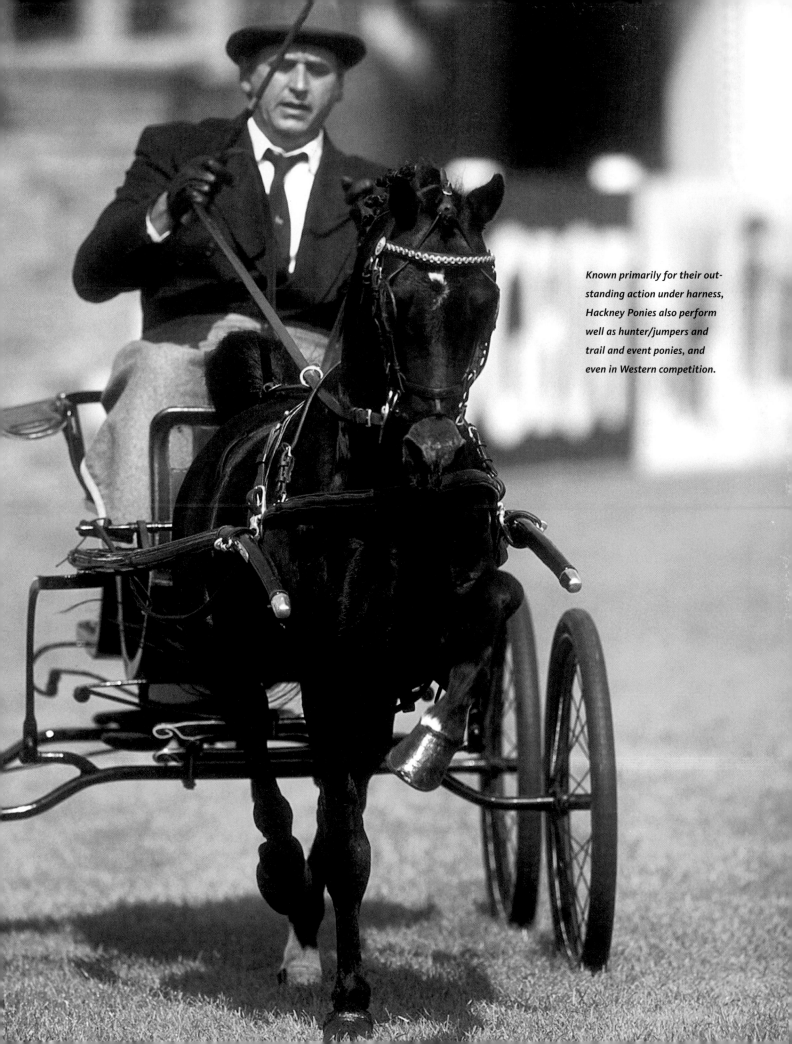

Known primarily for their out-standing action under harness, Hackney Ponies also perform well as hunter/jumpers and trail and event ponies, and even in Western competition.

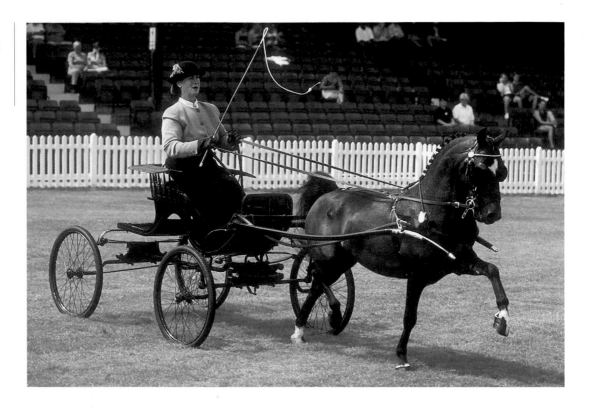

The Hackney Pony was created as a separate breed in the 1870s from trotting breeds like the Norfolk and Yorkshire crossed on Fell Pony and Welsh mares.

Most Hackney Ponies are bay, brown, or black, with minimal white markings.

neck is set smoothly onto the shoulders, which are muscular and sloping. The back is short and straight, the croup long and slightly rounded with a tail that springs from high up. The tail is carried gaily. The legs are slender but very strong, with good joints and hard feet.

Color

Hackney Ponies are almost always bay, brown, or black. Chestnut occurs rarely but is allowed, as are roan and gray. White markings are permitted but usually consist of only a narrow blaze, snip, or strip, and white not much higher than the fetlocks.

BREED ASSOCIATION FACTS AND FIGURES
According to the Hackney Horse Society (incorporated in 1891):
- The Hackney Pony does not have its own studbook but is registered in the same book as the Hackney Horse.
- The database does not include an actual count of all animals registered.
- Four hundred to 500 new animals are registered each year, of which 90 percent are Hackney Ponies.
- Hackney Ponies are most popular in the Midwest, especially in Ohio, Michigan, Indiana, and Illinois.

Kerry Bog Pony

Since at least the seventeenth century, small, semi-wild ponies have lived on the peat bogs of southwestern Ireland. Most local people considered them a part of the native wildlife. Nobody is entirely sure when they first arrived. The ponies were remarkable in their ability to survive on the bogs where suitable food is extremely scarce, the weather is wet and windy most of the time, and the footing is either perilously boggy or dangerously rocky.

The ponies were said to "live on air," but they actually survived on heather and sphagnum moss, which have very low nutritional qualities. They may also have eaten kelp along the shore, as did the ponies on the Shetland Islands. The little ponies somehow learned to navigate through the marshes, unfailingly picking their way around soft spots that could trap them and rarely slipping on rocks.

From the seventeenth century on, they were caught by local people and used to pack peat out of the bogs, for fuel, and kelp out of the ocean, for food and fertilizer. The little ponies were extremely easy to work with and astonishingly strong given their

HEIGHT: 10–11 hands

PLACE OF ORIGIN:
Southwestern Ireland

SPECIAL QUALITIES:
Uniquely adapted to move over boggy ground because of their unusually low body mass, relative to height, and their special walk.

BEST SUITED FOR:
Children's sport pony, driving, and work with disabled riders

This Kerry Bog foal is one of only 150 or so registered representatives of this unusual breed.

small size. People quickly learned to trust the ponies to find the safest routes through the bogs. They were reputed to have a sixth sense about avoiding invisible, dangerously soft areas.

Some owners broke the ponies to harness and used them to haul carts filled with peat. The gentle ponies were turned loose to fend for themselves when they were not needed and caught again when there was work to be done. For children, they were said to be as easy to ride as a chair.

There were few, if any, organized breeders of Bog Ponies. The animals just reproduced naturally. For a long time there were enough of them to go around. In 1804, during the Peninsular Wars, the cavalry discovered the ponies and bought many of them to use as military pack animals. Few, if any, returned. About the same time, donkeys arrived from Spain and replaced the ponies both as beasts of burden and as cart animals. A bit later, gasoline replaced peat as a fuel source and the ponies were no longer needed at all.

With their low body mass and unique walk, Kerry Bog Ponies are well adapted for moving over marshy or boggy land.

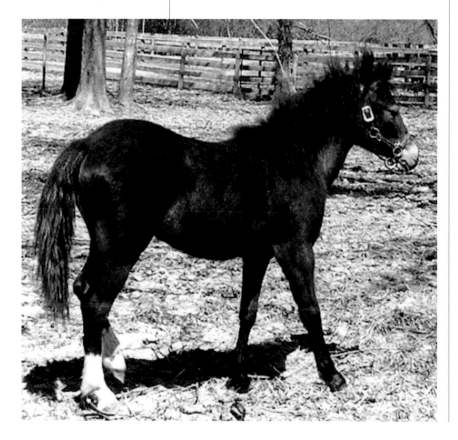

Initially, the Bog Ponies were abandoned and ignored, and then, sadly, they became objects of derision. More than a few were used for target practice.

A Horse Lover to the Rescue

In 1994, John Mulvihill, of Kerry, who knew and remembered the ponies from his childhood, began looking for them on the bogs. Although knowledgeable people told him they were extinct, he didn't accept it. In time he spotted a few ponies on the hills that didn't look quite like other ponies. After he brought them to his own pastures, he became more convinced that these animals were not just everyday crossbred ponies.

DNA analysis of Mulvihill's stallion Flashy Fox and his sire Dempsy Bog revealed a genetic marker that set them apart not only from all other local ponies but also from all other pony breeds known in Ireland and the entire United Kingdom. Mulvihill searched out mares that were the right type and confirmed their heritage with blood samples. After extensive searches, his initial group consisted of only twenty ponies, probably the very last of their kind.

He established sound management and breeding practices for the herd at his farm. Word spread and interest increased, and in 2002, Ireland recognized the Bog Ponies as the Irish Heritage Pony, and Mulvihill and others started the Kerry Bog Pony Society. After further DNA testing, the breed received the official seal of approval from the Irish Equine Centre. (It is interesting to note that although the once famed Irish Hobby Horse has long been thought to be extinct, many knowledgeable people in Ireland believe that the Kerry Bog Ponies are, in fact, the same breed.)

An American Interest

In 2002, when Mike and Linda Ashar of Vermilion, Ohio, expressed interest in some little ponies they saw in an Irish pasture, their guide organized a meeting with Mulvihill. A Morgan enthusiast, Linda

Ashar noticed that the Kerry Bog Ponies resembled little Morgans, with the same beautiful expression, slightly dished face, and huge, expressive, gentle eyes. They were proud but friendly and curious. Mares and stallions lived quietly together in the same pastures with young foals. She wanted to import some into the United States.

In 2003, the Ashars imported a small breeding herd of ponies, which is now established at their Thornapple Farms. Mrs. Ashar is the American liaison to the Kerry Bog Pony Society in Ireland.

Breed Characteristics

These sure-footed ponies have slightly flashy, straight, and level action with good balance. Their weight per hand of height is proportionately far lower than that of most other breeds, a helpful adaptation for walking on wet bogs. Their gaits are similarly adapted to the soft going. Particularly at the walk, they do not "track up," meaning that the hind feet do not step into the prints left by the front feet but come just to the outside. As each foot strikes a new location, it makes the shallowest hole possible in marshy ground. In Ohio, the Ashars have observed that the ponies don't stress the soil as much as other breeds; they seem to float without sinking in.

According to Mrs. Ashar, Kerry Bogs are strong, smart, and very athletic. They make very suitable small sport ponies for young riders, an excellent choice for people with physical limitations, and wonderful driving ponies and companion animals for adults.

Conformation

Kerry Bog ponies average 10 to 12 hands. They are elegant ponies that the Irish describe as being of draft use. The heads are of average size, slightly dished and with small ears. The eyes are very large. The neck is of medium length and strong. The shoulder is well laid back, and the body rounded and muscular, with a deep chest and a short back. The winter coat is long and dense,

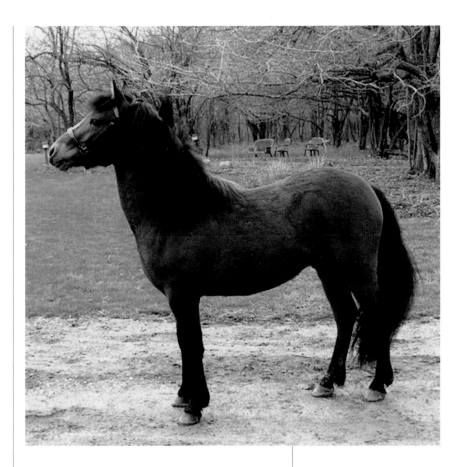

Kerry Bog Ponies do equally well living semi-wild in the harsh Irish peat bogs or as pleasure ponies and human companions.

enabling the ponies to tolerate harsh weather. As seen in profile, the angle of the hooves is steeper than on most horses and the pasterns are relatively upright. This conformation is thought to be an adaptation to life on the soft bogs. Remarkably, even in constant wetness the hooves remain sound.

Color

These ponies may be found in all solid colors including palomino. White markings on the face and lower legs are common. Many have flaxen manes and tails. The society does not accept Pintos for registration.

BREED ASSOCIATION FACTS AND FIGURES
According to the American Kerry Bog Pony Society (founded in 2005):
- There about 150 registered Kerry Bog Ponies in the world.
- There are now 11 in the United States.
- At least one new foal is expected in 2005 at Thornapple Farms; others are expected but have yet to be reported elsewhere.
- A filly and a stallion will be imported in 2006.

Lac La Croix Indian Pony

HEIGHT: Mares 12–12.3 hands; males 12.3–13.2 hands

PLACE OF ORIGIN: Ojibwa Nation, especially Minnesota and northern Ontario

SPECIAL QUALITIES: Known for sure-footedness, cleverness, tractability, and tolerance of human beings

BEST SUITED FOR: Driving, riding, hauling; work with beginning and disabled riders

As far back as the native people of northeastern Minnesota and northern Ontario can remember, small horses have lived in the area. The oral history of the local Ojibwa goes back at least two hundred years, and the story of these tough little ponies is part of the history of the people. The Ojibwa land along the border between Canada and Minnesota is heavily forested and punctuated with hundreds of lakes and streams. Winters are long and severe. Traditionally, the Ojibwa used the ponies mostly in winter to pull logs and pack out traps and pelts over the snow. They were also ridden year-round, typically in thick forests, often on difficult footing. Speed was not a priority; tractability, cleverness, and ability to negotiate the terrain were more important.

Management of the ponies often amounted to turning them loose to forage for themselves. They flourished until gasoline-powered vehicles took over their work and various outside authorities began to make decisions about their existence. By then the horses were semi-wild, coexisting peacefully with the people. They lived in little bands that sometimes wandered into the remote Indian villages but often remained almost invisible as they foraged in the deep woods.

Starting in the 1930s, missionaries and officials at the Minnesota reservation village of Vermillion ordered that the ponies were to be killed, for reasons that are unclear. One excuse given for killing them near another village, Nett Lake, in the 1950s, was that children had seen a stallion breeding mares, which the religious authorities considered to be morally unacceptable behavior on the part of the horses. Quite a few ponies were also shot and sold as dog food by local white men. In time, the ponies disappeared completely from northeastern Minnesota.

Across the border in Canada, the Ministry of Health decided for unknown reasons that the few remaining ponies posed a health risk and declared that the animals should be eliminated. In 1977, Fred Isham heard this news from some of his relatives at La Croix and decided he simply had to take action.

A Dramatic Rescue

Lac La Croix is a fairly large border lake. The Boise Forte band of Ojibwa lives in the village of La Croix on the Canadian side. On the American side, the Boise Forte Ojibwa live on reservations at Nett Lake and Lake Vermillion. In spite of the international border, the people of the villages are closely related. The elders of the three villages decided to round up the remaining few ponies and transport them back to Minnesota to avoid the planned Canadian extermination. Once the last individuals were rescued, the people hoped to develop a plan to save the breed.

Fred Isham's friend Walter Saatala agreed to provide a home for the horses,

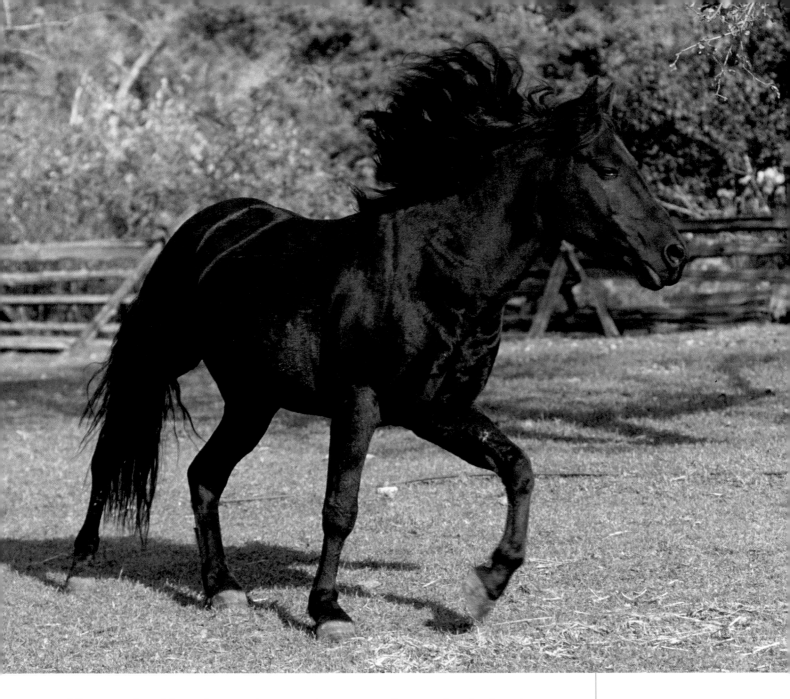

and former rodeo rider and roper Omar Hilde came in to capture the few semi-feral mares that lived near the remote village. Because there was no road access, the only way to transport the horses was to wait until winter and then haul them out by truck over the ice.

The capture effort required help from many of the La Croix villagers. Finding and roping the elusive, frightened horses in ice and snow in a forest and then loading them onto a truck posed an enormous challenge, but they succeeded. At the time, only four female ponies were found. Problems continued after the rescue, when one of the mares nearly starved to death eating commercial grain and hay. For generations the ponies had eaten wild grasses, browsed on buds, and stripped the bark off poplar trees, very much like deer. It took time for their digestive bacteria to adjust to the sudden change to commercial horse feed.

Reestablishing a Herd

Because historical research indicated that the ponies descended from random crosses between Spanish Mustangs and Canadian Horses around the time of the French and Indian War (1754–1763), the rescuers decided to cross a Spanish Mustang on the

The Lac La Croix Indian Pony was rescued from the brink of extinction in the late 1970s.

rescued mares, and they selected an animal named Smokey, a son of Yellow Fox (Spanish Mustang Registry #3).

At the time of its rescue, the breed did not have an official name. The name Lac La Croix Indian Pony commemorates the location of the final rescue and honors the people who saved the ponies. In 1993, Rare Breeds Canada (RBC) became involved with the preservation of the breed and began to bring the ponies back to Canada. Since the involvement of the RBC, record keeping has greatly improved, breeding is more comprehensively managed, and trends can be easily spotted. A few dedicated breeders operate in Minnesota, but the majority of the horses now reside in Canada.

With the total population approaching one hundred in 2005, depending on expected foal yield, all but sixteen of the ponies have had DNA extracted from mane samples to provide animal identification and confirmation of parentage and to begin a herd book for registration purposes. In addition, Dr. Gus Cothran, of the University of Kentucky, is working to include these horses in the Heritage Genome blood-typing project. Among many other things, this research will help scientifically determine the true origin of the horses. His initial research indicates "some type of British pony or at least 'cold blood' horse type as an ancestor of the LLCIP. However, the data also suggest that there could be some Iberian ancestry."

Lac la Croix are sturdy fairly short-legged ponies, well suited to packing.

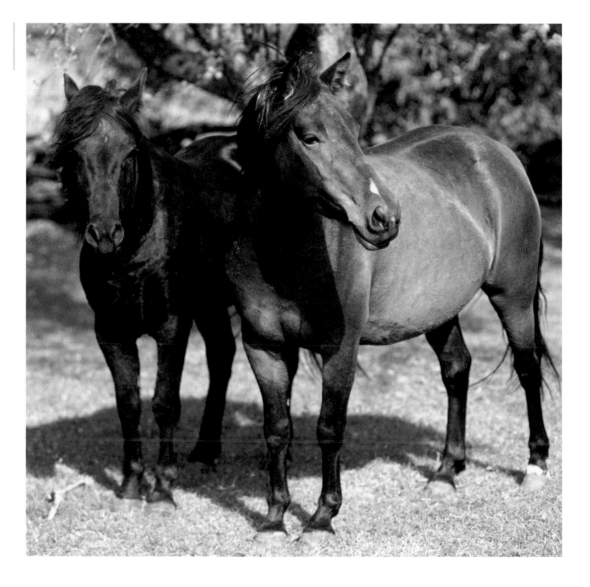

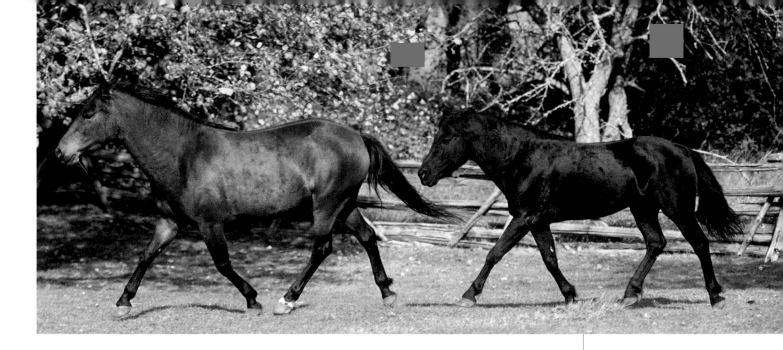

Jane Mullen, of the Lac La Croix Indian Pony Society, says, "I believe this supports our research that the LLCIP is a descendant of the Canadian Horse (cold blood) and the Spanish Mustang (Iberian ancestry)." With Dr. Cothran's expert assistance in the management of small populations, effective strategies are being developed to help the breed remain both genetically distinct and genetically healthy well into the future.

Breed Characteristics

These strong ponies are well able to carry adults or to pull sizable loads. Not surprisingly, they are sure-footed and willing when asked to push their way through dense brush. They are not gaited, but the trot and canter are very smooth and flowing. They have great stamina, and are intelligent and curious. Lac La Croix are excellent family horses for both riding and driving and said to be quite tolerant of human ineptitude. They make excellent horses for beginning handlers and have been very successful in handicapped riding programs.

Conformation

Lac La Croix Indian Ponies are relatively small. Mares usually stand between 12 and 12.3 hands and stallions 12.3 and 13.2 hands. The forehead is broad, tapering toward a fine muzzle. The ears are small, profusely

haired, and set well apart. The nostrils have flaps, which close to keep out inclement weather. The withers are low, the back is straight, and the croup is sloping, with a low-set tail tucked well into the buttocks.

The cannons are very thick, solid, and strikingly large for a horse this size (often measuring 7.5″ to 9″ on mature animals) with slight feathering on the back. The hooves are small, strong, and very hard. The tail and forelock are abundant, and the thick mane often falls on both sides of the neck.

Color

Lac La Croix can be any solid color other than palomino, white, or cream but are predominantly bay, black, grulla, or dun. Small white markings on face and lower legs are fairly common.

Though not a gaited breed, the Lac La Croix has a very smooth trot and canter and is quite comfortable to ride.

BREED ASSOCIATION FACTS AND FIGURES

According to the Lac La Croix Indian Pony Society (officially established in 2004):

- In 1977, at the time of rescue, the total population was four mares.
- By June 2005, the total population was 93, comprising 18 adult males, 34 adult females (9 of them in foal), 13 geldings and barren mares, 15 males under the age of three, and 13 females under the age of three.
- There are 14 farms in Minnesota and Canada that breed Lac La Croix Ponies.

Newfoundland Pony

HEIGHT: 11–14.2 hands

PLACE OF ORIGIN:
Newfoundland, Canada, with
genetic contributions from
England, Ireland, and Scotland

SPECIAL QUALITIES: A
hardy, stocky pony whose
extremely dense winter coat
is often a strikingly different
color from the summer coat

BEST SUITED FOR: Family
pleasure, beginning riders,
and driving

The English officially settled Newfoundland in 1560. From the very early days of settlement, hardy ponies formed an important part of both the workforce and the culture. John Guy imported Dartmoor Ponies in 1611, followed shortly after by a shipment of unnamed ponies brought by Lord Falkland. Other importations followed. The primarily English and Scottish settlers brought with them the types of animals with which they were most familiar and that were readily available for shipping at convenient seaports. This meant mostly multipurpose or draft-type ponies from the west and southwest of England and Ireland and some from Scotland.

As settlement on Newfoundland increased in the 1800s, more small draft horses came over from New England and Nova Scotia. Sable Island Ponies arrived in 1852, and Welsh Ponies much later, in 1939. The foundation breeds generally considered to be the early ancestors of the Newfoundland are the Connemara, the Dartmoor, the Exmoor, the Fell, the Highland, the Galloway, and possibly the New Forest.

The ponies could handle all forms of transportation and work. They hauled kelp from the beaches and logs for firewood. They pulled sleighs in the winter, plowed gardens and fields, and did general farmwork. Most of their work took place from fall through early spring. In the summer, when the majority of people were at sea fishing, the ponies roamed loose, grazing and breeding freely. Fences were unknown, so from the early 1600s on, the Newfoundland Pony developed as a blend of numerous breeds.

The ponies adapted quite successfully to the harsh climate. In 1935, an official census counted 9,025 ponies on Newfoundland. Numbers began to decline after that, however, first when tractors began doing the work the ponies had always done, and later when free-roaming animals were banned. In the 1970s, the ponies became a source of cheap meat for France and were very nearly exterminated.

Just before the point of extinction, a few interested individuals organized support for the ponies that had been so important for nearly four hundred years. The Newfoundland Pony Society was formed in 1980 to gather the ponies and establish captive herds. The group located and registered three hundred ponies, although the total population at the time was thought to be considerably higher. In 1997, Newfoundland Ponies were officially designated as a heritage breed, the first

THE PACING GALLOWAY

In *The Newfoundland Pony*, Andrew Frasier writes that in 1992 a tiny remnant remained of one interesting subtype of Newfoundland Pony known as the Pacing Galloway. These animals were true pacers. It was said that they could easily pace a distance of twenty-five miles, at a speed that frightened many onlookers. Frasier located only one young pacing stallion, which he hoped to use for breeding. He also discovered a few mares and geldings, some actually rescued from trucks on the way to slaughter, but many of the mares were too old to be successfully bred.

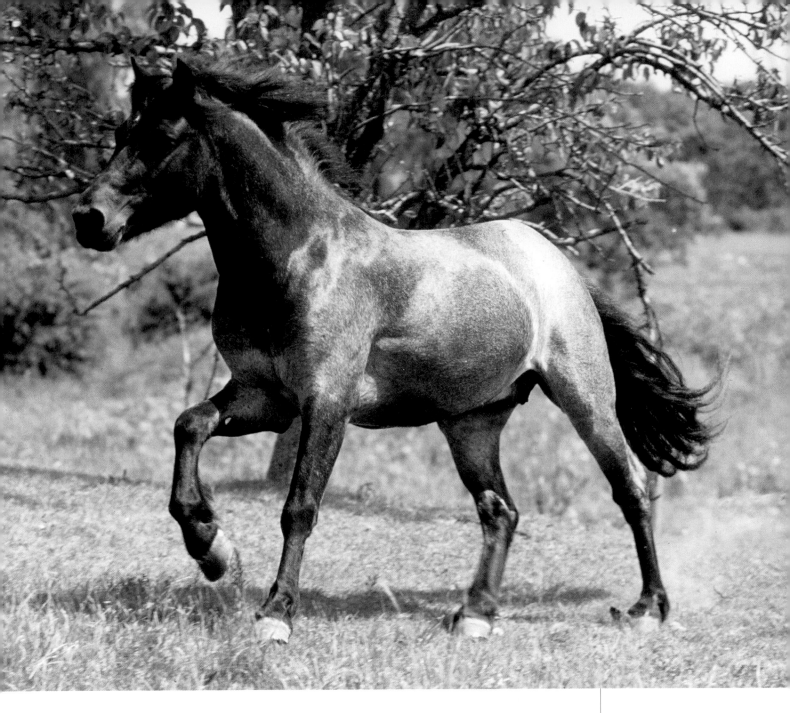

from Newfoundland, and the Newfoundland Pony Society became the organization responsible for the protection and preservation of the breed.

Breed Characteristics

Newfoundlands have made a successful transition from hard work to recreational use. Riding instructors appreciate their docile temperament, and they have been successful at open horse shows. They make excellent family horses for riding and driving and are ideal for sleighs.

Conformation

The Newfoundland usually stands between 11 and 14.2 hands and weighs between 400 and 800 pounds. It has a small head with small, sharply pointed ears and large expressive eyes. The ears usually contain a great deal of thick hair, which protects the animal from insects in summer and helps retain heat in winter. The horses are stocky, with a strong, muscular neck and a short back. The croup is sloping, with the tail set low.

Seen from the side, the ponies have a deep chest; the distance from the withers to the bottom of the chest is about the same

In the winter, this sleek pony will grow a heavy coat that may be a completely different color.

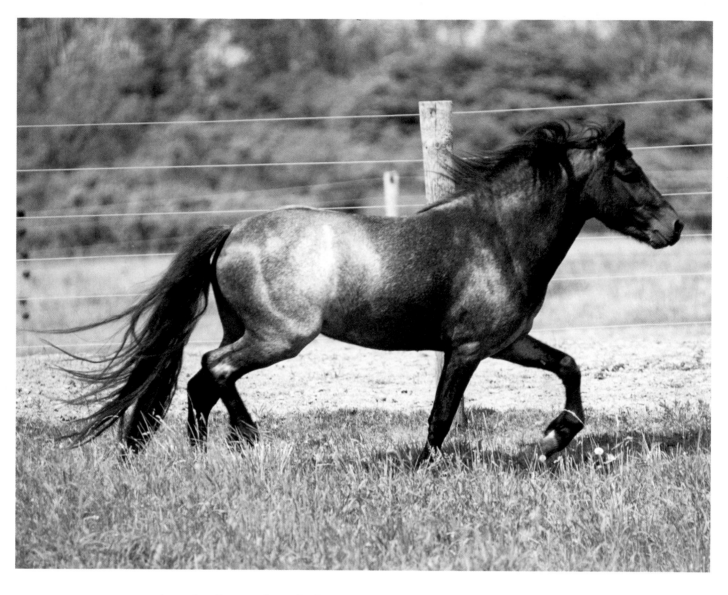

The Newfoundland has a number of breeds in its lineage, including the Connemara, the Dartmoor, the Exmoor, and the Fell.

as the distance from the bottom of the chest to the ground. Viewed from the front, the legs are close together and the chest is narrow. The coat is very thick and dense in winter. The mane is thick and in winter usually falls to both sides of the neck, but in summer it lies only on one side.

Color
The usual colors are black, bay, and brown. Roans are common. Chestnut, gray, and dun appear, as does true white (white horses have pink skin; gray horses have dark skin). The ponies have minimal white markings. Many ponies show dramatic color changes between winter and summer. Pintos are not allowed in the registry.

BREED ASSOCIATION FACTS AND FIGURES
According to the Newfoundland Pony Society (founded in 1980):
- There were 307 registered ponies in 2005.
- Up to six foals are added each year.

Pony of the Americas (POA)

One of today's most popular breeds of children's ponies was developed in the 1950s when a lawyer from Iowa who bred Shetland Ponies bought an Arab/Appaloosa mare that had been bred to a Shetland Pony stallion. The mare produced a colt that was white with black splotches all over its body, including a mark on its flank that looked like the perfect imprint of a hand. The owner, Les Boomhower, named his colt Black Hand. Boomhower admired the pony tremendously for his beauty, conformation, and disposition, which were later reliably passed on to his offspring.

Boomhower decided to use Black Hand as the foundation sire for a new breed and called in some Shetland friends to help work out the details. They set up a new registry with very strict standards to produce high-quality Appaloosa-colored ponies. They wanted the ponies to stand between 44 inches and 52 inches and to have loud Appaloosa coloring, so they required that the spotting be visible from forty feet. They intended the animals to have small, dished heads like Arabs but muscular bodies like

HEIGHT: 11.2–14.2 hands

PLACE OF ORIGIN: Iowa

SPECIAL QUALITIES:
Athletic; loudly colored with Appaloosa patterns

BEST SUITED FOR:
All-around pleasure and competition mount for children and young adults

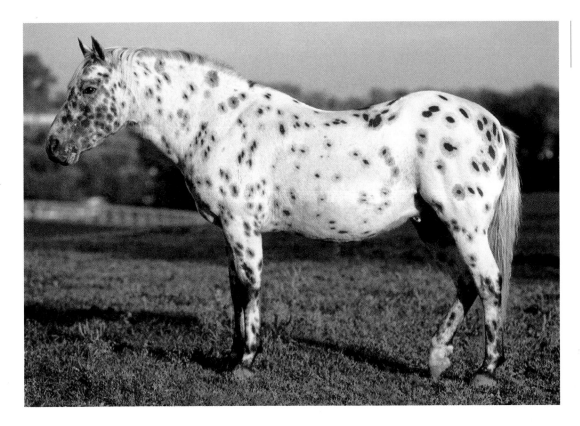

The colorful Pony of the Americas is a popular choice for Western pleasure shows.

Quarter Horses. In addition, they wanted ponies for children to ride and show, so the new breed also had to be gentle and easy to train. They succeeded beyond their wildest dreams.

In 1954, Black Hand became registry #1. Within a year, the organization had twenty-three members and twelve registered ponies. Today, the registry lists more than 47,000 ponies and accepts crosses to Appaloosas, Arabians, Connemaras, Galicenos, Australian Palouses, Morgans, and Thoroughbreds, as long as the foal meets other breed requirements. In addition, planned crosses to Quarter Ponies, Shetlands, half Arabs, Anglo Arabs, Spanish Mustangs, and Welsh Ponies are subject to individual approval. The registry does not accept any pinto, paint, or pintaloosa coloration, or ancestry that indicates of any of these breeds.

The Appaloosa-like markings on a POA must be visible from a distance of forty feet.

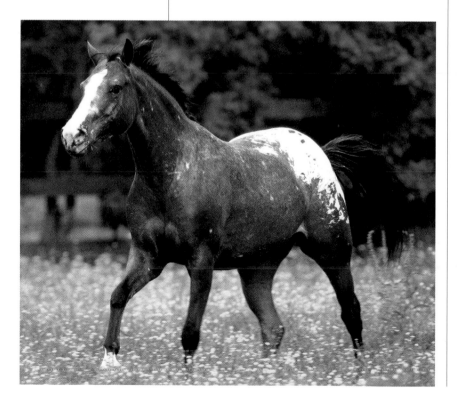

Over time, the height limit has increased to between 46 inches and 56 inches, but the breed has otherwise retained its original qualities. The upper age limit for children showing the ponies has changed from sixteen to nineteen, and many state and local clubs exist for POA enthusiasts. The Pony of the Americas Club (POAC) sanctions state and regional shows, as well as a popular world show. The organization is unusual in its sincere efforts to develop quality in its young human competitors as well as in their animals. Its motto is "Try hard, win humbly, lose gracefully and if you must . . . protest with dignity."

Breed Characteristics

Although the breeders originally developed the POA as a Western or stock-type pony, its athletic ability, sound build, and gentle disposition have carried it quite successfully into the worlds of endurance, event riding, show hunters, and both combined and pleasure driving.

Conformation

The POA is a finely made, medium-sized pony with a slightly dished profile and large, expressive eyes. The neck is well proportioned and slightly arched. The withers are prominent, and the chest is deep and wide. The shoulders are well sloped. The short, straight back connects to broad, strong loins. The croup is long, muscular, and rounded. The legs are strong and solid with good muscling, strong tendons, and sloping pasterns. The hooves are broad and high at the heels, with bold, clearly defined vertical light or dark stripes.

Color

A POA should have Appaloosa coloring visible from forty feet. There must be mottled skin somewhere on the animal. The most common areas for mottling are around the eyes, on the muzzle, and on the genitals. The pony should have visible white sclera and striped hooves.

Shackleford Banker Pony

A series of narrow sand-dune islands runs for nearly 175 miles along the coast of North Carolina, separated from one another by inlets and from the mainland by larger bodies of water called sounds. Although the entire chain of islands is known as the Outer Banks, each individual island has a name, and one of these is Shackleford Island. Until the 1980s, which saw a tremendous building boom, the Outer Banks were very

sparsely populated by people, but for as long as anyone can remember there have been wild horses on the islands. Their history is an impressively long one, dating back to the days of the Spanish explorers.

Exactly when and how horses first came to the islands is not documented. In 1521, Lucas Vasquez de Ayllon, who had been granted the right to explore and colonize the area by the king of Spain, sent an expedition carrying horses and other livestock that probably landed at Cape Fear. In 1526, Ayllon himself arrived with six ships; five hundred men, women, and slaves; three Franciscan friars; and eighty-nine horses. The Spanish unwisely stole some Indian

HEIGHT: 13–14.3 hands

PLACE OF ORIGIN: Shackleford Island, Outer Banks of North Carolina; originally of Spanish stock

SPECIAL QUALITIES: The oldest documented horse population in North America and a historic treasure for both the state of North Carolina and the genetic history of America's horses

BEST SUITED FOR: Pleasure riding and driving; are good children's mounts

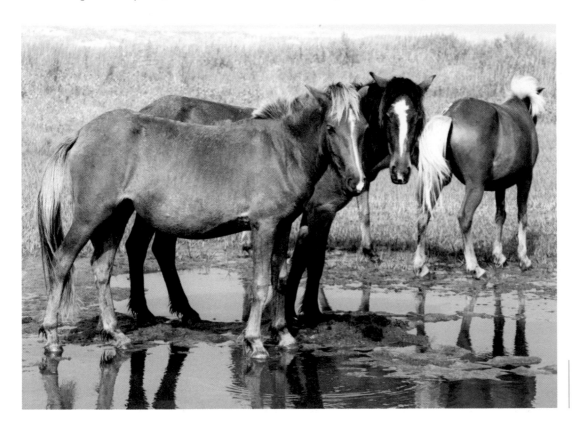

For centuries, wild horses have lived on the Outer Banks of North Carolina.

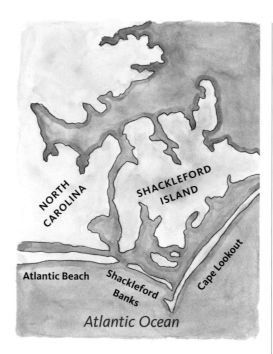

children to sell as slaves in the Caribbean, which caused an immediate Indian uprising, and the Spanish were forced to flee the area without their livestock or belongings.

Between 1584 and 1590, Richard Grenville and Sir Walter Raleigh brought more livestock to the area, purchasing animals in Hispaniola and taking them to the coast of what is now Virginia. In 1585, Grenville's ship *Tiger* foundered on what was probably Portsmouth Island. Although the ship was ultimately saved, it appears that all the livestock were pushed overboard to lighten the

LINKS TO SPAIN

Speculation abounds regarding the origins of the Banker Ponies — whether they swam to the islands from the wrecked ships of Spanish explorers or were intentionally brought there. Dr. Gus Cothran, of the Gluck Equine Center at the University of Kentucky, performed genetic testing of the herd in 1997 and established a link with Spanish horses through several genetic variants. One in particular is a very old genetic marker that is easily lost through **genetic drift** (random changes in gene frequency, especially in small populations). Cothran reports that he has seen this variant in only two other equine populations: the Puerto Rican Paso Finos and the Pryor Mountain Mustangs of Montana. Because the marker is still present in the population of horses from Shackleford, it indicates there has been very little admixture of other breeds.

load; some may well have made it to shore and survived. For the next hundred years or so, there were many Spanish and English shipwrecks that might have set horses free in the area. No one knows for sure which of these first horses survived to become the ancestors of today's Shackleford Horses.

Challenges and Protection

As the human population increased on the Outer Banks in the twentieth century, the horses' presence became controversial. Some said that the horses were ruining the natural environment. Others noted that the horses had been on the islands since the late 1500s and the islands had remained in good condition until other species were introduced, proving that the horses were not the root of the environmental problems. After much debate, a federal law was passed in 1998 protecting the Shackleford Banks wild horses.

The history of these horses is quite similar to that of the better-known Assateague and Chincoteague horses of Virginia, but the Shacklefords have remained a more isolated population. On Chincoteague, outside stallions, including Mustangs and Arabians, have been brought in over the years in an effort to limit inbreeding of the island horses. On Shackleford, no outside horses were ever crossed in.

Islanders on both Shackleford and Chincoteague have had a long-standing tradition of rounding up their herds each year to count them and brand the foals. When the herd becomes too large, about every two to four years, horses are rounded up and seventeen to twenty of them are removed. There was a roundup in 2005; another is not expected until 2009. Horses are selected for removal based on the number of particular genetic lines that exist on the island, all genetic information having been verified by the University of Kentucky.

The roundups are managed jointly by the Foundation for Shackleford Horses and

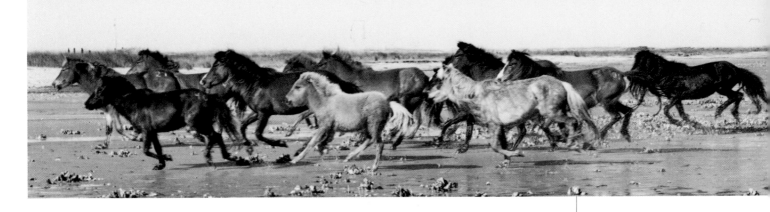

the National Park Service. All removed mares over the age of four are taken to Cedar Island to join other horses there. Other horses are taken to the mainland.

Once they arrive, they are the property of the Foundation for Shackleford Horses, which pays for all vaccinations and tests and makes sure that before they are adopted, the horses adjust to eating commercial feed, and that young horses are socialized to the point that they lead well. Older horses are sent for training with a professional trainer before adoptions are allowed. The costs incurred by the foundation are often greater than the income from adoption fees, but the foundation feels strongly that the horses should be given every possible advantage for a good life in a good adoptive home.

Breed Characteristics

Banker Ponies are extremely hardy and well suited to the islands. In the winters they are rough and shaggy, but in the summers they are always fat and sleek and in excellent health. They know just where to dig in the sand to find fresh water, which seeps into holes they have pawed open. The primary food source for all Banker Ponies is a nutritionally poor salt grass. The quality and quantity of this grass limits the size of the animals and the size of the herds.

Conformation

These are small horses, averaging between 13 and 14.3 hands. Banker Ponies display many of the conformation characteristics of the Spanish horses, including a comparatively long, narrow head with a flat or slightly convex profile, a body that is narrow when seen from the front but fairly deep when seen from the side, and a croup that is almost always characterized by a low tail set.

Color

The colors found in the herds vary somewhat. Shackleford Bankers may be buckskin, dun, bay, chestnut, and brown. There is a black stallion in the herd, several chestnut horses with flaxen manes and tails, and some pintos. No gray horse has ever been recorded in this herd.

These ponies are very pure representatives of the Spanish horses that first came to North America in the 1600s.

The ponies are rounded up every year so that new foals can be branded.

BREED ASSOCIATION FACTS AND FIGURES
- The herd is maintained at 110–130 individuals.
- About a dozen foals are born every year.
- Every few years the ponies are rounded up, and selected animals are sold to good homes.

Shetland Pony

HEIGHT: Maximum in the United States, 11.5 hands; in Canada, 11 hands

PLACE OF ORIGIN: Shetland Islands, Great Britain, with probable ancestral roots in Scandinavia

SPECIAL QUALITIES: A small, sound, versatile breed of great hardiness

BEST SUITED FOR: Driving; traditional child's mount

The Shetland Islands lie about one hundred miles off the north coast of Scotland. The landmass of the entire island group is approximately 550 square miles, about one tenth the size of Los Angeles County, California. The climate is cold, wet, and endlessly windy. The tough native grass provides relatively low nutrition. In spite of these conditions, archaeological evidence indicates that small ponies, quite like the modern British Shetlands, lived on the islands at least two thousand years ago. These ancient ponies probably had origins similar to those of the small ponies found in Iceland, Scandinavia, Ireland, and Wales. Historians believe that the very first ponies may have arrived on the Shetland Islands from Scandinavia before water divided the lands, around 8000 BCE, and later crossed to Scotland with the early Celts. Whatever the true origin of these ponies, they are one of the oldest distinct breeds and have long been domesticated. A ninth-century carving from the island of Bressay in the Shetlands depicts a hooded priest riding a very small pony.

The climate and conditions on the islands shaped these tough little animals. To conserve body heat in the bitter cold, the ponies developed short limbs, a short back, a thick neck, very small ears, a dense coat, and an extremely heavy mane and tail. Big animals were likely to starve and delicate animals to succumb to accident or illness. Only the small, smart, quick, tough ponies survived. The hills were rocky, steep, and very uneven, so they developed sure-footedness and a long, striding gait to cover many miles each day in their search for food.

Even today, nearly all of the people of the islands work as either fishermen or small-scale farmers known as crofters. For hundreds of years, the crofters on each island have maintained communal grazing ground for their ponies and sheep in order to keep the animals off valuable farming acreage, known as "in-by" land. This common grazing ground is called the **scattald,** which is rough, heather-covered moorland. Remarkably, both the ponies and the sheep have developed good nutritional conversion rates for this poor-quality food and provide fairly high milk yields for their young. Many scattalds have access to beaches, and the animals eat seaweed at low tide, which supplements the scant pasturage and boosts mineral intake.

Historically, crofters did not ride their ponies. They left them on the scattalds until they were needed to carry peat, which was used for fuel. There were few roads, and the ponies worked in all sorts of weather carrying woven saddlebags called **kishies** hung from wooden **klibbers,** or pack frames, on their backs. The ponies often carried half their body weight in peat over several miles of difficult terrain. Until better roads made wheeled vehicles feasible, Shetlands were almost exclusively pack ponies. Today, most crofters leave their ponies on in-by land during the winter and put them out on the scattald in May, after foaling, to run with a stallion.

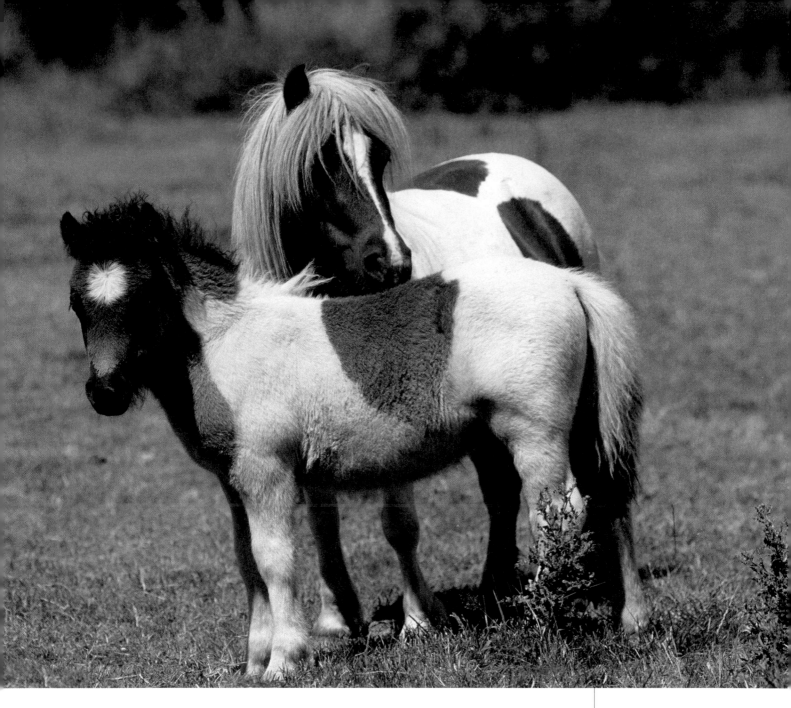

The Era of the Pit Pony

Until 1847, Shetland Ponies were hardly known or used outside of the Islands, but when the Mines Act barred children from doing heavy underground work throughout Britain, they were replaced by these small, hardy ponies. Other breeds also worked in the mines, but only the Shetlands could travel into the narrowest shafts. Hundreds of Shetland geldings were sold to the mines, along with most of the best stallions.

The herds on the islands were greatly depleted, and the quality of the remaining island ponies suffered. In the late nineteenth century, Lord Londonderry and various mine owners and island breeders recognized the need for improvement and took action. In 1891, they published the first studbook, with 457 ponies that had been inspected by the committee for correctness of type and conformation. The upper height limit was fixed at 42 inches, and all colors other than spotted were allowed. ("Spotted" in this case means Appaloosa-like coloring. Pinto coloring, which the British call **piebald** [black and white] and **skewbald** [brown and white], is permitted.)

For many people, the Shetland Pony embodies the ideal child's pony.

Ponies worked the mines until World War II and were still being used in small numbers up until the 1970s. When the ponies became known outside the islands, they became the playthings of the wealthy. The royal family was very fond of Shetlands, and the late queen mother became the breed's patron. Many children throughout Britain and later Europe and North America learned to ride on Shetland Ponies. But in the Depression years of the 1920s and '30s, the market crashed.

In time, Welsh Ponies replaced Shetlands for entertainment, and gasoline-powered engines replaced them for transport. Island mares and fillies were hard to sell, because it cost more to ship them off the islands than they were worth. Even after the boom's collapse, however, a sustained level of interest in Shetlands continued. In Britain, the Shetland Pony Society developed a system of awards for ridden and driven ponies, and they can still be seen competing at shows throughout the country. There is also a Shetland Grand National in December.

The Shetland in North America

Shetlands began to make an appearance in the United States around 1850. The first animals were not registered with any breed association. The American Shetland Pony Club (ASPC) was founded in 1888, three years before the British association, to protect and preserve the breed in this country. A number of the first ponies to arrive were superb harness animals and were immediately selected to be tiny, fashionable driving teams. Excellence in harness has continued to be an emphasis of the breed in this country.

In the 1970s, interest in traditional purebred Shetlands as children's mounts fell, and prices dropped to the point that breeders could not afford to stay in business. The American Shetland Pony Club then opened a division that emphasized fine harness and show ponies, more than children's mounts. The short-legged, stocky, British Shetland was crossed with Hackneys and Welsh Ponies to add height, length of leg, and neck refinement. This variety came to be known as the Modern American Shetland, sometimes casually known as show Shetlands. Today, Modern American Shetlands compete as high-stepping driving ponies. At the same time, the ASPC designated the more traditional variety as the Classic Shetland. The ASPC continues to maintain show divisions and breed standards for these ponies as well.

Breed Characteristics

Classic American Shetlands are excellent mounts for children and fine family pets. They are good movers, nice jumpers, and make first-rate, fun driving ponies for the whole family. Modern American Shetlands are more animated and refined in type than the Classics. They are particularly well suited to fine harness and show classes but also make nice pleasure driving ponies.

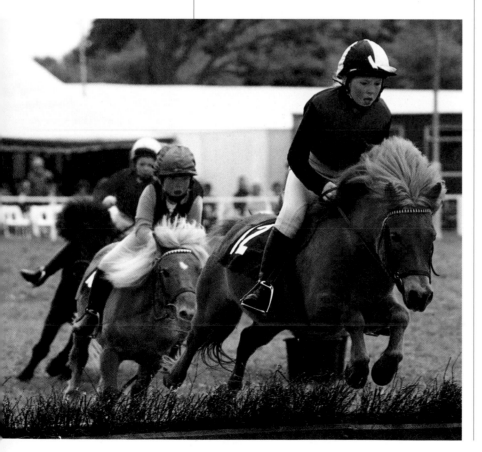

Not your typical Grand National competitors, these Shetlands and their riders nonetheless take their jobs seriously.

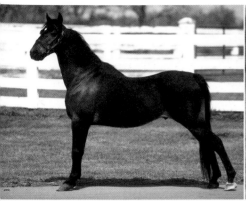
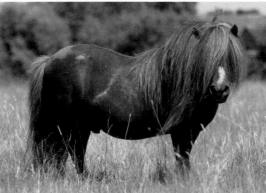
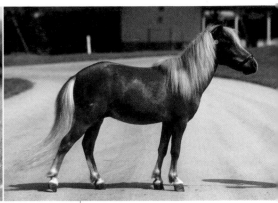

Conformation

Over the years, the height limit for the breed in the United States has increased to 46 inches and in Canada to 44 inches though it remains 42 inches in Great Britain. The United States has a separate breed standard for each variety. According to the ASPC rulebook, the Classic American Shetland possesses style and substance. The short head is clean-cut with a fine muzzle, large nostrils, brilliant eyes, wide forehead, and sharp, small ears. The length of the neck is in proportion to the body, and the shoulders are sloping. The Classic is more refined than the original imported Shetland, with a well-balanced, strong, sturdy body and substance in the chest and hindquarters. The legs are set properly under the body, the forearms well muscled, knees and cannon bones broad and well defined with ideally shaped pasterns with proper size and angle of pasterns and feet. Strong, short cannons support the knees and hocks. The tail is set high on the croup. The mane, foretop, and tail are full. The coat is fine and silky. Extremes in length of neck, body, legs, and action are undesirable.

The Modern American Shetland should be a strong, attractive pony blending the original Shetland type with refinement and quality. The head is carried high on a well-arched neck. The pony's structure should be strong but show refinement, with high withers, sloping shoulders, springy pasterns, and sturdy feet.

Color

Shetlands may be of any color, either solid or mixed, except Appaloosa. No particular color is preferred. Recognized colors are albino, bay, black, brown, buckskin, chestnut, cremello, dun, gray, grulla, palomino, perlino, pinto, roan, silver dapple, sorrel, and white. No discrimination is made because of the color of the eyes.

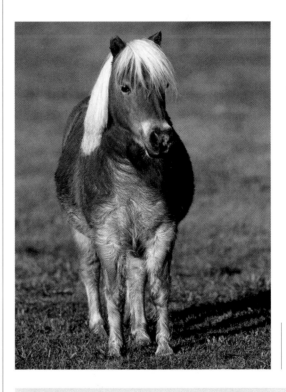

No matter what type, Shetlands are lively, intelligent, and often playful companions.

Over the years, the original Shetland type (center) has been developed into other types, as seen in the Modern American Shetland on the left and the Classic American Shetland on the right.

BREED ASSOCIATION FACTS AND FIGURES

According to the American Shetland Pony Club (founded in 1888):

- There are about 95,000 registered Shetland Ponies.
- The association does not track the number of new foals added each year.

Welara Pony

The Welara was developed by crossing one of the most beautiful breeds of horses, Arabians, with one of the most beautiful breeds of ponies, Welsh. This cross has been popular with many people, especially in England and the United States, for more than one hundred years. These ponies are beautiful, sound, athletic, and affectionate, but somehow they existed for many years without a registry or a breed association of their own.

One early breeder of Welsh/Arab crosses was Lady Wentworth, of the famous Crabbett Stud, in Sussex, England. In the 1900s, she imported top Welsh Pony mares and bred them to her finest Arabian stallions, especially her Polish Arabian stallion, Skowronek. Describing the offspring as "the most beautiful pony on the face of the earth," she continued to produce lovely ponies without making an effort to establish a new breed, a pattern followed by other breeders of Welsh/Arab crosses in England, the United States, Canada, and other countries. It wasn't until 1981 that a group of friends in California organized a registry for what had become known as the Welara Pony.

The goals of the registry were to collect, record, and preserve the pedigrees of Welara Ponies, to publish a studbook, and to develop and promote the breed. Since its inception, the registry has become international, with members in the United States, Canada, England, Wales, New Zealand, Australia, Jamaica, and Germany. In Europe, Welaras are sometimes referred to as sport ponies or riding ponies, though these designations may also include ponies with breeds such as Thoroughbreds in the mix. The true Welara must be a combination of Welsh and Arabian blood. Welara-to-Welara crosses are allowed, but no pony may be less than one-eighth or more than seven-eighths Arabian or Welsh. No other breed or combination of breeds is permitted.

The association does register half-Welaras, known as Welara Sport Ponies. These animals must be 50 percent or more Welara, and 50 percent or less an outside breed. Very often the outside breed is Thoroughbred, a popular combination with hunter and jumper enthusiasts, but crosses to other breeds have also been successful. At the time of this writing, offspring from embryo transfers are not accepted for registry in either the full Welara or the Welara Sport Pony registry.

Breed Characteristics

The Welaras are hardy, spirited, very refined ponies. They are probably best known as beautiful hunter ponies but also work well as jumpers and event ponies, as well as trail and pleasure driving animals. Although their greatest fame is in hunter classes, there is no reason they should not also be very successful as Western contest animals.

Conformation

Ponies must measure between 11.2 and 15 hands as adults to be registered. Stallions usually stand 14 to 15 hands, while mares are a little smaller at 13.1 to 14.3 hands.

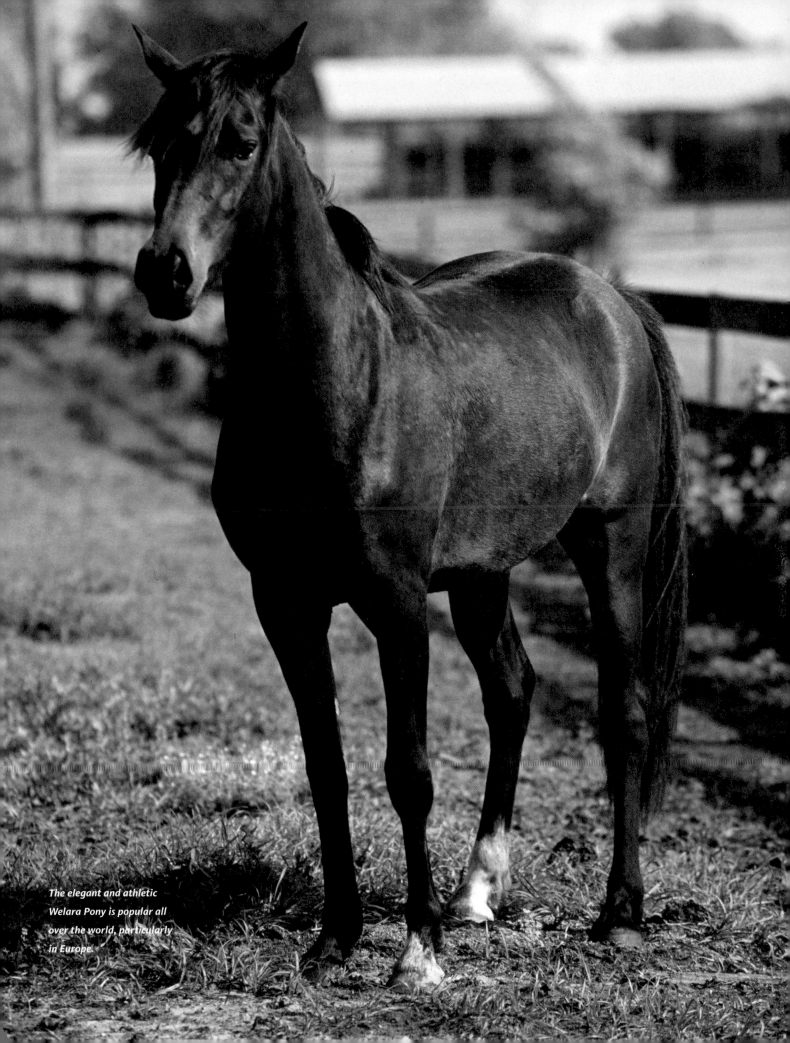

The elegant and athletic Welara Pony is popular all over the world, particularly in Europe.

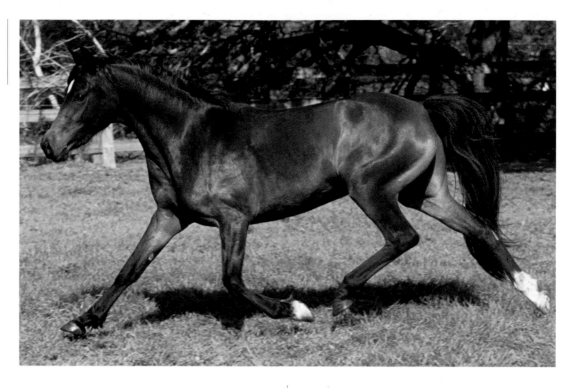

This Welara shows its heritage from both the Arabian and the Welsh Pony in its beauty, refinement, and nice movement.

The head is small and clean-cut, with a tapering muzzle and a slightly concave profile below the eyes. The eyes are wide-set and bold. The ears are small and pointed, the nostrils large and open. The neck is lengthy, arched, high set, and perhaps slightly cresty in stallions. Shoulders are long and well laid back, and the back is short and muscular. The croup is long and comparatively horizontal, with naturally high tail carriage. The flanks are deep and muscular. The squarely set, straight legs have large, clean joints. The hocks have prominent points and turn neither in nor out. The pasterns are moderately sloped. The hooves are round with open heels.

BREED ASSOCIATION FACTS AND FIGURES

According to the American Welara Pony Society (AWPS) (founded in 1981):

- This is an international registry with stock and breeding farms in Canada, England, Jamaica, France, Australia, and New Zealand, as well as in the United States.
- There are 1,524 animals currently registered in North America.
- The AWPS registers 100 new foals each year.
- The breed is most common in Oregon, Washington, and the central United States.

Color

All colors and patterns other than Appaloosa patterns are eligible for registration. White markings on the face, legs, or body are allowed.

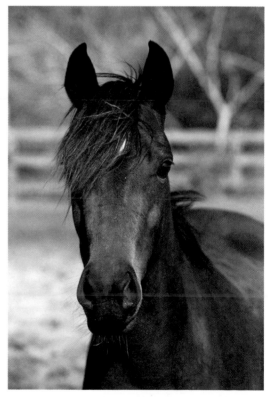

Welaras can be any color except Appaloosa.

Welsh Ponies and Cobs

The original Welsh Mountain Pony lived in the hills and valleys of Wales before the Romans arrived in Britain. The severe winters and meager vegetation kept the ponies small but also made them tough, resourceful, and hardy. Standing about 12 hands (48 inches) tall, the Welsh Mountain Pony was soundly built and sure-footed. It had considerable intelligence, tremendous natural jumping ability, and impressive

HEIGHT: 11–13.2 hands for ponies; 13.2 hands (with no upper limit) for Cobs

PLACE OF ORIGIN: Wales

SPECIAL QUALITIES: Beautiful animals noted for soundness, excellence of movement, and jumping talent

BEST SUITED FOR: Jumping, driving, children's pleasure

endurance—all assets essential to survival in the tough, mountainous Welsh terrain.

The ancestors of the Welsh Pony were probably ancient Celtic ponies. The obvious Arab-like appearance of the Welsh traces back to the time of the Roman occupation, when Arabian and other desert-bred horses first arrived in England. In 55 BCE, Julius Caesar greatly admired the beautiful British chariot horses he saw. Later infusions of desert horses came when Britons returned from the Crusades.

During the reign of King Henry VIII (1509–1547), these smaller horses suffered greatly when the ruler decreed that all horses under 15 hands be destroyed in an

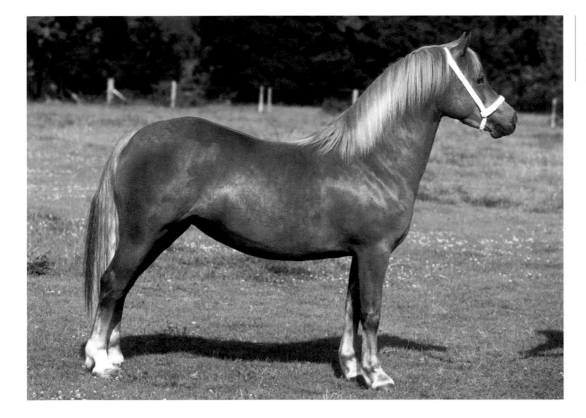

The sturdy yet elegant Welsh Pony has a distinguished history dating back to the time of the Romans.

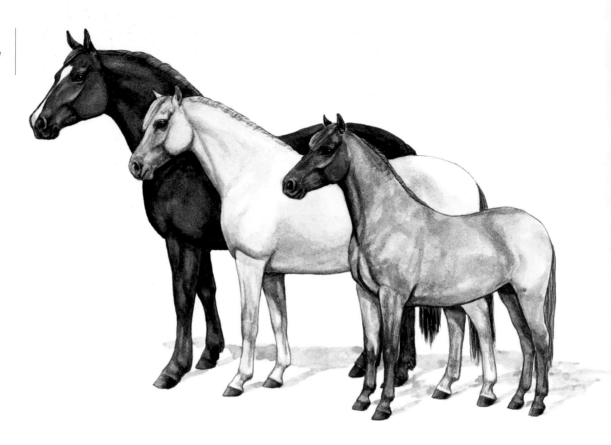

Here, from left to right, are a Welsh Cob, a Welsh Pony, and a Welsh Mountain Pony.

attempt to force farmers to breed larger horses more useful to armored knights. To save their ponies, farmers turned them loose in the rugged Welsh hills. Little bands of ponies retreated to the roughest, most remote areas of the hills and managed to elude discovery. Like their ancestors, they survived nicely, becoming more athletic and clever during their banishment. After the edict was rescinded, farmers recaptured their ponies and began crossing the larger ones onto various draft breeds, creating the Welsh Cob. The high head carriage, lofty action, and feathered fetlocks seen today on Welsh Cobs are reminders of that legacy.

Several Types of Welsh Pony

Since the end of the nineteenth century, the Welsh Mountain Pony, the Welsh Pony, and the Welsh Cob have maintained their own dominant physical characteristics. The word *cob* means a small, solidly built horse. The Welsh Pony and Cob Society in Wales governs the studbook and standard for

each variety and distinguishes the ponies by size and by type, as follows:

- **Section A:** Welsh Mountain Pony, under 12 hands
- **Section B:** Welsh Pony, under 13.2 hands
- **Section C:** Welsh Pony (cob type), under 13.2 hands
- **Section D:** Welsh Cob, 13.2 hands, with no upper limit; some may reach 15 or even 16 hands

The original and smallest type is the Welsh Mountain Pony. The Welsh Pony is a slightly larger version of the Welsh Mountain Pony. This type reflects the contribution of Hackney blood and, near the end of the 1800s, the prepotency of a small Thoroughbred stallion named Merlin, whose influence was such that Section B Welsh Ponies are still sometimes called Merlins.

Section C ponies are of cob type, meaning that they have a heavier build than the Section B Welsh Ponies of the same height. During the Crusades (1100–1500), quite a few desert-bred horses were brought back to Britain. They were often crossed on the

Welsh Pony, producing taller animals. Andalusians were also crossed in, which added substance.

Section D animals are cobs. In the old days, Welsh Cobs did farmwork, but because they were much faster and more responsive than draft horses, they were also ridden. References from the Middle Ages describe the Welsh Cobs as "fleet of foot," good jumpers, good swimmers, and able to carry substantial weight. Before true draft horses arrived, Welsh Cobs performed many mundane tasks, but because they were fast and athletic, they also made good military mounts. Henry Tudor's rise to the throne in 1485 is credited largely to the Welsh militia mounted on cobs.

The Welsh Pony in America

The first Welsh Ponies arrived in the United States in the 1880s. George Brown, of Aurora, Illinois, imported quite a few between 1880 and 1910. Through his efforts, the Welsh Pony and Cob Society of America was formed in 1906.

As with many other breeds, interest fell off during the Depression but revived as the economy recovered. During the mid-1950s, Welsh Ponies became increasingly popular as children's show ponies, especially hunters. Over the next decades, the boom continued, with about five hundred new members joining the association each year. At one point, the Welsh Pony was the fastest-growing breed of pony in America, though other breeds, such as the POA, have increased in popularity more recently.

Breed Characteristics

Always beautiful, Welsh Ponies make excellent riding and driving ponies and outstanding jumpers, and they are well known for their pleasant disposition. The action is straight, quick, and free, both in front and behind, with hocks well flexed. Section B and C Welsh Ponies are sometimes seen in the United States today in shows and parades in draft hitches.

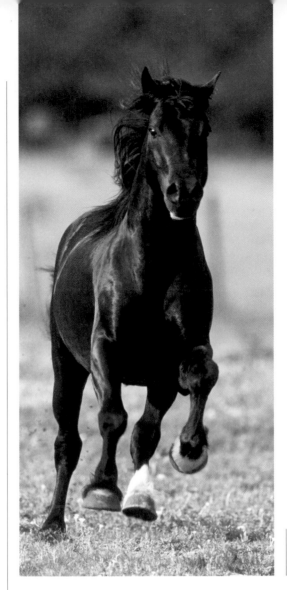

The Welsh Pony has long been valued for its ground-covering trot and extraordinary stamina.

MEDIEVAL COBS

British knights used the Welsh Cob, or **rouncy,** in the fifteenth century. The warhorses of the day were known as **destriers,** a term that described their use, not their breeding. Destriers were big and heavy so they could bear a knight in full armor, a load that sometimes went to three hundred pounds. Between conflicts, however, knights were inclined to travel long distances at the trot, and destrier trots were frequently bone jarring. During distance travel, it was common for the knight to ride the comfortable cob and for his serf to ride the warhorse or run alongside. For battle or jousting tournaments, they switched mounts.

Because the rouncy had to be able to keep up with the big destriers for long distances at the trot, excellence at the trot was highly valued. During peaceful times, trotting matches between cobs were popular, and the sale value of one of these horses often depended on how far it could trot without difficulty. The ground-covering trot of the Welsh Cobs has been legendary for centuries. It is not surprising that these horses are being rediscovered as driving increases in popularity.

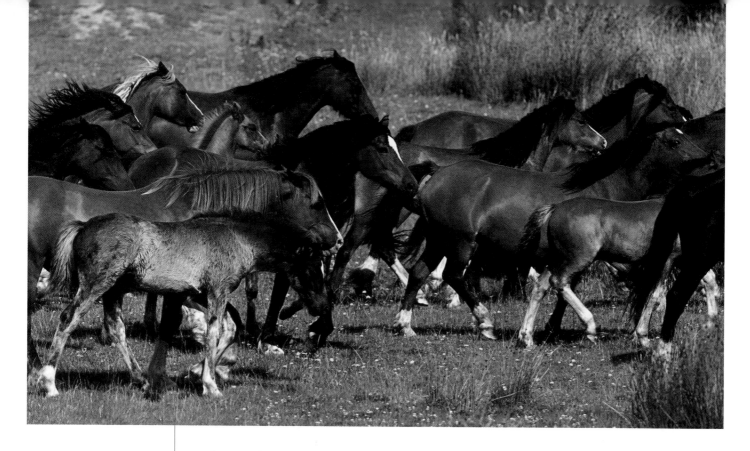

In spite of the prevalence of bays in this picture, gray is a more common color in the breed, along with brown and chestnut.

There is also a Welsh Part-Bred Register for horses, cobs, and ponies whose breeding is not less than 25 percent registered Welsh. Part-bred Welsh are very popular in show jumping, eventing, dressage, and driving.

Conformation

Section A, Welsh Mountain Pony: Height cannot exceed 12 hands. The head is small, with neat, pointed ears; big, bold eyes; and a wide forehead. The jaw is clean-cut, tapering to a fine muzzle. The preferred profile is concave, never too straight or convex. The neck is carried well, with shoulders sloping back to well-defined withers. The legs are set square, with good, flat bone and round, dense hooves. The tail is set high and carried gaily.

Section B, Welsh Pony: Height cannot exceed 13.2. The general description is the same as above but with greater emphasis placed on riding pony qualities, while still retaining the true Welsh quality and substance.

Section C, Welsh Pony of Cob Type: Height cannot exceed 13.2 hands in Wales or 14.2 hands in the United States. This is the stronger, sturdier version of the Welsh Pony.

Section D, Welsh Cob: Height is over 13.2 hands, with no upper limit. The general character is of strength, hardiness, and agility. The body must be deep, supported by strong limbs with good joints and an abundance of flat bone. Action must be straight, free, and forceful. The knees should be bent and then the entire forelegs extended from the shoulders as far forward as possible in all gaits, with the hocks well flexed, producing powerful leverage.

Color

For all types, any solid color is accepted. Gray, brown, and chestnut are the most common colors. White on the face and lower legs is permitted. Pinto and Appaloosa patterns are not allowed.

BREED ASSOCIATION FACTS AND FIGURES

According to the Welsh Pony and Cob Society of America (established in 1906):

- There are 44,047 purebred animals registered.
- The half-Welsh registry contains 6,515 animals.
- There are about 900 new registrations each year.
- The breed is found throughout North America.

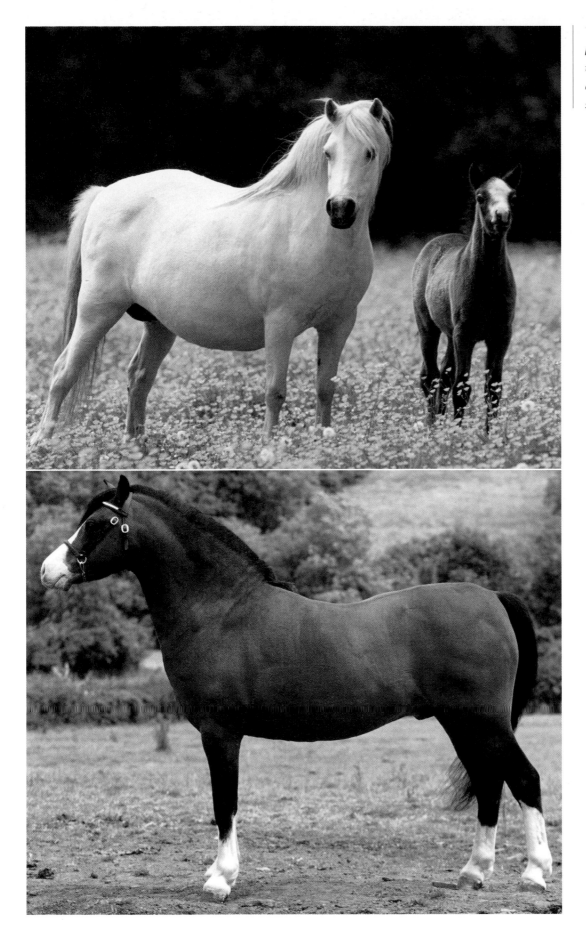

The top picture shows an example of the refined Welsh Mountain Pony; the bottom one depicts the sturdier and more substantial cob type.

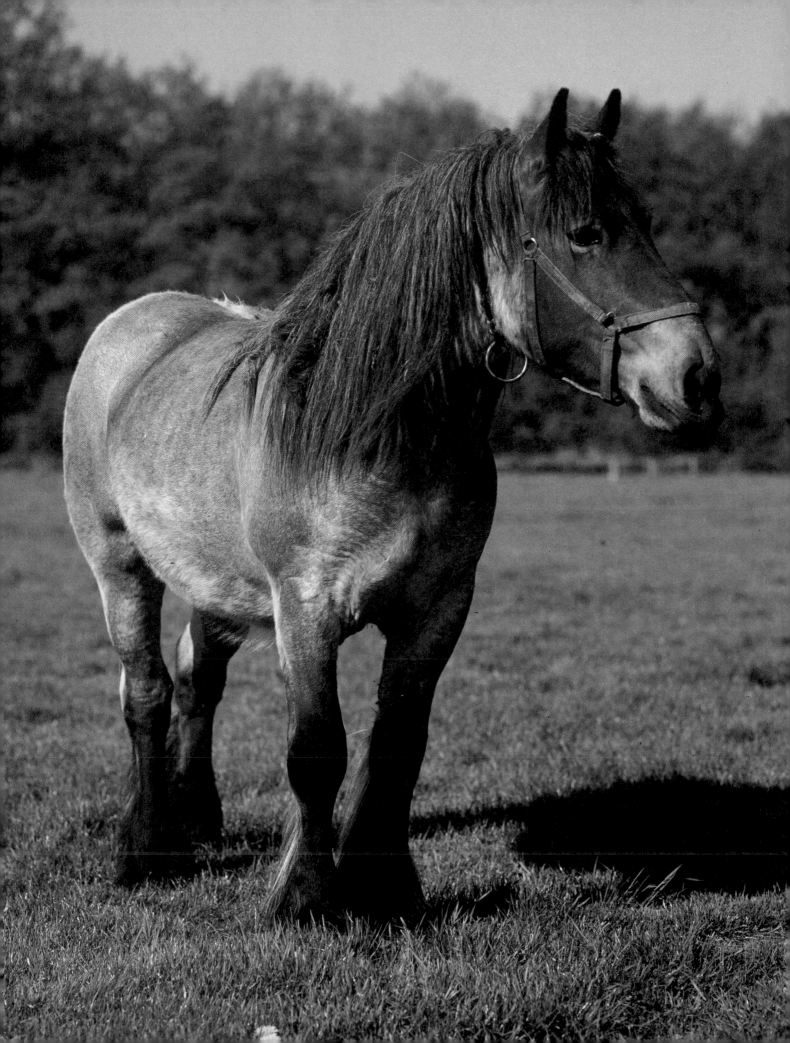

Heavy Horses, Donkeys, and Mules

ALL THE TRUE DRAFT BREEDS we have today originated along the coastal areas of what are now northeastern France, Belgium, Holland, Germany, and Denmark. There the soil was very fertile but extremely wet and heavy. It produced the nutritious horse feed necessary for the growth of big horses — and it took powerful horses to work the farms.

These big horses arose at least in part from the "giant forest horse" of Europe, an animal with the scientific name *Equus robustus, Equus germanicus,* or *Equus stenonis.* The remains of these "coldblooded" horses have been found from a million years ago, while the oldest form of the lighter Przewalski horse goes back about 110,000 years.

Giant is a relative term. The forest horse stood perhaps 15.3 hands and weighed about 1,250 pounds. Our draft horses originated from this ancient stock some five thousand years ago, and were selectively bred into the tall and massive horses we know today.

Only two living draft breeds were developed on our shores — the North American Spotted Draft, still an evolving breed, and the rare American Cream Draft, unique in the world.

Heavy draft horses like this Brabant have played an important role in human history.

American Cream Draft

HEIGHT: Mature mares, 15–16 hands; mature males, 16–16.3 hands

PLACE OF ORIGIN: Iowa

SPECIAL QUALITIES: Unusual cream color, with amber or hazel eyes and full white mane and tail

BEST SUITED FOR: Commercial carriage driving, parade hitches, farm work, riding, and pleasure driving

The strikingly colored American Cream Draft is the only recognized breed of draft horse still surviving that originated in the United States. The breed descended from a cream-colored draft-type mare of unknown ancestry purchased in central Iowa in 1911. Old Granny, as she was called, belonged to a well-known stock dealer. Her foals attracted attention because of their unusual color, and they sold for well above average prices.

Granny herself was eventually sold to the Nelson Brothers Farm, where she remained for the rest of her very productive life. By 1946, she was credited as the foundation dam of 98 percent of the horses registered in the recently formed breed association.

In 1920, Eric Christian, a veterinarian, was so impressed with a colt of Granny's that he implored the Nelson brothers not to geld the animal, intending to create a new breed. This colt, known as Nelson's Buck No. 2, is considered the progenitor of the breed, though he remained a stallion only one year and sired only one registered cream-colored colt, Yancy No. 3, out of a black Percheron mare.

One of the most influential stallions in the history of the breed was Silver Lace No. 9, a great-great-grandson of Nelson's Buck that was foaled in 1931. His mature weight of 2,230 pounds, considerably heavier than most Creams to that point, was credited to his light sorrel Belgian dam. His owner, G. A. Lenning, promoted him around the state, and he quickly became the most popular stallion in the area. At the time, however, Iowa law required all stallions standing for public stud service to have a certificate of soundness and a permit issued by the state department of agriculture. The permit was issued only to stallions of recognized breeds. Because Silver Lace did not belong to a recognized breed, the only way around the law was to create a breeding syndicate. Only people who owned shares in the Silver Lace Horse Company could breed their mares to Silver Lace.

Silver Lace's breeding career unfortunately coincided with the Great Depression, a very difficult time for farmers. At one point, Lenning saved Silver Lace from the auction block by hiding him in a neighbor's barn. Despite the economic hardships, several breeders made serious efforts during those years to improve both color and type of Cream Drafts by linebreeding and inbreeding. Outcrosses between quality Cream horses and top individuals of other draft breeds brought greater quality and size to the emerging breed.

A DISTINCT BREED

In 1990, genetic testing based on gene marker data established that the American Cream comprises a distinct group within draft horses. They are not any more similar to Belgians than they are to Percherons, Suffolks, or Haflingers. Prior to this scientific evidence, many thought Creams to be merely a collection of similarly colored individuals.

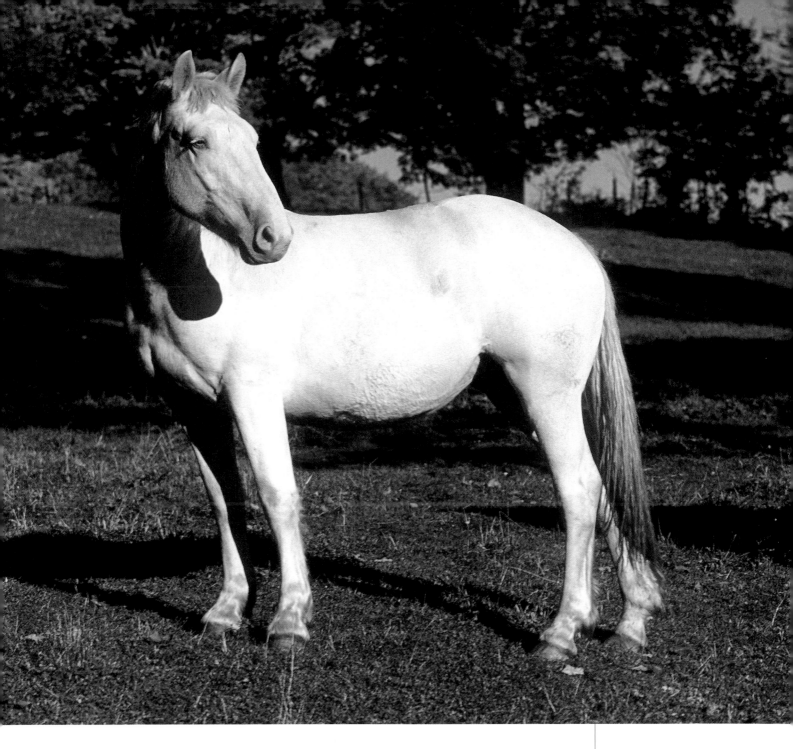

Beginning in about 1935, the horseman C. T. Rierson bought all the good Cream mares sired by Silver Lace that he could find. He used these mares to finally develop the new breed of draft horses that Dr. Christian had envisioned. In 1944, twenty owners and breeders formed a new breed association. In 1948, the National Stallion Enrollment Board recommended that the organization be recognized, and in 1950 the Iowa Department of Agriculture gave the American Cream Draft privileges equal to all other recognized draft horse breeds.

Breed Characteristics

Its striking cream color distinguishes the American Cream from all other draft breeds. Among draft breeds, the movement of American Creams is particularly smooth and easy; they pick their feet up and set them squarely back on the ground. Today the American Cream Draft is used to pull newly-weds at weddings and for parade hitches.

The American Cream Draft is one of only a few draft breeds that were developed entirely in the United States. Many of these horses are used for pleasure driving and riding, and at least one shows in dressage.

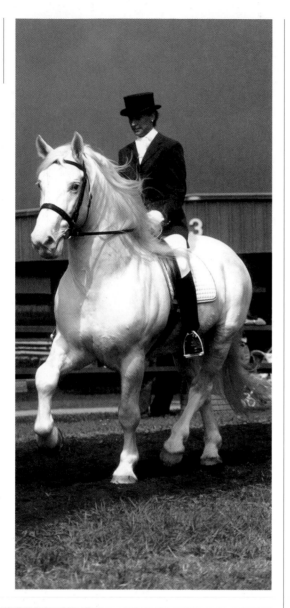

American Cream Draft Horses can be used for pleasure riding, even dressage, as this photograph proves.

Conformation

The American Cream Draft is a medium draft horse. Mature mares, five years and older, stand 15 to 16 hands and weigh between 1,500 and 1,600 pounds. Mature males measure 16 to 16.3 hands and weigh 1,800 pounds and up.

The head is refined and well proportioned to the body, with large, wide-set eyes; small expressive ears; and a flat profile. Interestingly, foals' eyes are almost white during their first year and acquire color as the individuals mature. These horses are short-coupled, with round, muscular hindquarters, a wide chest, and good sloping shoulders. They are deep through the heart girth, with well-sprung ribs; solid, strong legs set wide apart; and strong, sure feet.

Color

The coat must be light, medium, or dark cream. All horses have a white mane and tail and amber or hazel eyes. Pink skin is required for registration. The mane and tail are long and full. Though docking the tail of draft horses is an ancient tradition, in this breed the tail is not docked. A blaze and socks or stockings are desirable.

On the advice of Dr. Phillip Sponenberg, DVM, PhD, of the American Livestock Breeds Conservancy and the Virginia-Maryland Regional College of Veterinary Medicine, foals with Cream breeding that are too dark to be accepted for registry can be appendixed to the registry. These animals may be crossed on cream-colored individuals, which should strengthen rather than dilute the Cream genes and enable breed numbers to increase more rapidly. Until such time as the books are closed to outside breeding, a Cream mare with dark skin and light mane and tail will be accepted as foundation stock. All stallions, however, must have pink skin and a white mane and tail to be accepted for registration.

BREED ASSOCIATION FACTS AND FIGURES

According to the American Cream Draft Horse Association (established in 1944):

- There were 350 American Cream Draft Horses registered in 2004, up from 222 in 2000.
- The association also lists 40 "tracking horses," which may be either horses with Cream characteristics that are by pedigree Cream Draft crossed on another draft breed or purebred Cream Drafts that don't meet the color requirements. Within guidelines, tracking horses may be used as breeding stock to produce purebred Cream Draft foals.
- About 30 new purebred foals are added to the registry each year.
- Although quite rare, these horses may be found in many parts of the United States.

Belgian

The little country of Belgium (about one fifth the size of Iowa) lies on the coast of the North Sea between the northeast border of France and the southwest border of Holland. The area all along this part of the coast is extremely fertile lowland. The excellent soil and heavy rainfall in the area provide abundant hay and grain with the nutrients necessary for the development of big, powerful horses.

HEIGHT: 16–18 hands

PLACE OF ORIGIN: Belgium

SPECIAL QUALITIES: Sorrel with flaxen mane and tail; high-stepping action

BEST SUITED FOR: Both hitch and pulling competition

The ancestors of the modern Belgian were large black horses known as Great Flemish Horses, which existed in the region even before the time of Caesar (100–44 BCE). The Great Flemish Horse was the foundation of all draft breeds we know today. If you trace back when horses were first domesticated, these heavy horses descended from an animal known as the "giant forest horse," which, although not giant by our standards, represented an entirely different equine branch than the light horse breeds.

In the first part of the nineteenth century, European breeders refined the heavy Belgian breed considerably, although those horses were still quite different from the

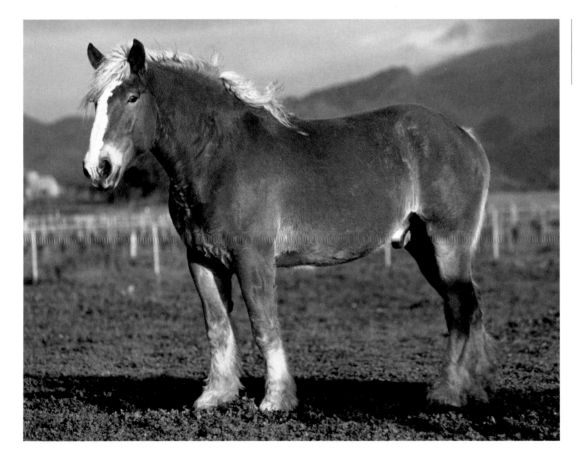

Though other colors are accepted, the preferred color for Belgians in North America is sorrel.

Belgians we know in North America today. Belgians in Europe were outcrossed to other breeds to add refinement and to reduce the feathering on the legs. The black color of the original Flemish horse gave way to bay, chestnut, and roan.

The official studbook for the breed was established in Belgium in 1886. Breeders in that country linebred and sometimes inbred to fix the type and create **prepotency** (dominance of a particular gene or group of genes). The government paid awards for the best stallions and mares as determined by a system of district shows and a large, prestigious national show. Horses that did not win were usually dropped from breeding programs.

Belgian Horses first came to the United States in 1866. In 1885 and 1886, the Wabash Importing Company in Indiana sold several shipments of Belgian stallions to horsemen in Indiana and neighboring states. In 1887, owners formed a breed association in Wabash, where the headquarters remains today. The association grew steadily until 1893, at which point

Belgians are still seen in many places pulling carriages and other types of transport.

importations virtually stopped because of an economic depression.

In 1899, the economy improved somewhat and both horse breeding and horse importation began to pick up. Still, until the early twentieth century, Belgians were less popular than Percherons, Clydesdales, and Shires in North America. The turning point in popularity came when Belgium sent an impressive array of horses to the 1904 World's Fair in St. Louis, sparking considerable interest in the breed. Both the easy keeping qualities and the working abilities of the horses have maintained their popularity ever since.

Developing an American Type

All importation of horses from Europe halted during World War I, but Belgian numbers in the United States continued to increase. By 1925, annual Belgian registrations had surpassed one thousand each year, reaching a record high of more than three thousand in 1937. Belgians had gained favor with American horsemen, who often said that they had the quietest disposition

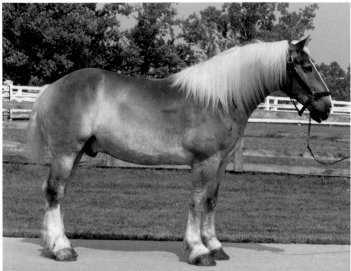
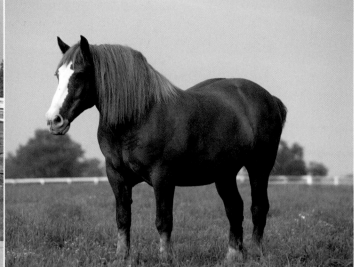

Compare the lighter, leggier, show type Belgian on the left with the more traditional draft type (right).

and were the easiest keepers and best shippers of any of the draft breeds.

During the times when European importations were halted, Americans began to develop their own type of Belgian Horse, which has continued to diverge from the much heavier European type. Over time, American breeders have developed a taller, more stylish horse with a focus on shades of chestnut and sorrel, to the extent that most North Americans are unaware that these horses come in other colors. Within the breed in this country, however, particular shades of chestnut and sorrel seem to come into and fade out of fashion.

Breed Characteristics

Modern Belgians are expected to move well at both the walk and the trot. For draft horses, this means lifting the knees smartly in long, free, powerful strides.

In the show ring, today's Belgians are considerably longer-legged than either their European kin or the older American working Belgian type.

Conformation

Show and hitch horses often mature to over 17 hands and routinely weigh as much as 2,200 pounds. The American Belgian has a lighter, more expressive head and a longer, leaner neck than the European Belgian. The profile is straight or slightly concave. The ears are small. The back is broad and short, and the croup muscular, rounded, and massive. The body is deep and short. The legs are strong, lean, and sound, with some feathering at the fetlock. The feet are large and well shaped.

Color

In North America, the most prized look is a chestnut or sorrel horse with a white mane and tail, four white stockings, and a blaze. Within these colors, horses with considerable roaning and highly dappled horses are fairly common. Very selective owners of well-matched parade hitches sometimes avoid both dappling and roaning, preferring the purer color. Bays, blacks, and grays appear infrequently but may be registered.

BREED ASSOCIATION FACTS AND FIGURES

According to the Belgian Draft Horse Corporation of America (founded in 1887 as the American Association of Importers and Breeders of Belgian Draft Horses):

- The association does not track total number of registrations.
- In 2003–2004, 3,132 new registrations were processed (both foals and adults).

Brabant

HEIGHT: 15.2–17 hands

PLACE OF ORIGIN: Belgium

SPECIAL QUALITIES:
Massively built; can weigh as much as 3,000 pounds

BEST SUITED FOR: Farmwork

The word "Brabant" signifies an area in what is now Belgium, once the duchy of Brabant. It also identifies a particular draft horse that originated in this region. In Europe, "Belgian" is a generic term applied to several slightly different breeds of heavy horse. To confuse Americans further, the Brabant itself goes by various names, depending on the area or country of origin. In southern Belgium it is called the Cheval de Trait Belge.

In northern Belgium it is called the Belgisch Trekpaard. In France it is the Cheval Trait du Nord, and in Holland it is the Nederland Trekpaard.

Brabants have been imported into the United States since the mid-1800s. They were crossed with local stock to develop the American Belgian, which continued to look very much like the stocky European version until the interruption of horse imports from Europe during the First and Second World Wars. Without imports, the Americans continued breeding horses from stock already in the country. During these periods, the American Belgian became taller, lighter-bodied, and more clean-legged than its European relatives. It also developed into a breed that was most frequently some shade of blond, chestnut, or sorrel.

At about the same time, in Europe, Brabants were being bred to be thicker-bodied and "draftier," with heavy feathering on

These young horses already show signs of the bulk and muscle that they will develop as adults.

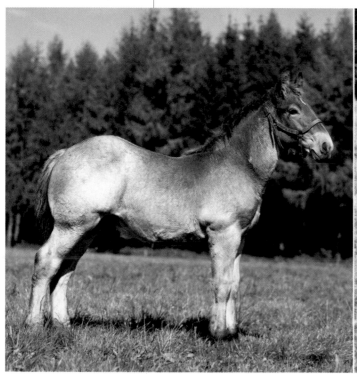

treelike legs. They come in a variety of colors, the most common being red bay or bay roan. American Belgians and European Brabants have continued to diverge and are now quite different. In recent years, some fanciers of the older, heavier type are again importing horses from Belgium and Europe. Thus the American Brabant today is truly the Belgians' Belgian. The heaviest of all the types of Belgian, it most closely resembles the original horses.

Breed Characteristics

Although they are massive, Brabants are easy keepers with a quiet, willing disposition. They are said to be ideal for the small-scale farmer who is interested in sustainable agriculture.

Conformation

The height of Brabants ranges between 15.2 and 17 hands, and they can weigh as much as 3,000 pounds. The Brabant has a large, neat head; a short, heavily muscled neck; and a powerful, deep body supported by very substantial legs.

Color

The most common colors are red bay and bay roan, but blue and strawberry roans are often seen. Solid dark bay is also relatively common. Black and gray occur rarely.

The powerful Brabant can weigh as much as 3,000 pounds, making it the heaviest of all the draft breeds.

BREED ASSOCIATION FACTS AND FIGURES

According to the American Brabant Association (formed in 1998):

- As a type of Belgian Horse, Brabants are registered by the American Belgian Draft Horse Corporation.
- Because the Belgian registry does not distinguish Brabants from Belgians at this time, estimates of Brabant numbers are not available. There are no more than 100 pure Brabants in the United States and Canada and approximately 500 Brabant x American Belgian crosses.
- There are fewer than 50 new registrations each year.
- There are Brabants in nearly every state in the United States, though the breed is most common in New England and the rest of the Northeast because the first major importer of Brabants, in the 1970s, was from Vermont.

Clydesdale

HEIGHT: 16.2–18 hands

PLACE OF ORIGIN: Scotland

SPECIAL QUALITIES: Long silky feathering on the lower legs that highlights exceptionally fluid and powerful movement

BEST SUITED FOR: Multi-horse hitches, draft work

These grand horses from the land of the river Clyde are the pride of Scotland. The breed dates back to the middle of the eighteenth century, when local mares were crossed on imported Flemish stallions to increase the weight and substance of the offspring. At the time, one of the main uses for the horses was to pack coal over poor or nonexistent roads.

The sixth duke of Hamilton (1724–1758) imported a dark brown stallion, which he allowed his tenants to breed to their mares free of charge. At about the same time, a wealthy farmer brought in a black Flemish stallion from England with a white face and some white on his legs. This stallion proved to be very popular, and as his colts and fillies were noted for their improvement in quality over local horses, they were highly sought.

A third stallion to leave his mark on the breed was Blaze, who won first prize at the important Edinburgh show in 1782. He was used to breed mares in the area for many years. Nothing was known of the pedigree of this horse, but his shape, style, and action indicated that he had coaching blood.

In the early 1800s, breeders began to keep written pedigrees. In 1808 there was a dispersal sale at the farm of a descendant of the farmer who had imported the first black Flemish stallion to the area. A two-year-old filly purchased at this sale had a pedigree that traced directly back to this stallion. According to the Clydesdale Horse Society in Scotland, practically every Clydesdale today has lineage back to this mare. She produced Thompson's Black Horse, or Glancer, a terrifically influential stallion described at the time as having

"a strong neat body set on short thick legs, the clean sharp bones of which were fringed with nice, flowing silken hair."

At its peak, the number of horses in Scotland reached around 140,000 on farms, plus an unknown but substantial number in cities and towns. A large proportion of these horses were Clydesdales. Between 1850 and 1880, many of the best stallions and a few good mares were exported, primarily to Australia and New Zealand. In terms of numbers, however, the top export year was 1911, when 1,617 stallions exited the country. During World War I, thousands of these horses were conscripted to the army, and shortly after the war, the breed began to decline in quantity as mechanization was increasingly adopted on farms.

This trend continued after World War II. In 1946 there were more than two hundred licensed breeding Clydesdale stallions in England; by 1949 there were only eighty; and by 1975 the Clydesdale was considered to be a "vulnerable" breed by the Rare Breeds Survival Trust in Great Britain. Since then, there has been renewed interest in these horses. The breed is now categorized as "at risk," which is a slight improvement. The breed's popularity rose in the 1990s, though there are still only about seven hundred registered broodmares and about one hundred registered stallions in

the United Kingdom. People are again using them for farmwork, logging, driving, showing, and even riding, but today most of these big, gentle horses are kept more to provide pleasure than to earn their keep through hard work.

The American Clydesdale Association was founded in 1879, only two years after the Clydesdale Horse Society in Scotland. In the United States, the Clydesdale has gone through considerable change in type, style, and height. In the 1920s and '30s, the demand was for a more compact horse. According to *The History and Romance of*

the Horse (1941), "The Clydesdale is smaller than most draft horses (smaller than the Percheron, Belgian or Shire)." This is certainly not the case today. The emphasis since the end of the 1930s has been for a taller, "hitchier" horse, meaning one that is bigger and more impressive-looking for parade and show hitches.

The Famous Budweiser Teams

The look and fame of the Clydesdale in the United States has been greatly influenced by the Busch family, and the Budweiser Brewery of St. Louis. During the years of

White markings on the face and legs are very common in the Clydesdale, and spots of white on the body are often seen, as on this foal.

Prohibition (1919–1933), when alcohol sales were banned, the Budweiser brewery managed to stay in business by producing a soft drink. When Prohibition was lifted and beer could again be legally sold, the brewery knew it was on the brink of a boom, and the Busch family celebrated. Part of the celebration was the surprise gift, given by August Busch Jr. to his father, of a magnificent eight-horse hitch of matched bay Clydesdales pulling a Budweiser beer wagon to carry the first beer produced after the end of Prohibition.

Since that time, the Budweiser Clydesdales have become the world-famous symbol of and ambassadors for both the brewery and the breed. Budweiser maintains three traveling eight-horse teams, which are seen by countless crowds at some three hundred parades, shows, and fairs across the country each year, as well as in widely viewed television commercials.

Budweiser has well-defined and strict requirements for its horses. They must be tall, impressive, well-built, sound horses with great movement and an absolutely unflappable disposition. The Budweiser horses are always bay with a wide blaze, stockings to the knee and the hock, and tremendous silky feathering on the legs. To this end, the Busch family and Budweiser have their own excellent breeding program. Because the Budweiser horses are so well known, and because they produce so many horses in a breed with otherwise small numbers, the Budweiser look has significantly influenced the look of the breed in this country.

Breed Characteristics

The Clydesdale Horse Society in Scotland states that Clydesdales should look handsome, weighty, and powerful but have a gaiety of carriage and outlook, giving the impression of quality and weight rather than grossness and bulk. Movement is very important. There must be marked but not exaggerated action as seen from all angles. When viewed from behind, every foot lifts clear of the ground, showing the sole of the foot. The extensive feathering on the legs highlights the active movement. The hair should be long and silky from knee or hock to fetlock.

Conformation

Massive yet elegant, Clydesdales are quite tall, standing 16 to 18 hands, with some

*In spite of their bulk, Clydesdales move gracefully, with high-stepping action. This is a **tandem hitch** (meaning that one horse is in front of the other). This type of hitch is difficult to drive well.*

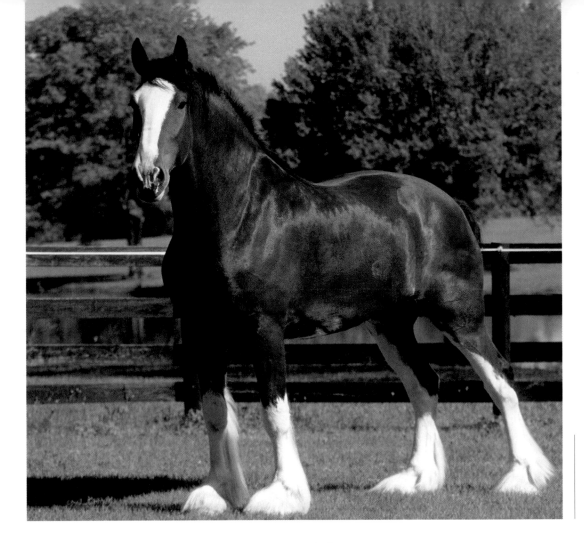

Because of the Budweiser teams, many people may believe that all Clydesdales look like this, but other colors do occur in the breed.

males reaching even greater height. They can weigh from 1,800 to as much as 2,000 pounds. A Clydesdale has a broad forehead with a flat profile, big ears, and a wide muzzle. The neck is well arched and long, springing out of oblique shoulders with high withers. The back is short and strong, and the body deep with well-sprung ribs. The quarters are long and well muscled.

Great emphasis is placed on the shape and quality of the feet. The hooves should be "open and round like a mason's mallet," says one description, and wide and springy, with no hardness. The pasterns must be long and set at a 45-degree angle from fetlock joints to hooves. The front legs must be placed well under the shoulders and straight from shoulders to fetlocks. The hind legs must be planted close together, with the points of the hocks turned inward. The thighs must come well down to the hocks, and the hind cannons must be straight from hocks to fetlocks.

Color

The usual colors are bay and brown, but roans are common and blacks do occur, as do grays and even chestnuts. White markings are characteristic of the breed, and it is unusual to see a Clydesdale without a white face and considerable white on the feet and legs. White body spots, usually on the lower part of the belly, sometimes occur.

BREED ASSOCIATION FACTS AND FIGURES

The Clydesdale Horse Society was formed in Great Britain in 1877. The American Clydesdale Association (formed in 1879) and then renamed the Clydesdale Breeders of the U.S.A.

According to this organization:

- In 2005, there are about 3500 Clydesdales in the U.S.
- About 650 new registrations are added each year, including foals and imports.

According to the Canadian Clydesdale Association (formed in 1886):

- Records are now kept by the Canadian Livestock Records Corporation, which reports slightly more than 400 horses.

North American Spotted Draft Horse

Spotted draft horses have been documented in art and mentioned in diaries and literature for hundreds of years. Draft-type spotted horses existed in medieval times — a brown-and-white draft horse served in Queen Elizabeth I's court, for example, probably as a drum horse. While they have always attracted attention, until recently these horses were individuals that happened to be born as pintos, rather than being a true breed of their own.

In the United States, interest in Spotted Draft Horses was probably sparked when an Iowa breeder collected more than twenty of them in the mid-1960s. Other owners have gathered and occasionally bred them as novelties, but it wasn't until 1995 that the North American Spotted Draft Horse Association (NASDHA) was formed to preserve and promote draft horses with pinto coloring and to increase public awareness of these rare and beautiful horses. Since then, interest in the horses has risen. At the same time, NASDHA has made concerted efforts to record, collect, and preserve the pedigrees of Spotted Draft Horses and to improve the quality of the horses. The organization is carefully laying the foundation for the development of a truly new breed.

Breed Characteristics

Spotted Draft conformation reflects the breed types of origin: for example, there is a clear Percheron/Belgian type. For the time being, horses accepted into NASDHA may be of any draft breed mixture, including Belgians, Percherons, Clydesdales, Shires, Suffolk Punch, and American Cream Draft. Of these breeds, crosses with Percherons are the most popular because the likelihood is great that the foals will be flashy black-and-white pintos.

There are four classes in the registry: Premium, Regular, Breeding Stock, and Indexed. Premium horses must be ⅞ draft blood and meet the color and height requirements. No gaited blood is allowed in pedigrees of horses in the Premium class, nor is blood from Appaloosas, ponies, donkeys, Saddlebreds, Gypsy Vanners, or Irish Tinkers.

In the Regular class, horses must be ½ to ¾ draft blood and meet the color and height requirements.

The Breeding Stock class is open to any non-colored or insufficiently colored mares or stallions produced by the combinations of horses allowed in the Premium and Regular classes, providing one of the parents was recognized by its breed as having pinto coloration and pattern.

The Indexed class allows the registration of horses of unknown pedigree. A horse must be 15 hands or taller. The owner must submit colored photographs. If the horse is accepted, it receives a permanent Index number on its registration papers. This animal may then be used in various cross-breeding plans to produce Spotted Draft Horses.

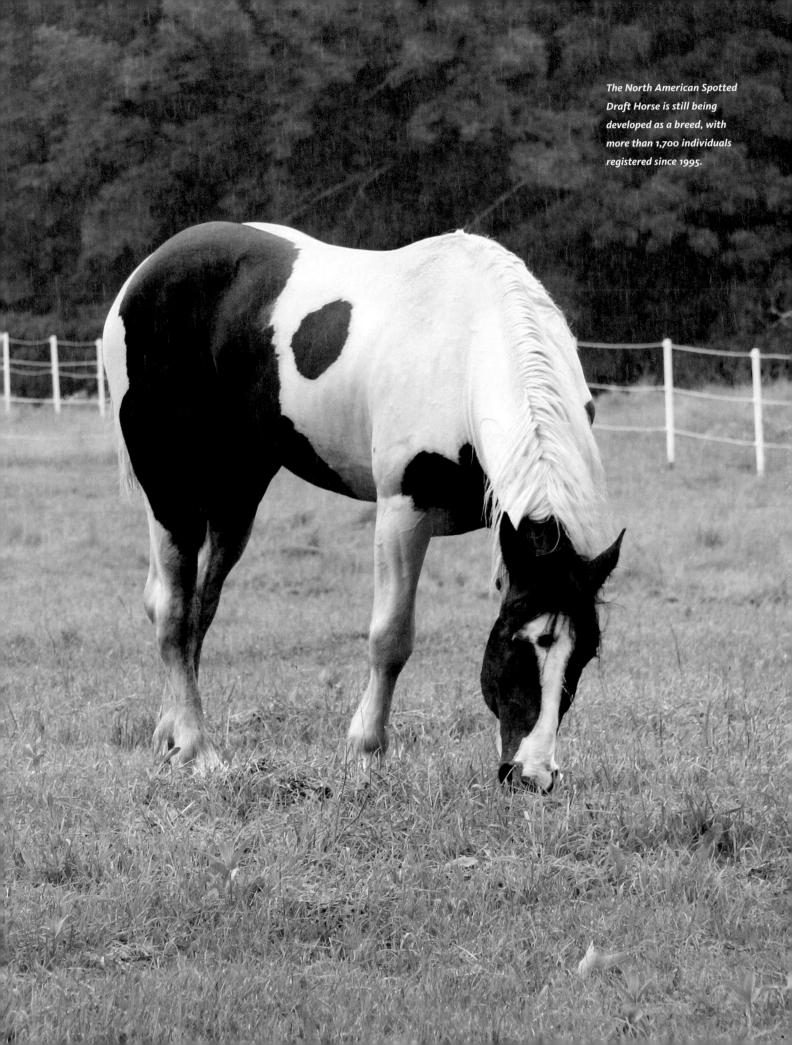

The North American Spotted Draft Horse is still being developed as a breed, with more than 1,700 individuals registered since 1995.

This photograph shows three spotted offspring of the same mare (second from left), all of different ages.

Conformation

The average height is 15 to over 17 hands; weight is 1,250 to 2,000 pounds. These horses must have a draft horse frame supported by clean, dense bone. They have short, muscled forearms and thighs, with legs placed well under them. Individuals should have an intelligent head with active ears and an arching neck with a clear-cut throatlatch. The shoulders should be upright, suitable for power rather than for action.

Depth and thickness from the withers to the legs are essential. The horses should be as deep in the flank as over the heart. The back is short and strong, with the ribs sprung high from the backbone. The hindquarters are wide apart, long, and smooth to the root of the tail. The croup is usually level.

Color

Pinto coloring is required and may include the tobiano, overo, or tovero patterns. (See Pinto chapter, page 279, for detailed descriptions.) The pigmented parts of the coat may be any solid color, but black and white, sorrel and white, and bay and white are most common in the Spotted Draft breed. Blue eyes are allowed, as are white or multicolored hooves.

BREED ASSOCIATION FACTS AND FIGURES

According to the North American Spotted Draft Horse Association (founded in 1995):

- More than 1,700 horses are registered.
- About 150 new horses are registered each year.
- As with all draft breeds, they are most common in the Midwest, but numbers are also increasing in Florida and California.

Percheron

The old French province of Le Perche lies in the district of Normandy, located about fifty miles southwest of Paris. This gently rolling area is one of the oldest horse-breeding regions in the world. Its limestone and clay substrate produces quality pastures that encourage the growth of large, strong horses with good, dense bone. The exact origin of this breed has been lost over time, although theories abound. There is some evidence that a

Percheron-type horse existed in the area during the last ice age. Possibly this horse was crossed on various types of incoming stock through the ages to produce the original Percherons. We do know that native mares of Le Perche were bred to Arab stallions first during the eighth century and later during the Middle Ages. Also during

the Middle Ages, imported Andalusian stallions were crossed on mares from Le Perche.

By the time of the Crusades, the Percheron was well known for its soundness, substance, style, and beauty and was often selected as a warhorse. By the seventeenth century, horses from Le Perche were

HEIGHT: 16–18 hands

PLACE OF ORIGIN: France

SPECIAL QUALITIES: Elegant, predominantly gray or black draft breed without feathering on the lower legs

BEST SUITED FOR: Harness and carriage

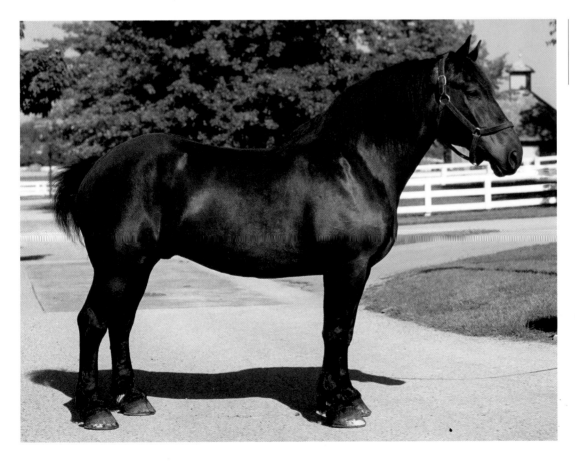

Though powerfully built, Percherons are elegant and showy, with very little feathering on the legs.

in demand for a variety of uses. Although they were large horses by the standards of the day, they probably stood between 15 and 16 hands and were not nearly as massive as today's heavy draft horses.

From Warhorse to Workhorse

In the eighteenth century, Arabians and the new English Thoroughbred stallions were imported into France and crossed on mares from Le Perche. At this time, Percherons were considerably lighter than today's Percherons and often served as coach horses as well as military and farm horses. Early in the nineteenth century, the French government established a stud at Le Pin in order to breed army mounts. Two gray Arab stallions imported in 1820 and bred extensively with Le Perche mares probably introduced the breed's predominant gray color.

By the middle of the 1800s, as the need for coach horses declined, breeders began to meet market demands by developing a large draft horse. Heavy mares from Brittany mixed with the remaining old Percheron stock produced the type of Percherons we recognize today. A horse named Jean Le Blanc, foaled in 1823, became the foundation sire for modern Percheron bloodlines.

Percherons were first imported into the United States in 1839, and thousands more followed in the last half of the nineteenth century. They quickly became the most popular breed of draft horse in the country. By 1930, there were three times as many registered Percherons as Belgians, Clydesdales, Shires, and Suffolks combined. But as mechanized agriculture arrived, all draft horse numbers plummeted. A few devoted breeders, including a number of Amish farmers who used and appreciated these horses, saved the Percheron from near extinction.

*A native of France, the Percheron has long been popular in the United States, where nearly 300,000 are registered. These horses are in a **unicorn hitch** (one in front and two behind), which is extremely hard to drive well.*

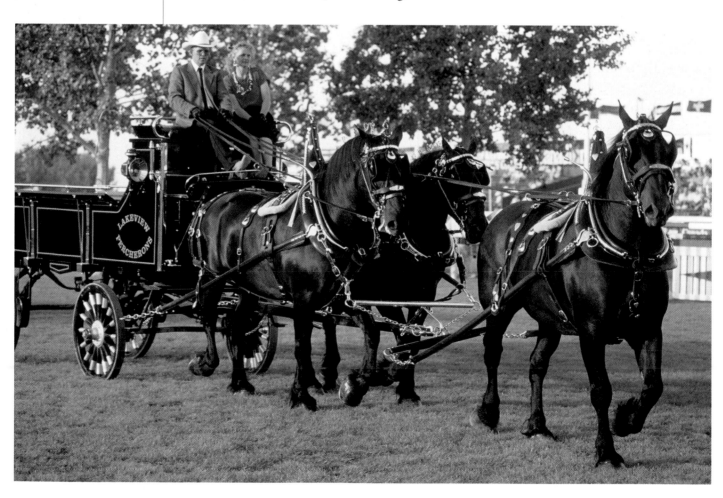

The 1960s saw a small renaissance in the draft horse business in this continent. Percherons are now used on small farms and for logging, as well as for hayrides, sleigh rides, parades, and shows. They pull carriages on city streets and are often present at special events and weddings.

Breed Characteristics

The Percheron is an elegant, heavy horse, active and showy, with free and comparatively low movement. Like most draft breeds, it is noted for its even temperament, intelligence, ease of handling, and willingness to work. The lack of feathering on the lower legs distinguishes the Percheron from other draft breeds. With its thin skin and fine coat, this breed may not be as hardy in extreme weather conditions as some other draft breeds.

Conformation

Tall horses with smooth strides are much in demand as hitch horses, and the modern Percheron often reaches 17 to 18 hands, and some individuals are even taller. Mature Percherons range in weight from about 1,600 to 2,400 pounds. Many quality horses do not reach the top height or weight but do provide the breed with a wide base for genetic variation.

The head is medium-sized, quite broad between the eyes, lean, and clean-cut. Stallions should have a bold, masculine head, while mares should have a more refined, feminine head. The chest is wide and deep, combined with a nicely curved neck and a neat throatlatch. The back is straight, broad, and strong, with a long, level croup and well-muscled quarters.

The horse should stand squarely on its front legs and have flat, well-defined knees and a good length of flat bone between the knees and the pasterns. It is important that the points of the hocks turn in slightly. At rest, the hocks should be fairly close together, and quite close together when the horse is walking or trotting. The feet are large and round, moderately deep and wide at the heel with a good frog.

Color

Blacks and grays are preferred and are most common, but bays, sorrels, and browns appear and may be registered. White markings are minimal.

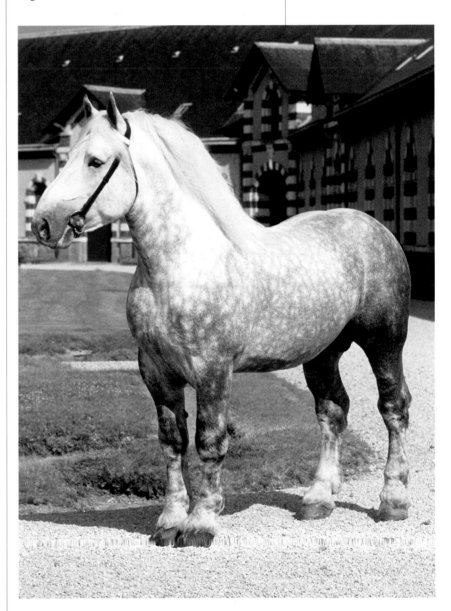

This dapple gray beauty brings to mind the horses used by bareback riders in the circus, many of which were and still are Percherons.

BREED ASSOCIATION FACTS AND FIGURES
According to the Percheron Horse Association (founded in 1876):
- The total number of horses registered is 289,000.
- Approximately 2,500 foals are registered each year.
- There are more Percherons in the United States than anywhere else, with most found in the Corn Belt states.

Shire

HEIGHT: 16.2–19 hands

PLACE OF ORIGIN: England

SPECIAL QUALITIES: Tallest of the draft breeds and heaviest after the Brabant; heavy feathering on the legs

BEST SUITED FOR: Farmwork, logging, pulling carriages or wagons

The Shire originated in the central regions, known as the Midlands, of England, particularly in the counties of Derbyshire, Leicestershire, and Staffordshire. Some think the breed can trace its history all the way back to the days of the Roman conquest. Certainly by the year 1068, people in the area were using heavy cobs as pack animals. If these early cobs cannot definitively be credited as the ancestors of the breed, most Shire historians accept that today's Shires descend in some part from the roughly 15.2-hand, heavy cob type used by the armies of King Henry II in the twelfth century. This was the era of knights in armor, and as a fully armored knight often weighed three to four hundred pounds, he required a horse of great strength and exceptionally calm temperament.

Between 1199 and 1216, records show that "a hundred stallions of large stature" were imported to England from the lowlands of Flanders, Holland, and the banks of the Elbe. The blending of these horses with the local cob mares, sometimes known as the English breed, clearly gave rise to the big, heavy draft horses produced in England in later centuries.

Another likely ancestor of the Shire is the English War Horse, or Great Horse, used for jousting and cavalry, though these large horses had few characteristics of the modern Shire. Knights probably selected any horse that was big and quiet enough to be used for their purposes, and the term English War Horse may describe what the horses did rather than a true breed.

In the sixteenth century, the dawning of the age of gunpowder quickly ended the days of knights in armor. The cavalry needed much smaller, faster horses, so the Great Horses began to work on farms and as cart horses. The total number of horses declined at this time, but farmers who realized the working worth of the horses continued to breed for size. Many historians think this is actually where the Shire as we know it began, developed from various crosses of large Flemish horses, smaller black Friesians, and the Almaine, a German draft horse useful for cart work.

The very early Shires, also known as English Cart Horses, were thick and powerful, with tufts of hair on their knees and on their upper lip. The heavy hair on the Shire's legs (**feathering**) and feet (**spats**) acquired importance and began to be selected for in the first half of the seventeenth century,

A MARK OF ROYAL FAVOR

Shires descend in some part from the heavy cob type used by the armies of King Henry II (1154–1189). He and succeeding kings made laws to increase the population of Great Horses. Edward III (1327–1377) made it illegal to sell a draft horse to a Scottish person or export one to Scotland, in order to maintain the supremacy of England's horses and to have the advantage in war. Henry VII (1485–1509) made it illegal to export a Great Horse anywhere.

Henry VIII (1509–1547) first applied the name Shire to the animal, and, to maintain adequate numbers of big strong horses for the military, prohibited in 1535 the breeding of horses under 15 hands. He also required landowners to maintain specific numbers of broodmares.

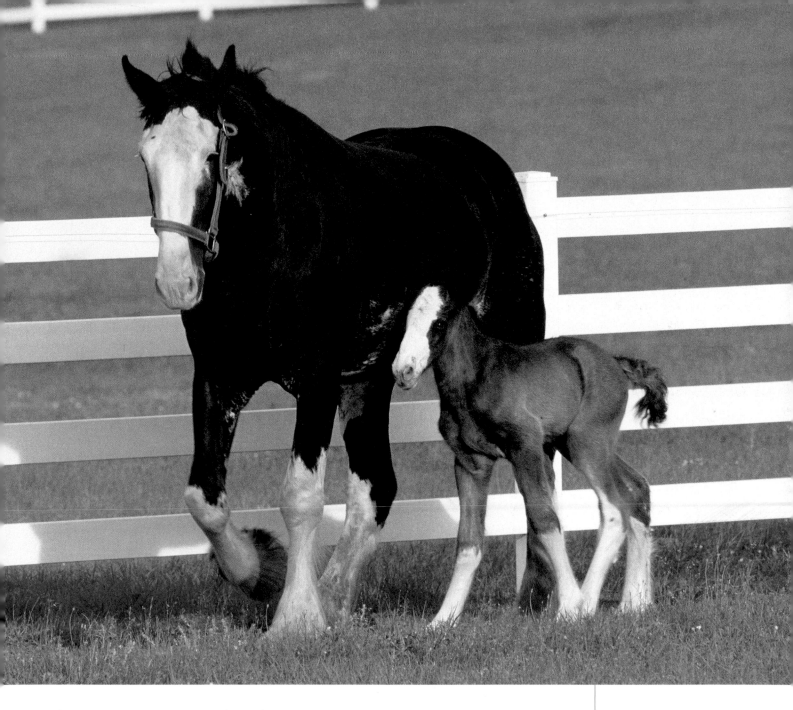

when Dutch contractors were brought to England to drain the Fens, a large marshy, swamp. The Dutch brought draft horses with them but also used many of the local Shires. The Dutch horses all had heavy leg feathering, which was essential for working in the heavy muck. The hair served to drain water off the legs, away from the skin and the pasterns, where it otherwise could have collected and harbored fungal infections. Work in the mud also required horses with huge, well-formed, wide hooves, open at the heels, traits that remain in the Shire.

Improvement in quality began in earnest with Robert Bakewell (1726–1795), the most famous livestock breeder in England at the time. He used inbreeding and linebreeding to establish the characteristics of the breed. The earliest recorded Shire stallion, known as the Packington Blind Horse, was born in 1755. Lincolnshire Lad, foaled 1865, was the greatest sire of his time, surpassed only by his son Lincolnshire Lad II, foaled 1872, who sired the great show winner Harold in 1881.

During the 1800s in England, the Shire became a working national treasure. Big Shire geldings moved countless heavy loads

The Shire is the tallest of the draft breeds, and this foal could grow to be as tall as 19 hands.

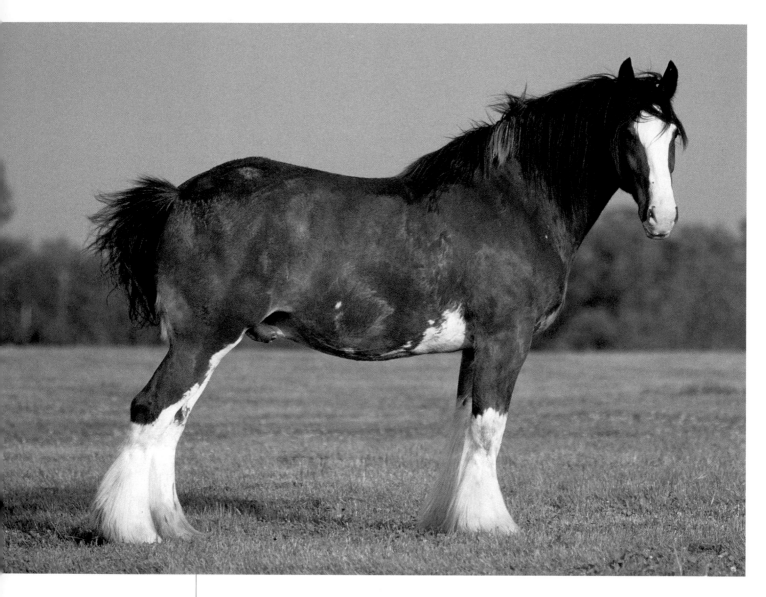

The heavy feathering characteristic of this breed was developed to protect the legs from the wet, mucky conditions of its native English countryside.

of goods from the docks along badly paved, uneven city streets. There was a great demand, decade after decade, for massive, tractable horses of great strength. The English Cart Horse Society was formed in 1878, and in 1880 the English Cart Horse studbook was established. In 1884 the organization became known as the Shire Horse Society.

Coming to America
Shires were imported to the United States from the mid-1800s. The American Shire Horse Association (ASHA) was formed in 1885, and the Canadian Shire Association (CSHA) was formed in 1888. Between 1900 and 1918, almost four thousand Shires were

imported to the United States. As mechanization came to farms, numbers of Shires and other draft horses quickly declined. However, over the past several decades, draft horses have enjoyed a comeback, and the Shire has been rediscovered. In the United States today, the Shire, while not numerous, is often considered the Rolls Royce of draft horses. They are used for farmwork, logging, pulling wedding carriages, and showing. Because of their size, beauty, and excellent movement, they are often crossed on Thoroughbreds or other light horse breeds to produce hunters and jumpers. In Canada, Shires have an active following of fanciers. Shires are seen at all the largest shows and fairs.

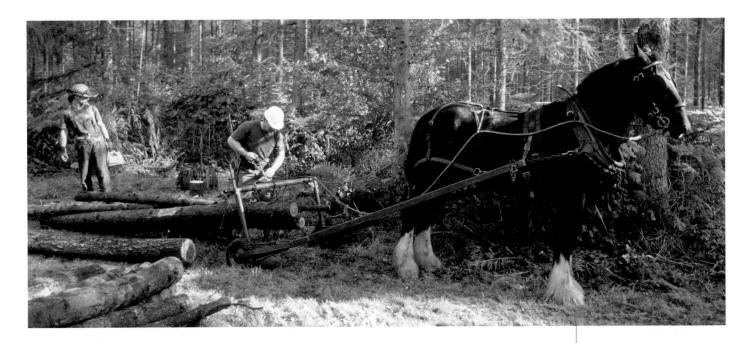

Breed Characteristics

Shires, the tallest of the modern draft breeds, are known for their enormous strength. In England in 1924, a single Shire named Vulcan, in a weight class of 1,708 to 2,100 pounds, registered a pull equal to 29 tons measured on a dynamometer. A pair of Shires, hooked one in front of the other, easily pulled a starting load equal to 50 tons, which was as much as the dynamometer could measure. According to witnesses, the front horse of this pair started the load by himself, and the second horse hit the collar and began to pull only after the load was moving.

Conformation

Shires range from 16.2 to 19 hands, averaging about 17.1, and weigh 1,500 to 2,200 pounds. The head is long and lean, with a broad forehead and a slightly Roman nose. The eyes are large, prominent, and docile, the ears sharp and sensitive. The long neck is slightly arched, muscular, and upright, and its deep sloping shoulders give the horse a commanding appearance. The chest is broad and muscular. The girth is deep and in proportion to the rest of the body. The back is short, strong, and muscular, with a sloping croup.

Strong front legs with broad joints are set well beneath the body. The long and sweeping quarters are wide, muscular, and well let down. The hocks are clean, broad, deep, and wide, set at the correct angle for leverage. The cannons are relatively short. The legs are well feathered with fine silky hair below the knees and the hocks. The feet are large and soundly made, moderately deep and wide at the heels.

Color

Accepted colors are black, brown, bay, gray, and chestnut. Although many horses have blazes and socks or stockings, excessive white markings and roaning are undesirable.

Shires are still used in North America and in Great Britain for farmwork, logging, and as impressive carriage horses.

BREED ASSOCIATION FACTS AND FIGURES

According to the American Shire Horse Association (formed in 1885):

- The Canadian Shire Association (CSHA) was formed in 1888. It ceased operation in 1941 when numbers fell to near zero, but re-formed in 1989 as the breed began to reappear in Canada.
- There are about 3,000 Shires in England, 1,000 in the United States, and 140 in Canada.
- The American association registers between 175 and 200 new horses a year; the Canadian association adds 20 to 30.
- Shires are found throughout North America, but heaviest concentrations are in the West and Midwest.

Suffolk Punch

HEIGHT: 16.1–17 hands

PLACE OF ORIGIN: Suffolk, England

SPECIAL QUALITIES: Extremely rare. In England fewer than 100 horses. World population of fewer than 3,500

BEST SUITED FOR: Farming and logging

The Suffolk Punch is perhaps the oldest draft breed in England. It originated on the farms of East Anglia, a peninsula surrounded by the North Sea on the east, south, and north and by the Fens — large swampy marshes — to the west. Because of the geographical isolation, local horses were hardly influenced by outside breeds. The farmers of Suffolk independently developed several unique breeds of livestock, including the famous Suffolk sheep, all ideally suited to their particular way of life.

Camden's Britannia dates the Suffolk Horse from 1506, but the breed was likely present and well defined before it was ever described in print, and it has changed very little since then. Some historians think the Vikings brought the ancient Jutland horse, which resembles the present-day Suffolk Punch, when they invaded in the eighth and ninth centuries. When Dutch engineers came to England during the sixteenth and seventeenth centuries to clear forests and drain the Fens, their Flemish horses may have influenced the Suffolk's weight and size, but few of its other traits.

The Dutch and English horses used to clear the swamps and marshes had huge, wide feet and heavy feathering from the knees and hocks down, which allowed water to drain off the horses' legs. By contrast, the Suffolks, who worked heavy clay soils that were dense but not swampy, were bred without feathering on the legs so that dirt could be easily brushed off. Their feet were proportionately smaller than the big draft horses', well suited to working on soft ground, and better able to avoid stepping on young plants.

Because they had few outside markets, the farmers of Suffolk traditionally used the animals they produced on their own farms and exported very few. The breed remained relatively unknown, staying pure and unchanged for centuries. In 1768, the foundation sire of the modern breed was born, a horse known as Thomas Crispin's horse of Ufford, or Crispin's horse. All Suffolks can trace their lineage back to this stallion.

When Suffolks were first exported to the United States in the late nineteenth century, they were well received by American farmers, but their total numbers here have never been high. As with other draft horses, when mechanization came to farms in both England and North America, the breed almost vanished. During the worst times, some farms in England sold forty horses in a single day, most going to slaughter. At its lowest point, in 1966, only nine Suffolk foals were born in all of England.

During the resurgence of interest in draft horses in the late 1970s and '80s, fanciers in the United States imported

WHAT'S IN A NAME?

The use of the word *Punch* in the name of the breed was first recorded in a sporting magazine in 1813. Interestingly, the word comes from the famous Punch-and-Judy puppet shows. Punch was a short, squat, chubby fellow, and his name came to describe any short, fat man or anything short and thick. One of the characteristics of this sturdy breed is relatively short legs, so horses of this type came to be called "punches."

some of the best remaining Suffolk Horses from England. There has been a substantial increase in the number of registered Suffolks since the 1990s, but the breed remains rare. In England, breed numbers hover between 150 and 200, with only about 75 breeding-age mares.

Breed Characteristics

The overall appearance of the Suffolk is of a pleasant, roundly molded whole unlike any other breed. During the worst times, some farms in England sold forty horses in a single day, most going to slaughter. Suffolks are prized as very easy keepers that are exceptionally long-lived. They can work well into their late twenties and more commonly produce foals into their twenties and sometimes beyond. At the first Agricultural Association show held in England, a mare reported to be thirty-seven at the time was shown with a filly by her side that was said to be her own.

Suffolks tolerate heat well. Because of this, the Pakistani government has purchased a number of them to cross in to their local breeds, planning to add substance to army horses and to produce large mules.

The sturdy Suffolk Punch, with its bright chestnut coloring and short lower legs, has changed very little over several centuries.

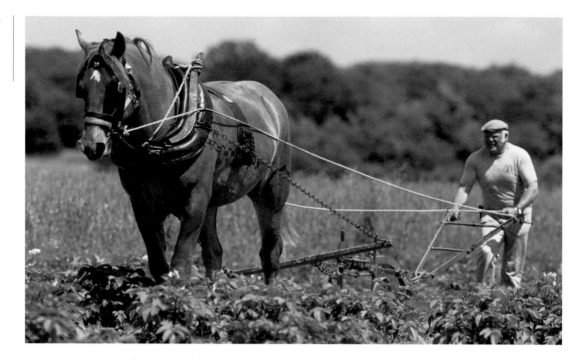

The Suffolk remains an ideal breed for horse-powered farms, especially for those involved with sustainable agriculture. They are also excellent for logging operations.

Conformation

The average height is 16.1 hands, but many stallions stand 17 hands or taller. Typical weight is 1,500 to 2,000 pounds. The Suffolk is large, symmetrical, and uniform in color and type. The intelligent head is set on a powerful arching neck. The shoulders are inclined to be upright, more suitable for power than action. Depth and thickness from the withers to the legs are essential. A Suffolk should be as deep in the flank as it is over the heart. The back is short and strong, with the ribs springing high from the backbone.

The quarters are long and smooth to the root of the tail, which springs higher up than in other draft breeds. The croup is usually level. The legs are set closer together on the Suffolk than on other draft breeds and placed well under the body, allowing them to move easily between rows of crops without destroying the plants. The legs are free of long hair and appear proportionately short, with strongly muscled forearms and thighs. The excellent feet are round and of fair size, and wear extremely well.

Color

Suffolks are always chestnut, although the word is often spelled without the first *t* — chesnut — as it was in old England. Seven shades are recognized: dark liver (approaching brown-black, also called mahogany), dull dark chesnut, light mealy chesnut, red, golden, lemon, and bright chesnut. A small star, snip, or strip is permitted, as is a little white on the legs, no higher than the fetlocks. No other white is allowed.

> **BREED ASSOCIATION FACTS AND FIGURES**
> According to the American Suffolk Horse Association (founded in 1890):
> - There are between 1,000 and 1,500 Suffolks in North America, with perhaps another 1,300 to 1,800 animals worldwide. This number is approximate because some horses, usually geldings, are sold without papers, some are never registered, and some die without the association being notified.
> - There are some 150 Suffolks in England, but only about 75 of these are breeding-age mares.
> - One hundred new registrations are added each year. Most are foals, but this number includes some new registrations of adult horses.

Donkeys

Donkeys are asses, which means they belong to the horse family but are a different species from horses. As an evolutionary group, asses are older than horses. The prevailing zoological opinion, now confirmed by genetic research, is that the immediate ancestor of the domestic donkey was an ass from North Africa known as the Nubian Wild Ass. Donkeys are common throughout North and Central Africa, in all countries

surrounding the Mediterranean, and throughout southern Asia and India. China has more than eleven million donkeys.

Historians believe that donkeys were domesticated between 5,000 and 6,000 years ago in Nubia (Sudan). Animals were probably among the earliest commodities that moved from Nubia to Egypt, and domestic donkeys were likely to have been in this group. The earliest-known remains date from the fourth millennium BCE in lower Egypt, where donkeys worked as pack animals before the first pyramids were built. By the third millennium BCE, wealthy Egyptians kept huge herds of donkeys as beasts of burden and as riding animals.

HEIGHT: Ranges from miniature (36" and under) to mammoth and Poitou (15–16 hands)

PLACE OF ORIGIN: Nubia (Sudan), North Africa

SPECIAL QUALITIES: Long ears and narrow but deep body frame to aid in heat dissipation; sure-footed, very strong for size; generally placid

BEST SUITED FOR: Packing and pulling, companionship, and guarding

Their intelligence, agility, and hardiness have made donkeys an important part of human history. They are still used in many parts of the world as pack, driving, and draft animals.

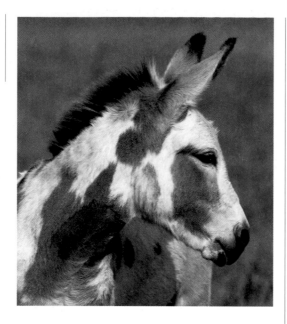

Before 3400 BCE, Libyan tribes possessed large herds of asses, and asses were also used as beasts of burden in Mesopotamia (Iraq). At Ur, in Mesopotamia, asses were honored animals favored by kings and queens. Various invaders are said to have taken donkeys to Europe in the second millennium BCE. The Greeks used them in the cultivation of grapes for wine, where their slender build allowed them to negotiate the rows without stepping on the plants. The Roman army took donkeys to northern Europe to use as farm and pack animals. The Romans also harnessed them four abreast to pull wagons. Donkeys first came to England when the Romans invaded Britain, in 43 CE.

Asses are best designed for carrying or pulling heavy loads. They have long been used as riding animals, but when ridden as we do horses, they are narrow and uncomfortable to sit. The rider's legs drag on the smaller ones, and too much of the rider's

BATHING BEAUTIES

Bathing in milk is an ancient beauty ritual. Cleopatra was famous for her lovely skin, and one of her secrets supposedly was frequent baths in ass milk. Decades later, the wife of Roman Emperor Domitius Nero is alleged to have always traveled with five hundred nursing asses so she could take milk baths.

weight is concentrated in a small area of the animal's back. For these reasons people often sit over the hind legs. When loading a heavy pack, careful owners distribute the weight across the length of the back from the withers to the rump. Asses are very strong and considerably more sure-footed on steep mountain trails than are horses. At times they have been kept as dairy animals. In ancient Syria, there were at least four classes of asses: a light and graceful variety reserved for ladies, a slightly heavier type used for general riding, an even heavier and less graceful variety used for farm- and draft work, and the famous exceptionally long-eared Damascus ass. To this day, asses perform most of the packing and draft work from Egypt across the Middle East and on into the Far East.

Donkeys in the New World

By the fifteenth century, the Spanish well appreciated the usefulness of donkeys, including their value in mule breeding. In 1495, four jacks (males) and two jennies (females) were shipped to Hispaniola among the first loads of horses because the Spanish considered them to be economically essential. Donkeys were a vital key to the success of their conquering and colonization efforts. They were used to do work and to breed mules. Paralleling the introduction, migration, and development of horses, asses spread to Mexico and later the western part of North America. Each Spanish mission along the frontier bred its own supply of mules.

As with horses, feral donkeys became well established as numbers of donkeys were either stolen by Native Americans or escaped from the early missions between the middle of the sixteenth century through the seventeenth century. By the first half of the nineteenth century, they were so common in some areas that they were regarded as pests and were largely exterminated, but they managed to survive in remote areas of the West. Some may still be found in the

Grand Canyon, among other places. The Bureau of Land Management has managed feral donkeys on public lands for more than three decades. When the population puts too much pressure on a given area, they are gathered and put up for adoption, as are Mustangs. Unfortunately, recent changes in federal protection of these animals means they will now be held for adoption for shorter periods of time and that more animals will be sold for slaughter.

Today, donkeys are enjoying a resurgence of popularity in North America. They are used in harness and as pack animals, and many people keep them just as pets. Donkey shows are well attended. Because of their calm disposition and tremendous neck strength, jennies are sometimes used to halter-break calves and even weanling horses. Donkeys also make fine guard animals, particularly to protect flocks of sheep from dogs and coyotes.

Different Kinds of Donkeys

In parts of the world where asses are commonly used, there are distinct breeds, but in North America, with the possible exception of the French Poitou and one or two others, those breeds remain obscure. Furthermore, importers usually kept poor records of asses, making it difficult to know much about the breeds of origin. For these reasons, the American Donkey and Mule Society organized animals by size rather than by breed or country of origin. The society recognizes the following groups:

The Miniature Donkey must stand less than 36 inches at the withers at adulthood. It is also called the Miniature Mediterranean. Although the term "Sicilian donkey" is often heard, it is factually incorrect. The original animals were imported not only from Sicily but also from Sardinia and other Mediterranean areas.

The Standard Donkey measures 36.01 to 48 inches. Donkeys of this size are often called burros, particularly west of the Mississippi.

The Large Standard Donkey stands 48.01 to 54 inches for females and up to 56 inches for males. The traditional name for these in the western United States was the Spanish Donkey.

The Mammoth, Mammoth Jackstock, or **Mammoth Ass** is 54 inches and up for females; 56 inches and up for males.

The Spotted Ass refers to those animals registered with the American Council of Spotted Asses (ACOSA), which is establishing foundation stock for a breed of Spotted Asses. Though asses of all types can be spotted, this is a trademark term for registered individuals. The terms *paint* and *pinto* are not used in reference to asses.

Donkey Characteristics

The scientific name of the domestic donkey is *Equus asinus.* Although they belong to the horse family, they are a different species. Donkeys have 62 chromosomes; while horses have 64. The donkey's gestation period is 370 days, or twelve months, compared with the horse's gestation period of 337 days, or eleven months.

The donkey's voice differs entirely from the horse's voice. Donkeys make an assortment of vocalizations, ranging from a sort

of soft humming or hooting to a sound like a rusty door hinge, all the way to the full bray, which can be startlingly loud and carries for a long distance. The voice and calls probably evolved as valuable adaptations for wild asses living in mountainous deserts, enabling individuals to locate and recognize each other when rocks prevent visual contact.

Donkeys are notoriously careful and keenly observant of their surroundings. They are well known for making their own decisions about where it is safe to walk; they cannot be forced. Anecdotes from around the world recount tales of donkeys refusing to cross bridges that later collapse. This highly developed self-preservation behavior has earned donkeys the reputation of being stubborn.

In the wild, social groups of asses are much smaller than horse herds. Donkeys form strong social bonds with their companions and can be difficult to separate from herd mates. There are more than a few stories of donkeys removed from a group who then find their way home over a long distance. The following tale is recounted in *The History and Romance of the Horse:*

"In March 1816, an ass belonging to Captain Dundas, R.N., then at Malta, was shipped on board the Ister frigate *Captain Forest* bound from Gibraltar for that island. The vessel struck on some sands off the Point de Gat, and the ass was thrown overboard, in the hope that it might possibly be able to swim to land; of which there seemed but little chance, for the sea was running so high that a boat which left the ship was lost. A few days after, when the gates of Gibraltar were open in the morning, the guards were surprised by Valiant, as the ass was called, presenting himself for admittance. On entering, he proceeded immediately to the stable of Mr. Weeks, a merchant, which he had formerly occupied. The poor animal had not only swum safely to shore, but without guide, compass or traveling map, had found his way from Point de Gat to Gibraltar, a distance of more than two hundred miles, through a mountainous and intricate country, intersected by streams, which he had never traversed before, and in so short a period that he could have made not one false turn."

Donkeys form intense bonds with herd mates. They make wonderful companions and guardians for horses, sheep, and other herd animals.

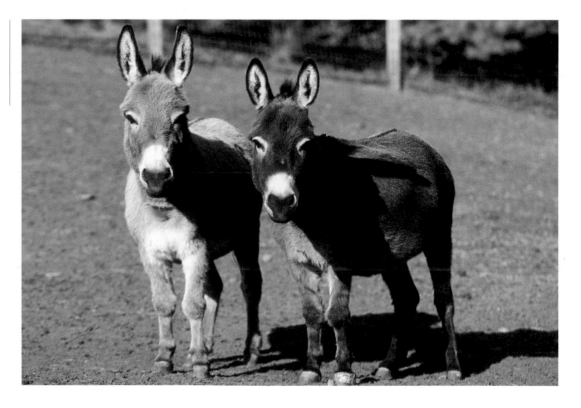

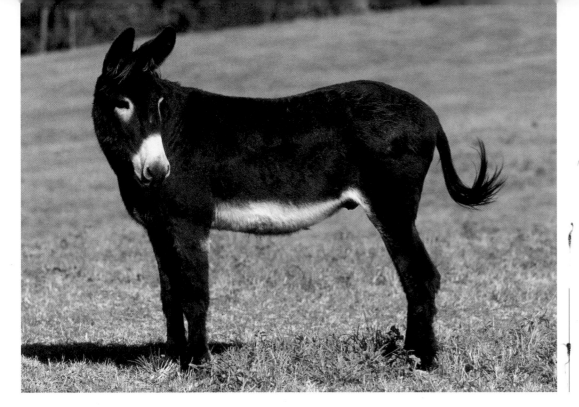

This male donkey would be called a stallion in Great Britain, but the correct term in North America is jack. Females are called jennets or, more commonly, jennies.

Conformation

A donkey's head is quite long, with proportionately large eyes and very long ears, usually marked at the base and the tip with large dark patches in lighter-colored animals. The neck is short, straight, and fairly upright, the withers almost flat. The mane is sparse and upright and without a forelock. The tail is almost cowlike, not much more than a short whisk broom with long tail hairs only at the tip. Most donkeys have small, high, narrow feet that don't need shoes. There are no chestnuts on the hind legs.

Donkeys usually have only five lumbar vertebrae, whereas in horses, six is more common. The donkey's body is much more angular, particularly over the hips, than that of a horse, and the body proportions differ. Donkeys are flat-sided (**slab-sided**), and they have a narrow chest.

Color

Until fairly recently, the color of domestic donkeys was mostly limited to black, shades of gray, and white. Many donkeys have a light or white muzzle, eye rings, and light hair on the belly and inner legs. Narrow dorsal stripes and crossing shoulder stripes are common, as are leg bars.

Spotted coloring is not unusual, although Appaloosa-like spotting does not occur.

Historically, brown was a relatively uncommon color, and bay, chestnut, and red or blue roan were virtually unknown. In recent years, however, fanciers have been selecting for exotic colors such as chocolate, a variety of reds, frost, and even a soft pink. But because donkeys differ genetically from horses, some common horse colors, such as palomino and buckskin, still do not occur. A few colors or patterns, such as "reverse dappling," with dark dappled spots on a light background, are unique to donkeys. Until recently, donkeys rarely had blazes, snips, or strips on the face or socks or stockings on the legs, but breeders, especially of miniature donkeys, now select for these markings as well.

BREED ASSOCIATION FACTS AND FIGURES

According to the American Donkey and Mule Society (ADMS) (founded in 1967):

- It is difficult to count the number of donkeys in North America because so many are not registered
- There are estimated to be about 250,000 donkeys and mules in the United States.
- Of those, about 37,750 are miniatures.
- Donkeys and mules are collectively called "longears" by fanciers.

Mules and Hinnies

HEIGHT: Any size from Miniatures, 36" (9 hands) to draft, 17 hands or more

PLACE OF ORIGIN: The Middle East

SPECIAL QUALITIES: Extreme strength, tremendous ability to tolerate work, intelligence, heat tolerance, sure footedness, good night vision, strong sense of self preservation.

BEST SUITED FOR: Any purpose for which horses may be used including all farmwork, driving, pulling, riding, packing, and racing

A mule is the hybrid offspring of a male ass (**jack**) and a female horse (**mare**). If a female donkey (**jenny**) is crossed on a stallion, the foal is called a **hinny.** Because mules and hinnies result from crosses between animals of different species with different numbers of chromosomes (donkeys, sixty two; horses, sixty four), and because the chromosomes do not match in shape, mules and hinnies are virtually always infertile. According to

Dr. David P. Willoughby in the *Empire of Equus,* a female mule, or molly, has a one in 200,000 chance of being fertile. Males, known as johns, are always infertile. However, johns must be gelded or they become difficult and dangerous to handle.

Mules have a very long and noble history. Humans were breeding them at least 3,000 years ago and probably much earlier. One of the first written records of equines being ridden is a letter from the Mari (Syrian) king Zimri-Lin (1782–1759 BCE) to his son, in which he advises him not to ride horses but to ride mules because he is a person of noble birth. The Hittites, who first appeared in Anatolia (Turkey) in about 2000 BCE and were a major power by about 1500 BCE, bred and sold mules. Their records tell us that a mule was valued at sixty sheep, while horses and oxen were

valued at only twenty sheep. Israelites were prohibited from breeding their own mules and had to import them from Armenia and other Near East sources. Prior to 1000 BCE mules were widely used in the Near and Middle East, where they replaced the donkey as the favorite royal beast.

In Greece, mules were used as draft animals and also for chariot racing in the Olympics, beginning about 500 BCE. Sixty-four grandly turned-out mules pulled Alexander the Great's funeral cortege (323 BCE). Marco Polo (1254–1324 CE) praised the Turkoman mules he saw in central Asia. By the tenth century, European clergy rode mules, and in the fourteenth century, European abbots put golden bridles on their mules. Even the pope in Avignon rode a mule. Mules became so popular as riding animals in Spain that King Ferdinand (1452–1516), fearing Spain's vitally important horse production and sales would suffer, declared it illegal for able-bodied men to ride them.

By the 1700s, mule breeding was a major industry in Spain, Italy, and France. The French province of Poitou produced some 50,000 mules annually, including a light type and a heavy type. The giant Poitou mules were extremely famous and sought after as draft animals all over the world. In order to produce these mules,

MULE OR HINNY: WHAT'S THE DIFFERENCE?

Research from Cornell University indicates that the answer is "not much." Some people have believed that the tail of a hinny is more like a horse's while the tail of a mule is more ass-like. Neither is true; in fact, there are no discernible differences between mules and hinnies. Hinnies are usually smaller than mules with comparably sized parents because, in the horse family, the size of the mare's uterus is an important factor in determining the size of the foal, and donkeys are smaller than horses. It would be wise to check any hinny facts you hear because many are actually folklore.

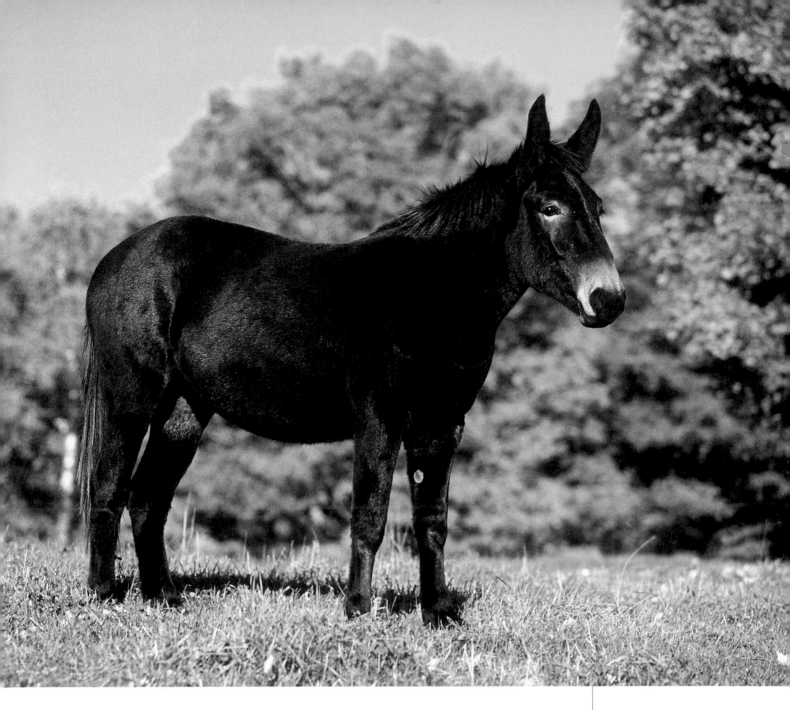

the French crossed their unique, very large, long-haired, heavily muscled, big-footed Poitou donkeys on selected draft-type mares known as *mulassiers,* or "mule makers."

Mules Come to the New World

In Central America, Mexico, and North America, donkeys were imported for pack and draft use and for mule breeding. They were sent with the first loads of horses shipped from Spain. In sixteenth-century Honduras, raising mules was one of the greatest sources of wealth. Nicaragua became even more famous, with more than 1,500 pack mules leaving the city of Nobre de Dios each day, crossing the Isthmus of Panama to take supplies to the Spanish settlements and to pack out gold and silver.

Every Spanish mission along the western frontier produced its own mules. They were essential working animals at Spanish settlements in Florida and New Mexico before 1625. The Indians in those areas learned mule-breeding techniques from the Spanish, and some of them dealt mules they had bred or stolen along with horses as they traveled north.

The mule combines qualities of both the horse and the donkey, making it a versatile, hardy, intelligent animal.

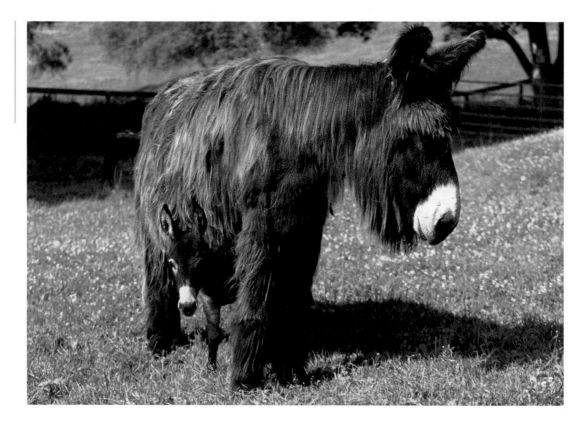

This giant long-haired Poitou donkey represents a French breed that was famous for producing excellent draft mules in the eighteenth and nineteenth centuries. Today the Poitou is quite rare.

One of the most famous mule breeders in the early United States was George Washington, who was very interested in advances in agriculture. He acquired a jack as a gift from the king of Spain and a Maltese jack from the Marquis de Lafayette. Washington stood both these animals at stud in 1788 and began promoting mules as working farm animals. The early production of mules in this country coincided with the invention of the cotton gin in 1793. Mules were ideally suited for the work associated with cotton production, and their numbers boomed as vast acreage was put into cotton.

In 1827, Henry Clay imported high-quality jacks and began breeding and furthering the use of mules. The census of 1850–1860 shows that mule production in that period increased faster than any other farm stock, with the total number of mules more than doubling. The mule population continued to multiply until 1925, when it peaked at 5,918,000 animals.

For nearly two hundred years, mule power hauled, hoisted, pulled, and packed this country into existence. Mules powered cotton gins and hauled Conestoga wagons, mail and passenger coaches, military equipment of all kinds, coal carts, and canal boats. Because mules are more heat tolerant than horses, they were widely used in the South for fieldwork and for crushing sugarcane. The still-famous twenty-mule teams pulled wagons loaded with more than thirty-six tons of borax through the desert

FASCINATING MULE FACTS

- In 1865, General Sherman instituted an act giving all freed slaves forty acres and an army mule, in an effort to promote self-sufficiency. Three months later President Andrew Johnson rescinded this act.
- Mules served in every American war up to the Korean. In a number of locations in World War II they were invaluable because they could travel where mechanized equipment literally could not make the grade. In Burma they were known as jungle jeeps.
- A team of plow mules pulled the funeral wagon of Martin Luther King Jr.
- The first cloned equine in history, foaled May 4, 2003, was a mule, Idaho Gem. This animal was related on both sides of its pedigree to the two top racing mules in North America.

of Death Valley, which sometimes reaches temperatures of 130 degrees F. The borax was loaded on the valley floor at an elevation of 190 feet below sea level and pulled uphill, over a rudimentary roadbed, through rock and sand to an elevation of 2,000 feet. The trip took twenty days. In the six years of their existence, five twenty-mule teams hauled more than twenty million tons of ore. To the credit of their drivers, no mule was ever lost or seriously injured and no wagon ever broke down, although within the two-man teams of driver and assistant, there were several murders.

Modern Mules

In addition to their prowess as plow and pack animals, mules have earned the respect of riders in a huge variety of disciplines. Coon hunters prefer mules because they are sure-footed and see well at night. Tourists are carried down the Grand Canyon on mules because they are strong, sure-footed, and careful. Cowboys use them on ranches to cut and rope cattle. In California and several western states, mule racing has become such a big sport that there is now pari-mutuel wagering on mules at some tracks.

When allowed by horse show rules, mules have competed and won against horses in jumping, dressage, three-day eventing, and reining. In a number of sports the rules were changed to ban mules after very expensive horses were beaten by long-eared creatures that brayed.

Shows just for mules take place all over the country and attract many participants. One crowd-pleasing event is jumping, also known as coon jumping, a sport that grew from the way coon hunters, who hunt at night, cross fences with their mules. The rider dismounts, stands next to the fence, and asks the mule to jump over, which it does from a standstill. Sometimes, especially if the fence is barbed wire, a blanket is thrown over the spot where the mule is to jump. The hunter climbs over the fence after the mule and safely remounts. In the show version, the jumps are wooden, the mules may be saddled or unsaddled, and the contest is for height. Mules are terrifically strong and their jumping style is unique. They rock back on their hocks and elevate the front half of the body, sometimes holding this position for a brief period before they spring over the fence. They can clear remarkable heights. A 13.2-hand (54-inch) mule named Carrie cleared a 6½-foot (78-inch) fence in this manner. The American Mule and Donkey Society says good jumping mules can jump 6 inches higher than the tips of their own ears.

In the past, mules were classified by the type of work they did. Some or all of these classifications can still be found, in older books about mules.

- Pit Mules used for underground mining were small, usually weighing between 600 and 900 pounds.
- Mining mules for surface work, and mules used in cotton and tobacco fields, were of medium size, usually 750 to 1,150 pounds.
- Farm mules varied in size. This group comprised any mule of any type that worked on a farm.

Mules can do anything horses can do, and have been used as draft and pack animals, for hunting and jumping, under saddle and in harness, and even for dressage.

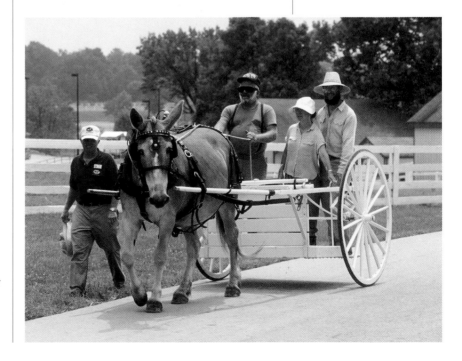

- Sugar mules, used on cane plantations, were inclined to be heavier and more compact than the lighter types. They usually stood 14.2 to 15.2 hands and weighed between 1,150 and 1,300 pounds.
- Draft mules stood 16 to 17.2 hands, with an average weight of 1,200 to 1,600 pounds.

Mules are often described by the name of the dam's breed; for example, a Quarter Horse mule results from crossing a jack on a Quarter Horse mare. Certain types are bred for specific reasons. Tennessee Walking and Missouri Fox Trotting mules are very popular for trail riding. Belgian mules are sought after, not only for their strength and size, but also because they tend to be a soft sorrel color that many admire. Thoroughbred mules are sometimes used for racing and even for foxhunting.

As mechanization came to farms and rural populations moved to the cities, mules became unfamiliar in North America, and somehow these fine animals, long favored by kings and farmers alike, became creatures of ridicule. They deserve better. Those who regard them just as peculiar beasts with long ears and a funny voice miss the point of these historically significant, hardworking animals. Mules aren't horses, but for good reasons they have earned respect for many centuries.

Mule Characteristics

Mules are astonishingly strong, have tremendous endurance, and are extremely long-lived and hardy. They are easy keepers, highly intelligent, affectionate with trusted owners, resistant to some horse diseases, and seem to remember everything.

Conformation

As is to be expected, a mule looks like a cross between a horse and a donkey. Its ears are longer than a horse's but shorter than a donkey's. A mule's conformation combines traits from both parents. The voice and call of a mule are also about midway between the parental species, part whinny and part bray. For shows and sales, mules today are

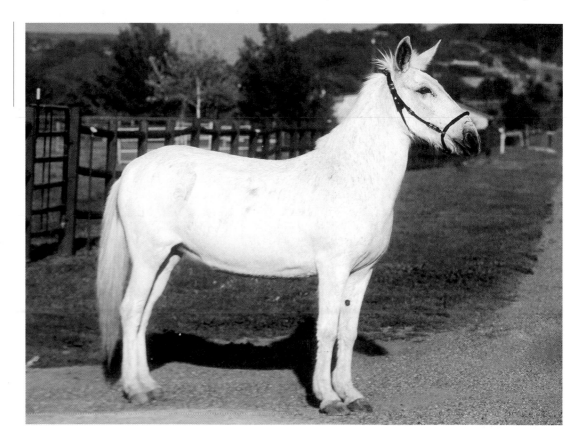

Mules are usually a solid color, but can have Appaloosa or pinto markings. Palomino coloring is not found in mules. A few have white stockings.

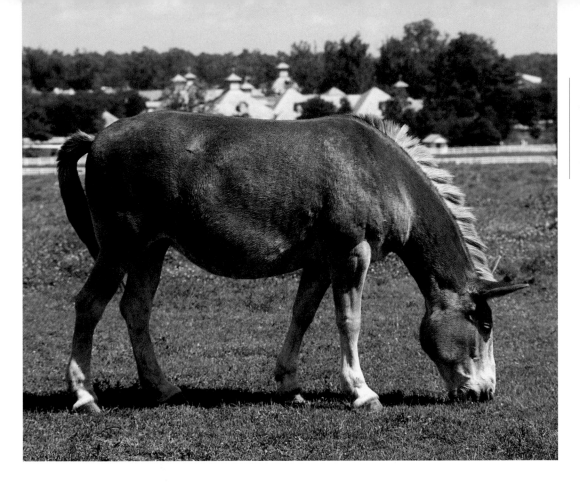

Mules come in a variety of sizes, from miniatures that stand under 48" to giant draft mules that stand 60" or over. This big fellow looks as though his dam was probably a Belgian.

classified by appearance, size, and use.

- Miniature mules, sometimes called pony mules, stand from 40 to 48 inches at the withers.
- Saddle mules usually stand 54 inches and up and are of a good saddle type, meaning they are not overly angular like donkeys but are round-barreled enough to carry a saddle and rider well and comfortably.
- Pack mules tend to be sturdy and short-legged. There is no height limit, but packers prefer shorter mules because they are easier to load. They usually weigh about 1,000 pounds.
- Work mules are the modern version of the old farm mule classification and include mules used for pulling equipment and wagons. This group usually ranges from 900 to 1,300 pounds.
- Draft mules stand 60 inches and up and weigh from 1,200 to 1,600 pounds or more.

In addition to the height and weight requirements, show classes have separate conformation standards for each type of mule.

Color

Most mules are a solid color, often black, red, or gray, with minimal facial and lower leg markings. Some horse colors, notably palomino, do not occur in mules. But because they are half horse, mules may have some horselike color patterns that are not seen in donkeys. There are many flashy Appaloosa-colored mules, and some loud overo pintos as well as tobianos. The genetics of the tobiano pattern occasionally produces mules that are a solid body color but have white stockings.

BREED ASSOCIATION FACTS AND FIGURES

According to the American Donkey and Mule Association (ADMS) (founded in 1967):

- It is difficult to count the number of mules in North America because so many are not registered and because both donkey and mule owners belong to the ADMS.
- There are about 250,000 donkeys and mules in the United States.
- Donkeys and mules are collectively called "longears" by fanciers.

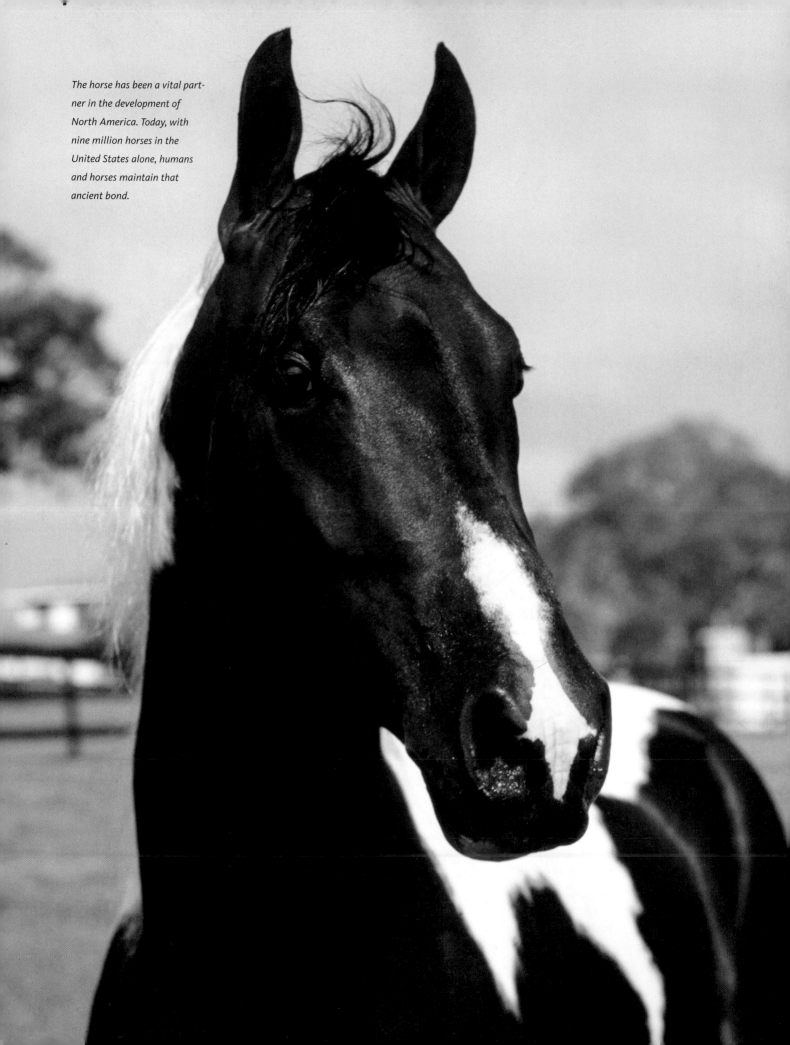

The horse has been a vital part-
ner in the development of
North America. Today, with
nine million horses in the
United States alone, humans
and horses maintain that
ancient bond.

Appendix

100,000 BCE Fossils indicate a pony much like the Exmoor was present in Britain.

15,000 BCE Cave paintings of horses in Spain; possibly suggesting halters in use.

8000 BCE Earliest horses may have reached what later became the Shetland Islands via existing land connecting the Shetlands with Scandinavia.

6500–3000 BCE Swampy plain connecting England to Europe becomes the English Channel.

5000 BCE Time by which most historians suggest the horse was domesticated.

3370–2690 BCE Battle-Axe people in Britain, first there to use domesticated horses.

3000 BCE Caspian-like horses are depicted in Persian literature and art.

2500 BCE Horses are introduced to Asia Minor.

2000 BCE Earliest evidence of domestication of Fjord-type horses in Norway.

1800 BCE Goths settle on Gotland; wild ponies already present.

1400 BCE Appaloosa-like color patterns appear on horses depicted in Greek and Egyptian art.

1000 BCE Turkmenian, ancestor of the Akhal-Teke, is recognized as a breed of desert race- and warhorses; sculpture shows that the Goths were using Gotland-type ponies to pull chariots.

700–900 BCE Waves of Celtic invasions bring Celtic ponies to the Iberian Peninsula.

638 BCE Both chariot and mounted horse racing events are held in the Olympics.

500 BCE Caspian-like horses depicted on the seal of King Darius the Great in Persia; first horses probably brought to Ireland by the Celts.

430–355 BCE Xenophon as a young teenager used gentle techniques to break the stallion Bucephalus. One of the first ever recorded use of such methods.

200 BCE Goths begin to migrate into eastern Europe.

100 BCE Appaloosa-colored horses are introduced to China.

55 BCE Julius Caesar arrives in Britain; is impressed with local chariot horses; white horses of the Karst are famous in Rome; exceptional snow white steeds are sent to Caesar from Hispania.

01 CE Vikings are selectively breeding Fjord Horses.

120 CE Roman Emperor Hadrian orders wall to be built across northern England to stop invading Picts and hires mercenaries from Friesland, who bring 600 large stallions that are crossed on local mares.

200 Romans import well-bred, probably Oriental, racing horses to England.

414 Goths invade Spain; bring Gotland Ponies.

555 Ostrogoths driven to the Tyrol in the Alps cross Arab-type horse on native Mountain Ponies.

632 Death of Muhammad. Arabian horses are being bred on a small scale in Arabia.

711 Moors invade Spain, bringing African Berber or Barb Horses.

800s Magyars bring fast, small, dun-colored horses to what is now Hungary.

847 Vikings first colonize Iceland, bringing horses with them.

910 First written record of horseshoe use.

930 First act of parliament in Iceland bans further importation of horses.

ca. 1000 Dutch begin building sea walls; develop large draft horses, especially Friesians

1012 Earliest reference to a Dartmoor Pony, found in the will of a bishop.

1066 William the Conqueror takes a large number of Norman horses from France to invade England.

1068 Sturdy packhorses are used in central England, likely ancestors of the Shire.

1086 First written records of Exmoor Ponies.

1172 Normans arrive in Ireland, bringing heavy warhorses.

1199–1216 100 "Stallions of large stature" imported into England from Flanders.

1251 First written records of Friesian Horses.

1264 The Teutonic Order establishes one of Europe's first stud farms at Georgenburg.

1285 First written record of Holstein Horses.

1300 Good documentation of first pure-bred Arabian Horses in Arabia, owned by King Nasir el Mohamed.

1327 King Edward III makes it illegal to sell an English Great Horse to a Scottish person.

1342 Earliest beginnings of Haflinger breed in the Tyrol.

ca. 1350–1900 Little Ice Age in northern Europe and North America: winters very severe; growing season shortened; North Atlantic sometimes impassable to ships. Icelandic Horse herds decimated. New England and Canada experience extremely harsh winters.

1493 Second voyage of Columbus brings first horses to the New World.

1506 Camden's Britannia lists this as first date for the Suffolk Horse.

1509 Salazar takes first horses to Puerto Rico.

1509–1547 Reign of King Henry VIII; edict to destroy all horses less than 14 hands and prohibiting the breeding of horses under 15 hands.

1519 Cortés lands in Mexico; brings horses including first pinto-colored horses and the first Galicenos to North America.

1521 Ponce de León brings horses to Florida.

1526 Possible first landing of Banker Ponies on the Outer Banks of North Carolina.

1529 De Soto lands in Tampa Bay.

1531 Pizarro arrives with horses in Peru.

1540 Coronado arrives in North America with horses.

1541 Cartier lands at site of Quebec with horses; total population of horses in North America is about 600.

1560 Ibarra takes horses to central Mexico to establish ranching; Newfoundland is settled.

1562 Emperor Maximilian II opens the stud at Kladrub, formally introducing the first Spanish horses to Austria.

1572 Spanish Riding School is founded in Vienna.

ca. 1573 Foundation of the Oldenburg breed.

1580 Archduke Karl (Charles) opens the stud at Lipizza (now Austria); de le Trigo finds 10,000 feral horses and cattle near an abandoned Ibarra town site in Mexico.

1610 Six horses and a mare, brought to the colony at Jamestown, are subsequently eaten by starving colonists.

1625 First Friesian horses shipped to the Dutch settlement of New Amsterdam, which later becomes Manhattan.

1629 First horses arrive in Boston from London.

1653 Stud at Memsen in Germany is founded; produces famous cream-colored horses for the House of Hannover.

1660 Charles II of England is the first royal to offer purses as prizes for horse races, at Newmarket.

1665 King Louis XIV sends first horses to New France/Canada; establishes a series of national studs in France.

1670 Tobacco planters at Williamsburg, Virginia, complain about invasions of large herds of wild horses ruining crops.

1679 Byerly Turk foaled.

1689 Byerly Turk is imported to England.

1690 Purses as large as $40,000 are offered for "short" or quarter-mile races in Virginia.

Late 1600s Father Kino establishes Mission Dolores, the first major Spanish horse– and livestock-breeding ranch in southern Arizona.

1700 Darley Arabian foaled.

1701 First studbooks kept on Lipizzans.

1704 Darley Arabian is imported to England.

1710 Most American Indian tribes are mounted.

1712 Legislature of Maryland passes laws to "prevent the great multitude of horses."

1730 Godolphin Arabian enters stud service in England.

1730–1770 First importations of English "bred"-Thoroughbred horses to America.

1732 Stud at Trakehnen is established.

1735 Stud at Celle is established to breed Hanoverians.

1737 First horses documented to have been put on Sable Island.

1740 Hacienda Campo Alegre is founded in Brazil; originates Mangalarga breed.

1752 The English Thoroughbred Janus is imported; had a major impact on quarter-mile race horse breeding.

1755 The Packington Blind Horse, first recorded English Cart Horse/Shire, is foaled; Shales or Original Shales, foundation sire of Hackney Horse breed, is foaled.

1760 Sixty confiscated/stolen Acadian horses are turned loose on Sable Island.

1765 In England, paintings and articles feature "miniature" horses.

1768 Thomas Crispin's horse of Ufford, foundation sire of the Suffolk Punch, is foaled.

1776 A request in Congress is made by an American diplomat for funds to purchase an American Horse (a recognized type), much later named the American Saddlebred, as a gift for Marie Antoinette; the Hannoverian state takes authority from the King to operate the Hanoverian stud.

1788 Messenger, a gray Thoroughbred greatly influential in Thoroughbred and Standardbred breed development, is imported to Philadelphia; George Washington advertises the jacks Royal Gift and the Knight of Malta at stud and begins promoting mules in agriculture.

1789 Justin Morgan is foaled.

1793 Cotton gin invented, causing demand for mules to skyrocket.

Late 1700s Great improvement in roads in both Britain and North America causes marked changes in types of horses used, from pack and riding animals to driving animals.

Early 1800s Lakota Sioux are familiar with wild curly-coated horses; donkeys arrive in Ireland from Spain, quickly becoming popular as both pack and cart animals.

1804 Lewis and Clark encounter Ni Mee Poo (Nez Percé) Indians on fine-quality, smooth-gaited spotted horses; during the Peninsular Wars in Ireland, the cavalry purchases all Kerry Bog Ponies available for use as military pack ponies, greatly depleting feral herds.

1806 First records of organized harness races in North America.

1813 First known use of the word **punch,** meaning short, squat, powerful animal, in the name Suffolk Punch, in a sporting magazine.

1816 Jary's Bellfounder, the first Hackney imported into the United States, is foaled.

1818 British Crown sells the Exmoor Royal Forest to a private owner.

1823 Jean Le Blanc foaled, foundation sire of modern Percherons.

1830 The Syrian Arabian stallion Shagya probably foaled.

1832 First American Thoroughbred Studbook notes many "Quarter Running Horses" as foundation animals.

1836 The Arabian stallion Shagya is imported to Hungary from Syria.

1839 First Percherons imported to North America.

1840 Mountain Pleasure Horse an established type common in eastern Kentucky.

1847 British Mines Act bans the use of children in mines; they are replaced by Shetland Ponies.

1849 Ethan Allen foaled; Rysdick's Hambletonian, foundation sire of Standardbreds, foaled.

1850 Racing four-mile heats is at peak of its popularity.

1855 Golddust, Morgan/part-Arab, foaled.

1856 Mormon Pony Express.

1860–1862 Pony Express.

1861 Establishment of the Oldenburg Studbook; John Rarey, world-famous horse tamer, enters an imported 24-inch, five-year-old pony in a Franklin County, Ohio, fair (first miniature horse reported in North America).

1865 Lincolnshire Lad foaled, the greatest sire of Shires at that time.

1866 First importation of Belgian horses to North America.

1867 Ethan Allen, great-grandson of Justin Morgan, aged 18, wins the world trotter record.

1870 Morgans can be found in every state and territory.

1871 Studbook founded for trotting and pacing horses.

1874 Folie foaled, foundation sire of the modern Haflinger.

1876 Battle of the Little Big Horn; Percheron Horse Association of America is founded.

1877 Clydesdale Society in Scotland is founded.

1878 Trakehner Studbook is established; English Cart Horse Society (Shire) is formed; Sultan Abdul Hamid of Turkey gives U.S. Grant the stallions Leopard and Linden Tree. Leopard is the first purebred Arab imported into North America. Both these stallions are later foundation sires of the Colorado Ranger Horses.

1879 American Clydesdale Association is founded.

1880–1910 Army imports 150 East Friesian stallions each year to breed heavier work- and artillery horses; first Welsh ponies are imported to North America.

1883 Hackney Studbook Society formed in England; Holsteiner breed association is formed in Germany.

1884 Cleveland Bay Society is formed in England to prevent the breed's extinction.

ca. 1885 Dr. Reuben Wilbur purchases the original stock that become the Wilbur-Cruce Horses.

1885 First Studbook is established for Canadian horses; American Shire Horse Association is formed.

1886 Black Allen, later known as Allen F-1, foaled, later becomes foundation sire of Tennessee Walking Horse breed; official studbook is established for the Belgian Horse in Belgium.

1887 The first Warmblood studbook is published in Holland; war between the U.S. Army and the Ni Mee Poo (Nez Percé) Indians results in the destruction of almost all the Indians' Spotted Horses; breed association formed for the Belgian Horse in the United States.

1888 Canadian Shire Horse Association is formed; studbook established for Hanoverians in Germany; first widely reported importation of a very small "miniature" horse from England; American Shetland Pony Club is founded.

1891 First studbook for Shetland Ponies is published in England; 457 are listed.

1898 Wild curly-coated horses are noted in Nevada; Polo Pony Society of England, now the National Pony Society, sets standards for each of England's native breeds of ponies.

ca. 1900 Horse named Doctor is purchased by the McCurdy brothers; becomes the foundation sire of the McCurdy Plantation Horses.

1900 Estimated Mustang population of two million in the American West; Utah makes it a felony to keep any stallion that is not purebred; only about 150 of the ancient native Gotland ponies still exist on Gotland.

1900–1918 Four thousand Shires are imported to the United States and Canada.

1901 First studbook is established for Irish Draught horses.

1904 Westphalian studbook is founded.

1907 Welsh Pony and Cob Society of America is formed.

1910 Fjordhorse studbook is established.

1916 Dales Pony Studbook opens (UK).

1920 Buck No. 2 foaled, progenitor of the American Cream Draft breed.

1920s Dr. Ruy d'Andrade gathers the last wild Sorraia Horses in Portugal.

1924 Dartmoor Breed Society is formed in England; in England, a Shire named Vulcan pulls 29 tons, and a Shire tandem pair pulls 50 tons.

1926 Estimated Mustang population is one million in the American West.

1928 Canadian Sport Horse Association is founded.

1930 In the United States, there are three times as many Percherons as Belgians, Clydesdales, Shires, and Suffolks combined.

1931 First wild Curly Horses are captured and broken to ride by non-Indians.

1935 Estimated Mustang population of 150,000 in the American West; census of 9,025 ponies in Newfoundland; Tennessee Walking Horse Breeders Association is founded.

1938 Appaloosa Horse Club is founded; Colorado Ranger Horse Association founded.

1940 American Quarter Horse Association is founded.

1941 Canadian Shire Horse Association ceases to exist due to lack of horses.

1943 Lipizzan horses are moved from wartime Vienna to rural Austria and Czechoslovakia for safety.

1944 American Cream Draft Horse Association is organized.

1945 Infamous war "trek" from East Prussia to West Germany begins with 800 Trakehners; finishes with about 100 nearly starved horses.

1946 More than 200 licensed Clydesdale stallions are recorded in England.

1947 Pinto Horse Association is founded; Trakehner Verband is founded to reestablish the breed after the devastation of World War II.

1948 Missouri Fox Trotter Registry is founded.

1949 Only 80 Clydesdale stallions are licensed in England; Norwegian Fjordhorse Association is founded.

1950 Spanish Mustang Registry is founded.

1954 Pony of the Americas Club (POAC) is founded.

1955 Twenty-one champion Norwegian Fjord Horses are brought to North America; only five registered Dales Ponies in England; U.S. Army returns Lipizzans to Vienna under the supervision of Gen. George Patton.

1957 First Gotland ponies are imported into North America.

1958 First modern Galicenos are imported into North America; all French regional breeds are consolidated as Selle Français.

1959 Galiceno Horse Breeders Association is founded in the United States.

1960 Sable Island Horses receive protection from Canada.

1964 American Quarter Pony Association is founded; Moyles finish second, third, and fourth in Tevis Cup.

1965 American Paint Horse Association is founded; Ancient Caspian breed rediscovered in Iran by Louise Firouz.

1971 Wild Horse and Burro Act gives the BLM management of all free-ranging horses on government land: Racking Horse Breeders Association of America is founded; 20 feral horses captured in the remote Cerbat Mountains of Arizona are later discovered to be closely linked to early Spanish horses.

1972 Spanish Barb Breeders Association is founded, documents only 30 remaining individuals; Azteca Horse Association is founded in Mexico.

1974 American Trakehner Association is founded.

1975 National Quarter Pony Association is founded.

1977 Twenty-seven horses from Kiger Mountains are gathered in BLM roundup and later proved to be a genetically distinct group closely related to early Spanish horses; last four free-ranging Lac La Croix Indian Pony mares are captured, transported to Minnesota, and rescued before being exterminated by the government; American Holsteiner Horse Association is founded.

1978 American Miniature Horse Association is founded.

1980 Newfoundland Pony Society finds only 300 ponies on the island.

1981 National Show Horse Registry is founded; American Welara Pony Society founded.

1986 Rocky Mountain Horse Association is founded; Shagya Arabian breeding begins in North America with the use of the stallion Bravo.

1987 United Icelandic Horse Congress is founded.

1989 Canadian Shire Horse Association becomes active again; Kentucky Mountain Saddle Horse Association is founded; only ten pure Gotland ponies exist in North America.

1990 The Westfalen Rembrandt wins the world championship in dressage with the highest score ever awarded to any horse; the Wilbur-Cruce ranch is sold to The Nature Conservancy; the Wilbur-Cruce horses are dispersed to conservation breeders.

1991 North American Single-footing Horse Association is founded; first Dales Ponies imported to North America.

1993 Dales Pony Association of North America is founded; Nokota Horse declared the North Dakota Honorary State Equine.

1994 Tiger Horse Association is founded; John Mulvihill of Kerry, Ireland, begins his quest to find the last remaining Kerry Bog Ponies; Guinness World Endurance Record given to two Brazilians who rode 8,694 miles in a year and a half on one pair of Mangalargas; Dennis and Cindy Thompson "discover" the Gypsy Vanner.

1995 North American Spotted Draft Horse Association is founded; the Spanish Barb Breeders Association creates a division for Wilbur-Cruce Mission Horses.

1997 First Gypsy Vanner is imported to North America.

1999 Nokota Horse Conservancy is founded.

2002 Mustang population is estimated at about 35,000 in the American West; Canadian Horse is officially proclaimed the National Horse of Canada; the Selle Français Baloubet De Rouet becomes the first three-time winner of the World Cup in show jumping; Ireland recognizes the Kerry Bog Pony as the Irish Heritage Pony; Kerry Bog Pony Society is formed in Ireland.

2003 First Kerry Bog Ponies are imported to North America; the mule Idaho Gem, the world's first cloned equine, is foaled.

Brands have been used as marks of identification in almost all countries and civilizations for a very long time. There are drawings in Egyptian tombs dating back to 2000 BCE of cattle being branded. In North America we are familiar with brands, used mostly in western states, for identifying the horses or cattle that belong to a particular owner or perhaps a ranch. Because brands are permanent markings on a horse, once placed they are recorded on the registration papers.

All western brands are registered in their state of origin. State brand inspectors attend horse sales to verify that horses being sold are the property of the people doing the selling and to make sure that the papers match the horses. Brand inspectors also often check horses traveling through particular states to make sure that they are not stolen and that the health papers match the horses.

Since about the mid-'70s, **freeze branding,** a method of permanent marking made with a branding iron dipped in liquid nitrogen to make it extremely cold, rather than with the traditional hot iron, has gained popularity. Freeze branding is sometimes used on the hip, a traditional location for hot branding, but is more often used on the neck. It is used most often to identify a particular horse.

Some breed registries, notably Standardbreds, now allow the horse's registration number to be freeze-branded onto the right side of the neck as a form of permanent identification, rather than using a lip tattoo, which was once the favored technique. Also, individual owners now sometimes have their horses marked with freeze brands on the neck, usually under the mane, either with the registration number or with a particular system of angled symbols, designed to be almost tamper-proof, that identify the horse.

This is done in many breeds but probably most often on Arabians. The Bureau of Land Management also uses this system to identify wild horses. With this clever method of angled brands, always placed on the left side of the neck, the BLM can permanently mark each horse with encoded information that includes its age and its registration number. The registration numbers indicate in which state the horse was originally caught. A freeze brand is sometimes difficult to read, especially when the horse has a heavy winter coat, but if clippers are used to remove the hair over the brand, it becomes immediately legible.

In western states, hot brands are still frequently used, especially on the big ranches, because it is traditional and because the system works extremely well. Different ranches have different systems

of identification. On the 165,000-acre Pitchfork Ranch, which is very famous for the quality of its horses, foals are halter-broken and branded in July, then turned back with their mothers until fall, when they are weaned. At branding time, each foal receives four brands: the pitchfork brand on the left shoulder, a number on his left buttock indicating his sire, a number on his left jaw identifying the family of his mother, and a number on the right jaw indicating the year of foaling. With this system breeders are able to recognize the horse at any time in his life and are able to tell how old he is and how he was bred.

In Europe, the purpose of branding is quite different. The brand is used not to signify ownership, but to signify that a horse has earned the right to be called by a particular breed name. In many European breeds, the horse must pass a rigorous inspection and evaluation process before it can be branded. The process is always much more difficult for stallions than for geldings, and there may be a separate system for evaluating mares. To be a branded stallion of these breeds is quite an achievement and an honor, and it indicates that the horse has excellent conformation and gaits along with whatever other qualities that breed deems important. This system is the source of the term *brand identification,* which is now commonly used in advertising.

In order to understand how coat color and patterns are inherited, it is necessary to understand a few scientific terms and conventions.

Genes are the structures that transmit inherited traits. Individual genes are situated at specific locations, known as **loci** (singular **locus**), on paired, threadlike chromosomes within cells. Because the chromosomes are paired, the genes are also paired. Each member of a pair of genes is called an **allele.**

In the simplest case, a gene may be either **dominant** or **recessive.** If a trait is dominant, it will be expressed; if recessive, it may be masked.

The convention is to use uppercase letters such as **A** and **B** to denote particular genes. It is also conventional to note the dominant allele with an uppercase italicized letter and the recessive with a lowercase italicized letter.

If the pairs of genes at a specific locus are the same, they are **homozygous;** if they differ, they are **heterozygous.** The genetic makeup of an animal is its **genotype.** The visual appearance of an animal is its **phenotype,** determined by the genotype.

When speaking of horse colors, the term **points** means the lower legs, the muzzle, the tips of the ears, and the mane and tail.

Seven Layers of Colors

Seven major genes regulate the expression of coat color for horses. We will consider only the dominant and recessive alternatives. In reality, a number of other modifiers may be involved, but their actions and their interactions are extremely difficult to understand. Even in the simplest cases, coat color genetics is affected by interplay of seven genes, not all of which work the same way. One way to simplify it is to think of the genetic color traits as being layered — that is, on top of each other.

Base Body Color

The first trait is the base body color, and it is a surprise to many to learn that there are only two of these. The horse's genes are coded either for red (which geneticists write as *ee*) or for black (*EE or Ee*). But the phenotypes (the visual appearance) for red

are chestnut, sorrel, palomino, cremello, red dun, and red roan. The phenotypes for black are black, brown, bay, buckskin, perlino, dun, grulla, and blue roan. Gray is a separate issue.

Red Base Color

The gene for red is recessive to black, which means that it may be a masked trait, hidden until it crops up in a later generation. Thus, two black parents can produce a red foal, but two red parents cannot produce a black foal. With two red parents *(ee),* the only possible outcome is another red horse.

Some people and some breed registries refer to red horses as chestnuts and others refer to them as sorrels, without much consistency of usage. Some registries use only chestnut or only sorrel; some use both. Some call redder horses sorrel but others call them chestnut; still others deem only horses with flaxen manes and tails to be sorrel. And many people consider sorrel a term for horses who are ridden Western and chestnut a term for horses ridden English.

The easy way around the chestnut/sorrel dilemma is just to use the word *red,* and geneticists usually do that. When they speak of red horses, they mean horses whose color falls within a spectrum ranging from yellowish red through bright or deep red to red-brown and all the way to liver. Chestnut/sorrels never have black points, but their mane may be dark. Many have mixed colors in the mane and tail; on some the mane and tail are the same shade as the body; and on some the mane and tail may be flaxen or off white (although this group does not include palominos).

Black Base Color

The black base color is trickier. The geneticists' definition of *black* is a horse that has no brown or red hairs anywhere, even when it sheds out. The most likely places to find brown hairs on a suspect black horse are around the muzzle, on the face, on the insides of the ears, on the inside of the legs above the knees or hocks, and sometimes on the flanks. If brown or red hairs are present, the horse is properly considered to be dark brown, not black, although it may look black, especially in its winter coat.

Some horsemen insist that a true black does not fade in the sun, but geneticists do not include this requirement in their definition. Using the geneticists' definition of the color, black X black crosses will never produce bay or brown offspring. Black is further complicated because it may also be affected by some subtle genes that are well beyond the scope of this discussion.

Distribution of Black

The second layer has to do with the distribution pattern of black. The gene that controls this is **A.** The allele *A,* when in combination with *E,* will confine black hair to the points and therefore produce a bay. The *a* allele when it appears allows black to be unrestricted. If *a* appears in conjunction with *E,* the horse will be a uniform, true black; however, in most breeds *a* is quite rare, so black horses occur infrequently. The **A** gene does not affect pigment distribution in red (*ee*) horses, making it impossible to tell which allele of the **A** gene might be present in red horses.

Dilution: The Cremello Gene

In the third layer, dilution genes modify the base body color. The cremello/perlino gene is a dilution gene, represented by **C,** and an allele of C known as C^{cr} causes pigment dilution. If the horse is *CC,* it will be fully pigmented. In the heterozygous case, $Cc^{cr},$ red horses will have their color diluted, but any black pigment is not affected.

This causes bay horses to become buckskins, because the body color is diluted but the black points remain unaffected. Chestnut/sorrel horses that inherit one cremello gene will be palomino. If a red horse inherits two cremello genes, it will be a cremello.

Because the cremello gene does not affect black pigment, however, it is difficult to tell if a black horse inherits one cremello gene. Phenotypically, he will look very dark and may be thought to be a true black, but he is actually what is known as **smokey black.** The truth of his genetics may become obvious only in the next generation when a palomino or buckskin foal is born, proving that the dilution gene is present. To make it more difficult, true black foals are often born as dark grulla,

what appears to be charcoal gray, or even some shade of dark bay. These foals eventually shed out to become true blacks.

The homozygous case adds even more confusion. With two copies of the cremello allele present, any coat color, including black, is diluted to a very pale cream with pink skin and blue eyes. These horses are sometimes called cremellos, sometimes perlinos, and sometimes albinos. They occur when two dilute-colored horses, such as palominos, are crossed.

The advantage of perlinos and cremellos in breeding programs is that they carry two dilution genes. This means that they are guaranteed to pass on one to their foals and thus the foals will have some sort of modified base color. They may be palominos, buckskins, perlinos, or cremellos.

Because perlinos and cremellos may be very pale, people sometimes confuse their color genetics with those for the lethal white gene. That gene, however, occurs only in conjunction with the overo color pattern (see page 385).

The Dun Factor

The next layer is a second dilution factor *D,* often called the **dun factor,** which dilutes both black and red pigment on the body but does not affect the color of the points. This is the gene that produces dorsal stripes and may also produce shoulder stripes and barring on the front legs. In North America, *D* is found only in a few breeds, mostly in what we would consider stock horses, Mustangs, and some ponies. Often confused with the cremello gene, it is a separate gene and works differently.

If a red horse inherits *D,* the color is diluted to a pinkish red, yellowish red, or yellow. These horses come in various shades and they include the colors known to horsemen as red and claybank dun. In an otherwise bay animal, *D* produces a yellow-red horse known as a buckskin dun. In an otherwise black animal, *D* produces a slate or mouse gray color with black points, known as a **grulla** or **grullo.**

The word *grulla* (pronounced GREW-ya) is derived from the name for a gray/brown Spanish shorebird. In some places, grullo (GREW-yo) is considered the masculine

form for the color and grulla the feminine, but in most of North America, either form is accepted and used.

Roaning

In the fifth layer, the roan gene (*Rn*) is dominant. It mixes white hair evenly throughout the body coat but does not affect the color of the legs and the face. For this reason, true roans usually have a non-roaned face and lower legs. Roaning is not **progressive,** meaning that it does not get lighter or more extensive as the horse ages. It may not be apparent in a foal's first coat, however, and it commonly changes seasonally, being lighter at some times of the year and darker at others. It was once believed that the *Rn* gene was lethal in the homozygous state, with embryos being resorbed very early in the pregnancy, but research at the University of California at Davis has disproved this theory. Several stallions have been documented to be homozygous for *Rn.*

Roans are commonly confused with other horses, particularly horses that are graying. Over time, however, a gray will develop white hair on the body, face, and lower legs, while a true roan will not. Roans may also be confused with the varnish roan Appaloosa pattern, which is caused by the **Lp** gene and completely unrelated to the roan gene. The varnish pattern is not stable and, like gray, will change over time. True roans are also often confused with some expressions of the sabino gene, which can cause flecks and partial roaning, but the genes are completely different.

Roan can act on any of the base body colors. When the gene mixes white hair into the coat of a horse that otherwise would have been black, that horse is commonly called a **blue roan.** Beyond that, there is a good bit of inconsistency in terminology. Some say that only a horse that would otherwise have been entirely red may be called a red roan, and a horse that otherwise would have been bay maybe called a bay roan, while others call a horse with any red on it a red roan and never use the term *bay roan* at all. Then there is strawberry roan, which has different descriptions in different places. Use whatever terms you prefer, but

be aware that others may have different ideas and descriptions.

Tobiano

The sixth trait layer is for the tobiano (see page 279) spotting pattern. The only spotting pattern that is regulated by a single gene (**TO),** the tobiano pattern may occur in conjunction with any body color. It is present from birth and does not change during the horse's life.

Appaloosa/ Leopard Complex

An entirely separate layer, Appaloosa coloring is regulated by several genes, and the genetics is extremely complicated. Collectively, the genes are referred to as the **leopard complex**.

White and Gray

In addition to all these layers of traits regulating color, the genes for white and for gray may or may not be present. The white gene **W** is a dominant trait: a true white horse occurs whenever **W** is present. From birth, white horses lack all pigment in skin and hair. Their skin is pink; their eyes may be brown or blue. These rare horses are sometimes called **albinos.** All other horses are *ww.*

Gray is also controlled by a single dominant gene (**G),** and whenever it is present the horse will be gray. Characterized by fading color, gray resembles the silvering of human hair. Gray horses may be born any color and are commonly, but not necessarily, dark at birth. As they age they lighten, gradually becoming white or white with red or black flecks, a color known as a **flea-bitten gray.**

Sometimes it takes a close look to determine whether a light horse is a gray or a true white. Gray horses will be seen to have dark skin, while true white horses have pink skin. Gray horses always have some pigment in the eyes.

It can also be difficult to tell if a foal is going to be gray. Graying usually begins around the eyes, so that is the first place to look. Usually a few gray hairs are visible even when the foal is only a day or two old.

All non-gray horses are noted as *gg.* Gray is produced by a dominant gene; at least one parent of a gray horse must be gray.

The Case of Overo

Color genetics is still an evolving subject, particularly for the pinto patterns other than tobiano. Because a mare is not bred until she is three, and it takes eleven months to produce one foal, research on color in horses is slow going. Photo and color pedigree analysis helps, but misidentification can lead to incorrect conclusions about whether a gene is dominant or recessive. Also, unusual patterns occur in some widely diverse breeds of horses but not in similar-looking ones.

FRAME OVERO

According to the American Paint Horse Association (APHA), the term *overo* is used to name three genetically distinct patterns. The first is the **frame overo.** As seen from the side, a horse with this pattern has a big area of ragged white, or several white patches, toward the center of the body, and the white is framed by color along the back and around the sides. The head usually has extensive white markings and the eyes are often blue. The pattern occurs in a limited number of horse breeds, all of Spanish ancestry, and often in our Spanish Colonial Horses.

It was long thought that a recessive gene governed the overo pattern, but in 1994 researchers at the University of California at Davis published an analysis they had done on color and pedigrees with the APHA. Their conclusion was that overo is actually a dominant gene, or group of genes. That conclusion has held up to scrutiny and it is now the prevailing belief.

When frame overos are bred to non-spotted horses, about half the foals are spotted, which is to be expected with a dominant gene. There are also, however, many documented cases of two non-spotted parents producing frame overo foals — which would happen with a dominant gene. According to the APHA, a closer look at the parents has sometimes revealed that one or the other was actually a minimally marked frame overo. Even without the body spot that is the usual hallmark of the pattern, this horse had the gene and passed it on to the offspring. This does not explain all such cases, and

research continues, but it is probably responsible for most of them.

Frame overo is also associated with the occurrence of **lethal white** foals, mentioned above. These animals are almost always born totally white. Because they lack necessary innervation to the gut, they die within a day or two of birth, unless they are humanely destroyed first. DNA tests are now available for the frame gene and the lethal white foals that can occur from it. Those with the gene can be mated to horses without it, resulting in about half frame and half non-spotted foals, completely avoiding lethal white foals.

SABINO

The second pattern, **sabino,** is extremely difficult to understand well because it can look like many different things. Sometimes called the great pretender, it is responsible for a huge amount of confusion about pinto colors. It is almost as common as both the tobiano and the overo patterns but not recognized nearly as often. In Spanish, the word *sabino* means pale or specked; in some places that word is used to describe fleabitten gray horses, animals that have nothing to do with pinto patterns.

According to the APHA, sabino horses usually have four white legs and feet. The white usually extends up the legs in ragged patches and then extends onto the horse's body starting at the belly. The head usually has a good deal of white and the eyes are commonly blue. A good many sabino horses have eyes that are partially blue and partially brown. Flecks, patches, and roan areas are common and can help distinguish sabinos from frame overos, which usually have more crisply delineated color lines.

Sabino occurs in many breeds, including Paints, Clydesdales, and even Thoroughbreds. When a surprise spotted foal turns up in breeds that do not welcome the colors, such as the British pony breeds and Quarter Horses, it is usually caused by the sabino pattern. To add further confusion, sabino is also involved on some horses that appear to be tobianos and others that seem to be frame overos.

When sabino is minimally expressed, the horse usually has four white socks and

a blaze, but there is often some hint that these are not ordinary white markings. There may be a ragged edge to the color or a long narrow extension up the leg. However, it is entirely possible for minimally spotted sabinos to be confused with non-spotted horses.

In the middle range of expression, sabinos are usually fairly easy to detect. Most have white extending from the belly, and roan or flecked areas in addition to the white. A few are almost entirely roan and are sometimes misidentified as roan horses.

The whitest of the sabinos are almost entirely white. Some have color only on their ears; some on the ears, chest, and the base of the tail. These are the famed Medicine Hats of the Plains Indians. The majority of sabinos at the white end of the color range are speckled and roaned, sometimes to the extent that they may be confused with Appaloosas.

It is now generally believed that the sabino pattern is transmitted by more than one gene and that some complicated genetic mechanisms may mask its expression in some instances.

SPLASHED WHITE

The **splashed white** pattern is the least common of the spotting patterns, although according to the APHA, breeders are increasingly using these horses in their breeding programs. Probably responsible for the remarkable color of the rare Abaco Barbs, this pattern also occurs in Paints, Icelandic Horses, and Welsh Ponies. It is now believed that the pattern is caused by a dominant gene.

A splashed white horse looks as if his parts have been dipped in white paint. The legs and the bottom portions of the body are white, as is the head. The eyes are often blue. The edges of the color are crisply defined, without roaning.

Deafness occurs fairly often in conjunction with splashed white, but in horses this is not an overwhelming problem as long as it is recognized and appropriate training methods are used.

amblers. Horses that have a gait just out of the true pace.

aphcal or **revaal.** An amble that is specific to the Marwari breed.

bald. White covering most of the face.

bascule. The arc that a horse's body follows over a fence when he jumps.

bonnet. See **war bonnet.**

breed. A collection of domestic animals (within a species) selectively developed by a group of breeders to possess certain specific traits.

breed standard. The mechanism breeders use to identify and perpetuate their desired traits; a listing of essential qualities for a breed.

brio. A regal, spirited bearing.

calf knee. When the knee falls behind the vertical line so that the knee appears to arc toward the rear.

camped-out. When the lower leg lines up behind the hock rather than squarely beneath it.

clubbed foot. A conformation deformity in which the hoof is extremely upright, usually with a hoof pastern angle of more than 60 degrees.

contracted or **sheared heel.** When the hoof is lopsided, with one side of the hoof wall higher than the other.

coon foot. A conformation deformity in which the hoof angle is very low and pastern angle may be even lower. It is usually seen in horses with very long pasterns, especially on the hind feet of older horses with long and/or weak pasterns, or when the suspensory ligament has become very relaxed.

cow-hocked. When the hocks seem to point toward one another while the lower leg is straight, seen from behind.

crossbreeding. Deliberately crossing horses of different breeds.

dam. The mother of a horse.

dentition. The number and arrangement of teeth.

dished. A concave profile characteristic of Arabians.

domestic and **domesticated.** Terms that describe groups of animals that have been selected and bred by human beings for various specific purposes.

dun-factor (adj.); **dun factor** (n.). A gene that contributes the darker **points** (the dorsal stripe, the shoulder stripes, and the zebra stripes sometimes found on the legs). The dun factor may also occur in colors other than buckskin: there are red duns of various shades and even some bays that show the dun factor. The dun factor is also associated with the color **grulla.**

feral. Descendants of escaped domestic horses that now live freely in the wild.

flat-foot walk. A gait performed by the Tennessee Walker that is comparable to the walk in other breeds, though Walkers usually effortlessly outwalk other breeds, traveling between four and eight miles an hour.

forging or **interfering.** One leg hitting another as the horse moves.

fox trot. A rhythmic diagonal gait in which the horse walks in front and trots behind.

frontal bosses. A pair of skin-covered bony protuberances, much like very small versions of the horns on a giraffe, above the eyes, larger in some horses than others. A distinctive characteristic of the Moyle.

gaited. A natural tendency to offer gaits other than the walk, trot, and canter.

genetic drift. Random changes in gene frequency, especially in small populations.

glass eyes. Blue eyes in a horse.

grulla (pronounced GREW-ya) or **grullo.** A soft mouse or dove color associated with the **dun factor.**

gunner. A horse that was used to pull artillery.

hinny. The hybrid offspring of a donkey dam and a horse sire.

hybrid. The offspring of two deliberately crossed, separate species. Hybrids are often infertile.

hyperkalemic periodic paralysis (HYPP). A genetic defect that causes a metabolic problem at the cellular level. Found in Quarter Horses that trace back to a particular stallion.

jack. A male donkey.

jagirdari. A land-owning abolition act enacted by the British in 1950 that deprived Indian noblemen of the means to support their many animals, causing thousands of Marwari to be shot, castrated, or sold to become beasts of burden.

jennet or **jenny.** A female donkey.

linebreeding. Breeding closely related animals, which can fix certain desirable traits in the offspring.

marcha. The naturally occurring, smoothly rhythmic gait of the Mangalarga Marchador. The smooth marcha gait comes in two forms, the *marcha batida* and the *marcha picada.*

Medicine Hat. A pinto horse with color only on a "bonnet" over the ears and on a "shield" over the chest. Considered magical by some Indian tribes.

merry walk. A fast yet smooth four-beat gait of American Walking Ponies.

mitochondrial DNA. Genetic material found outside the chromosomes in a part of the cell called the mitochondrion. It is passed on, nearly unchanged from generation to generation, entirely from the mother.

mules. The infertile hybrid offspring of a donkey sire and a mare dam.

mutton-withers. Very flat, almost indiscernible withers that resemble those of sheep.

offset knee or **bench knee.** When the long bone above the knee does not line up with the long bone below.

outbreeding, outcrossing. Deliberately crossing one line of horses within a breed to a very distant or unrelated line. The term is also occasionally used as a synonym for crossbreeding.

over at the knee. Angled forward.

overo. A form of pinto coloring. Overo horses rarely have any white extending across the back between the withers and the tail. Generally at least one, and often all four, leg is colored. The head markings often include a **bald** or **bonnet** face. The body markings tend to be irregular, scattered, and splashy. Usually the tail is one color. According to historians, the overo pattern is particularly suggestive of a strong Spanish Colonial link.

pace. A two-beat gait in which the legs on each side of the horse move in unison.

part-bred. See **Dales Pony.**

paso corto. The relaxed, medium-speed gait of Paso Fino horses, roughly equivalent in speed to a trot.

paso fino. An entirely inherited, unusually short-strided, four-beat lateral gait found only in the Paso Fino Horses. Horses not born into the breed cannot be trained to perform it.

paso largo. In Paso Fino horses, the extended form of the **paso corto** gait. Done at speeds ranging from a canter to a full-hand gallop.

piebald. Black-and-white pinto coloring.

points. The lower legs, muzzle, tips of the ears, mane, and tail.

prepotency. The ability of a sire consistently to pass along characteristics to his offspring.

prepotent sire. A sire that stamped his type on his offspring.

rack. A much faster version of the **slow gait.**

running walk. An extremely long, fast, gliding walk, which can cover from ten to twenty miles an hour. As the speed increases, the hind feet overstep the tracks left by the front feet by six to eighteen inches. A famous gait of the Tennessee Walkers.

sabino. A complicated color pattern most often found in pinto horses, probably caused by the action of several genes, and sometimes confused with overo, roan, or even gray horses, depending on the genetic expression.

Short-racing Horses. Horses used in short, usually about a quarter-mile, races.

single-foot. A particularly smooth four-beat gait with no evidence of pacing or trotting. The term comes from the tendency, among horses able to perform it, for the horse's weight to be supported by one foot on the ground at a time. When the horse moves, it produces four distinct hoofbeats of equal rhythm.

sire. The father of a horse.

skewbald. Brown-and-white pinto coloring.

slab-sided. Flat-sided.

slow gait. A slow, balanced gait during which the horse's weight is suspended on one foot.

species. A population of genetically related animals that for biological, geographical, or behavioral reasons is restricted to breeding among its own members in order to produce offspring that are capable of reproduction.

subspecies. A division of a species, which has usually arisen as a consequence of geographic isolation. Subspecies members are potentially capable of interbreeding with other members of the species. They are very close relatives.

termino. A graceful, flowing movement in which the front legs roll toward the outside as the horse strides forward. It can be as slow as a walk or as fast as an extended trot or even a slow canter.

tobiano. A type of pinto coloring. The face of a tobiano horse usually has markings like those of any solid-colored horse: a blaze, stripe, star, or snip. The tobiano often has four white legs, at least below the hocks and the knees. Spots are regular and distinct, often appearing in oval or round patterns that extend down over the neck and the chest. White may extend across the back. Tobianos tend to have dark color on one or both flanks, and the tail may be multicolored.

tolt. A smooth, fast, four-beat amble performed by the Icelandic Horse.

using horses. Horses that can do a wide variety of highly useful things, particularly on ranches.

vanners. Horses that are used to pull commercial wagons of all sorts.

walleyed or **fish-eyed.** When horses have eyes set too far toward the sides of their heads. These horses may have peculiar fields of vision, causing them to shy or bump into things.

war bonnet. A color pattern found in pinto horses featuring a white or bald face, with color only on the ears.

Every effort was made to confirm the accuracy of these listings. Any corrections or updates should be sent to Deb Burns, Editor, Storey Publishing, 210 MASS MoCA Way, North Adams, MA 01247.

Light Horses

ABACO BARB
Arkwild, Inc/The Abaco Wild Horse Fund
2829 Bird Avenue
Suite 5, PMB # 170
Miami, FL 33133
www.arkwild.org

AKHAL-TEKE
Akhal-Teke Association of America
(ATAA)
Rte. 5, Box 110
Staunton, VA 24401
(206) 485-4970
www.akaltekes.org

AMERICAN CURLY
American Bashkir Curly Registry (ABCR)
P.O. Box 246
Ely, NV 89301
(775) 289-4999
www.abcregistry.org

AMERICAN INDIAN HORSE
American Indian Horse Registry
9028 State Park Road
Lockhart, TX 78644
(512) 398-6642
www.indianhorse.com

Chickasaw Horse
Chickasaw Horse Association (CHA)
169 Henry Martin Trail
Love Valley, NC 28667
(704) 592-7451

Choctaw Horse
Return to Freedom: American Wild Horse
Sanctuary
P.O. Box 926
Lompoc, CA 93438
(805) 737-9246
www.returntofreedom.org/conservation/
conservation.htm

The Choctaw Horse Conservation Program
P.O. Box 926
Lompoc, CA 93438
www.red-road-farm.com/choctaw.html

AMERICAN PAINT HORSE
American Paint Horse Association (APHA)
P.O. Box 961203
Fort Worth, TX 76161-0023
(817) 834-2742
www.apha.com

AMERICAN QUARTER HORSE
American Quarter Horse Association
(AQHA)
P.O. Box 200
Amarillo, TX 79168
(806) 376-4811
www.aqha.com

AMERICAN SADDLEBRED
American Saddlebred Horse Association
(ASHA)
4083 Iron Works Parkway
Lexington, KY 40511
(606) 259-2742
www.asha.net

ANDALUSIAN/LUSITANO
International Andalusian and Lusitano
Horse Association Registry (IALHAR)
101 Carnoustie North, Box 200
Birmingham, AL 35242
(205) 995-8900
www.ialha.org

APPALOOSA
Appaloosa Horse Club (ApHC)
2720 W. Pullman Road
Moscow, ID 83843
(208) 882-5578
www.appaloosa.com

ARABIAN
Arabian Horse Association (AHA)
10805 E. Bethany Drive
Aurora, CO 80014
(303) 696-4500
www.arabianhorses.org

AZTECA
International Azteca Horse Association
(IAzHA)
c/o Donald M. Caskie
R.R. 2
Paris, Ontario
Canada, N3L 3E2
(519) 458-4410
http://www3.sympatico.ca/azcc/IAzHA.
html

Azteca Horse Registry of America
P.O. Box 998
Ridgefield, WA 98642
(360) 887-3259
http://www.azteca-horse.com/

Azteca Horse Association of the United
States
2613 Camino de Verdad
Mercedes, TX 78570

Asociación International de Caballos de
Raza Azteca
Av. Mexico 101
Col. De Carmen
Cayoacan
C.P. 042100
Mexico D.

CANADIAN HORSE
Canadian Horse Breeders Association
(CHBA)
Société des Eleveurs de Chevaux Canadiens
200 Rang St.-Joseph est
St.-Alban, QC
G0A 3B0
Canada
(418) 268-3443
http://www.clrc.on.ca/canadian.html

CANADIAN SPORT HORSE
Canadian Sport Horse Association (CSHA)
19752 Holland Landing Road, Suite 203
Holland Landing, Ontario
Canada L9N 1G8
(905) 830-9288
www.canadian-sport-horse.org

CASPIAN
Caspian Horse Society of the Americas
 (CHSA)
6109 FM 390 North
Brenham, TX 77833
(979) 830-9046
www.caspian.org

CERBAT
Cerbats may be registered with the Spanish
Mustang Registry.

Spanish Mustang Registry
8328 Stevenson Avenue
Sacramento, CA 95828
www.spanishmustang.org

CLEVELAND BAY
Cleveland Bay Horse Society of North
 America (CBHSNA)
P.O. Box 483
Goshen, NY 03752
(603) 863-5193
www.clevelandbay.org

The Cleveland Bay Horse Society (CBHS)
 York Livestock Centre
Murton, York YO1 3UF
England
+044 01904 489731
http://fcha.flahorse.com

COLORADO RANGERBRED
Colorado Ranger Horse Association
 (CRHA)
RD 1
Box 1290
Wampun, PA 16157
www.coloradoranger.com

DUTCH WARMBLOOD
The Dutch Warmblood Studbook in North
 America (NA/WPN)
P.O. Box O
Sutherlin, OR 97479
(541) 459-3232
www.nawpn.org

FLORIDA CRACKER
The Florida Cracker Horse Association
 and Registry (FCHAR)
P.O. Box 186
Newberry, FL 32669
(352) 472-2228
http://fcha.flahorse.com

FRIESIAN
Friesian Horse Association of North
 America (FHANA)
P.O. Box 11217
Lexington, KY 40574
www.fhana.com

Friesian Horse Society (FHS)
 (The North American affiliate of the
 German Friesian Horse Breeders
 Society — FPZV)
1785 Princeton-Summerland Road
P.O. Box 294
Princeton, BC
V0X 1 W0, Canada
(250) 295-3102
www.friesianhorsesociety.com/Home.html

GALICENO
Galiceno Horse Breeders Association
 (GHBA)
P.O. 219
Godly, TX 76044
(817) 389-3547

GYPSY VANNER
Gypsy Vanner Horse Society (GVHS)
5811 Osman Road
Cridersville, OH 45806
1-800-324-9397
www.gypsyvanners.org

HACKNEY HORSE
American Hackney Horse Society (AHHS)
4059 Iron Works Parkway, Suite 3
Lexington, KY 40511
(859) 255-8694
www.hackneysociety.com

HAFLINGER
American Haflinger Registry (AHR)
1686 East Waterloo Road
Akron, OH 44306
(330) 784-0000
www.haflingerhorse.com

HANOVERIAN
American Hanoverian Society (AHS)
4067 Iron Works Parkway, Suite 1
Lexington, KY 40511
(859) 255-4141
www.hanoverian.org

HOLSTEINER
The American Holsteiner Horse
 Association (AHHA)
222 East Main Street, Suite 2
Georgetown, KY 40324
(502) 863-4239
www.holsteiner.com

HUNGARIAN
Hungarian Horse Association of America
 (HHAA)
HC 71 Box 108
Anselmo, NE 68813
(308) 749-2411
www.hungarianhorses.org

ICELANDIC
United Icelandic Horse Congress (UIHC)
38 Park Street
Montclair, NJ 07042
(973) 783-3429
www.icelandics.org

IRISH DRAUGHT
Irish Draught Horse Society of North
America (IDHSNA)
HC65 Box 45
Pleasant Mount, PA 18453
(866) 434-7621
www.irishdraught.com

Irish Draught Horse Society (IDHS)
Secretary
Derrynagara, Collinstown
County Westmeath, Ireland
+353 04461199
www.irishdraught.ie

KENTUCKY MOUNTAIN SADDLE HORSE
Kentucky Mountain Saddle Horse
 Association
P.O. Box 54257
Lexington, KY 40555
(859) 543-1861
www.kmsha.com

Mountain Pleasure Horse Association
(MPHA)
P.O. Box 112
Mt. Olivet, KY 41064
(606) 724-2591

KIGER MUSTANG
Kiger Mesteño Association (KMA)
1124 NE Halsey Street, Suite 591
Portland, OR 97220
www.kigermustangs.org

LIPIZZAN
United States Lipizzan Registry (USLR)
707 13th Street SE, Suite 275
Salem, OR 97301
(503) 589-3172
www.uslr.org

MANGALARGA MARCHADOR
Mangalarga Marchador Horse Association
of America (MMHAA)
P.O. Box 770955
Ocala, FL 34477
(352) 368-5786
www.mmhaa.com

U.S. Mangalarga Marchador Association
(USMMA)
31613 N 136 Street
Scottsdale, AZ 85262
(480) 683-8848
www.USMarchador.com

MARWARI
Indigenous Horse Society of India
DUNDLOD House, Civil Lines
Jaipur - Rajasthan, India 302019
91-291-510101
www.horseindian.com

The Marwari Horse Breeder's Association
Umaid Bhawan Palace
Jodhpur, India 342006

McCURDY PLANTATION
McCurdy Plantation Horse Registry and
Association (McPHA)
1020 Houston Park
Selma, AL 36701
(334) 874-5432
www.mccurdyhorses.com

MINIATURE
American Miniature Horse Association
(AMHA)
5601 South Interstate 35W
Alvarado, TX 76009
(817) 782-5600
www.amha.org

The American Shetland Pony Club
(manages the American Miniature Horse
Registry—AMHR)
81 B East Queenwood
Morton, IL 61550
(309) 263-4044
www.shetlandminiature.com

MISSOURI FOX TROTTER
Missouri Fox Trotter Horse Breeders
Association (MFTHBA)
P.O. Box 1027
Ava, MS 65608
(417) 863-2468
www.mfthba.com

MORAB
International Morab Breeders Association
(IMBA)
International Morab Registry (IMR)
RR #3 Box 235
Ava, MD 65608
www.morab.com

Purebred Morab Horse Association
(PMHA)
P.O. Box 203
Hodgenville, KY 42748
www.puremorab.com

MORGAN
American Morgan Horse Association
(AMHA)
P.O. Box 960
Shelburne, VT 05482
www.morganhorse.com

MUSTANG
American Mustang and Burro Association
(AMBA)
P.O. Box 1013
Grass Valley, CA 95945-1013
www.bardalisa.com

Bureau of Land Management (BLM)
National Wild Horse and Burro Program
P. O. Box 12000
Reno, NV 89520-0006
www.blm.gov/whb/

North American Mustang Association and
Registry (NAMAR)
P. O. Box 850906
Mesquite, TX 75185-0906
(972) 289-9344

NATIONAL SHOW HORSE
National Show Horse Registry (NSHR)
10368 Bluegrass Parkway
Louisville, KY 40299
(502) 266-5100
www.nshregistry.org

NOKOTA
The Nokota Horse Conservancy (NHC)
420 South Broadway Street
Linton, ND 58552
(701) 254-4302
www.nakotahorse.org

NORWEGIAN FJORD
Norwegian Fjord Horse Registry (NFHR)
P.O. Box 685
Webster, NY 14580
(716) 872-4114
www.nfhr.com

Norwegian Fjordhorse Association
(Norges Fjordhestlag)
boks 14
N-6801 F¯rde
Norway

OLDENBURG
International Sporthorse Registry/
Oldenburg Registry of North America
(ISR/OLD NA)
939 Merchandise Mart
Chicago, IL 60654
(312) 527-6544
www.ISROldenburg.org

Oldenburg Horse Breeders Society (OHBS)
150 Hammocks Drive
West Palm Beach, FL 33413
(561) 969-0709

PASO FINO

Paso Fino Horse Association (PFHA)
101 N. Collins Street
Plant City, FL 33566
(813) 719-7777
www.pfha.org

Pure Puerto Rican Paso Fino Federation of
 America (PPRPFFA)
P.O. Box 2804444
Columbia, SC 29228
(803) 657-7950
http://puertoricanpasofino.org

American Paso Fino Horse Association
 (APFHA)
P.O. Box 2363
Pittsburgh, PA 15230

PERUVIAN PASO

American Association of Owners and
 Breeders of Peruvian Paso Horses
 (AAOBPPH)
P.O. Box 476
Wilton, CA 95693
(916) 687-6232
www.aaobpph.org/

PRYOR MOUNTAIN MUSTANG

Pryor Mountain Mustang Breeders
 Association
P.O. Box 884
Lovell, Wyoming 82431
(307) 548-6818

RACKING HORSE

Racking Horse Breeders Association of
 America
Route 2, Box 72-A
Decatur, AL 35603
(202) 353-7225
www.rackinghorse.com

ROCKY MOUNTAIN HORSE

Rocky Mountain Horse Association
 (RMHA)
P.O. Box 129
Mt. Olivet, Kentucky 41064
(606) 724-2354
www.rmhorse.com

SABLE ISLAND

Sable Island Green Horse Society (SIGHS)
CRO PO Box 64
Halifax, NS B2Y 2L4
Canada
(902) 499-3966
http://www.greenhorsesociety.com/

SELLE FRANÇAIS

North American Selle Français Association
 (NASFA)
P.O. Box 579
Waynesboro, VA 22980
(540) 932-9160
www.greenhorsesociety.com

SHAGYA ARABIAN

International Shagya Organization (ISG)
 (Umbrella organization for Europe,
 USA and Venezuela)
ziegelhuette 37, 91284 new house
+09156/ 929,510
www.shagya-isg.de

North American Shagya-Arabian Society
 (NASS)
Gwyn Davis (Information Officer)
9797 S. Rangeline Road
Clinton, IN 47842
(765) 665-3851
www.shagya.net

SINGLE-FOOTING HORSE

North American Single-Footing Horse
 Association (NASHA)
P.O. Box 3170
Carefree, Arizona 85377
(480) 488-7169
www.singlefootinghorse.com

SORRAIA

Sorraia Mustang Studbook
Othmaringhausen
58553 Halver
Germany
www.spanish-mustang.org/startsms.htm

SPANISH BARB

Spanish Barb Breeders Association (SBBA)
P.O. Box 598
Anthony, FL 32617
(352) 622-5878
www.spanishbarb.com

SPANISH COLONIAL HORSE/SPANISH MUSTANG

Spanish Colonial Horse
Southwest Spanish Mustang Association
 (SSMA)
P.O. Box 948
Antlers, OK 74523
ssma_g-j.tripod.com

The Spanish Mustang Registry (SMR)
Carol Dildine, Secretary
323 County Road 419
Chilton, TX 76632
(254) 751-7671
Dildine@hot1.net

The Spanish Mustang Registry (SMR)
HCR 3 Box 7870
Wilcox, AZ 85643
www.spanishmustang.org

Ranchero Stock Horse Association (RSHA)
603 B. Street
Corning Iowa, 50841
(641) 322-4802

Horse of the Americas Registry
www.HorseoftheAmericas.com

SPANISH JENNET

Spanish Jennet Horse Society (SJHS)
194 Halstead Lane
Cairo, GA 39827
(229) 377-6128
www.spanishjennet.org

STANDARDBRED

The United States Trotting Association
 (USTA)
750 Michigan Avenue
Columbus, OH 43215
(614) 224-2291
www.ustrotting.com

SULPHUR HORSE

The Sulphur Horse Registry (SHR)
10909 N. 15th E.
Idaho Falls, ID 83401
www.sulphurhorseregistry.com

American Sulphur Horse Association
(ASHA)
Box 1163
Mulino, OR 97043
www.americanspanishsulpur.org

TENNESSEE WALKER

Tennessee Walking Horse Breeders and
Exhibitors Association (TWHBEA)
P.O. Box 286
Lewisburg, TN 37091
(800) 359-1574
www.twhbea.com

THOROUGHBRED

The Jockey Club (JC)
821 Corporate Drive
Lexington, KY 40503
(859) 224-2700
www.jockeyclub.com

TIGER HORSE

Tiger Horse Association (THA)
1604 Fescue Circle
Huddleston, VA 24104
(540) 297-2276
www.tigerhorses.org

Tiger Horse Breed Registry (THBR)
39 Crazy Rabbit Road
Santa Fe, NM 87508
(504) 438-2827
www.tigrehorse.com

TRAKEHNER

The American Trakehner Association
(ATA)
1514 West Church Street
Newark, OH 43055
(740) 344-1111
www.americantrakehner.com

WESTPHALIAN

Westfalen Horse Association (WHA)
(Registry)
W381 S5225, Highway ZC
Dousman, WI 53118
(262) 965-2066
www.westfalenhorse.com

WILBUR-CRUCE MISSION HORSE

Spanish Barb Breeders Association
P.O. Box 598

Anthony, FL 32617
(352) 368-5878
www.spanishbarb.com

Part III: Color "Breeds"

BUCKSKIN

International Buckskin Horse Association
(IBHA)
P.O. Box 268
Shelby, IN 46377
(219) 552-1013
www.ibha.net

PALOMINO

Palomino Horse Breeders of America
(PHBA)
15253 E. Skelly Drive
Tulsa, OK 74116
(918) 438-1234
www.palominohba.com

PINTO

Pinto Horse Association of America
7330 NW 23rd Street
Bethany, OK 73008
(405) 491-0111
www.pinto.org

National Pinto Horse Registry (NPHR)
2812 Velarde Drive
Thousand Oaks, CA 91360
(805) 241-5533
www.pintohorseregistry.com

Part IV: Ponies

AMERICAN QUARTER PONY

American Quarter Pony Association
(AQPA)
P.O. Box 30
New Sharon, Iowa 50207
(641) 675-3669
www.aqpa.com

International Quarter Pony Association
(IQPA)
P.O. 125
Sheridan, CA 95681
(916) 645-9313
www.netpets.com/~iqpa

AMERICAN WALKING PONY

American Walking Pony Association
(AWPA)
P.O. Box 5282
Macon, GA 31208
(912) 743-2321

CHINCOTEAGUE

National Chincoteague Pony Association
2595 Jensen Road
Bellingham, WA 98226
(360) 671-8338
www.pony-chincoteague.com

CONNEMARA

American Connemara Pony Society
(ACPS)
2360 Hunting Ridge Road
Winchester, VA 22603
(540) 622-5953
www.acps.org

Connemara Pony Breeders Society
Hospital Road
Clifton, County Galway
Ireland
www.cpbs.ie

DALES

Dales Pony Association of North America
(DPANA)
P.O. Box 733
Walkerton, Ontario
Canada N0G 2V0
(519) 395-4512
www.dalesponyassoc.com

Dales Pony Society (DPS)
Secretary
Greystones, Glebe Avenue
Great Longstone
Bakewell, Derbyshire, DE45 1TY
England
+01629 640439
www.dalespony.org

Dales Pony Society of America (DPSA)
c/o C. MacDonald
261 River Street
Halifax, MA 02338
www.dalesponies.com

DARTMOOR

Dartmoor Pony Registry of America
Lory Eighme (Registrar)
816 Old Schuylkill Road
Pottstown, PA 19465
(610) 495-6530

American Dartmoor Pony Association
(ADPA)
203 Kendall Oaks Drive
Boerne, TX 78006
http://members.aol.com/adpasec/
myhomepage

Dartmoor Pony Society
57 Pykes Down
Ivybridge
Devon PL21 087
England
www.dartmoorponysociety.com

EXMOOR

North American Exmoors
Anne Holmes
P.O. 155
Ripley, Ontario
Canada N0G 2R0
(519) 396-6146

Canadian Livestock Records Corp. (CLRC)
(maintains the registry in Canada)
2417 Holly Lane
Ottawa, ON
K1V 0M7

The Exmoor Pony Society (EPS)
Glen Fern, Waddicombe
Dulverton, Somerset, TA22 9RY
England

FELL

Fell Pony Society (FPS)
Ion House, Great Asby,
Appleby, Cumbria, CA16 6HD
England
+01768 353100
www.fellponysociety.org

The Fell Pony Society and Conservancy of
the Americas
10844 Highway 172
West Liberty, KY 41472
www.FellPony.org

Fell Pony Society of North America
(FPSNA)
Secretary
17138 275th Street
Council Bluffs, IA 51503
(712) 388-2217
www.fpsna.org

GOTLAND

Swedish Gotland Breeders Society (SGBS)
3240 Hinton-Weber Road
Corinth, KY 41010
Kokovoko@kih.net

HACKNEY

American Hackney Horse Society (AHHS)
4059 Iron Works Parkway
Lexington, KY 40511
(859) 255-8694
www.hackneysociety.com

KERRY BOG

American Kerry Bog Pony Society
(AKBPS)
13010 West Darrow Road
Vermillion, OH 44089
www.kerrybogpony.org
www.Kerrybogponies.info
www.thornapplefarms.com

LAC LA CROIX

Lac La Croix Indian Pony Society (LLCIPS)
c/o Equi Lore Farm
341-1 Clarkson Road, RR#1
Castleton, Ontario
Canada K0K 1M0
(905) 344-1026
www.nexicom.net/~hfm2/equilore.html

NEWFOUNDLAND

Newfoundland Pony Society (NPS)
Box 5022, Water Street
St. John's, Newfoundland
Canada A1C 5V3
(709) 895-3199

PONY OF THE AMERICAS

Pony of the Americas Club (POAC)
5240 Elmwood Drive
Indianapolis, IN 46203
(317) 788-0107
www.poac.org

SHACKLEFORD BANKER PONY

Foundation for Shackleford Horses
FSH, Inc.
108 Amos Gillikin Road
Beaufort, NC 28516
(252) 728-6308
www.shacklefordhorses.org

SHETLAND

The American Shetland Pony Club (ASPC)
81 B East Queenwood
Morton, IL 61550
(309) 263-4044
www.shetlandminiature.com

Shetland Pony Stud-Book Society
Shetland House
22 York Place
Perth, PH2 8EH
United Kingdom
01738 623471
www.shetlandponystudbooksociety.co.uk

WELARA

American Welara Pony Society (AWPS)
P.O. Box 401
Yucca Valley, CA 92286
www.WelaraRegistry.com

WELSH AND COBS

The Welsh Pony and Cob Society of
America (WPCSA)
P.O. Box 2977
Winchester, VA 22604
(540) 667-6195
www.welshpony.org

Part V: Heavy Horses, Donkeys, and Mules

AMERICAN CREAM DRAFT

American Cream Draft Horse Association
(ACDHA)
193 Crossover Road
Bennington, VT 05201
(802) 447-7612
www.americancreamdraft.org

BELGIAN
Belgian Draft Horse Corp. of America
 (BDHCA)
P.O. Box 335
Wabash, IN 46992
(260) 563-3205
www.belgiancorp.com

BRABANT
American Brabant Association (ABA)
2331A Oak Drive
Ijamsville, MD 21754
(301) 631-2222
www.ruralheritage.com/brabant

CLYDESDALE
Clydesdale Breeders of the U.S.A. (CBUSA)
17346 Kelley Road
Pecatonica, IL 61063
(815) 247-8780
http://clydesusa.com

DONKEYS, MULES, AND HINNIES
American Donkey and Mule Society
 (ADMS)
P.O. Box 1210
Lewisville, TX 75067
(972) 219-0781
www.lovelongears.com

American Council of Spotted Asses
Registrar
P.O. Box 121
New Melle, MO 63365
(636) 828-5955
www.spottedass.com

NORTH AMERICAN SPOTTED DRAFT
North American Spotted Draft Horse
 Association (NASDHA)
60418 CR 9 South
Elkhart, IN 46517
(574) 875-3904
www.nasdha.net

PERCHERON
Percheron Horse Association of America
 (PHAA)
P.O. Box 141
Fredericktown, OH 43019
(740) 694-3602
www.percheronhorse.org

SHIRE
American Shire Horse Association (ASHA)
P.O. Box 739
New Castle, CO 81647
(970) 876-5980
www.shirehorse.org

SUFFOLK PUNCH
American Suffolk Horse Association
 (ASHA)
4240 Goehring Road
Ledbetter, TX 78946
(409) 249-5795
www.suffolkpunch.com

OTHER HORSE–RELATED ORGANIZATIONS

Adopt-A-Horse Program
Bureau of Land Management (BLM)
U.S. Dept. of the Interior WO-200
Washington, DC 20240
(202) 653-9194

For updated breed association addresses:
agrinet.tamu.edu/groups/ghorse

American Livestock Breeds Conservancy
 (ALBC)
P.O. Box 477
Pittsboro, NC 27312
(919) 542-5704
www.albc-usa.org

Canadian Livestock Records Corp. (CLRC)
2417 Holly Lane
Ottawa, ON K1V 0M7

Canadian Warmblood Horse Breeders
 Association (CWHBA)
Box 21100
2105 8th St. East
Saskatoon, SK S7H 5N9
(306) 373-6620
www.canadianwarmbloods.com

Rare Breeds Canada (RBC)
341-1 Clarkson Road
RR# 1
Castleton, ON K0K 1M0
(905) 344-7768
www.rarebreedscanada.ca

United States Equestrian Federation
 (USEF; formerly the American Horse
 Shows Association)
4047 Iron Works Parkway
Lexington, Ky 40511-8483
(859) 258-2472
www.usef.org

Print Publications

American Bashkir Curly Registry. "History of Curly Horses." Promotional material.

American Cream Draft Horse Association. "The 'Cream' of Draft Horses." Promotional material.

American Paint Horse Association. "History of the Breed." Promotional material, 2004.

The American Shire Horse Association. "Have You Considered the Shire?" Promotional material.

Bowker, Nancy. *John Rarey, Horse Tamer.* London: J. A. Allen & Company, 1996.

Brander, Sue. "Saving the Kerry Bog Ponies." *Horsemen's Yankee Pedlar,* March 2004.

Campbell, K. Personal communication (e-mail) with author, March 2005.

Chenevix-Trench, Charles. *History of Horsemanship.* New York: Doubleday, 1970.

Colorado Ranger Horse Association. "Colorado Rangerbreds." Promotional material.

Denhardt, Robert Moorman. *The Horse of the Americas.* Norman: University of Oklahoma Press, 1947.

Edwards, Elwyn Hartley. *The Ultimate Horse Book.* New York: DK Publishers, 1995.

"Florida Cracker Horses." *American Livestock Breeds Conservancy News* 13, no. 5 (September–October 1996).

Frasier, Andrew F. *The Newfoundland Pony.* St. Johns: Creative Publishers, 1992.

Getzen, Sam P. "Crackers, Florida's Heritage Horse Breed." Florida Cracker Horse Association.

Green, Dr. Ben K. *The Color of Horses.* Flagstaff, AZ: Northland Press, 1974.

Hagwood, John A. *America's Western Frontiers: The Exploration and Settlement of the Trans-Mississippi West.* New York: Alfred A. Knopf, 1967.

Haynes, Glen W. *The American Paint Horse.* Norman: University of Oklahoma Press, 1976.

Hendricks, Bonnie L. *International Encyclopedia of Horse Breeds.* Norman: University of Oklahoma Press, 1995.

Heymering, Henry, RJF and CJF. "Who Invented Horseshoeing?" *Anvil* XVI, no. 3 (1991), 35.

Howard, Robert West. *The Horse in America.* Chicago: Follett Publishing Company, 1965.

Hutchins, Paul, and Betsy Hutchins. *The Modern Mule.* Denton, TX: Hee Haw Book Services, 1978.

"Jacks, Jennets and Mules." *U.S. Department of Agriculture Farmer's Bulletin* no. 1342. Denton, TX: Hee Haw Book Service.

Krakauer, Jon. *Under the Banner of Heaven.* New York: Doubleday, 2003.

McCarr, Ken. *The Kentucky Harness Horse.* Lexington: University of Kentucky Press, 1978.

"McCurdy's Doctor F-79, the McCurdys of Alabama." *The Tennessee Walking Horse* (July 1948).

Mellin, Jeanne. *The Morgan Horse.* Brattleboro, VT: The Stephen Greene Press, 1961.

North American Spotted Draft Horse Association. "The Versatile Spotted Draft." Promotional material.

North American Spotted Draft Horse Association. *2003 Membership Handbook.*

Oelke, Hardy. *Born Survivors on the Eve of Extinction.* Warnego, KS: Premier Publishing Equine, 1997.

Palomino Horse Breeders of America. *Palomino Official Handbook,* revised. Tulsa, January 1, 2001.

Palomino Horse Breeders of America. *Rulebook for 2001.*

Patten, John W. *Light Horse Breeds.* New York: Bonanza Books, 1960.

Richardson, Clive. *The Fell Pony.* London: J. A. Allen, an imprint of Robert Hale Ltd, 2000.

Roe, Frank Gilbert. *The Indian and the Horse.* Norman: University of Oklahoma Press, 1955.

Schindler, Harold. *Orrin Porter Rockwell: Man of God, Son of Thunder.* Salt Lake City: University of Utah Press, 1966; reprint, 1993.

Sponenberg, Phillip D. *Horse Color.* Emmaus, PA: Breakthrough Publications, 1992.

Strickland, Charlene. *The Warmblood Guidebook.* Middletown, MD: Half Halt Press, 1992.

Swedish Gotland Breeders Society. "The Best Pony on the Planet." Promotional material.

Tegetmeier, W. B., and C. L. Sutherland. *Horses, Asses, Zebras, and Mules.* Horace Cox, Windsor House, Bream's Buildings, E.C., 1895.

Vernon, Arthur. *The History and Romance of the Horse.* Boston: Waverly House, 1939.

Wilbur-Cruce, Eva Antonia. *A Beautiful, Cruel Country.* Tucson: University of Arizona Press, 1989.

Willoughby, David P. *The Empire of Equus.* South Brunswick, NJ: A. S. Barnes and Co., 1974.

Web Site Sources

Acadian Cultural Society. "Acadian Cultural Society—History." www.acadiancultural.org/intro.htm

The Akhal-Teke Association of America. "Akhal-Teke Breed Standard." www.akhal-teke.org/standard.htm

Akhal-Teke Information. "The Parthian Empire." www.parthia.com

"American Bashkir Curly." International Museum of the Horse. www.imh.org/imh/bw/curly.html (1999)

The American Brabant Association. www.ruralheritage.com/brabant

American Cream Draft Horse Association. "The History and Development of the American Cream Draft Horse." www.americancreamdraft.org/1948Pamphlet.htm

American Donkey and Mule Society. "Longear Lingo: Official American Donkey and Mule Society Terminology." www.lovelongears.com/longearlingo.html

The American Indian Horse Registry. "What's an American Indian Horse?" www.indianhorse.com/define.htm

"The Original Indian Horse: Designed by the Great Spirit, Decorated by Man." http.freeyellow.com

"American Miniature Horse." International Museum of the Horse. www.imh.org/imh/bw/mini.html (1997)

American Miniature Horse Association. "About the Breed." www.amha.org/index.asp?KeyName=12

The American Paint Horse Association. "The Genetic Equation." www.apha.com/breed/geneticq.html

American Paint Horse Association. "Overo Pattern." www.apha.com/breed/overo.html

American Paint Horse Association. "Tobiano Pattern." www.apha.com/breed/tobiano.html

American Paint Horse Association. "Tovero Pattern." www.apha.com/breed/tovero.html

American Quarter Pony Association. "Breed Standards and History." www.aqpa.com/aboutus.htm

American Shetland Pony. *The Journal of the American Shetland Pony Club.* www.horseshoes.com/magazine/shetland/amstpncl.htm

The American Trakehner Association. Goodman, Patricia L. "The Trakehner Horse—A History." www.americantrakehner.com/The%20Breed/history.htm

The American Walking Pony Association Founder. "The American Walking Pony—History." www.browntreehorses.com.

"Andalusian History." Caballo Park. www.caballopark.com.au/andalusian_history.php

"Appaloosa History & Information." Alasar Farm. www.geocities.com/alasar_farm/Info.html

Appaloosa Horse Club. "Appaloosa History." www.appaloosa.com/Association/history.shtm

"Arabian Horse History: Arabian Horses in America: *Leopard." Bell, Becki. Equine Post, www.equinepost.com/resources/eps/epsViewArchive.asp?Archive=147

"Azteca." International Museum of the Horse. www.imh.org/imh/bw/azteca.html (1998)

"Azteca—A Horse Custom-Built for Performance, Style and Tradition." Caskie, Donald M. *Equiworld Magazine.* www.equiworld.net/uk/horsecare/Breeds/azteca

"Battle-axe People." www.peacelink.de/keyword/Battle-axe_people.php

Belgian Draft Horse Corporation of America. "Belgian History." www.belgiancorp.com/files/history1.html

A Brief History of Hungary. Stephen Palffy. www.users.zetnet.co.uk/spalffy/h_10t009.htm

Brown, Mary Beth. "Her Name Is Sal: Musings on the Way to Mundane." The Chicago Literary Club; presented to the Fortnightly of Chicago and the Chicago Literary Club, March 7, 2003. www.chilit.org/BROWN.HTM

Canadian Horse. Hillsden, Yvonne. "History of the Canadian Horse." www3.telus.net/cdnhorse/history.htm

Canadian Livestock Record Corporation. www.clrc.on.ca

The Canadian Shire Horse Association. Anderson, Chris. "The Shire Horse."

www.canadianshirehorse.com/readingroom.html

The Canadian Shire Horse Association. Leach, Mike, "Historical Development of the Shire." www.canadianshirehorse.com/shirehistory

Canadian Sport Horse Association. "History and Philosophy." www.canadian-sport-horse.org/history-phil.shtml

Casa de Whatever. "Horse Colors." http://greenfield.fortunecity.com/dreams/799/hc/horsecolors.htm

"The Caspian Horse." Kristull Exotics, Inc. www.kristull.com/caspian.htm

"Cerbat Horses." www.angelfire.com/az/xochitl/Cerbats.html

"Cleveland Bay." Scott, Jane. International Museum of the Horse. www.imh.org/imh/bw/cleve.html

Cleveland Bay Horse Society of North America. www.clevelandbay.org

"Clydesdale." International Museum of the Horse. www.imh.org/imh/bw/clyde.html (1997, 2001)

Clydesdale Horse Society. "The History of the Clydesdale Horse Breed." www.clydesdalehorsesociety.com/history.htm

"Connemara Pony." International Museum of the Horse. www.imh.org/imh/bw/conn.html (1997, 2001).

Dales Pony Society. "History." www.Dalespony.org/history.htm

"The Dartmoor Pony." International Museum of the Horse. www.imh.org/imh/bw/dart.html

Desert Heritage Breeds. Schneider, Silke. "The Discovery of the Wilbur-Cruce Horse in 1989 and Its History." www.horseweb.com/desertrarebreeds/history.htm

"Donkey." International Museum of the Horse. www.imh.org/imh/bw/donkey.html

The Dutch Warmblood Studbook in North America. "History." www.nawpn.org/history.htm

"English Channel." Wikipedia, http://en.wikipedia.org/wiki/English_Channel

Equinecolor.com. "Color Information." www.equinecolor.com/color.html

"The Exmoor Pony." International Museum of the Horse. www.imh.org/imh/bw/exmoor.html

The Fell Pony Society of North America. "The Fell Pony—Early History." www.fpsna.org/history

"Florida Cracker." International Museum of the Horse. www.imh.org/imh/bw/flcrack.html

Friesian Horse Association of North America. "Time-Line of the History of the Friesian Horse." www.fhana.com/Timeline.php

The Friesian Horse in Australia and New Zealand. www.friesianhorses.com.au

Friesian Horse Society, Inc. "A Noble and Dramatic History." www.friesianhorsesociety.com/Organization.html

"Galiceño." Hardcastle Ranch. www.Galiceno.com

Hackney Horse. Nowak, Karen. "Evolution of the Hackney Horse." www.cowboyheaven.com/breeds/breed17.htm (10/95)

Hackney Horse Society. "Breed History." www.hackney-horse.org.uk/history.asp

Hackney Horse Society. "History of the Hackney Horse and Pony." www.hackney-horse.org.uk/history.asp

"Haflinger." International Museum of the Horse. www.imh.org/imh/bw/hafling.html

Havemeyer Foundation. "Domestication, Breed Diversification and Early History of the Horse." Marsha A. Levine. www3.vet.upenn.edu/labs/equinebehavior//hvnwkshp/hv02/levine.htm

"Holsteiner." International Museum of the Horse. www.imh.org/imh/bw/holstein.html

Hungarian Horse Association of America. "The Hungarian Breed." http://hungarianhorses.org/history_breed.html

Icelandics on Ice. "Tolt." www.icelandicsonice.com/html/tolt.html

Ideal Portugal. "History of Portugal with Ideal Portugal.com." www.idealportugal.co.uk/info_pages.history

International Quarter Pony Association. "IQPA Description/History." www.netpets.org/horses/horsclub/descriptions/iqpony.html

Kentucky Mountain Saddle Horse Association. Patterson, Vera. "About Us: What Is the Kentucky Mountain Horse?" www.kmsha.com/about/index.html

"Kerry Bog Pony (Irish Heritage Pony) Information." www.ennisstud.co.uk/kerrybog.html

"The Kiger Mustang—History." High Desert Kigers and Matt Fournier Training Center. www.highdesertkigers.com

Lishmar Connemara Ponies. "History." www.irishpony.com/history.html

"Lipizzan." Horse Breeds, Oklahoma State University. www.ansi.okstate.edu/breeds/horses/LIPIZZAN

Lipizzan Association of North America. "Lipizzan History." www.lipizzan.org/History.htm

"The Lipizzaner." Horseshoes. www.geocities.com/Heartland/Village/4369/lippy.html

"Lipizzaner Horse." Government of Slovenia: Public Relations and Media Office. www.uvi.si/eng/slovenia/background-information/lipizzaners

"Lipizzaner—The Slovenian Breeding Pearl." Slovenija. http://marc.s5.net/clanek_ang.html

"Mangalarga Marchador." International Museum of the Horse. www.imh.org/imh/bw/mmarch.html

McCurdy Plantation Horse Association. "The McCurdy Plantation Horse." www.mccurdyhorses.com/themccurdyplantationhorse.htm

"Meet the Mangalarga Marchador." *The Gaited Horse Magazine.* www.thegaitedhorse.com/mangalarga.htm

Morab Publishing Archives. Luedke, Ted. "The Morab Horse Official History." www.boxlt.com/PUBLISHING/history.html

The Mountain Pleasure Horse Association. www.mtn-pleasure-horse.org

The National Museum of the Morgan Horse. Curler, Elizabeth. "Justin Morgan the Man." www.morganmuseum.org/html/justinmorgan.html

The National Museum of the Morgan Horse. "The Life and Times of Figure." www.morganmuseum.org/html/figure.html

The National Museum of the Morgan Horse. "Morgan Horses in American History." www.morganmuseum.org/html/amhistory.html

The National Museum of the Morgan Horse. "Morgan Horses in the Civil War." www.morganmuseum.org/html/civilwar.html

The National Museum of the Morgan Horse. "Morgan Horses in the West." www.morganmuseum.org/html/morganwest.html

"National Show Horse." International Museum of the Horse. www.imh.org/imh/bw/natshow.html

"The Newfoundland Pony." Newfoundland and Labrador Agriculture. www.gov.nf.ca/agricher&rab/svoll.htm

The Nokota Horse Conservancy: Saving the Native Horse of the Northern Plains. www.nokotahorse.org

"The North American Colonial Spanish Horse, part 1, History." Phillip D. Sponenberg. *Conquistador Magazine.* www.conquistador.com/mustang.html

"The North American Single-footing Horse Association." www.singlefootinghorse.com/info.html

"The Norwegian Fjord Horse." International Museum of the Horse. www.imh.org/imh/bw/nfjord.html

Nova Scotia Museum of Natural History and the Sable Island Preservation Trust. "Free as the Wind: Horses and Humans." http://collections.ic.gc.ca/sableisland/english_en/nature_na/horses_ho/humans-horses_ho.htm

Ohop Valley Hungarian Horse Farm. "History of the Hungarian." http://ovhhf.com/svhist01.htm

Oldenburg Registry North America and International Sporthorse Registry. "Eligibility." www.isroldenburg.org/?pid=mares_eligibility

"The Golden Palomino Horse." The Pennsylvania Palomino Exhibitors Association. www.pennpalomino.com/about/thepalomino.html

"Palomino." Cremello and Perlino Educational Association. www.doubledilute.com/palomino.htm

Palomino Horse Breeders of America, Inc. Burns, Shirley. "The Bottom Line (charts and statistics for 2000)."

"The Paso Fino." Gaited Horses. www.gaitedhorses.net/BreedArticles/Paso Fino.htm

Percheron. "The History of the Percheron." Draft-E-Knoll Farms. www.percheron.ca/history.htm

Peruvian Paso Horses. American Association of Owners and Breeders of Peruvian Paso Horses. "Breed Standard." www.aaobpph.org/pdf/breedstandart.pdf

Pinto Horse Association of America. "Pinto Horse Association Rulebook." www.pinto.org/pintorulebook.htm

POA Club. "History." www.poac.org/breed/history.htm

"Pryor Mountain Mustang." Poe, Rhonda H. The Gaited Horse Magazine. www.thegaitedhorse.com/pryor_mountain_mustang.htm

"The Pryor Mountain Mustangs." South Dakota Public Broadcasting. www.sdpb.org/TV/oto/horses/pryor_mtn.asp

"Racking Horse." Horse Breeds, Oklahoma State University. www.ansi.okstate.edu/breeds/horses/racking

RareSteeds.com. "Shagya-Arabian Breed Background." Lost Creek Ranch. http://raresteeds.com/LostCreek Ranch/breedbackground.htm

Rockin' Bar H Nokota Horses. "Nokota History." www.rockinbarh.com/Nokota History/nokotahistory.htm

"Rocky Mountain Horse." International Museum of the Horse. www.imh.org/imh/bw/rocky.html

Rocky Mountain Horse Association. "History of the Breed." www.rmhorse.com/history.html

Rocky Mountain Horse Association. "Registry Handbook." www.rmhorse.com/registryhandbook.html

"Sable Island: A Story of Survival." Nova Scotia Museum of Natural History and the Sable Island Preservation Trust. http://collections.ic.gc.ca/sableisland/english_en/index_en.htm

"Sable Island: How Horses Came to Sable." Nova Scotia Museum of Natural History and the Sable Island Preservation Trust. http://collections.ic.gc.ca/sableisland/english_en/nature_na/horses_ho/horses-came_ho.htm

"Selle Français." International Museum of the Horse. www.imh.org/imh/bw/sellefr.html

"Shagya Arabian." Horse Breeds, Oklahoma State University. www.ansi.okstate.edu/breeds/horses/shagya

"Shagya Arabian Breed." North American Shagya Arabian Society. www.shagya.net

"Shagya Arabian History." Webpony. www.white_arabian.tripod.com/shagyaarab.html

Sherman Farms Grullo Quarter Horses. "All About Grullo/Grulla Color." http://grullaorgrullo.homestead.com/files/on_grullo_color_5.htm

Sherman Farms Grullo Quarter Horses. "Grulla or Grullo." http://grullaorgrullo.homestead.com/index.html

"Shetland Pony." International Museum of the Horse. www.imh.org/imh/bw/shet.html

The Shetland Pony Stud-book Society. "About the Breed." www.equinepost.com/resources/eps/epsViewArchive.asp?Archive=147

"Shire Draft Horse." International Museum of the Horse. www.imh.org/imh/bw/shire.html

Smiling-horse.com. "Boulonnais." www.smiling-horse.com/boulonnais.html

"The Sorraia Horse Link to Antiquity." Dr. Hardy Oelke. Conquistador Magazine. www.conquistador.com/sorraia.htm

Southwest Andalusian & Lusitano Horse Club. "Andalusian History." www.sw-andalusian-club.com/history.htm

Spanische Hofreitschule. "History of the Spanish Riding School." www.spanische-reitschule.com/

"Spanish Barb." International Museum of the Horse. www.imh.org/imh/bw/sbarb.html

Spanish Barb Breeders Association. "The Origin of the Spanish Barb Horse." www.spanishbarb.com/the_spanish_barb/

Spanish Barb Breeders Association. "The Spanish Barb: An American Legacy." www.spanishbarb.com

Spanish Mustang Registry. Roubidoux, Ron. "Wild Horses of Utah's Mountain Home Range." www.frontiernet.net/~sulphur/Roubidoux1.html

The Spanish Mustang Registry. "The Spanish Mustang: History and Information." www.spanishmustang.org/info/whatisit.html

"Suffolk Draft Horse." International Museum of the Horse. www.imh.org/imh/bw/suffolk.html

BIBLIOGRAPHY CONTINUED

"Suffolk Punch." *Take Our Word for It,* issue no. 132 (August 1, 2001), 2. www.takeourword.com

"Suffolk Punch Draft Horses." *Farm & Garden.* http://www.farm-garden.com/ draft-horses/12/

The Suffolk Punch Pages. "About." www.suffolkhorse.com

Sulphur Horse. Cothran, E. Gus. "Genetic Analysis of the Sulphur Herd." www.sulphurhorse.com

The Sulphur Horse Registry. "History of the Sulphur Springs Herd Management Area and the Sulphur Horse Registry." www.spanishsulphurs.com/Sulphur_ SpringsHMA.html

"The Sulphur Springs Mustangs." Oelke, Hardy. www.Sulphurs.com

Sulphurs. "What the Experts Say about the Breed." www.Sulphurs.com

Sveinsstadir Iceland. "History and Gaits of Icelandic Horses." http://magnus.iceryder.net/custom3.html

"Tennessee Walking Horse: History." Tennessee Walking Horse OnLine. www.walking-horse.com/history.html

"Tennessee Walking Horse." International Museum of the Horse. www.imh.org/imh/bw/tenn.html

"Tiger Horse." Horse Breeds, Oklahoma State University. www.ansi.okstate.edu/ breeds/horses/tiger

"Tiger Horse." International Museum of the Horse. www.imh.org/imh/bw/tiger.html

"Tiger Horse Philosophy." Tiger Horse Breed Registry. www.tigrehorse.com/ PHILOSOPHY/philosophy.html

"The Tiger Horse." Poe, Rhonda Hart. *The Gaited Horse Magazine.* www.thegaitedhorse.com

"The Tiger Horse." TIGRE: The Tiger Horse Registry. www.geocities.com/ Yosemite/Trails/2787/

Trakehners International. "History of the Trakehner Horse." www.trakehners-international.com/history.html

"Welara History." The American Welara Pony Registry. www.welararegistry.com/ registry/History.html

Veterinary Genetics Laboratory. "Coat Color Genetics: Positive Horse Identification." Ann T. Bowling. www.vgl.ucdavis.edu/~lvmillon/coat color/coatclr3.html

Veterinary Genetics Laboratory. "The New Genetics of Overo." Laurie Fio. www.vgl. ucdavis.edu/~lvmillon/overo.htm

"Virginia Single-Footers." *The Gaited Horse Magazine.* www.thegaitedhorse.com/va_single.htm

"The Welara Pony." *Equiworld Magazine.* www.equiworld.net/uk/horsecare/Breeds/ welarapony/index.htm

"The Welsh Ponies and Cobs." International Museum of the Horse. www.imh.org/imh/bw/welsh.html

Welsh Pony and Cob Society. "The Society: Introduction" (the studbook). www.wpcs.uk.com/society/index

Western Haflinger Association. "Breed History." www.westernhaflinger.com/ standards.htm

Western Haflinger Association. "Breed Standards." www.westernhaflinger.com/ thehaf.htm

"Wilbur-Cruce Colonial Spanish Mission Herd." Return to Freedom: American Wild Horse Sanctuary. www.returntofreedom. org/conservation/wilbur.htm

XP Pony Express Home Station. MacKinnon, Bill. "A Fast Mail Service." www.xphomestation.com/mormonwar. html

Becoming an Effective Rider, by Cherry Hill. Develop your mind and body for balance and unity using a range of techniques that help riders reach full mental and physical potential, whether in recreational riding or formal dressage. 192 pages.
Paperback. ISBN 0-88266-688-6.

Easy-Gaited Horses, by Lee Ziegler. An in-depth guide to working with gaited horses by one of the world's leading experts on the subject. Includes line drawings and diagrams. 256 pages.
Paperback. ISBN 1-58017-562-7.
Hardcover. ISBN 1-58017-563-5.

Getting Your First Horse, by Judith Dutson. Buying your first horse is an exciting but often daunting experience. Dutson's expert guidance takes you step by step through the buying or leasing process and covers everything from what to look for in a horse to how to keep your horse healthy and happy. 176 pages.
Paperback. ISBN 1-58017-078-1.

Horse Breeds Poster Book, photographs by Bob Langrish. Suitable for hanging on bedroom walls, in school lockers, or even in barns, these 30 posters show horses in a range of colors and sizes, at work and in competition, with facts about the pictured breed included on the back of each poster. 64 pages.
Paperback. ISBN 1-58017-507-4.

The Horse Conformation Handbook, by Heather Smith Thomas. How to judge a horse for soundness, athletic potential, trainability, longevity, and heart. Analyzes all aspects of conformation in regard to a horse's performance and suitability for particular functions.
Paperback. ISBN 0-58017-558-9;
Hardcover. ISBN 0-58017-559-7.

Horsekeeping on a Small Acreage, 2nd ed., by Cherry Hill. Thoroughly updated, full-color edition of the best-selling classic details the essentials for designing safe and functional facilities whether on one acre or one hundred. Hill describes the entire process: layout design, barn construction, feed storage, fencing, equipment selection, and much more. 320 pages.
Paperback. ISBN 1-58017-535-X.

Storey's Horse Lover's Encyclopedia, edited by Deborah Burns. This hefty, fully illustrated, comprehensive A-to-Z compendium is an indispensable answer book addressing every question a reader may have about horses and horse care. 480 pages. Paperback. ISBN 1-58017-317-9.

Trail Riding, by Rhonda Hart Poe. This comprehensive resource with fundamental instruction and detailed advice on every aspect of trail riding is essential reading for everyone who rides anywhere other than in the ring. 320 pages. Paperback. ISBN 1-58017-560-0.

These books and other Storey books are available wherever books are sold, or directly from Storey Publishing, 210 MASS MoCA Way, North Adams, MA 01247 or by calling 1-800-441-5700.
www.storey.com